PINK
FLOYD
ALL THE
SONGS

PINK FLOYD
ALL THE SONGS

THE STORY BEHIND
EVERY TRACK

JEAN-MICHEL GUESDON & PHILIPPE MARGOTIN

BLACK DOG
& LEVENTHAL
PUBLISHERS
NEW YORK

Table of Contents

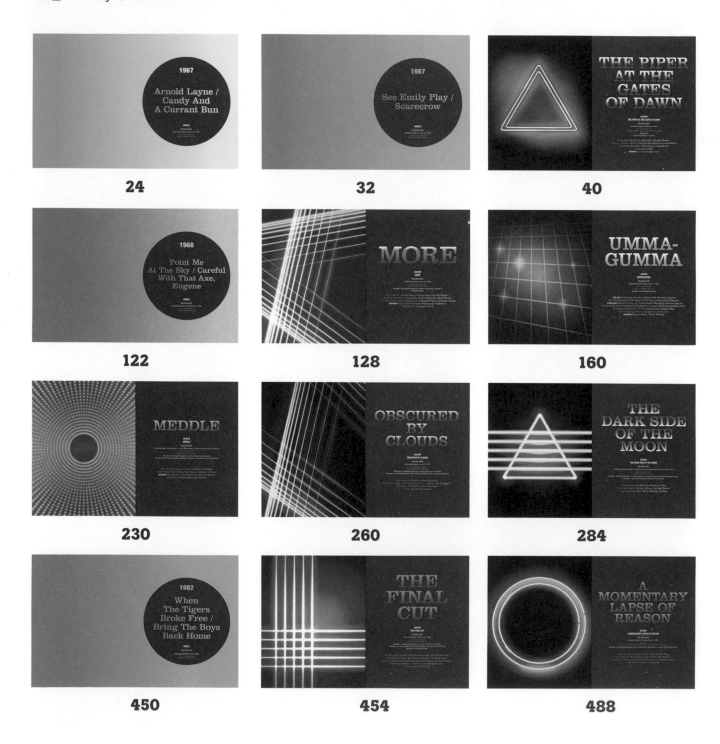

Foreword

Founded by Joe Boyd and John "Hoppy" Hopkins, the UFO Club opened its doors at 31 Tottenham Court Road on December 23, 1966. The occasion was marked by a show named "UFO Presents Night Tripper," which included underground movies from New York plus music from Soft Machine and...Pink Floyd. The Floyd presented psychedelic versions of old blues songs, an enthralling light show, and, most importantly, occupying the front of the stage, a singer and guitarist with long curly hair and a vacant gaze that gave him an air of being lost in his own strange thoughts. His name? Syd Barrett. Jenny Fabian, author of the book *Groupie*, would never forget the thrilling performance by the still largely unknown quartet: "They were the first group to open people up to sound and colour," she writes.

A few months later, on June 16 and August 4 respectively, the Floyd's first single, "See Emily Play," and first album, *The Piper at the Gates of Dawn*, were released, marking the start of Pink Floyd's vinyl odyssey, the magical adventure of four students named Syd Barrett, Roger Waters, Rick Wright, and Nick Mason. The adventure would continue with *A Saucerful of Secrets*, which saw the arrival of David Gilmour as Syd Barrett's successor (although Syd still has a presence on that album), the soundtrack of Barbet Schroeder's movie *More*, plus *Ummagumma*, *Atom Heart Mother*, *Meddle*, *The Dark Side of the Moon*, *Wish You Were Here*, and *The Wall*...truly legendary albums in which the genres heroic fantasy, space opera, psychedelia, symphonic rock, and musique concrète (concrete music) rubbed shoulders or followed in succession. Albums that took Pink Floyd to the top of the prog-rock hierarchy and enabled them to establish themselves as one of the most influential groups not only in the history of rock, but in twentieth-century music as a whole.

It is to this unique musical approach, which continues to attract real interest and inspire no less real musical vocations today, that this book pays tribute. From their first single in 1967 to the album *The Endless River* in 2014, Pink Floyd has recorded tracks ranging from the acoustic ballad to the orchestral suite, from the movie soundtrack to the concept album. Analyzing the words and music, detailing the instruments, recording studios, producers, sound engineers, session musicians, and telling countless anecdotes, *Pink Floyd: All the Songs* uniquely and exhilaratingly offers total immersion in the creative process of this British band. The book is based on Pink Floyd's official British discography (antecedent to the box set *The Early Years: 1965–1972*, released in November 2016). The outtakes described in it also form part of the official discography and therefore do not include bootlegs. These outtakes have been added to the track listings of several Pink Floyd albums rereleased on CD, notably *Works*, *Zabriskie Point*, and the Experience Edition series. Where the track listing of the US pressing differs, we have pointed this out. Similarly, in order to be as honest as possible with our readers, where the name of a musician or a recording date is uncertain or even unknown, we have indicated this with a (?). Finally, the B-sides of singles that have already been or are subsequently covered in the book within the context of an album are accompanied by an asterisk.

Over forty years ago, Pink Floyd went down in history with their three brilliant albums *Atom Heart Mother*, *Meddle*, and *The Dark Side of the Moon*. *Pink Floyd: All the Songs* turns the spotlight on the complete works, examining each one in a new and objective light. The curtain opens with "See Emily Play," the strange story of a young woman with a tendency to borrow other people's dreams and cry after dark....

Note: The order of appearance of the musicians in the technical listing for each track has been chosen on the basis of the orchestral position of each instrument in the group: first of all the guitars, followed by the keyboards, and then the rhythm section, comprising the bass and drums (or percussion). Additional musicians are listed after the band members.

Cambridge in the '60s: a punt
on the River Cam, with King's
College in the background.

The Cambridge Syndrome

Since the second half of the sixties, Cambridge has been known for more than just the excellence of its university. This small city, through which the River Cam meanders, owes at least part of its latter-day renown to a group of young progressive rock musicians who, postdating the Beatles and the Rolling Stones by a few years, ushered in rock's second revolution, that of psychedelia and avant-gardism. Three of Pink Floyd's founder-members grew up in Cambridge and underwent their musical initiation there at the beginning of the decade, a time when the musical life of the prestigious university city was astonishingly vibrant. "Cambridge was a great place to grow up," says David Gilmour. "You're in a town dominated by education, you're surrounded by bright people. But then it's also got this rural heart that spreads practically to the centre. There were great places to meet up with friends."[1] This intellectually stimulating place with its pastoral setting was to leave its mark on the early years of the Floyd.

Roger Barrett, the Soul of the Group

Roger Keith "Syd" Barrett, the soul of the group, was born at 60 Glisson Road, Cambridge, on January 6, 1946. He was the fourth of Winifred (née Flack) and Arthur Max Barrett's five children. An eminent anatomist and histologist at the university, Dr. Barrett was also an enlightened music lover (a member of the Cambridge Philharmonic Society) and, as a very good classical pianist, an experienced practical musician. It was therefore only natural that he should instill an interest in music in his three sons (Alan, Donald, and Roger) and two daughters (Rosemary and Ruth). At the tender age of seven, Roger and his sister Rosemary won a classical piano competition as a duo. Winifred was an extremely open-minded woman said by some to be related to Elizabeth Garrett Anderson, the first Englishwoman to have gained a degree in medicine and to have been elected a mayor.

In 1950, the Barrett family moved to a larger house at 183 Hills Road. After a few years, Syd entered the prestigious Cambridgeshire High School for Boys, where he took little interest in any of his subjects except art (for which he showed quite an aptitude), and displayed even less enthusiasm for the strict discipline that was enforced at the school.

On December 11, 1961, just a few weeks after being diagnosed with inoperable cancer, Arthur Max Barrett died aged fifty-two. Syd was profoundly affected by the loss. Before long, the family's worsening financial circumstances forced his mother to take in lodgers, radically changing the atmosphere that had reigned in the family home up to then. The teenager took refuge more than ever in his painting and music, and started listening to the US pioneers of rock 'n' roll, whose records were aired regularly on Radio Luxembourg, but also Lonnie Donegan, who started the fashion for skiffle in the United Kingdom.

After trying his hand at the ukulele and the banjo at the age of eleven, Syd took up the guitar two or three years later. His first instrument was probably an acoustic Hofner Congress, bought for £12, which he strummed in the family sitting room with friends on a Sunday afternoon. In spring 1962, Syd Barrett joined his first group, Geoff Mott and The Mottoes, which was the occasion for him to swap his acoustic guitar for an electric costing £25. According to Roger Waters, this was a Futurama III, imported by Selmer and manufactured in Czechoslovakia. It was the same model that George Harrison was using in Hamburg. In addition to Barrett, this neighborhood band comprised Geoff Mott on lead vocals and guitar, Tony Sainty on bass, and Clive Welham on drums. Their material consisted of the latest hits by the Shadows and rock 'n' roll numbers recorded a few years earlier by Eddie Cochran and Buddy Holly. The rehearsal venue was Barrett's home. "Roger's old playroom now had the atmosphere of a coffee bar as the teenagers chatted,

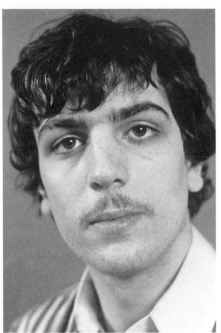

Syd Barrett in 1966. A mustache was *de rigueur* for any self-respecting English dandy.

smoked, listened to records or proudly showed off their new guitars," write Mike Watkinson and Pete Anderson.[2]

David Gilmour, a Child of Grantchester

At this time, Clive Welham was in the habit of turning up at Syd Barrett's house with one of his best friends, a certain David Gilmour. Born in Trumpington, a village near Cambridge, in 1946, David Jon Gilmour spent part of his childhood in the district of Newnham, specifically at 109 Grantchester Meadows, not far from the celebrated meadow bordering the Cam, which the group was to immortalize in a song a few years later. He was the eldest of Sylvia and Doug Gilmour's four children, the other three being Peter, Mark, and Catherine. Sylvia was initially a teacher and subsequently a film editor, working on a regular basis for the BBC, while Doug was a senior lecturer in zoology at Cambridge University. Like Syd Barrett, David Gilmour came from a family of intellectuals interested in different forms of artistic expression, in particular, music. "My parents sung well," he recalls, "my brother played flute, and my sister the violin."[3] He himself chose the guitar, under the influence of Bill Haley and Elvis Presley as well as various great names from the blues, from Howlin' Wolf to the duo Sonny Terry & Brownie McGhee, and the Shadows (featuring Hank Marvin on Stratocaster). And then there were the Beatles and the Rolling Stones, who

HE WAS NAMED ROGER BUT KNOWN AS SYD!

The origin of the nickname "Syd" is the subject of debate. According to Nick Mason, "Syd was not always Syd—he'd been christened Roger Keith, but at the Riverside Jazz Club he frequented in a local Cambridge pub, one of the stalwarts was a drummer called Sid Barrett. The club regulars immediately nicknamed this newly arrived Barrett 'Syd,' but with a 'y' to avoid total confusion, and that's how we always knew him."[5] Others maintain that Roger had simply found the first name of this drummer (or double bassist according to some) to his liking. Yet another version suggests that he had been renamed well before this time, during a boy scouting event at which he had opted to wear a cap rather than the traditional beret. Nevertheless, he never really took to it, especially in the presence of his family.

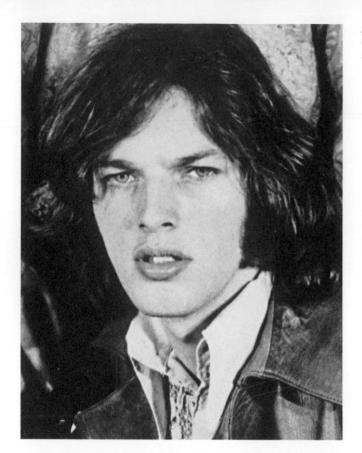

Around this time, David Gilmour, a childhood friend of Syd Barrett's, was a big fan of the Beatles and the Stones.

Roger Waters never went anywhere without his guitar, and Nick Mason recalls the motto inspired by a Ray Charles song that was inscribed on his instrument case: "I Believe to My Soul."

had started to shake things up. Years later, Gilmour would remember spending hours with Barrett playing the Stones' first single, "Come On," over and over again, music that sealed a firm friendship…

Roger Waters, the Group's Political Conscience

Another musician with similar musical tastes to Syd and David was George Roger Waters. Born in Great Bookham, Surrey, on September 6, 1943, George Roger, more readily called Roger, was the youngest son of Mary and Eric Fletcher Waters. His father, a physical education teacher, was simultaneously a devout Christian and a member of the Communist Party. A conscientious objector when Great Britain declared war against Nazi Germany, Eric served as an ambulance driver during the Blitz. Abandoning his pacifist ideals, he subsequently enlisted in the British Army, joining Z Company of the Eighth Battalion, Royal Fusiliers. On February 18, 1944, Second Lieutenant Waters fell at Aprilia, on the Italian Front, following the Allied landing at Anzio. As a result, Roger Waters, then aged five months, would never know his father. The resulting trauma was to haunt him for years and would play a key role in many of his future compositions, in particular those on the albums *The Wall* (1979) and *The Final Cut* (1983).

The following year, Mary Waters and her sons left Surrey, which was being subjected to heavy V-1 bombardment, to go and live at 42 Rock Road in Cambridge. A teacher by profession, Mary obtained a position at Morley Memorial Primary School on Blinco Grove, where she was to oversee not only her own son's education, but Syd Barrett's as well.

A few years later, Roger Waters entered the Cambridgeshire High School for Boys, where Syd Barrett also studied. Their initial bond was founded on rock 'n' roll and the Beat literature of Jack Kerouac and William S. Burroughs. Roger Waters was a politically committed teenager. By the tender age of fifteen, he was already a member of the Cambridge Young Socialists and the Youth Campaign for Nuclear Disarmament (YCND), a pacifist organization that advocated the unilateral nuclear disarmament of the United Kingdom. It was in one of the YCND's marches, for which he designed the poster, that he became firm friends with Syd Barrett.

All Roads Lead to London

In 1962, the paths of the three friends diverged as they pursued their different studies. In September, Syd Barrett embarked on an art course at Cambridge College of Arts and Technology (to which he had won a scholarship) on Collier Road, where David Gilmour was studying modern languages (including French); Roger Waters left Cambridge to study architecture at Regent Street Polytechnic in London.

Between 1962 and 1964, all three notched up a variety of musical experiences. Leaving Geoff Mott and The Mottoes, Syd Barrett joined Those Without in 1964 (the band's name was inspired by the title of Françoise Sagan's 1957 novel *Dans un mois, dans un an*, translated into English as *Those without Shadows*), which had risen out of the

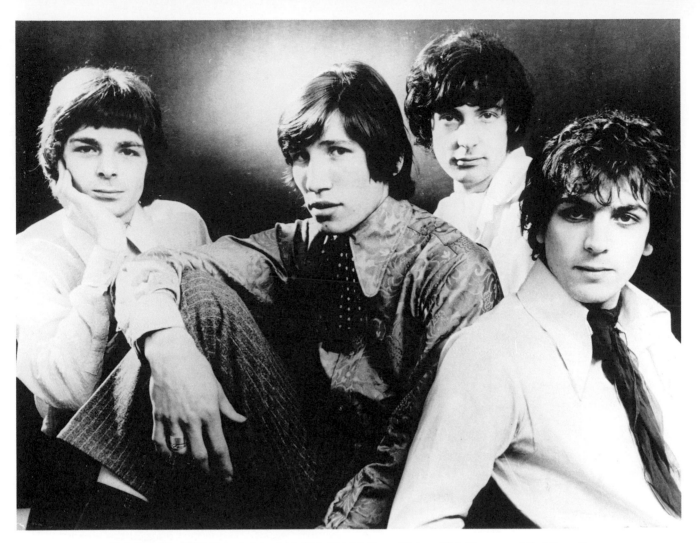

Pink Floyd in 1967. From left to right: Rick Wright, Roger Waters, Nick Mason, and Syd Barrett.

ashes of the Hollerin' Blues (whose name had been taken from Charley Patton's "Screamin' and Hollerin' the Blues," recorded in 1929). Syd played both a Hofner 500/5 bass and a 1960 six-string Hofner Committee.

David Gilmour played with various bands, including the Newcomers and the Ramblers, before joining the blues-rock group Jokers Wild in 1964.

As for Roger Waters, in autumn 1963 he became a member of Sigma 6, a group formed by two of his fellow students at the polytechnic, Clive Metcalf and Keith Noble. "I was doing architecture at the Regent Street Polytechnic," recalls Roger. "I suppose we formed several groups there. It wasn't serious, we didn't play anywhere. [...] We just sat around talking about how we would spend the money we would make. [...] In college there's always a room where people seem to gravitate to with their instruments and bits of things [...]"[4] Clive Metcalf was on bass, Keith Noble on vocals, Roger Waters on lead guitar, Rick Wright on rhythm guitar and keyboards, Nick Mason on drums, and, occasionally, Keith's sister Sheilagh Noble and Juliette Gale, Rick's future wife, also on vocals. At the beginning of 1964, the group was renamed the Abdabs (without Sheilagh Noble). Their

repertoire consisted of US standards such as "Summertime," blues such as "Crawling King Snake," and numbers written by Ken Chapman, a friend of Metcalf's who would become the group's manager. It was here that Roger Waters made the acquaintance of Rick Wright and Nick Mason.

Rick Wright and Nick Mason

Richard William Wright was born on July 28, 1943, in Pinner, Middlesex, to Daisy and Cedric Wright. His father was a biochemist at Unigate Dairies (then Uniq plc) and the family lived in Hatch End, a well-heeled suburb in northwest London. Rick was the beneficiary of a middle-class education, attending a very select private school. He initially learned piano and trumpet and, later, while convalescing from a broken leg, taught himself the guitar by listening to the American pioneers of the blues. He then developed this musical knowledge further at the Eric Gilder School of Music in London, where he studied composition and theory. It was at this time that he discovered the jazz of Miles Davis (the LPs *Kind of Blue* and *Porgy and Bess* in particular), John Coltrane, Horace Silver, Art Blakey, and others. Yet in 1962, he enrolled in the architecture program at Regent Street

Thirty-nine Stanhope Gardens, Mike Leonard's Victorian house where Pink Floyd started life.

Polytechnic. Nick Mason would remember him as "…someone quiet, introverted…"[5]

Nicholas Berkeley Mason hails from Edgbaston, a suburb of Birmingham, where he came into the world on January 27, 1944. In addition to their son, his parents Sally and Bill (properly Rowland Hill Berkeley Mason) also had three daughters: Sarah, Melanie, and Serena. Immediately after the war, Nick's father, a documentary filmmaker, was given the opportunity to join the Shell Film Unit. The entire Mason family moved to London, where they lived in the affluent district of Hampstead. The young Nick was put through a number of educational establishments and, inevitably, came to see the rock 'n' roll revolution as a potent message of emancipation. At twelve years of age, he would spend whole nights listening to the show *Rockin' to Dreamland* on Radio Luxembourg and bought himself Elvis Presley's early 78s. Smitten with rock 'n' roll, he dreamed of starting a band with his pals, even though none of them could really play an instrument! It was more or less by default that Nick turned to percussion, and partly too because he was given a pair of brushes as a present: "After the failure of my early piano and violin lessons, this seemed a perfectly legitimate reason to become a drummer."[5] The story then moves to Frensham Heights, a private school in Surrey (where he would meet his future first wife, Lindy), and subsequently, in 1962, the polytechnic, where he got to know Rick Wright and Roger Waters. "One afternoon, as I tried to shut out the murmur of forty fellow architectural students so that I could concentrate on the technical drawing in front of me, Roger's long, distinctive shadow fell across my drawing board," he recalls in his autobiography. "Although he had studiously ignored my existence up until that moment, Roger had finally recognized in me a kindred musical spirit trapped within a budding architect's body. The star-crossed paths of Virgo and Aquarius had dictated our destiny, and were compelling Roger to seek a way to unite our minds in a great creative adventure," writes the Pink Floyd drummer tongue-in-cheek, before shattering the illusion: "No, no, no. […] The only reason Roger had approached me was that he wanted to borrow my car."[5]

Leonard's Lodgers

Waters, Mason, and Wright (the latter in the meantime having quit the Regent Street Polytechnic for the London College of Music) decided to pursue their musical adventure together, leaving Metcalf and Noble to go their own way. Thirty-nine Stanhope Gardens, in the London district of Highgate, was a vast Edwardian house that had just been bought by Mike Leonard, a devotee of light shows who was a lecturer at Regent Street Polytechnic and Hornsey College of Art. This became not only their home but also their new rehearsal space. "Stanhope Gardens made a real difference to our musical activities," writes Nick Mason. "We had our own permanent rehearsal facility, thanks to an indulgent landlord: indeed, we used the name Leonard's Lodgers for a while. Rehearsals took place in the front room of the flat where all the equipment was permanently set up. Unfortunately, this made any study very difficult and sleep almost out of question since it was also Roger's and my bedroom."[5]

In September 1964, a new musician joined Leonard's Lodgers. A former pupil at Cambridgeshire High School, Rado "Bob" Klose was a long-standing acquaintance of David Gilmour and Syd Barrett. And it was with Syd that he came to London, taking up a place at the Regent Street Polytechnic (two years below the Waters-Wright-Mason trio) while Barrett pursued his study of painting at Camberwell

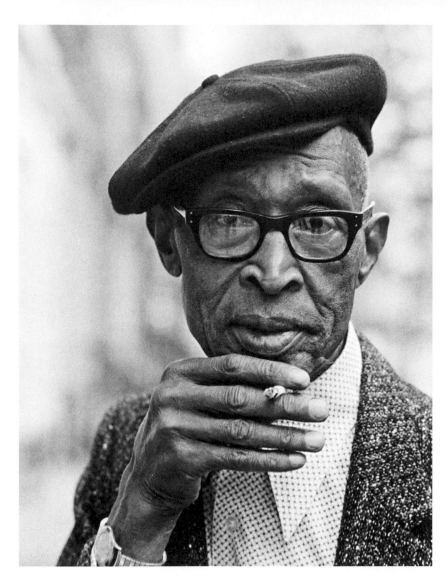

The bluesman Pink Anderson (shown here in 1973), from whom the group took the first half of its name.

A poster announcing two events described as a "POP DANCE—With Fantastic Effects" at All Saints Church Hall, where Pink Floyd performed regularly in 1966.

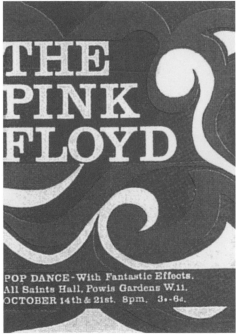

School of Arts and Crafts. Klose moved into the first floor of Stanhope Gardens, occupying the room vacated by Mason, who had moved back in with his parents for financial reasons. Klose was an experienced guitarist who listened to a lot of blues and jazz (especially Mickey Baker). He suggested to Waters, Wright, and Mason that they bring in Chris Dennis as singer. Then working as a dentist at the Northolt RAF base, Dennis happened to own, recalls Nick Mason, a "Vox PA system consisting of two columns and a separate amplifier with individual channels for the microphones."[5] Tea Set, the lineup with Dennis, lasted for just two short months, until the arrival of Syd Barrett.

"Syd" and the Birth of the Pink Floyd Sound

Roger Waters thought about bringing Syd into the band as soon as he heard that his childhood friend had come to college in London. "It was great when Syd joined," recalls Rick Wright. "Before him we'd play the R&B classics, because that's what all groups were supposed to be doing then. But I never liked R&B very much. I was actually more of a jazz fan. With Syd, the direction changed, it became more improvised around the guitar and keyboards. Roger started to play the bass as a lead instrument and I started to introduce more of my classical feel."[3] However, it seems that before joining the future Pink Floyd, Syd had doubts about how he would fit in. Bob Klose recalls his first appearance, in the middle of the rehearsal session (in the attic at Stanhope Gardens) that would seal Chris's fate: "Syd, arriving late, watched quietly from the top of the stairs. Afterwards he said, 'Yeah, it sounded great, but I don't see what I would do in the band.'"[5]

Two months after Syd Barrett joined, in December 1964 (or early 1965 according to some sources), the group recorded a demo of their first few songs in a small, Decca-owned studio in Broadhurst Gardens, West Hampstead. This comprised a cover of "I'm a King Bee" by Slim Harpo, three compositions by Barrett ("Butterfly," "Lucy Leave," and "Remember Me"), a collective number entitled, "Double O Bo," and Roger Waters's very first composition: "Walk With Me Sydney." Their first auditions were not long in coming—for a new club called Beat City, for the famous ITV television show *Ready Steady Go!* and for the

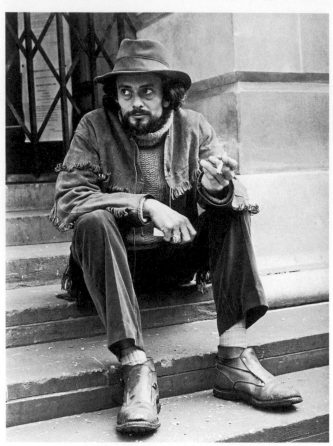

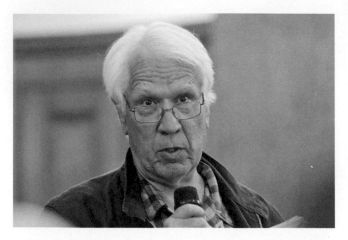

Peter Jenner (shown here in 2013), the Floyd's first manager.

John Hopkins, a key player in London's underground.

Countdown Club (three ninety-minute sets per evening). Bob Klose left the group in summer 1965 to concentrate on his studies, while Syd Barrett and David Gilmour set off for the South of France. It was soon after this that Tea Set was renamed the Pink Floyd Sound (as a tribute to two American South bluesmen) and the group was offered new gigs in various clubs and universities.

The "Happenings" at the Marquee Club

While their various engagements at the London clubs enabled the Pink Floyd Sound to make a name for themselves, it was without doubt their participation in the third Giant Mystery Happening at the Marquee Club that was to seal the band's future. These *happenings* (also known as the Spontaneous Underground), aimed at celebrating an alternative culture in full creative ferment, were the brainchild of American Steve Stollman, who had come to London to search for new talent with which to supplement his brother Bernard's label ESP-Disk.

On January 30, 1966, Stollman booked the Marquee Club (the Mecca of the English rock scene) for the first of the Giant Mystery Happening events, at which Donovan, Graham Bond, and Mose Allison appeared. He repeated the experiment on February 27 and again on March 13, and on every Sunday afternoon thereafter. It was as the Pink Floyd Sound that Syd Barrett, Roger Waters, Rick Wright, and Nick Mason rose to the challenge and participated in

the third event, billed on the flyers as the "Trip." Steve Stollman: "I hadn't a clue who they were, but someone suggested them."[6] Nigel Lesmoir-Gordon, an avant-garde filmmaker responsible for the 1966 documentary *Syd Barrett's First Trip*, recalls that Steve Stollman was looking for unconventional sounds for these Sunday sessions: "'I knew Steve Stollman. He was looking for experimental music, and nobody else wanted to play those Sunday afternoon sessions. That's how they got the Floyd.'"[6] Pink Floyd's lengthy, blues-derived psychedelic improvisations caused quite a sensation among the hip young Londoners lucky enough to find themselves at the appropriately named "Trip." Hoppy (real name John Hopkins), a leading photographer of Swinging London and a key figure in the British counterculture, remembers the first time he encountered the group: "It was like walking into a wall of sound, not unmusical, but certainly something like I'd never heard before."[7] Barrett, Waters, Wright, and Mason took part in Stollman's Marquee events again from March 27 to June 12, and then from September 30 to the end of 1966. (The exact dates of their appearances at the Spontaneous Underground are not known.)

It was at the Spontaneous Underground of June 12, 1966, that Peter Jenner first heard the hallucinogenic music forged by Syd Barrett, Roger Waters, Rick Wright, and Nick Mason. "The Floyd were mostly doing blues songs, but instead of having howling guitar solos with the guitarist leaning back, like all guitarists did back then, they were doing

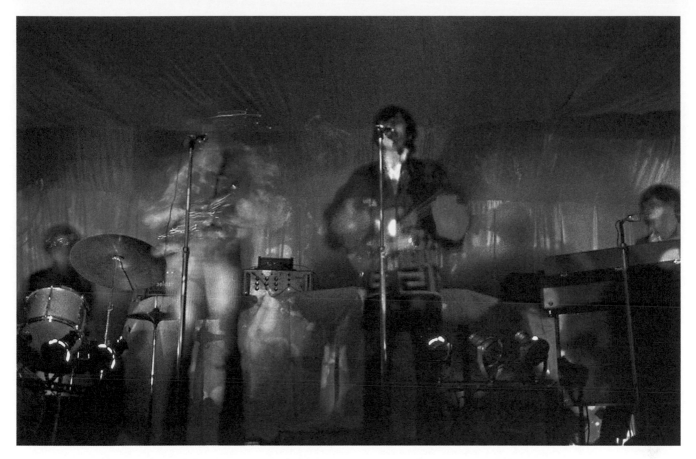

The Pink Floyd light show at the Architectural Association *students' party* on December 16, 1966.

cosmic shit. They weren't doing interesting blues songs. But it was what they did with them that was interesting. I think what Syd was doing was a way of being distinctive and filling in the gaps where you should have had a howling Clapton or Peter Green guitar solo. I was very intrigued."[1]

Jenner and King, Two Friends in Search of the New

The son of a vicar, Peter Jenner (born in 1943) studied economics at Cambridge and at twenty-one years of age was appointed a lecturer at the London School of Economics. Less interested in the theories of Malthus and Marx than in avant-garde music, it was not long before he quit that venerable institution and began to frequent some of Swinging London's trendier spots. He became a member of the Notting Hill community and a friend of the ubiquitous Hoppy (John Hopkins). In 1964, he helped to establish the Notting Hill Carnival, a celebration of Caribbean culture, and in 1966 he contributed to the founding of the London Free School. He was also a collaborator on the London-based underground newspaper the *International Times* (*it*). In spring of the same year, Peter Jenner set up an independent record company, DNA Productions, with Hoppy, Ron Atkins, and Alan Beckett, and fitted out a small studio in a former dairy at 46a Old Church Street, Chelsea. Joe Boyd was in charge of production and John Wood of recording at Sound Techniques, where the free-improvising ensemble

AMM and subsequently the avant-garde jazzman Steve Lacy recorded. While the music of AMM was interesting and unusual in that it no longer owed anything to the harmonic and rhythmic structures of the blues, it was also, like the free jazz of Ornette Coleman or Cecil Taylor, the preserve of a small number of neophytes. Hoppy being preoccupied with other projects, Peter Jenner partnered his longtime friend Andrew King in this new venture. Born in 1942, Andrew was also a vicar's son. A cybernetics expert, he quit his job at British Airways after becoming bored there. The two friends were on the lookout for avant-garde sounds.

September Meeting

Instinctively, Jenner set his sights on Pink Floyd, although at first he could not work out where their strange sonority came from: "[...] it turned out to be Syd and Rick," he recalls. "Syd had his Binson Echorec and was doing weird things with feedback. Rick was also producing some strange, long, shifting chords. Nick was using mallets. That was the thing that got me. This was avant-garde! Sold!"[5] Pink Floyd was innovative while at the same time preserving the original spirit of rock 'n' roll. Their experimentation and Syd Barrett's intriguing and seductive dandy image struck Jenner and King as providing all the necessary ingredients for success.

On that June 12, 1966, as soon as the Floyd had finished their set, Jenner rushed over to them and exclaimed: "'You lads could be bigger than the Beatles!' and we sort of looked

Roger Waters and Nick Mason with Andrew King (on the left), manager and cofounder of Blackhill Enterprises.

For Pink Floyd Addicts

The London offices of Blackhill Enterprises, located at 32 Alexander Street, Bayswater, would later house the independent label Stiff Records, launched in 1976, which signed artists such as Elvis Costello, Ian Dury, and Madness.

at him and replied in a dubious tone 'Yes, well we'll see you when we get back from our hols,' because we were all shooting off for some sun on the Continent."[3] Undaunted, Jenner got hold of their address from Steve Stollman and turned up at their Stanhope Gardens lair. "Roger [Waters] answered the door. Everybody else had gone off on holiday, as it was the end of the academic year [...] Roger hadn't told me to fuck off. It was just 'See you in September.'"[5]

And so, in September 1966, Peter Jenner and Andrew King became their official managers. "Peter focused on us. Of the two, Peter was the hustler—and the diplomat—who could talk his way into a deal. Peter describes himself as 'an A1 bullshitter—still am!' and had the added bonus of a link into the underground scene. Andrew was more relaxed, and a lot of fun to be around, but his taste for a good time sometimes led to moments of unreliability."[5] The first two things Jenner and King did were to create Blackhill Enterprises (named after King's cottage in Wales) and to use a small legacy that King had received to buy new equipment and a lot of spots for the light show.

Blackhill and the Free Concerts

On October 31, Barrett, Waters, Wright, and Mason became partners with Jenner and King in Blackhill Enterprises, whose offices were located at 32 Alexander Street, Bayswater. In keeping with the hippie philosophy of the day, any profits accumulated by the group—along with any from ventures with the other artists already signed or about to be signed by the production company—were to be distributed six ways. Those other artists would include Marc Bolan (the future leader of T. Rex, who married June Child, the Blackhill Enterprises secretary), Roy Harper, the Edgar Broughton Band, the Third Ear Band, and Kevin Ayers. "They were very nice,

an honourable exception to the shady rule about managers, and really cared for the people they worked for," notes Robert Wyatt, then the drummer and singer with Soft Machine.

Peter Jenner and Andrew King had the peculiarity of getting their artists to play in venues hitherto reserved for classical music, such as the Institute of Contemporary Arts in Mayfair and the Commonwealth Institute in Kensington, where Pink Floyd played on January 16 and 17, 1967, respectively. Little motivated by the lure of financial gain, Blackhill Enterprises would also initiate the free concerts in Hyde Park (having overcome the reservations of Parliament). Several of these jamborees would become engraved on the collective memory: that of June 29, 1968, featuring Pink Floyd, Tyrannosaurus Rex, Roy Harper, and Jethro Tull; and the Rolling Stones' concert of July 5, 1969 (in which Family, the Battered Ornaments, King Crimson, Roy Harper, the Third Ear Band, Alexis Korner's New Church, and Screw also appeared), dedicated to Brian Jones, who had died two days earlier.

The collaboration of Jenner, King, and Pink Floyd lasted until Barrett's departure. The arrival of David Gilmour marked the beginning of a new chapter for Roger Waters, Rick Wright, and Nick Mason, while the two producers would continue to manage Syd Barrett.

The UFO Adventure

Jenner and King, who had an extensive network of friends and acquaintances, introduced Pink Floyd to the nascent London underground movement, opening wide the doors of the London Free School and indeed those of all the iconic venues of Swinging London to them. The group played All Saints Church Hall, which became famous for its light shows; the Roundhouse, appearing alongside Soft Machine at the October 15 launch party for *it*, the counterculture

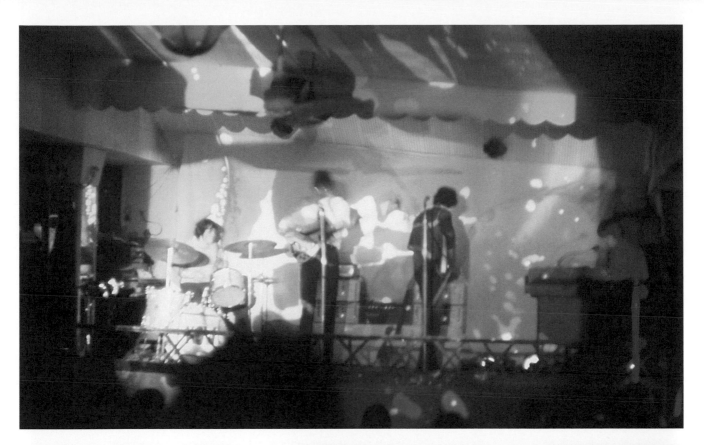

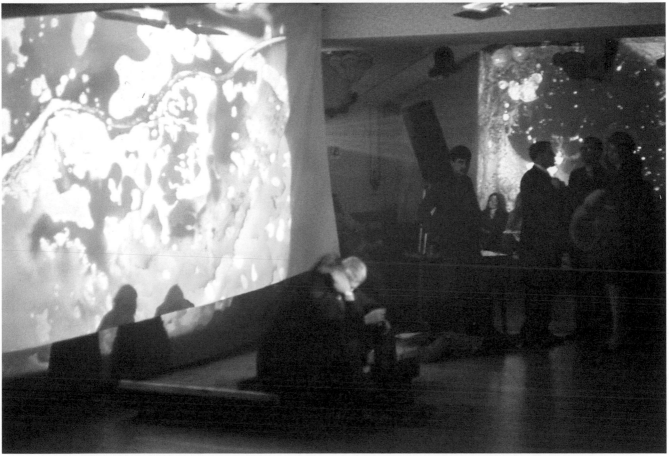

On December 23, 1966, Pink Floyd gave their first psychedelic show at the UFO. This was the opening night of the underground club, founded by Joe Boyd and Hoppy, which would help the group to achieve a certain notoriety. The Floyd would play ten or so gigs at the club between December 1967 and July 28, 1967.

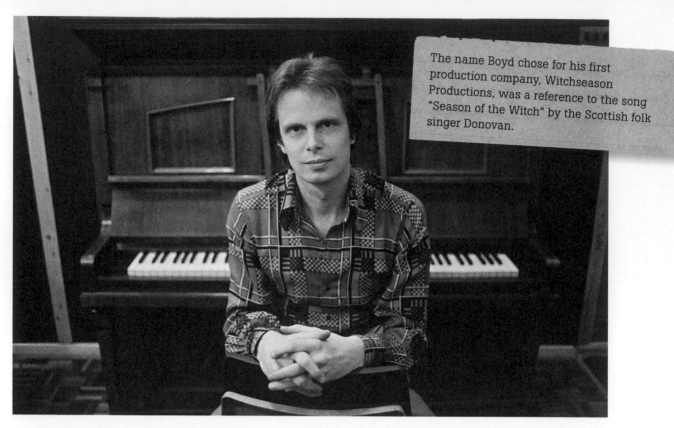

Above: Joe Boyd. **Right:** The four members of the Floyd leap with joy after signing their contract with EMI!

magazine founded by Hoppy, David Mairowitz, Pete Stansill, Barry Miles, Jim Haynes, and Tom McGrath; and finally the famous UFO Club, where they performed for the first time on December 23, 1966. This major center of alternative culture, founded by the irrepressible Hoppy and Joe Boyd, a twenty-four-year-old American responsible for recruiting and recording new talent for the Elektra label, would propel the group to the forefront of the alternative scene. As a result, the Floyd, somewhat despite themselves, became the emblematic group not only of the club, but of the entire London underground. Nick Mason would later write: "We may have been adopted as the house orchestra, but we rarely got to share the psychedelic experience. We were out of it, not on acid, but out of the loop […]. […] We were busy being a band: rehearsing, travelling to gigs, packing up and driving home. Psychedelia was around us but not within us. […] Of the band, Syd was perhaps intrigued by the wider aspects of psychedelia, and drawn to some of the philosophical and mystical aspects […]."[5]

By the end of 1966, the Pink Floyd Sound had already distanced themselves from the popular music of the US and made a mark for themselves as one of the major groups on London's new music scene. Andrew King would later reveal: "We didn't realise it, but the tide was coming up the beach, and the Pink Floyd were right on top of the wave."[5]

Joe Boyd and the Group's Recording Debut
On January 11 and 12, 1967, Pink Floyd recorded "Interstellar Overdrive" and "Nick's Boogie" for the soundtrack of

Peter Whitehead's documentary *Tonite Let's All Make Love in London*, followed two weeks later by "Arnold Layne" and "Candy and a Currant Bun." These recordings were made with Joe Boyd at Sound Techniques studios. Naturally, the American producer considered signing Pink Floyd to Elektra, but Jac Holzman, his former boss, who had only heard the group rehearsing onstage, was not particularly keen. Polydor, on the other hand, the label to which at that time the Who and Cream were signed, showed a real interest and offered a £1,500 advance. Too late…Bryan Morrison, originally engaged to line up gigs for the group, had entered into what proved to be fruitful negotiations with EMI. And so on February 28, 1967 (the date varies from source to source with other possibilities being February 1, as claimed by Nick Mason, although this seems improbable, and February 27), Syd Barrett, Roger Waters, Rick Wright, and Nick Mason, supported by Peter Jenner and Andrew King, signed a contract with the record company that had signed the Beatles, obtaining a £5,000 advance in the bargain. In Andrew King's words: "…a shit deal, but a thousand times better than the Beatles."[5] On the other hand, and here's the rub, a clause in the contract stipulated that they had to part ways with Joe Boyd, the producer of their first single and, more importantly, the founder of the UFO Club who had helped the group to take off. Barry Miles: "Even though he was being asked to sabotage his own deal with Polydor, Boyd agreed to do it because he thought that if 'Arnold Layne' was a hit, they would be foolish to use anyone else to produce the album."[3] In the end, this is precisely what they did.

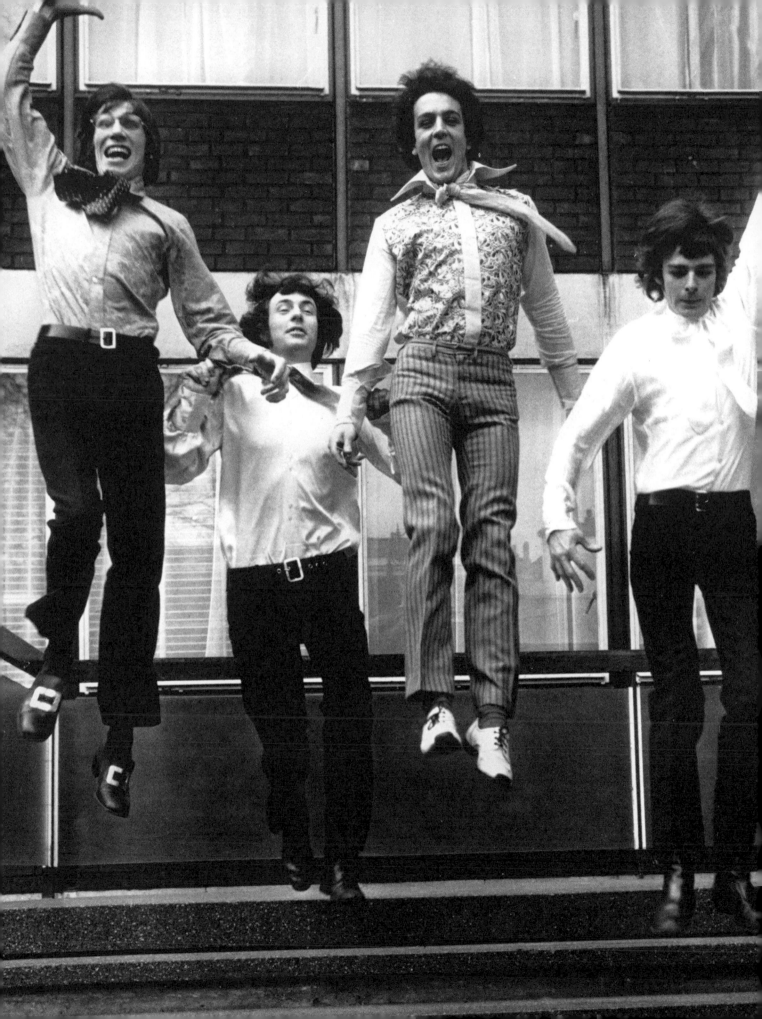

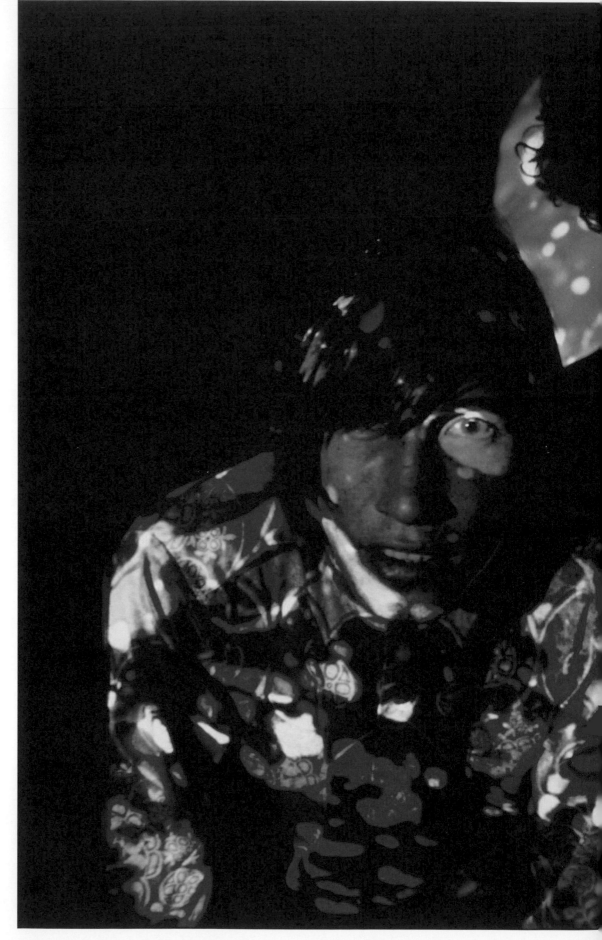

Spectacular and revolutionary lighting effects intensified the hallucinogenic impact of the quartet's music. At the outset, the Floyd's lighting wizard was none other than their landlord, Mike Leonard. It was his idea to attach pieces of colored cellophane and glass to rotating wheels positioned in front of spotlights. The stroboscopic effects or moving forms, projected onto the stage or onto the wall behind the musicians in perfect synchronization with the music, really came into their own during Syd Barrett's compositions. These light shows were to become one of the trademarks of Pink Floyd concerts.

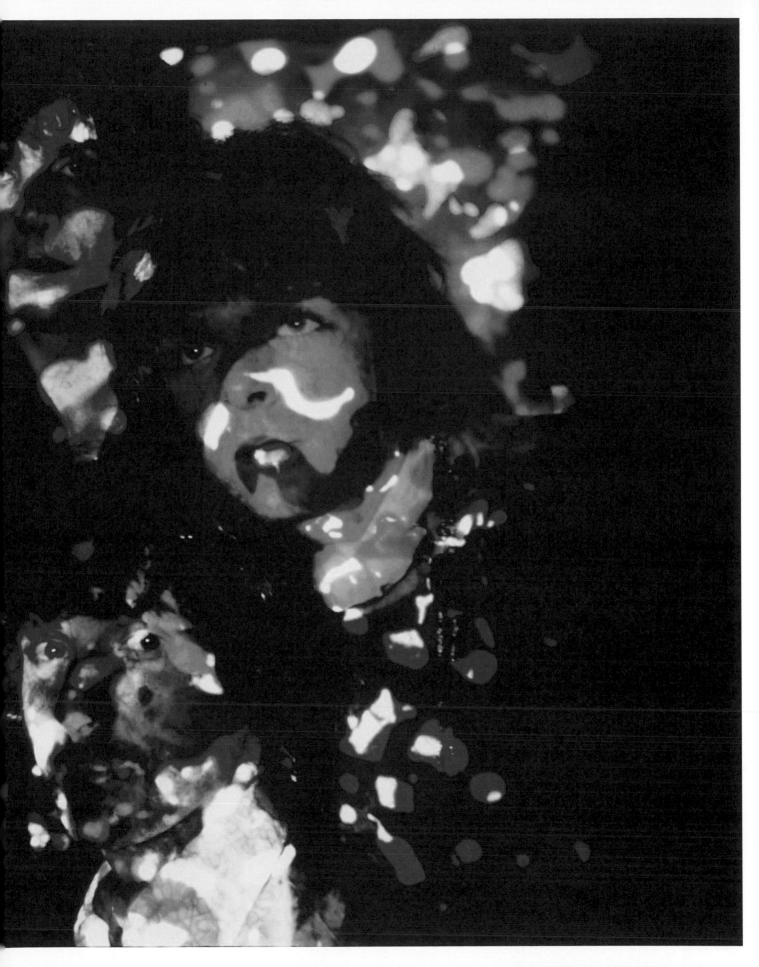

Joe Boyd, Creator of the UFO Club

Born on August 5, 1942, in Boston, Massachusetts, Joe Boyd was twenty-two when he first stepped foot on European soil. The occasion was the Blues and Gospel Caravan tour he was in charge of organizing. This former Harvard student had already made a name for himself in the world of music, and taking his first steps as a tour manager under the aegis of the famous impresario George Wein (founder of the Newport Jazz Festival), he organized a number of shows for the bluesmen Sleepy John Estes, Skip James, Sonny Terry & Brownie McGhee, and Muddy Waters. He was also responsible for the sound system at the July 1965 Newport Folk Festival, during which Bob Dylan went electric in front of a crowd of stunned folk traditionalists! In 1964 he organized various European tours for the jazzmen Roland Kirk and Coleman Hawkins in addition to the Blues and Gospel Caravan tour. It was on this occasion that he met John "Hoppy" Hopkins, who had come along to take photographs. A year later, in autumn 1965, Boyd returned to London, this time mandated by Jac Holzman to represent Elektra Records and recruit new talent.

London was swinging, and Joe Boyd intended to play a full part in counterculture life. With Peter Jenner, John Hopkins, Alan Beckett, and the jazz critic Ron Atkins, he set up DNA Productions. This company signed a management agreement with AMM, an avant-garde jazz band started in 1965 by the guitarist Keith Rowe, the saxophonist Lou Gare, and the drummer Eddie Prévost, which Boyd subsequently contracted to Elektra. Their long improvisations tending toward free jazz were to exert a certain influence on Pink Floyd, in particular Keith Rowe on the playing of Syd Barrett. (This can be heard on the album *AMMMusic*, recorded at Sound Techniques studios in June 1966 and produced by Hopkins, Jenner, Atkins, and Beckett.)

In 1966, Hoppy abandoned DNA Productions to throw himself into the adventure that was the London Free School (LFS), an "anti-university" comprising a night school and a community advice center whose aim was to offer an "alternative" education based on no-holds-barred debates on any subject with a social dimension. Boyd, his loyal comrade in arms, also got involved. Despite its commendable intentions, the venture got into financial difficulty and soon went under, but not before it had given birth to a number of countercultural institutions in the capital: the happenings at All Saints Church, the Notting Hill Carnival, the newspaper *it*, and the UFO Club.

The UFO, England's First Psychedelic Club

In 1966, Boyd decided to open a club, once again in partnership with Hoppy. The two men had become aware of the lack of a suitable venue for the development of underground culture, the Marquee no longer fitted the bill. Boyd would later claim that a void was waiting to be filled, and that hundreds of fans were looking for a central rallying point.[24] In December 1966, Boyd and Hoppy settled on the Blarney Club, a former Irish ballroom located below a couple of movie theaters at 31 Tottenham Court Road.

The room, accessed via a wide staircase, had shamrocks on its walls and a ceiling fan above. The UFO (standing for unidentified flying object)—the name favored in the end over "Underground Freak Out"—was born. The opening night was December 23, 1966. On the program, which was entitled "UFO Presents Night Tripper," were underground films by Kenneth Anger and Andy Warhol (imported directly from New York) plus performances by Soft Machine and Pink Floyd.

The initial agreement was for the club to be held on the two last Fridays of 1966 only. On the strength of the success of the first two events, the UFO reopened its doors in January 1967. In addition to Pink Floyd and Soft Machine, the club presented sets by groups such as the Crazy World of Arthur Brown, the Graham Bond Organisation, Procol Harum, Eric Burdon, Family, the Social Deviants, Tomorrow, Jeff Beck, and Ten Years After, many of which included experimental lighting effects created by Mark Boyle and announced on colorful posters designed by Michael English and Nigel Waymouth (of Hapshash and the Coloured Coat).

Joe Boyd's UFO Club was a laboratory of the counterculture and London's equivalent of San Francisco's Fillmore West or Winterland, the cradles of the *acid test*.

The Floyd very quickly became the club's totemic group, playing there between January and September 1967. The UFO literally supercharged the band's career, and its off-the-wall music and the light shows attracted more and more fans. "They were the first group to open people up to sound and colour,"[11] Jenny Fabian, Andrew King's girlfriend and co-author of the novel *Groupie*, would later write. "I'd lie down on the floor and they'd be up on stage like supernatural gargoyles […] and the same colour that was exploding over them was exploding over us. It was like being taken over, mind, body and soul."[5]

The UFO soon became a victim of its own success. Too small to accommodate its ever-increasing crowd, the club started having confrontations with the law. Hopkins's arrest on drug offenses in June 1967 marked the beginning of the end. After the owners of the premises canceled the lease, the club moved to the Roundhouse, whose exorbitant rent caused it to close its doors for good in October.

Producer (Briefly) of the Floyd

Throughout the UFO adventure, Boyd continued to work as a producer and talent spotter. When the filmmaker Peter Whitehead began to shoot a documentary on Swinging London, Joe Boyd was the natural choice of producer to record "Interstellar Overdrive," the Floyd song chosen for the soundtrack, at Sound Techniques studio in Chelsea on January 11 and 12, 1967. Boyd tried to get the group signed by Elektra, but met with a refusal from Jac Holzman. The Floyd then turned to Polydor, and the record label accepted an arrangement under which Boyd would act as their producer on an independent basis. Having been dismissed by Elektra in the meantime, Boyd then set up his own production company, Witchseason Productions, and produced the group's first single, "Arnold Layne"/"Candy and a Currant Bun," recording both songs on January 29. Unfortunately, Boyd's flair would not pay off. Bryan Morrison, taken on by Jenner and King to get bookings for the group, intervened with EMI and succeeded in obtaining a far more satisfactory contract. There

can be no doubt that Joe Boyd wanted his relationship with Syd Barrett, Roger Waters, Rick Wright, and Nick Mason to continue, but EMI had other plans. After the contract signing, the head of the A&R (Artists & Repertoire) department, Sidney Arthur Beecher-Stevens, who had never liked independent producers, demanded that the group work with EMI's own teams. "They owned Abbey Road after all. They wanted their own man, Norman Smith, who had recently been promoted from being the Beatles' engineer, to be our producer. That was the deal on offer, and we acquiesced […],"[5] recalls Nick Mason, before adding that Peter Jenner, who was given the unenviable task of informing Joe Boyd of these changes, regrets to this day having ousted him so abruptly, as does Andrew King, who has admitted that "The alacrity with which Peter and I left Joe standing was shameless."[5]

Promoter of British Folk Rock

However badly he took it, his brutal ejection from the Pink Floyd spaceship did not stop Joe Boyd from bouncing back. The young producer, who continued to officiate at Sound Techniques with engineer John Wood, now turned his attention to promoting the new British folk-rock scene, as embodied by the Incredible String Band (*The Incredible String Band*, 1966; *The Hangman's Beautiful Daughter*, 1968), Fairport Convention (*Fairport Convention*, 1968; *Unhalfbricking*, 1969; *Liege & Lief*, 1969), Nick Drake (*Five Leaves Left*, 1969; *Bryter Layter*, 1970), and Fotheringay (*Fotheringay*, 1970).

Returning to the United States in the seventies, Boyd made the excellent documentary entitled simply *Jimi Hendrix*, and collaborated on the soundtracks of two major movies of the decade: Stanley Kubrick's *A Clockwork Orange* (1971) and John Boorman's *Deliverance* (1972). Later he founded the label Hannibal, which went on to produce R.E.M.'s third studio album, *Fables of the Reconstruction* (1985), and Loudon Wainwright III's *Social Studies* (1999). In 2006, Boyd published his memoirs in the book *White Bicycles: Making Music in the 1960s*.

1967

Arnold Layne / Candy And A Currant Bun

SINGLE

RELEASE DATE

United Kingdom: March 10, 1967

Label: Columbia Records
RECORD NUMBER: DB 8156

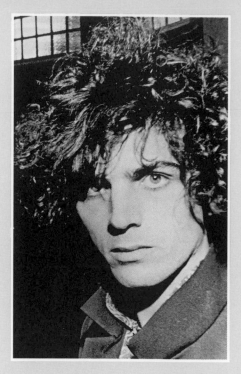

Syd Barrett, rock visionary and author *of* Pink Floyd's first hit, "Arnold Layne."

Arnold Layne

Syd Barrett / 2:53

Musicians

Syd Barrett: vocals, backing vocals (?), electric guitar, acoustic guitar (?)
Roger Waters: bass, backing vocals (?)
Rick Wright: organ, backing vocals (?)
Nick Mason: drums

Recorded

Sound Techniques, London: January 29, 31 (?), February 1 (?), 1967

Technical Team

Producer: Joe Boyd
Sound Engineer: John Wood

Genesis

At the end of January or the very beginning of February 1967, around two weeks after recording "Interstellar Overdrive," a new session was booked at Sound Techniques studios. This was financed by Bryan Morrison, who had been engaged by Jenner and King a while before to act as the Floyd's agent. Morrison's plan was for the group to record a number of songs that could be hawked around the record companies, notably EMI, the most prestigious of them all, thereby recouping the production costs. Jenner and King again asked Joe Boyd—who had just produced the first album of the Incredible String Band for his newly formed company Witchseason Productions—to produce it, and John Wood, one of the two owners of the studio and its sound engineer, to engineer it with Geoff Frost. And so on January 29 several songs were recorded, including "Arnold Layne" and "Candy and a Currant Bun." Morrison judged the results good enough for him to start selling, and he abandoned the idea of recording any more. These two songs would constitute the group's first single. Both were credited to Syd Barrett.

"Arnold Layne" dates from the period when Barrett was still living with his mother in Cambridge. "I thought 'Arnold Layne' was a nice name, and it fitted very well into the music I had already composed," he explains [...]. "I was at Cambridge at the time and I started to write the song. I pinched the line about 'moonshine washing line' from Rog, our bass guitarist, because he has an enormous washing line in the back garden of his house. Then I thought Arnold Layne must have a hobby, and it went on from there."[8] Arnold's hobby is a peculiar one: he steals women's clothing from

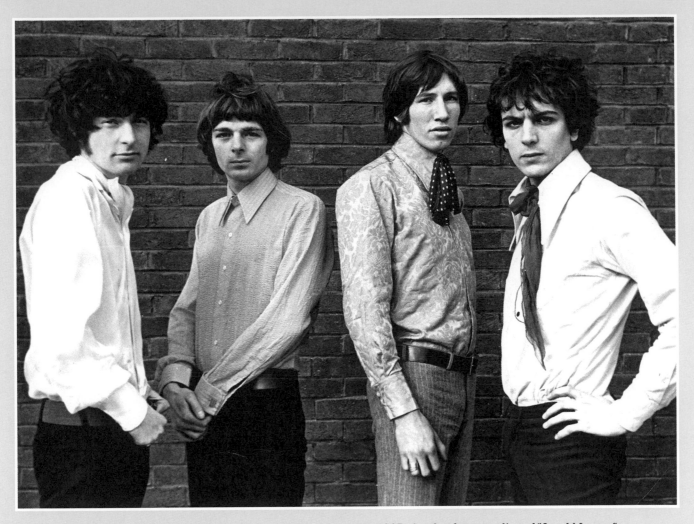

Nick Mason, Rick Wright, Roger Waters, and Syd Barrett in 1967, shortly after recording of "Arnold Layne."

clotheslines, then dresses in it and admires himself in the mirror. A strange pastime that feeds his fantasies and deviant behavior to the point where he is eventually caught red-handed. His punishment, which we are to understand as some kind of incarceration (prison? lunatic asylum?) is not long in coming: *Doors bang…*

The inspiration for "Arnold Layne" came from a real-life incident, as Roger Waters explains: "My mother and Syd's mother had students as lodgers […]. There was a girls' college up the road. So there were constantly great lines of bras and knickers on our washing lines, and Arnold, or whoever he was, had bits and pieces off our washing lines. They never caught him. He stopped doing it after a bit when things got too hot for him."[3] A song about fetishism, then, "Arnold Layne" sits somewhere between the Kinks' "Dedicated Follower of Fashion" (a broadside on trendiness) and the Who's "Pictures of Lily" (which deals with teenage fantasies). It is a song in which humor and a certain taste for provocation are never allowed to descend into vulgarity. The poet and Cream lyricist Pete Brown would heap praise upon the songwriter: "Syd was one of the first people to get hits with poetry-type lyrics. The first time I heard 'Arnold Layne' I thought 'Fucking hell!' It was the first truly English

song about English life with a tremendous lyric. It certainly unlocked doors and made things possible that up to that point no one thought were."[2]

All the same, when it was released in the United Kingdom as the A-side of Pink Floyd's first single, on March 11, 1967, it was immediately banned by the majority of radio stations, notably Radio London and Radio Caroline. Roger Waters perceptively explains: "I don't think the record was banned because of the lyrics, because you can't really object to them. I think they must be against us as a group. They don't seem to like what we stand for."[9] It was the *Morning Star* that would find the most appropriate adjectives for the song: "clever and ironic…"[9]

Having reached number 26 on the British charts on March 29, 1967, the song climbed to number 20 the next day, testifying not only to the influential role played by the counterculture media, but also to the efficiency of Blackhill Enterprises in buying up quantities of the single! The group had the idea of making a short promotional film to accompany "Arnold Layne," and entrusted its direction not to Peter Whitehead, but to Derek Nice, head of promotions at EMI and an acquaintance of June Child. The shoot took place in the village of East Wittering on the West Sussex

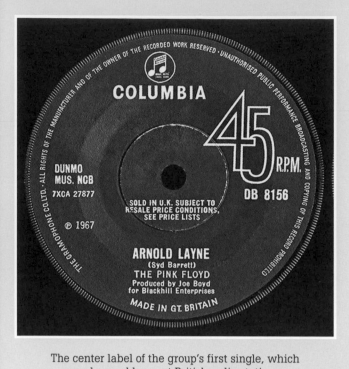

The center label of the group's first single, which was banned by most British radio stations.

There is a second promotional film of "Arnold Layne" that was shot in front of Saint Michael's Church in Highgate (Camden, North London). In it, Syd Barrett can be seen lip-synching. The initial effects of hallucinogenic drugs on his health are already in evidence.

coast, and cost the modest sum of £2,000. The film shows the four members of the group on a beach, their faces intermittently masked, in the act of dressing a mannequin.

Production

Joe Boyd would later confess that he no longer had a precise recollection of the recording sessions, while emphasizing: "One thing to note is that [the sessions] took place before the EMI deal and there was no guarantee at the time that [the songs] would be released on EMI."[10] Unfortunately for Boyd, the adventure continued after signing with the major—only without him.

For the time being, the Floyd took over the Sound Techniques studio, which was equipped with a console built by the highly talented Geoff Frost, a four-track tape recorder, also partly built by Frost, and four monitors, one assigned to each of the tracks! "[…] that was the usual practice in studios at the time!"[10] explains John Wood, looking back. Nick Mason recalls the speakers being Tannoy Reds, "[…] the definitive speaker of the period."[5] The recording took the whole of January 29, and the Floyd got down to it with the help of a plentiful supply of psychedelic substances, which were particularly appreciated by Barrett and Jenner…"I've never known so much dope consumed at a session!"[10] the sound engineer later opined.

"Arnold Layne" is a song the group regularly played live, one that could go on for considerably longer than ten minutes. For commercial reasons, the Floyd needed to bring it down to three minutes, the standard duration for a single.

It is Syd Barrett who launches the track, most probably on his 1962 Fender Esquire. He was also playing a

Danelectro 3021 around this time (see the UFO Club gig of January 20, 1967), although he favored the Fender as his main instrument. His playing is distinctly rock: he alternates a slightly distorted-sounding palm mute with strumming and arpeggios. He uses a Binson Echorec to obtain a mild echo, and there is apparently some reverb as well, no doubt courtesy of the famous EMT plate. Syd is supported by Roger Waters, who plays some superb bass on his Rickenbacker 4001S. Together, they establish a solid rhythm over which Rick Wright places chords on his Farfisa Compact Duo, the organ that would become one of the characteristic sounds of the group's early period. Syd is probably using a 50-watt Selmer Truvoice Treble-n-Bass amp, while Roger and Rick seem to be plugged directly into the console, as John Wood partially confirms: "We were doing quite a lot of DI'ing (direct injection) of the amps and things, which was a bit unusual in those days."[10] As for Nick Mason, he plays more of a pop rhythm on his Premier drums, with the snare drum and ride and crash cymbals dominating. Syd sings the lead vocal. His voice is pleasant and assured, and he doubles himself on backing vocals, assisted almost certainly by Rick or Roger. He also seems to play an acoustic rhythm guitar part (a Harmony Sovereign H1260?), which can be heard at 2:04.

It is the song's bridge that presented the biggest difficulties. With its vocal harmonies halfway between the Kinks and the Beach Boys, and Rick's organ solo, it was difficult to get right. As the excellent David Parker points out in his book *Random Precision*,[10] the annotations on the master tape box indicate some confusion over the number of takes

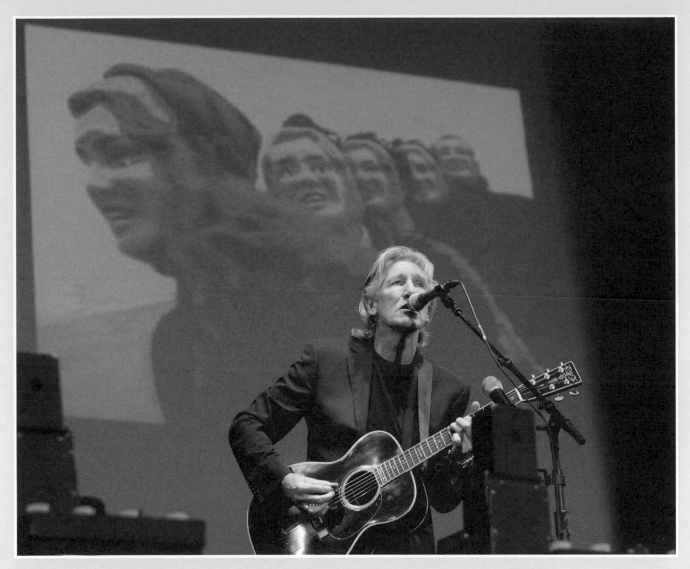

Roger Waters performing "Arnold Layne" in concert in 2006, with the 1967 promotional clip playing in the background.

(around eight), and also reveal that Rick's solo was the subject of a separate take. Careful listening bears this out: this section is slightly faster than that which precedes it, and Roger's bass sound is no longer exactly the same. The join occurs at precisely 1:31. Finally, the track is enhanced by snare drum effects played through the Binson Echorec (listen from 1:21).

Although a date of January 29 is recorded for the production, another session was required for the mixing, either January 31 or February 1, as Joe Boyd confirms: "I recall 'Arnold Layne' taking a day (to record) and another day to mix." And this mixing was not exactly straightforward. Boyd continues: "I remember Roger and I working the faders together on tricky cues, particularly the soaring organ level at the beginning of the solo."[10] Today only a mono mix of "Arnold Layne" is available.

"Arnold Layne" reveals the ability of Syd Barrett, whose approach in terms of both the words and music is unique, deviating considerably from the norm, and indicative of exceptional talent.

COVERS

During the "On an Island" tour (2006) with Rick Wright, David Gilmour played "Arnold Layne" several times. There is also a version recorded with David Bowie on May 29, 2006, at the Royal Albert Hall, which was released as a single on December 26 of the same year. Among other covers, it is worth mentioning those of the Boomtown Rats and, in France, Étienne Daho.

SIDE B

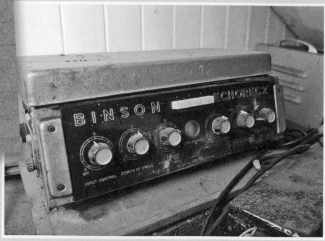

The Floyd's Binson Echorec discovered in the Stanhope Gardens house after having lain silent for many years...

Candy And A Currant Bun

Syd Barrett / 2:48

SINGLE

Arnold Layne / Candy and a Currant Bun

RELEASE DATE

United Kingdom: March 11, 1967

LABEL: COLUMBIA RECORDS
RECORD NUMBER: DB 8156

Musicians

Syd Barrett: vocals, backing vocals (?), rhythm and lead guitar
Roger Waters: bass, backing vocals (?)
Rick Wright: organ
Nick Mason: drums

Recorded

Sound Techniques, London: January 29, 31 (?), February 1 (?), 1967

Technical Team

Producer: Joe Boyd
Sound Engineer: John Wood

🎧 *IN YOUR HEADPHONES*

It is almost certainly Nick Mason who utters the phrase **Drive me wild** at precisely 1:00.

Genesis

In this song, Syd Barrett acts as a chronicler of his society, while at the same time lifting a corner of the veil on his inner world. He certainly captures the spirit of the times—the psychedelic revolution that insisted on waking up from the "long ontological sleep" (in the words of Timothy Leary, champion of the US counterculture) through the consumption of hallucinogenic drugs. "Candy and a Currant Bun" was initially named "Let's Roll Another One," a title that could not be more explicit. For the release of the single, EMI insisted that Pink Floyd change the song title along with the words of certain verses. As a result, curls of marijuana smoke are transformed into the aforementioned sweet treats, and the line *I'm high, don't try to spoil my fun* has disappeared altogether.

The story goes that Syd Barrett was very unhappy to discover that his references to drugs had been censored, but that Roger Waters dissuaded him from entering into open conflict with EMI over it. According to Mike Watkinson and Pete Anderson, "Waters disapproved of dope smoking in the studio, while Syd was naturally all for it. He often told friends that his fellow band members were 'dead straight.'"[2] However, if Peter Jenner is to be believed, Roger was not the only one to have assumed this responsibility: "I would suspect that it was self-censorship, that we all realised that it was…I wouldn't be surprised if Joe would have raised that, because Joe had a bit more knowledge of the industry and business and what you could get away with."[10] One cannot help wondering whether, in spite of all this, the currant bun might not have possessed certain peculiar virtues, just like

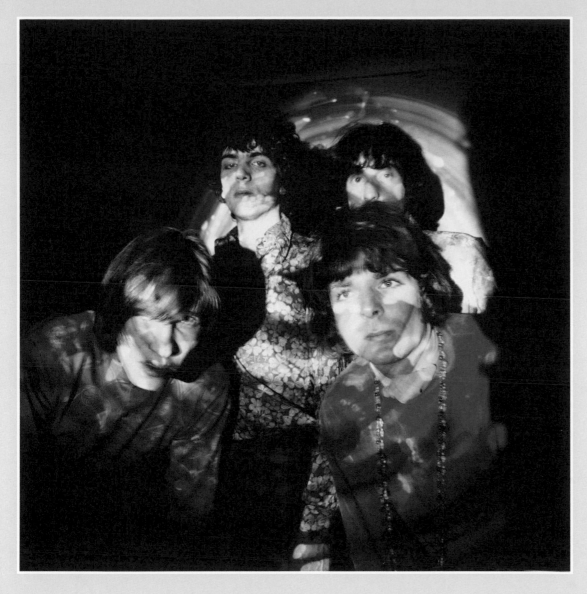

Portrait of a group named Pink Floyd. "Candy and a Currant Bun" was originally called "Let's Roll Another One," a title that speaks volumes!

the *Ice cream*, [which] *tastes good if you eat it soon*. That is to say erotic virtues. Hence the choice of this song as the B-side of Pink Floyd's first single!

Production

Syd Barrett was almost certainly aiming for the charts with "Candy and a Currant Bun": the song has a catchy tune, it is as psychedelic as one could hope for, and it is also highly original—in terms of both structure and harmony. All of which makes it a rollicking little pop song that perhaps deserved better than to be hidden away on the back of a single. Launched by a slightly distorted G from Wright on his Farfisa, it is Barrett who gets the track properly under way, firing off a very good overdubbed solo intro (possibly using a Selmer Buzz Tone pedal). He also plays a clearer-sounding rhythm guitar. Waters and Mason provide efficient support on bass and drums respectively. Wright, who maintains a discreet presence on the organ, launches into a fine solo at 1:20, giving Mason an opportunity to express himself with some passion, thereby demonstrating how impressed

he was with his recent discovery of Ginger Baker, the towering drummer of Cream. Barrett follows with a lead part played haphazardly rather than textbook-style, and in which he seems to favor feeling over technique (with much use of electronic effects from his Binson Echorec). He also seems to use his Zippo as a kind of bottleneck during this solo part on his rhythm guitar. After another sung section, the song moves toward a pretty frenzied coda (from 2:19) culminating in various effects that are not exactly easy to identify, although again generated using the Binson Echorec, and concluding with Barrett's guitar. Vocally, Syd gives an excellent performance, alternating his range with a more intimate style of delivery. Throughout the song a second voice can be heard accompanying Syd with some highly psychedelic *oohs* sustained by means of plentiful reverb. This is probably Waters, adding to the surrealistic feel of the track. "Candy and a Currant Bun" is a very good song that demonstrates the extent to which, even at this early stage in their career, Pink Floyd possessed an originality and a power that EMI would effectively harness and render productive.

1967

See Emily Play / Scarecrow

SINGLE

RELEASE DATE

United Kingdom: June 16, 1967

Label: Columbia Records

RECORD NUMBER: DB 8214

A poster for the "Games for May" concert on May 12, 1967, illustrated by Barry Zaid.

The sleeve of the single "See Emily Play" depicts a locomotive with children on board. This illustration is by Syd Barrett.

SIDE A

See Emily Play

Syd Barrett / 2:54

Musicians
Syd Barrett: vocals, electric rhythm guitar, lead guitar, backing vocals (?)
Roger Waters: bass, backing vocals (?)
Rick Wright: keyboards, backing vocals (?)
Nick Mason: drums
Recorded
Sound Techniques, London: May 18 or 20–21, 1967
Technical Team
Producer: Norman Smith
Sound Engineer: John Wood
Assistant Sound Engineer: Jeff Jarrett

COVERS
"See Emily Play" has been covered by All About Eve and Martha Wainwright, among other artists. However, the best-known version is surely David Bowie's, recorded during the *Pin Ups* sessions (1973).

Genesis

On May 12, 1967, Pink Floyd played a concert at the Queen Elizabeth Hall in London. Known as "Games for May" and billed as a moment of "space age relaxation for the climax of Spring—Electronic compositions, colour and image projections, girls, and the Pink Floyd," this gig had been organized by Peter Jenner and Andrew King with the blessing of the classical music promoter Christopher Hunt. "Games for May" marked a crucial stage in the group's development. Not only did it enable the group to get itself known beyond underground circles (the Queen Elizabeth Hall having been the preserve of classical music up to then), it also allowed it to test out its new compositions using the quadraphonic sound system specially designed by EMI's engineers (which was stolen after the concert). According to Nick Mason, this was "one of the most significant shows we have *ever* performed, since the concert contained elements that became part of our performances for the next thirty years."[5] In the absence of a first part, the Floyd created stage effects to their own taste, taking into account the fact that the crowd would be seated, which was relatively unusual at a rock concert.

On the set list for the Queen Elizabeth Hall show were ten or so songs plus a number of tape recordings. Syd Barrett composed a song especially for the event. This he named, naturally enough, "Games for May." It was this song that contained the seeds of "See Emily Play."

Andrew King, who at that time shared a flat with Rick Wright, recalls this period: "[…] I think Syd probably wrote 'See Emily Play' in that flat, because we had like a sort of… what you'd call a demo studio set up there in the living room

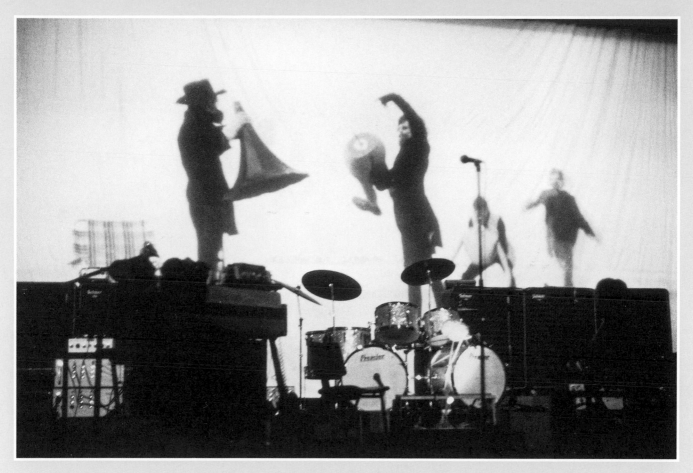

Images projected onto the stage of the Queen Elizabeth Hall for the group's first conceptual show on May 12, 1967.

[…] and he wrote it there as a sort of theme song for that concert."[10] It seems, however, again according to King, that the words had been written some time before, during the London Free School era.

Who is the Emily being observed at play by the song's narrator? It could be Emily Tacita Young, a famous sculptor in the making, who in 1966 never missed an evening at the London Free School or the UFO Club. It is also possible that this person who *tries but misunderstands*, who is *often inclined to borrow somebody's dreams* and who cries *soon after dark* was a product of Syd Barrett's fertile imagination—a young woman who appeared to him among the trees during an acid trip. Jenny Spires, a former girlfriend, has revealed that Emily was Syd's favorite first name, the name he would choose if he had a daughter one day. Finally, for Roger Waters, "Emily could be anyone. She's just a hung-up chick, that's all."[12] Although ignorant of Emily's identity, Waters claims to "know which woods Syd's talking about in 'See Emily Play.' We all used to go to these woods as kids. It's a very specific area—one specific wood on the road to the Gog Magog Hills [southwest of Cambridge]."[1]

Pink Floyd's second single was released on June 16, 1967, with the slogan: "Straight to Heaven in '67." While not quite attaining hit parade nirvana, "See Emily Play" nonetheless reached number 6 in the United Kingdom on July 29, just behind other hymns of the "Summer of Love"

such as The Beatles' "All You Need Is Love" and Scott McKenzie's "San Francisco (Be Sure to Wear Some Flowers in Your Hair)." The song was to play an important role in the Floyd's career by opening the doors of the radio and television stations, which had hitherto ignored them. Praised to the skies by the media, "See Emily Play" was championed by Radio London and Radio Caroline, and on July 6 Pink Floyd were invited to appear on the BBC show *Top of the Pops* for the first time to perform the hit. They would make return appearances on the thirteenth and twenty-seventh of that month. Barrett's composition has since been included in the Rock and Roll Hall of Fame's list of five hundred songs that have shaped rock 'n' roll.

Production

Pink Floyd recorded "See Emily Play" and "Scarecrow" during the sessions for *The Piper at the Gates of Dawn*, and "Bike" in particular. Not having been able to obtain the sound they wanted at Abbey Road, Syd Barrett, Roger Waters, Rick Wright, and Nick Mason went back to John Wood at Sound Techniques, where they had immortalized "Arnold Layne," this time with Norman Smith as producer. The real reasons for turning their backs on the EMI studios remain unknown, as John Wood explains: "Whether they couldn't book the time at Abbey Road or had tried recording it and couldn't get the sound, or whether it was just the

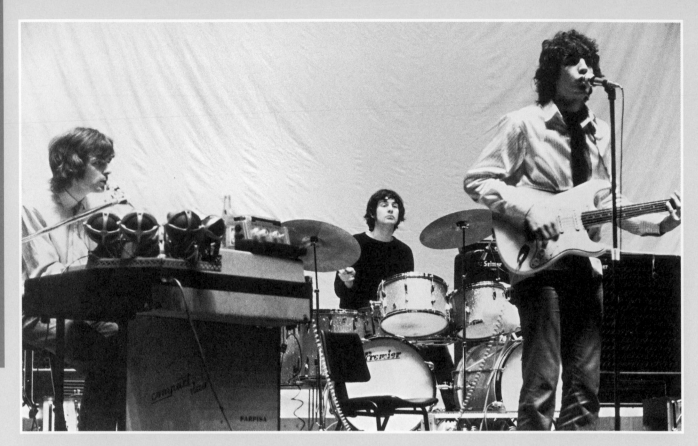

Pink Floyd rehearsing for "Games for May," at which the band experimented with quadraphonic sound.

'vibe' of having done a successful single there (at Sound Techniques) before, I don't know."[10] Whatever the problem was, they poached Jeff Jarratt, whom they liked, from Abbey Road: "[…] and they asked me to go across to Sound Techniques studio with them, to be the tape op over there on those sessions,"[10] confirms Jarratt. The session dates are not known for certain, but according to Jarratt, the recordings took place during a May weekend, either Saturday the twentieth or Sunday the twenty-first. The date of May 18, 1967, has also been suggested, but remains unconfirmed.

When the group got down to work, the song was still more than seven minutes long (again according to Jarratt), as per Floyd's habit of playing extra-long versions of their numbers live. John Wood recalls a lot of work being done on the master tape in order to cut it down to single format.

Right from the intro, the listener is taken by surprise by a glissando effect, perhaps obtained by Syd playing bottleneck on his Fender Esquire and altering the sound with heavy use of the Binson Echorec. Rick accompanies him from the very first bar with a short solo on his Farfisa organ. The rhythm section is efficient, with Nick playing his Premier kit (probably with two bass drums) in a style that is simultaneously pop and rock, and Roger, on his Rickenbacker bass, finding patterns that are somewhat unusual in this style of music. Syd, who also plays rhythm (his Esquire again), delivers an excellent lead vocal, supported by securely held harmonies courtesy of Roger and/or Rick. In the verses, an acoustic piano lick can be heard that also receives the inevitable Echorec

treatment. The effect is resolutely pop and highly characteristic of English record production of the day. The Floyd's keyboard player takes a second organ solo at 1:29, launched by Syd's distorted guitar, the lead man not hesitating to accompany him using his Zippo to obtain highly psychedelic effects.

The song is of such striking clarity that it was inevitable it should be released as a single. "'See Emily Play' is full of weird oscillations, reverberations, electronic vibrations, fuzzy rumblings, and appealing harmonies,"[12] wrote the *New Musical Express* (NME). During an interview for *Top of the Pops*, Rick Wright looks back at the recording: "Although it sounds a bit gimmicky, hardly any special effects were used. Take that 'Hawaiian' bit at the end of each verse, that was just Syd using a bottleneck through echo. The part that sounds speeded up, John Woods, the engineer, just upped the whole thing about an octave."[9] In creating this "Hawaiian" effect, Syd was actually inspired—according to Andrew King—by the guitarist Keith Rowe of the group AMM, who used a plastic ruler as a bottleneck! As for the famous accelerated section at 0:50, Rick can be heard playing two bars of piano that had been recorded at half the standard speed, the effect of which is to sound like a tack piano when played back at normal speed. This may have been a legacy from George Martin, who had used the same procedure with the Beatles on "In My Life" in 1965. All this was done under the watchful eye of Norman Smith, who had thoroughly assimilated the technique…The song ends with a fade-out during which Roger plays a two-note

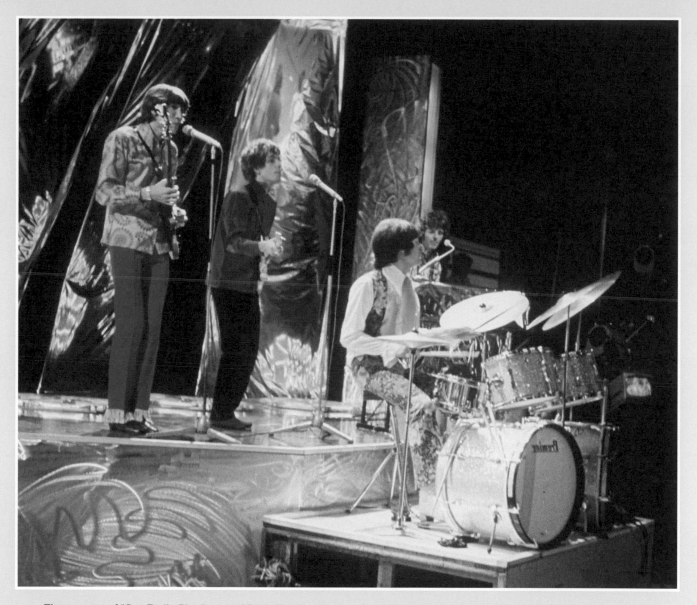

The success of "See Emily Play" earned Pink Floyd a place on *Top of the Pops* for three consecutive weeks in July 1967.

motif on his Rickenbacker, which he was to return to on "Careful with That Axe, Eugene" in 1968.

The A-side of this single is an excellent pop song that reveals the true scope of Syd Barrett's talent. The influence of the Beatles is in evidence here, with that combination of melody and innovation of all kinds that characterized the Fab Four in 1967. Norman Smith was able to subtly impose his vision as producer, without curbing the creativity and enthusiasm of his protégés. The result is a happy marriage of two musical and artistic visions. A marriage that was still, to say the least, a considerable way from what Pink Floyd would become in the seventies.

In a sense, "See Emily Play" marked the beginning of the end for Barrett with Pink Floyd. David Gilmour, then a member of Jokers Wild, took advantage of a brief trip to London to visit him while he was in the middle of recording "See Emily Play" with the Floyd. He recalls the shock of seeing his friend: "Syd didn't seem to recognise me and just stared back. [...]

He was a different person. I assumed he'd had too much of the old substances, which is what everyone else thought."[2] A little while later, Gilmour would be called upon to help out a Syd Barrett who had fallen into steady decline.

For Pink Floyd Addicts

On February 18 and 19, 1968, Pink Floyd shot a promo for "See Emily Play" for Belgian television. It is not Syd Barrett but David Gilmour singing and playing guitar with the group as he makes his first appearance with Pink Floyd on film. Syd has already[2] dropped out of the picture...

Norman Smith, Rock's Alchemist

For a number of years, Pink Floyd's name was closely associated at EMI with one of the very best producer–sound engineers on the English rock scene: Norman Smith, who had recorded every Beatles album up to and including *Rubber Soul* in 1965. Syd Barrett, Roger Waters, Rick Wright, and Nick Mason could not have found a better partner with whom to set out on their recording career—one who would help them to realize their ideas and express their extraordinary, fertile imaginations.

First Steps with the Beatles
Born in Edmonton, North London, on February 22, 1923, Norman Smith was a glider pilot in the Second World War, but saw no action. In 1959, after spending a few not particularly successful years as a drummer, percussionist, and trumpeter in a Dixieland band, the Bobby Arnold Quintet, Smith decided to reply to an advert placed by EMI in the *Times* (London). "The age cut-off was twenty-eight, and Norman was in his mid-thirties, so he pruned six years [actually eight!] off his age, and, to his surprise, was asked back for an interview, along with over a hundred other applicants. Asked by one of the interviewers what he thought of Cliff Richard, who was just emerging at the time, Norman was far from complimentary about Cliff. The interviewers, again to his surprise, tended to agree. And Norman was appointed as one of three new apprentices."[5]

At EMI, Norman Smith climbed the ladder rung by rung. "I had to start right at the bottom as a gofer, but I kept my eyes and ears open, I learned very quickly, and it wasn't long before I got onto the mixing desk."[13] And things got even better: on June 6, 1962, he was given the task of test-recording a group from Liverpool "with funny haircuts."[13] This was the beginning of an incredible adventure with the Beatles—one of the biggest groups in the history of rock and pop—which lasted from *Please Please Me* (1963) until *Rubber Soul* (1965).

A Creative Collaboration
In August 1969, when George Martin set up AIR studios, Smith succeeded him as head of the Parlophone label. A few months later, he took a little trip to the UFO Club to hear a young group by the name of Pink Floyd that Bryan Morrison had told him about. "'Their music did absolutely nothing for me,' he conceded. 'I didn't really understand psychedelia. But I could see that they did have one hell of a following even then. I figured I should put my business hat on, as it was obvious that we could sell some records.'"[14] To Peter Martland he gave a slightly different account of this first encounter with the Floyd, confessing that he was literally overwhelmed: "What I saw absolutely amazed me, I was still into creating and developing new electronic sounds in the control room, and Pink Floyd, I could see, were exactly into the same thing; it was a perfect marriage."[15]

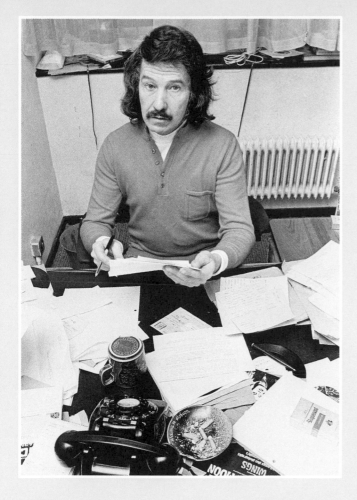

Norman Smith, the brilliant EMI producer and sound engineer. Following his close association with the Beatles, he allowed his name to be hitched to that of Pink Floyd, producing *The Piper at the Gates of Dawn*, their first album.

From this day on, he was fixated upon signing the group to EMI. He achieved this aim in February 1967. Norman, whose point of reference remained the Beatles, had the intelligence not to curb the sonic experimentation of his young protégés, even if he did occasionally try to refocus their lengthy improvisations. According to Nick Mason, "He was […] very good-natured and a capable musician in his own right. Most important of all for us, he was happy to teach us rather than protect his position by investing the production process with any mystique."[5] Aided by the sound engineer Peter Bown, Norman Smith would produce *The Piper at the Gates of Dawn* (1967) and *A Saucerful of Secrets* (1968). After that, feeling he no longer understood the group's artistic direction following Syd Barrett's departure, he donned his producer's hat no more than symbolically for the studio disc in the *Ummagumma* set (1969), the other disc being a live recording produced by Pink Floyd themselves, and for *Atom Heart Mother* (1970). "From our first day," explains Nick Mason, "Norman encouraged us to get involved in the whole production process. He was aware of our interest in the science and technology of recording when, in his words, 'most bands at the time were just trying to be part of the Mersey Sound bandwagon.'"[5]

Pink Floyd would take so well to production that they ended up being able to dispense with his services. The pupils eventually surpassed the master…

Stage Name: Hurricane

Norman Smith's reputation therefore owes a great deal to the Beatles and Pink Floyd, just as the Beatles and Pink Floyd owe much to Norman Smith in terms of their creative process in the studio. But there was more to his career than simply working with these two groups. Although he played a key role in the aforementioned Mersey Sound, producing Gerry and the Pacemakers, the Swinging Blue Jeans, and Billy J. Kramer and the Dakotas, his name is also associated with the Pretty Things (notably the concept album *S.F. Sorrow*, 1968), Barclay James Harvest (eponymous album, 1970, and *Once Again*, 1971) and Kevin Ayers (*The Kevin Ayers Collection*, 1983).

He would also score some notable successes as a singer-songwriter under the pseudonym Hurricane Smith (a nickname taken from Jerry Hopper's film of the same name released in 1952). "Don't Let It Die" (a song originally written for John Lennon) would get to number 2 in the United Kingdom in 1971, while "Oh Babe, What Would You Say" climbed to number 1 in the United States (Cashbox) and number 4 in the United Kingdom.

Norman Smith published his memoirs in 2007 under the title *John Lennon Called Me Normal* ("Normal" being the nickname Lennon had given him at the beginning of the sixties). He died on March 3, 2008, at the age of eighty-five.

THE PIPER AT THE GATES OF DAWN

ALBUM
THE PIPER AT THE GATES OF DAWN

RELEASE DATE
United Kingdom: August 5, 1967

Label: Columbia Records
RECORD NUMBER: SX 6157 (mono)—SCX 6157 (stereo)

Number 6
In the Top 20 for 11 weeks

Astronomy Dominé / Lucifer Sam / Matilda Mother /
Flaming / Pow R. Toc H. / Take Up Thy Stethoscope And Walk /
Interstellar Overdrive / The Gnome / Chapter 24 /
Scarecrow / Bike
OUTTAKE She Was A Millionaire

For Pink Floyd Addicts

Projection seems to have been the initial title chosen for the album.

The Piper at the Gates of Dawn and Syd Barrett's Magic Powers

By the time they signed with EMI on February 28, 1967, Syd Barrett, Roger Waters, Rick Wright, and Nick Mason had already recorded several songs in the studio, including, at Sound Techniques, their first single, "Arnold Layne" and "Candy and a Currant Bun," which would be released on March 11. They nevertheless remained a live band at heart whose performances in the clubs and other venues were based on lengthy psychedelic improvisations and elaborate lighting effects. Between January 5 and February 20, 1967, for example (the eve of the first *Piper at the Gates of Dawn* session), Pink Floyd played some twenty gigs, notably at the Marquee, the UFO Club, and the Commonwealth Institute. Gigs that, moreover, could be described as "multimedia" and that closely resembled the "acid tests" that were taking place at the same time in California under the aegis of the Grateful Dead and Jefferson Airplane. Furthermore, after the concert given on October 15, 1966, at the Roundhouse in Chalk Farm for the launch of the underground magazine *International Times* (*it*), Roger Waters revealed: "It's definitely a complete realisation of the aims of psychedelia. But if you take LSD, what you experience depends entirely on who you are. Our music may give you the screaming horror or throw you into screaming ecstasy. Mostly it's the latter. We find our audiences stop dancing now. We tend to get them standing there totally grooved with their mouths open."[11]

The First Progressive Rock Album

Recording an album would therefore be a new milestone for Pink Floyd. It was February 1967. A few months earlier (August 1966), the Beatles had rolled back the frontiers of rock music in spectacular fashion with *Revolver* (in particular "Tomorrow Never Knows"), and all the indications were that the songs they had been working on in Studio Two at Abbey Road since November (the single "Strawberry Fields Forever"/"Penny Lane" and the album *Sgt. Pepper's Lonely Hearts Club Band*) would represent a new high point. The Rolling Stones had also been exploring new paths with *Aftermath* (April 1966) and *Between the Buttons* (January 1967), as had Bob Dylan with his double album *Blonde on Blonde* (May 1966), the Doors with their first, eponymous, album (January 1967), the Byrds with *Younger Than Yesterday* (February 1967), and Jefferson Airplane with *Surrealistic Pillow* (February 1967)—not to forget Jimi Hendrix, who was getting ready to transform rock guitar with *Are You Experienced* (May 1967). In a word, good old rock 'n' roll had changed. The hour of psychedelia had come, a genre that is less a spaced-out reinterpretation of the blues than the soundtrack to acid trips—in a sense a rereading of *The Tibetan Book of the Dead*, which had inspired Timothy Leary, Ralph Metzner, and Richard Alpert to write *The Psychedelic Experience* in 1964.

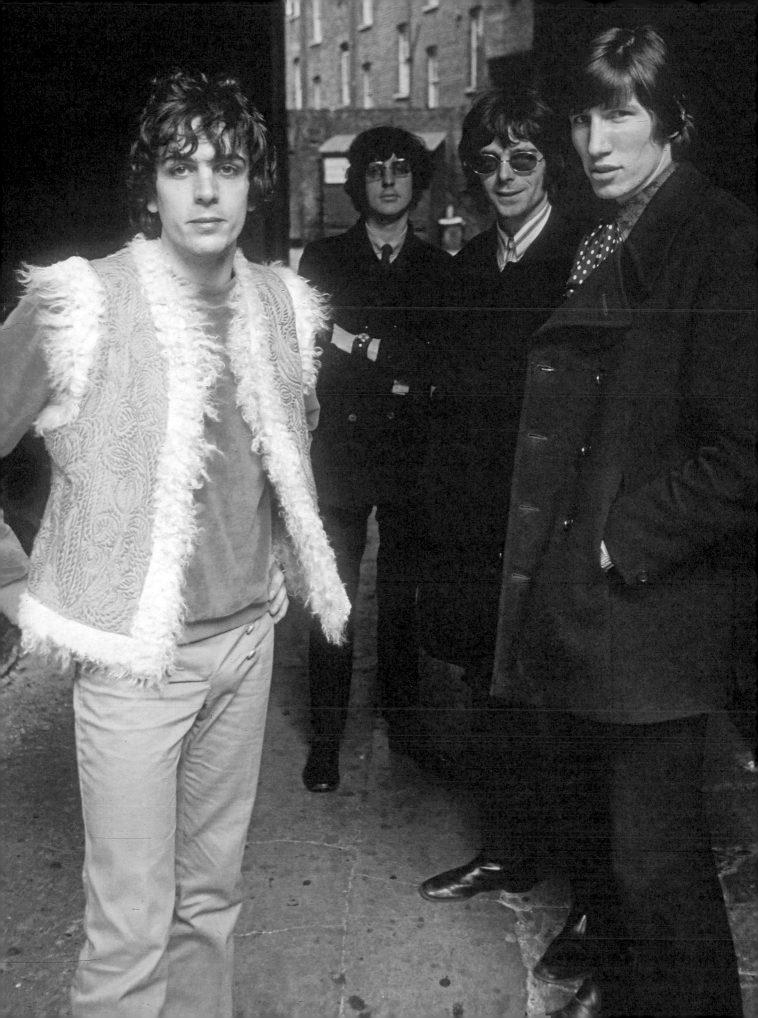

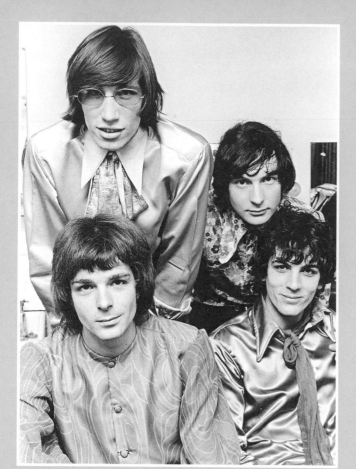

Pink Floyd in March 1967, during the initial recording sessions for *The Piper at the Gates of Dawn*.

A Highly Select Trio

While the EMI management was not exactly hostile to the changes occurring in the music world (thanks partly to company chairman Sir Joseph Lockwood, one of the few in the British record industry who really believed in the future of rock music), it nevertheless wanted to surround Syd Barrett, Roger Waters, Rick Wright, and Nick Mason with a solid team. Three individuals in particular would play a key role in the artistic success of the first album.

First of all, Norman Smith, the architect of the Beatles' sound up to and including *Rubber Soul*, acquired a wealth of experience working alongside George Martin. Smith was the producer Pink Floyd, and Barrett in particular, needed in order to realize their abundant ideas, structure their songs, and add this or that instrument so as to imbue their whole sound with more atmosphere. For them he represented a link with the Fab Four. Peter Jenner describes the effect this produced: "And then here were they, signed by EMI and being taken off to Abbey Road, which was where *The Beatles* recorded for God's sake, you know, WOW!!!"[10] It was not long, however, before the group started to question Norman's role. Phil May, the Pretty Things singer, whom Smith would also produce at the end of 1967 (on their album *S.F. Sorrow*), testifies: "It was hard [working with Syd Barrett's Pink Floyd]. But with Roger [Waters], he was such an egoist. I mean, the minute he could get rid of anybody who was doing anything in the

Floyd, he would. I mean, Roger wanted the Floyd for himself. [...] And Norman wasn't part of that scenario," and: "If there wouldn't have been Norman Smith, the [Pink] Floyd wouldn't have existed...well, they wouldn't have been able to sort of develop what they were trying to do. There was nobody with the ears Norman had."[16]

The second member of the triumvirate was the sound engineer Peter Bown, whom Julian Palacios describes as "a florid gay man in his forties with a Beatle fringe and jovial disposition, coupled with an extraordinary ear,"[17] and whom George Martin called an "electronics wizard." Having moved across from classical music, he was at this time one of EMI's crucial balance engineers. "Bown was one of Norman Smith's mentors," observes Kevin Ryan [co-author of *Recording the Beatles*]. "A senior engineer, Bown taught Smith the art of engineering when Smith was just starting out. [...] More than any other engineer at EMI, he experimented endlessly. Bown was gear-obsessed. He was always trying out new equipment and looking for unconventional ways of combining pieces to make new sounds. Bown was the best engineer for Floyd."[17] It is the same story from Andrew King, who, quite apart from his qualities as a brilliant technician, saw him as someone who was eccentric to say the least, someone who painted his nails with a coat of plastic because "[...] the faders [on the console] were wearing his fingers out."[10] He was so conscientious that he would have no hesitation in positioning

The entrance to the legendary
Abbey Road Studios.

Studio Two: the fabled home of the Beatles.

himself in front of the drummer for minutes on end in order to listen to the precise sound that was being emitted, before then trying to reproduce it in the control room. During the course of a long career, he would record many artists, including the Hollies. He had a hand in the mixing of the Beatles' *Let It Be* and would take charge of aspects of Syd Barrett's first two solo albums before focusing once more on classical music.

The third and final element in the trio was the tape operator Jeff Jarratt, whose job was to assist Bown (and, of course, make tea): "When I was asked to do the album, I went down to see them [play] at the Regent Polytechnic, to know what it was all about before we started working and their performance on stage was quite fantastic."[18] Jarratt would be promoted to sound engineer at the end of 1968. Among his achievements, he was able to pride himself on helping to record the Beatles' "Something" and John Lennon and Yoko Ono's *Wedding Album* in 1969.

In addition to this crucial threesome, other sound engineers and assistants who worked on the album included Malcolm Addey, Geoff Emerick, Harry Moss, Jerry Boys, Graham Kirkby, Peter Mew, Michael Sheady, and Michael Stone.

The Wind in the Willows

The Piper at the Gates of Dawn is first and foremost Syd Barrett's album. With the exception of "Take Up Thy Stethoscope and Walk" (credited to Roger Waters) and the instrumentals "Pow R. Toc H." and "Interstellar Overdrive" (credited to all four members of the group), all the songs are the work of the guitarist-singer. Barrett was undergoing a period of intense creativity at this time: he was composing, painting, and reading without respite, as well as

ingesting quantities of hallucinogenic substances that were gradually removing him further and further from day-to-day reality.

For all this, the songs by Barrett brought together on this debut Pink Floyd album are not escapist songs; they are an evocation (albeit idealized) of his childhood, of those carefree, tranquil years before his father's death. They bring to mind Lewis Carroll, Tolkien and his *Lord of the Rings*, and nursery rhymes inhabited by elves and fairies—but reinterpreted, or rather transformed by means of an immoderate consumption of psychotropic drugs. Indeed the album is named after the seventh chapter of *The Wind in the Willows*, the masterpiece of children's writing by Kenneth Grahame that was published in 1908. This novel tells of the adventures of Mole and Rat, who, during the course of their peregrinations on the River Thames, encounter the wealthy property owner Toad. Other characters include Rat's friends the cheerful Otter and his son Portly. Then there is Pan, the god of Greek mythology, half-man, half-goat, who, in the seventh chapter, appears to Mole and Rat in the guise of a helper: "Then the two animals, crouching to the earth, bowed their heads and did worship. Sudden and magnificent, the sun's broad golden disc showed itself over the horizon facing them; and the first rays, shooting across the level water-meadows, took the animals full in the eyes and dazzled them. When they were able to look once more, the Vision had vanished, and the air was full of the carol of birds that hailed the dawn." Syd Barrett was evidently not unmoved by this experience, this vision, for it seems to have influenced him strongly in the writing of the album as a whole. Peter Bown recalls the moment when the Floyd guitarist suggested this particular title: "'What about *The Piper at the Gates of Dawn*?' and I said: 'It's nothing really to do with the LP, is it?' and he said: 'Well, that doesn't matter! It's something new!'"[10]

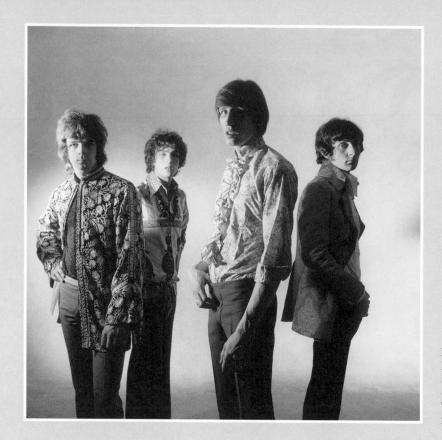

Rick Wright, Syd Barrett, Roger Waters, and Nick Mason dressed by Granny Takes a Trip for their first album.

The Recording

The sessions for *The Piper at the Gates of Dawn* began on February 21, 1967, at the EMI studios located at 3 Abbey Road in Saint John's Wood (North London). Because Studio One (the largest) was reserved primarily for the recording of orchestral works, and the Beatles were in the process of breathing life into *Sgt. Pepper's Lonely Hearts Club Band* in their customary Studio Two (made available to them twenty-four hours a day—unheard of in the recording industry!), Syd Barrett, Roger Waters, Rick Wright, and Nick Mason moved into Studio Three, a far more modestly proportioned room used for smaller bands, but ideal for rock. For Nick Mason, "[…] the recording for *Piper* went pretty smoothly […] there was general enthusiasm from everybody and […] Syd seemed to be more relaxed and the atmosphere more focused […]." This point of view was not shared by Norman Smith, however: "I always felt I was treading on thin ice the whole time, and I had to watch exactly what I said to Syd. He was always terribly fragile." Smith adds: "He would perhaps have laid down a vocal track and I would go up to him and say, 'OK, Syd, that was basically good, but what about blah, blah, blah?' I never got any response, just 'Hum.' We would run the tape again, and he would sing it exactly the same way."[5] On the other hand, Bown and Jarratt have expressed their amazement at Barrett's energy and sparkle: "He sometimes had to explain to me what it was about, or meant to be about," explains Bown to David Parker in his book *Random Precision*. "Always the bright, creative chap who couldn't sit still, always wanted to try something new, always had great ideas."[10] Looking back, Andrew King would have no hesitation in talking of his "magical powers."[10]

There would be more than fifty sessions in total, taking into account the recording, the mixing, and the mastering. This is no small number—especially as the album has only eleven tracks and the group gave priority to live takes. It should be recognized, however, that the music is relatively complex, difficult to get together, and above all incorporates an extremely wide range of electronic sounds, requiring fastidious studio work. This helps us to gauge a little more accurately the achievement of Norman Smith in channeling the improvised nature of the tracks and adapting it to the professional criteria of the day. However, if we compare this debut album to the Beatles', made in barely more than a dozen hours at the same place, and with more or less the same equipment, it becomes clear that the musical approach is radically different, not least because of the way rock music had changed between 1963 and 1967.

A Decisive Turning Point

The sessions for *The Piper at the Gates of Dawn* concluded on July 21, 1967, with the mixing of the stereo version. The album was released in the United Kingdom on August 5, during the Summer of Love. It would reach number 6 on the charts and remain in the British Top 20 for eleven weeks.

The LP was thus a commercial success, but it was also, most importantly, an enormous artistic success in the land of tea and Tolkien. In fact this first album by Pink Floyd marked a decisive turning point in the development of rock. With its experimentation of various kinds, its classical overtones, its spacey sonorities, and, in its lyrics, its journey into Barrettian "heroic fantasy," this is an album that

The storefront of Granny Takes a Trip, with its 1948 Dodge.

went far beyond the frontiers of pop. While it can sound like London's response to the West Coast Sound, it is also hailed as one of the seminal works of psychedelia. After the release of *The Piper at the Gates of Dawn*, which hit the stores two months after *Sgt. Pepper's Lonely Hearts Club Band*, the musical landscape would never be the same again. Pink Floyd may not have killed off pop music, but they certainly opened up the way for further experiments that would, before long, be labeled progressive rock.

Upon its release, *The Piper at the Gates of Dawn* was awarded four stars (out of five) by *NME* and the *Record Mirror*. Today it occupies number 347 in the list of 500 greatest albums of all time drawn up by *Rolling Stone* magazine.

The Sleeve

On the sleeve of *The Piper at the Gates of Dawn*, Syd Barrett, Roger Waters, Rick Wright, and Nick Mason can be seen sporting garments that had come straight out of Granny Takes a Trip, the hippie-chic boutique much loved by denizens of the capital's underground. The photograph, taken by Vic Singh, shows the band members in semi-close-up and multiplied three times. Vic Singh quit India for London with his parents at the end of the forties. After taking his first steps in photography alongside David Bailey and Norman Eales, he set up his own studio with valuable assistance from Vidal Sassoon, the emblematic hairstylist of Swinging London. Pattie Boyd, who was one of his first models, introduced Singh to her husband, George Harrison. "I used to go to lunch in Esher with Pattie and George—we were just mates," explains Vic Singh, "and one Sunday, as I was leaving he [George Harrison] said, 'Oh, this is for you. I've got

this lens and I don't know what to do with it, so you have it. You might be able to use it for something.'"[18]

The lens in question was a prism lens that multiplied the number of images of the subject threefold or fourfold. When Peter Jenner and Andrew King invited him to do the photography for Pink Floyd's first album, Vic Singh spontaneously decided to try this lens, which he fitted to his Hasselblad and used with Ektachrome film. "I first started with some test Polaroid shots, positioning them on the white background, which was a bit tricky as the prism lens multiplied each figure—they all overlapped each other!—so I had to get the figures positioned right or the whole thing looked like a mess."[19] In the end, Vic Singh's photograph resembles the kind of vision that might be experienced by someone undergoing an LSD trip.

On the back of the sleeve is an illustration by Syd Barrett, who, according to Andrew King, wanted to contribute in some way. "And it's a sort of…," King tries to explain, "actually I knew it was a cut-out, sort of reversed out photo."[10] What Barrett actually created was a montage with figures silhouetted against a gray background. This has been given a psychedelic makeover on the booklet accompanying the remastered CD that was released in 2011.

Technical Details

In moving into Studio Three of EMI Studios (renamed Abbey Road Studios around 1970), Pink Floyd was able to take advantage of first-rate recording equipment. The mixing desk was the legendary REDD.51, designed by EMI's engineers, which was primitive in appearance but outstanding in quality. The tape recorder was a four-track Studer J37 (EMI would

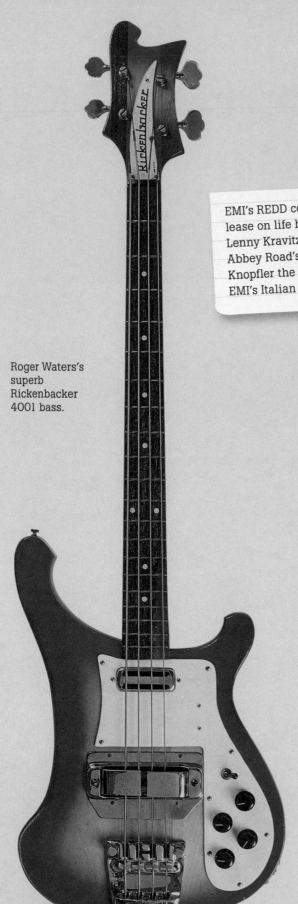

The famous Neumann U47, a direct rival of the U48 favored by Peter Bown.

EMI's REDD consoles were given a new lease on life by our friends the rockers: Lenny Kravitz bought the REDD.37 from Abbey Road's Studio One and Mark Knopfler the REDD.51 that had equipped EMI's Italian studio.

Roger Waters's superb Rickenbacker 4001 bass.

not acquire an eight-track 3M until 1968, by which time other London studios, such as Trident, were already benefiting from the technology), and the monitors were probably Altec 605As (although there is some disagreement over this, a number of commentators claiming they were Tannoys). Among the various effects used, those worth mentioning in particular are the EMT 140 reverb plate, the Fairchild 666 compressor, and the Fairchild 660 limiter, which Peter Bown coupled with the RS168 Zener compressor/limiter—a prototype he alone used in 1967 but which would soon find a place in the TG consoles (on which Pink Floyd would record their legendary *Dark Side of the Moon*)—but also the RS127, an equalizer nicknamed the "Presence Box," which was fabricated in-house. Also worthy of note is Artificial Double Tracking (ADT), which was developed in 1966 by the incredible engineer Ken Townsend at the express request of John Lennon, who could not bear to double his own voice and wanted a machine to do it for him! As for mics, Peter Bown favored Neumann U48s for the voice and Neumann U67s for the guitars, in addition to which various other models, such as the Sony C38, the AKG D19C, and the Neumann KM56, were also used.

The Instruments

Syd Barrett's main guitar was a white 1962 Fender Esquire bought in 1965, which he wrapped in silver-colored plastic film and decorated with metallic discs that had the advantage of reflecting the stage lighting effects. The acoustic instrument he favored was a Harmony Sovereign H1260, which was a guitar adopted by numerous guitarists including Jimmy Page and Pete Townshend. He also played a twelve-string acoustic that has not been securely identified. This may have been a Harmony 1270 or a Levin LTS5 imported by Rose Morris in England. (David Gilmour has mentioned that Levin guitars were used on the group's second album.)

Before Paul McCartney and Chris Squire turned the Rickenbacker 4001 bass into a thing of legend, Roger

Barrett with his Fender Esquire, customized in highly psychedelic style.

A Fender Esquire similar to Barrett's.

Waters was already playing one (model RM 1999, also imported by Rose Morris) with a Fireglo finish and a mono output. With it he used a plectrum and Rotosound strings, a setup that helped his somewhat guitaristic style to find its true identity. Rick Wright played a Farfisa Compact Duo organ, from which he draws sonorities that are immediately characteristic of early Floyd. He also played an acoustic piano, almost certainly Studio Three's Model B Steinway grand, a Mustel celeste, and what is probably a Hohner Pianet. Finally, since discovering the incomparable Ginger Baker of Cream at the end of 1966, Nick Mason had been playing a Premier drum kit with two bass drums. He can also be heard on the tubular bells.

For amplification, Syd Barrett evidently used a 50-watt Selmer Truvoice Treble-n-Bass 50 with a 2x12 cabinet, while Roger Waters was for the most part plugged into the console via a DI (direct injection) box—a method that Peter Bown was particularly fond of. When he chose to play through an amp, he turned to a Selmer Treble-n-Bass 100 with a Selmer Goliath 100 bass cabinet.

In terms of effects, the Binson Echorec occupied an important place in Syd Barrett's playing, as it did in the sound of Pink Floyd's subsequent recordings. Rick Wright also made systematic use of it in his keyboard parts. Syd loved distortion and wah-wah and seems to have used a Selmer Buzz Tone pedal and a Selmer Fuzz-Wah.

Astronomy Dominé

Syd Barrett / 4:12

Musicians
Syd Barrett: vocals, electric rhythm and lead guitar
Roger Waters: bass
Rick Wright: vocals, keyboards
Nick Mason: drums
Peter Jenner: megaphone

Recorded
Abbey Road Studios, London: April 11, 12, 17, 18, May 12, July 5, 18, 1967 (Studio Three)

Technical Team
Producer: Norman Smith
Sound Engineers: Peter Bown, Malcolm Addey
Assistant Sound Engineers: Jeff Jarratt, Peter Mew, Michael Stone, Graham Kirkby

For Pink Floyd Addicts

The precise phrases uttered by Peter Jenner in the song's intro are, for the most part, too nebulous to make out. The words *moon*, *Scorpio*, *Pluto*, and *all systems satisfied* can nevertheless be identified.

AN UNPARDONABLE LACK OF TACT...

The producer of the Electric Prunes, whose song "Are You Lovin' Me More (But Enjoying It Less)" was an inspiration to Syd, was Dave Hassinger. Then sound engineer at the legendary RCA Studios in Hollywood, Hassinger was thanked by his management in 1966 for involving himself in the career of the Prunes. It was also he who recorded the Rolling Stones' immortal "(I Can't Get No) Satisfaction" in May 1965, however. An unpardonable lack of tact...

Genesis

"Astronomy Dominé" is a Syd Barrett number that Pink Floyd was already performing live in 1966. Peter Wynne-Willson, the group's lighting engineer, was present at its creation: "I can remember him writing 'Astronomy Dominé,' which wasn't a one evening scene, he worked on it quite hard."[17] Syd's choice of title gives rise to a number of possible interpretations. It may derive from a French translation of *The Basic Writings of Bertrand Russell* (1961) in which the words of the British philosopher and mathematician "The world of astronomy dominates my imagination" are rendered as "le monde de l'astronomie domine mon imagination...." or it may have been inspired by *Prometheus Unbound* (1820) by the Romantic poet Percy Bysshe Shelley.

"Astronomy Dominé" is a galactic journey that takes us successively to *Jupiter and Saturn, Oberon, Miranda/Titania, Neptune, Titan.* It is also a journey that offers little hint of optimism. In this song, Barrett evokes *A fight between the blue you once knew, Stars* [that] *can frighten,* and, above all, *icy waters underground,* which, it is tempting to believe, could engulf everything. From this journey in space to a bad trip on LSD (the hallucinogenic drug of which the Pink Floyd songwriter was making pretty heavy use at this time) is but a short and not illogical step...It is interesting to see Barrett blithely combining references to astronomy, Shakespeare (Oberon, Miranda, and Titania are moons of Uranus, while Oberon is also the king of the fairies and Titania the queen of the fairies in *A Midsummer Night's Dream*, and Miranda is Prospero's daughter in *The Tempest*), and comic strips. The *Stairway scared* Dan Dare of the second verse is a science fiction character from *Dan Dare, Pilot of the Future*, created by Frank Hampson and published in *Eagle* comics between 1950 and 1969. Finally, it is worth considering whether, following the example of Dylan and the poets of the Beat Generation, Barrett was simply enjoying playing with words, with their music and double meanings, for, as Julian Palacios correctly observes, "in 'Astronomy Dominé' enchantment *is* sound."[17]

Some people at the time regarded this track as spawning the genre of "space rock," an idea that Roger Waters

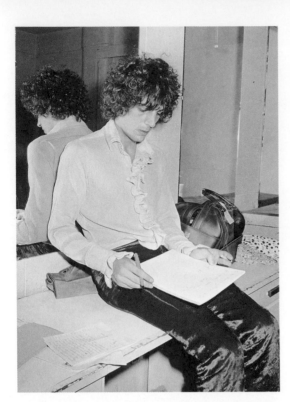
Syd Barrett in his dressing room in the second half of the '60s.

COVERS

There are more than twenty covers of "Astronomy Dominé," recorded by artists as diverse as Gary Lucas, Voivod (a heavy metal version), Nash the Slash, and Kevin Blechdom (on the banjo!). David Gilmour himself included it in the set list of his tour *Rattle That Lock* world tour, as the opener for the second half of his concerts (2015–16).

would strongly refute: "All that stuff about Syd starting the space-rock thing is just so much fucking nonsense. He was completely into Hilaire Belloc, and all his stuff was kind of whimsical—all fairly heavily rooted in English literature. I think Syd had one song that had anything to do with space—'Astronomy Dominé'—that's all. That's the sum total of all Syd's writing about space and yet there's this whole fucking mystique about how he was the father of it all. It's just a load of old bollocks."[20]

Production

Right from the intro, the Floyd plunges us into an atmosphere redolent of Cape Canaveral: voices simulating radio contact between the scientists at mission control and the astronauts in space, disturbing guitars, Morse code…Syd Barrett seems to have written the soundtrack to a science fiction movie, a mini space opera lasting four minutes that gives free rein to a fertile imagination, and inevitably stimulated by the hallucinogens he had been immoderately consuming. The results are unique, especially for 1967. No other rock group was adopting this kind of approach, that is to say one determinedly focused on experimentation and nonconformism, seeking new, improvisatory sonorities.

During the first session on April 11, the Floyd recorded the backing track. This seems to have caused them some problems, as they were not happy until the fourteenth take. The reason may be the difficulty Norman Smith had in channeling Barrett's playing, the guitarist proving himself incapable of delivering the same version twice. It has to be said that the unfortunate producer, who was more accustomed to recording melodic pop songs of the regulation three

minutes' duration, must, as Peter Bown describes, have felt somewhat disoriented: "Yes I do (remember Syd changing things)…because we had to do quite a few overdubs on the songs and Norman Smith would try and make notes as to what part of the song that was, and what take it was…[in the end, however] he didn't overdub many things."[10] And this can be heard in the results: despite its apparent complexity, "Astronomy Dominé" is singularly transparent in its arrangements, which is the mark of a great number. This backing track was based around Barrett's guitar, a superb part—simultaneously rhythm and lead—delivered on his Fender Esquire. The tones Syd draws from his instrument are unique and immediately identifiable. He obtains a relatively clear, though still subtly distorted tone from his amp and evidently uses his Binson Echorec, which, along with his Zippo for slide passages, was to become a trademark of his from around this time. Roger Waters supports him with some solid bass playing on his 4001, presumably plugged directly into the console. Rick Wright provides a reasonably discreet accompaniment, consisting mainly of layers of sound laid down on his Farfisa Compact Duo, using his pedal to vary the volume (2:18 and 2:23). Finally, Nick Mason delivers an excellent drum part, favoring tom breaks while giving plenty of emphasis to his footwork. (His two bass drum pedals squeaking slightly.)

The group dedicated the afternoon of April 12 to recording the vocals. This time, Syd and Rick share the singing, their different timbres complementing each other wonderfully. They harmonize with each other and even risk a sixth from 1:02 (in the fifth line of the song). During the course of the evening (from 7 p.m. to 2:15 a.m.), other voices are added and Syd records guitar overdubs. It is worth noting

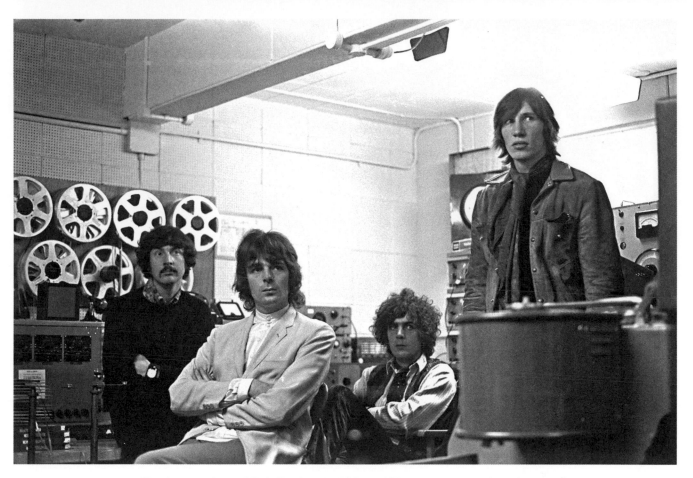

The four members of Pink Floyd at the BBC in 1967 to promote their first album.

the quality of his opening riff, a mixture of rock music and sci-fi movie with a touch of surf music for good measure (0:31). He opens with a guitar part (doubled) that, it has to be admitted, is almost an exact copy of the intro to "Are You Lovin' Me More (But Enjoying It Less)," a B-side by the Electric Prunes released in April 1967, just a few days before Pink Floyd entered the studio. (The A-side was "Get Me to the World On Time".) This implies that "Astronomy Dominé" was not yet composed in its final form at the time of the very first recording session for the album on February 21, six weeks earlier. The same E5 chord that launches the Electric Prunes' number can be heard, along with the same rhythmic pattern…Like all great songwriters, however, Syd transcends his borrowed material to create something personal and utterly original.

On Monday, April 17, it was Peter Jenner's turn to spring into action, having been given the honor of launching "Astronomy Dominé" with that highly distinctive radio voice. "Yes that's me on the megaphone […] I remember sitting there with Syd helping to write that bit. He had this book about planets and was reading through it—something like *The Observer's Book of Planets*, that sort of thing. Nothing really serious! Putting down…all the references came from that."[10] Listening to the stereo mix, the voice is on the right, while a generic whistle can be heard in the left channel, evidently generated by Syd's

Binson Echorec. Jenner's mission control voice is one of the track's strengths. It is closely followed (at 0:22) by a sequence of Morse code beeps devoid of any real meaning, and probably played by Rick on his Farfisa. Peter Jenner's megaphone makes a comeback at 2:40 to complete the Floyd's voyage into deep space. Conspicuous in the instrumental bridge (which begins at 1:34) is Syd's heavy use of his Echorec, as much to launch the notes he plays on his Fender as to generate a kind of electronic wind (1:40) that to some extent recalls "Echoes," which the group would record for the album *Meddle* (but without Syd…) in 1971. The song ends cleanly, with a rapid fade-out on the final chord. It would take four more sessions to finalize the different mono and stereo mixes. As the opener to Pink Floyd's debut album, "Astronomy Dominé" is a small masterpiece that testifies to Syd Barrett's immense talent.

The Post-Barrett Version

"Astronomy Dominé" continued to be played by the Floyd after Syd Barrett had left the band and David Gilmour had joined. Up to June 1971, in fact, when "Echoes" became their new centerpiece. In the meantime, Barrett's compositions underwent various transformations: the megaphone introduction was replaced by Rick Wright's keyboards, the first section was sung twice, and the second, instrumental section was extended by several minutes.

Lucifer Sam

Syd Barrett / 3:08

Musicians

Syd Barrett: vocals, electric rhythm and lead guitar
Roger Waters: bass, bass with bow, backing vocals (?)
Rick Wright: organ, piano (?), backing vocals (?)
Nick Mason: drums, maracas or cabasa (?), timpani (?)

Recorded

Abbey Road Studios, London: April 12, 13, 17, 18, June 1, 12, 27, 29, July 5, 18, 1967 (Studio Three)

Technical Team

Producer: Norman Smith
Sound Engineers: Peter Bown, Malcolm Addey
Assistant Sound Engineers: Jeff Jarratt, Michael Sheady, Jerry Boys, Michael Stone, Graham Kirkby

For Pink Floyd Addicts

Produced by Joe Boyd, the Purple Gang was recording their song "Granny Takes a Trip" at Sound Techniques studios at the same time that Pink Floyd was recording "Arnold Layne."

The Purple Gang, whose singer Peter Walker (with hood) may well be the hero of "Lucifer Sam."

Genesis

This song has its origins in the soundtrack for an animated film entitled *The Life Story of Percy the Ratcatcher* that Pink Floyd was planning to record. This was probably an adaptation of the seventeenth-century British fairy tale *Dick Whittington and His Cat* (the story of a poor orphan who grows prosperous thanks to the mouse- and rat-catching abilities of his feline friend, and a highly altruistic sea captain). The project (which had only been announced in the columns of *NME*) having failed to come to fruition, Percy the Ratcacher was then renamed "Lucifer Sam" by Pink Floyd. The most likely explanation is that Syd Barrett was inspired by *Dick Whittington and His Cat* to express his affection for his own cat: *Siam cat/Always sitting by your side/Always sitting by your side/That cat's something I can't explain*, he sings. As for Jennifer Gentle, *a witch*, this can perhaps be seen as an allusion to the fifteenth-century song "Riddles Wisely Expounded," in which three pretty and intelligent sisters, Jennifer, Gentle, and Rosemaree, all love the same knight.

Other hypotheses also exist. Syd Barrett may be alluding to a psychodrama that played out in the Beaufort Street flat of his friends Sue Kingsford and Jock Findlay, where all kinds of drugs were available. One evening, a regular visitor there named Thai Sam (renamed Lucifer Sam in the song) gave acid to a certain Alan Marcuson, who was not expecting it and had a bad trip. Yet again, it could be about Peter Walker, the singer with the Purple Gang, who liked to call himself Lucifer, or even Jenny Spires, the girlfriend of the songwriter, who had no shortage of suitors at the time. Interviewed years later, she rejected the idea that she had been Barrett's target: "Well, when I heard 'Lucifer Sam,' I didn't really think much about it. Of course, I think it's a wonderful song; I love it. It seems to have one foot in the past, musically, and one in the future. I was so used to hearing him sing and write songs and he had sent me poems and written songs to me in his letters, previously. Also, I knew the story of 'Lucifer Sam' and wasn't surprised by it. He often said to me 'You're so gentle and I love talking to you,' so it seemed normal, really."[20]

What, then, is the listener to think? The answer may lie in something Syd Barrett himself has said: "It didn't mean

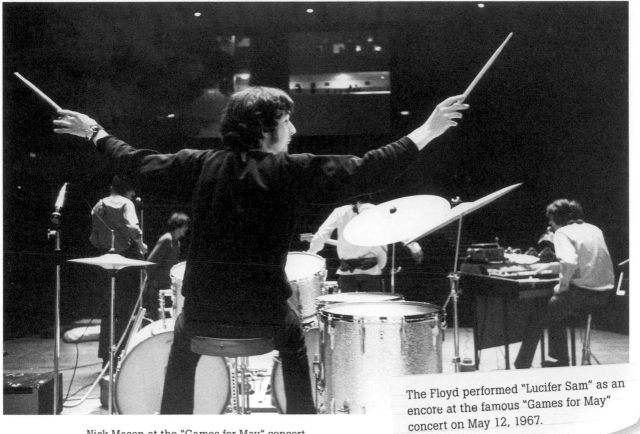

Nick Mason at the "Games for May" concert.

The Floyd performed "Lucifer Sam" as an encore at the famous "Games for May" concert on May 12, 1967.

much to me at the time, but after three or four months, it began to assume a precise meaning."[17] The songwriter is alluding here to a bad acid trip during which paranoia made his Siamese cat appear to him as a bad omen…

Production

After the influence of the planets in "Astronomy Dominé," Syd Barrett chose the musical world of the superhero for his wonderful "Lucifer Sam." It is presumably the signature tune of the US television series *Batman*, composed in 1966 by the gifted Neal Hefti, that inspired the musical atmosphere and riff of this amazing track (which in turn must have caught the ear of John Lennon for his "Hey Bulldog" of 1968). However, other influences can also be detected, such as Traffic's song "Paper Sun," released in May 1967.

The first session was held on April 12. The musicians turned their attention to "Lucifer Sam" (then called "Percy the Ratcatcher") after recording the overdubs for "Astronomy Dominé." Getting the ensemble right proved difficult, and the session went on until 2:15 a.m. The track kicks off with Syd's guitar and his superb riff reminiscent of the guitarist Dick Dale and numbers such as "Surf Beat" (1962). Once again it is with his Fender Esquire and the Binson Echorec that Syd obtains his highly distinctive sound. Roger Waters supports him with some very good work on bass, and Nick Mason delivers a fearsomely efficient drum part on his Premier kit, with much use of his ride cymbal and hi-hat. Rick Wright does not enter until the fourth

bar, curiously bringing himself in on his Farfisa organ with the volume pedal (unless, that is, this effect was introduced during mixing). It took seven takes to obtain a satisfactory backing track. The next day, maracas were added (sounding more like a cabasa) which can clearly be heard in the intro and at the end of the track. Roger innovates by playing his Rickenbacker 4001 with a bow throughout the instrumental bridge from 1:31 to 1:58. The effect is striking and reinforces the *Batman* theme song quality of the arrangements. During this same section, Syd can be heard bending short phrases on his Fender in order to imitate the meowing of a cat! Rick brought the session to a close with numerous organ parts. It was not until April 18 that "Lucifer Sam" established itself as the definitive title. On June 1, Syd recorded his lead vocal, in all likelihood doubled by means of ADT, the miracle machine that spared John Lennon the trouble of all that fastidious doubling of his own voice. June 12 was dedicated to the addition of other guitars, vocals, and also—as David Parker has revealed—timps and a piano. However carefully one listens out for them, however, these two instruments seem to have been buried on the final version. Following some last guitar and voice overdubs recorded on June 27, the remaining sessions were given over to the various mixes.

Once again, Syd Barrett has proved his innate talent for writing little pop-rock gems. It is only a shame that "Lucifer Sam" wasn't released as a single because it had all the makings of a hit.

Matilda Mother

Syd Barrett / 3:09

Musicians
Syd Barrett: vocals, backing vocals, rhythm and lead guitar
Roger Waters: bass, backing vocals
Rick Wright: vocals, keyboards, backing vocals
Nick Mason: drums
Recorded
Abbey Road, London: February 21, 23, June 7, 29, July 18, 1967 (Studio Three)
Technical Team
Producer: Norman Smith
Sound Engineers: Peter Bown, Norman Smith, Malcolm Addey
Assistant Sound Engineers: Michael Sheady, Peter Mew, Michael Stone, Jeff Jarratt, Graham Kirkby

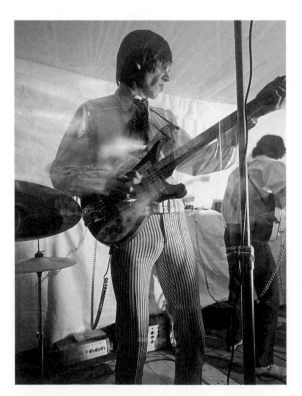

Roger Waters, with his Rickenbacker 4001 bass, in the midst of performing "Matilda Mother."

Genesis

"Matilda Mother" reveals Syd Barrett's fascination with children's tales and songs. In this instance, he has drawn on the imagination of Hilaire Belloc, an Anglo-French writer best known for his *Cautionary Tales for Children*, among them that of Matilda, "who told lies, and was burned to death." This is a tale that Syd's mother read to him as a child in their loving Cambridge home…

Syd Barrett was so enamored of Belloc's fable that in his initial draft of the song's lyrics he reproduced entire lines from the original, especially in the refrain: *And finding she was left alone/Went tiptoe to the Telephone/And summoned the Immediate Aid/Of London's Noble Fire-Brigade.* These phrases can be heard in the original version of the song, recorded on February 21, 1967. Barrett, Waters, Wright, and Mason did not for a second imagine that there could be the slightest problem with this. Against all expectations, however, when Andrew King asked Hilaire Belloc's rights holders for permission to use extracts from the text of "Matilda," the response was a firm refusal. "The iambic beat of Belloc totally fits the metre of the song. The Belloc estate weren't keen at all, so Syd replaced the extracts."[18] In reality, what Syd Barrett did was write a new story, a highly poetic text that plunges us into the heart of European legend (Tolkien again!) and that, at the same time, evokes the songwriter's childhood: a tale involving a king, a scarlet eagle with silver eyes, and a thousand mysterious riders. The final lines of the last verse allow no room for misunderstanding: *And fairy stories held me high/On clouds of sunlight floating by.*

Production

It was with "Matilda Mother" that Pink Floyd began recording *The Piper at the Gates of Dawn*. That Tuesday, February 21, the day of their very first session at Abbey Road—which would be followed by many more—was their baptism of fire. The studio had been booked for 11 p.m., a relatively unusual time for the team. " I simply remember the session because the circumstances were so odd,"[10] recalls Michael Sheady, then assistant sound engineer. And Peter Bown, the chief engineer, has a perfect

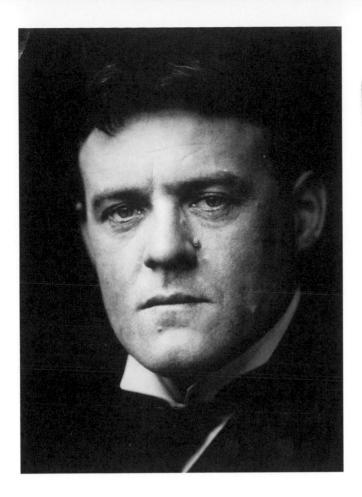

On the compilation *Masters of Rock*, released in 1974, the title "Matilda Mother" is spelled with an *h* ("Mathilda").

For Pink Floyd Addicts

Born at La Celle-Saint-Cloud in 1870, Hilaire Belloc emigrated to England two years later with his mother, following the suicide of his father, Louis Belloc. A fervent Catholic and a Liberal member of Parliament, Belloc owes his renown to his double talent as a polemicist (against H. G. Wells) and a poet (including *Cautionary Tales for Children*). Along with G. K. Chesterton, H. G. Wells, and George Bernard Shaw, he was one of the most famous writers of the Edwardian era. Hilaire Belloc died in 1953.

recollection of his first encounter with the group: "I went in number 3 studio where they were…and I opened the doors and I heard the sound and shit myself! I thought 'My God!' I've never heard anything like this in my life and I've got to record it!"[10] In the end, despite the mutual trepidation, the session passed off more or less satisfactorily, ending at 6 a.m. The group needed six takes to get a definitive backing track in the can (duration at this stage: 3:55). The track begins with Rick's organ, over which Roger plays an octave on his bass. Syd then comes in with arpeggios on his guitar. This produces a quasi-si-medieval sonority in perfect keeping with the words, a sound that it is tempting to think may have influenced King Crimson on their 1969 album *In the Court of the Crimson King*. The instrumental bridge is launched by Syd singing onomatopoeia (*pow, shhh!*) and apparently reinforcing his vocalizations by tapping his mic to obtain a percussive effect. Rick launches into a vaguely oriental-sounding organ solo supported by Nick's drumming (fairly distant in the mix, if the truth be told), Roger's bass, and Syd's guitar. After a reprise of the last line, the track draws to a close with a relatively long coda (thirty seconds or so) whose atmosphere is not unlike the conclusion of the Beatles' "I Want to Tell You" on the album *Revolver*. The time signature switches from four in a bar to three (3/4), and Rick takes a second organ solo while Roger goes into a frenzy on his Rickenbacker.

Rick sings lead, at least in the first two verses and the refrains, which he shares with Syd. The latter takes care of the bridge and the last verse. This sharing of the lead vocal seems as over the top as it is inexplicable on a three-minute track.

The second session took place on February 23, with Norman Smith, exceptionally, at the console. This was for mono mixes that do not seem to have been used. It was not until June 7, a little over three months after the previous session, that the Floyd reworked the song. The purpose was to add the various backing vocals. As Peter Jenner explains: "Norman would go out in the studio and play piano for them to rehearse harmonies, because back then harmonies were very big through The Beatles and The Beach Boys."[10] The result is a success, and the voices of Rick, Syd, and Roger add to the pop feel of this track. June 29 was devoted to the various edits (with Jeff Jarratt, who is involved for the first time on this song), and the best one can say is that the edit at 1:58, presumably in order to shorten the track, is far from successful. The harmonies at the end of the bridge do not tie in with the beginning of the last verse, and the dynamics are different. This is a shame, because "Matilda Mother" is another great Floyd song in spite of the scarcity of covers to which it has—thus far—given rise. It was nevertheless an important inspiration for the track "Fireworks" on Blue Öyster Cult's 1977 album *Spectres*.

Flaming

Syd Barrett / 2:46

Musicians
Syd Barrett: vocals, twelve-string acoustic guitar, rhythm and lead guitar, backing vocals, miscellaneous sound effects
Roger Waters: bass, backing vocals, miscellaneous sound effects (including a slide whistle)
Rick Wright: organ, piano, backing vocals, miscellaneous sound effects
Nick Mason: drums, miscellaneous sound effects
Recorded
Abbey Road Studios, London: March 16, June 27, 29, 30, July 18, 1967 (Studio Three)
Technical Team
Producer: Norman Smith
Sound Engineers: Peter Bown, Norman Smith
Assistant Sound Engineers: Jeff Jarratt, Graham Kirkby

For Pink Floyd Addicts

The Floyd performed "Flaming" on the French television show *Bouton Rouge*, produced by Jean-Paul Thomas and broadcast on February 24, 1968. Syd was absent and was replaced by David Gilmour on lead vocals and guitar. Fans would be treated to the sight of Roger Waters playing his slide whistle with an earnest look on his face!

Genesis
It is possible that "Flaming" could be the definitive version of a song entitled "Snowing," which proceeded no further than draft stage (in the form of a recording by Barrett and Waters). What is certain is that it offers a perfect illustration of Syd Barrett's poetic approach, that is to say the revisiting of nursery rhymes through the lens of his psychedelic experiences. *Alone in the clouds all blue/Lying on an eiderdown/Yippee! You can't see me/But I can you*: the first verse and the four that follow once again take us back to Syd's childhood, to adolescent games and the green meadows of Cambridge, to an era before tragedy struck the family with the death of his father. At the same time, however, these lines also evoke the "mystical visions" and "cosmic vibrations" of which Allen Ginsberg speaks in his poem "America." These succeed one another during a trip under the influence of a hallucinogenic drug, that is to say LSD, which for Aldous Huxley makes "this trivial world sublime" and renders the soul visible. Hence the song's protagonist *Sitting on a unicorn*, and then a dandelion, and *Travelling by telephone*.

"Flaming" is the A-side (with "The Gnome" on the flip side) of a single that was released exclusively in the United States (on the Tower Records label on November 2, 1967) in order to promote Pink Floyd's first US tour. This was in place of the single "Apples and Oranges"/"Paint Box," which was reserved for the European market. The song failed to chart.

Production
The first take of "Flaming," recorded on March 16, proved satisfactory. But it was not until June 27 that the group reworked it. This was also when the four tracks on the Studer J37 were transferred to a second tape recorder in order to free some space—in keeping with the technique favored by the staff at Abbey Road (roll on the 3M eight-track!). Following numerous overdubs, June 29 and 30 were reserved for editing and mixing, and on July 18 the stereo version was finalized.

"Flaming" is typical of Syd Barrett's universe. The colorful imagery of the words is complemented by musical arrangements that are at one with his psychedelic,

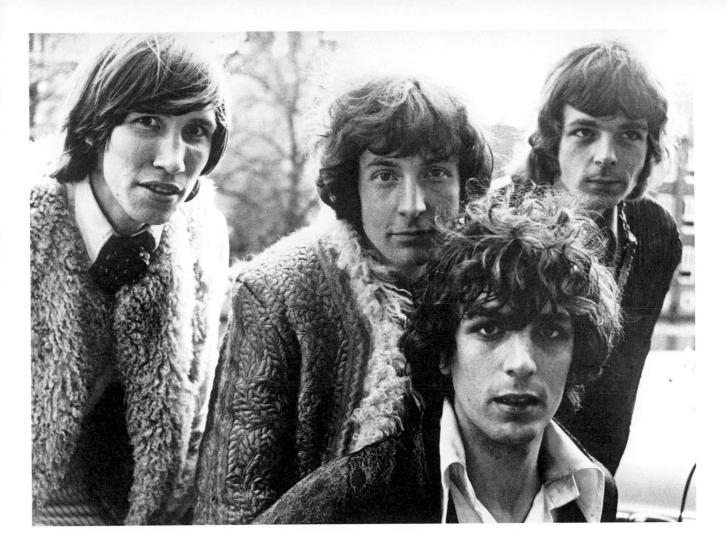

romantic, sugar-coated, whimsical visions. Nick Mason recalls that Norman Smith had strongly encouraged the band members to stray off the beaten track and make use of the many and varied instruments that were available to them at Abbey Road. And so, against the background of an organ most probably played through a Leslie cabinet, the Floyd abandon themselves to multiple sound effects that are not always easy to identify. We hear the ticktock of a clock (possibly Mason on his snare drum), a slide whistle played by Waters (who makes another appearance at 0:39 with a magnificent *cuckoo!*), mouth noises, someone whistling…all of this clearly under the guidance of Norman Smith and Peter Bown, who contribute various Studio Three effects (phasing, compression, etc.). Keith Rowe of the group AMM has said that Syd Barrett had taken his inspiration from "Later During a Flaming Riviera Sunset" (on *AMMMusic*) for the intro to "Flaming" and possibly for the title of the song as well. There is a certain similarity between the two tracks, the same idea of sonic mist, but this is where the comparison ends. The AMM intro is full-on musical experimentation, while the Floyd's evokes the atmosphere of a forest at night, pierced by the shrieks of owls or fantasy creatures. Waters's bass, Wright's organ, and Mason's ride cymbal, played cross-stick, then

make their entrance. The musical arrangements veer among psychedelia, carnival, and British pop. Barrett's voice possesses a gentleness and an innocence that are in complete harmony with the poetry of his text, an effect reinforced by backing vocals from Wright and Waters that produce a highly colorful result. Syd's voice is treated with ADT except in the third verse, in which he really does double himself.

New instruments make an appearance on this track: a small bell struck rapidly at 0:57, a twelve-string acoustic guitar (Harmony 1270? Levin LTS5?), and an acoustic piano. At 1:11 and again in the following verse, a Clavinet or, more probably, a varispeed piano (recorded slowly and then played back at normal speed) can be heard. This is more pronounced at the beginning of the instrumental bridge, where the effect is supplemented by emphatic use of the Binson Echorec. In this same section we can hear the sound of a mechanical toy with a characteristic clicking sound, and new vocal effects. Wright plays a sped-up piano solo, Barrett plays arpeggios and lead on his Fender Esquire, Waters plays a melodic motif in the upper register of his bass, and Mason incorporates numerous tom breaks into his drumming. After a final verse, the track ends cleanly with an organ chord and a peal of bells.

Pow R. Toc H.

Syd Barrett, Roger Waters, Rick Wright, Nick Mason / 4:27

Musicians
Syd Barrett: acoustic guitar, electric rhythm and lead guitar, vocal effects
Roger Waters: bass, vocal effects
Rick Wright: keyboards, vocal effects
Nick Mason: drums, vocal effects (?)
Unidentified musician: orchestral timpani, various sound effects

Recorded
Abbey Road Studios, London: March 21, 29, July 18, 1967 (Studio Three)

Technical Team
Producer: Norman Smith
Sound Engineers: Peter Bown, Norman Smith
Assistant Sound Engineers: Jeff Jarratt, Graham Kirkby

For Pink Floyd Addicts

As well as being the day "Pow R. Toc H." was recorded, March 21 was also when the first mixing session for "Lovely Rita," one of the tracks the Beatles were working on in neighboring Studio Two at Abbey Road, took place. Norman Smith took his protégés into the studio, allowing them to witness the creation of a part of *Sgt. Pepper's Lonely Hearts Club Band*.

Genesis

Hard-bitten Floyd fans have scrutinized this title for a meaning that corresponds to its musical atmosphere. Some think that Barrett, Waters, Wright, and Mason (this was a collective composition) were indulging in wordplay, notably by removing certain letters. Thus "Pow R. Toc H." can be read as *power touch*, or alternatively *power toke*. There is another, more rational explanation according to which "Pow R. Toch H." refers to a British club founded during the First World War, Talbot House, where officers and rank-and-file soldiers were shown equal consideration. Toc H. subsequently became the name of a Christian interdenominational organization. Andrew King, however, suggest that it might simply have been for the sounds that this title was chosen: "The '*Pow R. Toc H.*' name is just a noise, it's onomatopoeic. There's no meaning…I mean it might have been something to do with Toc H because of the war and everything, but I think basically it was onomatopoeic."[10]

"Pow R. Toc H." is the first instrumental on *The Piper at the Gates of Dawn*. It is a largely improvised piece of experimental music that would not have been out of place as a musical development of "Interstellar Overdrive." We are certainly a long way from the psychedelic and heroic fantasy style of Syd Barrett, whose influence is less in evidence here than on the album's other tracks. It is no doubt for this reason that "Pow R. Toc H." would have an afterlife under the highly evocative title "The Pink Jungle." This is the name the track was given in 1969 when it was incorporated into the musical suite *The Man and the Journey*.

Production

While not exactly known for their humor, the members of Pink Floyd display no shortage of it in this tumultuous instrumental. Syd Barrett opens the curious "Pow R. Toc H." with onomatopoeia centering on the sounds *poom chi chi*. In doing so, he shows himself to be a forerunner of today's beatboxers, a well-known phenomenon in hip-hop. As in "Matilda Mother," he marks the first beat of his vocalization by tapping his mic (or perhaps by exaggerating the plosive start of *poom*, while at the same time doubling himself by means of ADT). His bandmates are not exactly idle either, and it seems that Roger Waters is responsible

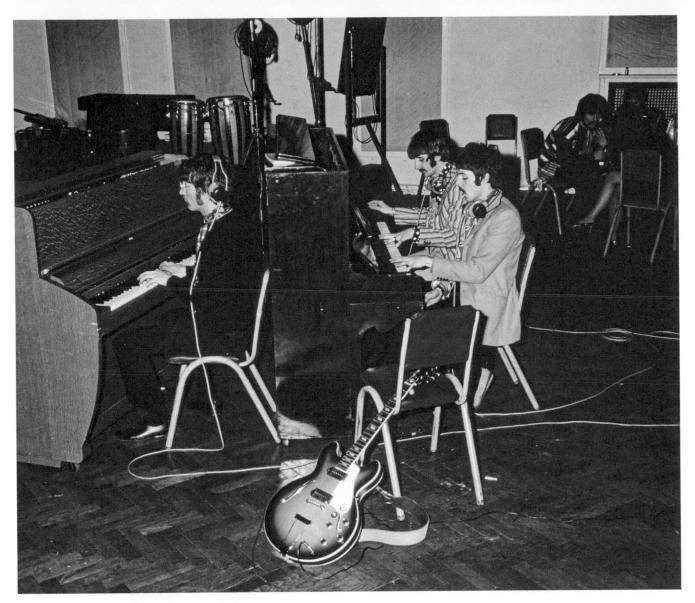

for the *doi doi*, while Rick Wright and Nick Mason fill the space with various calls and sympathetic noises. A percussive sound can even be heard that seems to have been made by striking the teeth with a fingernail or tapping the flat of the hand. There follows an exclusively instrumental section, based around a single F-sharp chord, in which Barrett plays his Harmony Sovereign H1260 acoustic and is accompanied by Mason (mainly on the toms), Waters on bass, and Wright with a bluesy solo, entirely characteristic of his style, on acoustic piano (almost certainly the Model B Steinway). At 1:45 the atmosphere changes, with the return of the calls and miscellaneous sounds, including effects produced by Syd on his Fender Esquire, again using his ever-present Binson Echorec, but also now with the intervention of orchestral timps played by a professional musician hired for the occasion. Peter Bown recalls: "It was played, as far as I remember, by a proper tympanist…I don't think he…he had no idea what was going to be asked of him and I seem to remember there were some pretty tricky tymp things asked."[10] The session records do not

mention the hiring of any outside musician, but "I wouldn't be surprised," agrees Peter Jenner, "if we did bring in a proper tympani player, because [Norman] might have tried with Nick and it didn't quite work and didn't sound like we wanted it to sound, because we didn't know quite how to hit the tympani with all those pedals and things."[10] Either way, the Floyd then pursue their instrumental journey with some organ whose panoramic image switches rapidly from right to left (at 2:20), with another section in which Barrett plays an arpeggiated motif on his Fender (at 3:07), and with a return to the onomatopoeia of the beginning. There then follows a finale in which shrieks and the Echorec share in a frenzied conclusion against a background of tom rolls.

This number was recorded on March 21, the group laying down the backing track in four takes between 2:30 p.m. and 7:30 p.m., and, following a break for supper, adding the various guitar, timpani, and organ overdubs between 8:30 p.m. and 1:30 a.m. The sessions of March 29 and July 18 were devoted to the mono and stereo mixes.

Take Up Thy Stethoscope And Walk

Roger Waters / 3:06

Musicians
Syd Barrett: electric rhythm and lead, backing vocals
Roger Waters: vocals, bass
Rick Wright: organ, backing vocals
Nick Mason: drums

Recorded
Abbey Road Studios, London: March 20, 29, July 18, 1967 (Studio Three)

Technical Team
Producer: Norman Smith
Sound Engineers: Peter Bown, Norman Smith
Assistant Sound Engineers: Jeff Jarratt, Graham Kirkby

For Pink Floyd Addicts

Roger Waters would take up the exclamation *Doctor Doctor* again at the very beginning of his solo album *Amused to Death*, released in 1992.

COVERS

"Take Up Thy Stethoscope and Walk" was covered by At The Drive-In (a hardcore band from El Paso, Texas) for *Invalid Litter Dept.* (2001), a four-track CD intended for the United Kingdom and recorded under the aegis of the BBC DJ Steve Lamacq. It is also worth drawing attention to the version by Ty Segall and Mikal Cronin on their album *Reverse Shark Attack* (2009).

Genesis

"Take Up Thy Stethoscope and Walk" is the first Roger Waters number to be recorded by Pink Floyd. The title was inspired by a passage in the Gospel according to Saint John 5:8: "Jesus said unto him, Rise, take up thy bed, and walk." The scenario is that of a patient who, lying on his hospital bed, complains to his physician that his head hurts and he has lost his appetite, before sinking into a verbal delirium that incorporates the phrases *Jesus bled*, *pain is red*, *greasy spoon*, and *June gloom*. The final verse offers a hint of optimism: *Music seems to help the pain/Seems to motivate the brain*. It looks as if Waters also enjoyed playing with the sound and rhyme of the words.

Above all, this song provides a sense of the difference in character between Barrett and Waters: while the first is a kind of dandy-dreamer who explores the infinite spaces of psychedelia, the second is more pragmatic, cynical, and mocking. Thus he sings *Doctor Doctor* nine times in a row with a sufficient sense of irony to suggest that a white coat is going to do nothing to solve his problem…

"Take Up Thy Stethoscope and Walk," which received its first two live performances at the Opera House in Blackpool and the Chinese R&B Jazz Club in Bristol on November 25 and 28, 1967, respectively, is reasonably faithful to Pink Floyd's stage performances, with masterly slide improvisations from Barrett.

Production

This first song credited to Roger Waters does not seem to have aroused any great interest on the part of his fellow band members because just one day was earmarked for its recording (March 20; March 29 and July 18 being reserved for the mono and stereo mixes, with Norman Smith at the console for the latter). The Floyd came to grips with the backing track between 2:30 p.m. and 6:30 p.m., recording six takes and retaining the fifth as the best. In the evening (from 7:30 p.m. until midnight), the four musicians overdubbed the voices.

It is Nick Mason, for a change, who launches the song, with a rhythmic snare or bass drum pattern that is pretty unusual for the Floyd. His playing, which from the beginning of the album is generally undermixed, is finally given the prominence and volume it deserves. As soon as the

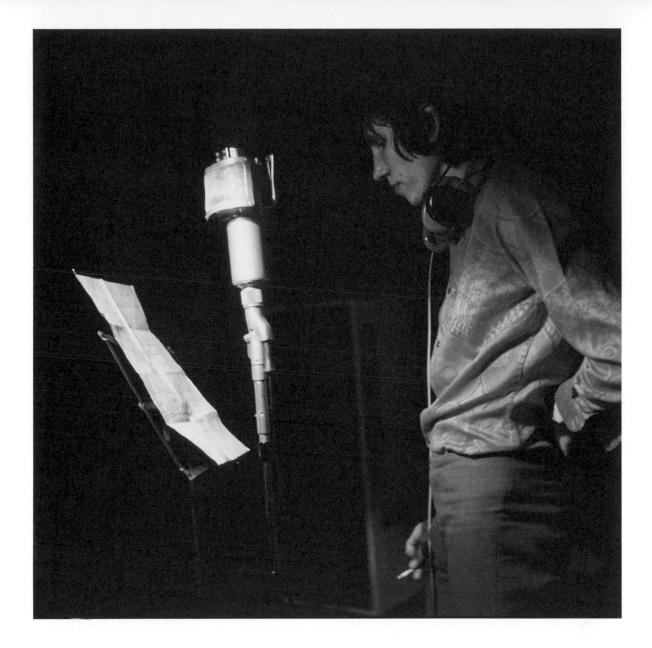

singing starts, the rock atmosphere of this track—hinted at by Nick's drumming—is confirmed, not only by the different vocal parts that answer one another, but also by the bass. The overall effect resembles the Kinks or the Who. For eight bars the voices are accompanied merely by Waters on his Rickenbacker 4001 and Mason on his Premier kit. It is apparently the bassist who spits out the *Doctor Doctor* call to which Syd Barrett and Rick Wright respond. Barrett enters on guitar with a very good rhythm part, demonstrating that he is more than capable of excellent timing on his instrument, before launching into an amazing funky passage at 0:33. Wright accompanies him on his Farfisa Compact Duo organ and plays an inspired solo over which Syd really takes off with a fairly unorthodox improvisation, finding his notes high up by the bridge, with tremolo, in a psychedelic frenzy akin to the way he used to play onstage. Roger supports his bandmates with a Tamla Motown–inspired bass riff, while Nick delivers a drum part in his own inimitable

style, marking the beat on the toms rather than on his snare drum and hi-hat. It is all too often forgotten that Mason's highly individual style of playing, resembling free-jazz improvisation, with ethnic-sounding, Ginger Baker–influenced touches, is one of the distinctive features of Pink Floyd. The group can be heard speeding up during this section (from 0:48), presumably intentionally. One of the most successful effects on the track occurs at 2:20, when the drums and organ switch places in the stereo image, indicating that they were recorded on the same track of the tape recorder. Finally, as happens so often, there are vocal effects (for example at 0:40 and 1:48) throughout the arrangements.

While "Take Up Thy Stethoscope and Walk" cannot, perhaps, be described as the best track on the album, this dry run from Roger Waters is nevertheless pretty good. Lacking any particular connection with the world of Syd Barrett, it is also far from representative of the masterpieces Waters would pen for the group in the years to come.

Interstellar Overdrive

Syd Barrett, Roger Waters, Rick Wright, Nick Mason / 9:41

Musicians
Syd Barrett: lead guitar
Roger Waters: bass
Rick Wright: keyboards, cello (?)
Nick Mason: drums, percussion (?)

Recorded
Abbey Road Studios, London: February 27, March 1, 16, 22, June 5, 27, 30, July 18, 1967 (Studio Three)

Technical Team
Producer: Norman Smith
Sound Engineers: Peter Bown, Norman Smith
Assistant Sound Engineers: Jeff Jarratt, Geoff Emerick, Graham Kirkby

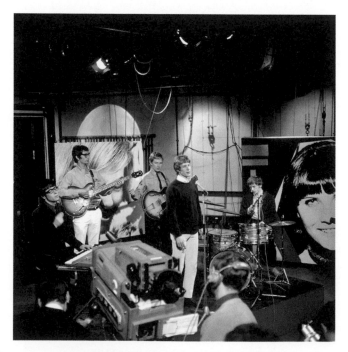

The band Manfred Mann, whose version of a Bacharach/David song inspired Syd Barrett.

Genesis

After "Astronomy Dominé," this incandescent instrumental is another episode in Pink Floyd's flirtation with space rock, whatever Roger Waters may think. The Floyd may have found the title in the pages of "The Ruum" (1953), a famous short story by the American science fiction author Arthur Porges ("The cruiser Ilkor had just gone into her interstellar overdrive beyond the orbit of Pluto").

Musically, the number originated in a riff that came to Syd Barrett in a slightly strange way. During the course of a rehearsal, Peter Jenner was humming a tune the band Love had just recorded for its first album, a song whose title he had forgotten (actually "My Little Red Book"). Barrett immediately started playing the tune on the guitar, adding various nuances of his own. "Interstellar Overdrive" was born. A lengthy improvisation then developed around this riff, the source of sonic experimentation that does indeed give the impression of a journey to the stars.

Pink Floyd had been playing "Interstellar Overdrive" since the end of 1966 (and had also performed it at the Roundhouse gig on December 31). During the course of these concerts, in particular at the UFO Club, this track, in which the four musicians gave themselves a great deal of freedom, became a kind of hymn of London's underground scene. In other words, it marked a complete break with the pop music of the day calibrated on the requirements of radio and television. Nick Mason provides a good explanation of the extent to which the recorded version and the stage version could differ: "'Interstellar Overdrive' is an example of a piece that on vinyl (as was) is a cut-down version of the way it was played at gigs. 'Interstellar' had formed a central plank of our live shows ever since Powis Gardens [the early shows at All Saints Church Hall]. Based around Syd's riff, the piece would generally be played with different elements structured in the same order each time. On the album it runs to less than ten minutes; live it could have lasted as long as twenty minutes."[5] In other words the familiar dichotomy between stage and studio.

This is what attracted the filmmaker Peter Whitehead: "I had an affair with Jenny Spires, who was Syd's girlfriend at the time. It was she who then introduced me to Syd in London when I was making *Tonite Let's All Make Love in London.* It was Jenny who kept saying 'your film's a bit odd, a

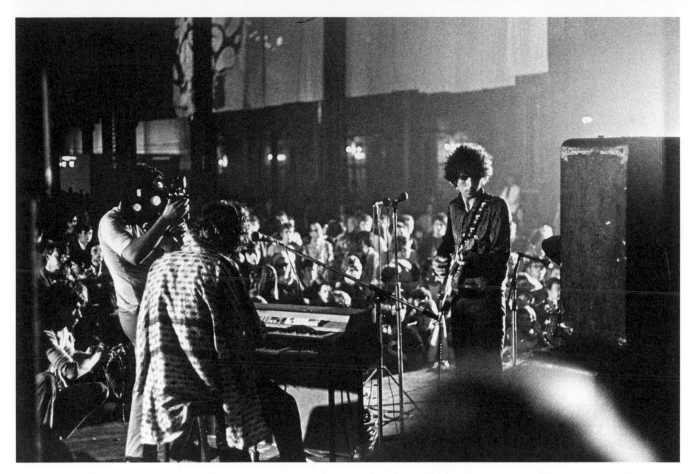

Pink Floyd on stage at Alexandra Palace on July 29, 1967.

bit weird…this music, you should listen to it,' so I went along to UFO and saw them performing. It was then that I decided out of the blue to use Pink Floyd as the music of *Tonite…*"[18]

Post-Barrett Version

Pink Floyd would continue to play "Interstellar Overdrive" live after David Gilmour had replaced Syd Barrett—up to the end of the seventies in fact (and often as an encore, as if to demonstrate the group's close connection with its roots in London's underground clubs). While Gilmour enhanced it with his virtuosity, the number was not fundamentally transformed. One notable change is that the riff would only begin after a long and very "spacey" organ intro from Wright. This development can be heard on various bootlegs.

Production

Before being immortalized at Abbey Road for the group's debut LP, "Interstellar Overdrive" had already been recorded twice in the studio. An initial recording of 14:56 duration was made in 1966 at the modest Thompson Private Recording Studios in Hemel Hempstead on the fringes of London. In spite of the very limited resources available to the group, this recording was of sufficient quality to be used the following year as the soundtrack for a short film by Anthony Stern entitled *San Francisco*. Pink Floyd recorded the track for a second time at Sound Techniques in London on January 11

and 12, 1967, with Joe Boyd producing and John Wood engineering. This is the recording used by Peter Whitehead in his documentary *Tonite Let's All Make Love in London*.

On Monday, February 27, 1967, Pink Floyd was in Studio Three, Abbey Road, for the first definitive takes, with Norman Smith producing. The session kicked off with "Chapter 24" before progressing to the second instrumental of the album (the first being "Pow R. Toc H."). Two takes were recorded, with the second, lasting 10:20, being retained as the best. Peter Bown, the sound engineer, recalls the volume being painfully high, forcing him to systematically employ limiters and compressors in order to avoid maximum distortion during recording. As it is, he thinks "'Interstellar Overdrive' may have been the one where I broke the microphones…I think it was."[10] As Peter Jenner would later aptly comment, at this time the Floyd lacked studio experience and found it difficult to handle the constraints that recording imposed. But they also needed to rediscover the feeling they used to experience during their marathon stage performances—hence the volume.

Right from the intro, Syd attacks with a low E chord on his Fender Esquire. He then launches into the amazing riff that is entirely typical of his style. As he has repeatedly proved, not least on "Astronomy Dominé," he adores descending (or ascending) progressions in intervals of a semitone. The sound is raw, with distortion from the amp,

Syd Barrett: a hallucinated expression to go with the hallucinogenic music...

Nick Mason delivering a hypnotic beat on "Interstellar Overdrive."

probably the Selmer Truvoice Treble-n-Bass 50 (captured with a Neumann U67 mic). Syd's riff rises in volume with the entrance of the bass, Roger following him, producing an aggressive, driving sound on his Rickenbacker 4001. Syd then reinforces his first guitar with a second (0:19), whose distorted tone is no doubt produced by his Selmer Buzz Tone pedal. When Nick enters on the drums, the listener is sent off on an interstellar journey with a veritable explosion of decibels. "Interstellar Overdrive" is constructed around Syd's riff, and the rest of the track is essentially a long improvisation divided into various more or less well-defined sections before returning to the initial riff for a magnificent finale. The sensations experienced by the listener during this track are inevitably influenced by the title. While it is true that the Floyd evoke a spacey atmosphere, they do this in part through the idea of experiencing an acid trip. The musicians apply themselves to giving these sensations shape with guitars drenched in Binson Echorec (Syd often playing Zippo-slide), with layers of organ sometimes laid-back and sometimes harrowing, with rhythmic breaks; hypnotic, tribal drumming; and sound effects worthy of the finest moments of musique concrète.

The Floyd completed the track at the session of June 27, the remaining dates being reserved mainly for the various edits and mixing. During the course of this session, the group recorded numerous drum, guitar, keyboard, and bass overdubs. Nick would also add a second drum part, as can be heard from 3:39, or just a ride cymbal (at around 1:00). It is also most likely the drummer who plays a percussion instrument (bongos?) with ample reverb at the very end of the track (around 9:33). Syd, meanwhile, alternates some distinctly intergalactic sounds created through the manipulation of his Echorec (5:34) with highly saturated power chords, as can be heard at 3:11. Rick executes solo passages

on his Farfisa organ (for example at 1:30 and 6:06), and also seems to play a short passage on the cello at 6:43—unless this is Roger using a bow on his Rickenbacker. More certainly, Waters doubles his bass in the intro and subsequently adds extra parts, including what seems to be a saturated bass at 5:13 with a sound resembling a Moog. Roger's contribution certainly got noticed, with two of his riffs evidently inspiring other musicians. Deep Purple seems to have drawn inspiration from the passage beginning at 1:02 for the refrain of "Space Truckin'" (*Machine Head*, 1972), and Argent would copy his bass line at 4:20 in their hit "Hold Your Head Up" (*All Together Now*, 1972).

"Interstellar Overdrive" was mixed in both mono and stereo. Which is better? In truth, both are interesting. The mono version possesses a power and a cohesion that are absent from the stereo mix. The improvisations seem less fragmentary, better structured, more fluid, and more logical, while the psychedelic aspect of the music also comes across more effectively. In stereo, the track loses something of its punch, except perhaps in the intro (although Rick's organ has totally disappeared from the mix). Its strong point, on the other hand, lies in its use of panoramic effects, especially at 8:40, where the stereo image shifts from right to left in extraordinary fashion. This was a complete success achieved on July 18 with Norman Smith at the mixing desk. Peter Bown explains: "Ah...that was something we built for the Pink Floyd. We built these special pan pots for the Floyd, which they used to use in the studio."[10]

A legendary Barrett-period Floyd track, "Interstellar Overdrive" paved the way for a "different" kind of rock music that was without equivalent at the time. Although clearly bearing the stamp of the group's brilliant guitarist, it also contains the seeds of the group's future albums and of the post-Barrett era.

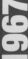

Roger Waters: the sound of the bassist's Rickenbacker 4001 is a key element in this Floyd classic.

Pink Floyd performed "Interstellar Overdrive" on October 25, 1969, at Amougies, a festival in Belgium supported by the French underground magazine *Actuel*. For this version of more than twenty minutes' duration, Waters, Gilmour, Wright, and Mason were joined onstage by Frank Zappa. There is a bootleg entitled… *Interstellar Zappadrive*.

For Pink Floyd Addicts

France was evidently picked out for special treatment, with "Interstellar Overdrive" issued on May 20, 1967, as the B-side of a single whose A-side was made up of "Arnold Layne" and "Candy and a Currant Bun" (wrongly spelled *Current*). This was a short version lasting five minutes. It seems to have been not rerecorded, but re-edited from the long version. The record was reissued in 1987. The original has become a holy grail for collectors… Another peculiarity of this French single is that a short biography of each musician appeared on the back of the sleeve. Here their heights are given as: Waters 1.83 m; Barrett 1.62 m; Wright and Mason 1.60 m. As the band members will appreciate… something clearly went wrong with the conversion process during publishing!

The Gnome

Syd Barrett / 2:14

Musicians
Syd Barrett: vocals, twelve-string acoustic guitar, backing vocals (?)
Roger Waters: bass
Rick Wright: celeste, backing vocals (?)
Nick Mason: drums, cowbell

Recorded
Abbey Road Studios, London: March 19, 29, July 18, 1967 (Studio Three)

Technical Team
Producer: Norman Smith
Sound Engineers: Peter Bown, Norman Smith
Assistant Sound Engineers: Jeff Jarratt, Graham Kirkby

IN YOUR HEADPHONES
In the stereo version of "The Gnome," Syd can be heard breathing in the right-hand channel during the first four seconds of the track.

J. R. R. Tolkien, the author of *Lord of the Rings*, may have been Syd Barrett's spiritual guide for "The Gnome."

Genesis

According to Peter Jenner, Syd Barrett wrote "The Gnome" during the summer of 1966, while living in Earlham Street in London's West End. This was around the same time he composed "Lucifer Sam," "Matilda Mother," "Flaming," and "Scarecrow." This mainly acoustic track is the first installment of the heroic fantasy triptych on the second side of *The Piper at the Gates of Dawn*, the other two being "Chapter 24" and "Scarecrow." Childhood memories that continue to haunt Syd Barrett: memories of Cambridge, of Grantchester Meadows, of nursery rhymes, of reading authors with fertile imaginations...The songwriter draws us into his world, which is the world of fairy tales. In this song he tells of a *little man*, a *gnome* named Grimble Grumble, who *wore a scarlet tunic* and a *blue-green hood*, and who *had a big adventure*: the discovery of nature, the sky, and the river, a discovery that caused him to cry *Hooray* in bliss.

The mark of Tolkien is apparent here. In *The Fellowship of the Ring*, the first volume of *The Lord of the Rings*, the hobbits are captured by Old Man Willow. "None were more dangerous than the Great Willow," writes Tolkien, "his heart was rotten, but his strength was green; and he was cunning, and a master of winds, and his song and thought ran through the woods on both sides of the river." The hobbits, those inhabitants of the "Middle-earth," owed their salvation to a strange character who sings nonsense rhymes, wears a blue coat, and sports a long brown beard. Another possible reference is Denys Watkins-Pitchford, who wrote and illustrated *The Little Grey Men* (1942) under the pen name BB. The influence lingers on here of Henry David Thoreau, who dreamed of "a people who would begin by burning the fences and let the forest stand" (*Walking*, 1862). In the United States "The Gnome" was released as the B-side of the single "Flaming."

Production

A day was all it took to record "The Gnome," although, as David Parker has pointed out, there is some doubt over the exact number of takes required. The sixth was retained as the best, but it has been impossible to locate the other five in the Abbey Road archives! As the musical arrangements

are relatively straightforward, the song presumably pre-
sented no great difficulties. It opens with a cowbell struck by
Nick Mason, accompanied by a guitar alternating between
the upper and lower notes of a fifth. This is most likely
Roger Waters playing high up on his Rickenbacker bass
and plugged directly into the console. After two bars, Syd
Barrett comes in simultaneously on lead vocal and twelve-
string acoustic guitar (Harmony 1270 or Levin LTS5?). His
voice, doubled by means of ADT, is gentle and positive, with
a pop-like character, and does not give the slightest hint of
his psychological troubles. In his memoirs, Nick Mason has
described an album made in a spirit of "…general enthu-
siasm from everybody," with Syd "more relaxed and the
atmosphere more focused."[5] And this is also the impression
conveyed to the listener. It seems to be Rick Wright support-
ing Syd with harmonies, and once again their two vocal tim-
bres blend perfectly. Roger delivers a very good bass line
that is relatively energetic for such a gentle song, but through
this he is able to impart a certain pace and dynamism to the
track, despite his instrument being recessed in the mix. In
the refrains, a second acoustic guitar is added and another
instrument contributes a chiming sonority. This is a celeste
played by Rick, more specifically a Mustel celeste, a key-
board instrument whose sound resembles that of the glock-
enspiel, with a gentle, silky resonance that clearly helps to
reinforce the nursery rhyme character of this song. In the
final verse, Syd is doubled by a second, whispering voice
with a long and very present reverb (his own? Rick's?). The
mono mix was completed on March 29 and the stereo on
July 18.

"The Gnome" is a good song, although some detractors
find it relatively weak. Syd had the ability to express images
and impressions in the simplest of ways, without seeking
to make an intellectual point. He allowed his instinct and
imagination to wander wherever inspiration took them,
and this has resulted in a poetic gem of great freshness,
qualities that would sometimes be lacking in the group's
later work.

Chapter 24

Syd Barrett / 3:42

Musicians
Syd Barrett: vocals, electric guitar
Roger Waters: bass, backing vocals (?), gong (?)
Rick Wright: harmonium, organ, Pianet (?), backing vocals
Nick Mason: cymbal, tubular bells
Recorded
Abbey Road Studios, London: February 27, March 1, 15, June 5, July 18, 1967 (Studio Three)
Technical Team
Producer: Norman Smith
Sound Engineers: Peter Bown, Malcolm Addey, Norman Smith
Assistant Sound Engineers: Jeff Jarratt, Graham Kirkby

Chapter 24 was also the name of an excellent British fanzine devoted to Syd Barrett.

For Pink Floyd Addicts

Indica was one of the two main countercultural bookstores in London (the other being Better Books) and the equivalent of the City Lights Bookstore in San Francisco. Located in Mason's Yard, it had been opened by John Dunbar, Peter Asher, and Barry Miles, who were able to count on valuable support from Paul McCartney (whose girlfriend at that time was Jane Asher, Peter's sister). The Indica Gallery, where John Lennon met Yoko Ono, was subsequently opened in the bookstore's basement.

Genesis

The *I Ching*, translated by the German sinologist Richard Wilhelm as the *Book of Changes*, lies at the origins of Chinese philosophy. "Nearly all that is greatest and most significant in the three thousand years of Chinese history has either taken its inspiration from this book or has exerted an influence on the interpretation of its text. Therefore it may safely be said that the seasoned wisdom of thousands of years has gone into the making of the *I Ching*,"[22] writes Wilhelm. During the sixties, when a significant proportion of young people were rejecting both Western consumer society and Marxist dialectical materialism, the *I Ching* was a key countercultural text. Syd Barrett himself extracted the essentials from it when writing his "Chapter 24," telling Barry Miles that "[...] most of the words came straight off that."[3] The latter has a clear recollection of the day Syd came into the Indica Bookshop, where Miles worked, to buy a copy of the Wilhelm edition, although he adds that he thinks "it was a present for the girl he had with him."[3]

Was the Pink Floyd singer-guitarist trying to imitate John Lennon, who had been inspired to write "Tomorrow Never Knows" by Timothy Leary's adaptation of the *Tibetan Book of the Dead*? This is what Barry Miles believes, and it seems quite plausible. Thus the title of Barrett's song refers to chapter twenty-four of the *I Ching*, entitled "The Return" (or "The Turning Point"). The Richard Wilhelm translation reads: "All movements are accomplished in six stages, and the seventh brings return. Thus the winter solstice, with which the decline of the year begins, comes in the seventh month after the summer solstice; so too the sunrise comes in the seventh double hour after sunset. Therefore seven is the number of the young light, and it arises when six, the number of the great darkness, is increased by one. In this way, the state of rest gives place to movement."[22] The first verse of "Chapter 24" follows this closely: *All movement is accomplished in six stages/And the seventh brings return/The Seven is the number of the young light* [meaning renewal]/*It forms when darkness is increased by one.*

Production

On Monday, February 27, Pink Floyd occupied Studio Three at Abbey Road between 7 p.m. and 2:15 a.m., where

they recorded two new songs: "Chapter 24" and "Interstellar Overdrive." The early part of the evening was given over to "Chapter 24." It was with the fifth take that they thought they had the song's rhythm track in the can. On March 1, Norman Smith replaced Peter Bown for a preliminary mix. On March 15, the group returned to the studio to add percussion, keyboard, and bell overdubs. However, it seems they were unhappy with the results, and so they decided to redo everything during the second part of the evening (from 6:30 p.m. to 12:30 a.m.). And it was on the basis of this sixth take that they would record the definitive version.

Nick Mason opens the song on the cymbal. (Some claim it is the famous gong struck by Roger Waters, but this seems highly unlikely.) Indeed Mason's role is pretty well confined to this percussion instrument—unless, as seems likely, it is also the drummer who plays the tubular bells that can be heard in the refrains. Rick Wright abandons his Farfisa organ for a while to accompany the whole proceedings on the harmonium. He plays a kind of drone over which he adds an oriental-sounding counterpoint, giving "Chapter 24" an Indian feel. Peter Bown recalls recording the instrument: "Harmonium was very much an 'in' thing…an 'in' musical instrument in those days. It was always dubbed on because it didn't make much sound. It was also a damned difficult thing to mike!"[10] However, in the second half, Rick returns to the Farfisa—no doubt connected to a Leslie speaker (listen between 1:50 and 2:08)—on which he plays a swirling organ part. He also plays arpeggios, mainly in the verses, on an electric piano (Hohner Pianet?). It seems that no guitar is present other than in the instrumental bridge (at 1:52 precisely), where Syd Barrett plays a chord on his Fender, connected to the Binson Echorec, which, after a short delay, produces a loop. (Listen between 2:02 and 2:08.) Another key element on "Chapter 24" is Roger's bass. He uses the instrument sparingly, allowing the track to breathe (employing the excellent trick of playing on every other line), making his interventions all the more effective when they come. Finally, the singing is of high quality as always, with Syd playing on the words and accents, and when Rick—and presumably Roger too—joins him in the harmonies, the results are superb.

What can we say about this song? It is obvious that the Fab Four were a major influence on both the words and the music. George Harrison was one of the first to have made Eastern philosophy popular among, and accessible to, Western youth, and he would drive the point home with "Within You Without You"—also recorded on March 15 (in Studio Two, next door to the Floyd's Studio Three)—Did the Floyd hear this and decide to record "Chapter 24" in its entirety the same day? It doesn't really matter. This new gem with words and music by Syd Barrett blends the East with British pop, and is a triumph.

Scarecrow

Syd Barrett / 2:11

Musicians
Syd Barrett: vocals, electric rhythm guitar, six- and twelve-string acoustic guitars, percussion (?)
Roger Waters: bass, percussion (?)
Rick Wright: organ, backing vocals, percussion (?)
Nick Mason: percussion
Recorded
Abbey Road Studios, London: March 20, 22, 29, July 18, 1967 (Studio Three)
Technical Team
Producer: Norman Smith
Sound Engineers: Peter Bown, Norman Smith
Assistant Sound Engineers: Jeff Jarratt, Graham Kirkby

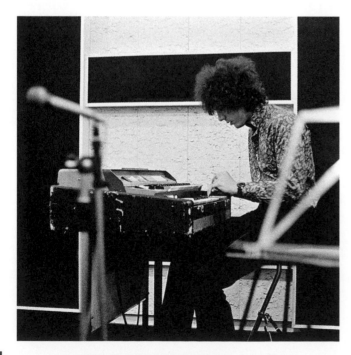

Syd Barrett trying his hand at the piano. Is he the scarecrow of the eponymous song?

Genesis

"Scarecrow" is another absolutely superb example of Syd Barrett's imagination at play, of his bucolic inspiration that was a legacy of his Cambridge childhood. In this song he presents not a gnome out of the pages of Tolkien, nor a rat from Kenneth Grahame's *The Wind in the Willows*, but a *black and green* scarecrow *with a bird on his hat and straw everywhere*. The songwriter draws a disturbing analogy: *The black and green scarecrow is sadder than me/But now he's resigned to his fate/'Cause life's not unkind/He doesn't mind* sings Barrett in the last verse. What are we to make of this? That the scarecrow is really none other than the songwriter? Or at least that he feels as detached from the world around him as the songwriter does? The scarecrow can perhaps be seen as the barely distorted reflection of what Barrett feels, with or without the help of psychedelic drugs. David Gale, a childhood friend of Barrett's, with whom the songwriter had shared various experiences, suggests that "Scarecrow" is a "a jolly cannabis song,"[17] while the "longer pieces, where he and Waters and Wright started hacking vast oceanic sound, were LSD-inspired."[17] What is certain is that Barrett the poet can be appreciated in this song, with rhymes that embellish the melody, such as: *everywhere/He didn't care; around/On the ground…*

From a musical point of view, and in keeping with the other two songs in the triptych ("The Gnome" and "Chapter 24"), "Scarecrow" has a folk feel. The influence of the Byrds album *Fifth Dimension* (in particular the song "I Come and Stand at Every Door") can be discerned. "Scarecrow" would be chosen as the B-side of the single "See Emily Play" (released on June 16, 1967). It is interesting to note that on later reissues, it has become "The Scarecrow."

Production

Pink Floyd began the March 20 session with some voice overdubs on "Take Up Thy Stethoscope and Walk." They then ended the evening brilliantly by recording "Scarecrow" in a single take. They returned to it two days later in order to add guitar and organ parts, and with that Syd Barrett's new song was finished. Simple. Peter Jenner

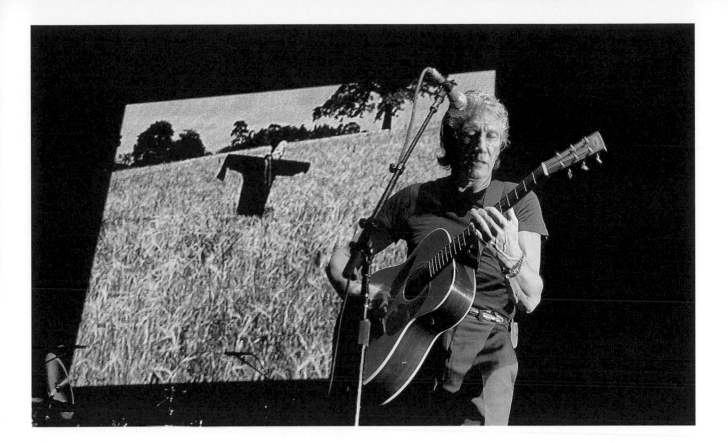

testifies to the songwriter's dazzling speed before Syd was irremediably affected by drugs: "Yes…Syd was so… he'd have an idea and he'd just do it. He was incredibly fast."[10] Once again, the track opens with percussion. This is probably Nick Mason striking what sounds like the metal rim of his snare drum, then a wood block, and finally a cowbell. It also seems logical that his colleagues would have lent him a hand, which might explain a slight drift in the timing, with some parts straying off the beat (for example at 1:21). Curiously, the superimposition of these three percussion instruments evokes the clumsy sound of a trotting horse, perhaps a way of reinforcing the rural aspect of the words. After eight bars (in 3/4), Rick Wright comes in on the organ (with a fade-in). His sound and melody possess an exotic color that calls to mind the musical ambiance of a Chinese restaurant…Syd then enters, singing and playing electric rhythm on his Fender Esquire. This gives rise to a somewhat medieval sonority. Rick supports him with backing vocals on the last line of each of the three verses. Finally, at 1:31, Syd launches into a surprising and highly successful coda on his Harmony Sovereign H1260 (which again is faded in), before Roger Waters joins him on his Rickenbacker 4001, played with the bow. Syd also picks up a second acoustic guitar, this time a twelve-string (Harmony 1270 or Levin LTS5). He plays a short phrase that is both subtle and highly guitaristic and that supports the bowed theme very effectively. The result is a success, making this coda one of the high points of the song. "Scarecrow" was mixed on March 29 (mono) and July 18 (stereo).

For Pink Floyd Addicts

A short film of "Scarecrow" was shot by British Pathé in July 1967. The four members of Pink Floyd can be seen walking in a wheat field with a scarecrow planted at its center, and then by the edge of a wood. Barrett picks up the scarecrow and takes it with him, eventually thrusting it into the middle of a pond. Mason and Waters act out a duel with imaginary pistols, and Waters falls down dead in the field…

This beautiful ballad from Syd Barrett, the penultimate track on the album, indicates the musical direction the group might have taken had the songwriter remained its leader. We would probably have had a very different Pink Floyd, oriented almost certainly toward pop songs, more British-sounding, with the charts in their sights—but without neglecting their taste for improvisation and sonic innovation. This, of course, is mere conjecture…

Syd Barrett and Rick Wright deep
in conversation during rehearsals
at the Queen Elizabeth Hall in
London on May 12, 1967.

Bike

Syd Barrett / 3:22

Musicians
Syd Barrett: vocals, electric rhythm guitar, sound effects
Roger Waters: bass, backing vocals, sound effects
Rick Wright: harmonium, acoustic piano,
backing vocals, sound effects
Nick Mason: drums, timpani (?), sound effects
Recorded
Abbey Road Studios, London: May 21, June
1, 5, 29, 30, July 18, 1967 (Studio Three)
Technical Team
Producer: Norman Smith
Sound Engineers: Peter Bown, Malcolm
Addey, Geoff Emerick, Norman Smith
Assistant Sound Engineers: Jeff Jarratt,
Jerry Boys, Graham Kirkby

For Pink Floyd Addicts

"Bike" was excluded from the track listing of Pink Floyd's first US album. It was, however, included on the compilations *Relics* (1971), *A Nice Pair* (1974), and *Echoes: The Best of Pink Floyd* (2001).

COVERS

The Japanese new wave band P-Model recorded "Bike" during the sessions for their album *Another Game* (1984). The American progressive-rock band Phish also covered the song (drummer Jon Fishman using a vacuum cleaner for the occasion).

Genesis

According to Andrew Rawlinson, a Cambridge friend, "Bike" (working title: "The Bike Song") was one of Syd Barrett's oldest compositions, one he had heard played at Roger Waters's home on Rock Road. This song is infused less with the dreamlike, psychedelic atmosphere of the previous three songs than with the atmosphere of a British music hall in the style of Charles Penrose, revealing yet another influence on the songwriter. At the same time, it can also be seen as a very personal adaptation of the children's verses *Now We Are Six* by A. A. Milne and even more obviously the fairy tale "The Gingerbread Man."

The main protagonist is a teenager (possibly Syd himself, as this song may be dedicated to Jenny Spires, his girlfriend of the day) who shows the girl he loves a bicycle he has borrowed, a bike with *a basket a bell that rings/Things to make it look good*. In doing so he hopes to seduce her, for she is a girl who *fits in with* his world. Barrett immediately topples the listener into the sphere of the unreal. In this world of his there is an old mouse named Gerald, a whole *clan of gingerbread men* and, in his room, clocks that chime. Jenny Fabian, co-author of the cult book *Groupie* (and a veteran of evenings at the UFO and Marquee clubs during the early days of Pink Floyd), describes "Bike" and most of Barrett's other songs as "signals from freaked-out fairyland."[18]

The simplicity of Barrett's lyrics only seem apparent. More specifically, the songwriter seems to deliberately cultivate ambiguity as he tells his story. The most obvious example occurs in the third verse, when Barrett sings: *I know a mouse, and he hasn't got a house./ I don't know why I call him Gerald*. It is very difficult to tell whether the narrator does not know why the mouse has no house or why it is called Gerald. This confusion corresponds very well to the music, the finale developing into a kind of a collage-like *musique concrète*.

Production

The last song on *The Piper at the Gates of Dawn*, "Bike" is also one of the most curious. The words and music are of an apparent lightness of tone, but leave a disquieting impression, if only for the juxtaposition of the main material with the chaotic finale. Some observers would see in this

the beginnings of the songwriter's future psychological collapse, as with Maurice Ravel and his Adagio assai. While this is possible, the main thing we should take from "Bike" is a sense of Barrett's talent, which expresses itself in a proliferation or teeming of ideas, even if we feel at the same time that he is teetering on the edge of the precipice.

The song was put together mainly on May 21 and June 1 and 5. The eleventh take was the one the group decided to go with. This time there is no intro, Barrett comes in right away with the words, his voice from the very first bar combining his characteristic psychedelic poetry with a semi-pop, semi-aloof timbre brilliantly captured by Peter Bown with the Neumann U48 and doubled by means of the indispensable ADT. The tune is simple and sticks in the mind. Jeff Jarratt: "I remember it because it was a catchy little tune. [Syd] went out and did it a few times in the studio…it was just one of those silly little ditties, you know…you hear it once and…the other thing was that it was so different to everything else."[10] The songwriter accompanies himself with a rhythm guitar part on his Fender Esquire, Rick Wright is on the harmonium (as in "Chapter 24"), but also plays the acoustic piano, and Nick Mason supports his bandmates in a rock mode that is more linear than is customary for him. In the first two refrains as well as the last, Roger Waters (probably) picks up his slide whistle again, creating a cartoon-like effect in an identical spirit to the one he achieved on "Flaming."

At the end of each refrain, two highly compressed raps on the snare drum (or timps?) can be heard. These are drowned in very present, very long reverb. In actual fact it is the same effect copied and edited in each time, the tail of the reverb being systematically cut off in order to fit in with the tempo of the track (for example at 0:23). In the third verse, Rick adds a new acoustic piano part that has probably been recorded slowly and sped up, as in "See Emily Play." Roger seems to come in on bass only in the final verse (at 1:30), whose tempo is perceptibly slower and in which Syd is joined by Rick and Roger in the backing vocals.

Finally, the last, somber, part of the track begins with what appears to be the Binson Echorec being kicked about by one of the musicians (from 1:52). Peter Bown recalls a session that may well have been for "Bike." "[…] I'll always remember when…I think I was in the studio when all of a sudden Roger Waters's foot came out BANG! I thought: 'Good God that's going to fall apart!'"[10] This is followed by a multitude of noises that are difficult to identify: probably the spokes of a spinning bicycle wheel against which different objects are held, notes played on the celeste, the strings of an acoustic piano being strummed, tubular bells (or small Asian gongs), a whistle, mechanical toys, and possibly Waters's Rickenbacker played with a bow high up the neck. This list is far from exhaustive! And finally, at 2:57, the track concludes with a loop of quacking rubber ducks, recalling the loop the Beatles added to the end of the second side of the album *Sgt. Pepper's Lonely Hearts Club Band*. This brings to a close Pink Floyd's debut album, their penultimate one with Syd Barrett in the lineup…

1967

Apples And Oranges / Paint Box

SINGLE

RELEASE DATE

United Kingdom: November 17, 1967

Label: Columbia Records

RECORD NUMBER: DB 8310

A film clip for "Apples and Oranges," in which Pink Floyd can be seen surrounded by crates of apples, was shot in Brussels on February 18 or 19, 1968. Syd Barrett is absent, and the lead vocal part is taken by Roger Waters, who is all smiles…

SIDE A

Apples And Oranges

Syd Barrett / 3:08

Musicians
Syd Barrett: vocals, backing vocals, electric rhythm guitar, lead guitar
Roger Waters: bass, backing vocals
Rick Wright: keyboards, backing vocals, vibraphone (?)
Nick Mason: drums, tambourine

Recorded
Abbey Road Studios, London: October 26 and 27, 1967 (Studio Two)

Technical Team
Producer: Norman Smith
Sound Engineer: Ken Scott
Assistant Sound Engineer: Jeff Jarrett (?)

Genesis

Following the promising success of *The Piper at the Gates of Dawn* (which reached number 6 in the British charts), EMI wanted to bring out a single as quickly as possible in order to target the Christmas market and launch the group's first American tour, which was scheduled for November 1967. Despite their desire to focus on albums, which correspond far better to their creative talent and the sort of music they intended to develop further, Syd Barrett, Roger Waters, Rick Wright, and Nick Mason had to give in to the demands of their record company. Peter Jenner, who acted as an intermediary between EMI and Pink Floyd, duly asked Syd Barrett to write a song for the new single.

The expression *to compare apples and oranges* means to liken things that are so different from one another that any meaningful comparison is impossible. The scenario we have here involves real apples and oranges: the narrator (in actual fact, the driver of a fruit delivery truck) notices an attractive young woman *Shopping in sharp shoes*, and before long a tender love story begins…"It's a happy song, and it's got a touch of Christmas. It's about a girl whom I saw just walking around town, in Richmond."[23] Going further, it is an evocation of his life there with his girlfriend Lindsay Corner, and of walks in Terrace Gardens and in the vast open space of Barnes Common. According to Julian Palacios, it was after one such stroll on Barnes Common that Syd wrote "Apples and Oranges."[17]

Musically, the song is fairly characteristic of the Anglo-American pop scene of the day. According to Roger Waters, "'Apples and Oranges' was a very good song. In

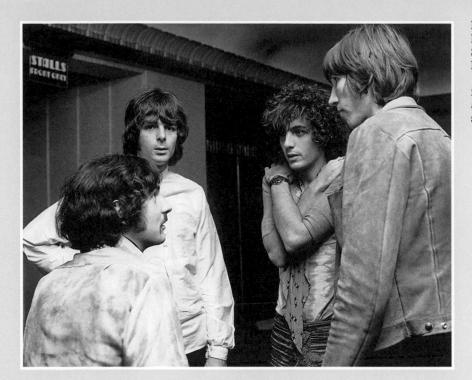

spite of mistakes and the production. I don't think it was bad. 'Apples and Oranges' was destroyed by the production."[17]

Barrett's last recording with Pink Floyd, "Apples and Oranges" was released (with "Paint Box") on November 18, 1967 (preceded by the promo disc the day before), exclusively in the United Kingdom. "This is Pink Floyd's most psychedelic so far," was the verdict of *NME*.[24]

Production

In reality, the birth of "Apples and Oranges" was a painful one for Syd Barrett. Tired and more or less befuddled by drugs, he was having difficulty coming up with new songs for the group. At the time, he was the group's only member capable of writing hits. He was the one the whole team counted on to keep the Pink Floyd machine on the move. The song took a long time to materialize, as Andrew King reports: "[…] God knows how many people were depending for their grocery bills on the Pink Floyd. Add it all up, and there were probably 50 or 60 people whose livelihood depended on the Floyd getting in the studio, making a good track and getting it out…and it wasn't happening. […] We were…we were panicking!"[10] In spite of the pressure, Syd came up with "Apples and Oranges," a song that is psychedelic to say the least, and which recalls the atmosphere of "A Quick One, While He's Away" by the Who or the Beach Boys' *Smiley Smile* period. The sessions would extend over two days, October 26 and 27, with, on the second day, more than twelve hours of uninterrupted recording (from 7 p.m.. to 7:45 a.m.), which can be seen as proof of the absolute urgency of releasing a new single!

Barrett launches the track on rhythm guitar accompanied by a second guitar that he plays with wah-wah pedal and a short delay courtesy of his Binson Echorec. The chords are reminiscent of the Beatles' *Sgt. Pepper's Lonely Hearts Club Band*, and the group rushes into a first verse, whose curious musical arrangement makes it difficult to understand what is going on harmonically. With the meowing wah-wah, it would have been useful to increase the volume of the first guitar or add a keyboard part in order to provide melodic support (although there is apparently an acoustic piano in there). The rhythm section is odd, with the drums relatively recessed in the mix and a very good, more ambitious, bass line along the lines of a walking bass. Mason adds a tambourine devoid of any reverb, the effect of which is to give it a very present sound. The refrain, by contrast, is airy and easy to memorize, and gives prominence to the vocal harmonies (Barrett, Waters, and Wright), Wright adding a radiant touch with a well-judged electric piano (or vibraphone?) part. Unfortunately the bridge, which begins at 1:17, is not especially convincing: the group does not seem very sure either of its interpretation or the arrangement, Mason's ride cymbal is frankly unnecessary, and the vocal harmonies never really take off. Only Wright, most likely on a Hammond M-102 organ, is able to justify his part. In the refrain that follows the bridge (from 1:50), Pink Floyd tries to create a Christmas atmosphere with angelic voices and counterpoint drowning in reverb, and in particular a very high voice (Wright?) that is close to breaking point. After a final verse-refrain sequence, the track concludes with a Larsen effect generated by the Fender Esquire—Barrett having delivered some very good work on the guitar, it should be pointed out. This is what the songwriter said to the *Melody Maker* of December 9, 1967: "It's unlike anything we've done before. It's a new sound. Got a lot of guitar in it. It's a happy song, and it's got a touch of Christmas."[25] It is regrettable that this very good number was recorded under pressure. A stereo mix made on November 14, 1967, does more justice to it.

SINGLE

A psychedelic Rick Wright: the keyboard player's song "Paint Box" was chosen as the B-side of the group's fourth single.

🎧 **IN YOUR HEADPHONES**

At 1:35 a bad edit produces a strange waver in the timing.

A short promotional movie for "Paint Box" was shot in Brussels in February 1968.

Paint Box

Rick Wright / 3:48

Musicians
Syd Barrett: acoustic guitar, rhythm and lead electric guitar, backing vocals (?)
Roger Waters: bass, backing vocals (?)
Rick Wright: vocals, keyboards, backing vocals (?)
Nick Mason: drums
Norman Smith: backing vocals

Recorded
Abbey Road Studios, London: October 23 (?), 24 (?) and/or 26 (?), 1967 (Studio Two)

Technical Team
Producer: Norman Smith
Sound Engineer: Ken Scott
Assistant Sound Engineer: Jeff Jarrett (?)

Genesis

"Paint Box" was the first song Rick Wright wrote for the group as an individual effort. During an interview in December 1996, the keyboard player reveals that he doesn't know why he named his song "Paint Box," but is more precise about the circumstances in which it saw the light of day: "'Paint Box' and 'Remember a Day' were done soon after Sid [sic] left and we still hadn't established the way the band was going to work," he explains. "Sid, I am sad to say, was no longer capable of working so it came down to Roger, Dave and myself writing songs and I think it came later that we started writing songs together."[26] Clearly Rick's memory is playing tricks on him, however, because "Paint Box" was recorded during one of the sessions devoted to the single "Apples and Oranges," during which Syd was well and truly present and still recording with the group.

"Paint Box" tells a strange story. The narrator is remembering the previous evening, which he spent in a club drinking a lot of alcohol with his friends. When waking up the following morning, he has the strange impression of *remembering this scene before*. Stranger still: *I open the door to an empty room/Then I forget*, sings Wright in a melancholy voice. A peculiar sensation, therefore, to which the music does full justice. This is a three-minute journey to the heart of psychedelia. A song, moreover, that testifies to Rick Wright's melodic sense and vocal ability.

Production

This first song to be written by Rick Wright already contains the seeds of the future, post-Barrett, Pink Floyd sound: his

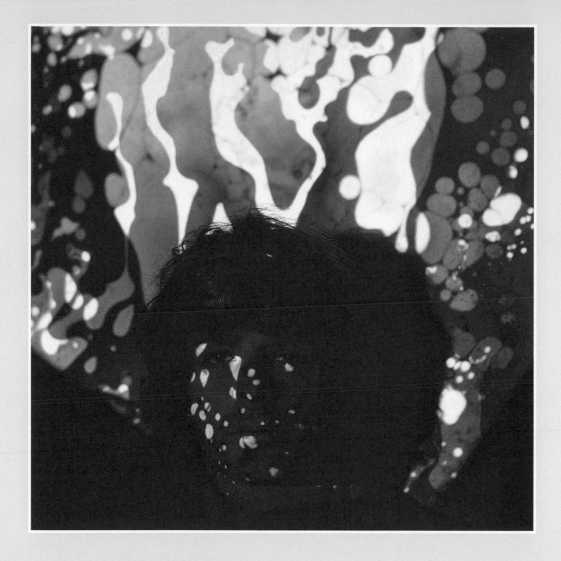

characteristic gentle voice, the minor ninth chord of which he was so fond, and the immediately identifiable rhythmic breaks. In many ways, it is also possible to make out an atmosphere that would culminate in the excellent "Summer '68" from the 1970 album *Atom Heart Mother*. For the time being, "Paint Box" seems a little awkward, at times complicated in its construction, and not always as rigorous as it could be in terms of timing. Nevertheless, it is not without a certain charm, and the future of the reborn Floyd can be discerned between the lines. The recording dates have not been securely established. Without having been able to confirm it, due to patchy documentation, David Parker, who has had access to the Abbey Road archives, believes the sessions to have taken place on October 23, 24, and 26, 1967 (see his very good book *Random Precision*[10]). The impression is given that the track was the result of some pretty intensive studio work, the structure being relatively complex. It is Syd Barrett who launches the intro, on both acoustic guitar (Harmony Sovereign H1260?) and overdubbed electric rhythm. Roger Waters accompanies him on his Rickenbacker 4001S with a very present bass lick, and Nick Mason comes in on his Premier kit with characteristic breaks of the kind he would become renowned for. He works his toms,

drawing from them a sound that calls to mind timbales. Rick is on acoustic piano and launches into the first verse with a quality of voice he would immortalize alongside that of David Gilmour on "Echoes" (on the 1971 album Meddle), one of Pink Floyd's masterpieces. At the beginning of each refrain (from 1:08 and 2:32), Rick makes a concession to Syd's writing style with a sequence of descending semitones. Syd himself delivers some very interesting guitar work, on both electric and acoustic. The song ends with a coda on which Rick can be heard playing a honky-tonk piano, or more likely a piano recorded slowly and then played back at normal speed in order to produce the distinctive sound already used on "See Emily Play," the group's previous single. It is interesting to note that on the version included on the compilation *Relics*, released in 1971, this coda has been reduced in length, bringing the overall duration down from 3:48 to 3:33. A stereo version was mixed on November 14, 1967 (the one used on *Relics*). Finally, it is interesting to note that the backing vocals are provided not by a member of the group, but by the producer, as sound engineer Ken Scott describes: "For any Hurricane Smith fans, 'Paint Box' was probably his entry into singing on record, as he performed a very prominent backing vocal part."[27]

A SAUCERFUL OF SECRETS

ALBUM

A SAUCERFUL OF SECRETS

RELEASE DATE

United Kingdom: June 28 or 29, 1968 (depending on source)

Label: Columbia Records
RECORD NUMBERS: SX 6258 (mono)—SCX 6258 (stereo)

Let There Be More Light / Remember A Day /
Set The Controls For The Heart Of The Sun / Corporal Clegg /
A Saucerful Of Secrets / See-Saw / Jugband Blues
OUTTAKES Early Morning Henry / In the Beechwoods / Instrumental /
John Latham / Reaction In G / Richard's Rave Up / Scream Thy
Last Scream / The Boppin' Sound / Vegetable Man

A high-angle shot of the four members of Pink Floyd taken at Sausalito, California, in November 1967 during their first US tour.

A Saucerful of Secrets and the Invention of Progressive Rock

No sooner had their debut album hit the stores than Pink Floyd was being pressed by EMI to get a new LP out. On Monday, August 7, 1967, three days after the United Kingdom release of *The Piper at the Gates of Dawn*, the four members of the group found themselves back in the studio for the first session on their second album. Further recording sessions as a foursome would take place on August 8, 15, and 16, and then in October and November. It was during this period that the mental health of the group's principal songwriter began to take a disturbing turn for the worse, having been steadily deteriorating since he moved into 101 Cromwell Road, South Kensington, with Lindsay Corner at the beginning of the year. It was in this "catastrophic flat,"[5] described by Julian Palacios as a "nexus for underground (and illicit) activities," where "painters, musicians, eccentrics, mystics and freaks mixed with film stars, pop icons and Chelsea aristocrats,"[17] that Syd, in Nick Mason's words, began to "unravel."[5]

A First, Chaotic Tour

A European and United States tour was planned for the end of 1967, but in the meantime the group was forced to witness Syd's increasingly erratic behavior on a daily basis without being able to do anything about it. After the cancelation of Pink Floyd's involvement in the Windsor Jazz Festival (August 11–12, 1967) due to the songwriter's health, the other members of the group tried to persuade Syd to consult a specialist. They made an appointment for him to see the eminent psychiatrist R. D. Laing, a great denigrator of institutional psychiatry and the author of *The Divided Self*. Roger Waters took Syd to North London, but the songwriter refused to get out of the car. "And I'm not sure that was necessarily a bad thing," concedes the bassist. "Laing was a mad old cunt by then…actually 'cunt' is a bit strong. But he was drinking a lot."[30] The practitioner nevertheless ventured a pretty disturbing opinion, which must have given Nick Mason and the others food for thought, with his confirmation that "Yes, Syd might be disturbed, or even mad. But maybe it was the rest of us who were causing the problem, by pursuing our desire to succeed, and forcing Syd to go along with our ambitions…"[5] Following this setback, the group alerted Barrett's brother, who saw nothing abnormal in Syd's behavior. They then contacted Sam Hutt, a "hip" physician well known in rock circles, who counted the Rolling Stones, the Grateful Dead, and the Who among his patients. Syd jetted off with the other members of the group to Formentera, an island to the south of Ibiza, where he would spend two weeks on vacation in Hutt's company. Unfortunately, at the end of this sunny interlude his mental health showed no sign of improvement, and the ensuing United States tour would only aggravate things.

It was therefore in the company of a guitarist-singer who was completely absorbed in his own inner world, incapable of communicating and, above all, totally unpredictable, that Roger Waters, Rick Wright, and Nick Mason left on tour in early September. Their itinerary took them to Scandinavia

1968

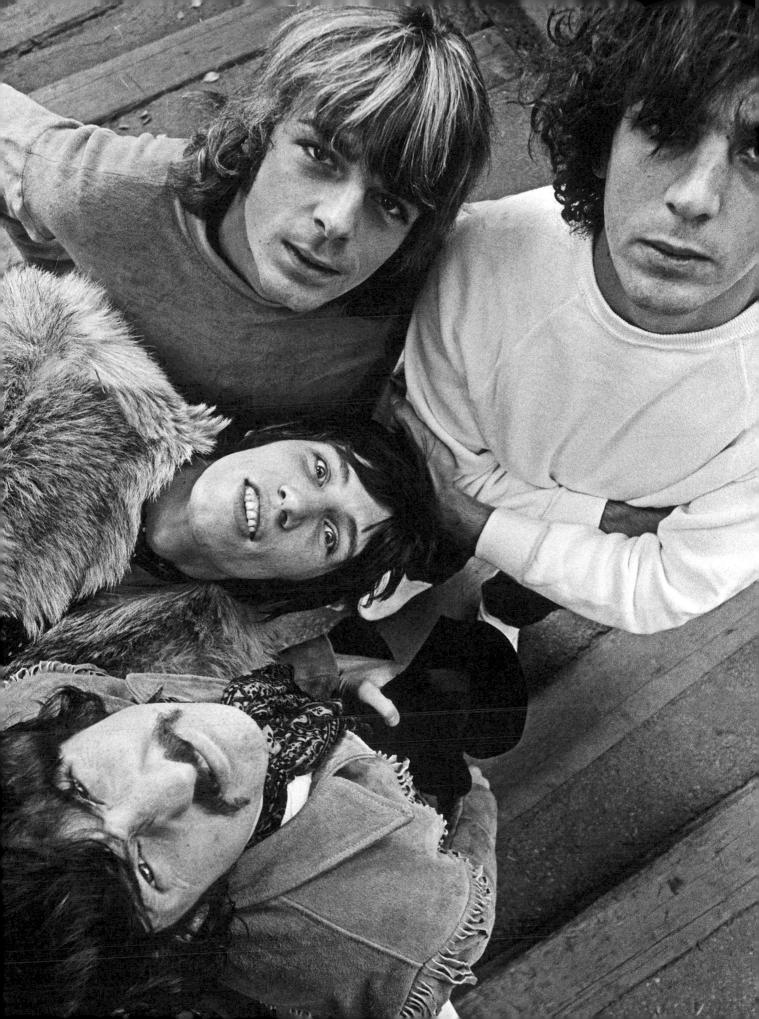

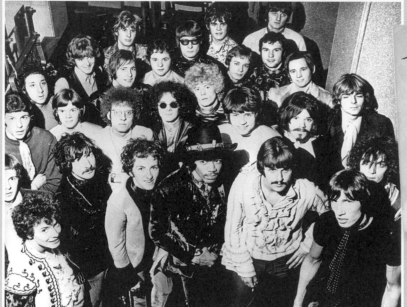

The Christmas Olympia Tour 1967, in which Pink Floyd took part alongside Jimi Hendrix and the Move.

(September 9–13), Ireland (September 15–17), and finally, following a number of shows in England (September 19–October 28), the United States (November 4–11, a tour initially scheduled to start on October 23 but postponed due to the late arrival of work permits). "That was an amazing disaster," explains Roger Waters, "Syd by this time was completely off his head."[3] Indeed Barrett was out of it to such an extent that he left his guitar behind before a concert in Los Angeles and remained mute when interviewed on *The Pat Boone Show* on November 6. "It was getting harder to work with Syd, because we couldn't reach him," explains Nick Mason. "He was getting more absent every time, in both senses of the word. He would forget to appear at the gigs. When we were at a radio broadcast he left the studio without warning. He wasn't showing up at the rehearsals anymore. In a word, he wasn't in the band."[3]

The Fool on the Hill
How did Syd Barrett end up in this situation, having led Pink Floyd so brilliantly on the road to success and barely nine months after the band had signed with EMI? His fate was sealed after the "Christmas on Earth Continued" concert at Kensington Olympia (Grand and National Halls) in London on December 22, 1967. Roger Waters, Rick Wright, and Nick Mason realized they had reached the point of no return and could no longer bury their heads in the sand. Syd had become totally uncontrollable and was holding back their career. What were the reasons for his mental deterioration? Drugs, certainly, as June Child, then the Floyd's secretary, dispassionately explains: "Syd took a lot of acid. Lots of people can take some acid and cope with it in their lives, but if you take three or four trips a day, and you do that every day…"[5] For his part, David Gilmour believes the condition of his childhood friend was more complicated than it seemed: "I don't actually hold with that theory myself. I've

said it before, but I always imagine that that would have happened anyway to him at some other point, and maybe the pressures of being a rock 'n' roll star and things like acid and stuff I suppose act as catalysts. I think it's more that he couldn't handle success on that level than it has to do with drugs really. And to do with his past life, his father dying and all that stuff which happened shortly before he was 15 or 16."[28] It would eventually transpire that Syd was suffering from schizophrenia.

The Gilmour Solution
Back in Europe, and despite the difficulties, Pink Floyd accompanied Jimi Hendrix on his British tour (from November 14 to December 5), a gig fixed up for them by Bryan Morrison. This would be a way for them to sample the delights of the rock star life following their chaotic experience in the United States. The group also succeeded in releasing its third single, "Apples and Oranges"/"Paint Box," on November 18, before resuming work on the new album. In order to see this through to a successful conclusion, three possible solutions suggested themselves to Waters, Wright, and Mason: keeping Barrett in the group but as a songwriter only (following the example of Brian Wilson of the Beach Boys, who at this time was no longer performing live but was writing for the band and working with it in the studio); keeping him on as a musician but supported by a second guitarist; or, far more radically, asking him to leave. For the time being, they opted for the second of these solutions, not least because it avoided a clash that would inevitably be painful for all concerned. Who, then, to turn to? The name of Jeff Beck was touted, but the group's choice quickly fell on David Gilmour, an old Cambridge friend—of Syd Barrett's in particular.

Nick Mason was the first to approach him, probably on December 6 at their concert at the Royal College of Art in London. Gilmour had no great interest in the group's

1968

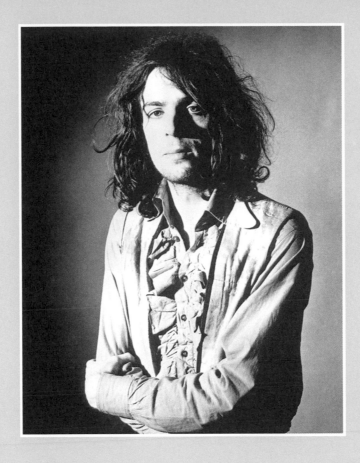

Syd Barrett. The unpredictable genius from Cambridge wrote himself out of the Pink Floyd adventure during the sessions for *A Saucerful of Secrets*.

music, but was seduced by Pink Floyd's professional status and growing fame, and agreed in principle before confirming his acceptance toward Christmas. "And then just after Christmas, right after their Olympia gig [in London]," recalls Gilmour, "I actually got a phone call...where I was staying. I didn't actually have a phone, or they didn't know it, but they sent a message through someone else that they knew that knew me, for me to get in touch for taking the job, so to speak. There was no real discussion, or any meetings to think about it or any auditions or anything like that. They just said 'Did I want to?' and I said 'Yes,' and it was as simple as that."[3] In his book *Pink Floyd: Pigs Might Fly*, Mark Blake describes a jam being held in EMI's Studio Two. From now on there would be five musicians in the lineup.

When he joined Pink Floyd at the end of 1967, David Gilmour was still a member of a band that called itself Bullitt and then Flowers (very "Summer of Love"!). In the company of David Altham (keyboards, sax), Rick Wills (bass), and Willie Wilson (drums), all former members of Jokers Wild, he had been on an extended tour of the European continent (Spain, France, and the Netherlands). Although he had had some fruitful encounters, notably with Jimi Hendrix, for whom he served as a tour guide in Paris for one night(!), the gigs were few and far between and were very poorly paid, and he returned to England suffering from malnutrition. He then got a job as a driver for the fashion designers Ossie Clark and Alice Pollock (creators of the "Swinging London" look) while thinking about forming a new band. A thrilling and unexpected adventure alongside Barrett,

Waters, Wright, and Mason was thus about to begin for Gilmour. "Dave," as he was known, took part in a number of concerts with them in January 1968: Aston University in Birmingham on the twelfth, the Winter Gardens Pavilion in Weston-super-Mare on the thirteenth, Lewes Town Hall on the nineteenth, the Pavilion Ballroom in Hastings on the twentieth, and Southampton University on the twenty-sixth.

The End of the Barrett Era

At the beginning of 1968, Syd Barrett was becoming increasingly uncontrollable and, it seems, less and less interested in Pink Floyd's music. To all intents and purposes he was no longer a member of the group and would record with them no more. Having initially been enthusiastic about the plan, he came to view Gilmour as an intruder: "He was probably completely confused, and angry that his influence was being steadily eroded," writes Nick Mason in his autobiography. "On stage, he put the minimum of effort into his performance, seemingly just going through the motions. This lack of contribution was probably his refusal to take part in the whole charade. As he withdrew further and further, this merely convinced us that we were making the right decision."[5]

Finally, after four or five concerts, the group effectively agreed to get rid of him. When they were getting ready to leave for their January 26 concert in Southampton, the decision was taken to go without Syd, as David Gilmour would reveal to Alan di Perna in 1993: "Someone probably said, 'Shall we go and pick up Syd?' And Roger probably said [in

conspirational tones], 'Oh no, let's not!' And off we went down to Southampton." [29]

Peter Jenner and Andrew King then decided to look after Syd's career, leaving Pink Floyd's in the hands of Steve O'Rourke (via Bryan Morrison). They had tried to find a solution together, but when Syd suggested adding "[...] two girl saxophone players to the line-up"[5] they called it a day...

In April, their association with Blackhill, the company set up by their two managers, came to an end, and Syd's departure and David's arrival were officially announced (Gilmour had signed a contract with EMI on March 18, 1968). Jeff Jarratt, the assistant sound engineer, was taken completely unawares: "[...] when I did hear about it...it was a total shock. And when I heard the Floyd would be doing their next recording with a different member of the band...I just couldn't believe it!"[10]

Syd's mental health did not improve, and although he went on to record two studio albums in 1970 (*The Madcap Laughs* and *Barrett*), he would gradually retire from public life, withdrawing to the suburbs of Cambridge, where he devoted himself to painting. Syd Barrett died on July 7, 2006, leaving in his wake many regrets and a small but extraordinary musical legacy...

In addition to citing his bandmate's depressive and delirious episodes, Roger Waters has told in numerous interviews that Syd's sense of humor was strongly influenced, like many British people of their generation, by *The Goon Show*. A good example is the Pat Boone fiasco, when Syd welcomed the presenter's questions before each take, but remained stonily silent while the camera was turning. Another is when he was presenting a brand-new song to the group at the beginning of 1968. Everyone had gathered around him to learn the chords and structure of the number, which was called "Have You Got It Yet?" But each time he pronounced these words, he changed the song. His bandmates, unable to follow, had no clue what was going on. "I actually thought there was something rather brilliant about it," recalls Roger Waters, "some clever kind of comedy. But eventually I said, 'Oh, I've got it now,' and put my guitar down and walked away."[30] And David Gilmour would confirm: "Some parts of his brain were perfectly intact—his sense of humour being one of them."[25]

An Architectural Style of Music

A Saucerful of Secrets is therefore the last Pink Floyd album with Syd Barrett in the lineup, albeit singing lead vocal only on his own composition, "Jugband Blues." As unpredictable and erratic as he had become, his removal from the group would give rise to some concerns on the part of the others. This is because it was Syd who had been responsible for the musical decision-making and most of the songwriting up to that point. Norman Smith also had doubts about the ability of the Floyd's remaining members to replace him as a songwriter, nonetheless this second album is clearly when the baton changed hands. Roger Waters is credited with three of the seven numbers ("Let There Be More Light," "Set the Controls for the Heart of the Sun," and "Corporal Clegg") and with Wright, Mason, and Gilmour would co-write the track from which the album takes its name ("A Saucerful of Secrets"), while Rick Wright composed "Remember a Day" and "See-Saw." The musical difference is striking. "I've always thought their music sounded deeply architectural," writes Barry Miles. "The change from the Syd Barrett period into the music of three architecture students was really quite dramatic...their architectural vision of music flowered into great cathedral constructions [eventually] taking up whole albums."[11] Barrett's heroic fantasy atmosphere (the songwriter having presided over the recording of *The Piper at the Gates of Dawn*), has virtually disappeared on this album (other than in the lyrics of "Jugband Blues" perhaps), giving way to longer musical frescoes that are more structured (in particular compared to the group's live appearances at the UFO Club) and more ambitious too, a musical style the critics would erroneously, but for the sake of convenience, hasten to label "space rock." With Barrett, Pink Floyd had pushed back the frontiers of pop; with Gilmour, they would, so to speak, invent progressive rock.

Gilmour's Stamp

From the very beginning, the new guitarist's contribution would prove essential to the Floyd's musical aesthetic. "[Dave] was much more a straight blues guitarist than Syd, of course, and very good," explains Rick Wright. "That changed the direction, although he did try to reproduce Syd's style live."[17]

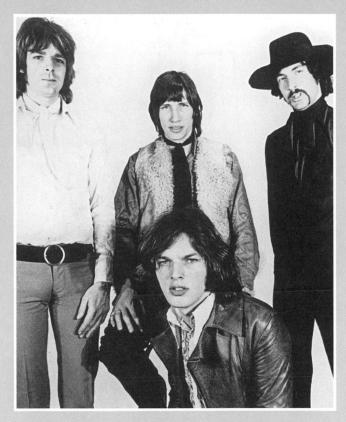

The first photograph of the new Pink Floyd
with David Gilmour, March 1968.

Poster by N. Kouninos greeting the
Floyd's arrival in California.

Paradoxically, it was with Gilmour, a rhythm 'n' blues guitarist, that Pink Floyd would go on to create an authentically European rock music, one that was at the same time oriented toward the cosmos and relatively dark-hued (the influence of Roger Waters). *A Saucerful of Secrets* was to be the first installment in a symphonic, progressive tetralogy that would continue with *Atom Heart Mother*, *Meddle*, and *The Dark Side of the Moon*.

When Gilmour joined the group, Norman Smith was convinced that he would claim the role of leader. But as Nick Mason explains, "Norman had obviously failed to register the rather tall bass player standing at the back!" All the same, the new guitarist felt he could play a key role within the group: "I thought I could contribute a musical discipline, being a better musician than all of them except Rick Wright," he would later declare. "I felt I had a gift for melody and hoped to make them better in this area."[31] And in fact Gilmour would steadily assert himself as album succeeded album, imposing his own stamp—consisting of an inimitable voice and dazzling guitar solos—that would become an integral part of the Pink Floyd sound. David Gilmour was the missing cog that would enable the group to scale the heights of glory.

A Less Than Unmitigated Success

Pink Floyd's second album was released in the United Kingdom (in mono and stereo) on June 28 (or 29), 1968, and quickly climbed to number 9 on the charts. It was also well received by the French public, who powered it to number 10. But although the LP was a promising commercial success

on either side of the English Channel, it was not exactly a resounding triumph overall. The British critics were somewhat scathing. The *NME* found the title song "long and boring," while Barry Miles, in the columns of the *it*, compared it unfavorably with Vladimir Ussachevsky's avant-garde electronic work "Metamorphosis" (1957). "I was surprised when *Saucerful* was criticised harshly in the press," comments Nick Mason with dry humor. "I thought it had some very new ideas."[1]

In the United States, where it went on sale on July 27, *Saucerful* was a flop, becoming the only one of the group's albums not to chart. More surprisingly, it was severely criticized by the countercultural magazine *Rolling Stone*, Jim Miller describing it as "mediocre" and regretting the departure of Syd Barrett. Today, opinions have shifted in the album's favor. The website AllMusic gives it three and a half stars, while *The Virgin Encyclopedia of Popular Music* awards it four.

The Sleeve

The sleeve of *A Saucerful of Secrets* was Pink Floyd's first to be designed by Hipgnosis, a graphic designers' collective founded by Storm Thorgerson (1944–2013) and Aubrey Powell (b. 1946) a little while before. Thorgerson was born in Potters Bar, Middlesex (now in Hertfordshire), but spent his childhood in Cambridge, where he made the acquaintance of Syd Barrett and Roger Waters at Cambridgeshire High School for Boys (his mother was friends with Roger Waters's). He then studied English and philosophy at the

A white Telecaster with a rosewood neck identical to David Gilmour's.

University of Leicester, followed by film and graphic art at the Royal College of Art. In 1968, Storm Thorgerson asked his friends Roger Waters and David Gilmour to persuade the EMI management to commission him to design the artwork for their second album (the Beatles having been the only other group up to this point who were allowed to externally commission covers).

The sleeve illustration is, without doubt one of the most fascinating in the entire history of psychedelic rock. It consists of superimposed cosmic elements that give the impression of a vision, of a journey in space and time. Thorgerson and Powell have revealed to *Q* magazine that they wanted to depict three "'altered states of consciousness,'—religion, drugs, and Pink Floyd music."[32] In another interview, Storm Thorgerson explains that "the cover is an attempt to represent things that the band was interested in, collectively and individually, presented in a manner that was commensurate with the music. Swirly, blurred edges into red astrology/Dr. Strange images merging into images, a million miles away from certain pharmaceutical experiences."[33] And continuing this theme: "In one's youth, [...] drugs, particularly acid, were pivotal in shaping your world view, but no specific style was derived from drugs. I never even smoked dope when I worked."[32] On the reverse are the black-and-white faces of Nick Mason, Roger Waters, David Gilmour, and Rick Wright, semi-obscured by the cosmic order. Exit Syd Barrett.

The Recording

The recording of *A Saucerful of Secrets* began on August 7, 1967. Between then and the end of the year, twenty or so sessions would be held in three different London studios: EMI, Sound Techniques (where nothing that was actually used on the album was recorded), and De Lane Lea. Of the dozen or so tracks mainly by Syd Barrett that the group worked on during this period, only two, "Set the Controls for the Heart of the Sun" and "Jugband Blues," would make it onto the album. The other sessions were devoted either to the group's next single, "Apples and Oranges"/"Paint Box," or to material that for the most part would end up on Syd Barrett's solo albums.

In 1968, the group recorded mainly at Abbey Road, with the exception of final mixing at De Lane Lea on May 8. They laid down some ten songs (none by Barrett other than outtakes, possibly). The very last session for this second album took place on May 15, a little more than nine months after the first. Altogether they had spent a total of more than fifty days in the studio (including mixing, editing, and mastering). This was an enormous length of time for a group at the start of its career, suggesting that the managers at EMI saw Pink Floyd as the future of rock.

Among the sound engineers who worked on the album were, at EMI, Peter Bown and also Ken Scott, who would have an outstanding career working with the Beatles, David Bowie, the Rolling Stones, Elton John, Lou Reed, and Devo, to mention just a few of his artists. Martin Benge was in charge of mixing (in the famous Room 53) before

1968

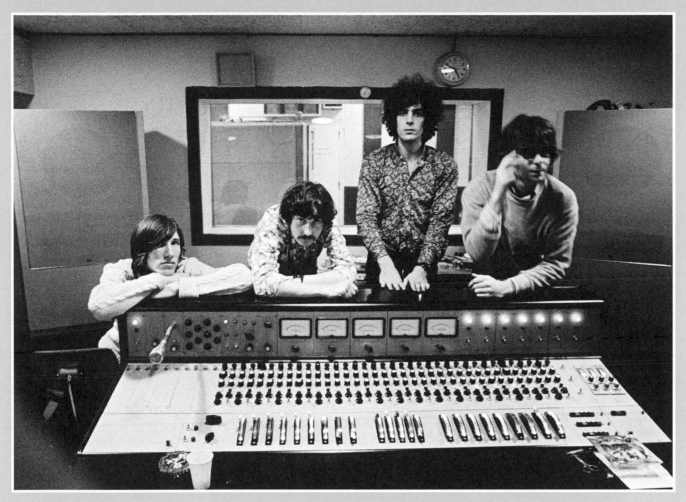

The four members of Pink Floyd in front of the Sound Techniques console at De Lane Lea Studios in 1967.

later turning toward classical music, notably collaborating with Yehudi Menuhin and Daniel Barenboim. The assistant sound engineers included John Barrett (Paul McCartney, Kate Bush), Jeff Jarratt (who had already worked on *The Piper at the Gates of Dawn*), John Kurlander (Elton John, Toto), Richard Langham, Peter Mew (Donovan, the Hollies), Michael Sheady (Syd Barrett, Stéphane Grappelli), and John Smith. Meanwhile the sound engineer at De Lane Lea Studios was Michael Weighell, who apparently worked without an assistant.

Technical Details

At both EMI and Sound Techniques, the equipment was by and large the same as that for the group's previous studio work. At De Lane Lea, then located at 129 Kingsway, London WC2, the control room was kitted out with a Sound Techniques console with eighteen inputs and four outputs (very popular at the time), a four-track Ampex AG-440 tape recorder, and four Tannoy Lockwood Major Studio Monitors. Among the main studio effects were a Fairchild 666 compressor and an Altec 436B. In the sixties, De Lane Lea was one of London's hip studios, attracting artists such as the Beatles, the Rolling Stones, the Who, and Jimi Hendrix.

The Instruments

After immortalizing his Fender Esquire on *The Piper at the Gates of Dawn*, Syd Barrett turned his back on it toward the end of 1967 in favor of a white Fender Telecaster. He seems to have used this only for the Floyd's second album, as he would hardly be seen playing it after that. As an acoustic instrument, his choice fell on the Levin LT 18. Roger Waters remained faithful to his Rickenbacker 4001, and Nick Mason kept faith with his Premier kit with two bass drums. Rick Wright introduces new sonorities with a Hammond M-102 "Spinet" organ, a Mellotron MK2, a vibraphone, and a xylophone. Future guitar hero David Gilmour was no better off for instruments than the others when he took part in the early recording sessions for the album. His only guitar was a white Fender Telecaster with rosewood neck that his parents had given him for his twenty-first birthday (March 6, 1967). In the studio with the Floyd he also borrowed Syd's Fender, which was reclaimed before long, leaving the group's new guitarist with his one and only instrument. David would soon take steps to remedy this, accumulating a fantastic collection of world-renowned guitars during the course of his career. As for effects, he used a Dallas Arbiter Fuzz Face, a Vox wah-wah, and the indispensable Binson Echorec. His amplifier was a 100-watt Selmer Stereomaster with Selmer 2x12 All Purpose speakers.

EMKA Productions, founded by Steve O'Rourke at the beginning of the seventies, shares its name with EMKA Ltd., a division of Universal Television that has no connection with the Pink Floyd manager, unlike EMKA Racing, a company he set up in 1980 in order to indulge his passion.

Steve O'Rourke, the "Best of Managers"

The (forced) departure of Syd Barrett (made public in April 1968) brought about far-reaching changes to the Pink Floyd team. Peter Jenner and Andrew King had already terminated their collaboration with Pink Floyd the previous month. They wanted to continue to oversee the career of the only member of the group whom they had ever believed in—Syd—while taking advantage of the glare of publicity to launch a young songwriter named Mark Feld who had just started an avant-garde folk group, Tyrannosaurus Rex, under the name Marc Bolan.

Pink Floyd's Brian Epstein

In the wake of their split from Jenner and King, which at least had the merit of clarity, Waters, Wright, Mason, and Gilmour signed a new management contract with Bryan Morrison, who immediately passed them over to his assistant. Steve O'Rourke had liked Pink Floyd's musical approach ever since their very first sessions at Sound Techniques studios. Born in Willesden (an Irish district of London) in 1940, O'Rourke was the son of an Irish fisherman from the Aran Islands who appears as a shark hunter in the famous 1934 semi-documentary *Man of Aran*. "Steve O'Rourke, after training as an accountant, had worked as a salesman for a pet food company," writes Nick Mason. "His employers eventually dismissed him when they discovered he was racing his company car at Brands Hatch every weekend and delegating his rounds to other salesmen so he could spend time running a club called El Toro in the Edgware Road. A subsequent three-month stint with another booking agency provided him with more than sufficient experience for Bryan to consider him fully qualified."[5] Andrew King would later admit: "Steve was much harder than Peter and I [...]. And I was rather jealous of him. He sorted out some big mistakes we'd made in our contractual relationship with EMI."[1] He also remarks that: "Steve had one client—the band—and nothing would compromise him in what he would do for the band. They could not have had a better manager."[1]

Steve O'Rourke rapidly climbed the rungs of the Bryan Morrison Agency. It was largely on his advice that in July 1968, just before Pink Floyd embarked on their second United States tour, Bryan Morrison sold his agency to NEMS Enterprises, the company founded by Brian Epstein, who had died a few months before, and now run by Vic Lewis.

At the beginning of the seventies, O'Rourke crossed a new threshold when he left NEMS to set up his own agency, EMKA Productions (named after his daughter Emma Kate), and, exerting more and more of an influence, convinced Waters, Gilmour, Wright, and Mason, then in the process of recording *The Dark Side of the Moon*, to quit Capitol in the United States and sign a more lucrative deal with Columbia, while remaining faithful to Harvest EMI in Europe. The change would only come into effect after the group's next album, *Wish You Were Here* (1975).

Racing Driver and Philanthropist

While looking after Pink Floyd's career and subsequently, after the clash with Roger Waters (it was Steve O'Rourke who would also take charge of negotiating the difficult separation), the careers of David Gilmour, Rick Wright, and Nick Mason, Steve O'Rourke would devote himself to another of his great passions. Having acquired a BRM 1957, and then a Ferrari 512 BB, in 1979 he started to take part in motor races (including the 24 Hours of Le Mans a number of times, notably with Nick Mason in 1982). He was also the designer of the Emka prototype, powered by an Aston Martin 5.5-liter V8. He subsequently took part in various other prestigious races including the BPR Endurance Series and the FIA GT Championship. Steve O'Rourke died of a stroke in Miami, Florida, on October 30, 2003. Mason, Wright, and Gilmour paid their last respects at his funeral, which took place at Chichester Cathedral in Sussex on November 14, 2003, with a performance of "Fat Old Sun" and "The Great Gig in the Sky," while Dick Parry (the saxophonist on *The Dark Side of the Moon*) played Steve's coffin into the cathedral on

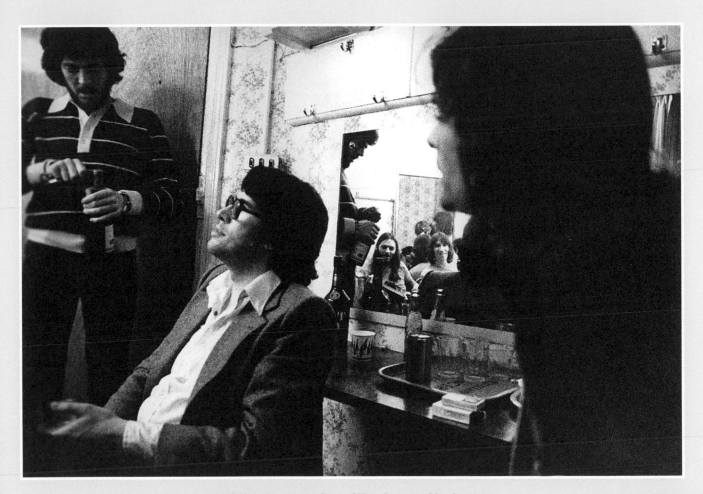

Pink Floyd manager Steve O'Rourke seated backstage.

his saxophone. Three years later, David would dedicate his solo album *On an Island* to his former manager.

The main characteristic of this honest and loyal manager (in spite of the reproaches leveled at him by Waters when the group split up) was to protect the image of his artists at all times while ensuring they benefited from the ideal creative conditions. Admired not least for his human qualities, Steve O'Rourke also discreetly supported various charitable organizations, in particular the EMI Music Sound Foundation and Nordoff Robbins Music Therapy.

For Pink Floyd Addicts

Steve O'Rourke makes a brief appearance in *Don't Look Back*, the documentary by D. A. Pennebaker about Bob Dylan's 1965 UK tour.

Roger Waters, with a white Fender
Precision borrowed for the French
television show *Samedi et
Compagnie* (ORTF), recorded on
September 6, 1968. The song "Let
There Be More Light" opens with
Waters playing a bass riff.

Let There Be More Light

Roger Waters / 5:39

Musicians
David Gilmour: vocals, electric rhythm
and lead guitar, backing vocals
Rick Wright: vocals, organ, backing vocals, vibraphone (?)
Roger Waters: bass, backing vocals
Nick Mason: drums, percussion

Recorded
Abbey Road Studios, London: January 18, March 25,
April 1, 23, 26, May 2, 1968 (Studio Three, Room 53)

Technical Team
Producer: Norman Smith
Sound Engineers: Ken Scott, Martin Benge, Peter Bown
Assistant Sound Engineers: Richard
Langham, John Barrett, Peter Mew

Roger Waters has the spaceship land near
Mildenhall in Suffolk, the location of a
Royal Air Force base.

For Pink Floyd Addicts

Roger Waters gives rein to his sense of
humor with an allusion to the Beatles'
"Lucy in the Sky with Diamonds": *The
servicemen were heard to sigh/For there
revealed in flowing robes/Was Lucy in
the sky.*

1968

Genesis

In his book *Inside Out: A Personal History of Pink Floyd*,
the group's drummer claims that Roger Waters had been
inspired to write "Let There Be More Light" by Pip Carter,
"one of the odder characters of the Cambridge mafia, now
deceased. Out of the Fens, and with some gipsy blood, Pip
worked for us at odd times as one of the world's most spec-
tacularly inept roadies—a hotly contested title—and had a
distressing tendency to remove his shoes within the confines
of the van."[5] But this is only one interpretation. In an inter-
view with the British rock magazine *ZigZag* in 1973, Roger
Waters revealed that he had always been, and still was, an
assiduous reader of science fiction. "I suppose the reason
I liked to read science fiction novels was that they give the
writer the chance to expound and explore very obvious
ideas. Sticking something in the future, or in some different
time or place, allows you to examine things without thinking
about all the stuff that everybody already knows about, and
reacts to automatically [...]. Also, you get some bloody good
yarns, and I like a good yarn."[34]

The songwriter may therefore have drawn his inspiration
from works by various great science fiction authors, such as
the Barsoom series by Edgar Rice Burroughs and the Rull
cycle by A. E. van Vogt. In the third verse, Waters refer-
ences *Carter's father*. John Carter is the main character in
the Barsoom series, a soldier in the American Civil War,
who, after being transported to the planet Mars, falls madly
in love with Dejah Thoris, a princess of the red people.
Later in the song, Waters evokes the Rull, a wormlike spe-
cies endowed with prodigious technological powers, and the
eleventh-century Hereward the Wake, also known as Here-
ward the Outlaw and Hereward the Exile.

There is also an allusion to Arthur C. Clarke's *Child-
hood's End* (1953), in which extraterrestrials bring to bear
their enormous skills in order to save planet Earth, and the
movie *The Day the Earth Stood Still* (1951), directed by
Robert Wise, which also deals with the theme of the highly
evolved, pacifist extraterrestrial.

Thus according to Waters, it is *aliens* who have the
ability to bring enlightenment to the world, or at any
rate to add to it, hence the song's title. In any case, the
world Roger Waters draws the listener into represents a

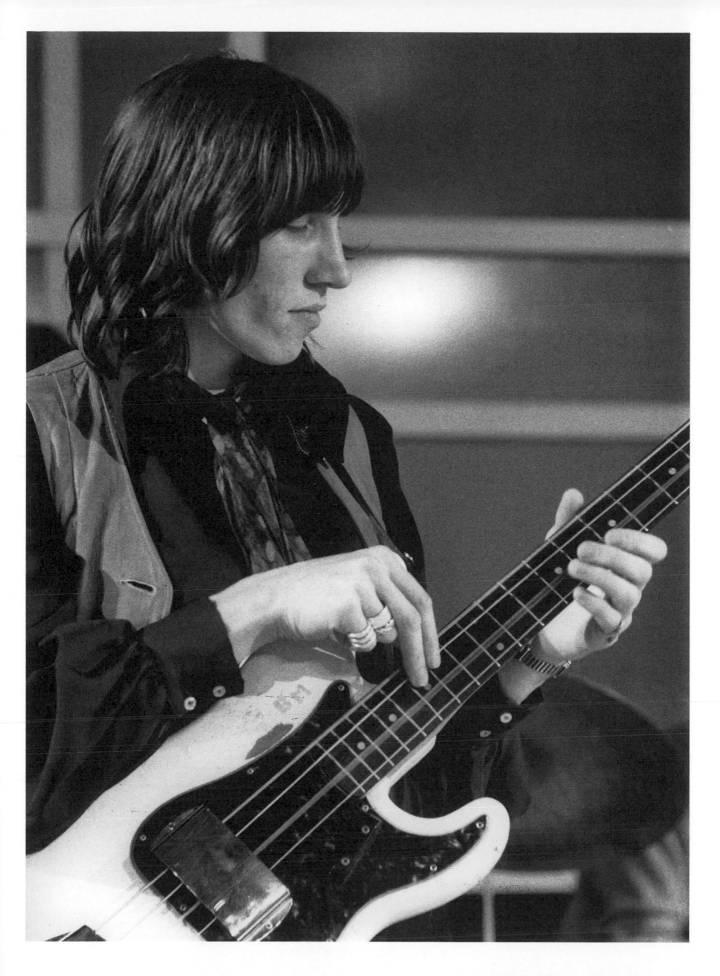

Norman Smith, who played a vital role as producer, particularly for "Let There Be More Light," which was recorded at Abbey Road.

🎧 **IN YOUR HEADPHONES**

At 1:27 in the stereo version of "Let There Be More Light," just before he starts the lead vocal for the first verse, Rick Wright can be clearly heard in the right-hand channel being brought in too early and immediately shut off again!

dramatic change from the world of Syd Barrett. Musically too, the difference is spectacular, with the theme of science fiction now the order of the day. "Let There Be More Light" was released as a single (with "Remember a Day" as the B-side) in the United States and Japan (without charting), and subsequently became one of the group's warhorses onstage.

Production

This track chosen to open their new album inaugurates the new musical direction taken by the Floyd now that Syd Barrett's influence had waned. The first session took place on January 18, 1968, just a few weeks after David Gilmour's arrival, a time when Syd was probably no longer recording with the group. "Let There Be More Light" (then named "Untitled") was recorded in a single take between 2:30 p.m. and 7:30 p.m. After various voice and guitar overdubs, the group then laid down a second take called "Rhythm Track," which would be added in on March 25.

"Let There Be More Light" begins with a highly energetic riff (in much the same vein as certain parts of "Interstellar Overdrive") in which Roger Waters is quickly joined by Nick Mason on ride cymbal and Rick Wright on Hammond M-102 organ with a rich, swirling sound. The Rickenbacker 4001, played at medium volume with plectrum,

has a somewhat aggressive edge. Waters is most likely plugged into his Selmer Treble-n-Bass 100 amp, although it is also possible he is connected to the console via a direct box. From 0:11, the bass is accompanied by a percussion instrument (bongos?) that is relatively recessed in the mix but nevertheless reinforces the percussive effect of the riff.

"Let There Be More Light" can be divided into three sections: a first with this riff played at around 100 bpm; a second at a slower tempo (approximately 78 bpm), featuring a vocal part and based on a new riff; and a closing, exclusively instrumental, section. The second section is introduced by a cymbal swell that facilitates the rhythmic transition (1:11). The base riff that Rick Wright's vocal line follows is now different, featuring a slightly oriental sound. The voice of the Floyd keyboard player is doubled, but without the help of ADT. He shares each verse with David Gilmour, who takes care of the "rockier" part with a more aggressive timbre and in a higher register.

At the second session on March 25, which was dedicated to the vocals, Pink Floyd added in the "Rhythm Track" to the first take of January 18. What does this consist of, exactly? On the face of it, this rhythm track—recorded, logic would dictate, on a single track—includes Gilmour's rhythm guitar, Wright's organ, Waters's bass, and Mason's drums.

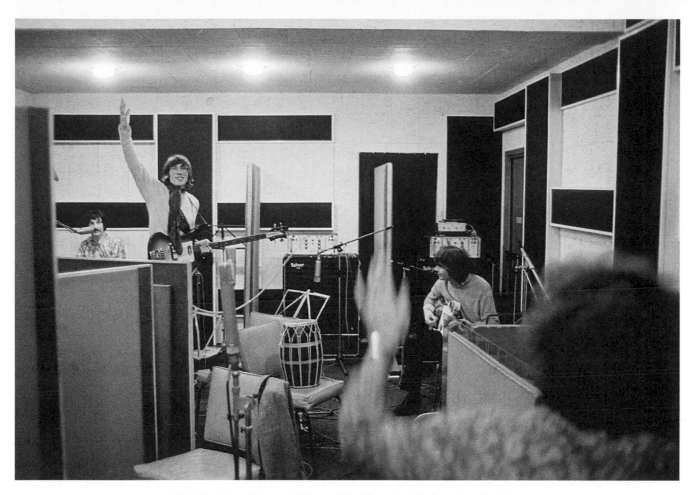

Pink Floyd working on *A Saucerful of Secrets* at De Lane Lea Studios.

It comes in at the beginning of the song's second section, as can be heard at 1:16, particularly in the left-hand channel of the stereo version. It is faded in in order to allow for smoother insertion, with Mason's crescendoing cymbal concealing the join. In this way the rhythm track comes and goes throughout the number, becoming prominent at opportune moments and also shifting position within the stereo spectrum, as at 1:40.

This brings us to the final, and exclusively instrumental, section (3:25). Here we have an opportunity to discover David Gilmour as a lead guitarist, as this is where he plays his first solo on disc with the group, on his white Fender Telecaster most probably plugged into Syd's amplifier, the 50-watt Selmer Truvoice Treble-n-Bass 50. Gilmour still lacks assurance and technical prowess. He is not yet the guitar hero of "Money" (*The Dark Side of the Moon*, 1973) or "Comfortably Numb" (*The Wall*, 1979), but his essential spirit is already present, with a style of playing that does not try to dazzle with technical prowess, instead placing an emphasis on emotion and matchless sound quality. He also uses the Binson Echorec, along with very present reverb perhaps added during mixing.

At around 4:00, the "Rhythm Track" material reemerges, accompanying a second and more energetic solo from Gilmour. The two solos intersect without interfering with

each other, and the same is true of Waters's bass. The track then develops into an improvisation and ends with the solo guitar brought to a sudden halt by the brutal stopping of the tape recorder (5:33). At the end of the coda, an instrument sounding like a vibraphone can be heard (from 5:17), played almost certainly by Wright.

The final overdubs, this time of the voices, were added during the April 1 session. This presumably includes Gilmour and Wright's backing vocals, but also Roger Waters's whispered accentuation of the words in the first part of the last verse. The remaining sessions were reserved for the various mixes and took place in Room 53.

"Let There Be More Light" is not exactly a straightforward track. It is neither easy to categorize nor immediately appealing to the ear. Listeners need to immerse themselves in its intricacies in order to appreciate its qualities in full. Upon the album's release, however, the *New Musical Express* would describe "Let There Be More Light" as the best song on the LP. In terms of production, it is worth noting the remarkable achievement of Norman Smith, who enabled this relatively complex piece to unfold with apparent ease. His experience was vital to the group. "Norman was a great teacher in terms of studio techniques,"[29] David Gilmour would say of him in 1993. And he was absolutely right.

Remember A Day

Rick Wright / 4:33

Musicians
Syd Barrett: acoustic rhythm guitar, electric lead guitar, vocal effects (?)
Rick Wright: vocals, piano, organ (?)
Roger Waters: bass, vocal effects (?)
Norman Smith: drums, backing vocals (?)

Recorded
De Lane Lea Studios, London: October 9–12, 1967; May 8, 1968 (?)

Technical Team
Producer: Norman Smith
Sound Engineer: Michael Weighell
Assistant Sound Engineer: ?

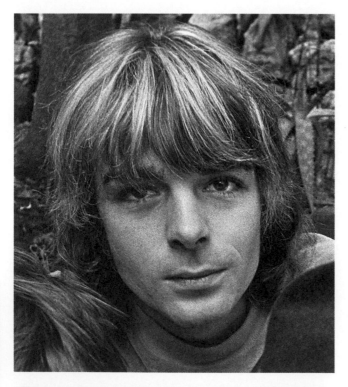

The melancholy face of Rick Wright, composer of "Remember a Day," a song about the end of the carefree days of youth.

Genesis

"Remember a Day" was written by Rick Wright at the time of *The Piper at the Gates of Dawn*. Moreover, it deals with a subject that was close to Syd Barrett's heart: the evocation of childhood and, more specifically, the often difficult transition from adolescence to adulthood. The narrator addresses his female companion: *Remember a day […] when you were young/Free to play alone with time/Evening never comes*. But the years have passed—the carefree years and perhaps the years of passion too—and there is no longer any question of playing. The elixir of eternal youth does not exist, or else only in the imagination of some people (and with the help of psychedelic drugs). *Why can't we reach the sun?/ Why can't we blow the years away*, asks Wright in a melancholy voice. Perhaps the songwriter was inspired in part by the Beatles, the phrase *Sing a song that can't be sung* strangely echoing *Nothing you can sing that can't be sung* from "All You Need Is Love," released on July 7, 1967, just a few months before the Floyd entered the studio…

"Remember a Day" was one of the first songs the Floyd recorded for *A Saucerful of Secrets*. The initial session took place at De Lane Lea Studios on Kingsway on October 9, 1967, during which "Jugband Blues" and "Vegetable Man" (not used on the album) were also cut. Syd Barrett was still present, physically at least, and did what was expected of him. Various sources quote an interview he gave in 1968 in which he looks back to this recording session: "I was self-taught and my only group was Pink Floyd. I was not featured on 'Corporal Clegg' but did play on another track written by Richard Wright. I forget the title but it had a steel guitar in the background"[35] clearly "Remember a Day."

Production

Because the EMI Studios were overbooked, the group had no alternative but to record externally, although still under the direction of Norman Smith. "Chappel Studios we used a lot," explains Peter Bown, "but we didn't put Pink Floyd in there because they wouldn't know what to do. De Lane Lea, they'd have had more idea…."[10] The sessions were held over four days, from October 9 to 12. Information is lacking about the number of takes, but the backing track must have been laid down on October 9. As David Gilmour was not

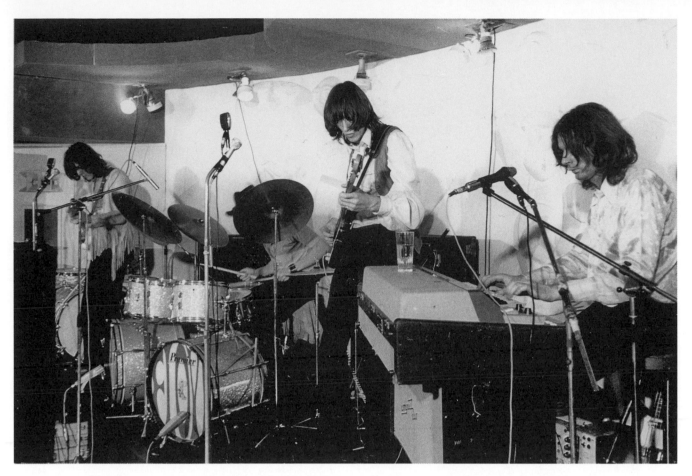

Pink Floyd in concert at the Bilboquet in Paris around the time that "Remember a Day" was recorded.

yet a member of the group, it is Syd Barrett who took care of the various guitar parts. It is therefore Syd playing acoustic rhythm guitar on his Levin LT 18 and lead most probably on his new white Fender Telecaster, which succeeded his Fender Esquire. He plays slide (with Zippo), and his handiwork is recognizable from the very first plaintive note sent into space by the Binson Echorec! He accompanies the song with phrases colored with abundant reverb before taking a rare, and on the whole successful, solo. Incredibly, his guitar playing resembles that of David Gilmour, and yet this is definitely Syd. It is impossible to overemphasize the importance of his influence on the Floyd sound. On keyboards, Rick Wright plays a highly lyrical piano part, alternating chord inversions with Romantic-sounding arpeggios. He also seems to lay down some organ pads that are very recessed in the mix. Roger Waters adopts a pop style on his bass, as can be heard in the intro, favoring the upper registers of his Rickenbacker.

Finally, the drumming holds a surprise. Behind the kit is not Nick Mason but Norman Smith. "'Remember a Day' had a different drum feel to our usual pounding style, and I eventually relinquished the playing to Norman," confesses Mason. "I really didn't like giving up my drum stool—and never have—but in this particular instance I would have struggled to provide a similar feel. Re-listening to this it feels more like a Norman Smith track than anyone else's."[5] This

seems odd, as the solo career of the future Hurricane Smith would demonstrate that his musical approach was diametrically opposed to that of the Floyd—except for the melodic character of "Remember a Day," which must have been to the producer's taste. As for his drum playing, it is excellent, Smith being an accomplished all-round musician. Here again, his style of playing mimics Mason's, at least in spirit. Why the Floyd drummer could not grasp what was required remains a mystery. During the solo passage (from 2:00) there are various vocal effects and mouth noises most probably executed by Syd, who often introduced similar effects into his own songs, for example in "Matilda Mother." Finally, in the coda, another voice seems to make itself heard (for example at 3:32), which, as Nick Mason confirms, is that of their omnipresent producer: "Apart from the rather un-Floyd-like arrangement, Norman's voice is also prominent within the backing vocals,"[5] he says. There are few backing vocals on this track, raising the question of whether Mason is talking about the same number.

"Remember a Day" was most likely mixed on May 8, 1968. This song proves that Rick Wright possessed a real gift for melody as well as an excellent voice. Up to this point in his career it was one of his best songs, its overall feel looking forward to his compositions of the *Atom Heart Mother* period, even if Nick Mason doesn't seem to relish Norman Smith's production.

Set The Controls For The Heart Of The Sun

Roger Waters / 5:27

Musicians
Syd Barrett: electric lead guitar
David Gilmour: guitar (?)
Rick Wright: organ, vibraphone, gong, backing vocals (?)
Roger Waters: vocals, bass
Nick Mason: drums
Seagulls: seagulls

Recorded
Abbey Road Studios, London: August 8, October 23, 1967; January 11, February 15, April 23, 26, May 2, 1968 (Studio Three, Studio Two, Room 53)

Technical Team
Producer: Norman Smith
Sound Engineers: Peter Bown, Ken Scott, Martin Benge
Assistant Sound Engineers: Jeff Jarratt, Richard Langham, John Barrett

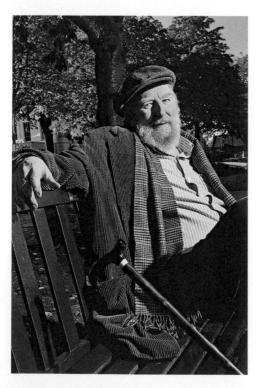
Michael Moorcock, author of *The Fireclown*, from which Roger Waters took his inspiration for this number.

Author Michael Moorcock was more than the inspiration for Roger Waters in his choice of title for "Set the Controls for the Heart of the Sun." Moorcock collaborated with the group Hawkwind on several of their albums (such as *Space Ritual* in 1973), and also with Blue Öyster Cult (notably on the song "The Great Sun Jester," inspired by Moorcock's novel *The Fireclown*, on the 1979 album *Mirrors*). Finally, he is present in the guise of the character Jerry Cornelius in *The Airtight Garage* by the French comic strip artist and writer Moebius.

Genesis

"It was one of my first songs of Pink Floyd, and one of my first compositions,"[3] explains Roger Waters. Most importantly, according to Peter Jenner it was "[...] the first song that Roger wrote that stood up against Syd's songs, which was significant at the time."[36] Waters wrote "Set the Controls for the Heart of the Sun" in autumn 1967. He took its title not from a poem by William S. Burroughs, as is often supposed, but from *The Fireclown* (1965), the fourth novel by the great science fiction writer Michael Moorcock. As for the words, Waters followed Barrett's example with "Chapter 24" and drew heavily on Chinese poetry, above all on the work of Li Shangyin, a poet of the late Tang dynasty (ninth century), confessing during a radio interview in the nineties that he had consulted a collection of translations by A. C. Graham, *Poems of the Late T'ang*. Certain passages can thus be traced back to their origins. *Little by little the night turns around* is taken from "Untitled Poem III"; the next line, *Counting the leaves which tremble at dawn*, from "Willow"; *One inch of love is one inch of shadow* from "Untitled Poem II"; and *Witness the man who raves at the wall/Making the shape of his questions to heaven* from a poem by Li He (eighth to ninth centuries).

Inspired by the wisdom of the East, Roger Waters has created a beautiful and poignant scenario that combines sadness, solitude, and suicide—amounting to a meditation on madness, it might be added. "'Set the Controls'...is about an unknown person who, while piloting a mighty flying saucer, is overcome with solar suicidal tendencies and sets the controls for the heart of the sun,"[36] explains Roger Waters. Musically, it was his first great classic, although he may well have spent several months wondering whether to play it to the other members of the group. The song has a clear four-partite structure consisting of: an intro, first two sung verses, a very "space rock" improvisation, and a last verse in the form of conclusion. It is also a work that allows great freedom for improvisation when performed onstage, as can be heard from the various recorded live versions: that on *Ummagumma* lasts for more than nine minutes; that on *In the Flesh*, Roger Waters's live album, lasts for seven minutes; and the version on the bootleg *The Band Who Ate Asteroids for Breakfast* goes on for sixteen minutes.

1968

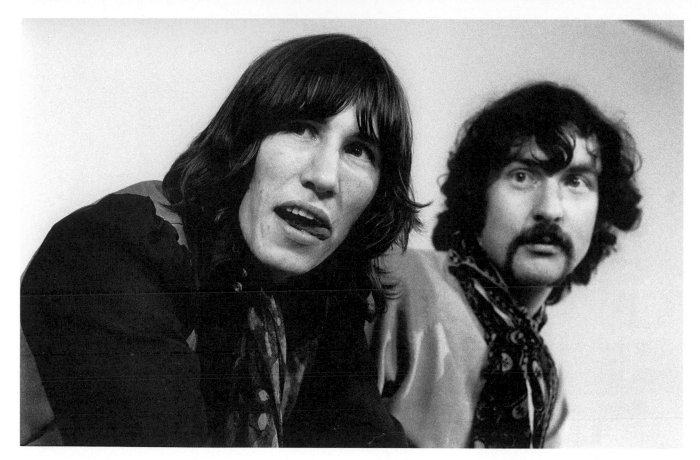

Waters and Mason, the rhythm section that powers "Set the Controls for the Heart of the Sun" to the fringes of the universe...

"Set the Controls for the Heart of the Sun" takes pride of place in the history of the progressive rock group—not just for its artistic value, but also for its particular scenario, allowing it to be seen as a kind of Pink Floyd space opera.

Production

On August 7, 1967, Pink Floyd entered the studio for the first session on their new album. The first song they recorded was "Scream Thy Last Scream," a Syd Barrett number that would not be included on the album even though it had, for a while, been considered as a potential single. When they returned to EMI's Studio Three the next day, "Set the Controls for the Heart of the Sun" became the first *Saucerful of Secrets* track they worked on. The base track was recorded in two takes, with the second retained as best. The song is built mainly on a bass riff played by Roger Waters. This motif has an oriental feel, and in spite of its apparent gentleness, hints at a lurking menace or tension. The sound of the Rickenbacker is velvety and enveloped in ample, very present reverb. This lends it a hypnotic character that commands attention from the very first notes. According to David Parker, who has had access to the Abbey Road archives, only two of the tape recorder's four tracks were used: the first for Nick Mason's drums plus additional cymbal, and the second for Roger Waters's bass and a guitar.[10] This suggests that *everything* was recorded "live." With respect to the drumming, Nick reveals the influence he

was able to exert: "[...] rhythmically it gave me a chance to emulate one of my favourite pieces, 'Blue Sands,' the track by the jazz drummer Chico Hamilton in the film *Jazz on a Summer's Day*."[5] Following the example of his model, Nick opted to use mainly his toms, which he strikes with timpani mallets. The effect substantially reinforces the meditative atmosphere of the track and gives the listener the distinct impression that he was enjoying his playing. The cymbal recorded on the same track was actually a gong (mixed well back) most likely played by Rick Wright, who was not at his keyboards during this first session. Roger Waters, who was usually in charge of this particular percussion instrument, was playing bass and, given that the group was recording "live," was unable to handle both instruments at once. Roger's bass track also includes a guitar part that must have been played by Syd Barrett, as David Gilmour had not yet joined the Floyd. Moreover, Gilmour would himself confirm in 1993: "[Syd's] also on a tiny bit of 'Set the Controls for the Heart of the Sun.' I think I'm on 'Set The Controls' as well."[29] It is certainly true that the guitar parts are discreet. Nevertheless, it would seem to be Syd who can be heard from 5:02 to the end. He takes up the melody of the riff on his Fender. Gilmour's contribution is extremely difficult to determine, but on the various televised and live performances he doubles Waters's riff. If this is also the case here, his guitar is barely audible (although it can apparently be detected between 1:49 and 1:54).

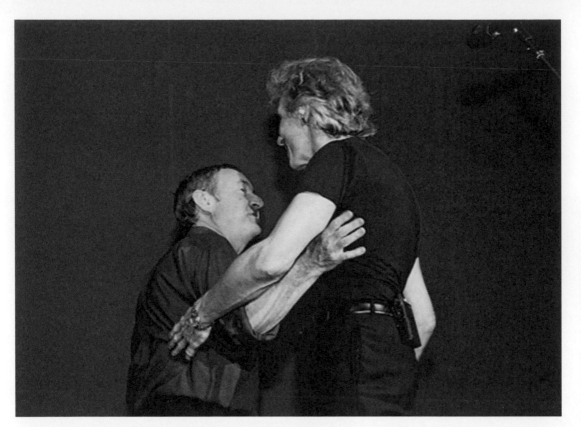

Left: In 2002, Nick Mason joined Roger Waters for a performance of "Set the Controls for the Heart of the Sun" at Wembley. **Right:** Pink Floyd at rest. Syd Barrett (smiling) is still a member of the group.

For Pink Floyd Addicts

The novelist Douglas Adams was inspired by "Set the Controls for the Heart of the Sun" to write his *Hitchhiker's Guide to the Galaxy* series). Here he describes a group named Disaster Area, the "loudest [...] rock band in the history of [...] history itself." Was he thinking of Pink Floyd?

During his two concerts at Wembley Arena on June 26 and 27, 2002, Roger Waters played "Set the Controls for the Heart of the Sun" with Nick Mason—for the first time in more than twenty years!

Roger Waters recorded his lead vocal during the second session, on October 23, 1967. His singing is gentle, almost confiding in tone. "The song—with a great, catchy riff—was designed to sit within Roger's vocal range,"[5] Nick Mason would later comment. And as in "Let There Be More Light," his singing, with ample reverb, tracks the bass motif. Devoid of any surging energy on his part, Waters distills his words in the manner of a spirit guide, indeed almost exhales them. As for Rick Wright, the keyboard player added the vibraphone part during this session, making an essential contribution to the mellow feel of the piece. A little less than three months later, on January 11, 1968, Pink Floyd would return to the studio to add some more overdubs. On this occasion Wright recorded his keyboard parts, which provide the only real harmonic support given the lack of rhythm guitar. He plays his Farfisa Compact Duo organ and uses his Echorec to create a sense of space. He also seems to play the Hammond M-102, in particular for solos in which he uses a wah-wah pedal (listen between 2:50 and 3:12), the whole thing drenched in reverb. During this same session, additional voices were added, including what sounds like an *Om*—the sacred syllable of the Buddhists—that can be made out at the back of the mix at 2:33 and 2:47. The unreal atmosphere of the track is further enhanced by the sound of seagulls (from 3:05), recalling the tapes played backward on the Beatles' "Tomorrow Never Knows" in 1966.

"'Set the Controls for the Heart of the Sun,' is perhaps the most interesting song in relation to what we were doing at the time," Nick Mason would later suggest, "since it had been constructed to make the most of what we had learnt."[5] This outstanding track marks an important transition in the group's career as the Floyd evolved toward new horizons and a musical form with a cleaner, more defined shape. It would not be until 1971 and "Echoes" that the Floyd would fully master its means of artistic expression.

1968

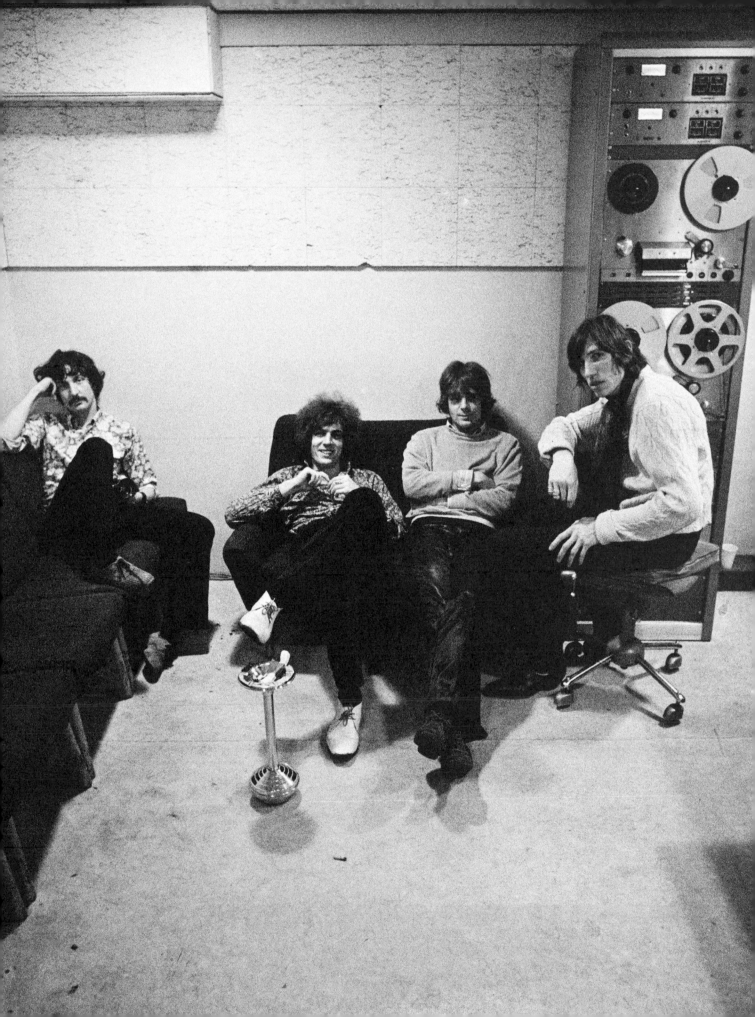

Corporal Clegg

Roger Waters / 4:12

Musicians
David Gilmour: vocals, electric rhythm and lead guitar, kazoo, backing vocals, sound effects (?)
Rick Wright: organ, backing vocals, kazoo (?), sound effects (?)
Roger Waters: bass, backing vocals, kazoo (?), sound effects (?)
Nick Mason: vocals, drums, kazoo (?) sound effects (?)
Stanley Myers Orchestra: horns
Recorded
Abbey Road Studios, London: January 31, February 1, 7–8, 12, 15, March 25, April 24, 30, 1968 (Studio Three, Studio Two, Room 53)
Technical Team
Producer: Norman Smith
Sound Engineers: Ken Scott, Martin Benge
Assistant Sound Engineers: John Smith, Michael Sheady, Jeff Jarratt, John Barrett, Peter Mew

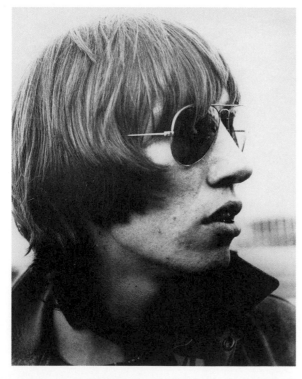

Roger Waters. "Corporal Clegg" was the bassist's first reference in song to the Second World War and the death of his father.

Genesis

"Corporal Clegg" is the first song in which Roger Waters evokes the Second World War. It is in a tone of derision that the musician chooses to look back at this apocalyptic period, marked for him by the death of his father, whom he would never know. The corporal of the title has a wooden leg he brought back from the war, a medal he found in a zoo, and a wife who is no doubt very proud of his bravery in combat, but who drowns her sorrows in gin, one little drop after another. *Corporal Clegg received his medal in a dream/From Her Majesty the queen/His boots were very clean*, mocks Waters in the final verse.

Behind the sardonic humor is an all-out attack on the authorities and the army, who send the country's youth into battle but display a revolting lack of gratitude once the guns fall silent. "Corporal Clegg is about my father and his sacrifice in World War II," explains the songwriter in a 2009 interview. It's somewhat sarcastic—the idea of the wooden leg being something you won in the war, like a trophy."[37] Hence the spuriously jolly atmosphere that to some extent, with its crowd noises and revelers' voices blending with the improbable kazoos, recalls Bob Dylan's "Rainy Day Women #12 & 35" on *Blonde on Blonde*.

In terms of its lyrics, Nick Mason would see "Corporal Clegg" as "a humorous forerunner of 'The Gunner's Dream,'"[5] another Roger Waters song (on the 1983 album *The Final Cut*).

Production

In 1968, Pete Bown was off work for a time for health reasons, and was replaced by Ken Scott so that the album in progress could be finished. Scott had already worked on the single "Apples and Oranges"/"Paint Box" at the end of 1967, and has a clear recollection of doing "a track with the new Floyd line-up that had the guitarist David Gilmour. That song was 'Corporal Clegg.'"[27] Scott would spend most of the rest of the year in the control room of Studio Two, working on the final stages of the Beatles' *White Album*.

The first session given over to this piece took place on January 31, with Syd Barrett no longer present. The backing track was recorded in six takes. The song opens with a

1968

At the heart of Waters's composition is the heavy toll paid by British troops during the Second World War.

The naming of the song's hero was not a matter of chance. The American engineer (of German origin) who invented the kazoo, played in this song by David Gilmour, was called...Thaddeus von Clegg!

very catchy rock riff played by David Gilmour on his Fender Telecaster, accompanied by Roger Waters on his Rickenbacker 4001. They are supported by Nick Mason, who pounds away at his drum kit, paying particular attention to his crash cymbal. Gilmour also plays a second guitar with a very distorted sound (courtesy of his Fuzz Face), and the overall sonority is reminiscent of Jimi Hendrix. When asked whether this resemblance was deliberate, Gilmour would reply: "No, not really. I didn't know what the hell I was trying to play at the time to be quite honest. I'd really no idea. What I was used to playing, the style I had, didn't fit Pink Floyd at the time, and I didn't really know quite what to do. Gradually over the years my style changed to fit Pink Floyd, and Pink Floyd changed to fit my style."[28] He also shared lead vocals with Nick Mason, a first for the drummer, who would not sing again until "One of These Days" (on *Meddle*, 1971). While Gilmour takes the first phrase of each verse, Mason sings the last two, delivering the lines in an ironic, even cartoon style. The effect is comic and counterbalances the guitarist's pop-rock timbre. Note the remarkable work that went into the vocal parts on "Corporal Clegg": Beatles-style harmonies in the verses, subtle counterpoint in the bridge (0:45), and three-part harmonies in the refrains. Of course, with Norman Smith producing, this should come as no surprise. Instrumentally too, there is a great deal going on: wah-wah in the refrains from Gilmour as he continues

with his Hendrix trip, Hammond M-102 organ from Rick Wright, and kazoo in both instrumental sections. The latter is probably played by Gilmour, no doubt assisted by his bandmates. In a program on RTB (the Belgian state broadcaster for the French-speaking part of that country) in February 1968, Gilmour can be seen playing not a kazoo but a slide whistle! For these instrumental interludes, the Stanley Myers Orchestra would record a six-strong horn section in EMI's Studio Two on February 12, destined in particular for the off-the-wall coda. In actual fact, one has to listen very carefully to hear them. Once again the spirit of the Fab Four is felt in the closing section of the track, with voices and various noises and sound effects merging with the ensemble. At precisely 3:03, Norman Smith can be heard caricaturally exclaiming *Git your hair cut!* in an example of typical British humor...The piece ends with various noises that are difficult to identify but that may well be airplanes and wailing sirens, an idea that will be taken up in 1979 in the intro to the album *The Wall*.

"I mean, 'Corporal Clegg' is a good piece of work,"[30] Roger Waters would claim in 2004. Not so far removed from the universe of Syd Barrett—at least musically—this song is nevertheless a long way from the Pink Floyd bassist's later style of composition, and even from his other contributions to this album ("Let There Be More Light" and "Set the Controls for the Heart of the Sun").

A Saucerful Of Secrets

Roger Waters, Rick Wright, Nick Mason, David Gilmour / 11:57

Musicians

David Gilmour: electric guitar, percussion (?), various sound effects, backing vocals
Roger Waters: bass, percussion, various sound effects, backing vocals
Rick Wright: organ, piano, Mellotron, percussion (?), various sound effects, backing vocals
Nick Mason: drums, percussion, various sound effects

Recorded

Abbey Road Studios, London: April 3, 5, 9–10, 23–24, May 1, 1968 (Studio Three, Room 53)

Technical Team

Producer: Norman Smith
Sound Engineers: Peter Bown (?), Ken Scott (?), Martin Benge
Assistant Sound Engineers: Peter Mew, Richard Langham, John Kurlander, John Smith, John Barrett

For Pink Floyd Addicts

Rick Wright would adapt the finale of "A Saucerful of Secrets" ("Celestial Voices") reasonably faithfully in "Cirrus Minor" (More, 1969), and also, in a vaguely similar spirit, in "The Mortality Sequence" (the first version of "The Great Gig in the Sky" on *The Dark Side of the Moon*). "Celestial Voices" also formed the concluding part of the suite *The Man and the Journey*, a concept developed by the group in 1969 to transform concerts into a sequence of works, either familiar or unfamiliar, based on a common theme.

On the first versions of the album, David Gilmour's surname was spelled *Gilmore.*

1968

Genesis

This long piece from which Pink Floyd's second album takes its name is a collective work born in the studio in spring 1968. "It was the first thing we'd done without Syd that we thought was any good,"[39] Roger Waters would later say. This instrumental track comprising four sections (in reality three movements, of which the last is divided into two sequences) was originally called "Nick's Boogie." After this it would be presented in concert under the successive titles "The Massed Gadgets of Auximines," "The Massed Gadgets of Hercules," and, ultimately, "A Saucerful of Secrets."

What could be the meaning of this title? Were the members of Pink Floyd issuing an SOS (based on the first letter of each word in the title)? It seems more likely that they wanted the listener to climb aboard their flying saucer for a long journey into space…

In an interview with *Mojo* magazine in 1994, David Gilmour recalls the development of this key work: "I remember Nick and Roger drawing out 'A Saucerful of Secrets' as an architectural diagram, in dynamic form rather than any sort of musical form, with peaks and troughs. That's what it was about. It wasn't music for beauty's sake, or for emotion's sake. It never had a story line."[39] No story line, then, but four distinct parts brought together under the title "A Saucerful of Secrets." It was not until 1969 and the United States pressing of *Ummagumma*, their fourth album, that each of these sections would be given a name: "Something Else," "Syncopated Pandemonium," "Storm Signal," and "Celestial Voices."

"Something Else" sets the scene, as it were: a harrowing, oppressive atmosphere, a kind of journey into terra incognita, where one imagines danger lurking around every corner. "Syncopated Pandemonium" is based on drums and dissonant piano chords plus various sound effects that evoke chaos. "Storm Signal" is also built on sound effects, and on keyboards too, giving way to the final section, "Celestial Voices," dominated by the organ and then the Mellotron—a coda whose ultimate aim seems to be to spread a sense of serenity. Or else to evoke total war (in space?).

More or less classical in structure (akin to a concerto or symphony), "A Saucerful of Secrets" was Pink Floyd's first experimental epic, with Roger Waters, Nick Mason, Rick Wright, and David Gilmour showing less of an artistic debt to

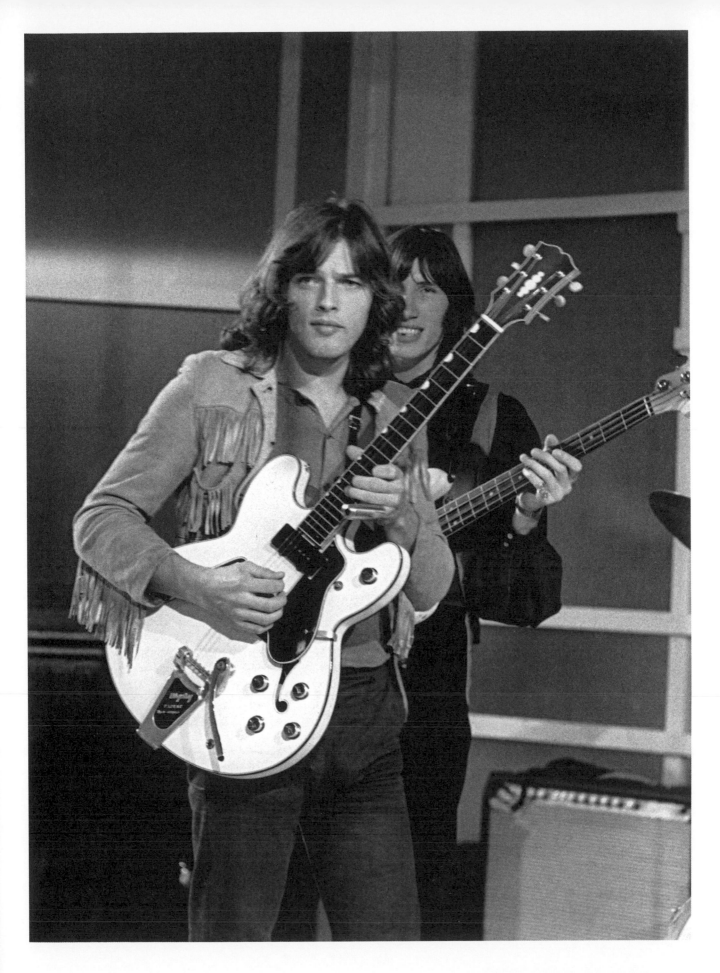

"A Saucerful of Secrets" was the first Pink Floyd composition post-Barrett (shown here attempting a sound effect using a rubber duck).

🎧 **IN YOUR HEADPHONES**

The very last chord (B major) of the final movement seems to be the result of a rather abrupt edit (at 11:44)...

the blues, but to avant-garde composers such as John Cage and Stockhausen. This piece contains the seeds of some of their future masterpieces. "'A Saucerful of Secrets' was a very important track," reveals David Gilmour, "it gave us our direction forward. If you take *A Saucerful of Secrets*, *Atom Heart Mother* and *Echoes*—all lead logically to *Dark Side of the Moon* and what comes after it."[40] It is also the track that gave rise to the first bone of contention between the four members of Pink Floyd and Norman Smith. "I did the title track [in reality 'Celestial Voices']," explains Rick Wright, "and I remember Norman saying, You just can't do this, it's too long. You have to write three-minute songs. We were pretty cocky by now and told him, If you don't wanna produce it, just go away. A good attitude I think."[39]

The group would perform "A Saucerful of Secrets" onstage regularly up to 1972 and occasionally over the following year. There are two official live versions—one on the album *Ummagumma* (12:49) and the other in the documentary movie *Pink Floyd: Live at Pompeii* (9:41)—as well as various bootlegs, that on *The Band Who Ate Asteroids for Breakfast* exceeding twenty-five minutes in length.

Production

Thus on April 3, 1968, Pink Floyd threw themselves into the longest and most ambitious musical work of their budding career. With this track of almost twelve minutes' duration, they by far exceeded the rock music standards of the day, which is something poor Norman Smith found difficult to comprehend. Nick Mason: "There is certainly a story that during the recording of *Saucer* he [Norman] was heard to remark that the boys would have to settle down and do some proper work once they had got this piece out of their system."[5] It is true that in *A Saucerful of Secrets* Pink Floyd definitely had something to unsettle Norman with, their producer having no great love of this type of thing (experimental to say the least) despite his evident and widely recognized open-mindedness. The working title "Nick's Boogie" had already been used for a previous, unrelated track recorded at Sound Techniques studios in January 1967. However, the Floyd decided to split it into three movements that they would get down on tape independently, and which would eventually be combined into a single piece. The sessions were organized as follows:

- April 3: first take retained as best for the first and second movements
- April 5: rerecording of the first movement and first take of the third movement
- April 9: rerecording of the third movement with overdubs
- April 10: new parts recorded, provisionally referred to as the "Wild Guitar Track" and "Wild Guitar Track with Piano," plus various overdubs of vocals and sound effects, and remixing of the first and second movements
- April 23: mixing of the third movement
- April 24: remixing of the second movement
- May 1: remixing of the first movement

In the end, it took seven sessions to complete this complex piece, which was relatively quick. It was Roger Waters who accidentally sparked the idea for "A Saucerful of Secrets." Nick Mason relates: "One starting point was a sound that Roger had discovered by placing a mike close to the edge of a cymbal and capturing all the tones that are normally lost when it is struck hard. This gave us a first section to work from, and with four individuals contributing freely, the piece developed quickly."[5] The musicians based their work on diagrams drawn by Waters and Mason that gave free rein to their ideas while retaining the structure in their heads. It sounds as if Gilmour, whose very first contribution as co-composer this was, may have been slightly perplexed: "My role, I suppose, was to try and make it a bit more musical, and to help create a balance between formlessness and structure, disharmony and harmony."[29]

The first movement ("Something Else") is actually based on Waters's cymbal, which makes its ominous, menacing presence felt in the very first bar. The effect is highly impressive, and listeners may wonder whether, in order to acquire such depth, the instrument was recorded at a slower speed. Someone can be heard manipulating the strings of an acoustic piano, following the example of John Cage and his prepared pianos. Rick Wright is on the Farfisa organ, and the plaintive sonorities he draws from his instrument are lugubrious and disturbing to say the least. Pink Floyd gives the impression of having been inspired by Ligeti's *Requiem*, which is not exactly an anodyne work. Various different percussion instruments can be heard that are difficult to identify, but presumably include chimes. Gilmour seems to strum his Fender periodically in order to produce sounds worthy of

For Pink Floyd Addicts

Pink Floyd performed an initial version of "A Saucerful of Secrets," then called "The Massed Gadgets of Hercules," on John Peel's *Top Gear* sessions for the BBC, recorded on June 25, 1968.

Syd Barrett, with heavy use of the Binson Echorec (0:37). The squeaking of rubber ducks contributes to the unreal atmosphere of this first movement—all the more so as they too are swamped in Echorec. Finally, horns, probably issuing from Wright's Mellotron MK2, emerge at the back of the mix from 2:30.

The second movement ("Syncopated Pandemonium," beginning at 3:57) is rhythmic. Nick Mason has revealed that this section was nicknamed "Rats in the Piano." It is constructed using various effects that the group had tried out during its stage performances, a (doubled) drum loop providing the momentum. Backward cymbals can be heard, as can a manhandled piano worthy of Iannis Xenakis (another architect-turned-musician), an organ pad serving as a harmonic (if that is the right word) foundation, and also Gilmour's guitar, which he employs in a rather unorthodox manner. The guitarist would explain in 1993 that his guitar was lying on the floor the whole time: "And I unscrewed one of the legs from a mic stand [...] I just whizzed one of those up and down the neck—not very subtly."[29] The end result is highly psychedelic, similar to the sound an EBow might have produced. (The EBow is a resonator that is passed over the strings of an electric guitar in order to generate an electronic sound similar to that produced by a guitar played with a bow.) This sequence was recorded on April 10 under the title "Wild Guitar Track with Piano."

The third movement comprises two parts: "Storm Signal" from 7:07 and "Celestial Voices" from 8:30. "Storm Signal" is based on Rick Wright's Hammond organ, the keyboard player establishing a very dark and sinister atmosphere, accompanied only by chimes that seem to quiver in the wind. The link with the preceding sequence is achieved via a more or less indefinable transition, a kind of electromagnetic storm, hence the title "Storm Signal." "Celestial Voices" is announced by a guitar sound obtained in all likelihood using the whammy bar of Gilmour's Telecaster (at 8:26). The mood is serene and collected, the harmonies melodic. Here the organ and bass dominate, with string sounds played by Wright on the Mellotron and choirs of angels (most likely a combination of the Mellotron and Floyd vocals) suggesting a sense of redemption. Finally, the guitarist's Fender (played slide with Echorec) contributes a somewhat mellow feel. The sky clearing after the battle, in a sense, and this is also how Waters defined the piece in an interview, although without it being entirely clear whether or not this was his idea of a joke...

"A Saucerful of Secrets" is an astonishing piece for more than one reason. First of all it is more musique concrète than rock; secondly, the members of the Floyd reveal a maturity that is remarkable for their age; and finally, their concept is utterly visionary because although they were inspired by more "serious" works (John Cage, Stockhausen, Pierre Henry), "A Saucerful of Secrets" can be regarded as the prototype for English progressive music. The four musicians threw themselves heart and soul into a work whose importance they no doubt sensed, but without grasping the full implications, motivated as they were by a desire for innovation and sonic experimentation, as Nick Mason explains: "All of us wanted to be involved all the time, so creating a percussion sound would find Roger holding the cymbal, David moving the microphone closer, Rick adjusting the height, and me delivering the coup de grâce."[5]

See-Saw

Rick Wright / 4:37

Musicians
David Gilmour: acoustic guitar, electric rhythm and lead guitar, backing vocals (?)
Rick Wright: vocals, organ, piano, Mellotron, xylophone, backing vocals (?)
Roger Waters: bass, backing vocals (?)
Nick Mason: drums, percussion

Recorded
Abbey Road Studios, London: January 24–25, 31, February 1, April 22–23, 26, May 3, 1968 (Studio Two, Studio Three, Room 53)

Technical Team
Producer: Norman Smith
Sound Engineers: Ken Scott, Peter Bown (?), Martin Benge, Peter Mew
Assistant Sound Engineers: John Barrett, John Smith, Richard Langham

For Pink Floyd Addicts

The working title of "See-Saw" was "The Most Boring Song I've Ever Heard, Bar Two," which speaks volumes about the group's opinion of it. Of course, this may simply have been a case of tongue-in-cheek humor!

Genesis

Although this song by Rick Wright may seem to describe a troubled sibling relationship, it is most likely about childhood and adolescence in a more general sense. This is also a subject that the Pink Floyd songwriter and keyboard player dealt with in "Remember a Day." *Childhood* and *adolescence*: two words so often equated with insouciance. The scenario is a brother and sister going on walks in the peaceful English countryside, walks that lead to the public park or down to the river. The songwriter looks back nostalgically at the fun they had throwing stones and playing on the see-saw: *She goes up while he goes down*. However, the feeling of happiness is ephemeral, for *She grows up for another man and he's down*, sings Rick Wright.

Some commentators have suggested that Rick Wright wrote "See-Saw" while he was living with Syd Barrett in Richmond. The main character in the song could thus be Syd himself, who made the acquaintance of his teenage sweetheart, Libby Gausden, in a children's playground. "We met on Jesus Green. There was a huge open-air swimming pool there which we all had membership of and we'd all swim from April to September to get our money's worth. Outside was a kids' playground. I was on the seesaw with somebody when he came up to me. He was very handsome. A bit spotty but lovely looking."[42]

Production

In this song, Rick Wright demonstrates that he shares not only Syd Barrett's fondness for seesaws, but also his keen sense of melody. In spite of its rather elaborate structure, "See-Saw" is a pop song in the best sense of the term. The first sessions were held on January 24 and 25, 1968 in EMI's prestigious Studio Two (the studio generally reserved for the Beatles), and it was not until day two that the group recorded its best take. As Syd Barrett was no longer present, it is David Gilmour playing the two guitar parts in the intro, the first on acoustic rhythm (the Levin LT 18) and the second on electric (the Fender Telecaster, which he uses for both rhythm and lead, its sound strongly colored by both the Binson Echorec and his Vox wah-wah). Nick Mason chooses to accompany him with brushes and, as can be heard in the opening bar, uses a very rapid echo

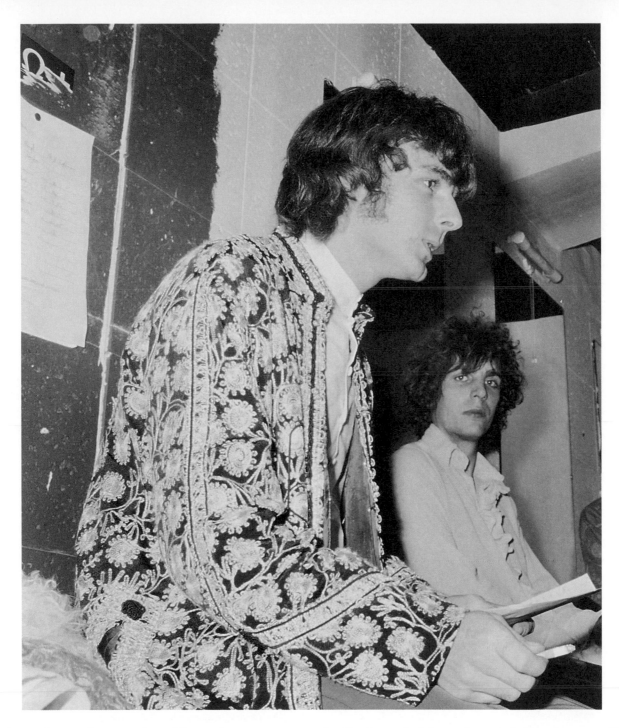

with his strokes on the snare drum. Mason does not restrict himself to the drum kit, however, and numerous other percussion instruments can also be heard, such as a triangle (for example at 1:50, albeit not in time!), a tambourine (from 2:33), and maracas in the coda (around 4:01). There also seems to be a gong at the end of the instrumental break (listen at 0:41). Roger Waters delivers a pretty dark-hued bass line that nevertheless has a reasonably melodic role within the ensemble. As for Rick Wright, the keyboard player busies himself with the Farfisa organ, the acoustic piano, the Mellotron MK2 (with a string sound), and the xylophone, which comes to the fore at 1:44. It is also Rick who sings lead vocal, his gentle voice so characteristic of

the Floyd sound of the early period. Abundant, very Beach Boys–style backing vocals add to the melodiousness of the song, in particular in the refrains (1:50).

The third song to be written by Rick Wright for the group, after "Paint Box" and "Remember a Day," "See-Saw" cannot exactly be described as his masterpiece, but it nevertheless gives a hint of his writing style and melodic feel that would subsequently assert themselves. On September 15, 2008, the day Rick Wright died, David Gilmour said of his friend: "He was gentle, unassuming and private but his soulful voice and playing were vital, magical components of our most recognised Pink Floyd sound."[43]And "See-Saw" provides a perfect example of that.

Jugband Blues

Syd Barrett / 3:00

Musicians
Syd Barrett: vocals, acoustic guitar, electric
lead guitar, backing vocals (?)
Roger Waters: bass, backing vocals (?)
Rick Wright: keyboards (?), recorder (?), backing vocals (?)
Nick Mason: drums
Unidentified musicians: Salvation Army
brass band, kazoo, castanets

Recorded
De Lane Lea Studios, London: October
9–11, 19, 1967; May 8, 1968 (?)

Technical Team
Producer: Norman Smith
Sound Engineers: Michael Weighell, M. Cooper (?)

For Pink Floyd Addicts

A video for "Jugband Blues" was shot at the end of 1967 (date and location unknown). In it, Syd, with a somber, melancholy air, can be seen surrounded by his bandmates, who do not exactly look cheerful either, with Waters blowing into a tuba and Wright into a trombone.

"Jugband Blues" was Syd Barrett's very last composition for Pink Floyd. And one of his best.

Genesis

"Jugband Blues" is the last song to be written and sung by Syd Barrett as a member of Pink Floyd. In it he gives remarkable poetic expression to both his descent into schizophrenia and his bond (or, on the contrary, the discord) with the other members of the group. The first verse is laden with meaning: *It's awfully considerate of you to think of me here/And I'm most obliged to you for making it clear/That I'm not here*. In other words, Barrett is thanking Waters, Wright, and Mason for considering him a member of the group still, even if he is no longer present mentally or physically.

In the second verse, relations reach the point of no return. *And I'm grateful that you threw away my old shoes*: the songwriter engages in sardonic humor in order to express his regret at no longer occupying a position at the heart of the group, which is the reason he didn't know *the moon could be so big* nor *so blue*. And this humor gives way to disenchantment, if not resentment: *And I don't care if nothing is mine/And I don't care if I'm nervous with you*. All that remains for Syd Barrett, then, is to do his *loving in the winter*, while asking himself, *what exactly is a joke?*

Production

"Jugband Blues" was recorded at De Lane Lea Studios in October 1967, the same day as Rick Wright's "Remember a Day" and Barrett's "Vegetable Man," another of the guitarist's songs that would fail to make it onto the album. October 9, 10, and 11 were most probably reserved for cutting the base track and vocals. "Jugband Blues" has no intro: the songwriter launches straight into the first verse. He sings with his characteristic nonchalance, his timbre simultaneously benevolent and detached, and his voice accentuated by a relatively strong delay. He accompanies himself on his Levin LT 18 (which he doubles), while Roger Waters is on his Rickenbacker 4001 and Nick Mason is on his Premier kit. Rick Wright, apparently not at the keyboard, may well be playing the recorder that can be heard from the beginning. Like most of Syd's songs, this is a pop number with simple backing harmonies (from 0:17), that incorporates a sequence of sonic experimentation.

Following a colorful second section incorporating a kazoo and castanets (from 0:39), "Jugband Blues" cedes

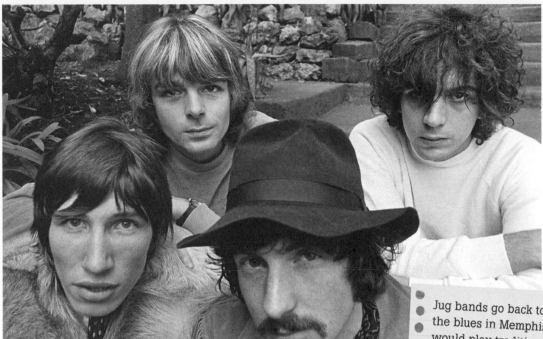

Left: Pink Floyd...
with a glum-looking
Syd Barrett.
Following page:
Syd Barrett
photographed in his
London apartment
in 1970 by
Mick Rock.

Jug bands go back to the very origins of
the blues in Memphis, when musicians
would play traditional instruments (such
as guitar and banjo) as well as objects
diverted from their primary function, such
as jugs and washboards, in ensembles.
The most famous band of this kind was
Will Shade's Memphis Jug Band.

center stage to a brass band. In *The Remarkable Roger Barrett*, a 2006 documentary about Syd Barrett, Norman Smith describes in some detail how this brass band section came into being: "To the end of this title, I said to Syd, 'You know, Syd, I really fancy some extra orchestrations going on this title.' So he said, 'Oh yeah,' and I said, 'I hear like a brass band.' So he said, 'Oh yeah...a Salvation Army Band.'—'Why a Salvation Army Band?'—'I don't know, really...but I think I can hear that, a Salvation Army Band on it!'"[45] Surprised, Norman complied with his wishes and gathered together between twelve and fifteen musicians, whom he recruited with some difficulty. On the day of the recording, most likely October 19, Norman got them settled in the studio to wait for the songwriter, who was late. When Syd finally made his appearance after half an hour or so, Norman immediately asked him what he wanted the brass band to play. "Just let them do what they like, just anything,"[5] he replied. Disconcerted, the producer protested that "we couldn't really do that because nobody would know where they were," adding, in Nick Mason's account, that in the end, "that's how it had to happen."[5] At this, Syd left the studio, leaving poor Norman to realize the songwriter's ideas by himself. As a seasoned musician, the producer finally decided to write out some chord charts so that the band could record its part. It seems that a recording with no instructions, in keeping with Syd's wishes, was also cut, but in the end it was Norman's arranged version that was used.

Barry Miles maintains that when asking for the brass band to play anything it liked, Syd was thinking of the completely unscripted orchestral sections in the Beatles' "A Day in the Life," which had greatly intrigued him.

But this by no means brings "Jugband Blues" to a close as the brass band is followed by an experimental sequence. This is launched by a series of off-the-wall chanted *la la las* (from 1:24) announcing a harrowing, unrealistic, hallucinatory atmosphere created by Syd on his Telecaster (which he plays with Echorec and Zippo). The brass band then returns and throws off all restraint. There is a certain similarity between what the band plays here and the intro to the future "Atom Heart Mother" of 1970 (between 0:30 and 1:25). After this section is brought to an abrupt stop (2:22), Syd's voice and acoustic guitar are faded in for what would be the final four lines he sings for Pink Floyd. This verse is highly poignant, above all in the way the songwriter concludes his song, wondering: *And what exactly is a joke?*

Syd Barrett, Peter Jenner, and Andrew King wanted to make this the group's next single, but everyone else, including Norman Smith, was against it. In the end, "Apples and Oranges" was chosen instead. Andrew King looks back at this decision: "Jugband Blues...which I always wanted to be a single...I mean maybe it was just too...near the knuckle, too close, too revealing and embarrassing. Great song...of a man totally cracking up."[10]

1968

It Would Be So Nice / Julia Dream

SINGLE

RELEASE DATE

United Kingdom: April 13, 1968 (April 19 according to some sources)

Label: Columbia Records
RECORD NUMBER: DB 8401

SIDE A

Captain Sensible, a member of the Damned and a disciple of Pink Floyd.

COVERS

Captain Sensible, the singer and guitarist of the Damned, paid homage to Rick Wright's song by covering it on his solo album *The Power of Love* in 1983.

It Would Be So Nice

Richard Wright / 3:44

Musicians
David Gilmour: acoustic guitar, electric rhythm and lead guitar, backing vocals (?)
Rick Wright: vocals, backing vocals, keyboards, recorder (?), vibraphone (?)
Roger Waters: bass, backing vocals
Nick Mason: drums, percussion

Recorded
Abbey Road Studios, London: February 13, March 5, 13, 21, April 1–3, 1968 (Studios Two and Three, Room 25)

Technical Team
Producer: Norman Smith
Sound Engineers: Peter Bown (?), Ken Scott, Phil McDonald
Assistant Sound Engineers: John Smith, Michael Sheady, Richard Langham, John Barrett

SPOT THE ERROR!

The cover of the Swedish version of the single, released in 1968, features a picture of the group without David Gilmour but with Syd Barrett, who by that time was no longer a member of Pink Floyd...

Genesis

This composition by Rick Wright (originally called "It Should Be So Nice") could almost be a celebration of everyday English life: starting the morning with breakfast and the newspaper, followed by some very British anxiety over the weather. But this would be far too pragmatic for Pink Floyd, who, with their first album in particular, took us by the hand and led us into the realm of fairies and gnomes. And true to form, at the end of the song Wright talks of a *dream that sends them reeling to a distant place.* He also mentions a *meeting.* To whom is he referring? We are forced to use our imagination because the songwriter provides no leads...

"It Would Be So Nice" comes as quite a surprise from Pink Floyd. Despite the fact that Roger Waters, David Gilmour, Rick Wright, and Nick Mason were in the process of recording their cosmic, progressive album *A Saucerful of Secrets*, this song sounds thoroughly pop, somewhat in the manner of the Beach Boys in the United States or beat groups such as the Hollies, the Searchers, and Herman's Hermits in the United Kingdom. In his book *The Dark Side of the Moon: The Making of the Pink Floyd Masterpiece*, author John Harris harks back to this song: "The first recorded work they released in the wake of his [Syd Barrett's] exit was Rick Wright's almost unbearably whimsical 'It Would Be So Nice,' a single whose lightweight strain of pop-psychedelia [...] rendered it a non-event that failed to trouble the British charts."[4] Again in Harris's book, Roger Waters admits that he does not like the way "It Would Be So Nice" is sung. "A lousy record,"[3] he adds, while Nick Mason goes even further, calling it a "fucking awful"[44] single.

Rick Wright, a chronicler of everyday English life in "It Would Be So Nice."

Released as a single on April 13, 1968, "It Would Be So Nice" disappeared. Since then it has been included on *The Best of Pink Floyd* (1970), *Masters of Rock* (1974), and the *Early Singles* bonus disc in the box set *Shine On* (1992).

Production

Listening to "It Would Be So Nice," one cannot help wondering whether this really is Pink Floyd. The extent to which the group does not sound like itself is disconcerting. The single is no more and no less than a pop song, one devoid of the precious, unique craziness of Syd Barrett. It has to be said that Syd, who until this point had been the only member of the group to provide his bandmates with brilliant and original singles, is sorely missed. Rick Wright takes on the task of replacing him, and tries to re-create his universe complete with its sugary pop side. He accomplishes his task without question on the pop score, but not on the level of Syd Barrett…Where Barrett succeeded in making his tunes simple and vital, Wright settles for flat imitation. The track is not completely without merit, but whereas it would have benefited from being performed by a pop group, played by the Floyd—it is beyond comprehension.

The first session was held on February 13 in EMI's Studio Two. The group cut two takes before redoing everything on March 5, this time in Studio Three, when they settled for the eleventh take. March 13 and 21 were reserved for the various overdubs, in particular of the vocals.

"It Would Be So Nice" begins with the refrain. The sound is pop and rock with a hint of Tamla Motown. Rick Wright's singing is supported by backing vocals from David Gilmour and Roger Waters, while Nick Mason relaxes with some nicely felt rolls on his toms. The verse brings a surprise: Waters's Rickenbacker pumps out a rhythm that is reminiscent, in a generic way, of children's television shows (an impression

reinforced by a vocal sound effect at 0:55). Wright plays a variety of keyboards including an acoustic piano, his Farfisa organ, and not particularly tasteful counterpoint on the Mellotron. (Listen at 0:37.) It also seems to be the songwriter playing the recorder (2:01) as he had on "Jugband Blues," and also on the vibes. Gilmour, who had been recording with the Floyd for only a short while, gives the impression of having little idea how to tackle his part. He can be heard playing acoustic in the verses and arpeggios on electric in the bridges, delivering tremolo (1:18) or wah-wah (2:10) effects as the piece demands. Moreover, he is playing his Telecaster and distorting it with his Fuzz Face, particularly in the coda, where he takes a solo once more influenced by Hendrix (right at the end of the song, from 3:41). Nick Mason, for his part, delivers some very good drums, alternating the different moods through his judicious and efficient playing. He also accompanies the verses with a percussion instrument that sounds like a glass bottle struck with a drumstick.

The group had to return to the studio on April 1 because of a problem with the words. The original lyrics referenced the daily newspaper the *Evening Standard*. As British radio stations were not allowed to provide free advertising, they could not broadcast this title. Wright was required to alter his words and the group to rerecord. The *Evening Standard* was therefore changed to the *Daily Standard*. Phil McDonald was given the job of doing the definitive edit on April 2 and 3.

"It Would Be So Nice" is the story of Pink Floyd's desire for a record release to help them get over Syd's departure. The pinnacle of folly was perhaps reached with the improvised gospel vocal in the coda from 3:22. However, we must not fail to emphasize the excellent production work (in particular on the backing vocals) of Norman Smith, who must have found the song not too remote in spirit from those he was to record as a solo artist under the name Hurricane Smith.

Julia Dream

Roger Waters / 2:28 (Relics version 2:37)

Musicians
David Gilmour: vocals, acoustic guitar, electric lead guitar
Rick Wright: Mellotron, organ, backing vocals
Roger Waters: bass, backing vocals (?)
Nick Mason: percussion
Recorded
Abbey Road Studios, London: February 13, March 25, April 3, 1968 (Studios Two and Three, Room 25)
Technical Team
Producer: Norman Smith
Sound Engineers: Peter Bown (?), Ken Scott, Phil McDonald
Assistant Sound Engineers: John Smith, John Barrett

For Pink Floyd Addicts

Released as a B-side in the United Kingdom, "Julia Dream" was chosen as the A-side for Japan in 1970, with "Summer '68" as the flip side.

Genesis

"Julia Dream" marks an important stage in Pink Floyd's career. It was the first song to be recorded without the involvement of Syd Barrett (although he was still officially a member of the group), the first with David Gilmour singing the lead vocal, and the second to be written by Roger Waters alone. Probably a little under Barrett's influence still, Waters gives us a glimpse into a "different" world. But this is where any comparison with the group's former songwriter ends. Whereas Barrett set to music nursery rhymes, Waters goes beyond mere anxiety to express real anguish in this song. Things start well, but before long, up surges the *misty master*, causing the narrator to wonder whether he is dying. The language belongs more to the lexicon of the nightmare than to that of the daydream: *Every night I turn the light out, waiting for the velvet bride/Will the scaly armadillo find me where I'm hiding?* Thank goodness for Julia, the *queen of all my dreams*, whose role seems to be to alleviate these fears…

"Julia Dream" is a psychedelic folk song and easily could have been performed by the Incredible String Band (or Nick Drake, a little later). This British B-side of Pink Floyd's fourth single would later be included on the compilations *The Best of Pink Floyd* (1970), *Relics* (1971), *Masters of Rock* (1974), and the *Early Singles* bonus disc in the box set *Shine On* (1992).

Production

For all "It Would Be So Nice" gives the impression that Pink Floyd was getting bogged down and losing their own identity, "Julia Dream" displays a new musical direction, one

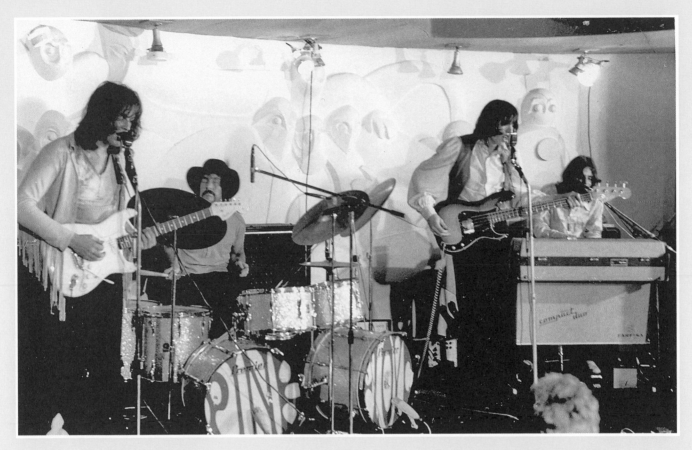

The quartet, with Gilmour, in concert in France in 1968. Syd Barrett is no longer a member of the band.

they would pursue a little later, on the album *More* in 1969. The pop feel of the A-side gives way to a darker, dreamlike atmosphere on the predominantly acoustic B-side.

Just two takes were needed to lay down the base track of "Doreen Dream" (the working title of "Julia Dream") on February 13. The first was selected as the best, and the vocals were added on March 25. This makes it the first song on which David Gilmour sang lead vocal by himself, having shared lead with Rick Wright on "Let There Be More Light," on which work had started on January 18 and continued at this same March 25 session. His voice is infinitely gentle, similar to Rick Wright's, and this was to prove one of the keys to the Floyd's success. Wright helps out on backing vocals, a combination of voices that would have its apotheosis in the awe-inspiring "Echoes" of 1971. As well as singing, Gilmour delivers an acoustic guitar part, most likely on his Levin LT 18. He also picks up his Fender Telecaster, playing it chiefly for the sake of the psychedelic effects that could be obtained with his Binson Echorec, the

whole thing swamped in long and heavy reverb. Gilmour mainly uses a bottleneck to slide over the strings, as can be heard especially at the end of the song, from 2:18. Like Gilmour, Wright is omnipresent, creating a flute tone on his Mellotron MK2. He literally floods the song with this sound, but instead of being intrusive, it lends the music an almost medieval color. He can also be heard reinforcing the dreamlike atmosphere of the song with pads on the Hammond M-102. Nick Mason's contribution is limited to striking a percussion instrument—probably bongos—with a drumstick under heavy reverb. Roger Waters is presumably playing his Rickenbacker 4001, although it sounds more like an upright than an electric bass. It is most likely the bassist who is also responsible for the vocal effects, for example at 1:52 and 2:00.

"Julia Dream" was mixed at this same session on March 25 and then mastered by Phil McDonald in Room 25 at EMI Studios on April 3, ready for the pressing of Pink Floyd's next single.

1968

Point Me At The Sky / Careful With That Axe, Eugene

SINGLE

RELEASE DATE

United Kingdom: December 6, 1968

Label: Columbia Records

RECORD NUMBER: DB 8511

SINGLE

SIDE A

For Pink Floyd Addicts

A video was shot for "Point Me at the Sky." It shows images of each member of the Floyd (except Roger Waters) sitting peacefully in a living room, and then Nick Mason and presumably David Gilmour in pilot's garb, flying in two different bi-planes. The first aircraft to be shown is a De Havilland DH.82A Tiger Moth, registration G-ANKB, while the second is an AVRO 504N, registration G-ADBO. At the end of the song we see Gilmour waving a handkerchief and running after a train as it pulls out of a station.

Point Me At The Sky

Roger Waters, David Gilmour / 3:34

Musicians
David Gilmour: vocals, electric rhythm and lead guitar, backing vocals
Roger Waters: vocals, bass, backing vocals (?)
Rick Wright: organ, piano, vibraphone, harpsichord (?), Mellotron, backing vocals
Nick Mason: drums, maracas
Unidentified musician: cello (?)

Recorded
Abbey Road Studios, London: October 22–23, 28–30, November 4–5, 1968 (Studios Two and Three, Room 70)

Technical Team
Producer: Norman Smith
Sound Engineer: Peter Mew
Assistant Sound Engineers: Neil Richmond, Anthony Clarke, Graham Kirkby, Alan Parsons

Among the assistant sound engineers on this song was Alan Parsons, who began his career with the Floyd. Parsons would contribute to the group's biggest success as the sound engineer on *The Dark Side of the Moon* (1973), the third-best-selling album in the history of music.

Genesis

In a BBC documentary broadcast in December 2007, Roger Waters (lyricist and co-composer) and David Gilmour (co-composer) explained that they wrote "Point Me at the Sky" at the urgent request of EMI, which wanted to release a single along the lines of the preceding ones. Although Syd Barrett was no longer a part of Pink Floyd when "Point Me at the Sky" was recorded (October and November 1968), he still cast a shadow over the group, and in particular over Roger Waters. Waters takes up the atmosphere of the nursery rhymes that Barrett was so fond of to tell us about a talented, and not a little insane, inventor. Henry McClean has built a *cosmic glider* and asks his friend Eugene to fly with him to the sky. The final words clearly announce the tragic end that awaits them: *And all we've got to say to you is good-bye*, followed by *Crash, crash, crash, crash, good-bye*, inevitably evoking the Icarus of Greek mythology who died as a result of flying too close to the sun…

The end of "Point Me at the Sky" may be sad, but the song's message is in perfect harmony with the happy philosophy of the flower children of the second half of the sixties. This is a heroic ode to the act of self-transcendence, to the discovery of new experiences, whether psychedelic or not, in short an indictment of the modern world with its mundanity and alienation. In spite of the sad ending, the musical atmosphere of this composition by Waters and Gilmour is reasonably cheerful, carried by a good dose of psychedelia that owes as much to Syd Barrett as it does to the Beatles (John Lennon in particular).

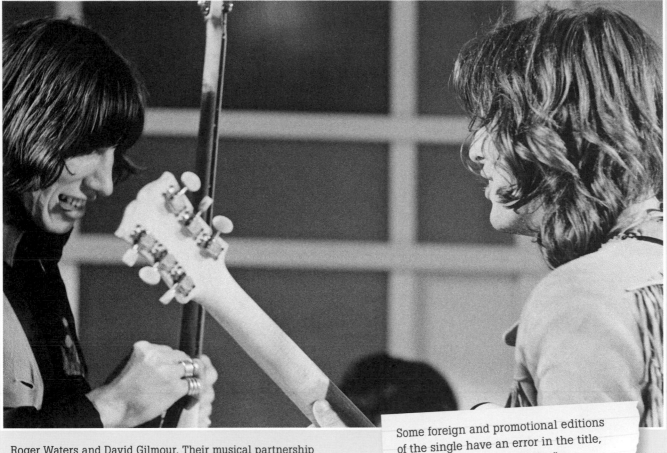

Roger Waters and David Gilmour. Their musical partnership achieved one of its early highs with "Point Me at the Sky."

Some foreign and promotional editions of the single have an error in the title, reading "Point Me to the Sky."

When it was released as a single on December 7, 1968, "Point Me at the Sky" failed to find its audience (any more than the B-side, "Careful with That Axe, Eugene," did). "That was the last of the unknown singles," the ever-perceptive Roger Waters would later comment, adding "I don't know why we did it. It was a constructed attempt and it didn't happen."[36]

Production

"Point Me at the Sky" required multiple sessions. Two takes from October 23 were used as the basis for the overdubs: the third for the first part of the song and the fifth for the second part. The track proved difficult to get right, with the various moods requiring fairly systematic production input. David Gilmour comes straight in with the vocal line, against a background of Hammond organ, vibes, and pedal-board bass notes, all played by Rick Wright. Gilmour's voice is gentle and the atmosphere serene. He also plays electric slide guitar for some very mellow sounds obtained with the Binson Echorec and reverb. This is followed by a rock sequence sung by Roger Waters, who is also excellent on bass, supported by the imperturbable Nick Mason, who works his Premier kit with considerable energy. This in turn develops into a refrain vaguely reminiscent of the Beatles' "Lucy in the Sky

with Diamonds," with Gilmour back on lead vocal supported by harmonies from his colleagues. According to the session records at Abbey Road, and also Glenn Povey's book *The Complete Pink Floyd*, a cello and a harpsichord were also recorded on October 29. If so, both instruments are totally inaudible, presumably buried in the mix. This may have been in order to avoid sounding too Beatles-like…"Point Me at the Sky" is a good pop-rock song from a band and its producer who were clearly looking for a hit, with Gilmour adding some guitar overdubs and a solo distorted with wah-wah, Wright an acoustic piano and Mellotron effects, and Mason some maracas. However, it is first and foremost the vocal arrangements that grab the attention, not least as a result of the group devoting part of the sessions on October 28, 29, 30 and November 4 to them. As a result, the refrains and, in particular, the bridge with its ethereal climax were enhanced with harmonies worthy of, well…Norman Smith.

Although well made, this single did not meet with the anticipated success, leading Pink Floyd to give up its quest for hit singles, written specifically for this purpose rather than for inclusion on an album. When the group returned to the charts more than eleven years later, it would be in the number 1 spot with "Another Brick in the Wall, Part 2," taken from the 1979 album *The Wall*.

"Careful with That Axe, Eugene" is one of the great collective works by Pink Floyd. Roger Waters's primal scream ensured that it would go down in legend.

SINGLE

SIDE B

For Pink Floyd Addicts

It should not be forgotten that the word axe, despite its connotations of slashing and severing, is also used by guitarists to designate their chosen instrument.

Careful With That Axe, Eugene

Roger Waters, Rick Wright, Nick Mason, David Gilmour / 5:45

Musicians
David Gilmour: vocals, electric rhythm and lead guitar, vocal effects
Rick Wright: organ, vibraphone, vocal effects (?)
Roger Waters: bass, voice and various vocal effects, gong (?)
Nick Mason: drums
Recorded
Abbey Road Studios, London: November 4, 1968 (Studio Two)
Technical Team
Producer: Norman Smith
Sound Engineer: Peter Mew
Assistant Sound Engineer: Neil Richmond

The scream that issues from Roger Waters in "Careful with That Axe, Eugene," and later "Another Brick in the Wall, Part 2" and "Run Like Hell" (*The Wall*) is perhaps to be interpreted as a primal scream along the lines of the psychotherapy of the same name that inspired John Lennon to write his first post-Beatles album, *John Lennon/ Plastic Ono Band*, in 1970.

Genesis
"Careful with That Axe, Eugene" was the culmination of a long creative process that had its origins in a collective work the group had begun performing in spring 1968 under the title "Keep Smiling People." It was already, at this stage, composed of three sections. The first was even recorded for use in *The Committee* (1968), an underground film noir by Peter Sykes with Paul Jones (the Manfred Mann singer) in the lead role. A few months later, the basics of "Keep Smiling People" reemerged in the suite *The Man and the Journey*, now named "Beset by Creatures of the Deep," then in abbreviated form (without the scream) in "Green Is the Colour" (on the *More* soundtrack), and again in a version entitled "Murderistic Women" (or "Murderotic Women"), which was played on John Peel's *Top Gear* sessions (1968). "'Careful with That Axe, Eugene' is basically one chord," explains David Gilmour. "We were just creating textures and moods over the top of it, taking it up and down; not very subtle stuff. There was a sort of rule book of our own that we were trying to play to—and it was largely about dynamics."[36]

How should the title of the song "Careful with That Axe, Eugene" be interpreted? Should we see the song as a kind of musical illustration of a horror story? The tale of a serial killer who goes on the rampage with an axe? Perhaps, but for Rick Wright there is no hidden meaning: "It's not a huge message to the world, you know. We often pick titles that have nothing really to do with the songs."[36] All the same, it is worth noting that "Point Me at the Sky," the A-side of the single, also begins with the phrase: *Hey Eugene, this is Henry McClean/ And I've finished my beautiful flying machine.* As for the

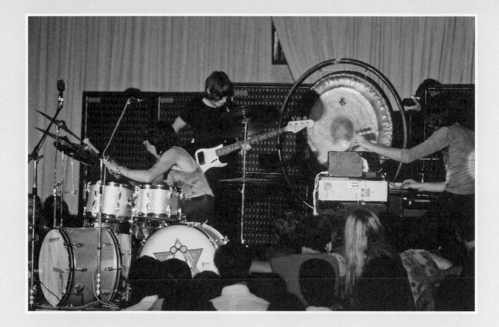

scream emitted by Roger Waters, if this is indeed a *primal* scream, it takes us down another path, that of primal therapy, a psychotherapy developed by Arthur Janov in 1967 whereby patients liberate themselves from their neuroses and profound discontent by regressing to the primal period (from birth to nine months) and the scream.

Live Versions
"Careful with That Axe, Eugene" was released as the B-side of this single on December 7, 1968 (sinking without a trace), and again in 1971 on the compilation *Relics*. From 1969 to 1973 the group regularly performed it onstage, generally preceded by "Green Is the Colour." Furthermore, it was when performed live that the piece would assume its full theatrical dimensions, as can be seen from the Pompeii (*Pink Floyd: Live at Pompeii*, 1972), or *Ummagumma* versions, which are far superior to the studio recording, mainly as a result of their dramatically constructed crescendos and the manifestly cathartic scream emitted by Waters. Yet another version exists (without the whispering), recorded under the title "Come in Number 51, Your Time Is Up" for the soundtrack of Michelangelo Antonioni's movie *Zabriskie Point* (1970).

Production
When Pink Floyd entered EMI's Studio Two on November 4, 1968, to work on "Careful with That Axe, Eugene," it was actually the second time they had undertaken to record it. The first was during their second United States tour, when the four Englishmen stopped off in Los Angeles on August 22 for long enough to get down six takes of an instrumental that was actually a very first version of this same piece. The LA version remained unfinished, however. It was therefore on November 4 that the group recorded the definitive rhythm track in two takes, the first being selected as the best. It is Roger Waters's Rickenbacker 4001 that is the real backbone of "Careful with That Axe, Eugene." His alternating octave Ds form a common thread through these five minutes and forty-five seconds of improvised, unclassifiable, harrowing, space-inspired, hypnotic, indefinable music. As Nick Mason has pointed out, this was a complex piece that could be summed up as "quiet, loud, quiet, loud again"[5]—in actual fact just quiet, loud, quiet.

The work starts with a simultaneously serene and tense atmosphere, Waters's bass setting the tone from the first two bars. Rick Wright introduces a gentle, mellow vibraphone sonority before teasing some oriental-sounding improvisations from his Hammond organ. David Gilmour is on electric guitar, most probably his new white Fender Stratocaster. He employs a violining effect (obtained with either his guitar's potentiometer or a volume pedal), and can also be heard singing in a falsetto voice drenched in heavy reverb, thereby accentuating the dreamlike character of the piece. Nick Mason embroiders rhythmic patterns on his ride cymbals before gradually picking up the pace and stressing the beat with a heavier stroke. The tension inevitably mounts and Waters whispers a menacing, oppressive *Careful with that axe, Eugene*, before letting out an initial scream that launches the second half of the track. Gilmour accompanies him with arpeggios and plays a distorted solo that he doubles with his voice. The effect is powerful and is the signal for his bandmates to really let it rip. The unflappable Waters keeps his bass riff going while continuing to scream into his mic. He also seems to set a gong vibrating at around 2:54. Calm is restored toward 4:10, and the vibraphone once again imposes its ethereal sonority. From this point on, Mason plays mainly his toms, at the end of the song leaving Waters and Gilmour to abandon themselves to numerous vocal effects, including chewing, sucking, and various other curious noises.

Whatever meaning is attributed to "Careful with That Axe, Eugene," this is a musical epic that confirms the new direction being taken by Pink Floyd while at the same time closing the book on the Syd Barrett era.

MORE

ALBUM

MORE

RELEASE DATE:

United Kingdom: June 13, 1969

Label: Columbia Records
RECORD NUMBER: SCX 6346

**Number 9 (United Kingdom), number 2 (France), number 4
(Netherlands)**

Cirrus Minor / The Nile Song / Crying Song / Up The Khyber /
Green Is The Colour / Cymbaline / Party Sequence / Main Theme /
Ibiza Bar / More Blues / Quicksilver / A Spanish Piece / Dramatic Theme
OUTTAKES Theme (Beat Version) / Hollywood / Seabirds /
Paris Bar (?) / Stephan's Tit (?)

More, a Psychedelic Soundtrack with a Touch of Folk

More was not the first time Pink Floyd had collaborated with the world of motion pictures: their music had already served as the soundtrack for a number of documentaries, including Peter Whitehead's *Jeanetta Cochrane* and *Tonite Let's All Make Love in London* (1967), Peter Sykes's *The Committee* (1968), and Anthony Stern's *San Francisco* (also 1968). But *More* was the first time they had written music specifically for a movie. As Rick Wright commented at the time: "Films seem to be the answer for us at the moment. It would be nice to do a science-fiction movie—our music seems to be that way oriented."[47] In the absence of an opportunity in science fiction, the four members of the Floyd would end up composing and performing the music for a story of love and self-destruction.

A Movie Debut with a Tragic Storyline

After studying in Paris, Barbet Schroeder became a spiritual younger brother of the masters of the French New Wave, writing for the French movie magazine *Cahiers du Cinéma* and getting his first break in moving pictures as Jean-Luc Godard's trainee on the set of *Les Caribiniers* (*The Soldiers*, 1963). After this he founded a production company with Éric Rohmer called Les Films du Losange, which produced Rohmer's Six Moral Tales between 1962 and 1972.

More was Barbet Schroeder's first full-length work and his first success. It is the story of Stefan (Klaus Grünberg), a German student from Lübeck who has just obtained a degree in mathematics. In need of a break, he hitchhikes to Paris. During a game of poker in a Paris bar, he strikes up a friendship with Charlie (Michel Chanderli), a big-time gambler and small-time crook with good connections in the criminal underworld of the French capital. One evening, Stefan and Charlie, who are poor, attend a party in an apartment in a well-to-do part of town. There, Stefan meets Estelle (Mimsy Farmer), a young and enigmatic New Yorker addicted to drugs, and it is love at first sight. A few days later, Estelle is preparing to leave for the island of Ibiza and suggests that Stefan join her there. There they embark on a torrid and chaotic love affair punctuated by moments of psychedelic euphoria and disappointment in matters of the heart, set against a background of hard and soft drugs. This scenario ends with the departure of Estelle—a new embodiment of the femme fatale—and the death of Stefan—the antihero of this modern Greek tragedy—from an overdose. "I had already been living in Ibiza for fifteen years," explains Barbet Schroeder, "so naturally I chose that location for the film. At that time I was thinking about a number of stories, stories that involved the figure of the 'femme fatale,' but a modern 'femme fatale.' Like a vampire movie. I was also influenced by the story of Icarus whose wings were burnt because he flew too close to the sun."[48]

Barbet Shroeder's Challenge: Movie "Anti-Music"

As seen through Schroeder's lens, Estelle and Stefan are symbols par excellence of the Western postwar generation, young

1969

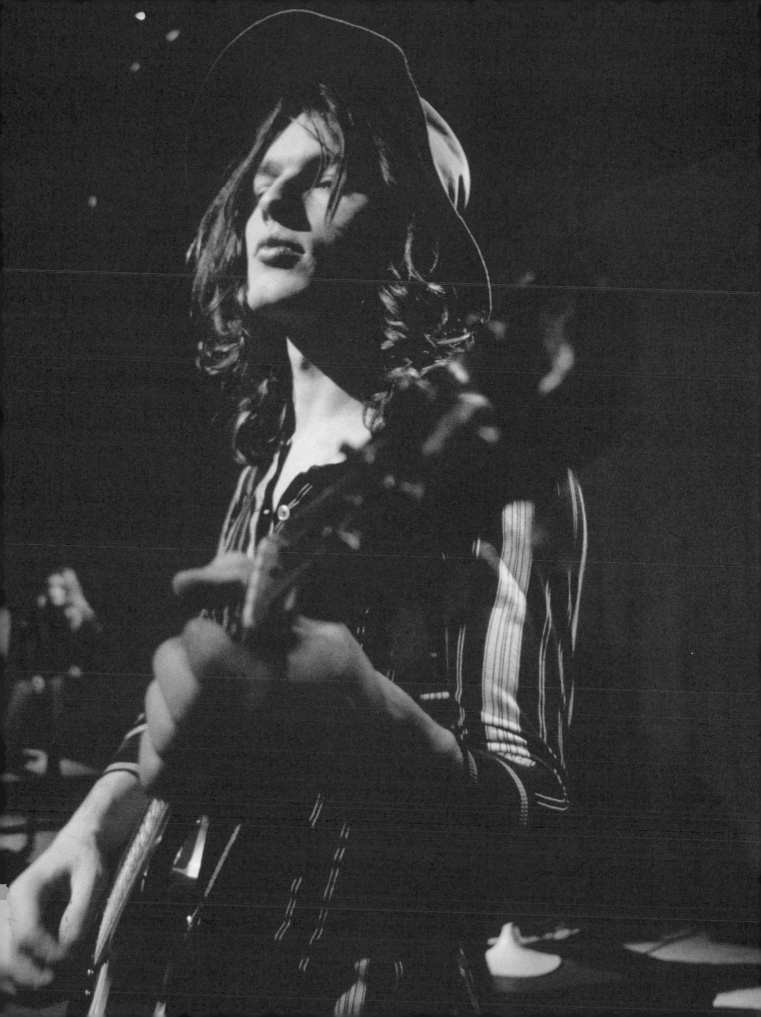

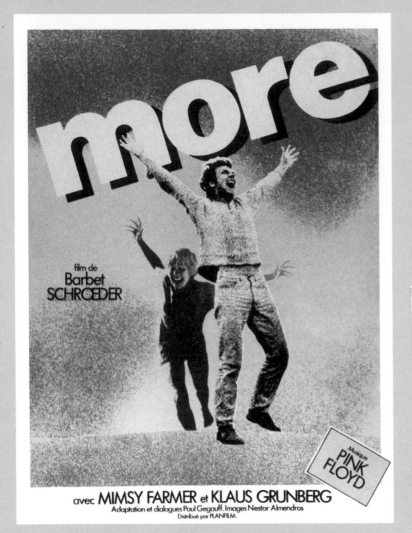

For Pink Floyd Addicts

On the album, the tracks are presented in a different order from that of the movie.

A poster for Barbet
Schroeder's movie,
screened at the
Cannes Film Festival
in May 1969.

people seeking an alternative way of life within a society that is affluent and materialistic, but marked still by the anguish of the Second World War and the Nazis' evasion of justice. This hallucinogenic love story, set against the majestic backdrop of Ibiza, is all the more intense because it is obvious that it can only end in tragedy. What was required was a musical soundtrack in tune with the emotions felt by the two main characters while also reflecting the atmosphere and special charm of Ibiza. "Like everyone at the time, I listened to the great proliferation of music," explains Barbet Schroeder. "I discovered Pink Floyd, who had only made two records and who fascinated and excited me." And the director continues: "[I decided] that this was the characters' music, this was what they listened to, what they liked to listen to."[49]

Barbet Schroeder therefore traveled to London to meet the four members of Pink Floyd. "I explained my idea to them…I'm against movie music. At the time, I was a real disciple of Rohmer, who was opposed to movie music. So for me, it's source music, as it is known. In other words, music that comes out of the scenes, that is part of the scenes, that is what the people are in the process of listening to […]. When we did the mixing, we rerecorded the music coming out of a loudspeaker in a room, for example.

In each case, we tried to respect the place and the texture of the place."[49]

"Barbet […] approached us with the film virtually complete and edited," explains Mason. "Despite these constraints and a fairly desperate deadline, Barbet was an easy man to work with—we were paid £600 each, a substantial amount in 1968, for eight days' work around Christmas—and there was little pressure to provide Oscar-winning songs or a Hollywood-style soundtrack. In fact, complementing the various mood sequences, Roger came up with a number of songs for the film that became part of our live shows for some time after."[5]

A Combination of Bucolic Folk and Hard Rock

More was also the Floyd's first complete album without Syd Barrett, although his influence can still be felt on some of the tracks, mainly the acoustic ones. The musical challenge with which Barbet Schroeder had presented the group allowed David Gilmour, Rick Wright, Nick Mason, and above all Roger Waters, who composed five songs and co-composed six others (out of a total of thirteen), to cross a new barrier. In this soundtrack, Pink Floyd abandoned the space rock of *A Saucerful of Secrets* (with the possible exception of

Stefan and Estelle on Ibiza. A psychedelic retelling of *Don Quixote*?

"Cirrus Minor") for a kind of bucolic folk ("Cymbaline" and "Green Is the Colour") that intermittently calls to mind the Incredible String Band and Fairport Convention, but also, and this was something completely new, for hard rock ("The Nile Song" and "Ibiza Bar").

Having said that, there is no lack of cohesion to the work as a whole. The compositions of a pastoral nature, just like the rock numbers and Spanish-sounding melodies—whether sung or instrumental—are so many stages in the dramaturgy of the movie. They amount to the perfect musical illustration of the journey undertaken by Estelle and Stefan from Paris to Ibiza—the word *journey* needing to be understood here in both the physical and emotional sense, for Barbet Schroeder claims that *More* derives from personal experience. It is an "utterly tragic story, a story about a femme fatale and heroin, not about the psychedelic generation."[49] And the director adds: "I introduced LSD into the movie as a way [for the characters] to stop taking heroin."[49] To put it another way, Pink Floyd's music, by turns tranquil and harrowing, accompanies a couple's steady decline on the Spanish island.

After being shown at the Cannes Film Festival in May 1969, Barbet Schroeder's film opened in New York movie

theaters on August 5 and in French theaters on October 21. It would also be released in various other countries, although not in the United Kingdom. The Pink Floyd album, meanwhile, had gone on sale in British record stores on June 13, 1969. And it was a hit, both there and more especially in Europe, reaching number 2 in France (certified gold in 1977), number 4 in the Netherlands, and number 9 in the United Kingdom. In the columns of the French music magazine *Rock & Folk*, Philippe Paringaux wrote: "*More* is a disc of stunning quality, and Pink Floyd are quite definitely one of the most mature groups (if not THE most) of the day. [...] *More* reflects [...] perfectly the spirit in which Pink Floyd have always conceived their music: technique of unwavering rigor at the service of a tumultuous imagination. The impossible marriage of madness and reason ('Main Theme' being the perfect illustration)."[47] And to sum up, Barbet Schroeder makes the following very apt observation: "To make an album, they would take a year, it was an extraordinary feat of work. And here, in two weeks, they achieved more than all their other albums together."[49] In the United States, on the other hand, where it was released on August 9, their LP

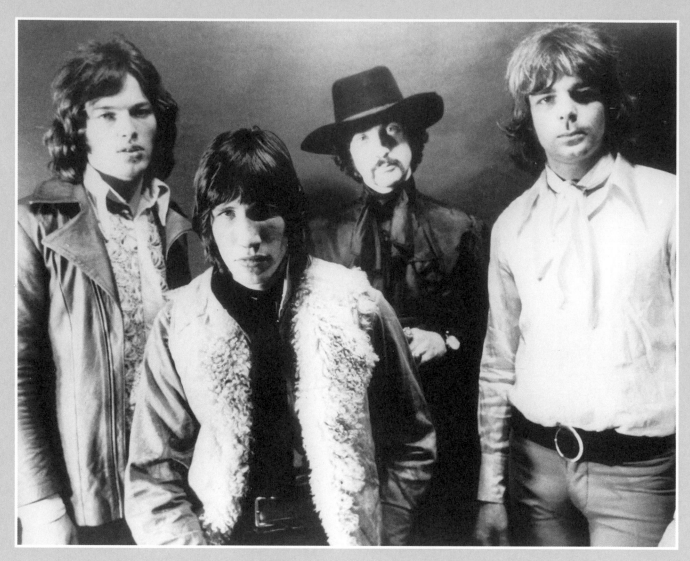

A group portrait of the Floyd, whose career took a new direction in 1969 with the composition of a movie score.

would make it only as far as number 153—and that was in 1973, after it had been reissued! When promoting his movie, the director would explain that not only did the US media have reservations about the picture, they literally detested Pink Floyd's music, which they regarded as indigestible.

The Sleeve

The *More* sleeve was the second to be designed for Pink Floyd by Hipgnosis. The photography is taken from a scene of the movie in which Stefan and Estelle, having concocted and ingested a magic potion containing hashish, pot, benzedrine, nutmeg, and banana (the skin of which is reputed to have psychedelic properties), set off to do battle with a windmill, just as Don Quixote did three and a half centuries earlier. The effect of the narcotics is subtly conveyed by the blue-and-yellow bichrome color scheme deliberately chosen by Storm Thorgerson to evoke an LSD trip. On the reverse is a black-and-white photograph of the couple communing with Ibiza's magnificent landscape.

The Recording

At the point where Pink Floyd became involved in writing and recording *More*, the group had been working since September 1968 on their future double album *Ummagumma*, which would not be finished until July 1969 and not released until October of that year. While they already had a lot on their plates, the group accepted this new project regardless, and quickly got down to work. Barbet Schroeder remembers: "We shut ourselves away in a studio for a week or two, I no longer remember how long. And, in an extremely intense manner, the music was composed and performed in great haste…and in a very rich way. There was no need for it to be composed for a specific image, because this was not movie music as such…I needed to check, and I even had stopwatches with me. I would say…'At this point, it would be better if it sounded like this.' But in actual fact it was as if they were making an album and I was using extracts from the album for this or that scene."[49] What's more, the director would find the music so emotionally powerful that he had to lower the volume in order to prevent the soundtrack from taking precedence over the movie!

The director Barbet Schroeder. An heir to the New Wave of French cinema, this psychedelic epic was his first full-length movie.

David Gilmour was distinctly unlucky with his surname! The guitarist appears in the credits for the movie *More* as "Dave Gilmore"—as he does on the early copies of *A Saucerful of Secrets*.

For Pink Floyd Addicts

More marked the end of the collaboration between Brian Humphries and Pye Studios. Soon after, the engineer joined Island and oversaw the recording of the superb album *The Last Puff* (1970) by Spooky Tooth. Humphries was also to record the live tracks on *Ummagumma* and would hook up with Pink Floyd again a few years later for *Wish You Were Here*.

In order to synchronize their compositions with the images, the Floyd employed an empirical method, as Nick Mason confirms: "There was no budget for a dubbing studio with a frame-count facility, so we went into a viewing theatre, timed the sequences carefully (it's amazing how accurate a stopwatch can be), and then went into Pye Studios in Marble Arch, where we worked with the experienced in-house engineer Brian Humphries."[5]

Because *More* was not an EMI project, Roger Waters, David Gilmour, Rick Wright, and Nick Mason had no access to Abbey Road Studios. As an alternative, their choice fell on the renowned Pye Recording Studios in London, where the Kinks, Donovan, the Searchers, and Long John Baldry had recorded before them.

The four members of the group were now, for the first time ever, their own producers. As Nick Mason comments, they did, however, have Brian Humphries by their side, a sound engineer who had previously worked with the Kinks and Nancy Sinatra, among others. The sessions were held at the beginning of February 1969, just a few days after Pink Floyd had performed "Set the Controls for the Heart of the Sun" and "A Saucerful of Secrets" live on French television (on ORTF's *Forum Musiques*).

Those involved are unclear about how long it actually took the group to record the soundtrack, but they all agree

that the project was brought to a conclusion with exceptional speed. According to Barry Miles, the recording was completed in five sessions extending from midnight to 8 a.m. In September 1969, Barbet Schroeder revealed to Philippe Paringaux that "Pink Floyd composed their music in the afternoon, while rewatching the movie, and then recorded in the evening five days in a row between midnight and 9 a.m. on a sixteen-track tape recorder. The guy at the studio told me he had never seen such conscientious musicians!"[50] In an interview with *Rock* magazine in 1971, the four band members confirmed this version of events, although they spoke of six sessions: "We liked it, although it was an incredible rush job. The guy came in and asked if we could do it right away. After viewing the footage and timing the different scenes, we went into the studio late at night, writing nearly all the material and recording it in six sessions. Just got it done in time. Later, we took some more time out in the studio to do the tracks up a bit for the album."[9] "Yes, it was eight days to do everything from writing, recording, editing...but everything we did was accepted by the director. He never asked us to redo anything."[3]

In addition to the thirteen songs on the album *More*, another three were recorded during the sessions: "Theme (Beat Version)," "Hollywood," and "Seabirds." They can be heard in Schroeder's picture, but as the master tapes have

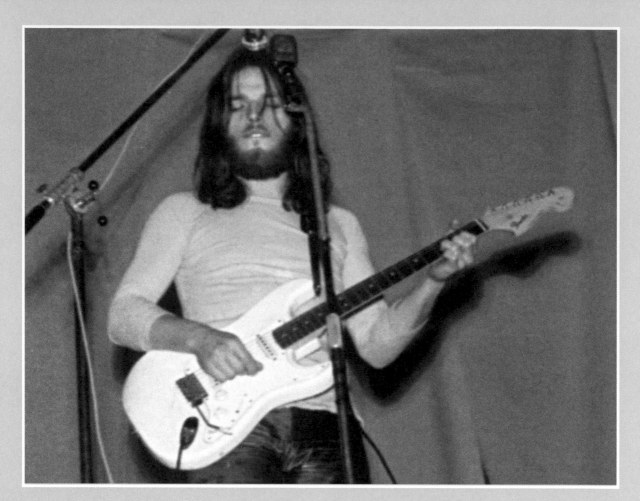

David Gilmour with his white Stratocaster, which he had been using since the end of the *Saucerful of Secrets* sessions.

apparently been lost for good, it looks unlikely that we will ever get the chance to play them on disc…"Fortunately, the original tapes of the music have never been found," the director has confirmed, "because there would have been a tendency to remaster, to make something very big out of something designed to be simply what the characters were listening to in the movie."[49] That's one way of looking at it…

Technical Details

Pink Floyd was thought to have recorded *More* on a sixteen-track Ampex MM-1000. The console was probably a Neve or a Neumann. According to the author Glenn Povey, however, two eight-track tapes emerged on the market at the end of the nineties with the name Bryan Morrison Agency (which was looking after the Floyd at that time) and the initials *BH*, most likely those of the sound engineer Brian Humphries, marked on the box. The vendor of the two tapes explained that he had worked at Pye Studios in the seventies and had been told one day that four multitrack tapes containing the *More* recordings were still in the studio archives but would soon be wiped under the company's ten-year rule. After he salvaged the tapes and attempted to remix them, two had been stolen, leaving the remaining two in his possession. These two tapes contained "Main Theme," "Paris Bar,"

"Stefan's Tit," "Ibiza Bar," and "Dramatic Theme." It is not now known what became of the tapes, but if genuine, they would indicate that Pink Floyd had recorded on an eight-track machine (probably an Ampex) rather than a sixteen-track as Barbet Schroeder claimed.

At Pye, the premises comprised two sound studios, the first, which Pink Floyd used in early 1969, measuring 40 by 30 by 16.5 feet (12 by 9 by 5 meters) and the second 20 by 20 by 16.5 feet (6 by 6 by 5 meters). Both were equipped with Tannoy/Lockwood monitors.

The Instruments

Toward the end of the *Saucerful of Secrets* sessions, the group had given David Gilmour a white 1966 or 1967 Fender Stratocaster with maple fingerboard and white pickguard. This would serve as his main guitar on *More*, in conjunction with the same amp that he had previously used. In terms of acoustic instruments, he seems to still be playing his Levin LT 18, but also uses a classical guitar with nylon strings, which has unfortunately not been identified. It might, however, be the same Levin Classic 3 used by Roger Waters on the show *An Hour with the Pink Floyd*, filmed for US television in April 1970. The other members of the group are playing the same instruments they had used on their previous record.

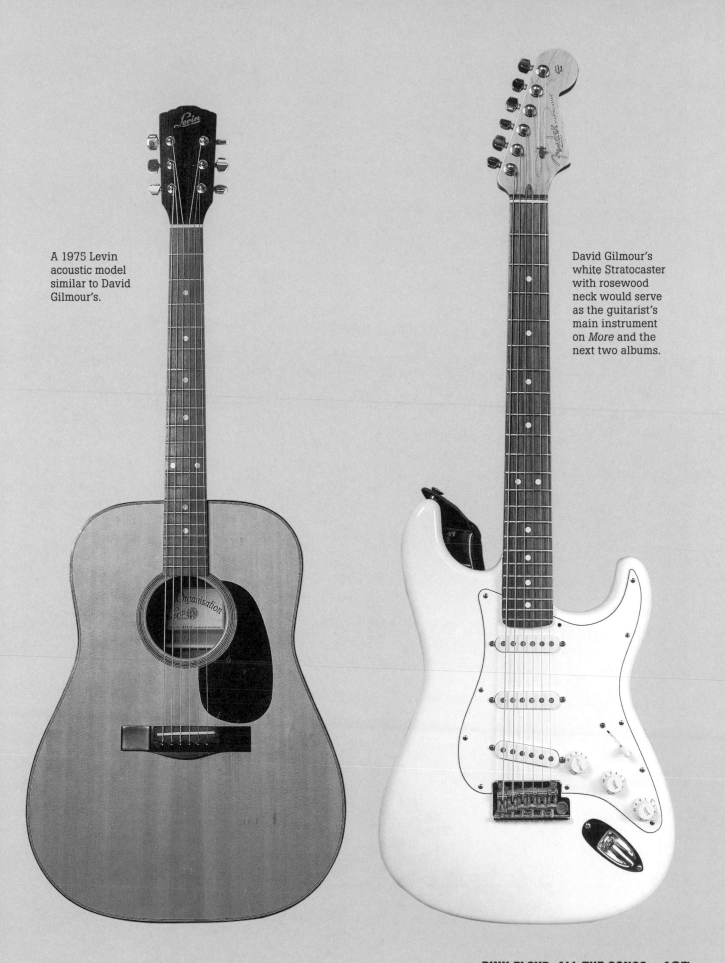

A 1975 Levin acoustic model similar to David Gilmour's.

David Gilmour's white Stratocaster with rosewood neck would serve as the guitarist's main instrument on *More* and the next two albums.

 IN YOUR HEADPHONES

By listening carefully around 0:55, it is possible to hear someone (Gilmour?) counting in: " ...2, 3, 4"!

Cirrus Minor

Roger Waters / 5:18

Musicians
David Gilmour: vocals, acoustic guitar
Rick Wright: keyboards
Roger Waters: bass, acoustic guitar (?)
Recorded
Pye Studios, London: early February 1969
Technical Team
Producer: Pink Floyd
Sound Engineer: Brian Humphries

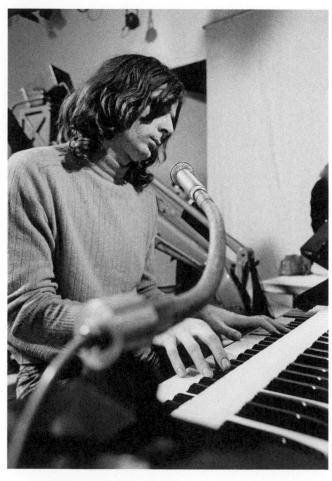

Rick Wright at the keyboard, creating the ethereal, floating sonorities of "Cirrus Minor."

Genesis

Cirrus is a Latin word meaning a "curl of hair." It is also the name of the clouds made up of separate filaments, usually white, appearing at elevations of 19,700 to 39,400 feet (6,000 to 12,000 meters), which are often said to resemble angel hair. Should the title of this song be seen as an explicit reference to the character Stefan's state of mind? Perhaps. The soothing notes of "Cirrus Minor" can be heard around three-fifths of the way through Barbet Schroeder's movie, while the young romantic from Germany is high on marijuana or heroin—although only the final two verses are actually sung in the movie.

Roger Waters's lyrics also make an important contribution to this fantastic and psychedelic journey. Following some gentle chirruping, the words tell of a yellow bird that, in a cemetery near a river, lazes in the midday haze and laughs in the long grass. Waters also describes a journey to Cirrus Minor (a planet on the outer fringes of the universe perhaps?) during which the narrator sees *a crater in the sun, a thousand miles of moonlight later.* This is a new incursion by the songwriter into the literary domain of science fiction and, at the same time, a new borrowing from Chinese poetry. The phrase *A thousand miles of moonlight* comes from a poem by Li He, from whom Waters had also taken his inspiration for "Set the Controls for the Heart of the Sun" (translated by A. C. Graham in his collection *Poems of the Late T'ang* as "On the Frontier"). "Cirrus Minor" would also be included on the 1971 compilation *Relics*.

Production

This superb ballad by Roger Waters opens with the sound of birdsong. Most probably taken from EMI's sound effects library (and added at Pye Studios), this sonic atmosphere plays an important role in the song. Not only can it be heard for almost a minute before the entry of the first instrument, it is present virtually throughout the number, accentuating the meditative atmosphere generated by the music and the words. Reverb of varying intensity is added in certain passages, especially during the fade-out, lending the birdsong an unreal character.

The key of "Cirrus Minor" is E minor: does this have any connection with the title? The sung section does not begin

1969

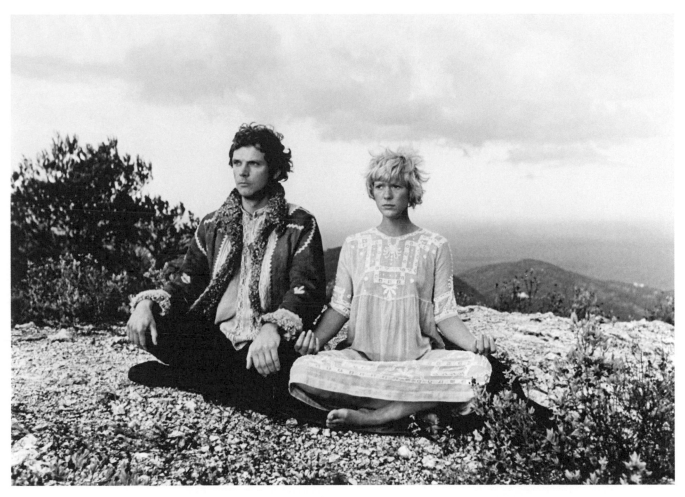

Stefan and Estelle in a meditative mood in the natural setting of the Spanish island.

until 0:58 and continues for no more than 1:45. While this is relatively short, it is long enough for the Floyd to establish an entrancing and almost wistful atmosphere. David Gilmour plays acoustic guitar, most probably his Levin LT 18, alternating strumming and arpeggios. Supported by Rick Wright's Farfisa organ, he also sings lead vocal in a gentle voice that is pitched relatively low in his range. He doubles this vocal part by singing along with himself on another track, which is to say without the help of ADT. There is some strong reverb in the fourth verse and particularly on the words Cirrus Minor, thereby heightening the intensity of the suggested images. Although difficult to verify, it sounds as if Gilmour is accompanied by a second acoustic guitar (listen between 2:30 and 2:40). Could this be Roger Waters playing? There can be no doubt, on the other hand, that Waters is on bass, albeit recessed in the mix.

After the birdsong and the sung verses, there is a third and last section in which Wright is on organ with Waters on his Rickenbacker bass. This time it is a Hammond M-102 organ that Wright plays, its mellow and ethereal sonority bearing some resemblance to that of the "Celestial Voices" section of the track "A Saucerful of Secrets" on the group's previous album. The ambiance is relatively cold, disquieting, and troubling, all the more so as Wright also uses a second keyboard (Hammond? Farfisa?), this time with the Echorec. The effect is psychedelic in a similar way to the group's first two LPs. The number concludes with the birdsong moving back into the foreground steeped in reverb.

The first track on the group's third album, "Cirrus Minor" is a very good introduction to the acoustic sonorities that would from now on form part of the group's range of musical expression. This piece presents a perfect blend of the evocative universe of Pink Floyd and the aesthetic of Barbet Schroeder.

COVERS

In 2007, Étienne Daho included an unlikely though successful cover of "Cirrus Minor" on a five-track EP that was supplied as a bonus disc with the deluxe remastered edition of his album L'Invitation.

The Nile Song

Roger Waters / 3:27

Musicians
David Gilmour: vocals, electric rhythm and lead guitar
Rick Wright: keyboards (?)
Roger Waters: bass
Nick Mason: drums
Unidentified musicians: hand claps
Recorded
Pye Studios, London: early February 1969
Technical Team
Producer: Pink Floyd
Sound Engineer: Brian Humphries

COVERS
"The Nile Song" has been recorded by a number of groups including the Human Instinct (*Pins in It*, 1971) and Voivod (*The Outer Limits*, 1993).

1969

Genesis

The power chords of "The Nile Song" ring out at the beginning of the movie *More*, when Stefan first meets Estelle. Roger Waters's lyrics have no more than a loose connection with this scene, however. Or, rather, he seems to have transposed the birth of the main characters' romance to Egypt. *I was standing by the Nile/When I saw the lady smile*, he writes. And then: *she spread her wings to fly*. A strange creature, then, the heroine of "The Nile Song." Is she an ancient Egyptian goddess with magical powers? Or a siren? After all, *She is calling from the deep/Summoning my soul to endless sleep*. Musically, "The Nile Song" is Pink Floyd's first foray into the world of hard rock, a genre pioneered by Cream that reached its culmination with Led Zeppelin, Black Sabbath, and Deep Purple (three British bands founded in 1968). This song undoubtedly contains the seeds of "Young Lust" and "In the Flesh" on *The Wall*.

In March 1969, "The Nile Song" was released as a single in various countries, notably France (with "Ibiza Bar" as the B-side) and Japan (with "Main Theme" as the B-side), but not in the United Kingdom or the United States. It was later included on the 1971 compilation *Relics*.

Production

"The Nile Song" is something of a showcase for David Gilmour's Dallas Arbiter Fuzz Face! The guitarist makes prolific use of the effect on this track, one of the rare cases in which he employs it so freely when playing rhythm (see also "Ibiza Bar"). His white Stratocaster is in all likelihood plugged into his Selmer Stereomaster 100-watt amp (with Selmer Goliath speakers). He delivers a performance that is impassioned, to say the least, in terms of both his guitar playing and his lead vocal. He plays power chords, probably recorded across a number of tracks in order to maximize their presence. In addition to his rhythm part, he also plays various solos strongly influenced by Jimi Hendrix. In places, he double-tracks his Fender licks (listen around 1:48), a technique he would use relatively often in the future, a prime example being the main solo on "Money" in 1973. As for his singing, up to now, we have been used to David delivering the lyrics in a gentle, delicate voice; this time he asserts himself with a distinct rasp. It is also apparent that in order

to boost its power, his singing is doubled using the ADT so beloved by Syd Barrett but by no means the usual thing done at Pye Studios. Roger Waters, the author of this hard rock number so uncharacteristic of his writing, provides solid support on his Rickenbacker 4001, although because of the way his bass is recorded, it has insufficient prominence. Instead of being plugged directly into the console as usual, the configuration seems to be the same as the one used by his fellow guitarist, only with different speakers, in this case the Selmer All-Purpose 50 (2 x 12). As for the drummer, Nick Mason gives a show of strength on this track. He can be heard smacking his Premier kit with ferocious power

and taking delight in incandescent tom breaks. Rick Wright seems to be absent from the recording, as no keyboards are audible. If, as seems likely, he is laying down accompanying pads on his organ, these are inevitably buried beneath the deluge of sound generated by his bandmates. The avalanche of decibels does not, however, mask the hand claps that can be heard distinctly in the intro.

"The Nile Song" is a muscular number that Barbet Schroeder preferred to use as a musical backdrop, for fear that it would gain the upper hand over the images. Although the same hard rock style can be found on "Ibiza Bar," it is nevertheless something of a rarity in the Pink Floyd catalog.

Crying Song

Roger Waters / 3:34

Musicians
David Gilmour: vocals, backing vocals, classical guitar, electric lead guitar
Rick Wright: vibraphone
Roger Waters: bass
Nick Mason: drums, bongos (?)
Recorded
Pye Studios, London: early February 1969
Technical Team
Producer: Pink Floyd
Sound Engineer: Brian Humphries

1969

With "Crying Song," Roger Waters crosses a threshold as a composer and melodist.

Genesis

This number by Roger Waters can be heard at a key moment in Barbet Schroeder's film, when Estelle is back in the apartment with Stefan, having been reduced to narcotics dealing in order to settle her debts. It begins at the precise moment that the camera pans over a poster of a nuclear mushroom cloud with the caption, *If the bomb goes off, make sure you get higher than the bomb*. The music—forming part of the narrative as the director wanted—is emitted by a humble cassette player. The lyrics, meanwhile, express the thoughts of Estelle and Stefan, thoughts that are once again disconnected as a result of their immoderate consumption of illicit substances. *We smile*, *We climb*, but also *We cry*. The concluding line *Help me roll away the stone* may be an allusion to the myth of Sisyphus. The burden that every human has to bear is a theme that the songwriter would later develop in *Animals* and then *The Wall*.

In terms of its musical material, "Crying Song" marks the return of a mellow, nostalgic, and pastoral atmosphere following the riot of decibels of "The Nile Song," a mood that would, in a sense, open up the way for the songs on the B-side of *Atom Heart Mother*.

Production

Barbet Schroeder chose to keep "Crying Song" firmly in the background in this scene. This is perhaps because the song is so beautiful that it risked upsetting the balance between the visuals and the music—like so much of the soundtrack. It is worth drawing attention here to the extraordinary progress made by Roger Waters in the art of songwriting. Interesting though they are, his most recent compositions ("Careful with That Axe, Eugene," "Let There Be More Light," "Set the Controls for the Heart of the Sun," and others) had given little hint of such a maturity of melody and emotion in his writing. His bandmates must have felt relieved that their bassist had turned out to be such a capable replacement for Syd Barrett. Of course the style is different, but the talent is on a par.

"Crying Song" is faded in and eventually fades out, like some sort of apparition. The general atmosphere is dreamlike, thanks mainly to Rick Wright's vibraphone. His playing is light and floating, and the instrument's crystalline sonority resonates with an almost oppressive tremolo, creating a

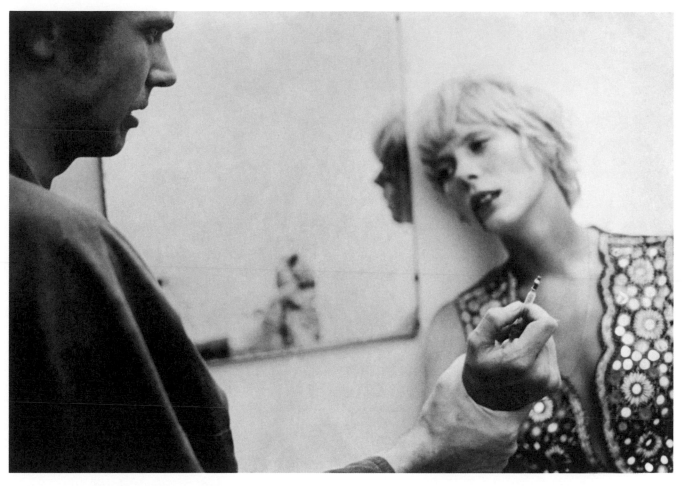

The slow decline of Stefan and Estelle, played respectively by Klaus Grünberg and Mimsy Farmer.

rippling effect that fosters a sense of reverie. Once again it is David Gilmour who takes the lead vocal, returning on this track, after bellowing out the words of "The Nile Song," to a gentle and soothing quality of voice. He delivers the words as if confiding in the listener, and seems to be harmonizing with himself. There is a certain oriental feel to the tune, which was one of the characteristics of Roger Waters's writing around this time.

Gilmour also plays acoustic guitar, this time an instrument strung with nylon strings, probably a Levin Classic 3. This mainly strummed part is faded in approximately ten seconds after the intro. His guitar seems to have been doubled on a separate track. Toward the end of the piece he plays an excellent solo on his Stratocaster in which, for the first time on disc, an initial, tentative version emerges of the style that would become one of the Floyd's signature sounds. He incorporates a lot of string bending and use of the whammy

bar, creating a highly sensual improvisation based around the vocal line and harmonized on a second guitar.

Roger Waters, meanwhile, provides support in the form of a heady and hypnotic bass part, developing a kind of drone on the note of D. He is presumably on his Rickenbacker 4001, although some sources claim that he is playing his white Fender Precision bought at the same time as Gilmour's Stratocaster. Finally, Nick Mason's accompaniment is minimal to say the least. After marking each beat of the bar on his snare drum in the introduction, he then restricts himself to the second and fourth beats, apparently without employing any other aspect of his drum kit, even the bass drum. Nevertheless, this single stroke with abundant reverb is a key element of the track. Certain sonorities seem to suggest that Mason also, at some stage, played the bongos on "Crying Song," for example at 1:46, which may be the echo of a badly erased or muted track.

Up The Khyber

Nick Mason, Richard Wright / 2:13

Musicians
Rick Wright: piano, organ, Mellotron (?)
Roger Waters: bass (?)
Nick Mason: drums
Recorded
Pye Studios, London: early February 1969
Technical Team
Producer: Pink Floyd
Sound Engineer: Brian Humphries

In Cockney rhyming slang, *Khyber Pass* denotes the posterior (*Khyber Pass; arse*). Another possible allusion is to the comedy adventure movie *Carry On Up the Khyber* (1968) by director Gerald Thomas and featuring Kenneth Williams and Sidney James.

Stefan and Estelle undergo a psychedelic experience under the Ibiza sun.

Genesis

This instrumental takes its title from the Khyber Pass, the thirty-seven-mile-long (sixty-kilometer) mountain road that cuts through the peaks of the Safed Koh range, linking Afghanistan with Pakistan, Kabul with Peshawar. During the second half of the sixties, the Khyber Pass, as well as being a mystical location, was also a "necessary" leg in the journey for anyone looking to consume or deal in narcotics (opium, hashish) from Afghanistan. In Barbet Schroeder's movie, "Up the Khyber" plays just after "Crying Song": it is on the other side of the cassette tape that Stefan turns over after he has discovered that Estelle is involved in narcotics dealing. In the suite *The Man and the Journey*, this song with considerable hypnotic power is known by the title "Doing It."

Production

Influenced by free jazz, "Up the Khyber" enabled the Floyd to rediscover a vein they had been mining since their earliest days. The lengthy live improvisations they had initiated with Syd Barrett and continued with David Gilmour frequently enabled the musicians to express themselves in a manner unconstrained by any commercial considerations.

Just like "Cirrus Minor" and "Crying Song," the track is faded in. Initially, Nick Mason alone can be heard, fluidly incorporating every element of his kit. It is interesting to hear him so at ease playing what are, after all, relatively complex rhythms. A bass instrument comes in at 0:12, alternating the top and bottom notes of an octave. This may be either a Mellotron or Roger Waters playing palm mute on his bass guitar. Rick Wright then enters with a dissonant piano part to which a hallucinatory stereo effect is applied, before adding a similarly discordant Farfisa organ. A percussion instrument heavily distorted courtesy of the Binson Echorec comes to the fore (listen between 0:57 and 1:27) before "Up the Khyber" is brutally interrupted by the sound of a tape being rewound. This brings the sequence to an end.

Nick Mason's drumming is the backbone of "Up the Khyber."

Green Is The Colour

Roger Waters / 2:59

Musicians
David Gilmour: vocals, acoustic rhythm guitar, classical guitar
Rick Wright: piano, organ
Roger Waters: bass
Lindy Mason: penny whistle
Recorded
Pye Studios, London: early February 1969
Technical Team
Producer: Pink Floyd
Sound Engineer: Brian Humphries

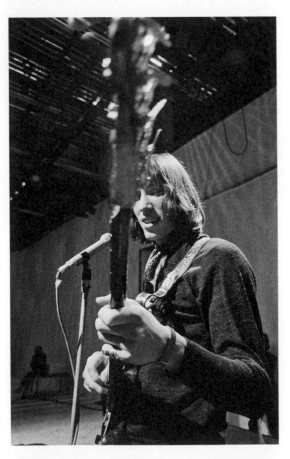

A sublime ballad by Waters, initially composed for the musical concept "The Massed Gadgets of Auximenes."

Genesis

Although "Green Is the Colour" was written by Roger Waters specifically for the *More* soundtrack, Pink Floyd performed the number live a month before the release of the album, on April 14, 1969, at the Royal Festival Hall in London to be precise, within the context of a show entitled "The Massed Gadgets of Auximenes—More Furious Madness from Pink Floyd." This show subsequently developed into another musical concept, the famous suite *The Man and the Journey*. In both cases this superb ballad is performed as an introduction to "Careful with That Axe, Eugene" (known as "Beset by Creatures of the Deep" in *The Man and the Journey*, in which it is called "The Beginning").

In Barbet Schroeder's movie, the calm and soothing melody of "Green Is the Colour" is heard for the first time in Estelle and Stefan's house by the sea on Ibiza, when everything seems blissful for the couple. The second occasion is during the café scene when Charlie, having traveled to Ibiza, advises Stefan to leave Estelle and return with him to Paris. The words perfectly underline Stefan's contradictory feelings: emotional harmony to start with, superseded by nagging doubts. In this song Roger Waters reveals himself to be an inspired poet (as well as a brilliant melodist): *White is the light that shines through the dress that you wore/She lay in the shadow of a wave/Hazy were the visions her playing.* And then, as if this serenity could only be fleeting: *Sunlight on her eyes/But moonshine made her cry every time.* Finally, intense sadness creeps into the last two lines: *Quickness of the eye deceives the mind/Envy is the bond between the hopeful and the damned.*

Pink Floyd would regularly perform "Green Is the Colour" onstage up to and including the Japan and Australia tour of August 1971.

Production

"Green Is the Colour" confirms Roger Waters's great gift for delicate and subtle acoustic ballads. The song opens with David Gilmour strumming an acoustic guitar (his Levin LT 18) accompanied by Roger's velvety bass. Almost straightaway, David comes in with an overdubbed solo on a

1969

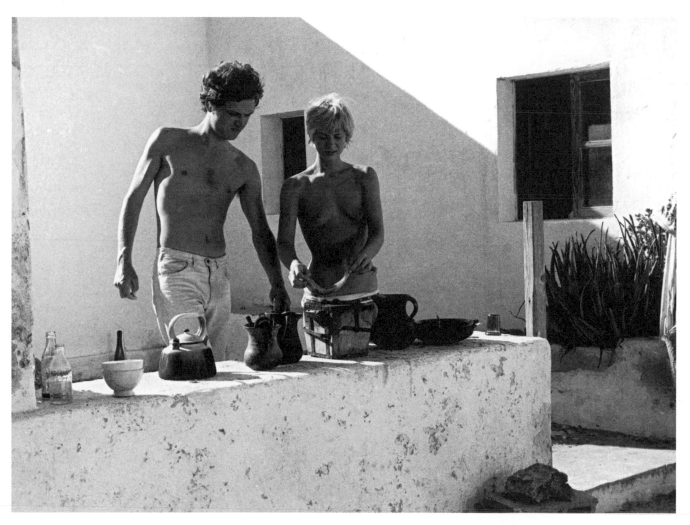

Stefan and Estelle prepare a cocktail designed to get them very high indeed.

second guitar, this time with nylon strings (a Levin Classic 3?), and continues to improvise in the same vein throughout the track. His vocal line is pitched toward the top of his range, and it sounds as if his voice is on the verge of cracking up, an effect that substantially reinforces the fragile, gentle, and poetic atmosphere evoked by the words. The timbre and texture of Gilmour's voice are absolutely unique, and over the course of his career he would establish himself as one of rock's greatest vocalists. While Nick Mason plays no part in this track (at least on the LP; in the film he can be heard on the drums), his wife Lindy, an experienced flutist, plays a penny whistle with plentiful reverb. Her interventions are of consistently high quality

and contribute to the bucolic atmosphere of the song. Rick Wright plays an acoustic piano, initially supplying a rhythmic chord-based accompaniment before launching into a solo first on the Farfisa organ and then on the piano. This means that in the coda (from 2:20), three instruments can be heard improvising at the same time: classical guitar, flute, and piano! And yet none of them gives the impression of either overloading the musical texture or of getting in the way of the others.

"Green Is the Colour" is a great song by Roger Waters. Although little known, it is one of Pink Floyd's undisputed successes. Barbet Schroeder uses it initially at normal volume and subsequently as background music.

Cymbaline

Roger Waters / 4:50

Musicians
David Gilmour: vocals, classical guitar
Rick Wright: acoustic piano, organ
Roger Waters: bass
Nick Mason: drums, congas
Lindy Mason: penny whistle
Recorded
Pye Studios, London: early February 1969
Technical Team
Producer: Pink Floyd
Sound Engineer: Brian Humphries

COVERS

"Cymbaline" was covered by Hawkwind in 1970. The song is included on the 1996 remastered version of the band's eponymous 1970 album.

The space rock group Hawkwind, who also recorded "Cymbaline," in the '70s.

For Pink Floyd Addicts

When performed live, "Cymbaline" would give rise to long improvisations such as that at Royaumont Abbey in France on June 15, 1971, during which David Gilmour rushed onstage to retune Roger Waters's G string while the bassist was in full flow!

Genesis

In "Cymbaline," Roger Waters raises the curtain on Shakespearian theater. *Cymbeline* is the title of a tale written by Shakespeare in 1611. In it, the great English playwright presents Imogen, the daughter of Cymbeline, king of Britain, who has defied the will of her father to marry Posthumus, a gentleman without fortune who is subsequently banished to Italy. Will Imogen remain faithful to him? Iachimo, whose acquaintance Posthumus has made in Italy, does his best to convince him otherwise…

This song takes us a long way from the Shakespearian plot, although it is possible to discern a strong interest in the fantastic on the part of the songwriter. A distinctly dark or ominous form of fantasy, that is, with ravens watching *from a vantage point nearby* before *closing in* and a *butterfly with broken wings…falling by your side*. The picture painted here is nothing short of a nightmare, and indeed it was under the title "Nightmare" that this song was incorporated into the musical concept *The Man and the Journey* (between "Quicksilver"/"Sleep" and "Daybreak, Part Two"/"Grantchester Meadows"). There is also, however, an element of humor and cynicism that ultimately makes the song even more captivating: *Your manager and agent are both busy on the phone/Selling coloured photographs to magazines back home*. Did Roger Waters already have some scores to settle with the music industry?

There are two versions of "Cymbaline": the one in Barbet Schroeder's movie (with an additional refrain and an extended organ solo, playing for a total of 5:18) and the one on the album, which has different words, particularly in the second verse, and is sung by a different voice. In the motion picture version, which plays while Stefan and Estelle are lying on her bed side by side smoking for the first time, Roger Waters sings: *Apprehension creeping like a tube train up your spine/Standing by with a book in his hand/There's peace in '39*, whereas on the album, David Gilmour sings: *Apprehension creeping like a tube train up your spine/Will the tightrope reach the end?/Will the final couplet rhyme?* Anxiety heaped on anxiety…

1969

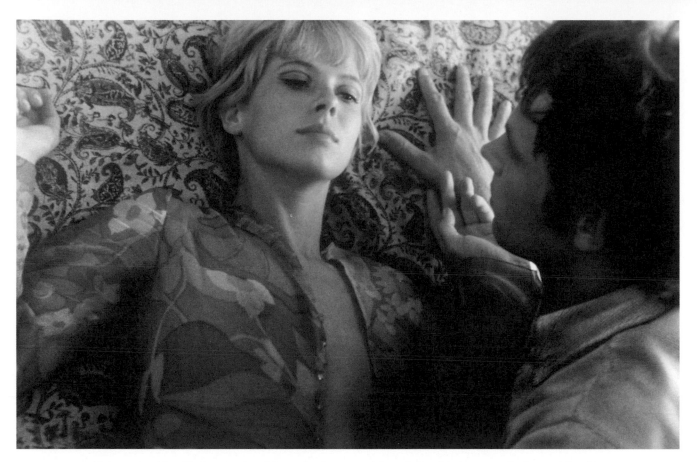

This song with a Shakespearian title marks the start of the relationship between Stefan and Estelle.

Production

"Cymbaline" is a relatively slow number with an uncluttered feel. David Gilmour opens this superb song with an E-minor chord on his classical guitar (Levin Classic 3?). The atmosphere is relatively dark and intimate, and yet the song possesses an airy, limpid quality thanks to the sublime melody composed by Roger Waters. Gilmour limits himself to playing chords on the guitar while singing the vocal line, which is subjected to heavy reverb. His performance is remarkable, far superior to that of Roger Waters in the movie version. He alternates a gentleness in the verses with flights of lyricism in the refrains, a combination that helps to make the song the great success it is. He doubles himself in order to reinforce his lead vocal, and a very clear time lag between the two voices (no doubt intentional) can be heard at 2:05 in the penultimate refrain. Gilmour then sings some scat passages, as he was fond of doing in concert. During the first four bars of the intro, careful listening (preferably through headphones) reveals the sound of a penny whistle in the far distance. This is Lindy Mason, Nick's wife. However, the sound is so faint that one cannot help wondering whether it is a badly wiped or simply muted track.

To turn to the percussion, Nick Mason is responsible for both a very good drum part (playing his Premier kit) and what sound like congas, with long and present reverb added. The general atmosphere also owes a great deal to the various keyboard parts played by Rick Wright. The keyboardist initially provides a characteristically syncopated and highly efficient piano accompaniment. He then adds chords on his Farfisa organ, whose sound is colored by some very pronounced tremolo from the Binson Echorec, before combining the sounds of his Hammond M-102 organ (from 3:17) and his piano. The coda is mainly Wright's (the guitar and drums having disappeared), and the combination of the various keyboards lends the song an almost mystical quality. Waters plays his Rickenbacker 4001 almost certainly plugged directly into the console, his clean, rhythmic accompaniment effectively underlining the harmonies of this track.

Of all the acoustic songs that Pink Floyd would record over the course of their career, "Cymbaline" is without doubt one of their greatest successes, in words, music, and interpretation.

For Pink Floyd Addicts

Roger Waters's lyrics reference a certain Doctor Strange, the famous Marvel Comics superhero. This is the second appearance by this character in the work of Pink Floyd, the first being his inclusion on the cover of *A Saucerful of Secrets*.

Party Sequence

Roger Waters, Rick Wright, David Gilmour, Nick Mason / 1:07

Musicians
Nick Mason: congas (?)
Lindy Mason: penny whistle
Unidentified musician: tbila
Recorded
Pye Studios, London: early February 1969
Technical Team
Producer: Pink Floyd
Sound Engineer: Brian Humphries

For Pink Floyd Addicts

"Party Sequence" was chosen to accompany the menu page of the *More* DVD, which was released in 2015.

A drug party on Ibiza, during which we hear the hypnotic percussion of "Party Sequence."

Genesis

In Barbet Schroeder's movie, "Party Sequence" provides the rhythmic accompaniment to a hippie party on the island of Ibiza, where Stefan has gone to join Estelle.

This track, which brings the first side of the LP to a close, is credited to the four members of Pink Floyd. Does this mean that Waters, Gilmour, Wright, and Mason all play percussion on it?

Production

Listening to this piece clearly raises questions about who played what. One of the musicians was without any doubt Lindy Mason, playing penny whistle for the third time on the record, after "Green Is the Colour" and "Cymbaline." But who are the (presumably two) percussionists? In the movie sequence, the conga and the tbila, a kind of Moroccan pottery bongo, are seen being played by two different people. And in the studio version these two same instruments can be heard. Nick Mason may well be playing the conga, but it is less certain that he would also be playing the tbila, as this instrument is being handled by a true specialist. Either way, it is unlikely that Waters, Wright, or Gilmour are involved. It is possible, however, that they originally recorded instrumental parts that were then dropped during mixing. This seems particularly likely in David Gilmour's case because in the movie version, which is longer than the album version (1:07 on the LP; 2:20 in the movie), an acoustic rhythm guitar part can clearly be heard.

In 2003, the Cité de la Musique in Paris held a Storm Thorgerson–designed exhibition dedicated to Pink Floyd, in which the original box of one of the master tapes for *More* was on display. On it, "Party Sequence" is listed as being in two parts (one and two). The second part is presumably the track heard in the movie immediately after the hippie party. This is a slower version featuring a single percussionist.

"Party Sequence" is a fitting evocation of the exotic nature of the location, Ibiza being geographically close to the coast of Africa, and in particular Morocco, a major producer of hashish, which is consumed in large quantities during the sequence in question.

1969

The opening phrases Stefan speaks at the beginning of the movie were written by Barbet Schroeder's friend and inspiration, the great American director Nicholas Ray, who made *Rebel without a Cause* (1955) with James Dean and Natalie Wood.

Main Theme

Roger Waters, Rick Wright, David Gilmour, Nick Mason / 5:28

Musicians
David Gilmour: electric lead guitar
Rick Wright: keyboards
Roger Waters: bass, gong (?)
Nick Mason: drums
Recorded
Pye Studios, London: early February 1969
Technical Team
Producer: Pink Floyd
Sound Engineer: Brian Humphries

The gong, an indispensable element of the Floyd's cosmic sound, was always struck by Waters onstage.

Genesis

This instrumental credited to all four members is heard twice in Barbet Schroeder's movie. The first time it is used to accompany the opening credits and initial scenes. Stefan has left Germany for France. He is shown hitchhiking in the pouring rain. Eventually, he is picked up and as Stefan dozes off, the following words of introduction can be heard: "I had imagined this journey as a quest. I'd finished my studies in math. I wanted to live. I wanted to burn all the bridges. All the formulas, And if I got burned, that was ok too. I wanted to be warm. I wanted the sun, and I went after it."

The second time occurs almost at the end of the movie, when Stefan bitterly acknowledges his failure. Once again the voiceover can be heard: "The psychedelic revolution rejects alcohol and heroin. This descent into egoism and alienation is the opposite of the liberation that I can see in those who have passed through to the other side." Words that accompanied Stefan's "initiatory quest" before eventually sounding like a condemnation.

Production

"Main Theme" opens with the sound of a vibrating gong, presumably struck by Roger Waters, that repeatedly veers back and forth between the stereo channels. The effect is hypnotic and threatening and fully justifies the introductory role of this track in Schroeder's movie. After thirty seconds or so, Rick Wright comes in with some pretty dissonant chords on his Farfisa organ, before being joined by Nick Mason's vaguely bossa nova drum beat and Roger Waters's bass, which is not unlike the rhythmic figure he plays on "Let There Be More Light" (*A Saucerful of Secrets*). It is Wright who plays the lead role in this "Main Theme," not least because he also produces some swirling effects on the organ, using a wah-wah pedal (from 1:25), but above all because of his excellent melody—again with an oriental feel—on the Farfisa. From around 2:52, David Gilmour can be heard playing solo phrases on his Stratocaster, presumably with the help of his whammy bar, but also using a bottleneck. The sound is relatively clear with a degree of reverb. At the end of the track a second guitar joins in, this time highly distorted (listen from 5:14). Also in this section, some electronic interference can be heard. Was this an error or a deliberate effect?

Ibiza Bar

Roger Waters, Rick Wright, David Gilmour, Nick Mason / 3:19

Musicians
David Gilmour: vocals, electric rhythm
and lead guitar, backing vocals (?)
Rick Wright: piano, organ, backing vocals (?)
Roger Waters: bass, backing vocals (?)
Nick Mason: drums
Recorded
Pye Studios, London: early February 1969
Technical Team
Producer: Pink Floyd
Sound Engineer: Brian Humphries

COVERS
Love Battery, a grunge band from Seattle, covered "Ibiza Bar" during the sessions for their EP and album *Between the Eyes*, released in 1990 and 1991 respectively.

Stefan, who has just arrived in France,
meets Charlie in a Parisian café.

Genesis

Contrary to what its title suggests, this collective composition fits into the soundtrack of Barbet Schroeder's movie toward the beginning of the action, in other words before Stefan arrives in Ibiza. It marks the encounter between the young German student and Charlie in a bar, a Parisian one. The lyrics are not closely aligned with the plot of *More*. In fact there is no discernible connection other than a spirit of mea culpa: *I'm so afraid of mistakes that I've made/Shaking every time that I awake/I feel like a cardboard cut-out man/So build me a time when the characters rhyme and the story line is kind.*

Production

Musically, "Ibiza Bar" could easily be mistaken for "The Nile Song." The confusion derives mainly from the intros, both of which modulate between two notes a tone apart while sharing more or less the same tempo (around 90 bpm), rhythmic figure, and hard rock sonority. Under these conditions it is difficult not to compare the two. "Ibiza Bar" differs in the way its harmonic structure develops, particularly in the refrains. These are harmonized by several voices (Waters, Wright?) in support of David Gilmour's lead vocal, whose timbre is just as raucous and "hard rock" as it is in "The Nile Song." The backing vocals with heavy reverb that emerge toward the end of Gilmour's first guitar solo (from 1:50) are another new element. But the rest of the musical arrangement is based on the same formula: the bass and drums drive the rhythm with the same power as in "The Nile Song" (with a very good bass line from Waters), providing Gilmour and Wright with an opportunity to let off steam on their respective instruments. Rick Wright plays the Farfisa organ, the Hammond M-102, and acoustic piano. Gilmour, meanwhile, imposes his Jimi Hendrix influences on the track, with the same strongly distorted rhythm guitar (courtesy of his Fuzz Face), and plays multiple solos on his Stratocaster that are equally distorted and also drenched in reverb. Although his style has not yet developed into that which would eventually define him, certain characteristics of his playing can already be identified (for example at 1:27).

More Blues

Roger Waters, Rick Wright, David Gilmour, Nick Mason / 2:13

Musicians
David Gilmour: electric lead guitar
Rick Wright: organ
Roger Waters: bass
Nick Mason: drums
Recorded
Pye Studios, London: early February 1969
Technical Team
Producer: Pink Floyd
Sound Engineer: Brian Humphries

For Pink Floyd Addicts

Despite their status as an iconic progressive (and psychedelic) rock band, in the seventies Pink Floyd used to regularly improvise on the twelve-bar blues at the end of their shows. This is borne out by the bootleg *More Blues*, recorded at the concert of November 21, 1970, at the Montreux Casino. The bootleg includes a version of this number that goes on for more than nine minutes as well as another "Just Another 12 Bar Original" that has never been included on an official release.

Genesis

Barbet Schroeder uses "More Blues" in the second part of the film. Stefan is working as a barman for Ernesto Wolf and selling marijuana and heroin to pay off Estelle's debts. This instrumental, credited to the four members of the group, serves as a reminder that Pink Floyd owe their name to two bluesmen of the Deep South, Pink Anderson and Floyd Council, and that they began life playing covers of classic blues numbers in London's underground clubs.

Production

In a 2006 interview, David Gilmour declared that "But… all my playing is rooted in the blues."[51] And he certainly proves it on "More Blues," which is something of a rarity in the Pink Floyd catalog. With the exception of "Seamus" on the 1971 album *Meddle*, which was the group's second "official" blues (an acoustic track whose electric counterpart, "Mademoiselle Nobs," can be heard in the movie *Pink Floyd: Live at Pompeii*), never again (leaving aside "Love Scene [Version 6]," an outtake from the soundtrack to *Zabriskie Point*) would the English quartet so wholeheartedly embrace this particular musical genre. Throughout the 2:13 length of this track, pride of place is given to the guitarist's Fender Stratocaster. He plays with feeling, and his phrasing, which involves a lot of string bending, takes on a cosmic dimension—his notes exploding with long and intrusive reverb. His guitar sound is clear, with only minor distortion, and he succeeds in producing a credible performance that expresses Stefan's feelings, faced with Estelle's physical and mental decline, to great effect.

To tell the truth, the originality of this blues number is largely down to the rhythm section, in particular Nick Mason's no more than sporadic interventions that enable Gilmour's guitar to truly breathe. Roger Waters delivers a bass line that is equally remarkable in the sense that it does not systematically support the drums, but plays along either with or without them. Rick Wright accompanies on the organ. Although discreet, his playing provides indispensable harmonic support and contributes inimitable color with his Hammond M-102. The track comes to an abrupt end at 2:10 with the sound of a tape recorder being switched off.

Quicksilver

Roger Waters, Rick Wright, David Gilmour, Nick Mason / 7:14

Musicians
David Gilmour: electric lead guitar (?)
Rick Wright: vibraphone, organ
Roger Waters: gong (?)
Unidentified musicians: sound effects
Recorded
Pye Studios, London: early February 1979
Technical Team
Producer: Pink Floyd
Sound Engineer: Brian Humphries

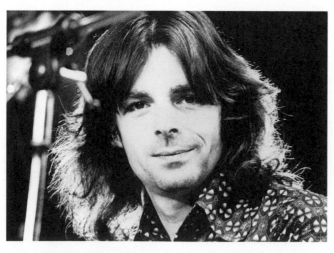

Rick Wright has pride of place in "Quicksilver," playing both the vibraphone and the Farfisa organ.

Genesis

Quicksilver is the name by which mercury was once known. Alchemists attributed astonishing powers to the element, not least the capacity to marry the material with the spiritual. Was it this esoteric dimension that inspired the four members of Pink Floyd when creating "Quicksilver"? Maybe so. The song occurs twice in the movie *More*: first of all after Estelle suggests that her lover try heroin at their house by the sea, and for the second time while the couple are tripping on LSD.

"Quicksilver" is therefore a drug song. It is also, and above all, an atmospheric improvisation in which different psychedelic moods intermingle against a background of avant-garde music and musique concrète, an improvisation that recalls certain passages of *A Saucerful of Secrets*. Renamed "Sleep" and reduced in length by some three minutes, "Quicksilver" would be reused in the two-part musical suite *The Man and the Journey*.

Production

The tone is set with the very first notes of this track; the 7:14 of "Quicksilver" can only be described as nightmarish. The intro immediately plunges the listener into a heavily worked sequence of sound effects including some kind of grille (or the strings of a piano) over which a stick is dragged or rubbed. The recording is slowed down and steeped in harrowing reverb. A gong is then heard (struck by Roger Waters?), sounding much like the one on "Main Theme." The sound is oppressive: it moves around the stereo image and reemerges in successive waves throughout virtually the whole of the piece. "Quicksilver" gives pride of place to Rick Wright, who initially plays a vibraphone with a crystalline, ethereal sonority that contributes a pleasantly space-like or otherworldly dimension. He then adds some Farfisa organ (played through the Binson Echorec), creating a lugubrious, dissonant counterpoint to the floating, aerial mood. Toward the end of this sequence, David Gilmour apparently picks up his Stratocaster and produces slide effects with a bottleneck used close to the bridge of his guitar (around 6:32). The purpose of writing "Quicksilver" was to evoke the torment of hard drugs, and in this it succeeds extremely well.

Quicksilver is also the name of a major Californian acid rock band, the Quicksilver Messenger Service, founded in San Francisco in 1964 by singers Dino Valente and Jim Murray and the guitarist John Cipollina. The name Quicksilver was chosen because the band's founding members were born under astrological signs influenced by the planet Mercury.

Stefan and Estelle in their pretty Spanish house, where drugs bring them closer to disaster with each passing day.

A Spanish Piece

David Gilmour / 1:05

Musicians
David Gilmour: acoustic guitar, classical guitar, voice
Recorded
Pye Studios, London: early February 1969
Technical Team
Producer: Pink Floyd
Sound Engineer: Brian Humphries

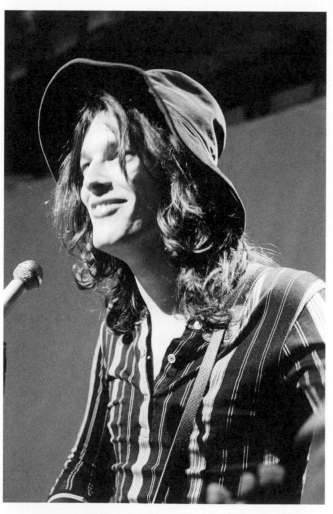

David Gilmour reveals an interest in Spanish music, specifically flamenco, in the aptly named "A Spanish Piece."

Genesis

"A Spanish Piece" was the first number in the Pink Floyd catalog to be credited to David Gilmour alone. It is a flamenco-style instrumental that is heard in the movie *More* when Stefan, upon arriving in Ibiza, sets off in search of Estelle and ends up at the hotel…Roger Waters explains: "We were told one bit had to be coming out of a radio in a Spanish bar, so we had to do something that suggested that. In the middle of it, David tried to make the sort of speech noises you'd expect to hear."[52] The album version indeed includes a number of spoken phrases, such as: *Pass the tequila, Manuel/Listen, gringo, laugh at my lisp and I kill you/I think/Ah this Spanish music, it sets my soul on fire.* All of these words were suppressed in the movie version, which seems to differ from the album track musically too, featuring an alternative guitar solo. Is this the "Spanish Music" listed on the original box of one of the master tapes seen in Paris during the 2003 Pink Floyd exhibition?

Production

David Gilmour would later explain that he had taken his inspiration for "A Spanish Piece" from the flamenco clichés familiar to every budding guitarist. His composition is based around the E and F chords that are typical of this particular musical style. The rhythm part is played on an acoustic guitar (the Levin LT 18?) with metal strings. Gilmour can also be heard tapping the soundboard of his instrument in order to mark the beat in the *golpe* manner. This percussive effect was probably overdubbed. He then plays an initial guitar solo with plentiful reverb, delivering entirely convincing licks and phrases with tremolo; for this he uses a classical guitar (Levin Classic 3?) with nylon strings. He wraps up his improvisation with a second guitar solo. David Gilmour is no Paco de Lucía, but this short sequence creates the perfect illusion.

1969

Dramatic Theme

Roger Waters, Rick Wright, David Gilmour, Nick Mason / 2:17

Musicians
David Gilmour: electric lead guitar
Rick Wright: organ
Roger Waters: bass
Nick Mason: drums
Recorded
Pye Studios, London: early February 1969
Technical Team
Producer: Pink Floyd
Sound Engineer: Brian Humphries

The enigmatic beauty of Estelle, one of
Mimsy Farmer's finest roles.

Genesis

The instrumental entitled "Dramatic Theme" is heard just before the denouement of the movie *More*. Having by force of circumstance become a barman, Stefan sees Estelle in the arms of Ernesto Wolf. Upon returning to their place, his anxiety only increases as he awaits his girlfriend. In order to calm down, he decides to have another shot of heroin…

Production

"Dramatic Theme," which brings the album *More* to a close, is actually a variation on "Main Theme." Although the tempo is slower (112 bpm as opposed to 136), the key is the same (G minor). Roger Waters plays more or less the same bass hook, inspired by "Let There Be More Light" from *A Saucerful of Secrets*, and Nick Mason delivers a similar drum part, merely replacing his toms with a rimshot on his snare drum. Rick Wright provides harmonic support with reasonably discreet pads on the Farfisa organ. The superb tune he plays on "Main Theme" is noticeably different here, however, and what's more virtually inaudible; it can just be made out at the back of the mix. This time it is David Gilmour who leads the dance on his white Stratocaster. He improvises throughout this sequence, alternating string bends and whammy bar. His guitar is strongly colored by long and ample reverb, but also by the Binson Echorec, which, by way of a conclusion, he overloads with feedback at the end of the track (from 2:00). The sound he creates with his subtly distorted (courtesy of his Fuzz Face) Stratocaster is spacey and ethereal.

"Dramatic Theme" is one of the three titles on the album whose master tape was exhibited at the Cité de la Musique in Paris in 2003 (the other two being "Main Theme" and "Ibiza Bar"). Let us hope that it reappears one day, enabling a high-quality remastering to be made. This final instrumental brings to a close the Floyd's first foray into the world of motion pictures, the results of which, taken as a whole, are not merely convincing but brilliant. And this was an experience the group would soon repeat.

The Man And The Journey: The Original Suite

Pink Floyd played concert after concert throughout 1969. No fewer than six in January, prior to the start of the recording sessions for *More*, and then a further twenty in February and March. The group, which had been trying to get itself together again following the departure of Syd Barrett, would take advantage of these gigs to perform a multitude of sonic experiments and stage "happenings," and also to try out an initial concept work in the form of *The Man and the Journey*, a musical suite organized around a central idea and consisting of new compositions as well as pieces taken from their existing repertoire. This would be performed onstage between spring 1969 and the beginning of 1970.

This suite lasted around forty minutes and comprised two parts. The first, *The Man*, tells the story of a day in the life of an average man in the postindustrial United Kingdom, and on a more metaphorical level of a man's life from birth to death. The idea came to Roger Waters after seeing writing on a wall of Paddington station along the lines of: *Get up, go to work, go home, go to bed, get up, go to work, go home, go to bed, get up, go to work, go home, go to bed, get up, go to work, go home, go to bed. How long can it go on? How long before you crack?* The second part, *The Journey*, has no real unifying theme. It is about a journey (of what nature? psychedelic?) based on improvisation.

Sonic Experimentation and Stage Happenings

The first performance of a suite called *The Man and the Journey*, later occasionally referred to as *The Massed Gadgets of Auximenes: More Furious Madness from Pink Floyd*, was given by Pink Floyd at London's Royal Festival Hall (South Bank) on April 14, 1969. From this time forward, the group's concerts would all be based around a specific concept, looking forward to the direction Roger Waters, David Gilmour, Rick Wright, and Nick Mason were to take over the subsequent decades, and in a sense prefiguring their future concept albums.

Each of their gigs was nothing less than a dive into the unknown. In addition to sonic experimentation, realized above all with the Azimuth Coordinator, a device that enabled sound to be panned around the auditorium, and the improbable sound effects produced by the group live, short scenarios, described as happenings, were acted out, such as the sawing of planks, the construction of a table, and the ceremony of tea being served to the musicians onstage during the show. (This would later be included as the last track, "Alan's Psychedelic Breakfast," on the album *Atom Heart Mother*.) The peculiarity of these scenarios and sound effects, which punctuated the concert, making it an unusual event to say the least, is conveyed by an eyewitness account from the journalist Michel Lancelot, who attended the concert given at the Théâtre des Champs-Élysées in Paris in January 1970: "While Nick Mason is hammering his cymbals and Rick Wright is hammering his vibraphone, the two others, David Gilmour and Roger Waters, the group's two singers, are seated on the stage [...] miming human labor with hammers, simple hammers [...]. And then, while David Gilmour continues to bang the hammer, Roger Waters, the bassist, is sawing away at a plank. Just listen to the incredible rhythm, it's extraordinary! And the most extraordinary thing, from the beginning of the second movement of this symphony about a day in the life of a man [...], there's a slightly ridiculous aspect to it, the sight of these men sitting down banging hammers, it doesn't really correspond to one's idea of what music is, and yet [...] this extraordinary rhythm, this movement of the whole, it's not done on record, for which the effects can be restarted fifteen times if need be, it is all done live, both the grinding of the saw and the hammering..."[40] As a result of the material difficulties involved in staging these little scenarios, it would not be long before Pink Floyd abandoned performances of this kind.

The "Man and the Journey Tour" played to twenty or so other British towns and cities (including Birmingham,

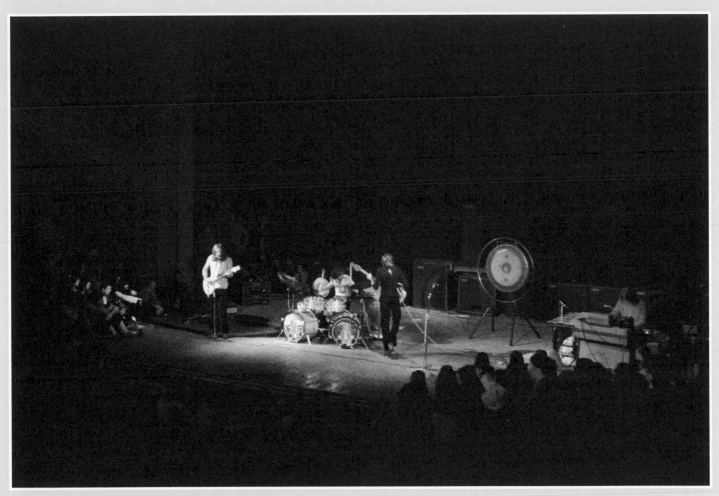

Breakfast onstage for the four members of Pink Floyd. A high point in the musical suite *The Man and the Journey*.

Manchester, and the university cities of Oxford and Cambridge) between April and June, with an interlude to appear on radio and television shows in West Germany (Stuttgart and Hamburg on April 19 and 23 respectively). The group resumed its performances of the suite in England in August (Plumpton Race Course, near Lewes, on August 8) before playing the Netherlands (Amsterdam on September 17; Maastricht on September 25) and France in January 1970 (Paris on January 23 and 24; Lyon on February 2). The French concerts are thought to be the last at which the suite was performed live.

The famed concert at Concertgebouw in Amsterdam on September 17, 1969, incompletely recorded by Dutch radio VPRO, gave rise to a bootleg. It was later officially released on the box set *The Early Years 1965–1972*, which also includes "Afternoon," "The Beginning," and "Beset by Creatures of the Deep" rehearsals of the *The Man and the Journey* concept for the show at the Royal Festival Hall in London on April 14, 1969.

UMMA-GUMMA

ALBUM
UMMAGUMMA

RELEASE DATE
United Kingdom: November 7, 1969
Label: Harvest Records
RECORD NUMBER: SHDW 1/2
Number 5 (the Netherlands)

LIVE DISC Astronomy Dominé / Careful With That Axe, Eugene /
Set The Controls For The Heart Of The Sun / A Saucerful Of Secrets
STUDIO DISC Sysyphus (Parts 1-4) / Grantchester Meadows / Several Species
Of Small Furry Animals Gathered Together In A Cave And Grooving With A Pict /
The Narrow Way (Part 1-3) / The Grand Vizier's Garden Party
(Part 1 - Entrance / Part 2 - Entertainment / Part 3 - Exit)
OUTTAKES Roger's Blues / Rest / Embryo

Ummagumma, a Freewheeling Album from the Floyd

Pink Floyd worked on their fourth album between September 1968 and July 1969. *Ummagumma* is atypical of the group's output not so much because it is a double album, but rather because it consists of a live disc and a studio disc. The first two sides comprise live versions of four titles taken from their earlier studio albums ("Astronomy Dominé," "A Saucerful of Secrets," "Set the Controls for the Heart of the Sun," and "Careful with That Axe, Eugene." The second disc, recorded in the studio, is the result of a more experimental approach in that the four musicians allowed themselves half a side each in which to give free rein to their imaginations. The challenge the Floyd set themselves was for each member of the group to express himself individually, as he saw fit, with no concern for any overall unity. The sound engineer Peter Mew recalls that on the first day, the group was assembled in the studio with Norman Smith, who asked the musicians whether they had any songs. "To which Floyd replied, 'No.' After that, it was decided that each of them would have a quarter of the album."[1] "The four pieces of the LP are very different, though there are pieces in all of them which link together," explained keyboardist Rick Wright in the columns of *Beat Instrumental* in 1970. "There wasn't actually any attempt to connect them all. We didn't write together, we just went into the studios on our own to record and then we got together to listen to them. We all played alone on our pieces, in fact [...]. I thought it was a very valid experiment and it helped me."[52]

Each member of the group was thus responsible for his own piece (or two pieces in the case of Roger Waters).

Born of fruitful competition, the five tracks on the studio disc reveal something of the musicians' personalities as well as of their improvisatory skills, even if all four band members were in experimental mode more or less. In "Sysyphus," Rick Wright has written a four-part symphonic poem that evokes the music of the big-screen historical epic here and the descriptive music of the classical composers there, while elsewhere still, somewhat more aggressively, presenting a strand of musique concrète. In "Grantchester Meadows," Roger Waters confirms his taste for the pastoral ballad (on the heels of the album *More*), while "Several Species of Small Furry Animals Gathered Together in a Cave and Grooving with a Pict" is a sound collage of a highly individual nature. In addition to providing a display of elegant guitar virtuosity in "The Narrow Way," David Gilmour seems to be looking forward to the musical atmospheres of "Echoes" and *The Dark Side of the Moon*, especially in the third movement of his piece. Finally, in "The Grand Vizier's Garden Party," Nick Mason displays a taste for exoticism and revels in the wide world of percussion.

The double album *Ummagumma* (1969) marks a turning point in Pink Floyd's musical output and would provide the group with a number of different avenues to explore over the next few years.

"Ummagumma"? Did you say, "Ummagumma"?

The album title, which sounds like a low rumbling noise, is a local slang expression for sex used by Syd and David when

1969

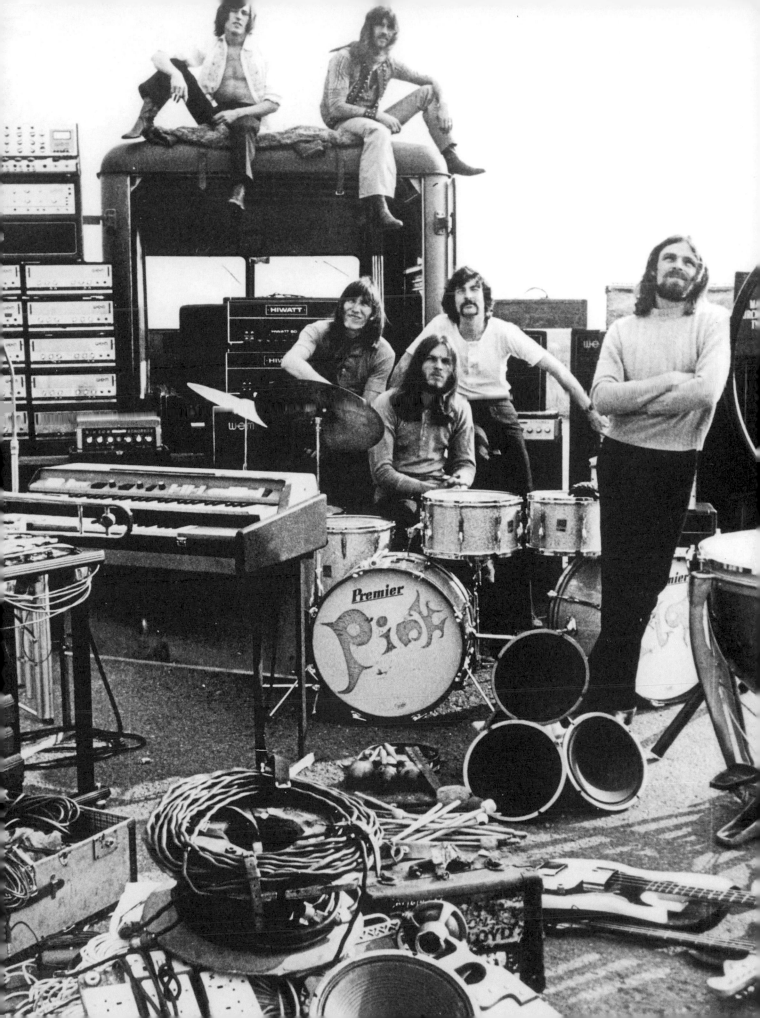

For Pink Floyd Addicts

The members of Pink Floyd have never really cared for *Ummagumma*. Roger Waters even referred to it as a "disaster"!

they were living in Cambridge. "It's just a name," explains Nick Mason. "It wasn't taken because it means anything; it was taken because it sounded interesting and nice. And it can be either made to sound like a chant or as a sort of exclamation."[53] Other explanations have also been put forward. *Umma* means *prophet* in the Chakobsa language spoken by the Fremen people in Frank Herbert's science fiction classic *Dune*, and we know what enormous fans the band members, in particular Rogers Waters, were of this particular literary genre.

Pink Floyd's fourth album was released in the United Kingdom and continental Europe on November 7, 1969 (on EMI's progressive music label Harvest, founded shortly before by Malcolm Jones with the help of Peter Jenner and Andrew King, who managed some of the label's artists), and in the United States on November 10. To start with, the bosses at EMI were skeptical to say the least. Roger Waters would later claim that they did not believe in *Ummagumma* and thought it would not sell at all. But, as the bassist observes, "[…] it came out and sold better, far better than anyone thought."[3] Against all expectations, the album was enthusiastically received by the rock media and the general public alike, above all in Europe—and not only because it was modestly priced for a double album. *Ummagumma* reached number 5 in the United Kingdom and the Netherlands, number 25 in West Germany, a disappointing number 89 in Belgium, and an even more disappointing number 117 in France (despite being awarded the Grand Prix International du Disque by the Académie Charles Cros). In the United States, *Ummagumma* progressed no further than number 74 on the Billboard chart, but would eventually be certified platinum.

The Madcap Breaks His Silence

Looking beyond the album's reception by the music critics and the public, how did Syd Barrett react to the release of the album? The group's former front man expresses himself in reasonably kindly terms in the *Record Mirror*: "They've probably done very well. The singing's very good and the drumming is good as well."[9] It is worth noting that rather than abandoning Syd since his ejection from the group, his former colleagues had helped him to record his first solo album, *The Madcap Laughs*, with David Gilmour and Roger Waters going as far as playing on and producing various tracks. Barrett's first solo LP was released on January 2, 1970, a little more than two months after *Ummagumma*. Compared to the surprisingly good sales of the group's fourth album, *The Madcap Laughs* was a relative failure, but at least Syd's former bandmates had done their bit, even if the album's co-producer, Malcolm Jones, would later question the value of their contributions.

The Sleeve

The sleeve of *Ummagumma*, designed by Hipgnosis, is one of the most famous in the history of rock music. The pictures were taken at the home of the parents of Libby January, a friend of Storm Thorgerson, at Great Shelford, near Cambridge. In the foreground, David Gilmour, sitting on a chair positioned against the frame of an open doorway, stares into the lens with his face silhouetted against the light. Behind him, Roger Waters is seated on the ground, while Nick Mason, wearing a hat, occupies the middle distance, and Rick Wright, doing a shoulder stand, brings up the rear. Based on this positioning, the Hipgnosis design studio had the ingenious idea of creating a Droste effect, that is to say repeating the motif of the first image ad infinitum within successive images. In the second version of the image, which appears within a frame hanging on the wall, we see Roger Waters sitting on the chair, Nick Mason in the doorway, Rick Wright staring at the sky, David Gilmour doing a shoulder stand, and so on…The overall effect creates the illusion of

1969

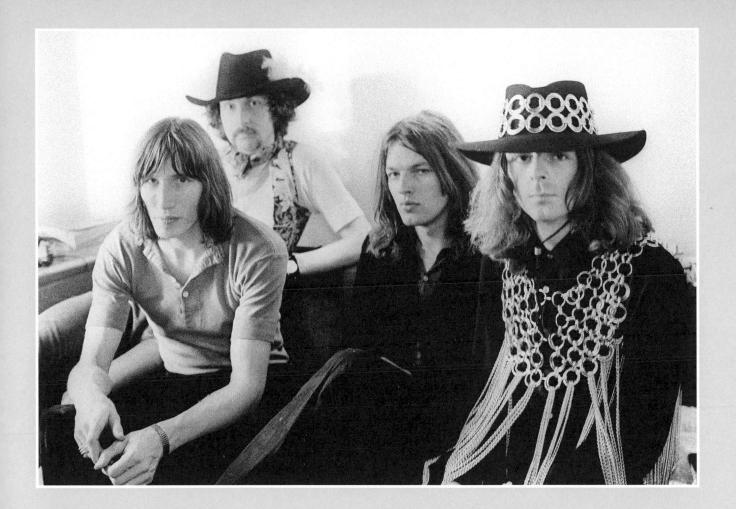

a 3-D photograph, the aim being, in Storm Thorgerson's words, "to illustrate the simple idea that Floyd music was multilayered [...]"[54]

On the back of the sleeve is a photograph of Pink Floyd's impressive hardware carefully laid out on one of the runways of London's Biggin Hill Airport by the roadies Alan Styles and Peter Watts, who can be seen in the picture. The equipment has been arranged in the shape of an arrowhead, creating the illusion of a military aircraft about to take off with its payload. The inner surfaces of the cover are adorned with black-and-white scenes of the musicians' private lives: a low-angle shot of David Gilmour in front of a tree stump inhabited by elves, Roger Waters with his wife Judy, a heavily bearded and mustachioed Rick Wright staring intently at the camera from a position next to his piano, and sixteen close-up shots of Nick Mason.

This sleeve has suffered various vicissitudes over the years. The original cover included a mistake in the concert dates of the live disc, which were given as June rather than as April 27 and May 2. This error was corrected on the remastered CD versions. It will also be observed that the inside photograph of Roger Waters with his wife Judy has been reframed on the CD version so that Roger alone can be seen. This is explained by the couple's 1975 divorce...

The Recording

The first disc, that is to say the live part of the album, was recorded twice, on April 27 and May 2, as Rick Wright explains: "The first time, at Mother's in Birmingham ["Astronomy Dominé" and "A Saucerful of Secrets"], we felt we'd played very well, but the equipment didn't work so we couldn't use nearly all of that one. The second time, at Manchester College of Commerce ["Careful with That Axe, Eugene" and "Set the Controls for the Heart of the Sun"], was a really bad gig, but as the recording equipment was working well, we had to use it."[52]

The studio portion of *Ummagumma* was recorded at EMI's Abbey Road Studios in London. Norman Smith is again credited as producer, but the reality was quite different, as Rick Wright explained to Nicky Horne on London's Capital Radio in December 1976: "That was at the time when we were splitting from Norman. He was getting less and less, if you like, involved in what we were doing, and virtually at the end he was just sitting in the background listening, but he realised I think that we were taking over production and it was a natural thing—a natural process."[55] Ever since Syd's departure, Norman had not really understood the musical direction being taken by the group, and so he gradually detached himself from them. "So he just

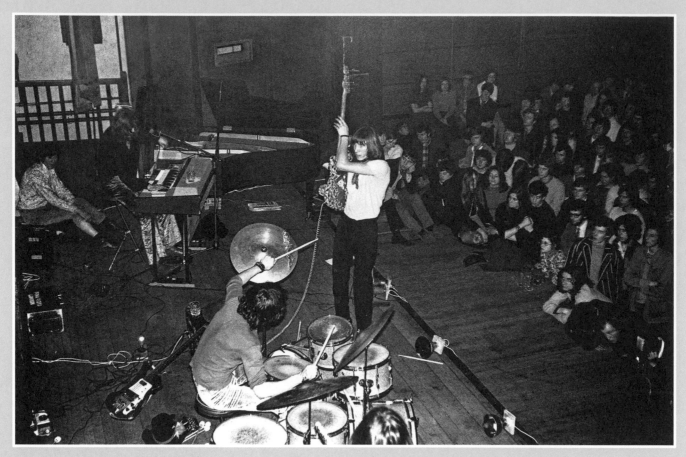

Pink Floyd onstage at the Théâtre des Champs-Élysées in Paris on January 25, 1970,
a few months after the release of their double album *Ummagumma*.

sort of let it happen," continues Wright, "and, there wasn't a sudden break, or a bad feeling at all; there wasn't all of us one day saying, 'Right, Norman, you're out!' We, all of us, realised that was what was happening, 'cos his good point I think early on was teaching us how to work in a studio."[55] Well grounded by this stage in recording techniques, the Floyd therefore took charge of production, leaving Norman as no more than a phantom producer.

"I wasn't fantastically amazed with the live album of *Ummagumma*," confesses Roger Waters in a 1970 interview, "but I think the idea for the studio side, doing one track each, was basically good. I personally think it would have been better if we'd done them individually, and then got the opinions of the others, put four heads into each piece instead of just one. I think each piece would have benefited from that, but by the time they were done, we'd used up our studio time. I was quite pleased by the way it came out, though. It sold a lot, which is something."[56]

Pink Floyd would require a total of forty-three recording, editing, and mixing sessions for the studio album. Three of these were dedicated to "Embryo," a title that would not be released until 1970, when it appeared on *Picnic: A Breath of Fresh Air*, a compilation of various artists recording for the Harvest label. It has since been included in the 1983 compilation *Works*, destined for the US market, and more recently in the CD collection *The Early Years: 1965–1972*, released in 2016. Five sessions were dedicated to "One Night

Stand," the working title of "Summer '68," which would not be included on an album until *Atom Heart Mother* (albeit in a rerecorded version) in 1970.

Between September 17, 1968, and July 5, 1969, the dates of the first and last recording sessions for the album, the group also found time to record its fifth single, "Point Me at the Sky"/"Careful with That Axe, Eugene" at the end of 1968, and to get down all the titles on its soundtrack for Barbet Schroeder's movie *More* in early February 1969! As well as being a very busy period for the band, this must have been a time of considerable inspiration…

Among the various sound engineers and assistants working on the project were some of the same names as before, most importantly Peter Mew at the console, but also a number of newcomers such as Neil Richmond (Motörhead, Soft Machine, and others); Alan Parsons, the future "master of sound" on *The Dark Side of the Moon* (who also worked on "Point Me at the Sky"/"Careful with That Axe, Eugene"); Anthony Mone; and Nick Webb. And then there are the two extraordinary engineers Phil McDonald (the Beatles, Derek And The Dominos, Syd Barrett, Deep Purple…) and Chris Blair (Genesis, the Cure, Kate Bush, Radiohead…), who attended only one of the final sessions on the album.

Technical Details

After a good deal of vacillation, in 1968 EMI finally agreed to acquire and bring into operation its first two eight-track

Roger Waters acquires a new bass, a white Fender Precision, which can be seen on the back of the album cover.

tape recorders (3M M23s). It was presumably on one of these machines that *Ummagumma* was recorded. Although this is a safe assumption as far as Pink Floyd's 1969 recording sessions are concerned, given that the group worked mainly in Studio Two (where one of the machines was installed) that year, it is less certain in the case of the group's 1968 work. That year the Floyd used mainly Studio Three, and it has not been possible to establish beyond doubt whether the second eight-track machine was in operation there. Similarly, the REDD.51 console is known to have been replaced in 1969 by the famous TG12345, but whether or not this was also used for the group's 1968 sessions is by no means easy to ascertain.

The Instruments

The image on the back of the album cover gives us an insight into the various instruments used by Pink Floyd at this time, particularly in concert. Among the items on display in this photograph, we can see Nick Mason's Premier drum kit with its two bass drums, a pair of maracas, two orchestral timpani; Rick Wright's vibraphone, trombone, and Farfisa Compact Duo organ; a Revox A77 tape recorder; a Binson Echorec II; David Gilmour's white Fender Stratocaster and a new, natural wood Telecaster (purchased after he lost his first [white] Telecaster during the 1968 United States tour); Roger Waters's Rickenbacker 4001 and newly acquired white Fender Precision; and finally the inevitable gong perched on the roof of the van. As for amplification, two Sound City L100 and two Hiwatt DR-103 amp heads can be identified, presumably used by Waters and Wright. Gilmour would soon switch to Hiwatt as well, but for his *Ummagumma* studio work he was almost certainly still using his Selmer Stereomaster with his white Stratocaster. Similarly, Waters's Rickenbacker was either played through his Selmer Treble-n-Bass 100 or plugged directly into the console. Last but not least, it is worth noting that Gilmour used a Leslie 147 speaker to modify his guitar sound.

Sysyphus Parts 1-4

Rick Wright / Part One: 1:09 / Part Two: 3:30 / Part Three: 1: 50 / Part Four: 7:00

Musicians

Rick Wright: Mellotron, organ, piano, electric harpsichord (?), electric guitar, vibraphone, tubular bells, voice, snare drum (?), cymbals (?)
Norman Smith: timpani (?), gong (?)

Recorded

Abbey Road Studios, London: September 17, 18, October 2(?), 8(?), 9(?), December 11, 17, 18, 1968; March 26, May 5, 7, 12, 1969 (Studio Two, Studio Three, Room Four)

Technical Team

Producer: Norman Smith
Sound Engineer: Peter Mew
Assistant Sound Engineers: Neil Richmond, Jeff Jarratt

For Pink Floyd Addicts

Pink Floyd and Rick Wright seem to have played "Sysyphus" only once onstage. And this was because they had no choice…The occasion was a gig in Birmingham in February 1970, and the reason was the late arrival of the truck carrying their equipment. A brief clip exists that was recorded from *Tomorrow's World* on the BBC.

Genesis

The idea of each member of the group composing his own piece and recording it alone for the *Ummagumma* studio album seems to have originated with Rick Wright. The Pink Floyd keyboardist, who opens the proceedings, takes the name of his musical work from a character in Greek mythology. Sisyphus was the son of Aeolus and Enarete, the husband of Merope (one of the seven Pleiades) and the founder and first king of the city of Corinth. He may also have been the father of Ulysses. After vanquishing Thanatos (the personification of death) and daring to defy the authority of the gods, Sisyphus was condemned for all eternity to roll a boulder up a mountainside in Tartarus (where, in Greek mythology, wrongdoers atone for their sins) toward a summit that he could never attain due to the weight of the rock, which would incessantly force him back down.

The inspiration behind Rick Wright's experimental symphonic poem in four parts was thus this archetypal hero who wanted to evade death but was unable to conquer immortality, a symbol of the absurd according to Albert Camus in his philosophical essay "The Myth of Sisyphus" (1942). "Theoretically you could do it live, and the only reason I did it virtually all by myself is that it was quicker that way," explains Wright. "I didn't write out scores, I drew graphs."[3]

Production

The four parts of "Sysyphus" are all very different. Unfortunately there is a lack of precise information about their respective recording dates.

"Ric's Scene [or Ricky's Scene], Part 1," the working title of "Sysyphus Part One," was recorded on September 17, 1968, kicking off the *Ummagumma* sessions. It would require a dozen takes. This first part, lasting barely a minute, plunges the listener into the world of the historical epic, with the fifth chords characteristic of that cinematic genre. Presumably Rick Wright's intention here was to evoke the antique origins of his hero Sisyphus. He can be heard producing various sounds, including strings and brass, on the Mellotron MK2. As revealed in the *Record Mirror* of January 25, 1969, however, it was Norman Smith who played the different percussion instruments, including the timpani and the gong (or orchestral cymbals?).

According to the author Glenn Povey, this short instrumental is actually an edit of the finale of the fourth part, which originally comprised a fifth section. A more logical explanation, however, is surely that this first sequence was copied and slowed down and tagged onto the end of "Sysyphus." This is borne out by the recording dates, the first part having been finished before the last. In terms of key, there is a difference of a fourth between the two, a consequence of the original version being slowed down.

The mood of this first section of "Sysyphus" is very different from that of "Astronomy Dominé" or "A Saucerful of

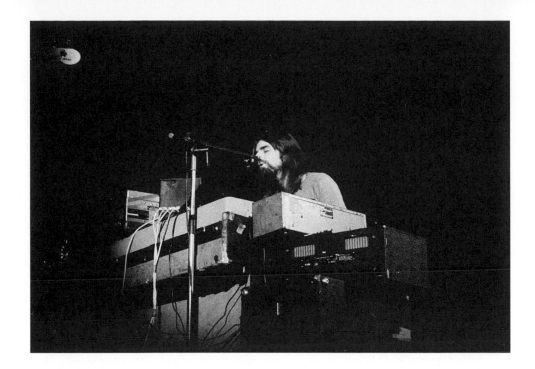

Secrets." It is always fascinating to see how certain musicians play completely differently in a solo context from the way they perform with their band. On the evidence of this piece, Rick Wright harbored a martial side that was more *Ben-Hur* than Pink Floyd.

The first part segues into the second via a cross-fade. Recording of this section also started on September 17, under the title "Ric's Scene, Part 2," before being definitively named "Sysyphus Part Two." Here Rick plays acoustic piano, in all likelihood the studio's Steinway B grand. His lyrical work vaguely suggests the influence of Russian or French composers such as Rachmaninov or even Debussy, although his style remains highly personal. At around 1:50, light and airy cymbals ring out, marking the start of free-jazz-style dissonances in the Cecil Taylor mold. Other percussion instruments also make an appearance, and stereo reverb is suddenly part of the picture, intensifying the sense of chaos, presumably with Norman Smith on the timpani.

The session dates for the third part (working title: "Ricky's Scene") are unclear. The musical material for this section is completely dissonant and lacking any formal principle other than the aleatory. According to Glenn Povey once more, the voice and electric harpsichord overdubs were added on March 26, 1969. This being the case, the latter would almost certainly have been the Baldwin electric harpsichord that EMI had acquired at the beginning of the year, the same instrument used on the Beatles' song "Because." Rick plays an improvised part on it, seeking out dissonances without any predictable structure. The instrument's strings can be heard groaning, and Rick seems to provide his own accompaniment on the snare drum and the bell of a cymbal. After recording an initial sequence, the keyboardist then, in order to intensify the chaotic effect, recorded another pass using the same instruments but totally independently

and mirroring the first in the stereo image. And as he still seems to have found his "Sysyphus Part Three" too mild, he then added some stress-inducing screams, sped up to sound even more unreal. This is not a track recommended for pregnant women.

This brings us to the fourth and last part: "Ricky's Scene, Part 4," or "Sysyphus Part Four," seven minutes of harrowing music, the recording of which began on December 11, 1968. This final track can be divided into four sections. The first begins with a peaceful, dreamlike, but oppressive atmosphere. Rick begins by producing a string sound on the Mellotron before adding vibraphone against a background of assorted birdsong—creating a similar pastoral mood to that of "Cirrus Minor" on the soundtrack to the movie *More*. Numerous instruments and sound effects can be heard, including an organ (or Mellotron) sound, modulated by an oscillator, which moves around the stereo spectrum; the sound of tubular bells (for example at 1:22); the Farfisa Compact Duo; and snippets of guitar played using the whammy bar in order to produce a plaintive effect (listen around 1:40).

Following a fade-out, the birds return, this time alone in their natural environment. This mood is interrupted by a bellowing chord played on what sounds like a pipe organ (perhaps recorded on the enormous instrument in the Royal Albert Hall?) and accompanied by timpani and a gong. The rest of the sequence is based mainly around two other, naturally dissonant organ parts and an acoustic piano whose strings are not only rubbed, but among which Rick Wright (as he would later reveal) inserted pieces of loose change in order to further distort the sonorities.

The piece concludes with a final sequence that is the aforementioned copy of "Sysyphus Part One," this time slowed down, during which Rick adds a choir of what sound like female voices to the Mellotron.

Grantchester Meadows

Roger Waters / 7:26

Musicians
Roger Waters: vocals, classical guitar, special effects
Recorded
Abbey Road Studios, London: March 24, April 25, 28, June 3, 1969 (Studio Two and Room Four)
Technical Team
Producer: Norman Smith
Sound Engineer: Peter Mew
Assistant Sound Engineers: Neil Richmond, Alan Parsons

 IN YOUR HEADPHONES
Attentive listening at 4:47 will reveal the sound of someone in the distance humming or possibly imitating the sound of a trumpet.

"Grantchester Meadows" in the '60s, a bucolic spot dear to Roger Waters's heart.

Genesis

Located just outside the prestigious university city of Cambridge, Grantchester is a green and peaceful village bordered by the River Cam. It was in this enchanting setting that David Gilmour came into the world and Roger Waters spent his childhood. This superb acoustic ballad is not unlike Proust's madeleine in that it evokes memories of the past. The very first notes plunge the listener into Pink Floyd's prehistory, into the youth of Waters, Gilmour, and even Syd Barrett, who came to Grantchester Meadows after school to play the guitar. "At Grantchester Meadows, teenagers caroused in the grass, far from parental eyes," writes Julian Palacios. "Sometimes, they would have drinks or ice cream in the tea gardens at the Orchard, under apple trees that exploded with blossoms in spring. By evening, pink clouds reflected in dark water, outlined by blue sky, as swans and kingfishers glide by."[17]

Roger Waters's lyrics paint a perfect picture of this atmosphere. He describes the crying of birds in the sky, *misty morning whisperings*, the song of the lark, the *barking of the dark fox*, and, even more directly, his teenage years (also, in a sense, the birth of Pink Floyd): *In the lazy water meadow/I lay me down* [...] *Basking in the sunshine of a bygone afternoon/Bringing sounds of yesterday into this city room.* However, change lurks behind this serene musical landscape. Change that can be as sudden as it is brutal and disquieting due to the *Icy wind of night* (the first line of the song) and the *gentle stirring sounds* that *belie a deathly silence.*

Production

Coming after Rick Wright's harrowing "Sysyphus," "Grantchester Meadows" offers a salutary return to tranquility and nature. The piece opens with forty seconds of recorded natural sound during which the song of a lark flits around the stereo field before being joined by a bee, completing the bucolic mood. It is interesting to note that the lark is on a relatively short loop of around three seconds (which repeats itself over and over until the end of the song), while the bee loop plays for ten seconds or so. Once this sonic landscape is firmly established, Roger Waters enters on classical guitar (the Levin Classic 3?), playing an arpeggiated pattern mainly on the two lowest strings (E and A). This accompaniment is answered by a solo part on a second

1969

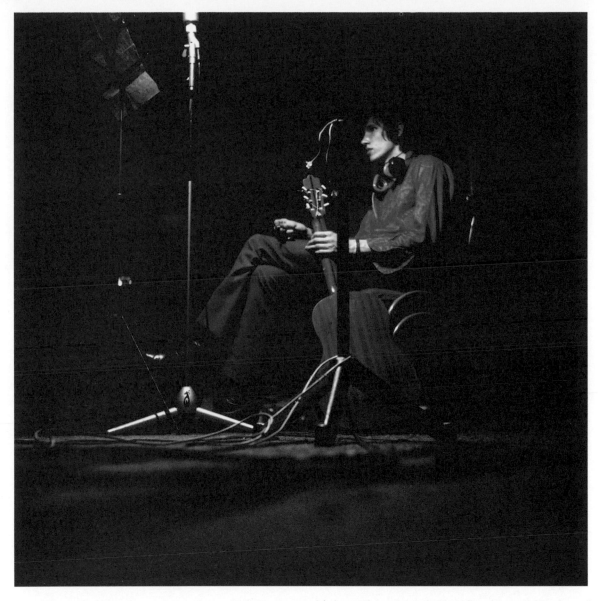

Roger Waters holding an acoustic guitar, which he plays in his beautiful acoustic ballad "Grantchester Meadows."

guitar, featuring a very pleasing counterpoint played mostly using the hammer-on technique. In keeping with the defined approach for this studio album, Waters also sings lead vocal, adopting a gentle, soothing tone of voice. He gives the impression of being doubled electronically by means of ADT. The effect works perfectly, except that at 3:22 the two voices get slightly out of phase on the word *sea*, betraying the fact that they were recorded on separate tracks in a stereo configuration. Furthermore, in the refrains, the phrase *Gone to ground* is mono, one of the two tracks having been muted in order to successfully create a sense of heightened proximity. In the second refrain (at 5:40), Waters harmonizes with himself.

At around 3:24, various other sound effects can be heard: a murmuring river that meanders delicately between the notes of the larksong, voices resounding in the distance, wild geese cackling before taking flight (4:15). Against this bucolic background, Waters plays a short guitar solo that is simple but effective. After he starts singing again, the natural sounds gradually gain the upper hand over the music, with the lark becoming ever more present, wheeling faster and faster, as if crazily, within the stereo field before being upstaged and replaced in the foreground by the bee. Someone can then be heard rapidly descending a staircase (Storm Thorgerson, according to some sources), chasing the insect with a flyswatter and eventually dispatching it! End of piece.

The first session for "Grantchester Meadows" is thought to have taken place on March 24, 1969. The song was completed on April 25 and mixed on April 28 and June 3. It was initially named "Roger's Scene, Parts 1 and 2," and then "Roger's Quarter, Second Movement" until Waters sensibly reconsidered...It is in the vein of the superb songs he wrote during the same period for *More*, such as "Green Is the Colour" and "Cymbaline." In terms of the melody, a certain similarity can be detected with the future "Goodbye Blue Sky," composed by the bass player in 1979 for *The Wall*.

Several Species Of Small Furry Animals Gathered Together In A Cave And Grooving With A Pict

Roger Waters / 5:00

Musicians
Roger Waters: voice, special effects
Ron Geesin (?): Scottish voice

Recorded
Abbey Road Studios, London: September 23 and December 17, 1968; March 18, 25, April 28, June 23, 1969 (Studio Two, Studio Three, Room Four)

Technical Team
Producer: Norman Smith
Sound Engineers: Peter Mew, Phil McDonald, Chris Blair
Assistant Sound Engineers: Jeff Jarratt, Neil Richmond, Anthony Mone

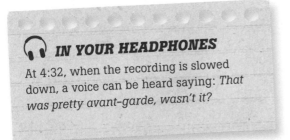

🎧 IN YOUR HEADPHONES
At 4:32, when the recording is slowed down, a voice can be heard saying: *That was pretty avant-garde, wasn't it?*

The friendship between Roger Waters and Ron Geesin, who could be Pict mentioned in "Several Species," dates from this period.

Genesis

Because "Grantchester Meadows" undershot Roger Waters's allotted half side of the LP, the bassist needed to get back to work. He then had the idea for this "naturalistic" collage, which demonstrates a desire to liberate himself from the usual song structure and to explore avenues that often resemble musique concrète (a form of electroacoustic music based on natural sounds). Convoluted as it is, the title "Several Species of Small Furry Animals Gathered Together in a Cave and Grooving with a Pict" sheds little light on Waters's intentions. During the first section of the piece, the noises of all sorts of animal (birds, frogs, and so on) can indeed be heard. The word Pict, meanwhile, denotes a member of one of various tribes that inhabited a large swath of Scotland from before the Roman invasion of Britain.

The second section is again a mini symphony of different sound effects over which Roger Waters declaims some rather strange-sounding verse (in the manner of Robert Burns, the great Scottish poet of the eighteenth century). It is possible to glean the following: the narrator has set himself up in Scotland as a mackerel fisherman only to become embroiled in a bloody conflict against the background of a religious war and the accession of the Catholic Mary Stuart to the throne of Scotland (a country that had recently become mainly Protestant). Roger Waters also mentions a claymore, which is a large sword used by Scottish warriors.

Production

As we have seen, the first section of this piece, the recording of which began in EMI's Studio Three on September 23, 1968, under the title "Roger's Tune," opens with the noises of various animals, all created by Roger Waters. He can even be heard using a duck call! These sounds are all accelerated and steeped in reverb, and the main intended effect is presumably humor. "It's not actually anything," Roger Waters would later explain. "It's a bit of concrete poetry. Those were sounds that I made, the voice and the hand slapping were all human generated—no musical instruments."[57] He can be heard slapping his hands (against his knees?) in order to create a rhythm (once again sped up) that is faded in from 0:26. Over this rhythm he plays a looped phrase that is a mixture of words and onomatopoeia (from 1:10). Around 2:19, piercing,

Was Roger Waters influenced by the John Lennon of "Revolution 9"?

varispeeded screams can be heard that would be just right for Halloween. In response to a journalist who inquired about the origins of the "chick's screams," an unidentified member of the group replied, to the amusement of all, that "The chick screaming is a very beautiful chick, she's very tall and thin and dresses in black, and she sits and drinks, and smokes cigarettes, and her name is Roger Waters."[57] Whether by chance or not, at around 2:51 and 3:13 these screams seem to take up the riff of "Astronomy Dominé."

The end of the rhythm announces the second part of the astonishing "Several Species of Small Furry Animals Gathered Together in a Cave and Grooving with a Pict," whose other working title was "Roger's Quarter, First Movement." A voice starts to declaim a text in a strong Scottish accent that makes the words difficult to understand and lends a humorous and caricatural tone. A short and very present delay adds to the formality of the text, creating the impression that it is being recited in an enormous stadium. It is tempting to believe that the orator of this parody is Ron Geesin, himself a native of Stevenston in Scotland, and more than capable of playing the "Pict" in question. "Roger's 'Several Species…' indicated the influence of his budding friendship with Ron Geesin,"[5] Nick Mason would later confirm. This friendship

would result in a major collaboration between Geesin and Pink Floyd on *Atom Heart Mother* in 1970. However, it would seem to be Waters, rather than Geesin, who recites the text. Either way, the voice then merges with numerous animal calls, all of a hallucinatory character, and following a final phrase delivered in a sententious and frenzied tone come four seconds of silence before the declamation eventually concludes with the words: *And the wind cried Mary*, an allusion to the similarly titled song recorded by Jimi Hendrix in 1967. The very last words of the piece are: *Thank you*. This Scottish parody was recorded in Room Four on June 23, 1969, not by Peter Mew, who engineered all the other studio tracks, but by Phil McDonald and Chris Blair.

This piece offers an insight into the wide creative range of the Floyd's bass player. He also displays a sense of humor that would not be greatly in evidence on the group's future albums—more's the pity. One swallow does not make a summer, as the saying goes.

"Several Species of Small Furry Animals Gathered Together in a Cave and Grooving with a Pict" was included on its own, in other words without "Grantchester Meadows," in the 1983 compilation *Works*. Should this be regarded as another example of Roger's humor?

The Narrow Way Part 1-3

David Gilmour / Part One: 3:28 / Part Two: 2:53 / Part Three: 5:57

Musicians
David Gilmour: vocals, backing vocals, acoustic and electric guitars, bass, keyboards, percussion, drums, Jew's harp, special effects

Recorded
Abbey Road Studios, London: January 16, 29, March 6, 17, 26, May 22, 27, June 17, July 5, 1969 (Studio Two, Studio Three, Room Four)

Technical Team
Producer: Norman Smith
Sound Engineer: Peter Mew
Assistant Sound Engineers: Neil Richmond, Michael Sheady, Richard Langham

David Gilmour plays a number of guitars on "The Narrow Way," notably his white Stratocaster.

Genesis

David Gilmour recalls the genesis of the album with absolute clarity: "We'd decided to make the damn album and each of us to do a piece of music on our own...It was just desperation really, trying to think of something to do, to write by myself. I'd never written anything before. I just went into a studio and started waffling about, tacking bits and pieces together."[3] The Pink Floyd guitarist even asked Roger Waters for help, with the lyrics at least. The reply he received was: "No, do 'em yourself."[36] Later, the author of this piece would deem it a pretentious waste of time.

"The Narrow Way" is a song in three parts. The first two are instrumental, with Part One centered on acoustic guitars, while Part Two is constructed around a pretty heavy electric riff with some keyboards. For Part Three, whose melodic elegance is already typically "Gilmouresque," the guitarist reused the words of "The Narrow Way," a segment of the suite *The Man and the Journey*.

These words are shrouded in mystery and evoke the *narrow way* that leads to the *darkness in the north* where *weary strangers' faces show their sympathy*. Little by little, the listener begins to grasp that these words are addressed to a person who has undertaken the long journey along this path, a person to whom the *night is beckoning*, who hears *the night birds calling*. The narrator describes the folly that lies within this person and urges him to cast his mind back to *the time when there was life with every morning*. It is difficult not to see this song as an allusion to the deterioration of Syd Barrett, who never really came back from his all-too-frequent psychedelic journeys.

Production

Of all the members of the group, David Gilmour took the longest to enter the studio. Whereas his bandmates had been working on their respective pieces since September 1968, it was not until January 16 that he decided to record "Dave's Scene," the working title of "The Narrow Way, Part One." Was he lacking in confidence, having joined the Floyd barely a year before?

This is an instrumental section whose style is a mixture of folk and the blues. Gilmour plays an acoustic guitar, presumably his Levin LT 18, apparently with drop D tuning (that

1969

is to say with the bottom E string lowered by a tone in order to obtain a D). He records himself on three tracks: on the first (which can be heard in the left-hand channel) he plays a rhythm part and on the second (in the right-hand channel) a combination of picking and strumming, while the third guitar (in the center) is used to support the other two. To this he adds various slide (bottleneck) licks, again on acoustic, with strong and very present reverb, and a second slide guitar in the form of his Stratocaster, played with a clear tone. On this he produces a series of very high notes close to the bridge with echo courtesy of the Binson Echorec (listen around 1:45). Reverb-laden percussion can also be made out (for example at 1:02). Finally, various electronic effects were added on January 29, notably an intro referred to in the recording notes as the "spiral effect." These seem to have been obtained from a lick played bottleneck on the Fender, lightly distorted (thanks to the Fuzz Face), looped through the Echorec, varispeeded and finally played backward. This sound is taken up again at various places and is complemented by what sound like notes produced on an organ or the Mellotron that pan around the stereo image (listen at 2:55).

The sessions for "The Narrow Way, Part Two" (working title: "Dave's Scene Second Movement") began on January 29. This section is based on a riff played by Gilmour on his Stratocaster with Fuzz Face distortion and a short delay. He doubles this on another track, and again on bass (Roger Waters's Rickenbacker 4001?). It forms an eight-bar sequence that is repeated virtually to the end of the piece. Gilmour resumed work on the recording on March 6, adding numerous overdubs including some percussion, most likely bongos and toms, which gets slightly out of time at the end of the sequences (listen at 0:32 and 0:51). He also plays a Jew's harp, although this blends with the numerous effects heard throughout the piece, making it difficult to identify. It is not at all easy to work out exactly which instruments were used to create these sounds, although guitars can clearly be heard, as can keyboards, including, presumably, the Mellotron. The sonorities are deeply distorted by means of every gadget at the guitarist's disposal: Binson Echorec, Fuzz Face, wah-wah, Leslie speaker (as on the guitar riff after 1:42), reversed and slowed-down tapes, and so on. Also during this session, Gilmour recorded a keyboard part that would serve as a link

with the next section. Finally, he added an organ on March 17 before mixing the section on June 17.

"The Narrow Way, Part Three" ("Dave's Scene, Third Movement") the first to be written by David Gilmour for the group…although recorded without the group because he plays all the instruments himself. The sessions took place on March 6, 17, and 26, and then May 27. A keyboard part makes the transition from the previous part to this, before giving way to the faded-in sound of a choir of male voices produced on the Mellotron. Gilmour clearly wanted to give pride of place to his Stratocaster, as there are no fewer than four different guitar parts here (not including the doubling). The first is played rhythm, its sound colored by a Leslie speaker; the second proposes a harmonic line featuring heavy distortion (and played solo at the end of the song); the third is clear-toned slide guitar; and the fourth is another lead guitar part, again played slide, with reasonably strong reverb and echo. Gilmour also plays acoustic piano, Farfisa organ, and bass, on which he seems to have recorded two distinct parts. Finally, as an all-round musician, he also delivers a very credible drum part, his fills curiously resembling Nick Mason's. First and foremost, however, the song derives its charm from his inimitable voice, alternately gentle and rougher edged, which he harmonizes in the refrains. The three parts of "The Narrow Way" were edited and mixed on July 5.

For Pink Floyd Addicts

The first movement of "The Narrow Way" seems to have been drawn from another composition by David Gilmour, "Baby Blue Shuffle in D Minor," which was recorded in December 1968 and broadcast on the BBC radio show *Top Gear* on December 15, 1968, although never released on record. This is also the piece that was to inspire the guitarist's "Unknown Song," unfortunately not used by Michelangelo Antonioni on the soundtrack of *Zabriskie Point*.

The Grand Vizier's Garden Party Parts 1-3

Nick Mason / Part One: Entrance, 1:00 / Part Two: Entertainment, 7:06 / Part Three: Exit, 0:39

Musicians

Nick Mason: drums, percussion, marimba
Lindy Mason: flute

Recorded

Abbey Road Studios, London: September 24, 25, October 1, 1968; January 21, 27, 28, April 2, 29, 1969 (Studio Two, Studio Three, Room Four)

Technical Team

Producer: Norman Smith
Sound Engineer: Peter Mew
Assistant Sound Engineers: Neil Richmond, Jeff Jarratt, Nick Webb

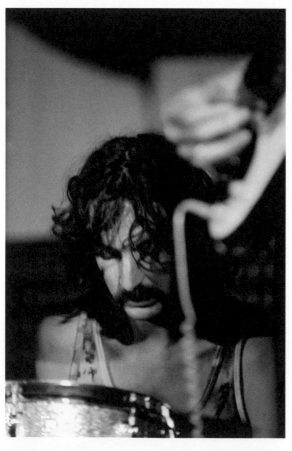

Nick Mason, the Grand Vizier of *Ummagumma*, in action.

Genesis

In his book *Inside Out: A Personal History of Pink Floyd*, Nick Mason remembers the piece he created for *Ummagumma*. "To create my section, 'The Grand Vizier's Garden Party,' I drew on available resources, recruiting my wife Lindy, an accomplished flute player, to add some woodwind."[5] And he adds: "For my own part, I attempted to do a variation on the obligatory drum solo—I have never been a fan of gymnastic workouts at the kit, by myself or anyone else."[5]

As its title unambiguously announces, "The Grand Vizier's Garden Party" is a sonic picture of the festivities held in his grounds by this high dignitary (of the Ottoman Empire, perhaps, or of some Arab land). The piece begins and ends with the gentle notes of Lindy Mason's flute. The setting for the main part, throughout which Nick Mason plays a wide range of percussion instruments, is the party itself.

Production

"Nicky's Tune," alias "The Grand Vizier's Garden Party, Part One—Entrance," first saw light of day in EMI's Studio Three on September 24, 1968. The main musician during this particular session was not Nick Mason, but his wife Lindy. The excellent flutist would also take part in three other Pink Floyd sessions in February 1969, all of them for the soundtrack of the film *More*. Here she plays a pastoral-sounding flute part that is recorded on two tracks, creating the impression of two players answering and overlapping each other's phrases. Nick Mason, the composer of this piece, clearly wanted an uncluttered, almost Zen-like atmosphere. This feeling of sublimity is shattered at 0:37 by a snare drum roll that shifts from mono to stereo at 0:53 and terminates with a single stroke of the cymbal and beat of the bass drum. This marks the end of the first act.

Studio work on the second part began on September 25. Known by the working title "Nicky's Tune, Section 2, Entertainment," this section was organized around four drum and percussion sequences. Two further sessions, on October 1 and January 27, would suffice for its completion.

The first of these sequences begins with timpani fed through the Binson Echorec in order to obtain an echo that

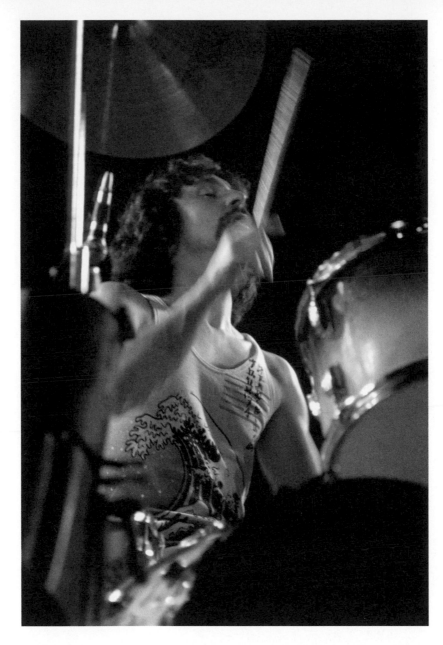

Left: "The Grand Vizier's Garden Party" affords Nick Mason an opportunity to play a rare solo.

Following page: Pink Floyd in concert at Le Bourget in 1970.

immediately pans from side to side of the stereo field. A gong, a triangle (or finger cymbals?), a cowbell, a snare drum, and a heavily distorted flute with short reverb all join in.

The second sequence begins with a muffled roll on the toms and the timpani (from 1:30), their sound enveloped in heavy reverb. A tune then emerges as if out of nowhere on the ghostly sounding marimba, which is joined before long by the flute.

Around 3:10, a roll is played on the timpani alone, announcing the start of the third section, referred to in the recording notes as "Rhythm Machine." This segment is built around tom and snare drum rolls plus a cymbal and what seems to be a sped-up wood block. Mason chose to mute each instrument for brief moments in a random way (presumably by placing patches of nonrecordable leader tape over the magnetic tape), in order to create an unexpected psychoacoustic gap.

The final sequence begins around 6:00. Here Nick Mason takes the inevitable drum solo, despite his lack of any real enthusiasm for this kind of thing. He nevertheless gives a very fine performance, ending this "Entertainment" (in actual fact the content bears little relation to this title) with a flourish…

The third and last part, "The Grand Vizier's Garden Party, Part Three—Exit" (otherwise known as "Nicky's Scene, Section 3"), returns to the flute of the beginning. In fact it appears that the whole of "Entrance" has been copied onto a single track and supplemented by Lindy Mason with two further flute parts to create a kind of canon-like polyphony. "Norman Smith was particularly helpful on the flute arrangements," Nick would subsequently acknowledge, although the studio manager was "less so by reprimanding me for editing my own tapes."[5] And it is in this joyful, pastoral atmosphere that the Grand Vizier's party draws to a close.

Embryo

Roger Waters / 4:42

Musicians: David Gilmour: vocals, acoustic guitar, electric guitar / **Rick Wright:** keyboards / **Roger Waters:** bass, gong (?) / **Nick Mason:** gong (?), cymbal / **Recorded: Abbey Road Studios, London:** November 26, December 3, 4, 1968; April 13, 1970 (Studio Two, Studio Three) / **Technical Team: Producer:** Norman Smith / **Sound Engineers:** Peter Mew, Anthony Clarke / **Assistant Sound Engineers:** Neil Richmond, Nick Webb

Genesis

"Embryo" is a song whose words and music were written by Roger Waters at the end of 1968. As David Gilmour confirms, recording work, begun on November 26 in the middle of the *Ummagumma* sessions, was suspended at a certain point: "We all went off it for some reason. We never actually finished the recording of it [...]."[36] Why was "Embryo" not chosen for inclusion on an original album? This remains a mystery as the song is a real success, starting with the utter originality of its subject matter. Through the lyrics, Roger Waters expresses the sensations of an embryo as it develops into a fetus. Eventually, right at the end of the song, the baby is born: *Here I go/I will see the sunshine show.* Before reaching this stage, however, the bassist has already tossed out a sequence of quirkily humorous lines such as: *Always need a little more room*, *Waiting here, seems like years*, and *All around, I hear strange sounds.*

Although not included on *Ummagumma*, "Embryo" was recorded "live" on December 2, 1968, for the BBC radio show *Top Gear* and after that was regularly performed in concert until 1971, featuring lengthy improvisations that sometimes took Waters's composition over the twenty-minute mark. As far as record issues are concerned, the song was chosen for inclusion on the compilation *Picnic: A Breath of Fresh Air* (1970) that united songs by various Harvest artists (notably "Into the Fire" by Deep Purple, "Mother Dear" by Barclay James Harvest, "The Good Mr. Square" by the Pretty Things, "Eleanor's Cake [Which Ate

Her]" by Kevin Ayers, and "Terrapin" by former Floyd member Syd Barrett) and a number of years later on *Works*, the 1983 Pink Floyd compilation released exclusively in the United States, and was eventually included in the box set *The Early Years: 1965–1972*, released in November 2016.

Production

On November 26, 1968, then, Pink Floyd entered the studio to record "I Am the Embryo," the working title of what was to become "Embryo." The first take was initially selected, before immediately being wiped at the second session, on December 3. The group duly rerecorded the base track, once again selecting the first take as the basis for the various voice, organ, and piano overdubs, which were completed the following day. But then the group seemed to lose interest and abandoned the song. More than a year after this final recording session, on April 13, 1970, Norman Smith was given the job of doing a stereo mix so that the song could appear on the Harvest compilation *Picnic: A Breath of Fresh Air.* The group was not present and would question the way its recording was marketed. "[...] EMI got Norman Smith to mix it, and they released it without our OK,"[36] David Gilmour would later declare.

"Embryo" is a slow, melancholy, and gentle piece. Like so many Roger Waters compositions from this period, it has an orientalizing melody. This impression is reinforced by the Mellotron flute sounds in the intro, the muffled gong and cymbal (struck on the bell), and the melodic

Roger Waters's remarkable bass line forms the backbone of "Embryo," the initial recording sessions for which date from autumn 1968.

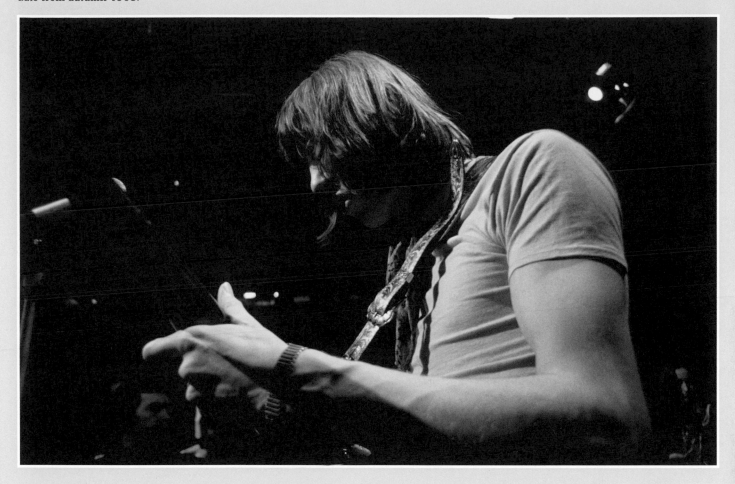

line supported by piano. On lead vocals is David Gilmour, singing in a characteristically silky voice. He can be heard doubling himself in the refrains, which bear a certain resemblance to nursery rhymes, and also playing acoustic rhythm guitar, presumably the Levin LT 18. For the instrumental part that follows immediately from the refrain (1:08), he plays electric, modifying the sound of his white Stratocaster with his wah-wah pedal in order to blend with the dreamlike atmosphere created by Rick Wright on keyboards. Wright can be heard at the same time on the Farfisa organ and the Mellotron, obtaining a steel drum sound from one of his keyboards, most probably by adding Echorec and/or chorus effects. In the coda (from 2:35), he improvises on the piano and at 3:08 is joined by the sped-up sound of crying children (made by Waters, some sources claim). While on the subject of Roger's contribution, it would be impossible to overstate the importance of his excellent bass line, which acts as the backbone of the song. His Rickenbacker 4001, played by Waters with abundant glissandi, has a velvety sound obtained in all probability as a result of being plugged directly into the console. It

is also with this instrument that "Embryo" concludes. It is a great shame that this track features on only two compilations because it deserves better!

For Pink Floyd Addicts

Rogers Waters would collaborate with Ron Geesin, the future orchestrator of "Atom Heart Mother," on the music for a documentary named *The Body*. In a possible nod to his partner, the corresponding record, *Music from the Body*, released in 1970, includes two titles composed by Geesin: "Embryo Thought" and "Embryonic Womb-Walk."

ZABRISKIE POINT

ALBUM
ZABRISKIE POINT
(ORIGINAL MOTION PICTURE SOUNDTRACK)

RELEASE DATE
United Kingdom: May 29 (30 according to some sources), 1970
United States: April 11, 1970
Label: MGM Records
RECORD NUMBER: MGM-CS-8120

TRACK-LISTING Heart Beat, Pig Meat /
Crumbling Land / Come In Number 51, Your Time Is Up
OUTTAKES Country Song / Unknown Song /
Love Scene (version 6) / Love Scene (version 4)

1970

Zabriskie Point, the Soundtrack of Disappointment!

Barely a year after *More*, the Floyd resumed their relationship with the motion picture industry when they agreed to contribute to the creation of the soundtrack for the new movie by the acclaimed Italian director Michelangelo Antonioni. Having won the Palme d'Or at the 1967 Cannes Film Festival for *Blow-Up*, his superb movie about the splendors of Swinging London, in *Zabriskie Point* he was now turning his attention to the US counterculture and the student protest movement in the universities of the West Coast.

The United States According to Antonioni

The movie, which takes its name from a place in Death Valley in the Sierra Nevada (California and Nevada), opens with a student meeting. A decision is taken to occupy the university and, if necessary, engage in an armed struggle in order to protest against the Vietnam War, racism, and more generally the recently installed Nixon administration. Mark (Mark Frechette) is a sympathizer with the cause rather than an active militant, but he has acquired a pistol all the same. When the police take the university by storm, a gunfight breaks out. A black student is killed, followed by a policeman. Mark pulls his gun out at the very moment the officer falls to the ground, but he is not the one who pulled the trigger. Afraid of being accused of murder, he steals a small tourist aircraft and flees the city.

Overflying the road that leads to Death Valley, Mark spots a car. At the steering wheel is a young woman by the name of Daria (Daria Halprin), the secretary of a real estate developer. Having run out of fuel and been forced to land, Mark is given a lift by Daria. The pair set off for Death Valley and indulge in some passionate lovemaking. Before long, however, Mark comes face-to-face with harsh reality once more: while returning the plane (now repainted in psychedelic colors), he is shot dead by a policeman. Daria learns the tragic news on the radio, and her hatred of the consumer society is intensified to a new pitch...

A Painful Birth

Michelangelo Antonioni immediately thought of Pink Floyd for the soundtrack of this celebration of flower power against the magnificent backdrop of Death Valley. The filmmaker had liked the Floyd ever since he saw them play at the launch party for the underground magazine *International Times* in London in October 1966. Following that he had been deeply impressed by the single "Careful with That Axe, Eugene," above all the live version on *Ummagumma*. At the end of 1969, after the initial contact had been made, Roger Waters, David Gilmour, Rick Wright, and Nick Mason jetted off to Rome. MGM had reserved rooms for them in the palatial Hotel Massimo D'Azeglio on Via Cavour, not far from the studio where they were to record. In his book, Nick Mason runs through the group's daily timetable: "Due to the short notice of the project, and Michelangelo's work schedule, we could only get time in the studio between midnight and nine in the morning. This meant a routine of trying to sleep during the day, cocktails from seven to nine, and dinner until eleven

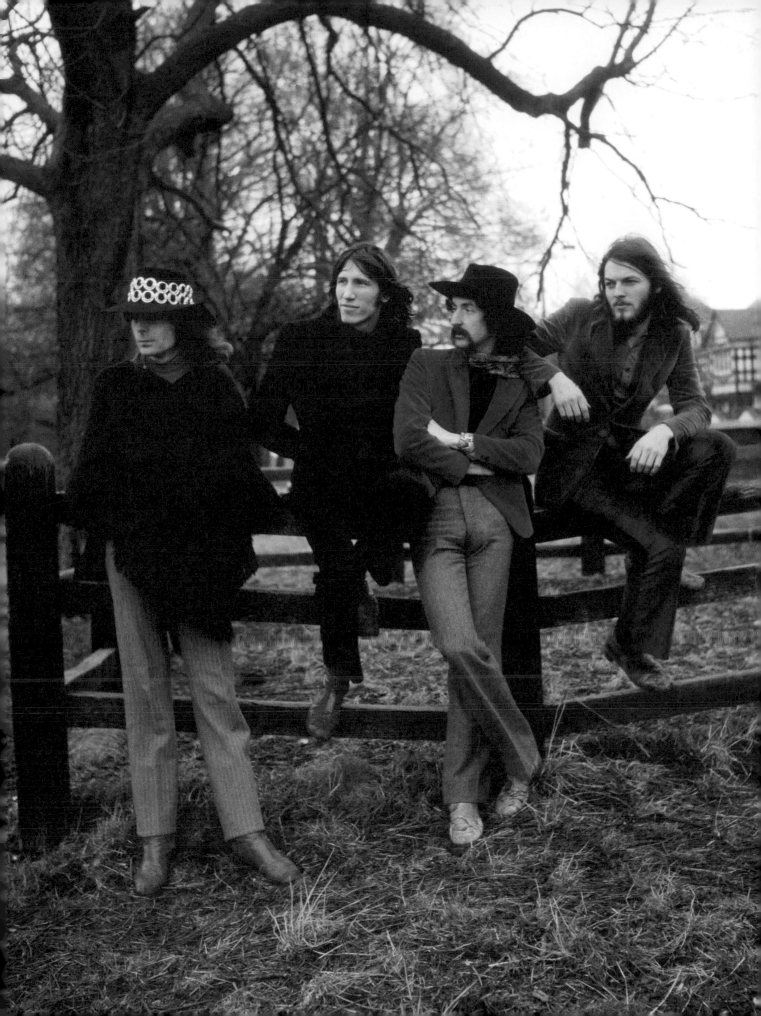

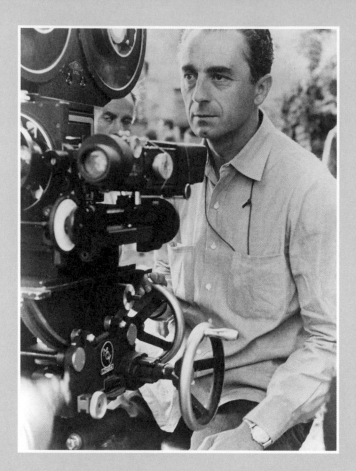

Michelangelo Antonioni, whose relationship with Pink Floyd would be turbulent, to say the least, during the recording of the movie soundtrack.

For the record, the Floyd is believed to have cut a "Christmas song" during the Roman sessions as a gift for Antonioni. To judge by Nick Mason and Rick Wright's laughter as they recall the number on air with Ted Alvy at KPPC-FM in October 1971, this was more of a gag than anything else...

relying on the help of the sommelier to use up the $40 per head allowance." He adds that they then "rolled down Via Cavour, exchanging banter with the hookers on the street corners, to the studios where we would do battle with the director and his film."[5] The atmosphere of the Italian capital may have been conducive to artistic creation, but relations between the four musicians and the director grew more and more tense as the sessions went on, mainly because of Antonioni's desire to control everything. "[...] each piece had to be finished rather than roughed out, then redone, rejected and resubmitted," writes Mason. "Roger would go over to Cinecittà to play him the tapes in the afternoon. Antonioni would never take the first effort, and frequently complained that the music was too strong and overpowered the visual image. One device we tried was a mood tape. We sub-mixed various versions and overdubs in such a way that he could sit at the mixer and literally add a more lyrical, romantic or despairing feel by sliding the mixer fader up or down. It still didn't work."[5] "We could have finished the whole thing in about five days because there wasn't too much to do," confirms Roger Waters. "Antonioni was there and we did some great stuff. But he'd listen and go, and I remember he had this terrible twitch, he'd go, 'Eet's very beauteeful, but eet's too sad,' or 'Eet's too strong.'"[9]

With the help of Don Hall, a DJ on the underground radio station KPPC-FM in Los Angeles and a connoisseur of Appalachian music, Michelangelo Antonioni therefore decided to look to other talented songwriters to help him complete the soundtrack. In the end, the album *Zabriskie Point (Original Motion Picture Soundtrack)* includes only three songs by Pink Floyd: "Heart Beat, Pig Meat," "Crumbling Land," and "Come In Number 51, Your Time Is Up." In addition, it comprises recordings by Jerry Garcia ("Love Scene"), Garcia's band the Grateful Dead (an excerpt from "Dark Star"), Kaleidoscope ("Brother Mary," "Mickey's Tune"), Patti Page ("Tennessee Waltz"), the Youngbloods ("Sugar Babe"), Roscoe Holcomb ("I Wish I Was a Single Girl Again"), and John Fahey ("Dance of Death"). The Floyd struggled to understand what was going on, as Nick Mason explains: "I mean, it was a huge disappointment to us, really, because, like...There were things that we might have did [sic] which we really thought were better than what eventually went on."[58] And Roger Waters raises the stakes by suggesting that Antonioni was worried that Pink Floyd might steal the show: "He was afraid of Pink Floyd becoming part of the film, rather than it staying entirely Antonioni. So we were quite upset when he used all these other things. I mean if he had used things which we found better..."[9]

The rerelease of the original soundtrack on CD in 1997 included a bonus disc that in addition to four versions of Jerry Garcia's "Love Scene" improvisations also contains some of Pink Floyd's other recordings for the project: "Country Song," "Unknown Song," and "Love Scene" versions 6 and 4. For the sake of completeness, it is also worth mentioning here that Pink Floyd recorded various other songs too during the Italian sessions, including "The Riot Scene," which would be reborn three years later under the title "Us and Them" (*The Dark Side of the Moon*), "Take Off," "On

ANTONIONI's
ZABRISKIE POINT

Metro-Goldwyn-Mayer presents A Carlo Ponti Production / A Michelangelo Antonioni Film "ZABRISKIE POINT" / Starring MARK FRECHETTE, DARIA HALPRIN and ROD TAYLOR / Written by Michelangelo Antonioni,
Fred Gardner, Sam Shepard, Tonino Guerra and Clare Peploe / Executive Producer, Harrison Starr / Produced by Carlo Ponti / Directed by Michelangelo Antonioni / Panavision & Metrocolor 🦁 MGM

A poster for Antonioni's movie, featuring Mark Frechette and Daria Halprin.

the Highway," "Auto Scene," "Aeroplane," "Explosion," "Looking at Map," and so on.

The album *Zabriskie Point* was released in the United Kingdom on May 29, 1970, three months after the movie premiere in New York on February 9. (It had its UK premiere in London on March[5].) Without exactly being a huge hit, the soundtrack album would enable Waters, Gilmour, Wright, and Mason to expand their audience and, in a sense, it paved the way for the group's first large-scale tour of the United States.

The Recording

Pink Floyd thus recorded most of their *Zabriskie Point* soundtrack in the studios of International Recording in Rome at 172 Via Urbana. The group seems to have been in Rome for a good part of November, although the sessions apparently took place mainly between the fifteenth and the twenty-second. Rick Wright provides some detail (differing here and there from Nick Mason): "It's all improvised, but nonetheless it was really hard work. We had each piece of music and we did about six takes of each, and he'd choose the best. Antonioni's not hard to work with, but he's a perfectionist. He was with us in the studios every night for two

weeks, from nine in the evening until eight the next morning, every night for two weeks to get 20 minutes of music. It was hard, but it was worth it."[9]

Opened by Giuseppe Antonino Biondo in 1959, the International Recording Roma studios were originally intended for sound recording, but after being acquired by the corporation NIS Film in 1968, they expanded their activities to take in international cinematic and domestic televisual post-production.

No definitive listing of the tracks recorded by Pink Floyd while working there in November 1969 has ever been drawn up. Nevertheless, it is known for sure that the following titles were cut in Rome: "Heart Beat, Pig Meat," "Come in Number 51, Your Time Is Up," "Love Scene," and "The Riot Scene." The sessions then continued at Abbey Road Studios in London for five days in December and three in January, with Phil McDonald at the console assisted by Neil Richmond. The group also seems to have worked at Advision Studios on Gosfield Street, London. Other numbers that would see the light of day as part of this project include: "Country Song," "Crumbling Land," "Take Off," and the various versions of "Love Scene." Once again, this list is probably not exhaustive.

Heart Beat, Pig Meat

Roger Waters / David Gilmour / Nick Mason / Rick Wright 3:12

Musicians
David Gilmour: vocals
Rick Wright: organ
Roger Waters: vocal effects
Nick Mason: drums (?), percussion (?)
Recorded
International Recording Roma Studios, Rome:
November 15–22, 1969
Abbey Road Studios, London: January 5
and 15, 1970 (Room Two, Room Three)
Technical Team
Producer: Pink Floyd
Sound Engineer (EMI): Phil McDonald

1970

> **For Pink Floyd Addicts**
>
> The version heard in the movie differs slightly from that on the album. It is a different mix, and certain sequences have been edited and put together in a different order.

Genesis

The musical cocktail devised by the musicians of Pink Floyd for their first piece of music for *Zabriskie Point* is a blend of percussion, voices, organ, and sound clips. Michelangelo Antonioni uses "Heart Beat, Pig Meat" at the very beginning of the movie, during the opening credits and student meeting. A television or radio journalist can be heard talking indistinctly. Among the first phrases that can be made out are: *These teenagers are sometimes so freaked out they cannot sit up straight in class/Perhaps white people are more impressed than black people…a better impression.*

Production

Listening to "Heart Beat, Pig Meat," it is immediately clear that Pink Floyd's musical approach here is quite different from the one they adopted for *More*. The atmosphere is far more tense and less psychedelic. The piece opens with a rhythm loop recorded using an instrument that is difficult to identify. It could be a bass drum or a tom, or equally a self-made or improvised percussion instrument. The dull sound is reiterated by the Binson Echorec, producing a stampede-like effect. Present throughout the track, this loop generates a palpable and somewhat disquieting tension. A sung vocal emerges from the depths with long and powerful reverb. This is presumably David Gilmour vocalizing in the same falsetto voice that he uses on "Careful with That Axe, Eugene." The melody is indefinable, creating a mysterious, dreamlike impression. Rick Wright is the only one to play a harmony instrument, in this case an organ (the Hammond M-102?), on which he improvises short sequences that reappear sporadically throughout the piece. Finally, Roger Waters, as he was fond of doing (listen to the various live versions of "Careful with That Axe, Eugene"), produces numerous vocal effects that depend heavily on the Binson Echorec. "Heart Beat, Pig Meat" would not be what it is without its many sound clips, which include voices on the radio, television excerpts, title music, and dialogues of one kind or another. The track was remixed at Abbey Road on January 5 and 15, 1970, under the title "Beginning Scene." Without exactly setting the world on fire, this instrumental fulfills its role of movie opener perfectly.

Mark and Daria, an emblematic countercultural couple in the lunar landscape of Death Valley.

Crumbling Land

Roger Waters / David Gilmour / Nick Mason / Rick Wright 4:16

Musicians
David Gilmour: vocals, acoustic guitar, electric guitar
Rick Wright: vocals, organ, piano
Roger Waters: bass
Nick Mason: drums, timpani, gong (?)
Recorded
Abbey Road Studios, London: December 13, 15–17, 1969;
January 1 and 5, 1970 (Studio Two and Room Three)
Technical Team
Producer: Pink Floyd
Sound Engineer: Phil McDonald
Assistant Sound Engineer: Neil Richmond

IN YOUR HEADPHONES
Toward the end of the song, at around
3:40, the sound of urban road traffic
can be heard. Nick Mason recorded this
in Rome.

Daria making her way to Phoenix, Arizona, in a borrowed car,
to the strains of David Gilmour singing "Crumbling Land."

Genesis

The lyrics written by Pink Floyd for this song can be seen as an allegory of the movie. The man living on a hill with *many shining things*, including a gleaming car and diamond rings, could well be Daria's boss, the person she is on her way to meet in Phoenix, Arizona. It is also a song about the harm wreaked by the pollution of the industrial age. On the ground, a *dealer* (whether of automobiles or drugs is not entirely clear, although the Ford production lines are mentioned) *coughs and dies* while the *eagle flies in clear blue skies*. The world is in wrack and ruin, hence the title of the song. Nevertheless, there is a message of hope: at the end, the eagle abandons this doomed world and flies into the sun.

With their second composition for Michelangelo Antonioni's movie (the director may be represented by the man described in the lyrics as appearing in the sand like a mirage), Pink Floyd has played the card of traditional American music, one that is ideally suited to the natural scenery of Death Valley. Is it a parody of the music of Jimmie Rodgers and Hank Williams or a genuine homage to it? David Gilmour would later confide that a country and western tune of this kind "could have got done ten times better by numerous American groups, but he used ours. Very strange…"[36]

Production

It was in London, rather than Italy, that "Highway Song" (the working title of "Crumbling Land") was recorded. The Floyd took six sessions to complete the song, the second three given over mainly to remixing. It is a surprising piece of work that sounds somewhat like a pastiche of the Byrds, Crosby, Stills & Nash, or even the Grateful Dead. David Gilmour can be heard picking his acoustic guitar (Levin LT 18?) and white Stratocaster simultaneously. Nick Mason lays down a very good rhythm with brushes (and sticks on the ride cymbal), switching to the timpani (sadly undermixed) in the two bridges. It is said that five kettledrums were provided for the December 15 overdubs. Roger Waters supports his bandmates with a country-style bass line, while Rick Wright plays Hammond organ and piano. Wright shares the lead vocals with Gilmour, and the results are on the whole pleasing.

Come In Number 51, Your Time Is Up

Roger Waters / David Gilmour / Nick Mason / Rick Wright / 5:05

Musicians
David Gilmour: vocals, electric rhythm and lead guitar
Rick Wright: vocals (?) keyboards
Roger Waters: voice, bass
Nick Mason: drums

Recorded
International Recording Roma Studios, Rome:
November 15–22, 1969
Abbey Road Studios, London: January 1 and 5, 1970
(Studio Two and Room Three)

Technical Team
Producer: Pink Floyd
Sound Engineer (EMI): Phil McDonald
Assistant Sound Engineer (EMI): Neil Richmond

David Gilmour makes an extremely good contribution—
both rhythm and lead—on his white Strat.

Genesis

This instrumental piece is used at the very end of the film, at the moment when the desert home of Daria's boss blows up, symbolizing the consumer society in the process of falling apart. The hippie utopia, which has its roots in the work of Henry David Thoreau, is shown at this moment to be the only credible response to the materialism that has been put in place as the supreme value. In the movie, this track, which runs for 5:05, stops at 3:43. Its title, "Come In Number 51, Your Time Is Up," is a phrase taken from a sketch in the satirical and surrealist BBC Two show *Q5*, created by Spike Milligan in March 1969, in which the English comic actor parodies boat-rental clerks, who used the expression to call in customers who had exceeded their time. There are no words in "Come In Number 51, Your Time Is Up," which is actually a retreading of "Careful with That Axe, Eugene," the piece released as a single in December 1968 and included in a magnificent live version on the double album *Ummagumma*, which had gone on sale in October 1969, shortly before the *Zabriskie* project. It was this number that had prompted Antonioni to approach the quartet for the soundtrack of his movie.

Production

"Come In Number 51, Your Time Is Up" was recorded in Rome in November 1969. This twin of "Careful with That Axe, Eugene" is in a lower key than the original, namely E minor. The slower tempo is closer to that of the live version on *Ummagumma*. This instrumental foregrounds the various upper-register vocals sung in all likelihood by both David Gilmour and Rick Wright. These voices are both more numerous and more present, each one drowned in powerful reverb. Roger Waters whispers various phrases (rendered incomprehensible by a significant delay) that pan furiously from side to side of the stereo field, although not the famous "Careful with That Axe, Eugene." In terms of the musical arrangement, Rick Wright's organ lays down mellow pads over which Roger Waters's bass riff warbles. Nick Mason marks the tempo mainly on a ride cymbal, and Gilmour plays a clear-toned Stratocaster with a tremolo obtained either from the Echorec or his guitar's volume control. At 2:53, Waters's scream, substantially more virile than the one

Daria's boss's house explodes to the sound of
"Come in Number 51, Your Time Is Up," an
adaptation of "Careful with That Axe, Eugene."

on the album version of "Careful," marks the transition of
this piece toward a harder style, with a distorted second solo
guitar, unbridled drums and organ, and a loud and meaty
bass. At 3:46, a thunderous *Yeah!* contributes to the over-
charged atmosphere. The track was remixed in London on
January 1 and 5, 1970, under its working title "Explosion."
Antonioni could not have found a better musical accompani-
ment for his closing sequence. "Come In Number 51" is an
out-and-out triumph.

The primal cry of Daria—emitted by Roger
Waters, actually—at the moment of the
explosion, to express metaphorically his
disgust with the consumer society, is not
the first primal cry in the work of Pink
Floyd, but it is certainly one of the most
famous in the cinema! Coincidence?

Zabriskie Point Outtakes

Pink Floyd recorded a number of songs for the *Zabriskie Point* sessions that would not, in the end, be used in the movie. Four of these were included as "official" outtakes on the double CD released by Sony in 1997: *Zabriskie Point (Original Motion Picture Soundtrack)* (88697638212). Others can be found on a more recent release, the box set *The Early Years: 1965–1972,* which came out in November 2016. It is only the four outtakes on the 1997 CD that we will consider here.

Country Song

Roger Waters / David Gilmour / Nick Mason / Rick Wright / 4:42

Musicians: David Gilmour: electric lead guitar / **Rick Wright:** piano / **Roger Waters:** bass / **Nick Mason:** drums / **Recorded: International Recording Roma Studios, Rome:** November 15–22, 1969 (?) / **Abbey Road Studios, London:** December 12, 13, 17, 1969; January 5, 1970 (Studio Two) / **Technical Team: Producer:** Pink Floyd / **Sound Engineer:** (EMI): Phil McDonald / **Assistant Sound Engineer (EMI):** Neil Richmond

Genesis

Pink Floyd like to wrong-foot their public, and the only thing that's country about this song, which they composed specially for *Zabriskie Point,* is its title. It is more of a rock ballad with an abundance of distorted guitar. Is this why Antonioni decided against including it in his movie?

"Country Song" presents two characters in an unusual kind of fable: a king who hugs the border *in the shadow under the trees,* and the Red Queen who awaits news of him. The tale takes a completely abstract turn when it becomes a question of gold in the treasury and then a game of chess lost by the queen, who starts to cry. She ends up smiling *at the cat, who smiled back.* The spirit of Lewis Carroll is not far away…

Production

It is not known for certain whether "Country Song" was worked on in Italy, but it was the first take recorded at EMI on December 12, 1969, that served as the base for the various overdubs. The real framework of the piece is provided by Rick Wright's rhythmic piano, which is supported by Nick Mason's drumming and Roger Waters's bass. David Gilmour takes care of the acoustic guitar and the singing. In the verses he harmonizes with himself in a gentle, fragile-sounding voice, before adopting a more raucous rock style on the refrains. This was also an opportunity for him to let it rip on his Stratocaster, strongly distorted courtesy of his Fuzz Face, and the resulting sound is reminiscent of that of "The Nile Song" on *More.* He plays the song out with a solo on his Fender, but definitely not one of the best of his career…In its present state, "Country Song" is more like a demo than a finished piece, but some listeners may question the strength of the song itself.

For Pink Floyd Addicts

"Country Song" is also known by the titles "The Red Queen" and "Looking at the Map."

The light aircraft "borrowed" by Mark. It is shown here being given a psychedelic makeover.

Unknown Song

Roger Waters / David Gilmour / Nick Mason / Rick Wright / 6:01

Musicians: David Gilmour: acoustic guitar, electric guitars / **Rick Wright:** keyboards / **Roger Waters:** bass / **Nick Mason:** drums / **Recorded: International Recording Roma Studios, Rome:** November 15–22, 1969 / **Abbey Road Studios, London:** December 12, 13, 17, 1969; January 5, 1970 (Studio Two and Room Three) / **Technical Team: Producer:** Pink Floyd / **Sound Engineer (EMI):** Phil McDonald / **Assistant Sound Engineer (EMI):** Neil Richmond

Genesis

"Unknown Song" is a partly acoustic number reminiscent of the version of "The Narrow Way, Part 1" (from the album *Ummagumma*) that was renamed "Baby Blue Shuffle in D Major" for a live show recorded for the BBC on December 2, 1968. David Gilmour has pride of place. Antonioni rejected the track despite its fitting the atmosphere of the movie pretty well—in particular Mark the student and Daria the secretary's quest for the absolute in a world dominated by consumerism. This song is also known by the title "Rain in the Country."

Production

"Unknown Song" is apparently also an unfinished song. It is clearly a recycled version of "The Narrow Way, Part 1," featuring similar arrangements, an identical tempo, and the same key (D). Although credited to all four musicians, David Gilmour was presumably the main author of this

instrumental. He can be heard picking an acoustic guitar (on the right) and playing lead electric (on the left) and electric slide (in the center). He is not joined by his bandmates until 1:54, when Nick Mason comes in on drums and Rick Wright on keyboards, but most prominently Roger Waters on bass, with a hook that he would reuse in the "Funky Dung" section of "Atom Heart Mother" on their next album (of the same name). For the time being, he plays for only a little over seven bars before stopping and picking up the same motif a little further on, at 2:37, and then continuing virtually to the end of the track. Curiously, Waters sticks with the same notes despite the changing harmonies, giving the impression of having been recorded alone in his own corner without taking any account of the others! "Unknown Song" is not exactly an indispensable number in the group's discography, but it contains the seeds of a section of their future (and magnificent) next album.

The four members of Pink Floyd. The "Love Scene" imagined by Antonioni inspired them to create several very different versions.

Love Scene (version 4)

Roger Waters / David Gilmour / Nick Mason / Rick Wright / 6:46

Musicians: Rick Wright: piano / **Recorded: International Recording Roma Studios, Rome:** November 15–22, 1969 / **Technical Team: Producer:** Pink Floyd / **Sound Engineer:** (?)

Genesis

Pink Floyd recorded six versions of "Love Scene," none of which Antonioni used in the soundtrack of his movie. On the other hand, two of them, "Love Scene (Version 4)" and "Love Scene (Version 6)," can be found on the double album CD released in 1997.

"Love Scene (Version 4)" is a long, romantic improvisation on piano by Rick Wright (although the piece is again credited to the four members of the group). The piano has a vibraphone-like sonority, inevitably calling to mind a highly elegant style of modern jazz, in particular the Modern Jazz Quartet's *Third Stream Music*.

Production

Rick Wright would later explain that he preferred to compose while improvising, spending hours playing tunes and chords that would dissipate as quickly as they came. Fortunately, the tape was running for "Love Scene (Version 4)." His performance is surprising and betrays a sensitive and no doubt introverted and fragile personality. His playing is a blend of jazz and classical, revealing the influence of pianists such as Bill Evans and Duke Ellington, but also Debussy and Satie—all in moderation, however, as Wright forges his own, highly personal style here. While his technique may not have been on the same level as that of the great performers—as he himself would regret—it was sufficiently expressive to enable him to skillfully convey all his emotions. And that is the mark of a real musician.

Love Scene (version 6)

Roger Waters / David Gilmour / Nick Mason / Rick Wright / 7:12

Musicians: David Gilmour: electric lead guitar / **Rick Wright:** piano / **Roger Waters:** bass / **Nick Mason:** drums / **Recorded: International Recording Roma Studios, Rome:** November 15–22, 1969 / **Abbey Road Studios, London:** December 17, 1969 (Studio Two) / **Technical Team: Producer:** Pink Floyd / **Sound Engineer (EMI):** Phil McDonald / **Assistant Sound Engineer (EMI):** Neil Richmond

Genesis

"Love Scene (Version 6)" brings about a radical change of musical atmosphere. Here the Floyd plunges headlong into an electric blues of the kind that has been played since the 1950s in the clubs and recording studios of Chicago. Also known by the compelling title "Pink Blues" and recorded as "Alan's Blues," this track provided David Gilmour with an opportunity to channel the brilliance of the greats, in particular West Side luminaries such as Otis Rush, Magic Sam, and Buddy Guy.

Production

Here, then, the Floyd tries another foray into the twelve-bar blues for their musical accompaniment to the love scene. Pride of place goes to Gilmour's Fender Stratocaster with distortion from the Fuzz Face. The guitarist plays with enormous feeling, even if he does not yet display that exceptional touch that was to make him unique on albums to come. There are signs that the track was not completely finished, such as traces of a badly wiped initial guitar solo (listen at 0:33 and 0:49) and a number of wrong notes at inopportune moments (for example 1:53 and 2:40). Nevertheless, given the length of the improvisation, the group could surely be forgiven for thinking the director had sufficient material from which to choose a flawless excerpt. Gilmour shares the solos with Rick Wright, who likewise delivers some very fine phrases on the piano. As for the rhythm section, Mason and Waters do an efficient job. Originally recorded in Rome, the track was mixed at Abbey Road on December 17, 1969.

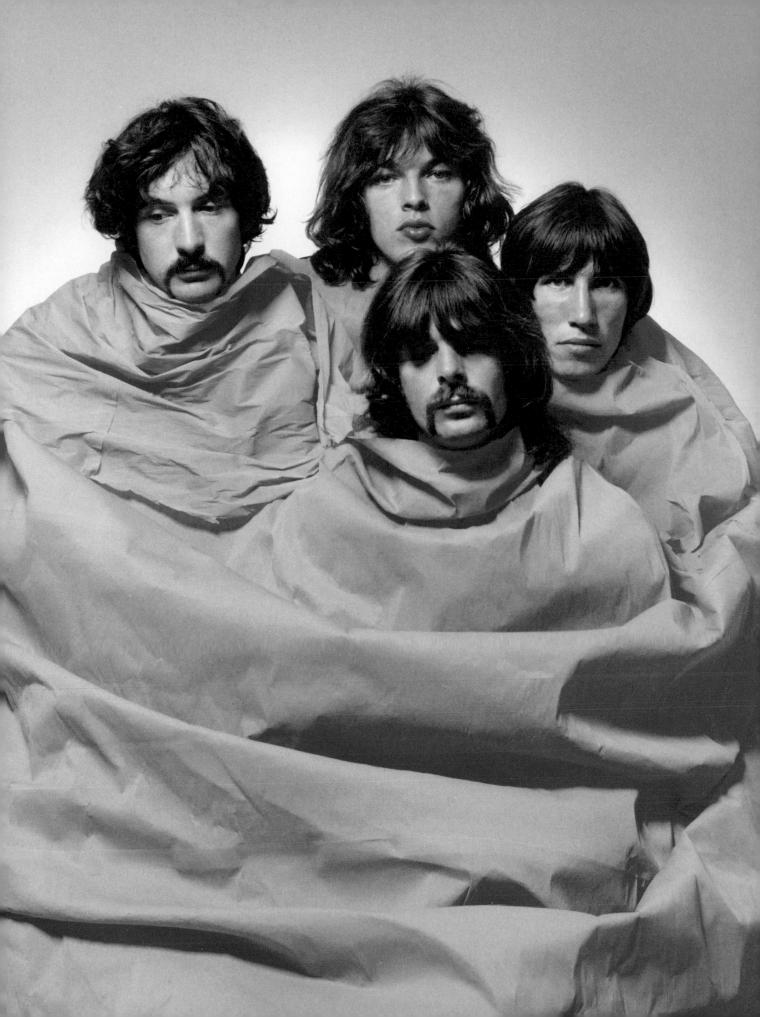

ATOM HEART MOTHER

ALBUM
ATOM HEART MOTHER

RELEASE DATE
United Kingdom: October 10 (October 2 according to some sources), 1970

Label: Harvest Records

RECORD NUMBER: SHVL 781

Number 1 (United Kingdom), number 4 (France),
number 5 (the Netherlands), number 8 (West Germany)

Atom Heart Mother (Father's Shout – Breast Milky – Mother Fore –
Funky Dung – Mind Your Throats Please – Remergence) / If /
Summer '68 / Fat Old Sun / Alan's Psychedelic Breakfast
OUTTAKE No One Tells Me Anything Around Here

For Pink Floyd Addicts

In 1971, Stanley Kubrick approached Pink Floyd about using the music of "Atom Heart Mother" in his movie *A Clockwork Orange*. As a result of his indecision regarding the choice of extracts, and more importantly because of his demand to use the extracts as and when he saw fit, the group declined...

Atom Heart Mother, Symphony for a Cow in E Minor?

When they were released in February and June 1967 respectively, the single "Strawberry Fields Forever"/"Penny Lane" and the album *Sgt. Pepper's Lonely Hearts Club Band* seemed to announce nothing less than an aesthetic revolution. Thanks to the Beatles—and more particularly the magical Lennon–McCartney partnership, for whom creativity in the studio henceforth took precedence over the energy of live performance—composers, arrangers, singers, and instrumentalists on the rock scene were fired by new ambitions. Although for many of them the guitar remained the key element, a range of different instruments began to take on an increasingly important role in the emergence of progressive rock. These included the flute (Jethro Tull and then Genesis), the saxophone (Soft Machine, Van der Graaf Generator), and new types of keyboard including the Mellotron and the synthesizer (the Nice, King Crimson, Yes). What's more, this broader range of instruments helped to lift barriers and promote a fusion between rock and classical music under the impetus of a new generation of virtuosi who had been to music college: Keith Emerson of the Nice, Jon Lord of Deep Purple, and Rick Wakeman of Yes to name a few. Some of these improbable encounters between rock and classical music took a disastrous turn, for example Concerto for Group and Orchestra (1970) composed by Jon Lord and conducted by Malcolm Arnold, which could have ruined Deep Purple's career. Others were out-and-out triumphs both artistically and commercially: Procol Harum's "A Whiter Shade of Pale," inspired by two works of J. S. Bach (the F-major sinfonia from the cantata *Ich steh mit einem Fuß im Grabe* and Orchestral Suite no. 3 in D Major); Jethro Tull's "Bourée" (on the album *Stand Up*, 1969), an adaptation of the bourrée from Bach's Suite for Lute no. 1 in E Minor; and the album *Ars Longa Vita Brevis* (1968) by the Nice, which includes an adaptation of the intermezzo from Sibelius's symphonic *Karelia* Suite.

The Symphonic Dimension

The members of Pink Floyd, who had voyaged through the infinite spaces of psychedelic rock in their first two studio albums and even in the soundtracks they had composed for Barbet Schroeder and Michelangelo Antonioni, would take up a new challenge in what was to be the fifth album in their official discography. The decision to endow their music with a symphonic dimension dates from the "The Man and the Journey Tour," and more specifically from the culminating concert of June 26, 1969, billed as "The Final Lunacy," when the four musicians were joined on the stage of the Royal Albert Hall in London for their finale by the brass of the Royal Philharmonic Orchestra and members of the Ealing Central Amateur Choir (conducted by Norman Smith!). The experiment having been both exciting and promising from a musical point of view, and the support of the EMI management having substantially firmed up in the wake of the commercial success of *Ummagumma*, Roger Waters, David Gilmour, Rick Wright, and Nick Mason decided to explore this avenue further on their next album—or at least on one of its two sides.

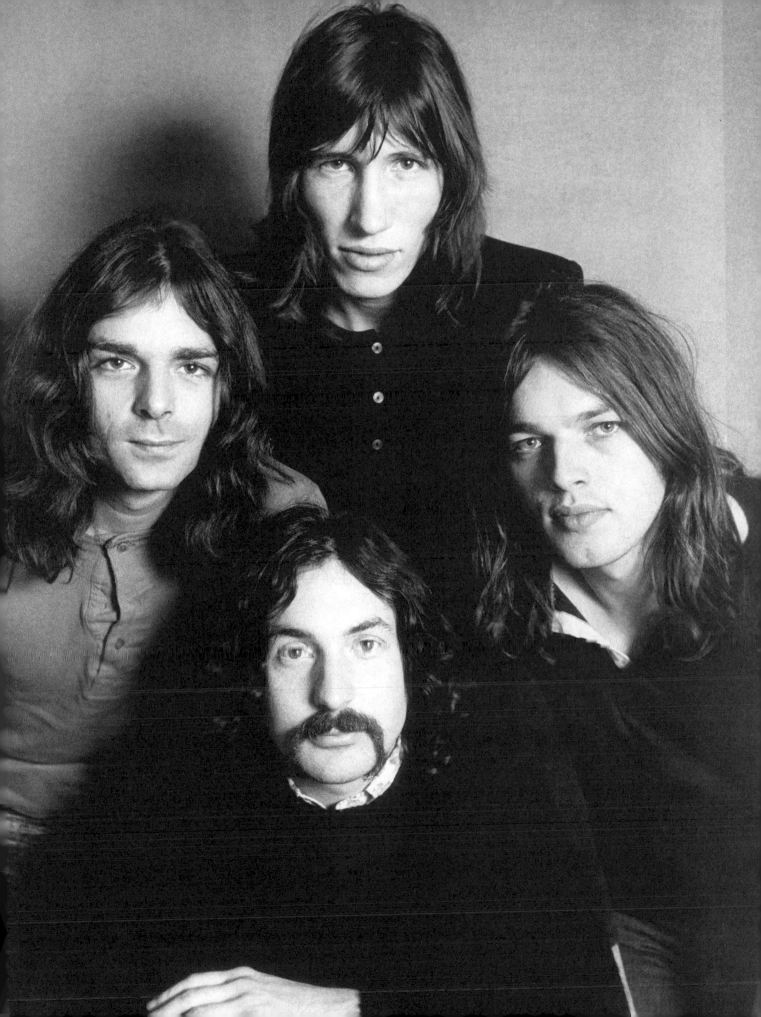

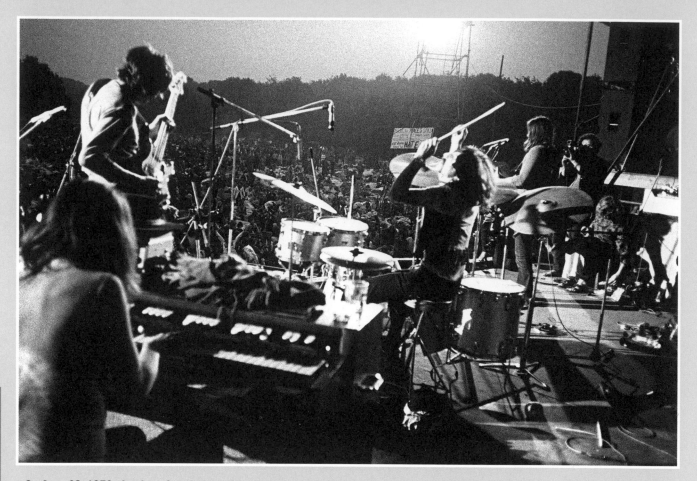

On June 28, 1970, the day after their performance at the Bath Festival of Blues & Progressive Music '70, Pink Floyd appeared at the Holland Pop Festival in Rotterdam. Or more accurately June 29, because the group actually went on stage at around four o'clock in the morning. They played "Atom Heart Mother," which was announced as *The Amazing Pudding*.

Ron Geesin Makes His Entrance

It was at this time that the Scottish composer and arranger Ron Geesin came onto the scene. The paths of Pink Floyd and Ron Geesin had crossed a number of times during the second half of the sixties, the first occasion having been at the "14 Hour Technicolor Dream" at Alexandra Palace on April 29, 1967. Geesin was subsequently inducted by the tour manager Sam Cutler into the Floyd's inner circle and became a close friend of Nick Mason and his wife Lindy as well as Roger Waters. "I was getting on well with Roger as a human, you know, we played golf together,"[9] he recalls. The artistic collaboration between Geesin and Waters—two atypical musicians—was born with the recording of the highly experimental "Several Species of Small Furry Animals Gathered Together in a Cave and Grooving with a Pict" on the album *Ummagumma*. It was to continue on *Atom Heart Mother* and in their creation of a soundtrack for *The Body*, a documentary directed and produced by Roy Battersby and narrated by Frank Finlay and Vanessa Redgrave (all three of them members of the Trotskyite Workers Revolutionary Party). The concept was to make the human body the lead character in a movie while at the same time showcasing the latest discoveries in biology and anatomy. The music was released on November 28,

1970 (almost two months after *Atom Heart Mother*), in the form of an album entitled *Music from the Body*. This album comprises a total of twenty-two titles—including eight written or co-written by Waters—in which traditional instruments (guitar, piano, and so on) are combined with sounds made by the human body (cries, laughter, breathing, flatulence). It is interesting to note that the other members of Pink Floyd played on the very last track on the album, "Give Birth to a Smile," Geesin having in the meantime befriended Wright and Gilmour, although the guitarist would reveal to Geesin on the occasion of a special performance of "Atom Heart Mother" in 2008 that he had always found his Scottish humor difficult to take…

Geesin's presence was also explained, however, by the fact that all four members of the Floyd were feeling somewhat jaded at this point in their career, as the Scotsman recounts in his excellent book *The Flaming Cow* (2012): "[…] it was obvious to me at that time that the group was getting close to running on empty. It had toured extensively and internationally; it was becoming famous; it was being encouraged, pushed by EMI Records and manager Steve O'Rourke, to get the next album out."[60] In short, they needed help, and the friendly Geesin was the person they turned to as the embodiment of that help. Rick Wright confirms that their inspiration

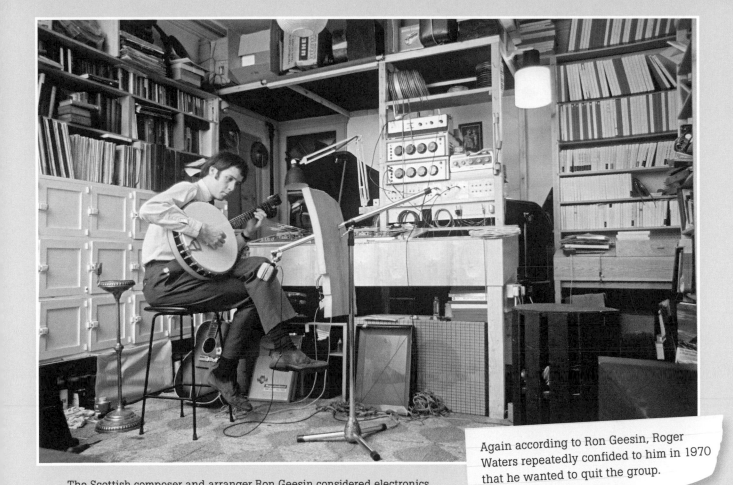

The Scottish composer and arranger Ron Geesin considered electronics to be a little like painting, claiming that it enabled him to create a sonic palette and paint with sounds. Geesin was to play a key role in the final version of "Atom Heart Mother."

Again according to Ron Geesin, Roger Waters repeatedly confided to him in 1970 that he wanted to quit the group.

had waned a little: "We did get into a lazy period. There was a point when we sat about not knowing what to do. That was before and during 'Atom Heart Mother.'"[9] Geesin may have been the group's chosen solution, but he would pay a price that must have left a bitter taste in his mouth…

The Album

"Ron seemed an ideal choice to create the arrangements on 'Atom Heart Mother,'" writes Nick Mason. "He understood the technicalities of composition and arranging, and his ideas were radical enough to steer us away from the increasingly fashionable but extremely ponderous rock orchestral works of the era."[5] Ron Geesin takes up the story: "It would have been around the time of finishing the music for *The Body* in March that Nick and Roger first asked me if I would do something with a tape they had compiled at EMI Abbey Road Studios. None of the group could read or write music in the conventional sense, but they wanted 'something big' that would have to be written, 'scored' […]"[59]

Pink Floyd were due to leave for their third United States tour in a few weeks' time, on April 9. Geesin complied with their request: "They handed me this backing track, and I wrote out a score for a choir and brass players, sat in my studio, stripped to my underpants in the unbelievably hot

summer of 1970."[1] The work in question would give its name to Pink Floyd's fifth album and fill the whole of the first side. The second side comprised four tracks: "If" (Roger Waters), "Summer '68" (Rick Wright), and "Fat Old Sun" (David Gilmour) in a pop-rock-folk mode, plus "Alan's Psychedelic Breakfast," a collectively composed avant-garde quasi-instrumental piece.

Atom Heart Mother went on sale in the United Kingdom and the United States on October 10, 1970 (October 2 in the UK according to some sources). There was a danger that the group's new symphonic orientation would put off fans from the early years, those who had succumbed to the psychedelic, fairyland charms of *The Piper at the Gates of Dawn* or the space-rock vibe of *A Saucerful of Secrets*. Not true! The album took Pink Floyd to the number one spot (in the United Kingdom) for the very first time. It would also reach number 4 in France, number 5 in the Netherlands, number 8 in West Germany, and a disappointing number 55 on the United States Billboard chart (before eventually being certified gold in the US). At the time of its release, Roger Waters declared: "The album is less experimental than 'Ummagumma,' much nicer to listen to. I think it's by far the best, the most human thing we've done."[9] *Atom Heart Mother* was also unanimously

and wholeheartedly acclaimed by the press. For example *Beat Instrumental* wrote in its December 1970 issue: "With this utterly fantastic record, the Floyd have moved out into totally new ground. Basically a concept album, the A-side title track utilizes Pink Floyd, orchestral brass and mixed choir. All blend to form a totally integrated theme which is the great strength of this LP. Great, great, great and I'd love to hear it in quadriphonic."[58]

In retrospect, however, the group would be less than completely satisfied with the album, and in particular with Ron Geesin's contribution to it. In 1972, Nick Mason summarized the views of all four band members in the *New Musical Express*: "Well, we'd all like to do it again. We'd all like to re-record it. It wasn't entirely successful. But it was extremely educational."[9] And in 1984, Roger Waters would express himself in far stronger terms on BBC Radio 1: "If somebody said to me now, 'Right, here's a million pounds, go out and play "Atom Heart Mother,"' I'd say, 'You must be fucking joking. I'm not playing that rubbish!'"[57] Indeed the feelings of the group toward Geesin—whether justified or not—ran so high that they didn't mention him in the credits, even in the remastered editions, despite the choral director John Alldis being acknowledged with "special thanks." Mason, who remained friends with the unfortunate Scottish composer-arranger, would justify himself by explaining that the album did not represent the direction that Pink Floyd wanted to move in at that time.

From Mrs. Constance Ladell to Lulubelle III

After the album was recorded it became urgent to find a definitive name for the new LP's flagship track, the working titles having successively been "Untitled Epic," "Epic," and then "The Amazing Pudding." On July 16 the group were gathered in the control room of the BBC's Paris Cinema (in London) with Ron Geesin, waiting to play live for the radio show *Peel Sunday Concert*. Geesin pointed to the early edition of the *Evening Standard* and said to Waters: "You'll find a title in there."[57] The bassist flicked through the newspaper and came across an article headlined "Atom heart mother named," referring to a certain Mrs. Constance Ladell, the first British woman to be fitted with a nuclear-powered heart pacemaker. The journalist, Michael Jeffries, explains that the device had been implanted in the body of a fifty-six-year-old woman at the National Heart Hospital in London. The energy source that powered the pacemaker was plutonium-238 (180 milligrams) enclosed in a tiny capsule. Waters immediately saw what an original title this would make and suggested it to his bandmates, all of whom found it a brilliant idea! Finally baptized, the piece in turn gave its name to the album. Some remember it differently. Although the *Evening Standard* edition of July 16, 1970, has since been reproduced and verified, Gilmour and Mason recollect "[...] a story about a woman having a baby who had this thing put in her heart"[9] (in the words of our esteemed guitarist!).

Once again, the sleeve is the work of Hipgnosis, and of Storm Thorgerson in particular. "...I wanted to design a non-cover, after the non-title and the non-concept album something that was not like other covers, particularly not like other rock or psychedelic covers—something that one would simply not expect,"[58] he explains. Different ideas were proposed at the time, two examples being a diver in a swimming pool and a young woman in an evening dress, standing at the foot of a staircase. Pink Floyd eventually opted for the third design: a close-up of a cow in a field. According to Thorgerson, what won the four members of the group over was not "[...] the attitude of the cow herself, who seems to be saying, 'What do you want?', out of curiosity rather than aggression, but the whole nonsensical 'What the fuck is an ordinary old cow doing on the front of one of the world's most progressive psychedelic albums?' [...]"[58]

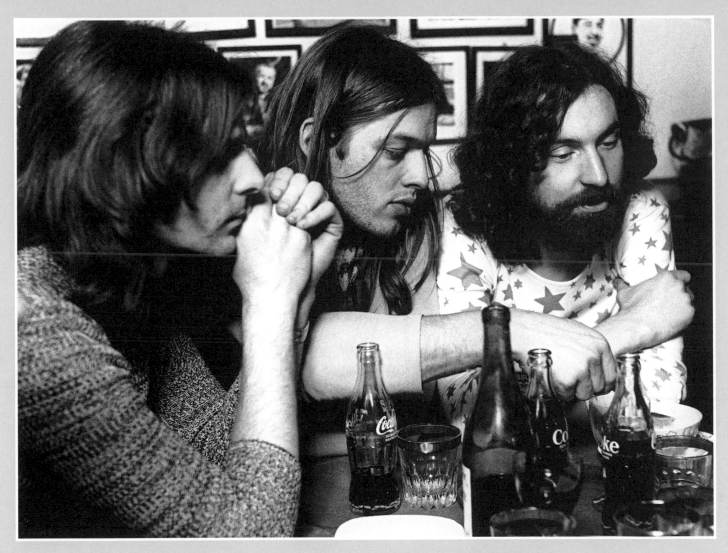

A moment of relaxation backstage for Rick Wright, David Gilmour, and Nick Mason.

Was Storm Thorgerson influenced by Andy Warhol's *Cow* wallpaper? Perhaps. It is known, at any rate, that the designer, having jumped in his car and driven out into the peaceful English countryside, took a picture of the first cow he came across in a field near Potters Bar in Hertfordshire. The phlegmatic quadruped was called Lulubelle III. On the reverse of the sleeve, three more cows stare back at the lens. The inside illustration consists of a black-and-white photograph: cows yet again, this time relaxing in a field after a hard day's work…On the subject of ruminants and their connection with the album, Nick Mason would make an observation in the November 1970 issue of *Rolling Stone* magazine that was enigmatic to say the least: "There is a connection between the cows and the title if you want to think of the earth mother, or the heart of the earth."[9]

The Recording
Studio work for the Floyd's fifth album began on March 2, 1970, and continued until July 21 of that year. The group once again used Abbey Road Studios (now definitively renamed following the release of the eponymous Beatles album in September 1969), requiring around thirty sessions in total. The piece "Atom Heart Mother" alone needed around twenty. The recording sessions were clustered into two main periods: the first in the month of March and the second in June and July, the group going on tour to the United States in between. Before leaving for the States, however, Roger Waters had given Ron Geesin a tape containing the bare bones of the future "Atom Heart Mother" so that the Scotsman could come up with his own arrangement.

Upon returning in June, the Floyd went back to Abbey Road to resume recording. The arranger had fulfilled his task, composing a score for twenty choral singers, who would be conducted by John Alldis, a section of ten brass instruments, and a cello part that would be played by the Icelandic virtuoso Hafliði Hallgrímsson (not credited on the LP). However, the sessions would take place in an atmosphere of antagonism emanating in particular from the brass section, various members of which adopted an openly hostile attitude toward Geesin. In the end, the song would be recorded as well as could be expected under the

A superb Gibson J-45, identical to the one used on the album by David Gilmour.

For Pink Floyd Addicts

When Pink Floyd had their equipment stolen in the United States in May 1970, one of the staff members at the hotel where they were staying tactfully suggested that they offer the local police a reward in order to speed up their investigations. To their great surprise, the truck was found the following day…

circumstances, becoming the first piece of rock music to occupy an entire side of an album. The other four tracks were worked on exclusively after the United States tour, and mainly in July (with the exception of "Fat Old Sun," which the group cut in June).

The album was produced by Pink Floyd, although Norman Smith is credited as "Executive Producer." This was the last time he would be associated with the group. The technical team consisted once again of Peter Bown at the console, assisted by Alan Parsons, who ceded his place temporarily to John Kurlander and Nick Webb (for the mixing).

Technical Details

Pink Floyd recorded the bulk of *Atom Heart Mother* in Studio Two at Abbey Road, now that the Fab Four were no longer in residence (and no longer even together, for it was a month after the Floyd's first session in March 1970 that Paul McCartney officially announced he was leaving the Beatles). By this time the 3M M23 eight-track tape recorder was well and truly in service, as was the TG12345 console. As for the mics and assorted studio effects, this equipment was essentially the same as it had been for the preceding albums.

The Instruments

On May 16, 1970 (May 22 according to some sources), toward the end of their third US tour, Pink Floyd found themselves in New Orleans and were due in Houston for their next gig. Unfortunately, they discovered that the truck containing a large part of their equipment had been stolen from outside the Royal Orleans Hotel, where they were staying. The stolen items included David Gilmour's two guitars (his white Stratocaster and a brand-new black Stratocaster with rosewood neck that he had recently purchased at Manny's Music in New York City); Roger Waters's two basses (his Rickenbacker 4001 and his white Fender Precision); Nick Mason's two drum kits; one of Rick Wright's two organs and

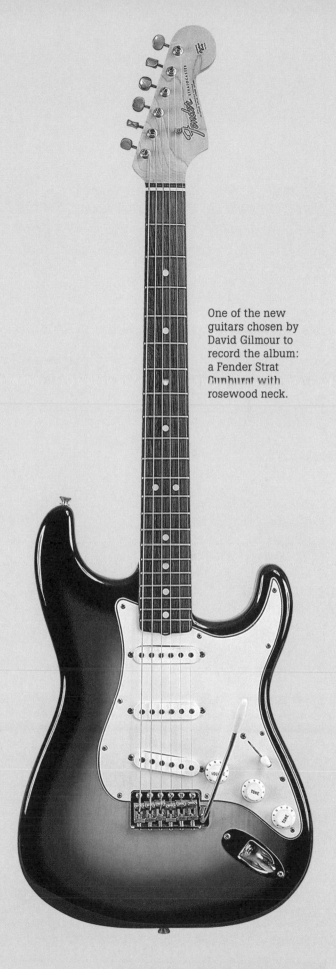

One of the new guitars chosen by David Gilmour to record the album: a Fender Strat Sunburst with rosewood neck.

a piano; their 4,000-watt, twelve-speaker PA system; the five Binson Echorecs; and all the cables and mics needed for the sound system. Fortunately, most of the instruments were eventually recovered, with the exception of the guitars. The remaining dates on the tour were nevertheless canceled, and Gilmour returned to Manny's Music, where he bought his famous black Stratocaster with maple neck, the legendary 1969 "Black Strat."

When the group had started recording the new album in March, Gilmour was still using his white Stratocaster. After returning to the studio in June, he switched to his new "Black Strat" as well as a second Stratocaster, this time a Sunburst (a 1959 model with a 1963 rosewood neck that he would fit to his "Black Strat" not long after), given to him by Steve Marriott of Humble Pie. In terms of acoustic instrument, he seems to be using a Gibson J-45, as can be seen from the official promo clip of "Grantchester Meadows" recorded during a television appearance on KQED TV on April 28, 1970, in San Francisco. Roger Waters abandoned his Rickenbacker for good after the New Orleans theft, opting instead to use two Fender Precision basses, one black, which was to become his main instrument between 1974 and 1978. For the March sessions, he is thought to have been using his 4001 still (no doubt along with his white Precision). Nick Mason and Rick Wright were playing more or less the same instruments as before, with Wright also using the Abbey Road Moog IIIP.

As for amplification, Gilmour, Waters, and Wright were plugged into Hiwatt Custom 100 DR-103 All Purpose 100-watt amp heads connected to WEM Super Starfinder 200 (4x12) speakers, but it is also highly likely that they used the amplifiers that belonged to Studio Two. Gilmour and Wright also used a Leslie 147 speaker.

Atom Heart Mother

Nick Mason, David Gilmour, Roger Waters, Rick Wright, Ron Geesin / 23:43
Father's Shout: 0:00–2:52 / Breast Milky: 2:53–5:26 / Mother Fore: 5:27–10:11 / Funky Dung: 10:12–14:56 /
Mind Your Throats Please: 14:57–19:12 / Remergence: 19:13–23:43

Musicians
David Gilmour: electric rhythm and lead guitar
Rick Wright: organ, piano, Mellotron
Roger Waters: bass, percussion (?), sound effects
Nick Mason: drums, percussion, sound effects
Ron Geesin: arrangements
John Alldis: conductor (choir and brass)
The John Alldis Choir: sopranos: Eleanor Capp, Jessica Cash, Rosemary Hardy, Hazel Holt; altos: Margaret Cable, Peggy Castle, Meriel Dickinson, Lynne Hurst, Geoffrey Mitchell, Celia Piercy, Patricia Sabin; tenors: Rogers Covey-Crump, Peter Hall, John Whitworth, Kenneth Woollam; baritones: John Huw Davies, Brian Etheridge, Bryn Evans, Brian Kay; bass: David Thomas (according to Ron Geesin)
The Philip Jones Brass Ensemble: three trumpets, three trombones, three French horns, one tuba
Hafliði Hallgrímsson (?): cello

Recorded
Abbey Road Studios, London: March 2, 3, 4, 24, June 13, 16–24, July 8, 13, 15, 17, 1970 (Studio Two and Room Four)

Technical Team
Producer: Pink Floyd
Executive Producer: Norman Smith
Sound Engineers: Peter Bown, Phil McDonald
Assistant Sound Engineers: Alan Parsons, John Leckie, John Kurlander, Nick Webb

For Pink Floyd Addicts
On the back of "Atom Heart Mother," Pink Floyd became the first rock group to take part in the Montreux classical music festival (September 1971).

Genesis

Since recording "A Saucerful of Secrets" in spring 1968, and performing the suite *The Man and the Journey* at the Royal Festival Hall on April 14, 1969 (renamed *The Massed Gadgets of Auximenes: More Furious Madness from Pink Floyd* for the occasion), Roger Waters, David Gilmour, Rick Wright, and Nick Mason had dreamed of writing a long work in several movements.

The first band member to get down to work was David Gilmour. At the end of 1969 he composed an "epic" theme that reminded him a little of the music for the movie *The Magnificent Seven* (1960), composed by Elmer Bernstein. Hence the title given to the piece at the very beginning: "Theme from an Imaginary Western." During a rehearsal, Waters heard—and liked—this sequence of chords, which conjured up images of "horses silhouetted against the sunset."[53] Before long, David Gilmour began to work on the idea—to some extent an evocation of wide, open spaces—with Rick Wright. Gilmour recalls: "We sat and played with it, jigged it around, added bits and took bits away, farted around with it in all sorts of places for ages, until we got some shape to it."[53] As a result, the guitarist's original composition developed into a considerably longer piece made up of several parts.

The earliest-known public performance of this work took place on January 17, 1970, when Pink Floyd included it in a concert at the Lawns Centre in Cottingham (near Hull) in England. Two further British performances followed on January 18 and 19, and then another at the Théâtre des Champs-Élysées in Paris on January 23. On this occasion, David Gilmour presented the as yet unnamed piece ("Here's the last piece we're going to do for you, although we don't really know what we are going do...we only wrote it last week and so...um...here we go!")[59] The initial version of the future "Atom Heart Mother" must already have taken shape by January 16, the day before its first public outing.

"Atom Heart Mother": from Honing to Recording

In February, the Floyd continued to hone their new (and still untitled) piece across the length and breadth of England in at least five concerts. Finally, on March 2, they entered Abbey Road Studios to cut an initial version, referred to

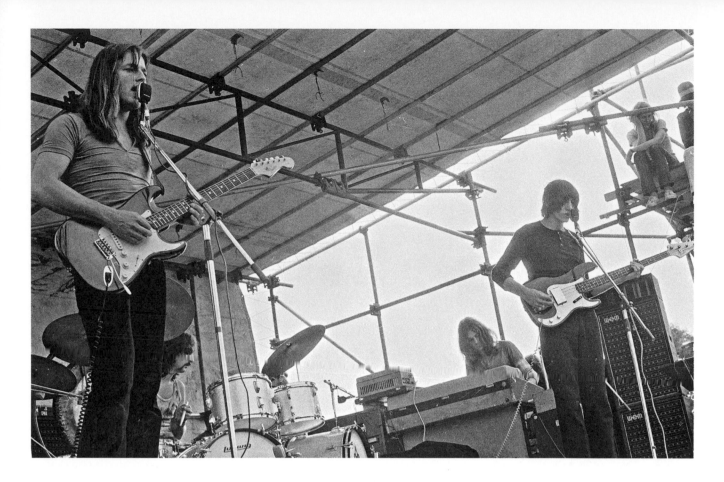

as "Untitled 1," with Peter Bown and Alan Parsons engineering. The unusual length of their piece—more than twenty-three minutes—presented the group with a major problem. According to Nick Mason, EMI's technical staff refused to edit one-inch eight-track tapes, which were a relatively new technological innovation. This implies that the musicians had to record their parts in a single pass with as few mistakes as possible. "Roger and I embarked on what can only be described as an Odyssean voyage to record the backing track. In order to keep tracks free for the overdubs we had bass and drums on two tracks, and the whole recording had to be done in one pass."[5] Given the absence of electronic clicks or quantization, the two unfortunate musicians had no other choice but to estimate the beat and rely on their memory to tell them where they were in the various sequences. (Neither Waters nor Mason could read music.) This explains a certain fluidity in the timing. However, Ron Geesin would dispute this version of events, maintaining that the tape he had been given as the basis for his arrangements was effectively a collage of various short sections.

The following day's session (March 3) was given over to mixing and editing the third take, which had been marked "best." Organ, guitar, voice, and piano overdubs were done the next day. Finally, on March 24, there were new drum and voice takes, followed by the editing and mixing of the various sequences. This session was supervised by Phil McDonald and John Leckie, and it was this mix that Roger Waters

would pass on to Ron Geesin to work from. Assuming it bore a resemblance to the live recording of January 23 from the Théâtre des Champs-Élysées, this version must have differed appreciably from that on the LP. The piece opens with mewing seagulls, the main melody is not yet defined, and certain sections are either totally distinct or do not yet exist, notably the one with Gilmour and Wright singing falsetto. Overall, however, the framework is in place, and this "Untitled 1" would end up being played some twenty-three times between January and the end of April. "It was the full, or expected, length of around twenty-three minutes," recalls Geesin, "and had all the drums, bass, organ, piano and guitar chord parts, with the addition of the guitar solos, in their final positions. The introduction was just a simple opening drone with some gong-like cymbals, and the first effects sequence was sketched in for length. The second effects, or 'excursion,' section was originally percussion only, but was changed by the group later."[60]

The group wanted the Scottish composer-arranger to pad out the sound, and he proposed using a choir and brass. As the production budget would not stretch any further, Steve O'Rourke made it clear to him that there had to be a limit of twenty singers and approximately ten brass. This meant Geesin was unable to engage players from the New Philharmonia Orchestra as he had originally intended, but instead used the Philip Jones Brass Ensemble. To conduct the choir, he suggested John Alldis. Finally, judging the second theme played by David Gilmour to be lacking in substance, he

Ron Geesin at the Cadogan Hall on June 15, 2008, during a performance of "Atom Heart Mother" as part of the Chelsea Festival (London).

proposed adding a cello solo, and the name of the Icelandic virtuoso Hafliði Hallgrímsson was immediately suggested.

Geesin's Final Shaping

On April 9, Pink Floyd kicked off their third United States tour with a concert at Bill Graham's Fillmore East in New York City. Geesin was therefore left to his own devices in London without any precise indication of what was expected of him: "With them in the States, I just couldn't do anything with the tape [...] I didn't really know what they wanted."[9] For its part, the group continued to hone the piece onstage, but following the theft of its equipment in New Orleans on or around May 16, it canceled the final dates of the tour and returned home earlier than anticipated. "[...] when they came back, the panic was on," recalls Geesin. "You know, everyone wanted it in a couple of weeks or so, typical show biz bloody panic. Nobody knew what was wanted."[9]

Geesin got down to work with a vengeance on May 25, having, it seems, spent a couple of hours with Rick Wright on May 21 in order to work out how to begin the choral section and to choose some motifs, and with David Gilmour in order to spice up the initial theme of the piece that Gilmour had developed on the guitar. They reached a somewhat vague, tacit agreement that gave Geesin carte blanche to complete and fill out the rest of the piece. From May 29 to June 12, a time of stifling heat in the British capital, the Scotsman literally shut himself away in his lair at 208 Ladbroke Grove, London. Having listened to the tape over and over again, Geesin started to write a score that would link

up all the various Floyd compositions and proceeded to make various changes. In the end it was he who gave the whole thing its structure: sixteen sections that he labeled A to Q (leaving out O):

A. Intro
B. First theme (ten bars at 72 bpm)
C. Development of the intro
D. Development of the first theme
E. Trio (bass, organ obbligato [sixteen bars at 144 bpm])
F. Bass, organ obbligato punctuated with drums
G. As before, but with slide guitar
H. As before, with more incisive slide solo
I. Choir and organ chords
J. Funky section
K. Development of the first theme
L. Solo percussion
M. Repetition of D
N. Repetition of E and F
P. Repetition of G and H
Q. First theme to the end

These sixteen parts would be organized into six movements during the final recording of what would later be named "Atom Heart Mother."

A Difficult Task

The main difficulty encountered by Ron Geesin was the wide range of beats. "There were variations between sections that weren't due to any progression, just to an accident," he explains. "Dropping back in tempo when it really should have increased a bit, maybe; or it would be better to

1970

The choral director and conductor John Alldis the indispensable partner of Ron Geesin, and responsible for making the "Atom Heart Mother" recording sessions a success.

have a sudden change, rather than a very slight change."[53] And he continues: "So it was a problem, when it came to actually recording the live musicians on top of the prerecorded tracks, to get the tempo right. It's normal anyway for classical musicians to have problems with the beat. Classical beat sense and rock beat sense are quite different."[53]

The group was back at Abbey Road on June 10. Voices, timpani, and sound effects (skillfully devised by Waters and Mason for sections C and L) were added to the piece, now renamed "Untitled Epic," and subsequently "Epic," as Geesin notes on his score. Drum, guitar, and bell overdubs were added on June 16, and on the following day piano, more guitar, and a click track. On June 17, Geesin met the copyist George Bamford, who had the unenviable task of writing out the parts of all the musicians in just two days. On June 18, a Hammond organ, a Mellotron, voices, and various sound effects were recorded.

At 2:30 p.m. the next day, Friday, June 19, three trumpets, three trombones, three French horns, and a tuba were ready and waiting for Ron Geesin in Studio Two of Abbey Road. These were elite professional musicians who took little interest in the task in hand other than to get the job done as quickly as possible. The atmosphere was electric, and Geesin was somewhat on edge. He immediately met with hostility from certain musicians, in particular one of the three horn players, who sensed his nervousness. "One horn player was particularly awkward—making little remarks, and asking questions he knew the answers to,"[53] adds Geesin, who was a composer-arranger rather than a conductor. The session became confrontational. Nick Mason recalls the episode:

"With microphones open they knew every comment would be noted and their discreet laughter, clock-watching, and constant interruptions of 'Please sir, what does this mean?' meant that recording was at a standstill, while the chances of Ron being had up on a manslaughter charge increased logarithmically by the second."[5]

Just when Geesin thought he had completely lost control of the session, John Alldis, the choral director dropped in more or less by chance to gauge the atmosphere of this first recording. As a seasoned conductor, Alldis agreed, at Geesin's urgent insistence, to take up the baton at this session, while the Scotsman made do with a supervisory role and took refuge in the control room. Order was thus restored, and a second overdub session on June 20 completed the brass players' involvement in the recording.

In the first session of Sunday, June 21, starting at 2:30 p.m., also held in Studio Two, the group got down the organ as well as various percussion parts for section L (in Geesin's configuration of the piece). According to the notes seen by Glenn Povey, this recording was named "Experimental percussion section with train sounds." John Alldis then arrived with twenty choral singers for the second session, which started at 8 p.m. Directed by the hand of the master, the choir quickly recorded its part. Before reaching this point, however, Geesin discovered to his horror that he had made a mistake in his score over section J, the future "Funky Dung." Nick Mason had pointed out that Geesin had taken the second beat in the bar as the first, which resulted in all the subsequent bars getting out of phase! Maintaining his composure, and above all simply not having the

Roger Waters and Rick Wright during a concert in Copenhagen, Denmark, in November 1970. Waters has replaced the Rickenbacker with one of his new Fender Precisions.

time to correct his score, Geesin commented, that even if there were a mistake in the music, he would not let it affect the recording!

The next day the choir returned to finish the job, and it seems that Hafliði Hallgrímsson recorded his cello part on June 23. Further sessions followed on June 24 and July 8 and 13, during which the Floyd added various other instruments and miscellaneous effects. July 15 and 17 were given over to the mixing (in Room Four). On July 16, "Untitled Epic" was definitively renamed "Atom Heart Mother," after the article in the *Evening Standard*. Roger Waters would officially announce the piece under this name during the Hyde Park Free Concert in London on July 18.

Recognition a Long Time Coming

Ron Geesin would later judge "Atom Heart Mother" to have been perhaps not perfect, but reasonably successful all the same. He maintains that it could not have been any better than it was, given that it was realized using limited resources and with a lot of pressure during the development phase. Nick Mason's verdict, however, would be "Good idea, could try harder."[5]

In spite of the differing opinions and the lack of recognition of Ron Geesin's input from the group and its fans, there were numerous public performances of the work, complete with choir and brass, notably on June 27 at the Bath Festival of Blues & Progressive Music '70 in the United Kingdom, where it was introduced as "The Amazing Pudding." Over the course of the years, the piece would attract increasing levels of interest from all over the world, and the Scottish composer-arranger would receive regular requests for the score. Finally, in 2012, Ron Geesin would

receive official recognition when "Atom Heart Mother" was included in the music syllabus of the 2012–2013 French *baccalauréat*.

The Six Movements of "Atom Heart Mother"

"Father's Shout" (Geesin's sections A, B, C, and D)

The intro is mainly Geesin's work. The piece opens with an organ drone on E with a gong becoming audible in the background. Trombones then surge forward and are immediately joined by trumpets playing open fifths.

This intro is followed by the exposition of the main theme on the three horns (an instrument used by composers of music for westerns!) and the four members of Pink Floyd. Waters is most probably playing his Rickenbacker (because this was recorded before the New Orleans equipment theft), Mason his Premier drum kit, Wright his Farfisa and Hammond organs, and Gilmour presumably his white Stratocaster, delivering a clear-toned (like Waters's bass) rhythm part.

The next section is a development of the intro that assumes epic proportions when played on the trumpets and horns. All of a sudden, various sound effects burst onto the scene: whinnying and galloping horses, gunfire, whistling and exploding shells, and a motorbike starting up, transporting the listeners to a 1914 battlefield. Finally there is a return to the main theme.

"Breast Milky" (Geesin's sections E, F, G, and H)

This second movement is somewhat romantic in mood, hence the addition of Hafliði Hallgrímsson's cello, accompanied by Waters's bass and Rick Wright's organ. This inevitably brings Saint-Saëns's "The Swan" to mind.

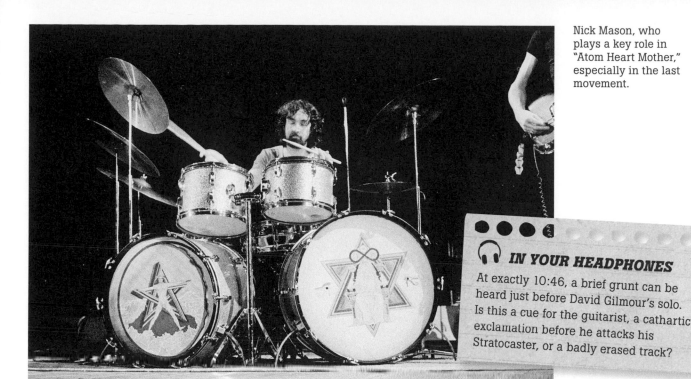

Nick Mason, who plays a key role in "Atom Heart Mother," especially in the last movement.

Mason gradually insinuates himself into this atmosphere with tom breaks, before leaving the field to David Gilmour, who plays a slide solo that is probably doubled. Gilmour's playing possesses a soft-edged, airy quality that reveals him by this point to have completely mastered his style and technique and acquired his uniquely subtle touch. Various studio photos indicate that he may be playing his 1959 Stratocaster Sunburst. This floating mood gives way to more of a rock feel with the use of Fuzz Face on the guitar, the addition of piano, and the return of the brass.

"Mother Fore" (Geesin's section I)
Another floating mood. Enter a female singer whose ethereal voice is enveloped in reverb. She is accompanied by Hammond M-102, bass, and hi-hat. The various levels of the John Alldis Choir then come in progressively over Wright's organ pads, creating a Carl Orff–like atmosphere. The intensity and complexity increase, and the tension mounts to the point where Mason's contribution expands into a full-blown accompaniment on the drums.

"Funky Dung" (Geesin's section J)
The fourth movement opens with Roger Waters's heavy, funky bass. He is actually recycling the riff he had previously recorded for "Unknown Song," a title the group had laid down for the soundtrack of Antonioni's movie *Zabriskie Point*, but that was not in the end used. He is accompanied by Rick Wright on Hammond organ and Mason on drums. Enter Gilmour and his Stratocaster (the "Black Strat"?) with a very bluesy, slightly distorted solo with ample reverb. His style, which would develop into one of Pink Floyd's trademarks (reaching its zenith over the group's next four or

five albums), is immediately recognizable. This solo gradually gives way to a return by the choir, which expresses itself through onomatopoeia and is supported by the brass, a piano, and the rhythm section of Waters, Mason, and Gilmour (the latter playing clear-toned rhythm guitar).

"Mind Your Throats Please" (Geesin's sections K and L)
In this section we return to the main theme, which then develops into an experimental sequence that did not form part of the first version given to Geesin in March. It consists of various distorted sounds, mainly keyboards (organ, Mellotron, piano), brass, voices, and choir, played backward and transformed by various electronic effects: reverb, Binson Echorec, Leslie speaker, harmonizer, and so on. We hear the sound of a train before the brass returns and combines with various fragments of the intro and the main theme in a cacophony worthy of Stockhausen. A voice can be heard uttering the words "silence in the studio." It is interesting to note that this section, which had originally been named "Experimental percussion section with train sounds," does not actually include any percussion, at least until the appearance of the train.

"Remergence" (Geesin's sections M, N, P, and Q)
The main theme is restated once more, followed by a recapitulation of the second movement, "Breast Milky," with discreet support from the brass in the cello section and a solo from David Gilmour (with Echorec II and strong panoramic effects) in the rock section. The piece then concludes with a grandiose and heroic finale involving all the musicians and ending on a chord of E major, whereas the main key of the piece had been E minor. Immediately prior to this, at 23:07 precisely, Nick Mason launches into a long snare drumroll!

Ron Geesin, a Temporary Floyd

Ever since 1967, Ron Geesin and Pink Floyd had shared the billing for various musical events, such as the famous "14 Hour Technicolor Dream" at Alexandra Palace on April 29 of that year, and a number of gigs at Middle Earth in Covent Garden. But it was not until a few years later that they would embark upon an artistic collaboration.

The Banjo and Surrealism

Ronald Frederick Geesin was born in Ayrshire, Scotland, on December 17, 1943. He spent his childhood in the county of Lanarkshire, where his father built the family home with his own hands. As a teenager, Geesin showed little interest in music, unlike his two young sisters, who were learning the piano. Instead he preferred to go on long bicycle rides along the winding roads of the Clyde Valley. Everything changed when his parents gave him a banjo for his sixteenth birthday. His enthusiasm for the instrument was boosted by the fashion for traditional jazz in the United Kingdom at this time. Around this same period he also discovered the music of George Gershwin (*Rhapsody in Blue*), the early masters of classic jazz, in particular the piano virtuoso Fats Waller, and the world of Surrealism.

A Manipulator of Sound

Having eventually become a pianist and joined a jazz band known as the Original Downtown Syncopators, Ron Geesin embarked on a series of contracts with clubs. In 1967 he decided to pursue a solo career and recorded his debut album, *A Raise of Eyebrows*—the first stereo record to be issued by Transatlantic Records—before founding his own label Headscope and setting up a home studio in the basement of a house at 34 Elgin Crescent (just around the corner from Portobello Road) in London. He developed a real passion for electronics, sound effects, and acoustic manipulation of every kind, which he would achieve with multiple tape recorders that he did not always use in the prescribed way!

Through writing the music for a number of television ads and short movies, Ron Geesin started to become known and appreciated within the music world, in particular by the highly influential BBC presenter John Peel; by Steve O'Rourke, then manager of Pink Floyd (whom he had known, in fact, since the days of the Original Downtown Syncopators); and by the tour manager Sam Cutler, who introduced him to Nick Mason and his wife Lindy. Geesin taught the Floyd drummer the rudiments of making perfect tape joins and collages, and he gained entry into Mason's world: "One pleasant spin-off of this relationship was that Ron wrote the music for the soundtrack of one of my father's documentaries—*The History Of Motoring*—and I like to think they both enjoyed the experience."[5] In 1969, Nick and Lindy introduced Ron Geesin to Roger and Judy Waters. He then, inevitably, met Rick Wright, with whom he shared an interest in American jazz.

The Floyd's Right-Hand Man

Ron Geesin was an influence on Roger Waters's experimental track "Several Species of Small Furry Animals Gathered Together in a Cave and Grooving with a Pict" on *Ummagumma*. They then worked together on the music for the documentary *The Body*, which was released in the form of an album entitled *Music from the Body*. Later in 1970, Geesin was chosen to help the group record the suite "Atom Heart Mother," probably, he believes, for the following reasons: "I was well known and trusted by at least three of Pink Floyd; I had produced (composed and made) original work which surprised, amused and teased those three; and a fair proportion of that work was for radio, films and TV where I had to fit in to an existing structure [...]."[60] But these were not the only reasons why the group chose him: at the beginning of 1970, the Floyd found themselves in a creative impasse and were beginning to run out of new ideas. Under pressure from O'Rourke and EMI to release a new album, they needed an external stimulus to help them to rediscover

The arranger Ron Geesin, whose instrument of first choice was the banjo.

their momentum and move forward. And it was Ron Geesin who was to provide this stimulus.

Post–Pink Floyd

The recording of "Atom Heart Mother" and the commercial success of the album opened up new opportunities for Ron Geesin. After producing the album *Songs for the Gentle Man* (1971) for the folk-rock singer Bridget St. John, he composed the music for a number of movies, notably John Schlesinger's *Sunday Bloody Sunday* (1971), Stephen Weeks's *Ghost Story* (1974) and *Sword of the Valiant* (1984), and Cary Parker's *The Girl in the Picture* (1985). His later albums, meanwhile, combine acoustic and electronic instruments, and avant-garde music and ambient sounds, as in *As He Stands* (1973), *Right Through* (1977), *Magnificent Machines* (1988), and *The Journey of a* Melody (2011). Ron Geesin revealed in an interview in the nineties[61] that by this time he had lost contact with all of Pink Floyd except Nick Mason.

If

Roger Waters / 4:30

Musicians
Roger Waters: vocals, bass, acoustic guitar
David Gilmour: electric guitar
Rick Wright: Moog, organ, piano
Recorded
Abbey Road Studios, London: June 12, 25, July 4, 5, 8, 13, and 21, 1970 (Studio Two and Room Four)
Island Studios, London: dates not known
Technical Team
Producer: Pink Floyd
Executive Producer: Norman Smith
Sound Engineer (not known for Island): Peter Bown
Assistant Sound Engineers (not known for Island): Alan Parsons, Nick Webb

Marianne Faithfull, who has recorded "Incarceration of a Flower Child," another song by Waters about Barrett.

Genesis

Musically, the exquisitely romantic "If" follows on in a direct line from Roger Waters songs such as those he composed for the *More* soundtrack and the very peaceful and pastoral "Grantchester Meadows" on *Ummagumma*. In terms of its lyrics, however, the nostalgia that dominated "Grantchester Meadows" has given way to a deep despair and boundless regrets that seem to gnaw at the songwriter.

There are indeed regrets: *If I were a swan, I'd be gone*, *If I were a good man, I'd talk to you more often than I do*. In the second verse, however, the mystery starts to unravel a little. *If I were asleep, I could dream, If I were afraid, I could hide, If I go insane, please don't put your wires in my brain*: all the indications are that the narrator now finds himself in a psychiatric asylum. "If" tackles a theme that had haunted Roger Waters at least since Syd Barrett's forced departure from the band, and one that runs through several of his other major compositions, such as "Brain Damage" on *The Dark Side of the Moon*, "Wish You Were Here" on the album of the same name, and "Pigs on the Wing" on *Animals*. After leaving Pink Floyd himself years later, Waters would include this song in the set list of his two major tours, "The Pros and Cons of Hitch Hiking" in 1984–85 and "Radio K.A.O.S." two years later.

Production

It is no easy task to trace back the making of "If." Roger Waters started to record the song at Island Studios in London between January and March 1970, while working on the soundtrack of the documentary *The Body* with Ron Geesin. It was then rerecorded at Abbey Road in June, this time with the group. The final version is thought to result from a splicing together of sections from both recordings without it being possible to determine which section originated in which studio or, indeed, where the different parts have been joined.

The first session at EMI is known to have been held on June 12, soon after the Floyd's return from the United States. At this stage the song was entitled "Roger's Song." It was rerecorded on June 25 and again on July 4, and it was the sixth take that was used as the basis for future overdubs. Roger Waters accompanies himself with arpeggios on a

Roger Waters, composer of the moving Pink Floyd ballad "If."

classical guitar (Levin Classic 3?). He sings lead vocal and his voice is soft, fragile, and full of feeling. Often eclipsed by the voices of Rick Wright and more especially David Gilmour, Waters is nevertheless a superb singer, not least because he has a talent for conveying his emotions. He is also clearly accompanying himself on the bass, presumably his Fender Precision. At 1:12 a new instrument, recorded on July 5, makes a brief appearance. This is a Moog synthesizer, almost certainly a Moog IIIP, the one used by the Beatles on their album *Abbey Road*. The sound is discreet, but it serves to add an avant-garde touch to the folky feel at the beginning of the song. Then comes an instrumental section with sustained Hammond organ played by Rick Wright, over which Gilmour takes a guitar solo, probably on his newly acquired "Black Strat." He makes abundant use of bending, in other words pulling on the strings with the fingers of the left hand in order to create a slide effect. His guitar sound is distorted courtesy of the Fuzz Face and drenched in stereo reverb. Furthermore he doubles himself and harmonizes

with his other guitar track toward the end of the solo. After the vocal line resumes, Rick Wright adds acoustic piano, and Nick Mason contributes a restrained accompaniment on his hi-hat before adding drums for the second instrumental section (at 3:16). Here, Wright starts to improvise on the piano and Gilmour delivers a second solo, which he harmonizes with two distinct guitar parts. It is interesting to note that at 3:50 his solo shifts from stereo to mono without any reverb. Is this the point where the Island Studios and Abbey Road Studios recordings are spliced together? Finally, Waters himself provides the vocal harmonies in the last verse of the song. The final mixing was completed on July 21, during the last session on the album, and this is also the day the two recordings were edited together.

The opening song on side two of the vinyl incarnation of *Atom Heart Mother*, "If," is without doubt one of the triumphs of the album, a perfect vehicle for denouncing the phenomenon of alienation from the world, a theme to which he would repeatedly return throughout his career.

Summer '68

Rick Wright / 5:29

Musicians
David Gilmour: vocals (?) backing vocals, acoustic guitar, electric rhythm and lead guitar
Rick Wright: vocals, backing vocals, piano, organ, Mellotron, harmonium (?)
Roger Waters: bass, backing vocals (?)
Nick Mason: drums, maracas, bongos (?)
Unidentified musicians: trumpets

Recorded
Abbey Road Studios, London: December 4, 9, 10, 16, 1968; January 16, 1969; July 5, 13, 14, 19, 20 1970 (Studio Two and Room Four)

Technical Team
Producer: Pink Floyd
Executive Producer: Norman Smith
Sound Engineers: Peter Mew, Peter Bown
Assistant Sound Engineers: Neil Richmond, Alan Parsons, Nick Webb

Genesis

This is without doubt one of the most beautiful songs *ever* written by Rick Wright. In it the keyboardist tells the story of a brief love affair. *We met just six hours ago, the music was too loud*, he sings, and *We say good-bye before we've said hello.* Is this song based on a real-life experience? Perhaps. The narrator, possibly a rock star, seems to care very much about what his partner is feeling. *Perhaps you'd care to state exactly how you feel*, he wonders, before asking again in the refrain: *How do you feel?* Noting that he has hardly even had time to grow to like the young woman, and that he *shouldn't care at all*, he then acknowledges bitterly that their time was passed in silence. He knew the woman would soon leave to go and *greet another man*, while for him, the narrator–rock star, *Tomorrow brings another town, another girl like you…*Feelings in which regret rubs shoulders with a certain weariness against the last rays of sunshine from the Summer of Love…

Rick Wright would later reveal that he liked the lyrics of "Summer '68." "Although I don't think that the lyrics were good, they did at least say something that, I felt, was a real genuine feeling and therefore that's cool."[36]

Production

"Summer '68" is one of Rick Wright's great triumphs and one whose musical eclecticism is immediately apparent. It reveals his taste for pop, for the Beatles, the Beach Boys, and even the Baroque, with a hint of Bach coming through in the brass parts. The final result, however, is a unique work that only Wright could have written.

The genesis of the song goes back to the *Ummagumma* sessions. The initial base tracks of "One Night Stand"—the future "Summer '68"—were actually laid down on December 4, 1968. Other sessions would follow on the ninth, tenth, and sixteenth and also one month later, on January 16, 1969. By this stage the piece was more or less complete. Instead of being included on *Ummagumma*, however, it was put aside and not revived until *Atom Heart Mother*, its particular character being better suited for this new album.

It was thus on July 5, 1970, that is to say almost a year and a half after they had abandoned it, that the four musicians found themselves working on the song once again in Studio

Two, Abbey Road. This was the same day they recorded the
Moog for "If" and got down to the final mixing of "Fat Old
Sun." They rerecorded the base track of the 1969 version
of "Summer '68" and then proceeded to edit and remix the
song on July 13 and 14, before adding various reverse sound
effects on July 19 and doing the final mix the following day.
In practice it was a difficult piece to make, all the more so as
sections of different mixes had to be combined in order to
obtain a master. But the group's hard work paid off, and the
final result is a little pop–progressive rock gem that speaks
volumes about the talent of its songwriter and performers.

In the first part of the song, Rick Wright sings the lead
vocal. He accompanies himself on piano and is supported
by some superb bass from Roger Waters. (The sound is
more Rickenbacker 4001 than Fender Precision.) This is a
pop ballad that unfolds with the successive entry of a Ham-
mond organ, vocal harmonies sung by Wright himself, a
hi-hat, and a backward cymbal effect that ushers in the first
refrain. This is sung most likely by David Gilmour and Rick
Wright together, in particular the countermelodies, which
are very much in the style of the Beach Boys. In this section
the piano is greatly compressed, the bass and drums provide
solid support, maracas and what are probably bongos (listen
at around 1:40) reinforce the rhythm, and David Gilmour
accompanies on the acoustic guitar (the Levin LT 18?).

This brings us to the instrumental section. Despite
some controversy on this score, it is a real trumpet that

can be heard at this point. Glenn Povey has gleaned from
the Abbey Road records that on December 16, 1968, two
unidentified session musicians were paid a total of £18
for playing brass instruments. The phrasing and quality
of sound leave no room for doubt that it is a real instru-
ment that can be heard here, rather than a synthesizer. On
the other hand, in various other sections where the trum-
pet reappears, around 3:30 and 4:40, it is reinforced by
brass sounds produced on the Mellotron and also perhaps
by a harmonium, the latter also having been recorded on
December 16. It is worth noting that David Gilmour helps
to enrich the musical texture of these two sections with
an electric rhythm guitar part (albeit difficult to make out)
along the same lines as the distorted guitar part he plays
during the initial instrumental section in which the trumpet
is unsupported.

The song's bridge, which comes just before the coda,
recalls the atmosphere of the intro. Wright plays some
highly lyrical piano and also a second piano part in the bass
register, accompanied by Gilmour's acoustic guitar. The key-
boardist sings in a gentle voice supported most probably by
Gilmour and Waters, the three of them once again adopt-
ing a distinctly Beach Boys–like vocal style. Furthermore,
Rick Wright would claim in 1972 that *Surf's Up*, one of the
Californian band's masterpieces, was a favorite of his. Fol-
lowing the return of the brass, "Summer '68" ends on an
A-major chord.

Fat Old Sun

David Gilmour / 5:22

Musicians
David Gilmour: vocals, backing vocals, acoustic guitar, electric slide guitar, electric lead guitar, bass (?), drums, recorder (?)
Rick Wright: organ, backing vocals (?)
Recorded
Abbey Road Studios, London: June 11–13, July 5, 1970 (Studio Two)
Technical Team
Producer: Pink Floyd
Executive Producer: Norman Smith
Sound Engineer: Peter Bown
Assistant Sound Engineer: Alan Parsons

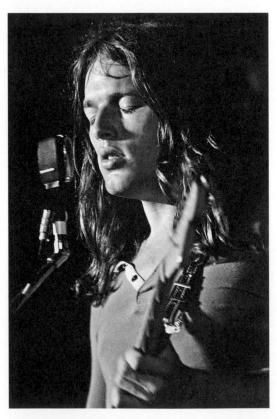

"Fat Old Sun" is the second song for Pink Floyd with words and music by David Gilmour. Could it be about the loss of youth?

Genesis

After "The Narrow Way" on the album *Ummagumma*, "Fat Old Sun" is only the second song to be written and composed entirely by David Gilmour for Pink Floyd. It covers themes that were as dear to the guitarist as they were to the group as a whole. *Distant bells, new-mown grass smells so sweet/By the river holding hands, roll me up and lay me down*: these lines take us back to Grantchester Meadows, the guitarist's birthplace and the onetime playground of Syd Barrett and Roger Waters. What's more, Gilmour seems to have written it at the same time that Waters wrote "Grantchester Meadows" on *Ummagumma*.

Gilmour is therefore returning here to his teenage years: the scene is set at dusk on a summer's evening, when the last rays of sunshine are glinting on the River Cam and the *evening birds are calling*. The narrator shares this special atmosphere with his companion…A second hypothesis is that the *fat old sun* that is setting could also be an evocation of youth and a carefree existence, both of which have now gone forever—in short, the end of an era. Hence the bells that can be heard in the distance, symbolizing the inexorable passage of time…(Gilmour would take up this idea again in "High Hopes" on the album *The Division Bell*.)

Musically, "Fat Old Sun" is folky in character, and is sung by David Gilmour in a reedy, nostalgic voice. In the early seventies, Pink Floyd would regularly perform the song live in a version sometimes approaching fifteen minutes in length, but later dropped it in favor of *The Dark Side of the Moon* concept. Decades later (from 2001), David Gilmour would include it in the set list of his solo tours. "I've always liked the song, one of the first I ever wrote," he told the *Sun* in 2008. "I tried to persuade the rest of the Pink Floyd guys that it should go on *Echoes: The Best of Pink Floyd* but they weren't having it."[62]

Production

"Fat Old Sun" begins and ends with the sound of bells ringing out across the countryside. David Gilmour uses this sound clip to set a distinctly pastoral scene. He chooses to play this sublimely beautiful composition on acoustic guitar, probably his new Gibson J-45, whose sound seems to have been either processed with a harmonizer or more

The extremely bucolic banks of the River Cam, a landscape familiar to, and beloved of, David Gilmour, who was inspired by it to write "Fat Old Sun."

straightforwardly doubled with a second acoustic. In the background he creates a floating mood on his Stratocaster (the "Black Strat" or his Strat Sunburst), sounding here like a pedal steel guitar, with strong, deep reverb applied to slide chords. It is also believed to be Gilmour on bass (Waters's Fender Precision), which he plays very well, resembling in every respect the style of the instrument's owner. Gilmour had succeeded in establishing himself in the group for two main reasons: his incredible guitar playing and his outstanding singing. And on this song he provides a demonstration of both, delivering the vocal line in a high register verging on falsetto, with that unmistakable vocal texture that is all his own.

Rick Wright joins him on the organ, most likely the Hammond M-102. Then comes the refrain, which is launched with a short drum break. Some listeners believe they can detect a resemblance between the song's delicate melody and the Kinks' "Lazy Old Sun" (on the 1967 album *Something Else by the Kinks*). Leaving aside the similarity between the two titles, however, Gilmour's "Fat Old Sun" owes nothing to the earlier song. At the end of the refrain, the harmonies take on a curiously Slavic color, reinforced by a background guitar with reverb that sounds like a balalaika. (Listen at 1:53!) The effect may be surprising, but it provides the perfect lead-in

to the return of the third verse. And it is at this moment that things get a little uncomfortable, for David Gilmour is also playing the drums. He would regret it later, but on this version he is the one seated at the drum kit, as on *Ummagumma*'s "The Narrow Way: Part Three." His drumming lacks assurance, he seems at times to be caught off guard by the drum breaks, and his timing is not always what it might be. This is particularly noticeable in the coda (listen at 4:16) during his excellent, heavily distorted Stratocaster solo, parts of which recall Eric Clapton's "Layla." During this instrumental section it is possible to make out a recorder with reverb in the background, also perhaps being played by Gilmour. This sonority, which merges with the general atmosphere, reinforces the bucolic character of the track, paving the way for the return of the church bells in the form of a conclusion.

"Fat Old Sun" was recorded quickly: the base track was laid down (and the first take selected as "best") on June 11, the vocal and recorder overdubs were added the next day, and the guitar and sound effects on June 13. This excellent track, perhaps one of the guitarist's best, was then mixed on July 5. However, it may be because of the weakness of the drum part that Gilmour was unable to convince the other members of the group to include the song on the compilation *Echoes: The Best of Pink Floyd* (2001).

Alan's Psychedelic Breakfast

Roger Waters, Nick Mason, David Gilmour, Rick Wright / 13:00
Rise and Shine: 1:00–3:34 / Sunny Side Up: 4:29–7:44 / Morning Glory: 8:17–11:54

Musicians
David Gilmour: electric lead guitar, acoustic guitar
Rick Wright: piano, organ
Roger Waters: bass
Nick Mason: drums, sound effects
Alan Styles: voice

Recorded
Abbey Road Studios, London: June 18, July 10, 17, 19, 20, 21, 1970 (Studio Two and Room Four)

Technical Team
Producer: Pink Floyd
Executive Producer: Norman Smith
Sound Engineer: Peter Bown
Assistant Sound Engineers: Alan Parsons, Nick Webb

Genesis

"Alan's Psychedelic Breakfast," which concludes *Atom Heart Mother*, is an experimental piece that would not have been out of place on *Ummagumma* or even on the album *Music from the Body*. "We were all frantically trying to write songs, and initially I thought of just doing something on the rhythm of a dripping tap […] then it turned into a whole kitchen thing,"[9] explains Roger Waters. According to Nick Mason, "Alan's Psychedelic Breakfast" stems from a collaboration: "[…] Alan's Psychedelic Breakfast was another great idea—gas fires popping, kettles boiling, that didn't really work on record but was great fun live. I've never heard Roger lay claim to it, which makes me think it must have been a group idea."[39]

The Alan in question on this final track of the album is Alan Stiles, one of Pink Floyd's road managers, who also did the cooking when the group was on tour. He is pictured on the back of the *Ummagumma* sleeve. Nick Mason would give the following affectionate description of him in 1973: "He was older than us and had been in the army and was physically big, even for his job. He got to be such a star that we were afraid to ask him to do things like lifting gear. He is a real character. In the end we had to fire him."[9] Apart from this, Mason maintains that there was no particular reason to have made him the protagonist of this song.[9] Although the group has often been derided for its overly serious image and deficient sense of humor, it clearly displays a sense of fun in this piece, as David Gilmour confirms: "We do take our music seriously, but that doesn't mean it all has to be serious."[9] However, this would not prevent certain critics from laughing (to varying degrees) at, rather than with, the results, which they deemed to be excessively naive.

In the end, Pink Floyd would perform "Alan's Psychedelic Breakfast," which is divided into three sections ("Rise and Shine," "Sunny Side Up," and "Morning Glory"), no more than a handful of times. In order to do the piece properly, roadies were required to actually serve breakfast to the musicians onstage. A number of performances of the piece were given between December 18 and 22, 1970, that the last of these, which took place in Sheffield City Hall, England, gave rise to a bootleg recording. On this the Floyd can be heard prolonging "Rise and Shine" with a bluesy improvisation and

During the Floyd concert at the Théâtre des Champs-Élysées on January 23, 1970, one of the first public presentations of "Atom Heart Mother" was given. A European radio station transmitted the show. The journalist Michel Lancelot introduced the four musicians to listeners, who learned that Waters has "a face of Christ," that Wright is fond of composer Stockhausen, that Gilmour is "the beautiful kid of the group," and that Mason is the drummer...

For Pink Floyd Addicts

Morning glory is also the name of a flowering plant whose seeds contain ergine, a hallucinogenic alkaloid that produces effects similar to LSD. Hence Alan's highly "psychedelic" breakfast!

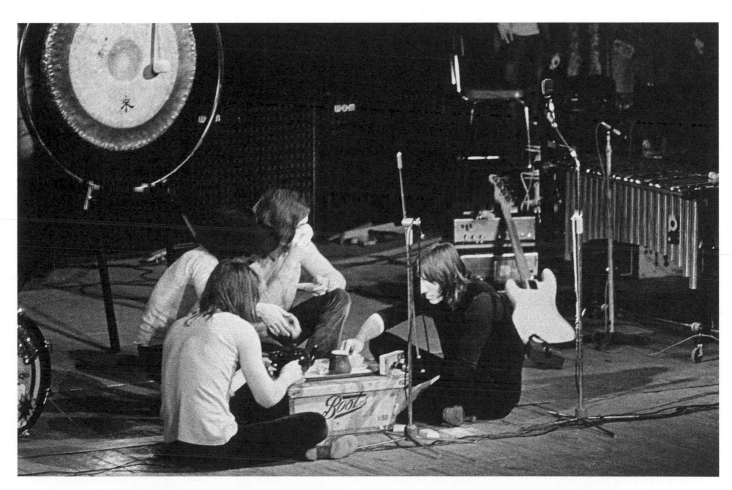

The refreshments enjoyed by the four members of Pink Floyd during "Alan's Psychedelic Breakfast" is a legacy of the tea ceremony performed during the concerts of the 1969 *Man and the Journey* Tour.

Breakfast Tips No. 2

TRADITIONAL BEDOUIN WEDDING FEAST

A filling breakfast to satisfy the largest appetite best served in a tent in the Sahara. (Serves up to 250).

You will need:
1 medium camel.
1 medium North African goat.
1 spring lamb.
1 large chicken
1 egg
450 cloves of garlic.
1 bail of fresh coriander.

1- Take the prepared chicken and stuff with the egg, which should be hard boiled, and pad out with coriander.

2- Stuff the lamb with the chicken.

3- Stuff the goat with the lamb.

4- Stuff the camel with the goat. A pre-prepared camel is rather more convenient - don't be afraid to ask your butcher. Spike with the garlic and brush with butter before cooking.

5- Spit roast over a charcoal fire in an arid desert area for best results.

A recipe for a Bedouin wedding feast accompanied the *Atom Heart Mother* CD. Not your usual kind of breakfast!

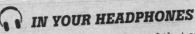 *IN YOUR HEADPHONES*

Attentive listening will reveal that at the end of the track, after declaring "My head's a blank," Alan picks up a set of car keys and opens a door. A car can then be heard starting...

then making themselves comfortable for "Sunny Side Up" and drinking tea before moving calmly into the final section.

Production

It was Nick Mason who undertook to record, in his own London kitchen, the various sounds that would accompany the curious "Alan's Psychedelic Breakfast." Having been initiated by Ron Geesin into the art of making perfect collages on tape, he performed this task using quarter-inch tape while Alan Stiles commented on the breakfast he was preparing. After returning to Abbey Road, Mason categorized and named each sound, and in some cases made a tape loop. A first session was held with the group on June 18 to record the base track, then called "Alan's Story." Almost a month later, on July 10, Mason's various sound effects were then edited along with others from the EMI sound library. That day the Floyd also rerecorded the base track and edited the "Tape Delay" loops. Overdubs, notably piano, were then added on July 17, and two days later the base track was recorded yet again. The editing, cross-fades, and mixing were completed on July 20 and 21.

A Breakfast in Three Acts!

"Alan's Psychedelic Breakfast" is divided into three sections. The first, "Rise and Shine," opens with the sound of dripping water. The different sonic elements of this breakfast are then gradually added, as Roger Waters explains: "On the

At 7:52, toward the end of "Sunny Side Up," Alan's monologue seems to contain the words: "Do you know Elton John?" At this point in time the singer-songwriter was in the early stages of his long career, having just released his second, eponymous album containing the superb "Your Song."

Elton John, a very young singer at the time, is referenced by Alan Stiles in his monologue.

record it's a carefully set up stereo picture of a kitchen with somebody coming in, opening a window, filling a kettle, and putting it on the stove. But instead of the gas lighting, there's a chord, so he strikes another match, and there's another chord, and another match, and so on, until it finally goes into a piece of music."[9] The whole of this little scene—at least until the entry of the music—is constructed around the voice of Alan Stiles: "Oh, Er, Me flakes...Scrambled eggs, bacon, sausages, tomatoes, toast, coffee... Marmalade, I like marmalade...Yes, porridge is nice, any cereal...I like all cereals...Oh, God." Some of his words are repeated by means of the "Tape Delays" recorded on July 10. Each of the seven matches that is struck is accompanied by a musical exclamation based on a single E-major chord, a reasonably soothing sequence in perfect harmony with Alan, who calmly goes about preparing his breakfast. Rick Wright plays two piano parts with reverb, Nick Mason marks time with his hi-hat, and Gilmour launches into a solo, some of which is played slide through a Leslie speaker, while Wright answers him on the organ. This section concludes with the whistling of the kettle, the music having gradually faded away.

In the next sequence, "Sunny Side Up," Alan Stiles continues his monologue: "Breakfast in Los Angeles, macrobiotic stuff…" More sounds follow: boiling water being poured, the clinking of a glass bottle, a cup being filled, a spoon stirring, someone swallowing, background music, cornflakes being poured into a bowl, sugar being sifted, cornflakes being mixed with a spoon, the crackle of cornflakes… Gilmour is then faded in on acoustic guitar, picking a folky ballad on what is most probably his Gibson J-45. The mood is bucolic and brings to mind the future "A Pillow of Winds" on the group's next album, *Meddle*. Gilmour answers this first guitar part with a solo improvisation, again acoustic. This instrumental is complemented by a clear-toned slide guitar accompaniment of which certain aspects (listen at 6:07) once again recall "A Pillow of Winds." The piece concludes with the sound of bacon frying in a pan. Toward the end, Alan resumes his soliloquy.

This brings us to the third and final section: "Morning Glory." At precisely 8:16, the edit joining this sequence to the preceding one can be clearly heard. Chords ring out (against the background sounds of still-frying bacon) and the piece then gets into its stride with Nick on drums, Rick on piano and Hammond organ, and Roger on bass. David does not come in until later (9:52), playing a kind of improvised melody on his Fender with Fuzz Face distortion and at the same time relaunching Alan's monologue. The roadie continues to drone on about marmalade, concluding with the highly revealing phrase: "My head's a blank." The psychedelic breakfast draws to a close with a return to the kitchen and the sound of the sink filling with water, slippers shuffling about, a cupboard being closed, a bowl and cup being placed into the water, a door slamming, and the tap dripping just as badly as it was at the beginning of the track.

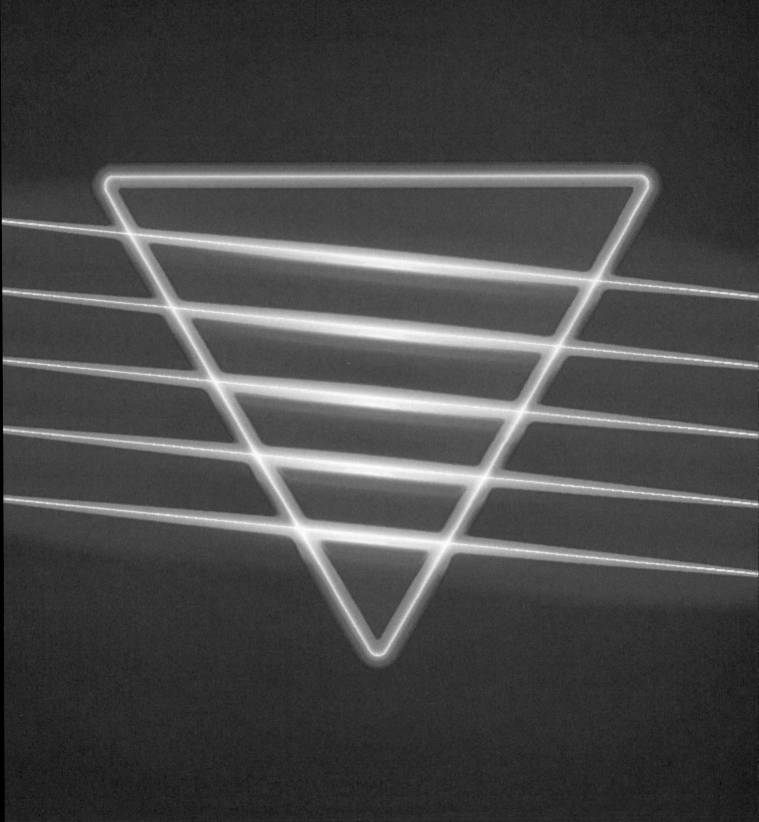

RELICS

ALBUM
RELICS

RELEASE DATE
United Kingdom: May 14, 1971
Label: Starline
RECORD NUMBER: SRS 5071
Number 32 (United Kingdom), number 152 (United States), number 29 (Australia)

Arnold Layne / Interstellar Overdrive / See Emily Play /
Remember A Day / Paint Box / Julia Dream / Careful With That Axe,
Eugene / Cirrus Minor / The Nile Song / Biding My Time / Bike

The four members of Pink Floyd photographed by Storm Thorgerson, a friend of the band and the brilliant illustrator of its album sleeves.

Relics, "A Bizarre Collection of Antiques & Curios"

By summer 1970, Pink Floyd had resumed their punishing touring schedule: firstly in France and the United Kingdom (July 26–September 12, 1970), followed by the United States and Canada (September 26–October 23), and then Europe again (November 6–29). On December 11 the group embarked on a promotional tour for *Atom Heart Mother*, which had been released on October 10. Nearly seventy concerts were scheduled in Europe and the United States between December 11, 1970 (Brighton), and November 20, 1971 (Cincinnati, Ohio). In the meantime, the recording sessions for the Floyd's sixth album, *Meddle*, had begun in January 1971.

Two Eras in One Compilation

Because of the touring and because the release date for the next album was some way off, the EMI bosses decided to issue a compilation LP (the second after *The Best of the Pink Floyd*, released in 1970) in order to maintain Pink Floyd's popularity at its peak. *Relics* covers the group's two distinct eras up to this point—the Syd Barrett era and the David Gilmour era, uniting singles, album tracks, and the unreleased "Biding My Time" in the following order: "Arnold Layne" (single), "Interstellar Overdrive" (*The Piper at the Gates of Dawn*), "See Emily Play" (single), "Remember a Day" (*A Saucerful of Secrets*), "Paint Box" (the B-side of "Apples and Oranges"), "Julia Dream" (the B-side of "It Would Be So Nice"), "Careful with That Axe, Eugene" (B-side of "Point Me at the Sky"), "Cirrus Minor" (*More*), "The Nile Song" (*More*), "Biding My Time" (unreleased), and "Bike" (*The Piper at the Gates of Dawn*).

EMI released *Relics* on its Starline label on May 14, 1971, in the United Kingdom and on July 15 across the Atlantic. *Circus* magazine gave the LP a good review, declaring: "If you want to get into Pink Floyd for the first time, this would be a good album to get."[9] The compilation went on to reach number 32 in the United Kingdom (and was certified gold). In the United States it would climb no higher than number 152 on the Billboard chart. Nick Mason recalls: "Relics came out in May, just before we played at the Crystal Palace Garden Party. This was our first major concert in London for some time and one of the outdoor events that the British can be very good at."[5]

The Sleeve

The original cover illustration for *Relics* was a pen and (black) ink drawing by Nick Mason, which includes various "improbable" items, some of which produce sounds (an organ, bells, drums, cymbals, trumpets, and even a cuckoo), while others derive from the nautical world (a bathyscaphe, an anchor, a lifeboat) brought together on a vessel of a most unusual kind. The artistic style evokes that of the renowned American cartoonist Rube Goldberg. The title of the album and the name Pink Floyd appear in the top left-hand corner as if carved into a mountainside. There is also a subtitle, which runs around a semicircular banner at the foot of the organ pipes: "A Bizarre Collection of Antiques & Curios." When *Relics* was released on CD in 1995, a new cover was designed by Storm Thorgerson and Jon Crossland, who have respected the original concept in their illustration of an assembly of weird and wonderful machines against a blue background.

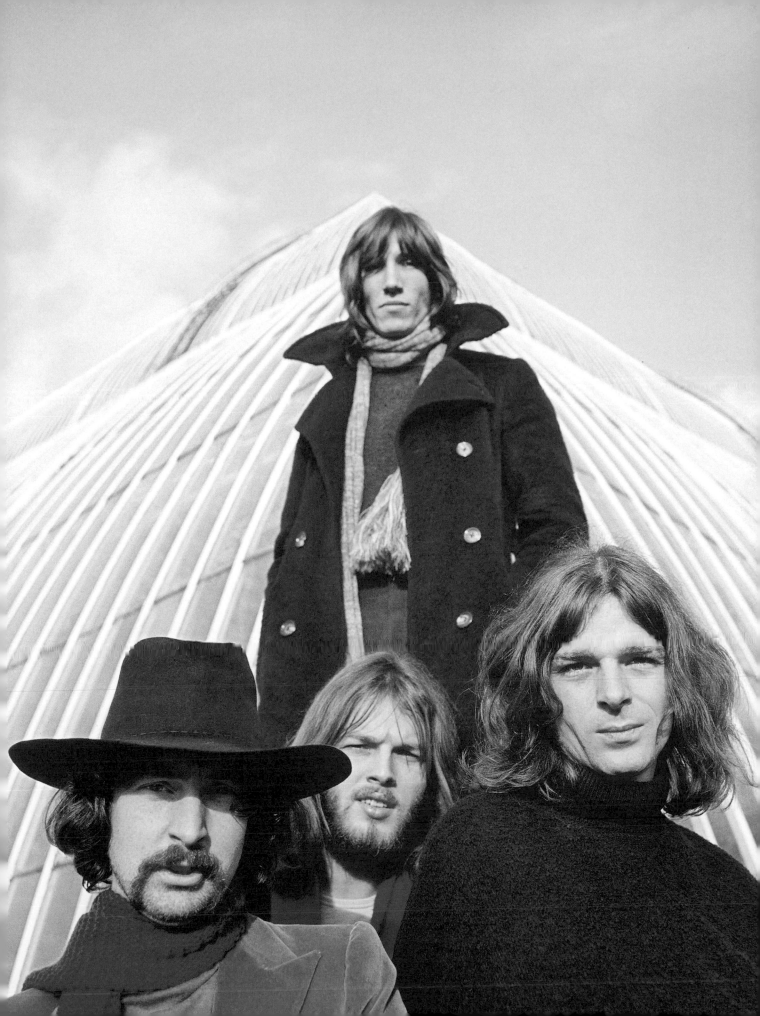

Biding My Time

Roger Waters / 5:16

Musicians
David Gilmour: electric rhythm and lead guitar, acoustic guitar
Rick Wright: piano, organ, trombone
Roger Waters: vocals, bass
Nick Mason: drums

Recorded
Abbey Road Studios, London: July 19, 1969 (Studio Three)

Technical Team
Producer: Norman Smith
Sound Engineer: (?)

Genesis

In the suite *The Man and the Journey,* "Biding My Time" is known by the title "Afternoon" and is positioned between "Tea Time"/"Alan's Psychedelic Breakfast" and "Doing It"/"The Grand Vizier's Garden Party." It is one of the most unusual Roger Waters compositions in the Pink Floyd catalog. More specifically, it maintains the link between the group and its rhythm 'n' blues origins. Although a bluesy number, it ends with a traditional jazz feel.

The words also have something of the blues about them. They amount to a critique of work on an assembly line or in an office. *I'll never pine for the sad days and the bad days/When we was workin' from nine to five,* sings Waters. The message is clear: any form of Taylorism (in other words dismally repetitive work) or exploitation of man by man in order to drive productivity leads inevitably to alienation. For the narrator, however, those days are over. He now plans to spend his time *by the fireside, in the warm light,* basking in the *love in her eyes.* The years have gone by and a well-earned time of well-being has arrived…Might this be the reason why "Biding My Time" was never included on an original album by Pink Floyd?

Production

Contrary to the information provided on the sleeve of *Relics,* "Biding My Time" was recorded not on July 9, but on July 19. The mystery remains, however, of why the Floyd went back to the studio at all at this point, having only just finished mixing *Ummagumma.* They completed the recording in one session, and it was the fourth take that was used as the basis for the overdubs. David Gilmour opens "Rest"—the working title of "Biding My Time"—in jazz-blues style with a combination of solo line and chords on his white Stratocaster. His guitar sound is gentle and hushed, and he is closely supported by Roger Waters's bass and Nick Mason's hi-hat. This New Orleans–inspired intro comes as something of a surprise from a group that had recently recorded tracks as experimental as "Sysyphus" and "Several Species of Small Furry Animals Gathered Together in a Cave and Grooving with a Pict" (on *Ummagumma*). It is Waters who sings lead vocals—in a serene, yet nostalgic voice. Gilmour accompanies him on

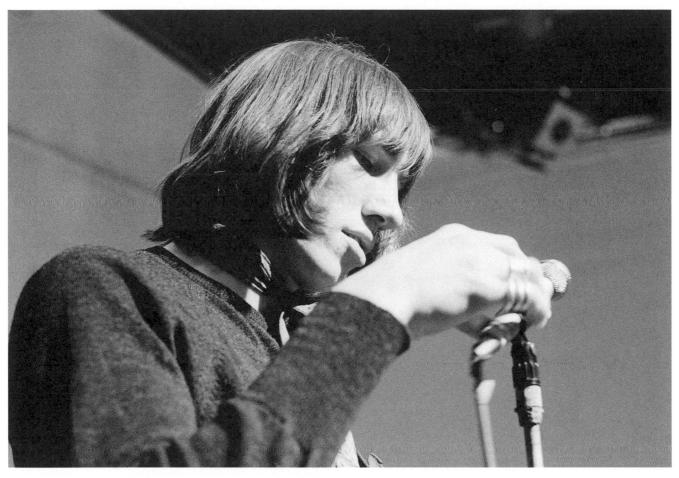

Roger Waters, the composer and singer of "Biding My Time," a jazz–blues number that comes as something of a surprise after *Ummagumma*.

acoustic guitar, and Rick Wright supports him with a very good piano part. The instrumental bridge that follows possesses a more playful, rocky quality. It is after the second verse (from 1:54) that the New Orleans color truly comes into its own. Here, Rick Wright picks up a trombone—an instrument he had been playing since his teenage years—and delivers a solo that is nothing short of astonishing, particularly as he doubles it with a second track, reinforcing the fanfare-like effect of this section. The piece then develops into more of a rock number, with Gilmour leading the charge on his highly distorted Stratocaster. His playing, including a bold three-minute solo, demonstrates that he had perfectly mastered the styles of the luminaries of the genre, in particular that of Hendrix, one of Gilmour's

major influences. Meanwhile his bandmates are not exactly idle: Nick Mason delivers an excellent drum part, pounding his skins furiously (he can be heard furiously maltreating his two bass drums at 4:26!), Roger Waters plays with feeling and power, and Wright continues to support Gilmour with a (double) harmonizing trombone part and some highly inspired playing on the Hammond organ (3:59).

Onstage, this number would provide its performers with an opportunity to let it rip, as they did at the gig of September 17, 1969, at the Concertgebouw in Amsterdam, which is the basis of an excellent bootleg. It seems likely that the atypical character of "Biding My Time" relative to the group's other work was one of the reasons the song never made it onto an original album.

MEDDLE

ALBUM
MEDDLE

RELEASE DATE
United Kingdom: November 5, 1971 (November 13 according to some sources)
Label: Harvest Records
RECORD NUMBER: SHVL 795
Number 3 (United Kingdom), on the charts for 85 weeks
Number 2 (the Netherlands), number 69 (France), number 70 (United States)

One Of These Days / A Pillow Of Winds / Fearless
(You'll Never Walk Alone) / San Tropez / Seamus / Echoes
OUTTAKES Nothing part 1-24 / Anything / Play The Blues /
Wild Thing / Knozze (Nozzee) / Bottles

The four members of Pink Floyd, all set to record a follow-up to "Alan's Psychedelic Breakfast."

Questioned in September 1970 by a journalist who wanted to know how he envisaged the future, Roger Waters replied: "I dunno, really. I have no idea what is going to happen next."[9] We, of course, do…

Meddle,
a Mature Work

Just three months after the British release of *Atom Heart Mother*, Pink Floyd was back in the studio working on their next album. Over the preceding weeks they had been on tour in the United States and Europe—a schedule they would resume in 1971 in the aim of promoting their new album planetwide: Europe to start with, followed by Japan and Australia for the first time. After this it would be back to Europe and then off to North America again. An infernal cycle that explains why the sessions for *Meddle* were spread out over almost nine months.

The Culmination of a Concept
Based on Little "Nothings"

When they turned up at Abbey Road on January 4, 1971, for the first recording session devoted to their new album, Roger Waters, David Gilmour, Rick Wright, and Nick Mason had not yet written a thing. In an interview given in April 1971, David Gilmour confessed to the interviewer that Pink Floyd was "the laziest group ever,"[9] and that other groups would be horrified to see how they wasted their studio time. Nevertheless, the Floyd had a concept they wanted to develop: a sort of follow-up to "Alan's Psychedelic Breakfast." Their idea was to make an album on which kitchen utensils (cutlery, glasses…), tools (a saw), other miscellaneous objects (cigarette lighters), and even "instruments" they had made themselves would replace traditional musical instruments. David Gilmour describes one of their experimental sessions: "We actually built a thing with a stretched rubber band this long [about two

feet]. There was a g-clamp this end fixing it to a table and this end there was a cigarette lighter for a bridge. And then there was a set of matchsticks taped down this end. You stretch it and you can get a really good bass sound. Oh, and we used aerosol sprays and pulling rolls of Sellotape out of different lengths—the further away it gets the note changes. We got three or four tracks down."[25]

This project, which they would resume under the name *Household Objects* two years later, after *The Dark Side of the Moon*, soon revealed its limitations, and the four members of Pink Floyd settled on another concept: "With no new songs, we devised innumerable exercises to try and speed up the process of creating musical ideas," explains Nick Mason. "This included playing on separate tracks with no reference to what the rest of us were doing—we may have agreed on a basic chord structure, but the tempo was random. We simply suggested moods such as 'first two minutes romantic, next two up tempo.' These sound notes were called 'Nothings 1–24' and the choice of name was apt."[5]

Some of these twenty-four sketches would be assembled, reworked, and renamed "Son of Nothings," and then "Return of the Son of Nothings." Like "Atom Heart Mother," "Return of the Son of Nothings" was a long piece of more than twenty minutes' duration. It received its first public performance at the Norwich Lads Club on April 22, 1971. Renamed "Echoes," it was selected as the one and only track for side two of *Meddle*. Side one, meanwhile, contained five numbers. Two of these are credited to

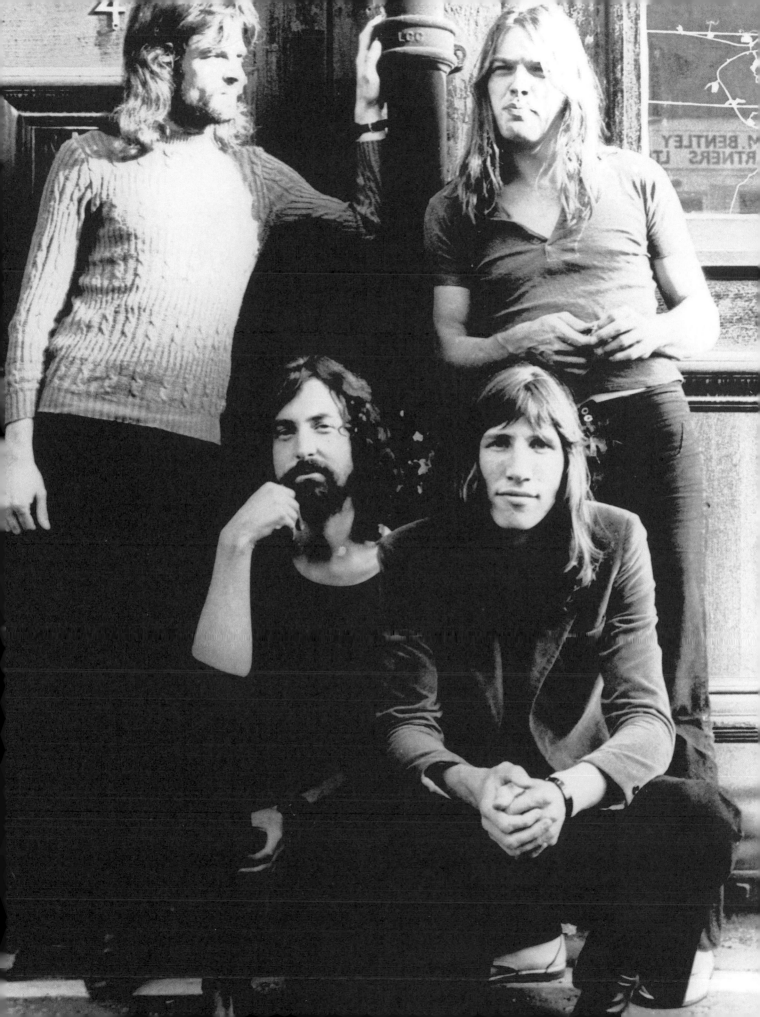

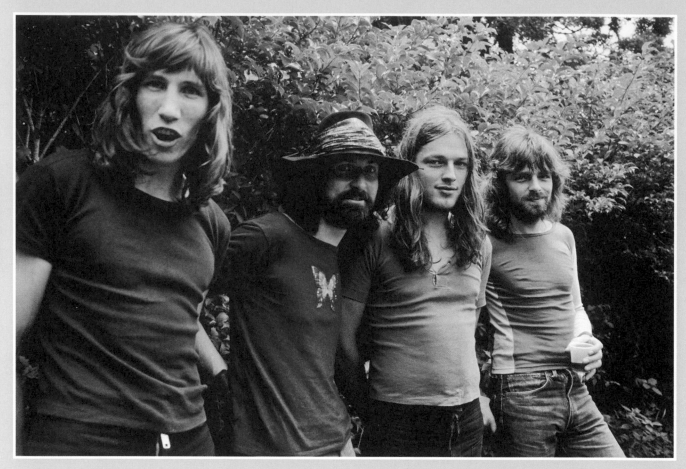

Roger Waters, Nick Mason, David Gilmour, and Rick Wright, beating new musical paths.

Waters-Gilmour-Wright-Mason ("One of These Days" and "Seamus"), two others, for the first time since "Point Me at the Sky" in 1968, were composed by Gilmour and Waters ("A Pillow of Winds" and "Fearless"), while "San Tropez" was written by Waters alone. More than forty-five minutes of pure bliss!

The First Real Pink Floyd Album

"We did loads of bits of demos which we then pieced together, and for the first time, it worked," explained David Gilmour to *Mojo* magazine in May 1994. "This album was a clear forerunner for *Dark Side of the Moon*, the point when we first got our focus."[39] The sixth Pink Floyd studio album can be regarded in effect as the group's first magnum opus in which it displays its unique, idiosyncratic touch, the first properly mature Pink Floyd album. *A Saucerful of Secrets* had been made under the continuing influence of Syd Barrett; *More* and *Zabriskie Point* were soundtracks developed in line with the precise instructions of their respective directors; the studio album *Ummagumma* was the result of individual efforts by the four members of the group rather than a joint project as such, while for many, the follow-up album *Atom Heart Mother* had been given its definitive form by Ron Geesin. *Meddle*, by contrast, was the fruit of a collaboration of four like-minded musicians motivated by a shared desire to explore new avenues and to position themselves in the vanguard of musical developments, but without seeking to be elitist.

While demonstrating proper group cohesion, *Meddle* was also Pink Floyd's first album to point up David Gilmour's role as a singer and guitarist, of course, but also as a composer of melodies. For Clive Welham, the drummer of Jokers Wild, "Dave was responsible for the melodic side of Pink Floyd. When he first joined them they were in a form that wasn't really to his liking. I think it's Dave who put the form into their music, made them a more mature band in that sense."[53] And it is the same story from Jean-Charles Costa, writing in the columns of *Rolling Stone*: "*Meddle* not only confirms lead guitarist David Gilmour's emergence as a real shaping force with the group, it states forcefully and accurately that the group is well into the growth track again."[66]

Meddle was released in the United States on October 30 and in the United Kingdom and continental Europe on November 5, 1971 (November 13 according to some sources). In Britain the album climbed to third place and would remain on the charts for more than a year and a half. In the Netherlands it peaked at number 2, and in West Germany at number 11. In France it was certified double gold (200,000 copies sold) and in the United States double platinum (two million copies sold).

Following the example of Jean-Charles Costa in *Rolling Stone*, the rock critics were pretty unanimous in emphasizing

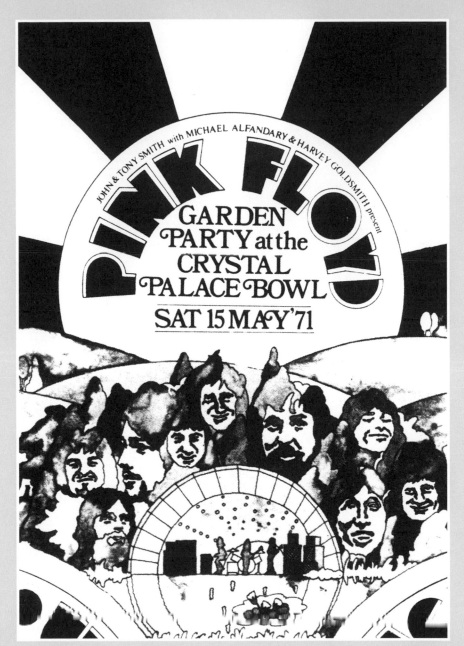

Poster for a Pink Floyd concert at Crystal Palace during which they would perform "The Return of the Sons of Nothing," a suite that was to evolve into "Echoes."

the artistic merit of *Meddle*. The British magazine *Sounds* spoke of a side one that was full of surprises and a side two, "Echoes," which is one of "the most complete pieces of music Pink Floyd have ever done." For Allen Evans, writing in the *NME*, the "Floyd have created dramatic music without having to draw off the strength of full brass and a choir...An exceptionally good album."[67] In France, Alain Dister wrote in *Rock & Folk* that *Meddle* had been prefigured by *Atom Heart Mother*, adding: "Even if it makes less of an impact at first hearing than at second, one has to acknowledge that it is key to the group's musical development because it brings one period—of traditional influences—to a close and provides a blueprint for the next. Both albums are essential to where Pink Floyd are at present: ready to embark upon a new path, to completely renew themselves."[68]

For their part, Pink Floyd would retain a fundamentally positive memory of the making of this LP: "Overall,

the whole album was immensely satisfying to make," writes Nick Mason. "As *Atom Heart Mother* had been a bit of a sidetrack, and *Ummagumma* a live album combined with solo pieces, *Meddle* was the first album we had worked on together as a band in the studio since *A Saucerful Of Secrets* three years earlier."[5]

Listening to *Meddle*, the homogeneity, creativity, and originality of the album are striking, belying the fact not only that the Floyd recorded it in three different studios, but also that their sessions were regularly interrupted by concerts and tours in Europe and far-flung Japan and Australia. To say nothing of a fifth North American tour on which they embarked with the album barely finished. As previously mentioned, this sixth album marked the beginning of their mature period and would define their future sound and identity. "We're consciously approaching this one differently,"[9] declared Nick Mason in February 1971, a month after the

DAVID GILMOUR **ROGER WATERS**

RICK WRIGHT **NICK MASON**

These promotional photos of the quartet are typical of the progressive scene.

For Pink Floyd Addicts

Rock critics have not always held *Meddle* in particularly high esteem. Michael Watts of the *Melody Maker* lambasted it, earning himself the gift of a spring-mounted boxing glove from Nick Mason.

start of recording. And the final results bear this out. *Meddle* is a landmark in their discography and a prelude to the extraordinary *The Dark Side of the Moon*.

The Recording

The making of the album would extend from January 4 to September 11, 1971, and would require forty or so sessions, some of which are unfortunately not documented. The first Pink Floyd album to have been recorded in three different studios, *Meddle* was also the first album the musicians produced entirely by themselves. Exit Norman Smith, who graciously acknowledged that "These guys now knew what they wanted, and so it was silly for me to contribute any more [...]."[13] According to Smith, Roger Waters already had the makings of a producer, as indeed did David Gilmour. "I personally think that the two of them together were a greater force than Syd Barrett ever was."[13]

The sessions began at Abbey Road on January 4, 1971, with Peter Bown and John Leckie engineering. While Peter Bown had been a faithful traveling companion of the group ever since *The Piper at the Gates of Dawn*, John Leckie, hired by EMI in February 1970, was collaborating with Pink Floyd for the first time on this album. Just twenty-two years of age, he already had an impressive CV, having been tape operator on such important albums as *John Lennon/Plastic Ono Band* (1970), George Harrison's *All Things Must Pass* (1970), and *Barrett* by Syd Barrett. (His name would subsequently be associated with Paul McCartney, Simple Minds, Public Image Ltd., the Stone Roses, Radiohead...) "I first saw Pink Floyd at London Free School on the same night that Cream played their second gig at Cooks Ferry Inn, Edmonton," recalls Leckie. "It was 1967 and we went to see Pink Floyd rather than Cream because we knew they were

psychedelic and we wanted to see a 'San Francisco' style light show." He adds: "I was a big fan of *Ummagumma* and when I saw 'Engineer: Peter Mew' on the credits and heard the record I realized, 'That's what I want to do.'"[46]

Throughout the whole of January, the four members of Pink Floyd engaged in experiments that yielded no concrete results other than the twenty-four small pieces entitled "Nothings," some of which would be recycled into material for the album. "They were left alone," confirms John Leckie. "Colin Miles, who was the only person at EMI who could 'relate' to Pink Floyd, used to turn up occasionally with a couple of bottles of wine. Maybe some spliff. They worked hard, though; it wasn't a party."[71]

Other than for a few sessions in the studio on January 20, 21, and 24, between January 17 (at the Roundhouse in London), and February 26, 1971 (at the Stadthalle in Offenbach, West Germany), Pink Floyd was touring again in Europe. They returned to Abbey Road on March 7—and would remain there until March 25. This hiatus in their recording process brought home to them the need to adopt a different way of working, as David Gilmour explains in May 1971: "We spent about a month in the studios in January, playing around with various ideas and recording them all. Then we went away to think about them. Now we are letting things take a natural pace. We're refusing to take any pressure on the album. If people ask us about a release date, we just tell them that they can have it when it is ready."[9] It was at this point that the group decided to move to a different studio. The reason? "This was because EMI, in another display of their innate conservatism, would not commit to the new sixteen-track tape machines," explains Nick Mason. "In a fit of high dudgeon, we insisted we had to have access to one and marched off to AIR, where we

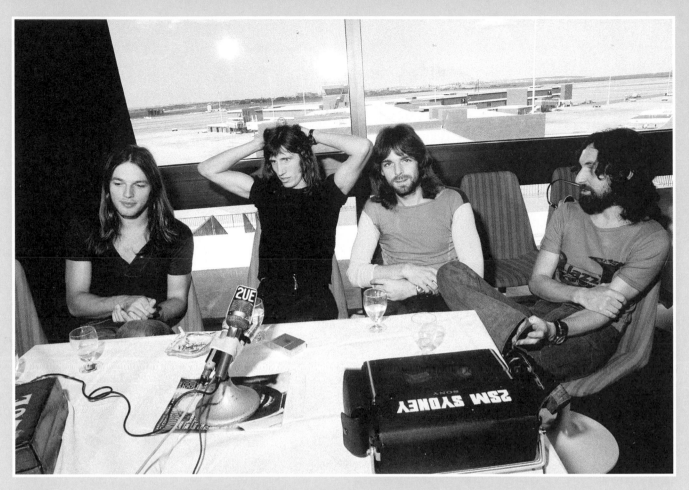

Pink Floyd at a press conference in Australia in August 1971.

did the bulk of the work."[5] It should be explained that at this time, EMI was still using its eight-track tape recorders even though sixteen-tracks had become the norm. This was astonishing behavior from the record company that had produced all the Beatles albums, the biggest-selling records of the era! As a result, Roger Waters, David Gilmour, Rick Wright, and Nick Mason took themselves off to AIR Studios. The Associated Independent Recording Studios had recently been set up by George Martin, who, exasperated by the stinginess of the EMI board, had left Abbey Road in 1965 to become an independent producer. It was therefore in the studio of the former Fab Four producer, equipped with cutting-edge technology, that *Meddle* was recorded, with Peter Bown and John Leckie still at the controls. Although it is believed that seventeen sessions took place there between March 30 and September 21, not all have been documented. Similarly, there is a lack of technical detail concerning Pink Floyd's sessions at Morgan Studios in Willesden, London, between July 19 and 29. All that is known are the names of the two sound engineers there: Rob Black and Roger Quested.

The Sleeve

The title chosen for Pink Floyd's sixth album is most likely the contraction of two words: *middle* and *medley*. Perhaps Waters, Gilmour, Wright, and Mason had found the perfect point of artistic equilibrium ("middle") at which to record the best of their music ("medley").

Once again, the cover sprang from the fertile imagination of Hipgnosis and Storm Thorgerson. The latter is said to have originally been considering photographing a baboon's bottom, an original and provocative but clearly rapidly abandoned idea. While they were on tour in Japan, the members of Pink Floyd managed to steer their friend Storm Thorgerson in a different direction. The photographer Robert Dowling then took the shot that would ultimately be used: a close-up of an ear combined with luminous ripples in the water. "Good plan," comments Thorgerson. "The two separate images, ear and water, were sandwiched together—'sandwich' being a technical term for superimposition—to produce the final indifferent result."[65]

Although the sleeve has to be opened out (the photograph wraps around the front and back) in order to fully appreciate Thorgerson's design scheme, the artwork and the specific colors chosen (dominated by green and blue) convey a reasonably precise idea of the music, in particular that of "Echoes," a work that is simultaneously dreamlike, psychedelic, and possesses a distinctly aquatic feel. Another aspect that heightens the sense of mystery (and at the same time says a great deal about the popularity of Pink Floyd) is that as with *Atom Heart Mother*, neither the name of the group nor the title of the album feature on the cover. Despite all

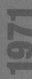

The Floyd at Royaumont Abbey, 20 or so miles from Paris, where they played on June 15, 1971.
The concert was filmed by French television and broadcast on July 12.

this, *Meddle* is the least liked by Storm Thorgerson of all the album sleeves he designed for Pink Floyd.

Technical Details

As we have seen, the album *Meddle* was recorded in three different London studios: EMI's legendary Abbey Road Studios, AIR Studios, and Morgan Studios.

At George Martin's AIR Studios, located at 214 Oxford Street in the heart of London, Pink Floyd benefited from a custom Neve 24x16 console (equipped with the renowned 1073 preamp) and a sixteen-track Studer A80 tape recorder. The Floyd took over the smaller Studio Two, which was used mainly for bands, whereas Studio One was reserved predominantly for recording movie music. Having opened its doors on October 6, 1970, AIR Studios became such a success that a second venue was opened in 1979 on the island of Montserrat in the Caribbean. This was devastated by Hurricane Hugo in 1989, after which AIR then recentered its operations on London, opening a new complex at Lyndhurst Hall, a former Victorian church in the suburb of Hampstead.

Morgan Studios, located at 169–171 High Road, Willesden, began life toward the end of 1967 and soon attracted considerable numbers of artists. Among the masterpieces recorded here are *Tales from Topographic Oceans* by Yes,

Berlin by Lou Reed, and *Seventeen Seconds* by the Cure. In 1971, both studios, each equipped with a Cadac 24x16 console, a 3M M56 sixteen-track tape recorder, and Tannoy Lockwood monitors, were made available to Pink Floyd.

Finally, in September 1971, the group decided to do a quadraphonic mix at Command Studios, also in the British capital (at 201 Piccadilly). Having opened in 1970 in what had formerly been BBC premises, the complex offered three independent studios equipped with automated API 24/24 consoles, Scully sixteen-track tape recorders, and a quadraphonic mixing system that was no doubt the reason Pink Floyd had chosen this place. Command Studios closed down just a few years later, in 1974, but not before a number of highly prestigious clients, such as Roxy Music, Deep Purple, and King Crimson, had availed themselves of its services. Unfortunately, the *Meddle* quadraphonic mix never saw the light of day.

The Instruments

Around this time, David Gilmour started to expand his guitar collection. The instruments he used on the album included a double-neck Fender 1000 pedal steel guitar he acquired in Seattle around October and a Bill Lewis custom twenty-four-fret (compared to twenty-one for the Strat) purchased in Vancouver, also in October. But he still preferred his "Black

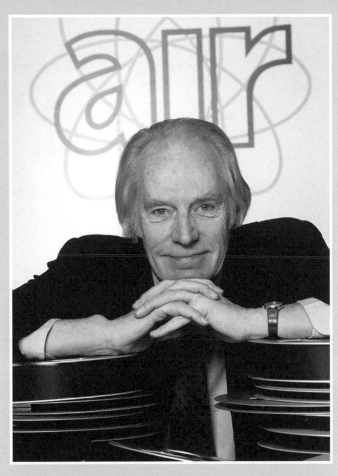

George Martin, the legendary producer of the Beatles and founder of AIR Studios.

A black Stratocaster identical to David Gilmour's "Black Strat" except for the neck, which is maple on the original guitar and rosewood in this photograph.

Strat" for studio work. In terms of acoustic, he almost certainly used his Gibson J-45. For guitar effects, he bought a Dallas Arbiter Fuzz Face BC108, which was more aggressive than the previous model, and a DeArmond volume pedal. There was no change in his amplification, any more than there was in that of Roger Waters, who moreover continued to use his Fender Precision basses, in particular the Precision Sunburst with the rosewood neck that seemed to have won his favor in the studio as well as onstage. Rick Wright may well have been playing an EMS VCS3 synthesizer for the first time on this record, probably the "Putney," although there is some doubt about exactly where on the album it is used (other than generating the artificial wind sound on "One of These Days"). As for Nick Mason, the drummer was still playing his Ludwig kit.

During a Pink Floyd concert on November 15, 1971, the crowd shouted out to the band to play "See Emily Play." Roger Waters's retort was: "You must be joking!"[9]

One Of These Days

Roger Waters, Rick Wright, Nick Mason, David Gilmour / 5:59

Musicians
David Gilmour: electric lead guitar, pedal steel guitar, bass
Rick Wright: piano, organ
Roger Waters: bass, EMS VCS3 (?)
Nick Mason: voice, drums

Recorded
Abbey Road Studios, London: March 15, 1971 (Studio Three)
AIR Studios, London: March 30 and
May 28, 1971, (Studio Two)
Morgan Studios, London: July (precise dates
not known) 1971 (Studios One and Two)

Technical Team
Producer: Pink Floyd
Sound Engineers: Peter Bown (Abbey
Road and AIR), Rob Black (Morgan)
Assistant Sound Engineers: John Leckie (Abbey
Road and AIR), Roger Quested (Morgan)

According to Nick Mason, the roadie was late returning to the studio with the new strings because he had been making an impromptu visit to his girlfriend, who ran a boutique. The young man's secret was betrayed by the new pants he was wearing when he got back.

Genesis

"One of These Days," the first track on side one to be recorded by Pink Floyd, is a collective work that in one sense takes the group back to the space-rock era of *A Saucerful of Secrets*. In reality, of course, it is one of the hardest, edgiest rock tracks they ever wrote. Leaving aside the few words uttered by Nick Mason, this opening track on *Meddle* is an instrumental in three parts.

The piece begins with a raging wind, the result of a very simple sound effect. The first part is built around two basses that answer each other. Accompanied by Rick Wright on keyboards, this long instrumental development generates a palpable, harrowing tension. For the second section, the Floyd develops an experimental sequence that introduces the following threatening phrase from Nick Mason: "One of these days I'm going to cut you into little pieces." Which Roger Waters said to Jimmy Young, a BBC presenter who vocally disliked the group's music. The third and final section is nothing less than a musical maelstrom. This closes the same way the number opened: with the whistling wind.

Pink Floyd started to play "One of These Days" in public in June 1971, five months before the release of *Meddle*. The song was also issued as the A-side of a single in the United States (with "Fearless" as the B-side) and also in Japan (with "Seamus" on the flip side). A version can be heard on *Live at Pompeii*, this time under the title "One of These Days I'm Going to Cut You into Little Pieces." The song was also played on the "Momentary Lapse of Reason Tour" (1987–1990, which appeared on the live album *Delicate Sound of Thunder*, 1988) and the "Division Bell Tour" (1994, which appeared on the live album *Pulse*, 1995). The studio version can also be heard on the compilations *A Collection of Great Dance Songs* (1981), *Works* (1983), and *Echoes: The Best of Pink Floyd* (2001).

Production

In 1971, Michael Watts of *Melody Maker* wrote a damning review of *Meddle*, criticizing the album as a whole as weak, unhip, and old hat, and the track "One of These Days" in particular as "a throwback to the Ventures' 'Telstar.'"[9] The critic's unreliable ears had clearly failed to pick up on the originality and power of this remarkable piece or to identify

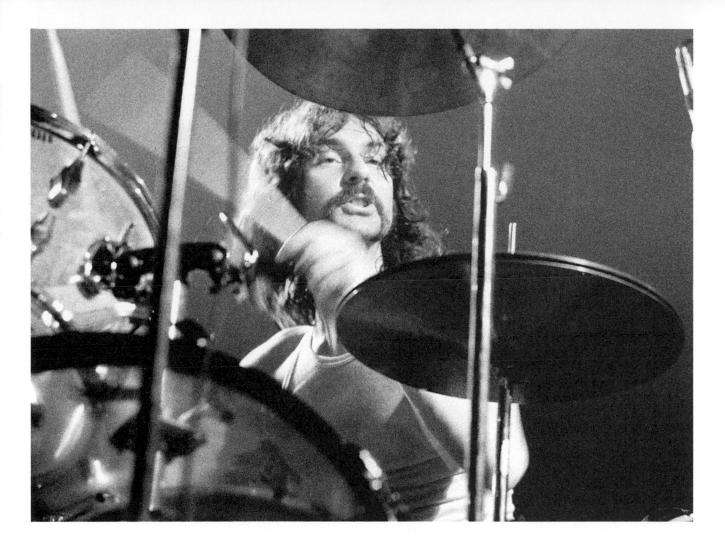

the real inspiration behind it—the main theme of the cult British science fiction series *Doctor Who*, first broadcast on BBC One television in 1963. The show's theme music had been written by Ron Grainer and arranged and realized by Delia Derbyshire, a composer of startling electronic music. As chance had it, in around 1966, Derbyshire was briefly an associate of the brilliant Peter Zinovieff, who went on to develop the EMS VCS3 synthesizer a few years later. Immortalized by the Floyd on *The Dark Side of the Moon*, the VCS3 is also thought to have been used to create the double-tracked wind effect heard at the beginning and end of "One of These Days." There can be little doubt that it was the *Doctor Who* theme music that came to Roger Waters's mind when he heard David Gilmour trying out ideas on his guitar with the Binson Echorec. "It is Roger who had the idea," recalls Gilmour. "I was working on rhythms in this style and he decided to do the same thing on the bass. He found this riff on the bass, the same one that I had played on the guitar."[63]

Unfortunately there is a dearth of information concerning the recording of "One of These Days." Some parts almost certainly derive from recordings made in January, when Pink Floyd was working on their twenty-four "Nothings." The first documented session, however, dates from March 15 and was held in Studio Three at Abbey Road. Once the bass track had been laid down, the group added various guitar, bass, piano, organ, and backward cymbal overdubs. It was probably on this same day that Nick Mason's voice was recorded, under the titles "Dialogue 1" and "Dialogue 2." Following the transfer of Abbey Road's eight tracks to AIR Studios' Studer sixteen-track on March 30, Glenn Povey has been able to find no other record of this track until May 28, when the Floyd recorded the bridge, under the title "Alien Orchestra," with various guitar, piano, cymbal, and organ overdubs. In an interview, however, David Gilmour clearly describes the recording of the basses during a session at Morgan Studios. And as this bass part forms the backbone of the piece, either "One of These Days" was recorded mainly in these studios, or else the bass part was rerecorded in its definitive form after the various sessions at Abbey Road and AIR.

"One of These Days" occupies a unique place in the Pink Floyd discography, as David Gilmour explains: "We went to Morgan Studios, and decided that Roger and I would play two basses live."[63] Gilmour adds that he picked up the main bass guitar and Waters the spare. Unfortunately the strings on the spare were completely dead, and a roadie was immediately sent out to buy a new set. "It's a most

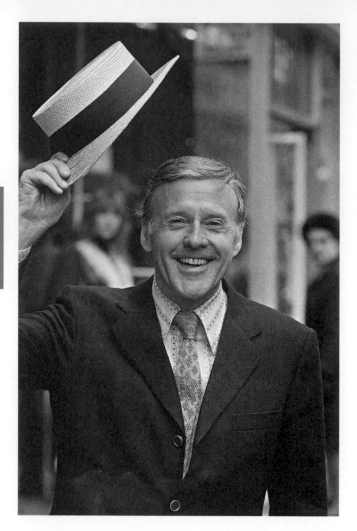

The singer and BBC presenter Jimmy Young, the Floyd's target in "One of These Days."

For Pink Floyd Addicts

Having been a highly popular singer in the fifties, enjoying number one hits with "Unchained Melody" and "The Man from Laramie," and following a brief spell at Radio Luxembourg, Jimmy Young became one of BBC Radio One's first disc jockeys. Between 1967 and 1973, his morning show attracted large numbers of listeners (although presumably not from those circles interested mainly in rock and underground culture). After that he presented a show on BBC Radio Two that was also a big hit with the public.

unlikely story," continues Gilmour, "because we waited for around five hours [three hours according to Nick Mason!], counting the minutes and money draining away."[63] Tired of waiting for the roadie to return, they decided to record the two bass parts with the old strings, despite their lack of brilliance and punch. "You can actually hear it if you listen in stereo. The first bass is me. A bar later, Roger joins in on the other side of the stereo picture."[29] John Leckie, the assistant sound engineer, recalls that: "[Roger] had the straight bass through one amp and the Binson signal coming out of another, and a DI line into the mixing desk. He fiddled around with the tape speed on the Binson until the echo was in exact double time with the bass line he was playing."[64]

It is over this driving rhythm created by Waters and Gilmour, and against a background of synthesized wind (courtesy of the VCS3), that Wright enters with a series of chords played most probably on a piano strongly colored by a Leslie speaker, each chord announced by a reversed cymbal–Hammond organ combination. This creates a fantastic effect that is one of the signatures of the piece. The sound of a reversed hi-hat can also be heard between 1:54 and 2:05. Then comes what sounds like Mason's bass drum(s), struck with considerable power, and Gilmour's first

intervention on his Bill Lewis, played with equal power. This guitar is plugged into his new Dallas Arbiter Fuzz Face BC108, which was far more aggressive than the previous model, and has a highly distorted sound with impressive sustain. Gilmour also uses his whammy bar to add vibrato to his notes. His playing is apparently doubled on a second track, and at 2:35 he can be heard harmonizing with his other guitar line, the two guitars opposite each other in the stereo picture.

The bridge of this track is somewhat experimental in nature. It grows out of a kind of bass solo played by Gilmour and involves a combination of guitar effects, percussion, and reversed sounds. David Gilmour explains: "For the middle section, another piece of technology came into play: an H&H amp with vibrato. I set the vibrato to more or less the same tempo as the delay. But the delay was in ¾ increments of the beat and the vibrato went with the beat. I just played the bass through it and made up that little section, which we then stuck on to a bit of tape and edited in. The tape splices were then camouflaged with cymbal crashes [audible between 3:41 and 3:43]."[29] It is also during this sequence that Nick Mason utters his memorable phrase *One of these days I'm going to cut you into little pieces*. "The line was recorded at double-tape speed

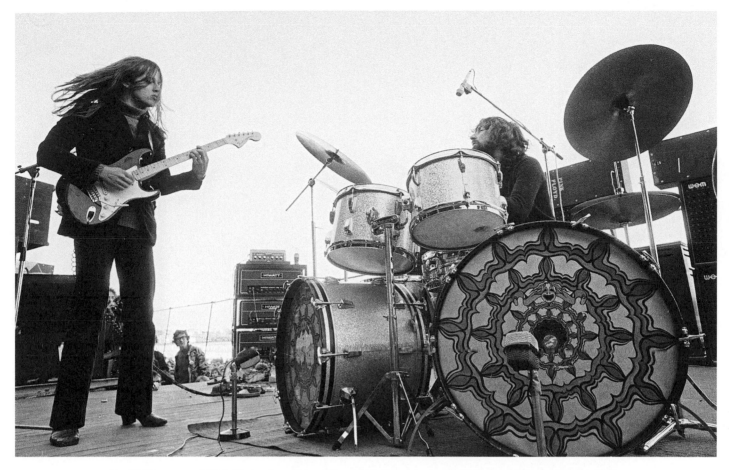

David Gilmour and Nick Mason in action at Randwick Racecourse, Sydney, Australia, in August 1971.
They demonstrate a remarkable musical rapport in the opening track of *Meddle*.

using a falsetto voice; the tape was then replayed at slow speed,"[5] explains the drummer. But apparently the result was not yet quite right, because the decision was then taken to play it through a ring modulator, producing the final cavernous, quasi-monstrous voice!

The last section of the piece is a long rock improvisation during which Mason lets it rip on his Ludwig, Wright plays Hammond organ and piano, and Waters and Gilmour continue their dual bass line. The guitarist also launches into one of his first solos on double-neck pedal steel guitar (although he would later claim not to remember what instrument he had used). The sound is highly distorted rock, and he gives the impression of taking enormous pleasure in playing the instrument, which is tuned in open E minor (E, B, E, G, B, E). "I guess I was never particularly confident in my ability as a pure guitar player," he is on record as saying, "so I would try any trick in the book. I'd always liked lap steels, pedal steels and things like that."[29] Where the one and only key change on the track occurs (from B minor to A major at 4:53), he can be heard playing two distinct solo lines, one in the right-hand channel and the other in the left. His playing, imbued with deep feeling, is superb. The piece concludes with a return to the synthesized wind.

COVERS

"One of These Days" has a number of covers. One is by Gov't Mule (on the 2014 album *Dark Side of the Mule*).

On July 20, 2016, David Gilmour opened the second part of his show with "One of These Days"—which had not been played by the band or its members since 1994.

A Pillow Of Winds

Roger Waters, David Gilmour / 5:13

Musicians
David Gilmour: vocals, acoustic guitar, electric lead guitar
Rick Wright: organ, vibraphone
Roger Waters: bass, acoustic guitar (?)
Nick Mason: drums

Recorded
Abbey Road Studios, London: March 21 and 25, 1971 (Studio Three)
AIR Studios, London: March 30 (other dates not known), 1971 (Studio Two)
Morgan Studios, London: July (precise dates not known) 1971 (Studios One and Two)

Technical Team
Producer: Pink Floyd
Sound Engineers: Peter Bown (Abbey Road and AIR), Rob Black (Morgan)
Assistant Sound Engineers: John Leckie (Abbey Road and AIR), Roger Quested (Morgan)

Genesis
Contrasting strongly with the previous track, a harrowing, hardish rock number, the second track on the album brings balm to the ears. As attested by its title, a poetic formula borrowed from mah-jongg, it is a ballad in the form of an invitation to dream. Nick Mason claims that Roger, Judy, Lindy, and he used to play the Chinese game together regularly.[5]

Like the title, Roger Waters's lyrics (sung by David Gilmour) evoke peace and tranquility: *A cloud of eiderdown draws around me, softening the sound/Sleepy time when I lie with my love by my side/And she's breathing low and the candle dies.* From the very first lines, peacefulness and harmony reign. Then come nocturnal dreams, punctuated by nature's rhythms, followed by impressions of morning, when *the night winds die* and *the first rays touch the sky* and the hero of the song rises *like a bird in the haze.* In one sense, the song can be seen as a hymn of praise (Roger Waters–style) to the all-powerful sun…Other observers have seen the *golden dawn* of the third verse as an allusion to the well-known society of the same name devoted to the study of the occult, whose members included such great literary figures as William Butler Yeats, Henry Rider Haggard, Arthur Machen, and, of course, Aleister Crowley. However, there is no evidence to support this theory, Roger Waters having never (to the best of our knowledge) shown any interest whatsoever in the Hermetic Order of the Golden Dawn or the neo-paganism with which it is associated.

Production
The group began recording this beautiful song, known still as "Dave's Guitar Thing," at Abbey Road on March 21. It is an acoustic ballad typical of David Gilmour's style: folk, country, and rock influences go hand in hand with certain West Coast sonorities, representing the diametrical opposite of Syd Barrett's resolutely English pop. The first take was used as the base track. The song begins with three guitars playing arpeggios: two acoustic instruments in the center and on the right of the stereo field (the Gibson J-45?), and an electric (the "Black Strat"?) on the left. It is assumed that David Gilmour plays all three, although it is possible that Roger Waters lent a hand by playing one of them. Gilmour also—and of this there is no doubt whatsoever—plays a slide

1971

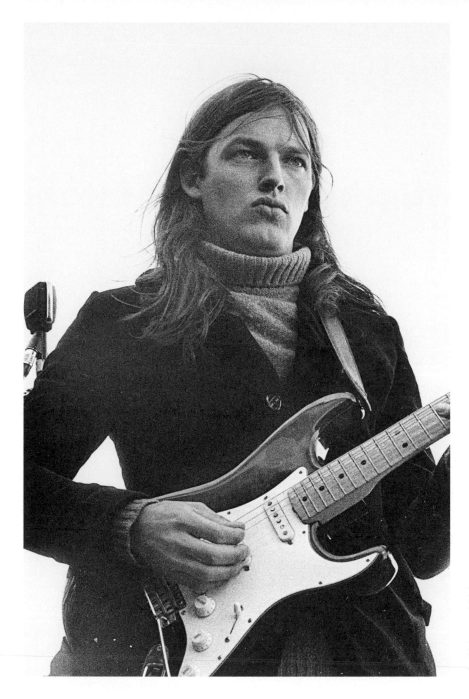

David Gilmour with his "Black Strat," almost certainly one of the guitars he used to record "A Pillow of Winds."

guitar part, demonstrating his unique and characteristic touch: mellow, gentle, warm. He also sings lead vocal and doubles his own voice.

There is a question mark over one of the instruments, the bass guitar played by Roger Waters. It is clearly a fretless instrument, a type of bass not previously used on a Pink Floyd record. Although not especially characteristic, the specific sound would seem to leave no doubt about this. Is it a bass that happened to be lying around in the studio? It is impossible to know. Rick Wright provides support on the Hammond organ, but also on the vibraphone, which comes in at 3:00. Nick Mason is happy to provide an extremely discreet rhythmic accompaniment, confining himself simply to marking the beat on his hi-hat.

On March 25, the group recorded some additional guitar and vibraphone tracks. Gilmour probably added electric slide guitar parts at this stage, in particular the doubled solo with extremely melodic phrasing in the instrumental bridge (listen from 3:03), but also some acoustic slide guitar (for example in the coda). On March 30, the EMI eight-track tape was then copied to the sixteen-track machine at AIR Studios. Aside from this technical procedure, however, there is a lack of information about the work done at AIR. With the track more or less finished, the following sessions were most probably used for mixing and of course for the cross-fading that links "A Pillow of Winds" to the synthesized wind of "One of These Days."

Fearless
(included You'll Never Walk Alone)

David Gilmour, Roger Waters (Rodgers & Hammerstein) / 5:11

Musicians
David Gilmour: vocals, electric rhythm and lead guitar, six-string and twelve-string (?) acoustic guitar
Rick Wright: piano, organ, backing vocals (?)
Roger Waters: bass, fuzz bass, six-string and twelve-string (?) acoustic guitar
Nick Mason: drums, maracas, tambourine
Fans of Liverpool F. C. (Kop): soccer supporters' chanting

Recorded
AIR Studios, London: May 9, 10, September 11, 1971, other dates not known (Studio Two)
Morgan Studios, London: July (precise dates not known) 1971 (Studios One and Two)

Technical Team
Producer: Pink Floyd
Sound Engineers: Peter Bown (AIR), Rob Black (Morgan)
Assistant Sound Engineers: John Leckie (AIR), Roger Quested (Morgan)

For Pink Floyd Addicts

Nick Mason mentions Family. In 1971, Roger Chapman's band released an album entitled...*Fearless*.

COVERS

"Fearless" was covered by Fish (the former lead singer of Marillion) during the sessions for his album *Songs from the Mirror* (1993). The Black Crowes have also performed an excellent version of the song in concert.

Genesis

"Fearless" is the second composition on *Meddle* by the Waters/Gilmour duo. According to Nick Mason, the title "was an overused expression—a soccer-inspired equivalent of 'awesome.'"[5] The group had picked it up from Tony Gorvitch, the manager of Family and a close friend of Steve and Tony Howard. "Fearless" has developed particular associations with the Liverpool soccer supporters (especially those of the "Kop" stand), who sing "You'll Never Walk Alone" at the end of matches. This is because the same chant occurs a number of times in the Pink Floyd song: very surreptitiously, indeed barely audibly, at the beginning (0:24) and in the middle (2:08) of the song, and very clearly, indeed a cappella, at the end (from 4:40). According to Mark Blake, the chant used here was recorded live at a Liverpool versus Everton derby.

Two major questions remain: Why did the Floyd incorporate the supporters' chant into the song at all? And why did they choose this iconic Liverpool chant given that the two members of the band who were keenest on soccer, David Gilmour and Roger Waters, had no particular liking for this club? According to Rick Wright, "We featured the Liverpool supporters because they're the best football crowd in the country for what we wanted."[36]

Some people, however, believe that instead of looking to the fervor with which the supporters are singing for an explanation, the answer is to be found in the words themselves. Very simple and heartening, the lyrics contain a message that could not be clearer. Even in adversity, the words say, we should never lose hope, and we should turn to those around us for support: *Walk on, walk on/With hope in your heart/And you'll never walk alone/You'll never walk alone.* This message of optimism is similar to that of the first verse of "Fearless," whose words describe the difficulties that can be encountered in life and the succor those around us can bring.

Others have seen the song as an allusion to Syd Barrett, who was struggling to forge a solo career around this time. How could one not see Syd in the idiot who *faced the crowd smiling*, Syd the king (of psychedelia, that is) who had forfeited his crown, whom the abuse of psychotropic drugs had led into an unknown world, into a

The four members of Pink Floyd as part-time soccer players.

"madness" that is synonymous not with "insanity" but with an alternative reality.

Among the many other hypotheses is the more political explanation put forward by some commentators whereby Roger Waters, an avowed pacifist ever since the death of his father, the soldier and staunch socialist, had a fondness for Liverpool because of the city's conspicuous left-wing politics. For those who support this interpretation, the words can be seen as a kind of ode to the city: *You say the hill's too steep to climb/You say you'd like to see me try.*

"Fearless" closes with the Liverpool Kop chanting the club anthem "You'll Never Walk Alone," a song written by Richard Rodgers and Oscar Hammerstein II for the musical *Carousel*, first performed on Broadway in 1945.

Production

Before being named "Fearless," this song was known rather more prosaically as "Bill," and it was under this title that it was first worked on in AIR's Studio Two on May 9. The seventh take, which was earmarked as the base track, was recorded most probably by Nick Mason on drums, Roger Waters on bass, and David Gilmour on Stratocaster. The guitar is tuned to open G and the sound is slightly distorted, courtesy of the Fuzz Face. During the ensuing overdubs it was Waters who most likely played first acoustic guitar (on the right of the stereo image), because this composition was written under the influence of Syd Barrett, as the bassist himself acknowledges: "Funnily enough, that was a tuning that Syd showed me. It's a really beautiful open G tuning,

for anybody who wants to tune their guitar: G-G-D-G-B-B."[36] After doubling this guitar part, Waters then recorded a fuzz bass, which, although discreet, can be heard throughout the coda (from 3:57). He also seems to have added to, or rerecorded, his initial bass line that same day. Gilmour floats Stratocaster effects over the song's mellower passages, combining violining and feedback using his volume pedal (or the Strat's potentiometer) with distortion and substantial use of reverb. He can also be heard playing harmonics (at around 1:18 and 3:21).

The next day brought new overdubs. This time a twelve-string acoustic guitar (on the left of the stereo image) added by either Gilmour or Waters as well as a very discreet organ part (from 1:55) and a piano, both played by Rick Wright. Mason in turn recorded maracas and a tambourine over the coda, both of which are drenched in reverb. The vocal parts, of which the date and place of recording are not known, are sung mainly by David Gilmour, again in a gentle, breathy voice. Gilmour double-tracks himself in order to add substance to his initial take, and either the guitarist or Rick Wright can also be heard harmonizing with the main voice. The last documented date on which this track was worked was September 11, and this was almost certainly one of the last sessions devoted to the album. "Fearless" is one of the triumphs of *Meddle*. The sound engineer John Leckie corroborates this. "'Fearless' is still the one that everyone in Liverpool plays.[…] Not just for the football chant but those churning acoustic guitars. That's the one that the La's and all those bands tell you is the classic Pink Floyd track."[71]

San Tropez

Roger Waters / 3:44

THE BB LEGEND

Legend has it that David Gilmour had a liaison with Brigitte Bardot during his stay in Saint-Tropez in 1965. "It's a myth," he told the newspaper *Le Parisien* (the edition of September 18, 2015). "We played with Pink Floyd at a party in Deauville in 1967 which she attended with her husband Günter Sachs. But I didn't really meet her."

Musicians
David Gilmour: electric slide guitar, electric rhythm and lead guitar
Rick Wright: piano
Roger Waters: vocals, bass, acoustic guitar (?)
Nick Mason: drums

Recorded
AIR Studios, London: dates not known
Morgan Studios, London: July 27, 1971, other dates not known (Studio One)

Technical Team
Producer: Pink Floyd
Sound Engineers: Peter Bown (AIR), Rob Black (Morgan)
Assistant Sound Engineers: John Leckie (AIR), Roger Quested (Morgan)

The seafront at Saint-Tropez, which inspired Waters to write…"San Tropez."

Genesis

The Roger Waters song "San Tropez" is an evocation of the Mediterranean resort in the South of France made famous all over the world by Brigitte Bardot. The small port in the *département* of Var was well known to David Gilmour as he and Syd Barrett had performed for loose change to the café terraces there in the early sixties before Pink Floyd had even been formed. More importantly it had been one of the venues in the group's tour of the festivals of the South of France in the summer of 1970. While several concerts were canceled, the one they played at Les Caves du Roy in Saint-Tropez within the context of the music festival there on August 8, 1970, was a great success. It was most likely the memory of their stay in Saint-Tropez that inspired Roger Waters to write this jazzy little number with somewhat cryptic words.

The meaning of the first verse is not at all clear. The narrator seems to touch on his fame, on solitude, and on a lover who offers to console him…The second line of this verse has been puzzling listeners ever since the song was recorded. The problem centers on the meaning of the word *rind* in the line: *Slide a rind down behind a sofa in San Tropez*. Is this simply an enigmatic phrase of the kind that is by no means uncommon in the songs of Pink Floyd? Or does the famous "rind" refer to the skin of a fruit with hallucinogenic properties? Of course it might just be an error made when transcribing the words, as the booklet of the CD versions seems to indicate by changing the words *Slide a rind down…* to *Slide a line down…* From here it requires no great leap of the imagination to visualize a line of cocaine.

In the second verse, the narrator refers to his modest origins (*Owning a home with no silver spoon*) and his current jet-setting lifestyle (*I'm drinking champagne like a good tycoon*), surely, at the same time, an allusion to the jet set that made Saint-Tropez its summer meeting place, above all after the success of the movie *And God Created Woman* (1956), directed by Roger Vadim and starring Brigitte Bardot. In the third and final verse we return to reality *by a country stile*, and with it a hankering after simple pleasures: *And you're leading me down to the place by the sea/I hear your soft voice calling to me*. The voice of the narrator's loved one, then, rather than that of some siren…

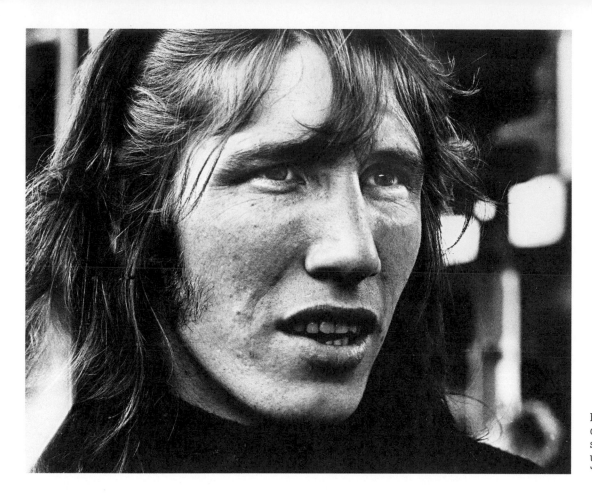

Roger Waters, composer of the superb and unexpectedly jazzy "San Tropez."

Production

"'San Tropez,' a song Roger brought in complete and ready to record, was inspired by the Floyd expedition to the south of France the previous summer and the house we had rented there,"[5] writes Nick Mason. A fully finished composition that Waters presented to his bandmates, it is the only song on the album whose writing involved no collaboration whatsoever. Apparently recorded in a hurry, under pressure from EMI to ensure that the album was finished before the Christmas holidays, "San Tropez" was most probably the last song recorded for *Meddle*. Save for the one known recording session, at Morgan Studios on July 27, there is no technical information relating to the making of this track.

From the very first notes, the listener is struck by the frothiness of the song, which is entirely in keeping with the sunshine of Côte d'Azur and Saint-Tropez, inexplicably misspelled in the song title. Waters has succeeded in composing a jazz-inspired ditty of which one would never have thought either him or the Floyd (given their back catalog) capable. We are a long way here from the troubled or introspective moods of the other tracks on this album; Waters has taken a leaf out of Burt Bacharach's book and come up trumps!

It is clearly Waters playing the acoustic guitar (the Gibson J-45?), on which he lays down an excellent groove. He is also playing his Precision bass and takes the lead vocal for the first and last time on the album. His voice is gentle, sensual, and displays certain inflections of which Gilmour himself would not have been ashamed. He doubles himself on a second track without trying to harmonize with his other part. He is supported by Nick Mason, who delivers a pop-style drum part rather than seeking to bring out the song's jazz side. Rick Wright plays a prominent role because his excellent piano part is recorded in stereo and therefore foregrounded in the mix. He colors the song with quite harmonically rich chords, jazz having been one of his favorite musical genres ever since his teenage years.

David Gilmour does not come in until the end of the second verse, when he plays a slide solo in two parts. In the first (at 1:15), he is almost certainly playing his (here clear-toned) "Black Strat" and harmonizes with himself on a second track. The result reinforces the cool character of the song. In the second (from 1:31), the sound has more of an edge to it and he may be using his Lewis with a different setting and very light distortion. Here he does not harmonize with himself but simply doubles his solo. For the remainder of the song he goes back to a clear tone in order to support his bandmates rhythmically, but takes the opportunity to throw in the odd little lick to wonderful effect (for example at 2:00).

The last section of "San Tropez" belongs to Rick Wright, who delivers a superb solo improvisation on the piano, here and there recalling Duke Ellington, whom he greatly admired.

Seamus

Nick Mason, David Gilmour, Roger Waters, Rick Wright / 2:17

Musicians
David Gilmour: vocals, acoustic guitar, harmonica
Rick Wright: piano
Roger Waters: bass
Seamus (the dog): barking
Recorded
AIR Studios, London: May 24, 25, 28, 1971 (Studio Two)
Morgan Studios, London: July 26, 1971 (Studio Two)
Technical Team
Producer: Pink Floyd
Sound Engineers: Peter Bown (AIR), Rob Black (Morgan)
Assistant Sound Engineers: John Leckie
(AIR), Roger Quested (Morgan)

IN YOUR HEADPHONES
At precisely 1:00, someone can be heard uttering a phrase at the back of the studio, but what exactly is being said? Speculation ranges from "here is…[?]" to "very theatrical."

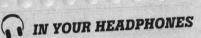
For Pink Floyd Addicts
The second part of this blues song was chosen by Tom Stoppard for the self-directed movie of his play *Rosencrantz & Guildenstern Are Dead* (1990).

Genesis
The group brings side one of *Meddle* to a close with a blues number in the form of a "novelty track,"[5] to borrow Nick Mason's expression. The words glorify an old dog named Seamus, a border collie. Nick Mason explains: "Dave was looking after a dog, the Seamus in question, for Steve Marriott of the Small Faces. [In reality Marriott had already left that group and joined Humble Pie.] Steve had trained Seamus to howl whenever music was played. It was extraordinary, so we set up a couple of guitars and recorded the piece in the afternoon."[5] For David Gilmour, the piece connects with the old acoustic blues tradition of Leadbelly and Bill Broonzy…

Production
Although the writing credit goes to all four members of Pink Floyd, in reality this twelve-bar blues was improvised in the studio. Having come up with the words, all that remained was to get the song down on tape. This was done at George Martin's AIR Studios on May 24. The working title was "Shamus," a phonetic (mis)spelling of the dog's name. The song opens with an acoustic rhythm guitar (the Gibson J-45 in the right-hand channel) whose strings have probably been lowered by a tone (to D, G, C, F, A, D) in order to better match the howling of the dog. It is Gilmour on guitar, and he also delivers a second acoustic guitar part (stereo left), this time played slide, which sounds as if it is tuned to drop D (in other words with just the bottom E string lowered a tone). Waters follows on bass, no doubt tuned the same way, and then Rick Wright on piano, taking a solo at 1:28. In addition to playing the guitar and singing, Gilmour also recorded a harmonica part that can be heard throughout the first verse, although not without some difficulty. Nick Mason, meanwhile, is not involved at all. The next day saw the recording of piano overdubs and May 28 the addition of further howling from the dog, harmonica (again buried in the mix), and slide guitar. Finally, on July 26, the track was mixed at Morgan Studios, with instructions to lower the volume of Seamus's contribution in the intro!

The Floyd would return to the song when shooting *Pink Floyd: Live at Pompeii*, renaming it "Mademoiselle Nobs." On this recording Waters plays Gilmour's "Black Strat," while Gilmour plays the harmonica but does not sing. (A bass can be heard that was added in the studio.)

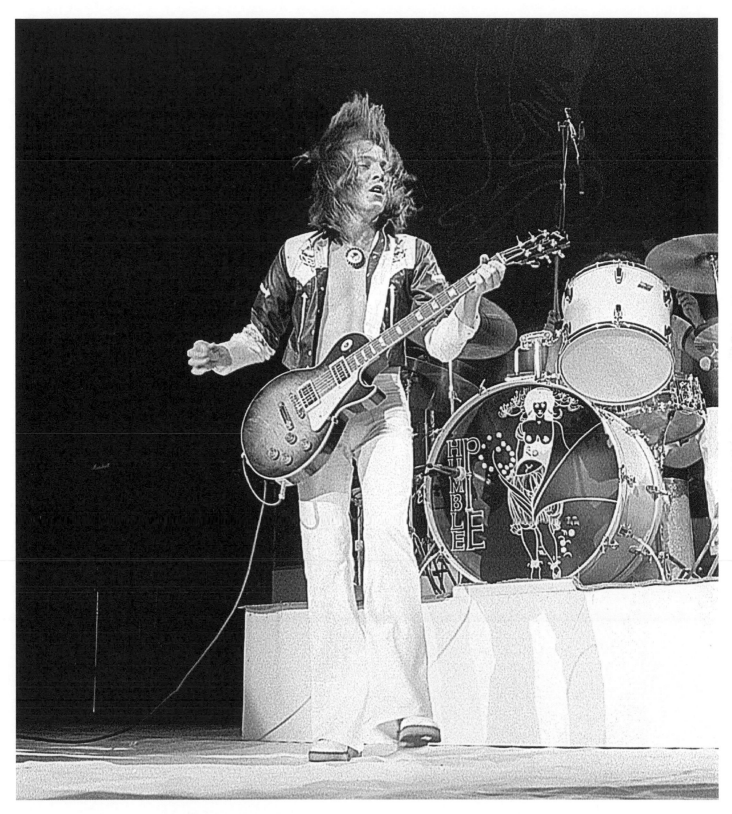

Steve Marriott of Humble Pie. It is his dog, a Border Collie, that "sings" on "Seamus."

Echoes

Roger Waters, Rick Wright, Nick Mason, David Gilmour / 23:31

Musicians
David Gilmour: vocals, electric rhythm and lead guitar, effects
Rick Wright: vocals, piano, organ, fuzz organ, effects
Roger Waters: bass, fuzz bass, effects
Nick Mason: drums, percussion (?), effects

Recorded
Abbey Road Studios, London: March 7, 11, 12, 15, 19, 1971 (Studio Three)
AIR Studios, London: March 30, April 8, 9, 10, 13, 14, 26, 27, 28, May 1, 1971 (Studio Two)
Morgan Studios, London: July (precise dates not known) 1971 (Studios One and Two)

Technical Team
Producer: Pink Floyd
Sound Engineers: Peter Bown (Abbey Road and AIR), Rob Black (Morgan)
Assistant Sound Engineers: John Leckie (Abbey Road and AIR), Roger Quested (Morgan)

A SONG OF NO FIXED TITLE

The title "Echoes" went through a number of mutations. After changing from the "Son of Nothings" to "Return of the Son of Nothings" and finally to "Echoes," the piece was occasionally renamed by Roger Waters for individual concerts: on November 15, 1972, at Böblingen, a suburb of Stuttgart, Waters (it was always him) introduced it to the audience as "Looking through the Knotholes in Granny's Wooden Leg," and the following day in Frankfurt as "The March of the Dam Busters."

Genesis

"Echoes" is the final version of another long musical piece that the members of Pink Floyd had been working on since January 1971 in Abbey Road Studios and that they performed live for the first time in Norwich on April 22 under the title "Return of the Son of Nothings" (or "Son of Nothings" or "Nothings"). However, it was a brilliant discovery by Rick Wright and Roger Waters that would lead to the shaping of this legendary track into its final form. While Rick was playing the piano in the studio, Roger suddenly asked him whether it would be possible to feed his piano through a Leslie speaker via a microphone. "That's what started it," confirms Wright, adding: "That's how all the best Floyd tracks start, I believe."[39] Nick Mason recalls how the idea was then implemented: "The most useful piece was simply a sound, a single note struck on the piano and played through a Leslie speaker. This curious device, normally used with a Hammond organ, employs a rotating horn that amplifies the given sound. The horn, revolving at a variable speed, creates a Doppler effect, just as a car passing the listener at constant speed appears to change its note at it goes by. By putting the piano through the Leslie, this wonder note of Rick's had an element of the sound of Asdic, the submarine hunter, about it." He continues: "Combined with a wistful guitar phrase from David, we had enough inspiration to devise a complex piece, which evolved into 'Echoes.'"[5] And this is how the space opera that was "The Return of the Son of Nothings" turned into an aquatic epic...

In his very last interview, given to *Mojo* magazine in July 2007, Rick Wright claimed "Echoes" as being his own idea. "The whole piano thing at the beginning and the chord structure for the song is mine, so I had a large part in writing that. But it's credited to other people, of course."[72]

Roger Waters, who wrote the words, claims that the inspiration for them came to him shortly after Syd Barrett left the group, in the London flat he shared with his future wife, Judy Trim, in Shepherd's Bush, while watching people come and go in the street. Whereas the initial live versions had lyrics that evoked the planets, the ultimate version contains various marine references.

What is the message Waters wanted to convey through these words? Could the albatross that *hangs motionless upon the air* and the *rolling waves in labyrinths of coral*

The four members of Pink Floyd attain their artistic maturity with the suite "Echoes."

caves be allegories of a journey into the narrator's subconscious? An introspective journey that leads to the main idea of the third verse, which seems to be saying that the world would be a better place if people communicated through empathy rather than allowing antipathy or aggression to bring them into conflict. *And do I take you by the hand and lead you through the land* could be an attempt to convey the idea that fulfillment can be achieved with the help of other people. This would make "Echoes" an appeal for unity and perhaps even the announcement of a new era.

A different interpretation is also possible. We could see Wright's note imitating the echo of a sonar and the marine allusions as evoking an aquatic big bang, or more specifically the birth of life on Earth, which started in the ocean depths. *No one knows the wheres or whys.* This phrase in the second verse poses the question that has haunted humankind since time immemorial: does the universe have a creator or it all the result of mere chance? Waters ventures to provide an answer at the end of the fourth verse with the implacable declaration: *And no one flies around the sun.* Hence (perhaps) the early titles of this piece: "Son of Nothings"

and "Return of the Son of Nothings." Hence also the cry of despair in the form of a conclusion: *And so I throw the windows wide and call to you across the sky.* Rarely has the sound of a song's words been in such perfect harmony with the purity of its melodies and the simultaneous impression of desolation and nostalgia.

Although the structure of "Echoes" is very similar to that of "Atom Heart Mother," the song differs from the earlier work in one important respect: the absence of brass and choir, which makes it far easier to perform live. Says Rick Wright: "[…] it's fantastic to play live. I love playing it."[72] A performance of "Echoes" had already been given under its definitive title prior to the worldwide release of *Meddle* in November 1971, when Adrian Maben's cameras filmed Pink Floyd playing the piece (in a two-part version) in October for the documentary *Pink Floyd: Live at Pompeii*. Waters, Gilmour, Wright, and Mason would continue to include it in their set list until the mid-seventies with a saxophone solo from Dick Parry in the 1971–1973 concerts and with contributions from the backing singers Venetta Fields and Carlena Williams in the 1974–1975 performances. Having been

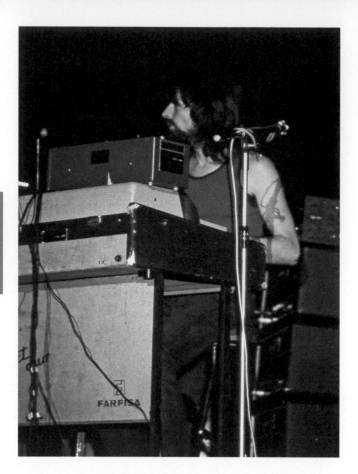

Rick Wright on keyboards. The Farfisa organ makes an important contribution to the sound of "Echoes."

Among the various sketches for music not in the end used in "Echoes" is Roger Waters's "Brain Damage," which would be revived for *The Dark Side of the Moon*.

reduced to a trio following the departure of Roger Waters, the group returned to the work again on the "Momentary Lapse of Reason Tour" (1987–1990). The most astonishing version of all, however, is the acoustic one that Gilmour, quite properly accompanied by Rick Wright, performed live at Abbey Road Studios. This version is included as a "hidden track" on the DVD *Remember That Night, Live at the Royal Albert Hall*, which was recorded in May 2006.

Production

Running for more than twenty-three minutes, "Echoes" is one of Pink Floyd's three longest pieces, along with "Atom Heart Mother" and the nine-part "Shine On You Crazy Diamond." According to the sound engineer John Leckie, it would never have seen the light of day but for Roy Harper and his 1971 album *Stormcock*. Consisting of four tracks of between seven and thirteen minutes' duration, Harper's album (also recorded at Abbey Road) is thought to have influenced the group in the length of its songs. Nick Mason disputes this, but it seems highly likely that Harper—who would later sing lead vocal on "Have a Cigar"—strengthened their resolve to reiterate what they had undertaken the previous year with "Atom Heart Mother."

It was on the basis of various parts of the *Nothings* project, recorded and assembled in January 1971, that the group defined the structure of "Return of the Son of Nothings," the future "Echoes." One of the early sketches, "Nothing Part 14," can be found in the box set *The Early Years*

1965–1972, released in November 2016. This takes the form of a seven-minute improvisation on four chords that prefigures one of the sections in the final version.

Properly speaking, the "Echoes" sessions took place between March 3 and 19. It was the sixteenth take that was used as the base track for the various overdubs. The musicians were still recording on an eight-track tape recorder at Abbey Road. It was only on March 30 that they abandoned EMI to continue in George Martin's AIR Studios, which were equipped with a sixteen-track machine. Ten or so sessions are documented, the last of which took place on May 1. Unfortunately there are no precise details concerning Morgan Studios, if the Floyd really did work on the piece there. All that is known is that the atmosphere was good, that one of the driving forces was Roger Waters, who spent a lot of time in the control room, monopolizing to a considerable extent the role of producer, that David Gilmour was at the forefront of things in the studio, and that Rick Wright and Nick Mason assumed a more reserved role. "Roger and Dave were running the show, but everybody was contributing,"[72] John Leckie would reveal, while Rick Wright would admit in an interview that it had been "a glorious song to make in the studio."[72]

"Echoes" can be divided into seven parts.

An Extraordinary Epic in Seven Acts

The first section begins with that introductory note played on the piano by Rick Wright, a note that could be described as the undisputable signature of the piece, if not of *Meddle* as a

Image taken from Stanley Kubrick's *2001: A Space Odyssey*. "Echoes" synchronizes perfectly with the sequence "Jupiter and Beyond the Infinite."

whole. Before obtaining this very special sound, the famous ping, the group had had to fight hard to convince the technical team at Abbey Road to comply with their wishes, that is to say to feed the piano signal, captured by a mic, through a Leslie speaker. Having finally argued their case successfully, Wright was able to test the result. Things suddenly fell into place for the four members of the group: that one note acted as a catalyst that inspired them to compose the rest of their masterpiece. In his very last interview, Rick Wright confirms the power of that B: "I'd hit that one note on piano and the whole place would erupt."[72] Resonating like a submarine sonar, this note invites the listener to embark on a journey and at the same time is a call to awakening. Curiously enough, the note that can be heard on the album version derives from the very first trials, which proved impossible to reproduce later with the same resonance and richness!

This first part develops toward an improvisation by Wright on the piano, his sound still colored by the Leslie speaker, and an initial intervention by David Gilmour on his "Black Strat," which he plays here without distortion. In his infinitely expressive, distinctly bluesy playing, he displays an exceptional touch. A background accompaniment can be heard that seems to be made up of pedal steel guitar and Farfisa pads, both drenched in Binson Echorec. After Roger Waters's entry on his Fender Precision, the bassist is joined by Nick Mason on his Ludwig kit, and backward cymbal effects contribute to the overall picture. Wright also fleshes out the arrangement on his Hammond organ.

The second section (from 2:57) gives way to the lyrics. Gilmour and Wright share the lead vocal in the first two verses, Wright singing the higher voice and Gilmour the lower. Their respective vocal timbres combine wonderfully, each singer possessing a natural gentleness that results in one of the best-ever vocal performances by Pink Floyd. Gilmour would concur in September 2008: "The blend of his and my voices and our musical telepathy reached their first major flowering in 1971 on "Echoes."[75] The end of each verse is followed by a superb riff played simultaneously by Gilmour and Waters in the style of "Astronomy Dominé" and "Interstellar Overdrive." There then follows a second guitar solo with Gilmour literally in a state of grace, the notes leaping from his Stratocaster with consummate feeling before taking on more of a rock feel with Fuzz Face distortion. This sequence ends with a return to the main riff.

The third section (from 7:01) comprises a funky sequence in exactly the same spirit as "Funky Dung" on "Atom Heart Mother." Mason's drumming suddenly switches to stereo (in all likelihood thanks to ADT) with the exception of the overdubbed cymbal crashes in mono. The rhythm section functions supremely well here, with Waters energetically pumping the beat on his Precision bass, Wright delivering a excellent Hammond organ part featuring some great soul licks (each positioned at one extremity or other of the stereo image) and Gilmour playing two rhythm parts, the first clear-toned and the second distorted. The guitarist takes another solo at 7:25, this time with a far more aggressive,

John Lennon, a source
of inspiration for Roger
Waters in "Echoes."

For Pink Floyd Addicts

John Lennon inspired Roger Waters. The bassist demonstrates this in "Echoes" by "borrowing" a line from "Across the Universe," a song on the Beatles album *Let It Be* (1970): *Inciting and inviting me* in the case of Lennon; *Inviting and inciting me to rise* in the case of Waters...

spacey feel. As Phil Taylor, Gilmour's guitar technician, clearly explains, all the guitar parts in "Echoes" are played on his "Black Strat" alone, the Lewis not getting a lick in.

The fourth section (from around 11:20) is the most startling. It begins with a somewhat disturbing sonic backdrop that Waters creates by sliding a bottleneck along his bass strings with plenty of Echorec. The sonority is that of a kind of magnetic wind or a fearsome insect, and indeed this section was referred to during the sessions as the "Bumble Bee Bass Section." During the March 12 session at Abbey Road, the Floyd decided to add some sound clips from the EMI sound library: a wind effect from 12:40 (taken from volume 56) and cawing crows from 13:15 (taken from volume 7).

And to intensify this bleak atmosphere even further, David Gilmour adds one of the most distinctive features of the piece: lugubrious seagull calls on his "Black Strat," this time over-dubbed at AIR Studios, presumably on April 26. In reality, chance played an important part in the creation of this particular effect, explains Rick Wright: "One of the roadies had plugged his wah-wah pedal in back to front, which created this huge wall of feedback. He played around with that and created this beautiful sound."[72] With the connections reversed,

precise handling of the wah-wah, immoderate use of the Binson Echorec, and perfect mastery of technology, Gilmour was able to create some incredible sounds rarely associated with the sonorities produced by a guitar.

The fifth section opens (around 15:00) with the dying down of the Waters-manufactured wind and the emergence of the Farfisa organ. The atmosphere here is more ethereal and less harrowing. The ping from the beginning can once more be heard, Mason does some excellent cymbal work, and Wright produces bass tonalities on his organ that are drenched in Fuzz Face distortion (April 27 session). Gilmour then joins them with a palm mute B on the guitar (probably doubled by means of ADT), which he maintains through several key changes. This section is actually the final outcome of "Nothing Part 14" mentioned previously. The general tension then increases with a long crescendo, Waters comes in on bass, Mason on toms, and Wright with melodic lines on the Farfisa. Gilmour allows his Fender to ring out again at 18:15 with a highly melodic and rhythmic motif, playing along with the delay from his Binson Echorec. The effect is awe inspiring and generates a feeling of elation and solemnity at the same time. Waters is now playing fuzz bass, thereby underpinning the flights of fancy of the "Black Strat."

1971

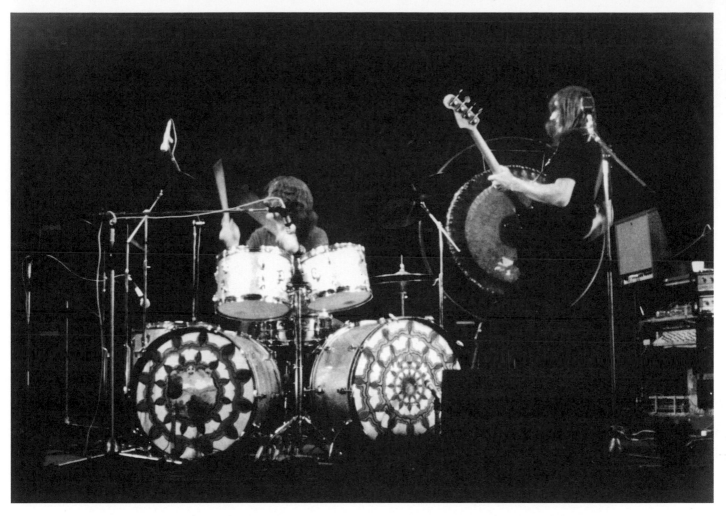

Nick Mason and Roger Waters onstage in 1971. "Echoes" had become an indispensable part of their set list.

In the sixth section (from 19:12), the vocal line returns with the final verse sung by Gilmour and Wright, their voices this time apparently fed through a Leslie speaker. This sequence concludes with a threefold reprise of the main riff

The seventh and final section (from 21:18) is built around a nostalgic atmosphere in which Wright and Gilmour answer each other with interlocking instrumental parts, the first on his piano fed through the Leslie and the second on his "Black Strat" with a clear tone and as expressive a sound as before. From 22:10, what sound like synthesized voices surge forward. In reality, as John Leckie explains, these were the result of a rather-out-of-the-ordinary sound effect: "We had two stereo tape machines on either side of the room. We put the tape on the first machine, and then ran it maybe five feet across the room on to a second machine, with both of them recording. The signal started on the first machine, and as much as eight or nine seconds later, it would come out of the next one—and then feed back. You could sit there for hours, with everything you played being repeated; and after a while, incredible things would start to happen. The abstract bit at the end of Echoes—the part that sounds kind of choral—was done like that."[6] This brings to a close the extraordinary rock epic, one of Pink Floyd's greatest successes.

Andrew Lloyd Webber was evidently greatly inspired by "Echoes" when composing the theme of the overture for his musical *The Phantom of the Opera.* Roger Waters nobly decided not to take legal action...

Not all the band members shared the same enthusiasm for the work, however. Waters would later speak of a "foretaste" in the work and Gilmour would describe it as casting a useful light on the future direction they were to take, while Mason pronounced the piece "a bit overlong."[74] Only Rick Wright had a sense of its true worth, declaring shortly before his death that he still regarded "Echoes" as "one of the finest tracks the Floyd have ever done [...]. It was a highlight."[72]

For Pink Floyd Addicts

All the rushes of the movie, which were stored at the Archives du Film de Bois-d'Arcy in France, have been destroyed. Having decided they were of no interest, the curator, a certain Monsieur Schmidt, had the 548 35mm reels incinerated...

NEWS

Pink Floyd: Live at Pompeii, the Last Hurrah of Psychedelia

In 1971, three European television channels—ORTF (France), Bayerischer Rundfunk (West Germany), and RTBF (Belgium) decided to make a documentary about Pink Floyd performing in an unusual location. The young Scottish (now French) director Adrian Maben was chosen to shoot the movie. After lengthy deliberations and repeated contact with the members of the group and manager Steve O'Rourke, the filmmaker, who was also a great lover of art and history, had the unusual idea of shooting the musicians in a Surrealist setting, among paintings and sculptures by Delvaux, de Chirico, Magritte, and Tinguely...However, following a trip to southern Italy, he eventually opted for the magnificent and ancient setting of Pompeii, and he managed to persuade Roger Waters, David Gilmour, Rick Wright, and Nick Mason to play there...without an audience: "This was a time when the thing to do, so it seemed to me anyway, or the big thing not to do, was to film a group and the audience reaction," explains the director. "This all culminated in Woodstock, where you have I don't know how many millions of people. [...] And I thought would there be any point in doing that again with the Floyd? [...] So maybe the main idea of the film was to do a sort of anti-Woodstock film, where there would be nobody present."[73] Although agreeing to perform, the group refused to mime. The director took up the challenge, despite live performance imposing certain awkward technical constraints, not least that of "recording a whole group on an eight-track tape recorder, which is

very difficult,"[38] as David Gilmour would explain in a later interview.

A Concert with No Audience

This live concert with no audience was shot in the amphitheater of the ancient city of Pompeii between October 2 and 7, 1971. Three numbers were performed and recorded in situ inside the amphitheater. "Echoes" (parts one and two) is the wonderful long suite from the album *Meddle*, which was to be released a few weeks later and whose music assumes its full mystical power as it reverberates around the ancient stones of the theater, permeated with the spirit of classical drama. "A Saucerful of Secrets," a track that had given its name to the group's second album, is a composition whose cosmic atmosphere was also ideally suited to the locale, the first three sections of the work, "Something Else," "Syncopated Pandemonium," and "Storm Signal" expressing a kind of chaos that could be thought to evoke the destruction of Pompeii by Vesuvius, with the fourth and final part, "Celestial Voices," restoring a sense of serenity. Finally, "One of These Days," the opening track of *Meddle*, an instrumental driven by two bass lines and punctuated by a single utterance made by a voice (Nick Mason's) that sounds as if it is emanating from beyond the grave: *One of these days, I'm going to cut you into little pieces.* Curiously, with the exception of a few shots that happen to have Gilmour in them, the Floyd drummer is the only member of

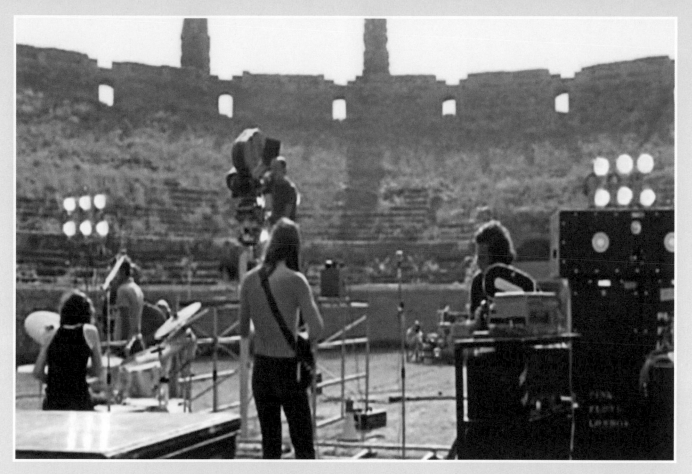

Pink Floyd performing in the legendary ancient Roman theater. A show with no audience...

the group to appear on-screen during this piece. The reason is that the reels containing the shots of the other musicians had all been lost, leaving only the images filmed by this particular camera! Mason would retain a mixed memory of the shoot: "The deal we did turned out to be very hard work, and we never saw any money from it for a long time. On the other hand, it turned out to be a very useful and, I think, a very good film."[71]

The Dark Side of the Movie...

Unfortunately, various timing problems and technical setbacks would force Pink Floyd to record all the other songs for the documentary in the studio in Paris (at the Europa Sonor on Avenue des Ternes and at the Studios de Boulogne) between December 13 and 20, 1971. The tracks in question are: "Careful with That Axe, Eugene" (*Ummagumma*), "Set the Controls for the Heart of the Sun" (*A Saucerful of Secrets*) and "Mademoiselle Nobs" (a version of "Seamus" on *Meddle*, Nobs being the name of Madona Bouglione's Russian wolfhound,, who "sings" the blues. In the final edit, these shots are intercut with views of the Pompeii site and flowing lava.

The movie, a musical UFO of sixty minutes' duration consisting of the live concert at Pompeii and the scenes shot in Paris, opened in September 1972 and met with great success. A second version (since released on DVD) was released two years later. Having been extended to eighty minutes,

it contains a number of extra scenes shot at Abbey Road during the initial recording sessions for *The Dark Side of the Moon*. Finally, a third version, longer still (at ninety-one minutes), and also the most fascinating, was released in 2003 with the label *Director's Cut*. Various sequences have been added: the Abbey Road footage offering an insight into the making of some of the masterpieces that would end up on *The Dark Side of the Moon* ("On the Run," "Us and Them," and "Brain Damage"), some short conversations between Adrian Maben and Pink Floyd, images of the Apollo missions, and a sequence of computer-generated images depicting the disappearance of Pompeii beneath the flows of lava from Vesuvius. In a nutshell, *Pink Floyd: Live at Pompeii* is a captivating record of one of the most unusual concerts in the history of rock...

Forty-five years after the Pink Floyd concert in Pompeii, David Gilmour returned on July 7 and 8, 2016, as a solo artist, this time performing in front of an audience. The city of Pompeii took the opportunity to make the guitarist an honorary citizen.

OBSCURED
BY
CLOUDS

ALBUM

OBSCURED BY CLOUDS

RELEASE DATE

United Kingdom: June 2, 1972

Label: Harvest Records
RECORD NUMBER: SHSP 4020

Number 6 (United Kingdom), on the charts for 14 weeks
Number 1 (France); number 3 (the Netherlands); number 46 (United States)

Obscured By Clouds / When You're In /
Burning Bridges / The Gold It's In The… / Wot's… Uh The Deal ? /
Mudmen / Childhood's End / Free Four /
Stay / Absolutely Curtains

For Pink Floyd Addicts

Barbet Schroeder approached Roger Waters to ask him to do another movie score, this time for a Hollywood production, but "the producers refused to agree to his conditions," claims the director, "finding Roger's financial demands…too high."[74]

Obscured by Clouds:
A Touch of French Exoticism

In February 1972, Pink Floyd interrupted preproduction work on their new album (*The Dark Side of the Moon*) for a few weeks in order to compose and record the soundtrack for Barbet Schroeder's new film *La Vallée*. Following their successful experience with *More* and the relative failure of *Zabriskie Point*, this was the third time the group would throw itself into the task of writing a movie soundtrack. The result is an album of disparate songs with a carefully controlled sound. It seems that the director's request came at just the right time, that is to say as something of a distraction following the Floyd's hard work on *Meddle* and their no less testing preparation for *The Dark Side of the Moon*. More than a few fans, however, would accuse the latter of eclipsing *Obscured by Clouds*.

Good Things Sometimes Come in Threes
Following *More* in 1969, this was the second and last time Barbet Schroeder would turn to Pink Floyd for a soundtrack to one of his movies. *La Vallée* depicts a journey to utopia that demystifies the ideals of a hippie generation more concerned with personal growth than with inventing alternative social models.

The movie describes the journey of self-discovery of a group of six people in search of a legendary valley located in a "white spot" on the map, a place in which no Westerner has ever set foot. The main character is Viviane. The young woman leads a monotonous existence as wife of the French consul in Melbourne, Australia. Her only real interest lies in

tracking down Oceanic artifacts, in particular rare feathers, which she sells in Paris. During a stay in New Guinea, Viviane meets Olivier, a member of a group of hippie explorers who have fled Western civilization, and their mentor Gaëtan. It is at Gaëtan's instigation that the small band decides to set out in a Land Rover for the mysterious valley that symbolizes "liberty regained." Viviane throws her lot in with the band of travelers and before long becomes Olivier's lover, and then Gaëtan's. She is deeply transformed by life in the community and her discovery of its aboriginal rites. For her there is no longer any question of returning to the well-ordered, high-society existence she had previously led. Especially once she has seen the valley emerging through the thick mist…

The Album
"We must destroy time to become one with it." Along with the themes of sexual liberation and experimentation with narcotics, this phrase spoken by Gaëtan in Viviane's presence, shortly before setting out on their expedition, perfectly sums up Barbet Schroeder's cinematographic concerns, which he asked Pink Floyd to transpose into music. "It was similar to *More*," reveals the director. "This was clearly the music the characters in the movie were listening to. I also have to say, however, that as far as the title music is concerned, it was fantastic to have this music soaring above the zones the plane was flying over […], zones that were otherwise just white spots on the map. During

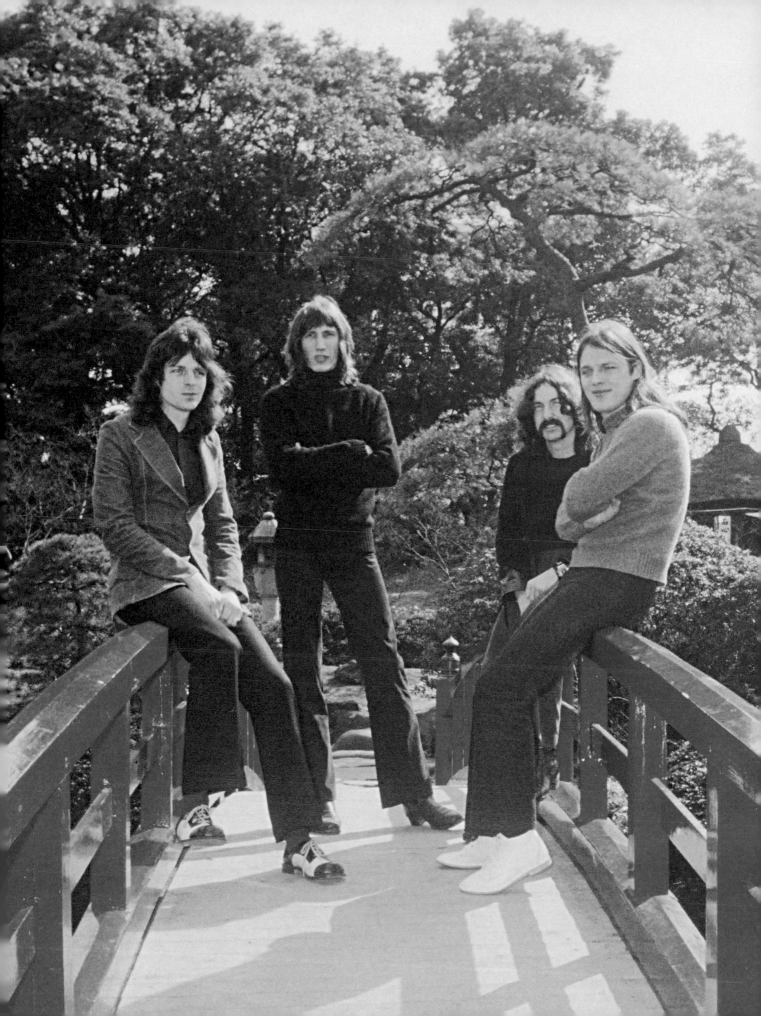

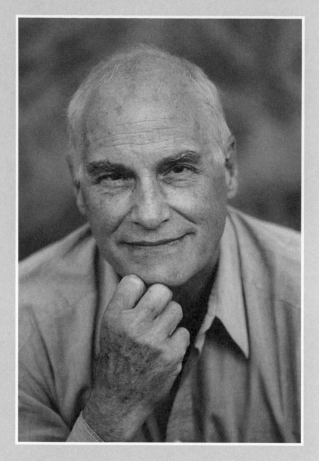

Barbet Schroeder (shown here in 1990) teamed up with the four Englishmen once again for his second full-length movie, *La Vallée*.

French poster for Schroeder's movie, a journey of self-discovery into the heart of New Guinea.

this part, then, it was not the music the characters were listening to, it was movie music proper."[69] And the director continues: "The music was recorded within two weeks at a château located a hundred or so kilometers from Paris. We slept and recorded in the château and they composed there. Everything was done on the spot. And as with *More*, it was done with great intensity and in great excitement. It was the same style of working, except that there [at Hérouville], we did at least show the movie in order to check how the pieces worked once they were recorded. This was already something of an improvement on *More*."[69] "Standard rock song construction was optional," explains Nick Mason, "one idea could be spun out for an entire section without worrying about the niceties of choruses and middle eights, and any idea in its shortest, most raw version could work without the need to add solos and frills."[5] And it was this very creative freedom that enabled the four members of the group to find new inspiration at a time when they had already started to record the future *The Dark Side of the Moon*.

The album comprises a total of ten tracks, some with vocals, some instrumental. Ten tracks that reflect the atmosphere of Schroeder's film extremely well. There is even some music here that must count as among Pink Floyd's best—definitely "Wot's...Uh the Deal," and perhaps "Free Four" too. As Mason himself would say, this was not a Pink

Floyd record, but rather a collection of songs that everyone liked. It may even be the last Floyd album to be born of a real collaboration among Waters, Gilmour, Wright, and Mason, despite the fact that it was David Gilmour who, following "Echoes" on the album *Meddle*, once again played a dominant role in his double capacity as singer and soloist (he plays an impressive number of solos on the soundtrack) and also, in a certain sense, as co-creator of the musical atmospheres (in particular with Rick Wright). Nevertheless, the member of the group Barbet Schroeder had the most time for was the bassist. "Roger Waters was an extraordinary individual and someone I greatly admired," the director would later say. "I realized he was the genius of the group. His personality stood out from the others."[74]

The album was released in the United Kingdom (and continental Europe) on June 2, 1972, and in North America on June 17, not with the title *La Vallée*, but as *Obscured by Clouds* (due to a disagreement with the film company). Not surprisingly, as it was a French-made movie, it was in France that Pink Floyd's seventh studio album performed best, reaching number 1 on the charts. It would climb to number 3 in the Netherlands and Denmark, and number 6 in the United Kingdom, where it was unanimously acclaimed by the critics. "There are still examples of those soaring, whirling Floyd numbers, just to dispel any doubts they're 'becoming too commercial,'"[78] wrote Peter Erskine in *Disc*.

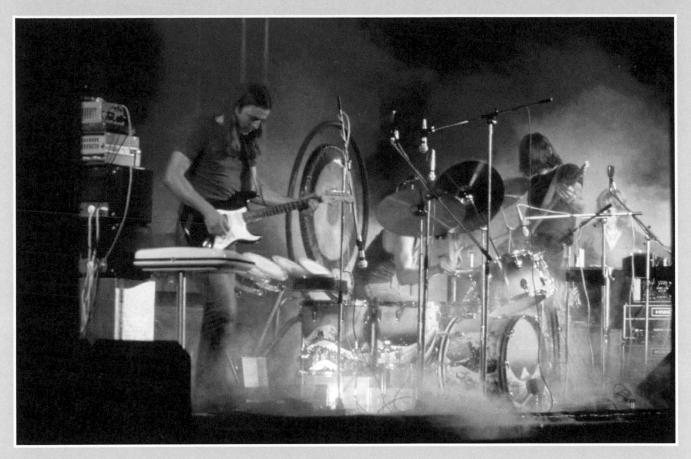

Pink Floyd in concert. On David Gilmour's right can be seen the EMS Synthi
Hi-Fli guitar effects processor he acquired in 1972.

For Andrew Means in *Melody Maker*, the album contained "some of the most aggressive instrumentals the Floyd have recorded."[79] In the United States, by contrast, *Obscured by Clouds* made it only to number 46 (but then Schroeder's movie was not distributed there until 1977).

A Movie Soundtrack Made in Hérouville

The château referred to by Barbet Schroeder is Hérouville, located not far from Auvers-sur-Oise and Pontoise and a mere thirty or so miles from Paris. Built in 1740, composer Michel Magne purchased it in 1962 (with a friend, the painter Jean-Claude Dragomir, who died in 1965). Magne turned the "left wing" of the property into a space for his creative work. Following the destruction of this wing in a fire in 1969, Michel Magne set up a production company (SEMM) and fitted out a 328-square-foot recording studio, benefiting from natural light, this time in the "right wing," which he named the Strawberry Studios. At the same time, Michel Magne developed the concept of a residential recording studio (that is to say a venue that offered recording facilities plus meals and accommodations), and the rest is history. With the help of the sound engineers Gérard Delassus, Gilles Sallé, Dominique Blanc-Francard, and Andy Scott, some of the most important albums of the 1970s were recorded at the Château d'Hérouville, including *Camembert Electrique* (1971) by Gong; *The Slider* (1972) by T. Rex; *Honky Château* (1972)—named for obvious reasons!—*Don't Shoot Me I'm Only the Piano Player* (1973), and *Goodbye Yellow Brick Road* (1973) by Elton John; *Saturday Night Fever* (1977) by the Bee Gees; *Pin Ups* (1973) and *Low* (1977) by David Bowie; and of course *Obscured by Clouds* by Pink Floyd. There was also an infamous concert given by the Grateful Dead on the grounds of the château on June 21, 1971. In the meantime, Michel Magne had also equipped France's first sixteen-track mobile studio, the Strawberry Mobile, and kitted out a second studio at the château, the Frédéric Chopin.

Declared bankrupt in 1972, Michel Magne passed the baton to Yves Chamberland, owner of Studios Davout, who was succeeded two years later by Laurent Thibault. Magne never got over this failure and took his own life on December 19, 1984.

The Sleeve

The album was originally supposed to have a very different title, probably *Music from La Vallée* (which appears on the back of the sleeve), but a minor dispute between Schroeder's production company, Les Films du Losange, and the Floyd management resulted in a change of plan. The title used in the end, *Obscured by Clouds*, refers to the ultimate destination of the adventurers' journey: the valley that appears to them shrouded in thick mist at the end of their expedition.

The Château d'Hérouville, near Pontoise, France, where Pink Floyd recorded *Obscured by Clouds*.

This is also the title under which the movie would be released in the English-speaking world!

The sleeve, another designed by Hipgnosis, is somewhat strange. The photograph on the front is a still from the movie depicting one of the travelers in a tree, but deliberately out of focus—to the extent that it is impossible to make out the subject at all! "Since we believed that the Floyd were obviously beyond normal reality then out-of-focus was cool," explains Storm Thorgerson. "So was distorted or unnatural colour, like infra red film—a film developed initially for military purposes, I suspect, where normal colours were changed depending upon the original colour and on the exposure."[65] Barbet Schroeder offers a slightly different explanation for the blurring: "An amusing detail is that once again, [Pink Floyd] were delighted to be doing the music for the film, but they didn't want it to do too well relative to their serious work. I sent them a movie still for the cover of the LP. They really wanted to sabotage the thing, and so they blurred the photograph beyond all recognition…All one can see are these bubble-like shapes. It was not in any sense an *eye*-catching cover. They didn't want to have another experience like *More*."[69] Add to this the texture of the card, which was rather fluffy, with rounded corners (first edition only) and an inner sleeve of plain paper…

The Recording

In his book, Nick Mason notes that the songs on *Obscured by Clouds* were recorded at Strawberry Studios (at the Château d'Hérouville) "in the last week of February."[5] According to Glenn Povey, however, the album was recorded in two spells: February 23–29 and March 23–27, 1972. The mixing was then done at Morgan Sound Studios in Willesden, London, which the group had used during the closing stages of

Meddle, April 4–6. Between these two periods, Pink Floyd went on tour in Japan (March 6–13). It is also known that they had already started work on the future *The Dark Side of the Moon*.

By the time the Floyd found themselves in the Hérouville studio at the end of February, the deadline was therefore relatively short. Nick Mason confirms that recording was intense, which forced the group to be more efficient. "Sure, I thought it [the album] was particularly good from that point of view. It had a good, together feel. It was a fairly relaxed album, but it was, well, tight."[9] The four Englishmen arrived at the château with vague ideas about the music and would often leave the tapes running while they improvised, as Barbet Schroeder explains: "They had done a tiny amount of preparation, but still did everything in the studio. I described the mood I wanted, the mood I needed in order to evoke some scene or other… They mulled it over a little and then, with minimal preparation, literally made the record on the spot, in the studio, to the amazement of the technicians."[74] Roger Waters, Nick Mason, Rick Wright, and David Gilmour worked together in harmony, indulging in games of table soccer or Ping-Pong during their breaks and taking great delight in the French cuisine. The Floyd were still enjoying a period of calm before the dark clouds came along and blotted out the light. "I didn't detect any tension between them during the sessions,"[74] Schroeder would confirm.

As for the recordings themselves, it is highly likely that they were engineered by Peter Watts, even though his name does not feature in the album credits. Pictured on the back of the *Ummagumma* sleeve (on the right), Watts was the Floyd's road manager, but also their sound engineer for live gigs. This is confirmed by various witnesses

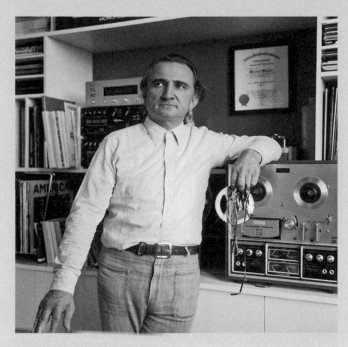

Michel Magne, who transformed the Château d'Hérouville into one of the most highly respected recording studios of the '70s.

The famous EMS VCS3 "Putney," one of the synthesizers that plays a starring role on the album.

including Dominique Blanc-Francard, who, without naming Watts, recalls "the front of house sound engineer who recorded the album."[77] Dominique Blanc-Francard, one of the rare French sound engineers of international stature, had worked at the Château d'Hérouville since February 1971, in other words for a little more than a year before the arrival of Pink Floyd. As he himself would explain, he did not become involved in the project until Peter Watts had finished recording the album: "Barbet [Schroeder] came down to listen [to the album], and requested a mono version for the movie. Andy Scott was the assistant at the time. The Floyd asked me to mix it, which I did."[77] Two different mixes were therefore done: a stereo mix by Peter Watts for the album and a mono mix by Dominique Blanc-Francard for the movie. During the three years he spent at the legendary studios, Blanc-Francard would record an impressive number of artists, including the Grateful Dead, Elton John, T. Rex, Magma, MC5, and Claude Nougaro. As for Andy Scott, the assistant sound engineer had been hired as the result of a misunderstanding. In the belief that he was dealing with Elton John's sound engineer, who was to record Honky Château in January 1972, Dominique Blanc-Francard showed Scott around the château and its facilities before the visitor, astonished to encounter such eagerness, revealed that he had simply turned up looking for a job. To Blanc-Francard's great irritation, Michel Magne immediately decided to hire Scott, reasoning that an English assistant would be extremely useful in the future. He was right, and Andy Scott went on to enjoy a remarkable career, working with such prestigious names as Elton John, Cat Stevens, David Bowie, Jean-Michel Jarre, Daniel Balavoine, and Jean-Jacques Goldman, to name just a few.

Technical Details

At Hérouville the Floyd used a sixteen-track Scully 100 tape recorder, the sixteen-channel Difona console that had been custom built for Michel Magne by Gérard Delassus (with an orange surround by Bernard Laventure), and Lockwood monitors. For the stereo mix, the Floyd returned to Morgan Studios, where *Meddle* had been mixed, to use the famous Cadac 24x16 desk and sixteen-track 3M M56 tape recorder.

It is interesting to note that the 24x16 console installed in 1972 in Hérouville's second studio, known as the Chopin Studio, was made to measure using modules manufactured by Studio Techniques, the company of Dutchman Maurice Van Hall, who used to import Scully and MCI equipment, along with other brands, into France.

The Instruments

The many studio photos that were taken provide reasonably precise information about the instruments the group used in the making of the album. Roger Waters played his Fender Precision Sunburst and a Martin D-35 acoustic, a model David Gilmour had in his collection from around this time. The Floyd guitarist used his "Black Strat" and most probably his Fender double-neck pedal steel guitar, and can also be seen using an EMS VCS3 Synthi A "Portabella." Rick Wright also used an EMS VCS3, although he favored the "Putney" model. Wright also supplemented his usual keyboards (the Farfisa, the Hammond M-102, acoustic piano, Mellotron) with a Fender Rhodes Mark I electric piano. In addition to his Ludwig kit with double bass drums, Nick Mason used orchestral timpani and a pair of congas that the studio made available to him.

Obscured By Clouds

Roger Waters, David Gilmour / 3:05

Musicians
David Gilmour: electric lead guitar, EMS VSC3
Rick Wright: EMS VSC3, keyboards
Roger Waters: EMS VSC3 (?)
Nick Mason: drums, electronic drums

Recorded
Strawberry Studios, Château d'Hérouville, Val-d'Oise, France: February 23–29, March 23–27, 1972
Morgan Studios, London: April 4–6, 1972

Technical Team
Producer: Pink Floyd
Sound Engineer (Hérouville): Peter Watts (?)
Sound Engineer (Hérouville, mono mix):
Dominique Blanc-Francard
Assistant Sound Engineer (Hérouville): Andy Scott

During the *Obscured by Clouds* sessions, Nick Mason plays one of the earliest models of electronic drum.

Genesis

The track from which Pink Floyd's seventh studio album takes its name is an instrumental credited to Roger Waters and David Gilmour, a track whose musical ambiance is based on long synth pads, a hypnotic beat, and distorted guitar. This piece is heard twice in Barbet Schroeder's movie: firstly during the opening scenes, when Schroeder's cameras are overflying New Guinea and its thickly forested mountainous regions partly concealed by banks of cloud, regions hitherto unexplored "that are not on the map, or, more accurately, are only shown as white spots," explains the narrator. The second time occurs at the end of the movie, after the group, which is on its last legs, has finally discovered the valley it has been looking for.

Production

"Obscured by Clouds" is based on a single A-minor chord. The keyboard sounds derive mainly from the two EMS VCS3s, the "Portabella" and the "Putney." They succeed each other in waves, progressively thickening the overall sound texture. To judge from the studio photos, David Gilmour and Rick Wright are the main synthesizer users. Other keyboards contribute to the general atmosphere as well, most probably the Farfisa, the Hammond M-102, and the Mellotron. Nick Mason also innovates on this track, using a new form of percussion: "I was able to try out a very early pair of electronic drums—not as advanced as later syndrums, more like electronic bongoes—on the opening sequence."[5] In actual fact, Pollard Syndrums would not see the light of day until 1976. For the time being it was very probably on the invention of Moody Blues drummer Graeme Edge and electronics engineer Brian Groves that Mason was marking the beat. He nevertheless reinforces this beat on his Ludwig kit, adding a second bass drum, his snare drum, and a hi-hat. In addition to the VCS3, David Gilmour also contributes on his "Black Strat" Fender, playing a melodic line with ample Fuzz Face distortion and sometimes bottleneck, and a short delay. His guitar seems to have been doubled by means of ADT. As for Roger Waters, it is difficult to discern the bassist's role as no bass guitar can be heard on this track. It is quite likely that he too was using a VCS3.

When You're In

David Gilmour, Roger Waters, Nick Mason, Rick Wright / 2:31

Musicians
David Gilmour: electric rhythm and lead guitar
Roger Waters: bass (?)
Rick Wright: organ, EMS VSC3 (?)
Nick Mason: drums
Recorded
Strawberry Studios, Château d'Hérouville, Val-d'Oise, France: February 23–29, March 23–27, 1972
Morgan Studios, London: April 4–6, 1972
Technical Team
Producer: Pink Floyd
Sound Engineer (Hérouville): Peter Watts (?)
Sound Engineer (Hérouville, mono mix):
Dominique Blanc-Francard
Assistant Sound Engineer (Hérouville): Andy Scott

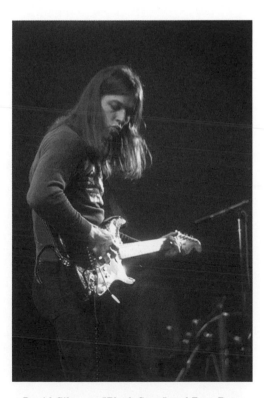

David Gilmour: "Black Strat" and Fuzz Face distortion on "When You're In."

Genesis

The title of this track has its origins in an expression much used by Chris Adamson, the Pink Floyd road manager and technician. Whenever anyone asked him how far he had gotten with some task, he would invariably answer: "I'm in. And when you're in, you're in."

Credited to all four members of Pink Floyd, "When You're In" follows on directly from the opening track, although it is very different in mood. The song is based on a rock-cum-hard-rock riff by David Gilmour that brings to mind "The Nile Song" on *More*. Linked together, the two numbers were performed by Pink Floyd as the opener to many of their 1973 concerts—in versions that stray in some way from the originals, it has to be said. Interestingly, Barbet Schroeder did not use the piece in the final *La Vallée* soundtrack.

Production

The second track on the album opens with three raps on the snare drum. Nick Mason works his Ludwig kit heavily and powerfully, pounding his ride cymbals throughout the whole of this instrumental, a track that can be described as forceful to say the least, despite its no more than moderate tempo. Roger Waters seems to be supporting the drummer on bass, although his presence is difficult to make out. Rick Wright makes his Hammond organ roar, and is apparently also playing his VCS3, whose sonorities blend with those of his piano. Despite all this, "When You're In" owes its particular color mainly to David Gilmour's guitar parts. Gilmour delivers a melodic motif with plenty of Fuzz Face distortion on his "Black Strat," which he plays through his Hiwatt DR-103 amp head connected to his WEM Super Starfinder speaker. He doubles himself on a second track, thereby boosting the power of his hook. In actual fact, the piece has two motifs that are played over and over again in a kind of loop before concluding with a fade-out of more than twenty seconds' duration. This is probably not the most original track on the album or the most essential in the group's discography. It is interesting to note that there are ten seconds of silence after the fade-out.

Burning Bridges

Rick Wright, Roger Waters / 3:30

Musicians
David Gilmour: vocals, electric rhythm and lead guitar, pedal steel guitar (?)
Roger Waters: bass
Rick Wright: vocals, organ
Nick Mason: drums

Recorded
Strawberry Studios, Château d'Hérouville, Val-d'Oise, France: February 23–29, March 23–27, 1972
Morgan Studios, London: April 4–6, 1972

Technical Team
Producer: Pink Floyd
Sound Engineer (Hérouville): Peter Watts (?)
Sound Engineer (Hérouville, mono mix): Dominique Blanc-Francard
Assistant Sound Engineer (Hérouville): Andy Scott

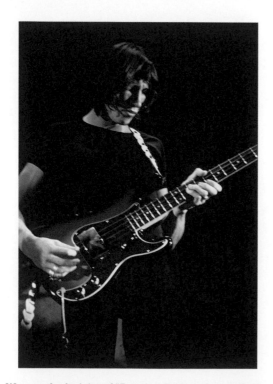

Waters, the lyricist of "Burning Bridges," contributes to the song's jazz-rock harmonies, a new departure for the bassist, on his Fender Precision.

Genesis

Although David Gilmour and Rick Wright sing "Burning Bridges" this penetrating ballad is the result of an—all too rare—collaboration between the keyboard player and Roger Waters. It is heard in the movie in the scene where Olivier shows Viviane his outstanding collection of feathers.

Bridges burning gladly/Merging with the shadow/Flickering between the lines/Stolen moments floating softly on the air: the first few lines written by Roger Waters seem to have no more than a remote connection to the screenplay of *La Vallée*—unless, that is, the flames and the riot of colors are intended to symbolize the exotic feathers. The second verse seems far more explicit. The *ancient bonds [that] are breaking*, the *dreaming of a new day*, and the *magic visions stirring* clearly relate to Viviane. After encountering the group of explorers who have broken with Western society, she decides to do likewise: burn her bridges and embark on a new life of adventure accompanied by a variety of amorous and psychedelic experiences. The same goes for the third and final verse, in which the heroine breaks the golden band. This clearly refers to Viviane's comfortable life as the wife of a senior official. "Burning Bridges" is one of the best songs on the soundtrack, of which Nick Mason was moved to declare: "I thought it was a sensational LP, actually."[36]

Production

The music for this beautiful ballad, whose harmonies occasionally hint at jazz-rock, was composed by Rick Wright, with lyrics by Roger Waters. It is also Wright's Hammond organ that is responsible for the main color of the song, creating a tranquil, gently drifting ambiance. Together, Mason and Waters lay down a very good rhythm with a fluid, floating feel. However, David Gilmour has taken the lion's share for himself. Not only does he split the lead vocal with Wright, he also plays various different guitar parts, including a rhythm part on his "Black Strat" that is lightly colored by his new Uni-Vibe. He also takes three solos: the first, highly inspired and incredibly heartfelt, on his Strat (at 1:26); the second and third (1:51 and 2:54) most likely on his double-neck Fender pedal steel guitar. "Burning Bridges" is an excellent song of which "Mudmen"—on the same album—is an instrumental variant.

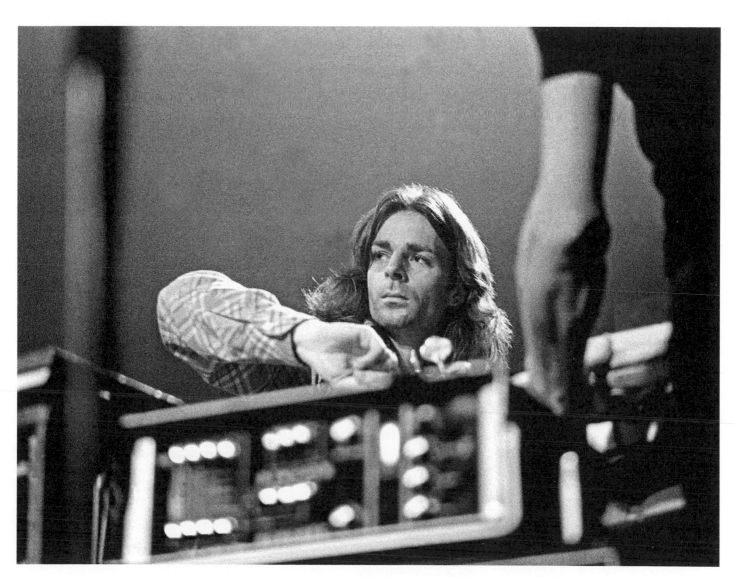

Rick Wright, the composer of "Burning Bridges" and chief architect of its sound.

The Gold It's In The...

Roger Waters, David Gilmour / 3:08

Musicians
David Gilmour: vocals, electric rhythm and lead guitar, bass (?)
Roger Waters: bass (?)
Nick Mason: drums
Recorded
Strawberry Studios, Château d'Hérouville,
Val-d'Oise, France: February 23–29, March 23–27, 1972
Morgan Studios, London: April 4–6, 1972
Technical Team
Producer: Pink Floyd
Sound Engineer (Hérouville): Peter Watts (?)
Sound Engineer (Hérouville, mono mix):
Dominique Blanc-Francard
Assistant Sound Engineer (Hérouville): Andy Scott

Bulle Ogier, who plays the lead, Viviane, in *La Vallée*.

Genesis

Four short verses and a long guitar solo designed to convey the thrill of adventure and the lust for faraway places that motivate the group Viviane has joined. Contrary to what the title of this song might suggest, Olivier, Gaëtan, and the others are not seeking to make their fortunes. Their expedition to this legendary valley in New Guinea, really a journey of self-discovery, symbolizes a new paradigm in which the cult of consumption and materialism is superseded by a return to nature and an ascetic way of life. In his lyrics, Waters reconnects with, or rather prolongs, the hippie dream, which was actually rather moribund by this time. The monotony of a sensible, well-ordered life has given way to a taste for adventure and the unknown. While Roger Waters was responsible for the words, it is to David Gilmour that we owe the distinctly rock feel of the music, which recalls the dark-hued, urban style of early Velvet Underground and the glam rock of T. Rex, Slade, the Sweet, and others. It is astonishing, to say the least, to hear the group flirting with this style given that it had just recorded *Meddle* and was already working on *The Dark Side of the Moon*. This offbeat number plays in the movie after Viviane has accepted an invitation to dine at the encampment and then wants to see and caress the exotic feathers one last time before returning to…civilization.

Production

For Pink Floyd, this movie soundtrack seems to have been a digression, a kind of recreational side step in their artistic development. The group throws off all restraint and embraces an effective, though not exactly unforgettable, rock style. "The Gold It's in the…" is a guitarist's piece, a rock number in which all the tropes of the genre are paraded one by one. The rhythmic drive is assured by the Mason-Waters duo, the first with his pop-rock drumming and the second with a solid, sinewy bass line. There may be some doubt, however, about whether Roger Waters is actually responsible for the bass on this track as certain phrases are not particularly characteristic of his playing. It could be that David Gilmour has taken his place, a hypothesis supported by the various session photos that show Gilmour recording with Waters's Fender Precision. It is definitely Gilmour playing

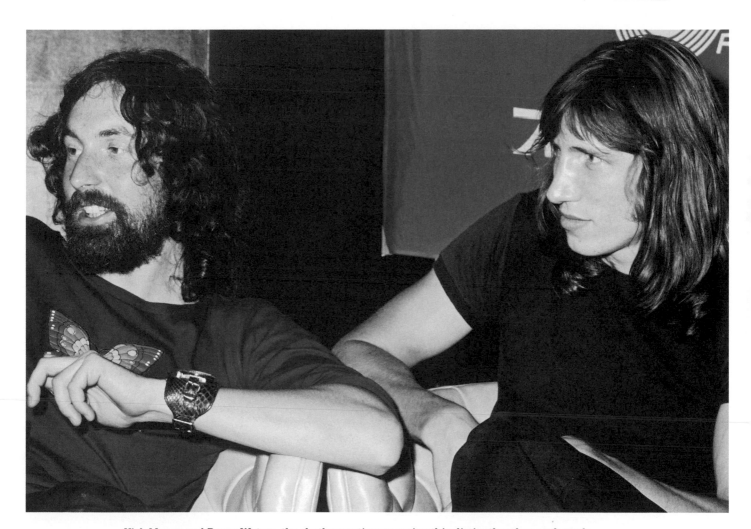

Nick Mason and Roger Waters, the rhythm section powering this distinctly urban rock track.

the different guitar parts, however, all with Fuzz Face distortion and all on his "Black Strat." He delivers a very good rhythm guitar, alternating riffs and power chords, doubling himself on a second track, with the two guitars facing each other in the stereo image. On top of this he plays multiple solos, from the intro to the last note of the track. After the final verse (at 1:15), he then lets it rip, improvising for nearly two minutes. When recording his solos, David Gilmour's tried and trusted method was to record several takes and then select the best passages, which he would then splice together or rerecord in full, which is evidenced here. It is also the guitarist who sings lead vocal, his voice doubled in order to give it a greater assurance and power. Interestingly, Rick Wright is not playing on this track.

1972

Wot's... Uh The Deal

David Gilmour, Roger Waters / 5:09

Musicians
David Gilmour: vocals, vocal harmonies, acoustic guitar, electric lead guitar (?), pedal steel guitar (?)
Rick Wright: piano, organ
Roger Waters: bass
Nick Mason: drums

Recorded
Strawberry Studios, Château d'Hérouville, Val-d'Oise, France: February 23–29, March 23–27, 1972
Morgan Studios, London: April 4–6, 1972

Technical Team
Producer: Pink Floyd
Sound Engineer (Hérouville): Peter Watts (?)
Sound Engineer (Hérouville, mono mix): Dominique Blanc-Francard
Assistant Sound Engineer (Hérouville): Andy Scott

For Pink Floyd Addicts

Pink Floyd never performed "Wot's...Uh the Deal" live, but David Gilmour played it during his "On an Island Tour" (DVD *Remember That Night*, 2007, and vinyl *Live in Gdańsk*, 2008).

Genesis

"Wot's...Uh the Deal" stands out as a real gem in the catalog of romantic-nostalgic songs written by David Gilmour and Roger Waters. And nostalgic is definitely the right word for this number, a subtle reflection on passing time. The narrator, who is clearly in his twilight years and a million miles from home, is doubly sad because he is both homesick and distressed to see himself growing old (*And I think I'm growing old*...and later *And I've grown old*). These few verses seem to sum up the long course of his life, from the promise of dawn (*Heaven sent the promised land*), which he grabbed with both hands, to the bitter acknowledgment of his old age and the years that have run away from him, while in the last verse there's no wind left in his soul...

In Barbet Schroeder's movie the very beautiful "Wot's... Uh the Deal" accompanies the lovemaking scene between Viviane and Olivier, an experience that was to provoke new sensations and arouse aspirations in the young woman...

The song's title is taken from the first line of the second verse: *Flash the readies...wot's...uh the deal* ("flash the readies" being British English for "show me the money").

Production

"Wot's...Uh the Deal" surprises firstly with the quality of its music and secondly with its title, which in all honesty does not live up to the sophistication of its harmonies. Whereas in the past the Floyd had always come up with striking and suggestive titles for their music ("A Saucerful of Secrets," "Echoes," "Set the Controls for the Heart of the Sun"), they seem to have had some difficulty with this new album. Nick Mason offers an explanation: "A whole series of songs were produced, but my perception is that the song titles were hurriedly allocated under pressure to meet the film schedule."[5]

This medium-tempo number opens with a descending scale played by two acoustic guitars answering each other across the stereo field. This is David Gilmour playing arpeggios on his Martin D-35 and doubling himself on a second track. Rick Wright accompanies with Hammond organ pads and acoustic piano. Nick Mason hits rim shots on his snare drum, and Roger Waters delivers a very good bass line on his Fender Precision. The charm of "Wot's...Uh the Deal" derives in part from Gilmour's superb lead vocal, in which

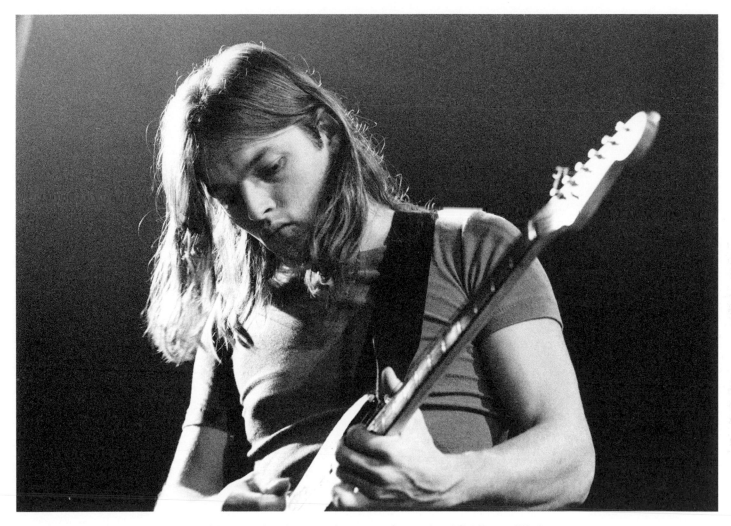

David Gilmour, who gives a performance of exceptional fluidity on "Wot's…
Uh the Deal," a song he would return to years later, on the Island Tour.

he displays his usual gentle delivery and highly distinctive timbre. He doubles himself and also harmonizes with himself here and there, lending the song a particular color that George Harrison would not have been ashamed of. Rick Wright also plays two very good piano solos, the first after the second refrain (at 2:35), and the second in the coda. During the course of these improvisations, it is possible to detect a number of licks that occur regularly in his playing and that can also be heard, for example, in "San Tropez" on *Meddle*. His style here is a blend of jazz and pop that is entirely in keeping with the spirit of the song. David Gilmour plays another solo with bottleneck on his "Black Strat." It is also possible, however, that he uses his pedal steel guitar for

this, although the sound is not as characteristic as in "Burning Bridges" on this same album. The guitarist is known, however, to have played the solo on a lap steel in concert with Rick Wright at the Royal Albert Hall in May 2006. The solo is a great success, his guitar as fluid as usual, lightly distorted with the Fuzz Face and colored by the Echorec, with reasonably deep reverb.

"Wot's…Uh the Deal" is not exactly typical of the Pink Floyd catalog, displaying greater similarities with US pop-folk than with English pop, but it is nevertheless a superb and far-too-little-known track, one that, moreover, was chosen as the B-side of the single "Free Four" in the Netherlands.

For Pink Floyd Addicts

It was not until 1994, with "Cluster One" and "Marooned" on the album *The Division Bell*, that a Wright-Gilmour credit would appear on any more tracks.

Mudmen

Richard Wright, David Gilmour / 4:18

Musicians
David Gilmour: electric lead guitar, VCS3 (?)
Roger Waters: bass, VCS3 (?)
Rick Wright: piano, organ, vibraphone, VCS3 (?)
Nick Mason: drums
Recorded
Strawberry Studios, Château d'Hérouville, Val-d'Oise, France: February 23–29, March 23–27, 1972
Morgan Studios, London: April 4–6, 1972
Technical Team
Producer: Pink Floyd
Sound Engineer (Hérouville): Peter Watts (?)
Sound Engineer (Hérouville, mono mix): Dominique Blanc-Francard
Assistant Sound Engineer (Hérouville): Andy Scott

The Mudmen gave the first-ever demonstration of their customs and traditions in 1957 before a crowd of 100,000. It is said that many of the spectators were so frightened that they ran away as fast as they could!

Viviane discovering the Mudmen…

Genesis

This instrumental, another of the album's triumphs, accompanies one of the more esoteric sequences in Barbet Schroeder's movie: Viviane and Olivier's encounter in the New Guinea mountains with an ancient sorcerer in possession of a large collection of bird feathers. In the village, strange creatures bedecked with mud, their faces concealed by grotesque masks, materialize before the young woman. Immediately afterward, the sorcerer, who never speaks, gives Viviane some extremely rare and beautiful feathers. The song's title refers specifically to these Mudmen who have literally bewitched the consul's wife. A mysterious legend is associated with these warriors from the Asaro Valley, not far from Goroka, who returned from an expedition to find that their women had been abducted and their village destroyed by a hostile tribe. They set out in search of the women but strayed into the swamp after nightfall. At daybreak the Asaro men entered the enemy village, their mud-spattered bodies sowing panic among the villagers and enabling them to rescue their women…

Production

"Mudmen" is an instrumental adaptation of "Burning Bridges" on the same album. The tempo is slower and the time signature has changed from 6/8 to 4/4, but the various sequences (all in the key of G) are similar. Inexplicably, the instrumental is credited to Wright-Gilmour, whereas "Burning Bridges" itself is given to Wright-Waters, despite neither the harmonies nor the melodic line having changed in the slightest…It features Wright on piano, vibraphone, and Hammond organ, Waters on bass (an instrument that sounds like his Rickenbacker of old), and Mason on drums—the stereo recording of which (other than a few sections in mono or where a delay has been added to the snare drum) is a real success—and Gilmour executing flights of lyricism on his distorted "Black Strat" set in space courtesy of his Binson Echorec. The sound generated by the two VCS3 synthesizers can be heard at 2:05, over the stereo field, while Gilmour plays clear-toned guitar with bottleneck. He uses a delay generated by the Echorec, the output from which is replayed in reverse on a separate track (from 2:24 in the left-hand channel).

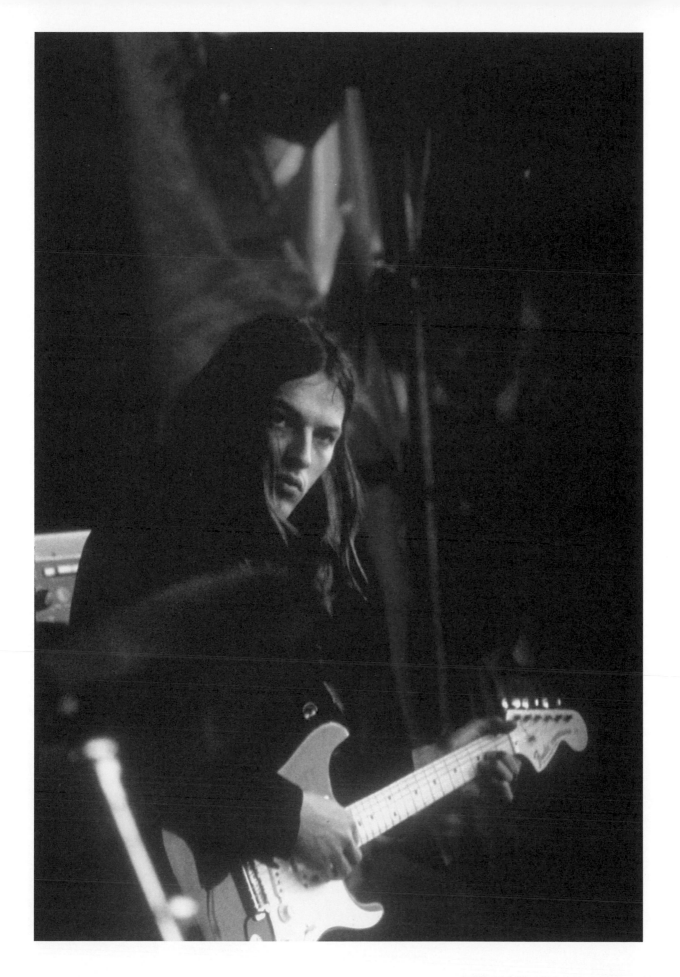

Childhood's End

David Gilmour / 4:34

For Pink Floyd Addicts

Gilmour is not the only musician to have been inspired by Arthur C. Clarke. In 1972 Genesis would follow suit with "Watcher of the Skies" on *Foxtrot*, and in 1976 Van Der Graaf Generator with "Childlike Faith in Childhood's End" on *Still Life*.

Musicians
David Gilmour: vocals, acoustic guitar, electric rhythm and lead guitar, VCS3 (?)
Rick Wright: organ, VCS3 (?)
Roger Waters: bass, acoustic guitar (?), VCS3 (?)
Nick Mason: drums, electronic drums
Recorded
Strawberry Studios, Château d'Hérouville, Val-d'Oise, France: February 23–29, March 23–27, 1972
Morgan Studios, London: April 4–6, 1972
Technical Team
Producer: Pink Floyd
Sound Engineer (Hérouville): Peter Watts (?)
Sound Engineer (Hérouville, mono mix): Dominique Blanc-Francard
Assistant Sound Engineer (Hérouville): Andy Scott

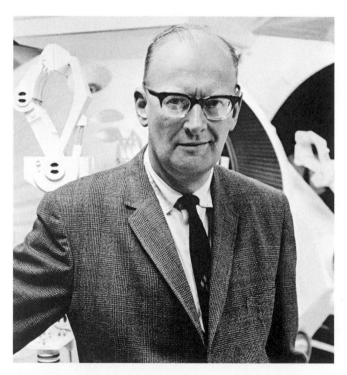

The famous science fiction writer Arthur C. Clarke, author of *Childhood's End*, whose title Gilmour borrowed.

Genesis

In this song with words and music by David Gilmour, the guitarist returns to a subject Pink Floyd had already tackled a number of times in other songs, in particular during the Syd Barrett era: the theme of childhood. More specifically the end of childhood, along with the choices and the fear of the unknown associated with that time. Gilmour takes the title for his song from a novel by the great science fiction writer Arthur C. Clarke. In *Childhood's End*, which was published in 1953, extraterrestrials land on planet Earth and put an end to the independence of humankind. Some observers have interpreted the words of the song as describing the final days of Jan Rodricks, the main character in the novel and in due course the last man alive on Earth. Others see Gilmour's lyrics, with their distinctly political overtones, as alluding to the unrest shaking the United States at this time, when young people were starting to demonstrate against the war in Vietnam.

Barbet Schroeder chose "Childhood's End" to accompany the sequences in which the band of travelers penetrate into the heart of New Guinea in their Land Rover. Pink Floyd would perform the song in a handful of shows in 1972–73 but only really until the release of *The Dark Side of the Moon*. The former Suede guitarist Bernard Butler would reveal that he had been enormously impressed by this number: "People used to say, 'Oh, you can't listen to that prog rock nonsense,' but I don't care. Some of their stuff is amazing. It takes my breath away."[36] And he adds: "Now I've discovered Pink Floyd, I can't understand why people listen to The Orb."[36] The song also demonstrates that David Gilmour is not only a good musician, but also a pretty decent lyricist. If not up to the standard of Roger Waters, this was no doubt because he lacked the confidence and the encouragement to impose his writing a little more, faced with such a talented (and domineering) partner!

Production

This piece opens with progressively rising keyboard pads that suggest the transition from childhood to adulthood. The sonorities result from a blend of Farfisa, Hammond, and also the VCS3, which contributes a bass drone. Around 1:00, electronic drums make their entrance, the same ones heard in the

Scene from the movie in which the hippie travelers penetrate into the heart of New Guinea in their Land Rover.

opening track, "Obscured by Clouds." They disappear again when the singing starts. However, before David Gilmour makes his vocal entry, singing in more of a rock voice than on any of the other tracks on the album (with the exception of "The Gold It's in The…"), he delivers two rhythm guitar parts on his Martin D-35 acoustic. For one of these parts the guitar seems to be tuned a tone lower than normal, with the strings apparently having less tension in them than otherwise. Roger Waters may be lending him a hand here, and he delivers a solid and efficient bass line on his Precision. In addition to playing his electronic drums, Nick Mason takes on the task of imparting a groove to the track with a heavy and somewhat basic rock beat on his Ludwig kit. Rick Wright joins in sporadically on his Hammond organ, marking the end of each verse with a short chord sequence.

And of course it is David Gilmour who dominates the proceedings with his numerous guitar parts—it is his song after all! In addition to the two acoustic rhythm guitar parts, he plays two more rhythm parts on his "Black Strat." These can be heard on opposite sides of the stereo image. They are lightly distorted and, as with the acoustic instruments, it seems that the guitar is tuned a tone lower for one of the parts. At 2:49, Gilmour takes an excellent solo, also with Fuzz Face distortion, and his style is that of the group's forthcoming major albums on which he would prove himself to be one of the best rock guitarists around. In particular, certain phrases in this solo anticipate "Shine On You Crazy Diamond," which the group would record in 1975. In his solos Gilmour tends to favor a clear and simple tone as often as he does a more elaborate sound, often set in space. In this case, he picks up the echo generated by his Binson Echorec and plays it back (in the left-hand channel) in answer to various phrases delivered on his Strat.

Free Four

Roger Waters / 4:17

Musicians
David Gilmour: acoustic guitar, electric rhythm and lead guitar
Rick Wright (?): VCS3
Roger Waters: vocals, bass, acoustic guitar (?)
Nick Mason: drums
Unidentified Musicians: hand claps

Recorded
Strawberry Studios, Château d'Hérouville, Val-d'Oise, France: February 23–29, March 23–27, 1972
Morgan Studios, London: April 4–6, 1972

Technical Team
Producer: Pink Floyd
Sound Engineer (Hérouville): Peter Watts (?)
Sound Engineer (Hérouville, mono mix): Dominique Blanc-Francard
Assistant Sound Engineer (Hérouville): Andy Scott

For Pink Floyd Addicts

"Free Four" was chosen as the A-side of the only single to be extracted from *Obscured by Clouds*. The B-side was "Stay" in the United States, "The Gold It's in The..." in Denmark, Italy, New Zealand, and West Germany, and "Absolutely Curtains" in Japan.

Genesis

In this song, Roger Waters tackles various themes with the intention, perhaps, of exorcising some of his own demons. Old age and death, in the first instance, via the memories of an elderly man: *You shuffle in the gloom of the sickroom and talk to yourself as you die* and *Life is a short, warm moment, and death is a long, cold rest.* Optimism is not exactly de rigueur in Waters's lyric writing. One reason for this is his traumatic childhood: *I'm the dead man's son. He was buried like a mole in a foxhole.* This is clearly a direct and unsparing reference to his father, killed during Operation Shingle (1944), and indeed to the musician's own childhood. Roger Waters would subsequently return to this theme in the albums *The Wall* and *The Final Cut*.

There are two different versions of the third verse of "Free Four." In the movie *La Vallée*, it takes the form of a piece of helpful advice being offered by the narrator: *So take my advice/And cut yourself a slice/And try not to make it too thick.* On the album *Obscured by Clouds*, Roger Waters makes a passing reference to his status as a rock musician: *So all aboard for the American tour/ And maybe you'll make it to the top.* And then, fatalistically: *And I can tell you 'cos I know/You may find it hard to get off.* In the movie, "Free Four" is heard after the band of travelers have arrived at the foot of the mountains and need to buy horses in order to be able to continue their expedition.

As happens so often, the title of the song plays on a linguistic ambiguity. In what appears to be a simple count-in at the beginning in order to establish the tempo, the "three" has become "free" ("one, two, free, four"). Might this signify the "four free ones"? Could it be an unintended metaphor for the phenomenal and unexpected fame the band would achieve with the impending release of *The Dark Side of the Moon*? A fame that would lead Waters, Gilmour, Wright, and Mason—the four—into an inevitable state of alienation from one another? Are these the band's final moments of freedom before being caught in the trap of *The Wall*?

Production

This song, which could easily have been performed by the Kinks or T. Rex, begins with an emphatic "one, two, FREE,

Old age, the subject broached by Roger Waters in "Free Four," seems to have haunted the young musician for a long time.

FOUR!" Musically, it is a pleasant acoustic ballad: light and jolly (despite the words, which are quite the opposite), but one that lacks any real melodic appeal. Waters is trying his hand here at something he does not really excel at, and is straying away from the subtle harmonies that are his forte. Two strummed guitars are an integral part of the rhythm section throughout the song. It is highly likely that they were played by Waters and Gilmour, as numerous studio photos show them recording with a Martin D-35. Waters also plays the bass (which is slightly too recessed in the mix) and sings lead vocal, which he doubles on a second track. His voice possesses an important characteristic: it immediately captures the listener's attention, like that of a radio commentator. And Waters certainly has a few tales to tell…Nick Mason delivers some straightforward, pop-style drumming far removed from his arabesques on *Ummagumma*. He is assisted by hand claps from his bandmates, creating the mood of a New Year's party. Rick Wright seems to be on the

VCS3, playing a G with a highly characteristic timbre (audible in the intro). Finally, David Gilmour plays the solo parts on his "Black Strat," again with Fuzz Face distortion. His improvisations are highly spirited, his phrasing harder edged than usual, and he also makes use of feedback on his guitar, coloring it further with his whammy bar (at 1:50). At 2:49 and 2:54 short phrases can be heard that sound like badly wiped tracks or unused solo parts that have emerged accidentally. It is interesting to note that behind each of his solos he plays a distorted rhythm part.

"Free Four" would get some radio airplay in the US and is a perfect illustration of the state of mind Pink Floyd were in when they undertook to record this second soundtrack for Barbet Schroeder. Resulting in a collection of disparate songs, the movie project came along at just the right time, providing the Floyd with a distraction after their hard work on *Meddle* and their no less taxing preparation for *The Dark Side of the Moon*.

Stay

Richard Wright, Roger Waters / 4:08

Musicians
David Gilmour: electric rhythm and lead guitar
Rick Wright: vocals, vocal harmonies,
piano, organ, Fender Rhodes (?)
Roger Waters: bass
Nick Mason: drums
Recorded
Strawberry Studios, Château d'Hérouville, Val-d'Oise,
France: February 23–29, March 23–27, 1972
Morgan Studios, London: April 4–6, 1972
Technical Team
Producer: Pink Floyd
Sound Engineer (Hérouville): Peter Watts (?)
Sound Engineer (Hérouville, mono mix):
Dominique Blanc-Francard
Assistant Sound Engineer (Hérouville): Andy Scott

"Stay," a song with a strong pop feel,
composed by Rick Wright.

Genesis
"Stay" is a composition by Roger Waters and Rick Wright whose subject is not so far removed from that of "Summer '68" on the album *Atom Heart Mother*. It is the story of a one-night stand, possibly with a groupie. *Stay and help me to end the day.* The narrator is intrigued by his companion, a mysterious creature by whose side he awakes as the morning dews herald a newborn day and the midnight blue turns to gray: *Because I want to find what lies behind those eyes*, sings Rick Wright. And he adds: *Rack my brain and try to remember your name.* A melancholy and even depressive song riddled with regrets and unanswered questions, "Stay" was not used in Barbet Schroeder's movie. It was, on the other hand, chosen as the B-side of the US single (with "Free Four" as the A-side).

Production
The music for "Stay" was apparently composed by Rick Wright and the words were written by Roger Waters. The harmonies are rich, the structure meandering, and the performances of uniformly good quality. All the same, listeners might be forgiven for wondering whether the same musicians who had recorded *Meddle* a few months previously could also have been responsible for this song. After all, we are a long way here from the progressive music they helped to develop. "Stay" is more of a pop song, but then Rick Wright had a good feel for melody despite his jazz influences, and this is also why he appreciated Syd Barrett so much as a composer and lyricist.

The song opens with intimate piano supported by a very good bass line from Roger Waters. It is Wright who sings, in a characteristically gentle voice, which he doubles, while harmonizing with himself in places. He plays a number of different keyboards, including what is most probably a Fender Rhodes, heard mainly in the refrains; a second acoustic piano, also played in the refrains; and a Hammond organ that can be heard in the background, recessed in the mix. Mason lays down a good beat halfway between pop and jazz-rock. As for David Gilmour, the guitarist accompanies on a clear-toned "Black Strat," using his wah-wah pedal to color the sound. His contribution to this track is of high quality, in particular his excellent solo at 2:41.

Absolutely Curtains

Roger Waters, David Gilmour, Rick Wright, Nick Mason / 5:51

Musicians
David Gilmour: VCS3 (?)
Rick Wright: VCS3, organ, Fender Rhodes, tack piano
Roger Waters: VCS3 (?)
Nick Mason: cymbals, timpani
Mapuga tribespeople: ethnic chanting
Recorded
Strawberry Studios, Château d'Hérouville, Val-d'Oise, France: February 23–29, March 23–27, 1972
Morgan Studios, London: April 4–6, 1972
Technical Team
Producer: Pink Floyd
Sound Engineer (Hérouville): Peter Watts (?)
Sound Engineer (Hérouville, mono mix):
Dominique Blanc-Francard
Assistant Sound Engineer (Hérouville): Andy Scott

Genesis

"Absolutely Curtains" is an instrumental credited to the four members of Pink Floyd. It is heard at the end of the movie, as the members of the expedition struggle across some steep terrain in thick mist. All of a sudden, while the others are resting, Viviane takes a few more steps and has a glimpse of the valley. This concluding track (and the musical accompaniment to the ultimate stage of the journey) is built around Rick Wright's keyboards and Mason's percussion. The voices of the Mapuga tribespeople then surge forward, reinforcing the mystical aspect of the expedition (and representing an alternative to the Western consumer society). Thanks to this aspect, "Absolutely Curtains" can be regarded as Pink Floyd's contribution to world music, as it was this instrumental that launched the encounter between rock (prog rock in this particular instance) and ethnic singing.

Production

The piece begins with a C drone on the VCS3 and pads laid down on the Hammond organ. The atmosphere is oppressive, and becomes all the more so when new sonorities created on a second VCS3 gradually merge with the other keyboards. Rick Wright comes in with an ethereal motif on his Fender Rhodes (from 0:25), before playing a tune on what sounds like a tack piano, in other words an instrument into each of whose hammers a thumbtack has been inserted, creating a distinctive sound not unlike that of the Japanese koto. It was presumably not by chance that this instrumental track would later be used as the B-side of the 1972 "Free Four" single in Japan (Toshiba/Odeon Records EOR-10149). Wright then plays a second melodic line on his Farfisa organ just as Nick Mason strikes his timpani with some power (1:03). A crescendoing cymbal then rings out, similar to others heard earlier in the piece. At 2:38, a snatch of a sung phrase is suddenly heard, coming as something of a surprise. This is soon faded out, giving way to the chanting of the Mapuga tribespeople, who are eventually left to bring "Absolutely Curtains" to a close unaccompanied. Strangely enough, of all the tracks on the album, it is probably this one that most closely resembles the characteristic Pink Floyd style.

The epic journey of Viviane, Olivier, and Gaëtan is about to end in the discovery of the valley—shrouded by thick clouds.

THE DARK SIDE OF THE MOON

ALBUM
THE DARK SIDE OF THE MOON

RELEASE DATE

United Kingdom: March 23 (March 24 according to some sources), 1973

Label: Harvest Records
RECORD NUMBER: SHVL 804

Number 1 (United States), on the charts for more than 800 (nonconsecutive) weeks, Number 1 (Canada), Number 2 (United Kingdom)

Speak To Me / Breathe / On The Run / Time / The Great Gig In The Sky / Money / Us And Them / Any Colour You Like / Brain Damage / Eclipse

David Gilmour playing a Jedson lap steel, which he occasionally used on tour: the entrancing sound of the "dark side of the moon."

The Dark Side of the Moon: The Ultimate Concept Album

On January 20, 1972, following three days of rehearsals at the Rainbow Theatre in London, Pink Floyd played the Brighton Dome. This was the first in a long series of concerts that by the end of the year would take the band up and down the United Kingdom, to North America, and back again to Europe (including the United Kingdom [again], Denmark, West Germany, France, Belgium, and Switzerland). A series of concerts that most importantly would enable the Floyd to hone the songs that made up the forthcoming album.

The First Steps on the Moon...

January 20, 1972. Inside the Dome, the crowd's impatient wait comes to an end when the stage is suddenly plunged into darkness and the hypnotic sound of a beating heart starts to pound out through the hall's speaker system. That evening, Roger Waters, David Gilmour, Rick Wright, and Nick Mason debuted six new pieces ("Speak to Me," "On the Run," "Time," "Breathe," "The Mortality Sequence" [soon to be renamed "The Great Gig in the Sky"], and "Money") to an entranced house, in spite of a technical hitch during "Money" that meant the tape loop could not be played.

This reception set the tone for the ensuing concerts on either side of the Atlantic, during which the group was able to systematically integrate into its set list all the component pieces in its new conceptual work *The Dark Side of the Moon: A Piece for Assorted Lunatics*—supplementing the above with "Us and Them," "Any Colour You Like" (initially entitled "Scat"), "Brain Damage," and "Eclipse."

Writing in the columns of the *Sunday Times*, Derek Jewell, who attended the February 17 concert at the Rainbow Theatre, enthused: "If all this sounds like *The Inferno* reworked, you would be only partly right. The ambition of the Floyd's artistic intention is now vast. Yet at the heart of all the multi-media intensity, they have [...] an uncanny feeling for the melancholy of our times [...] In their own terms, Floyd strikingly succeed." The journalist concludes that Pink Floyd "are dramatists supreme."[53] Renamed *Eclipse: A Piece for Assorted Lunatics* for the North American leg of the tour in April and May, the extended work readopted its previous title, *The Dark Side of the Moon: A Piece for Assorted Lunatics*, for the second part of the tour in September and November. As with "Echoes," this meant the songs on Pink Floyd's eighth album were presented to the public, developed, and even, in some cases, assumed their definitive form during the course of concerts given by the group.

The Birth of the Concept Album

The concept for the album had seen the light of day a few months earlier, in November 1971. Having already started to mull over ideas for an album, the group got together at Nick Mason's home on Saint Augustine Road in Camden, London, shortly after returning from the United States. "I remember sitting in his kitchen," explains Roger Waters, "looking out at the garden and saying, 'Hey, boys, I think I've got the answer,' and describing what it could be about."[81] According to Nick Mason, the individual themes

The four members of Pink Floyd with Dick Parry and the backing vocalists in concert during *The Dark Side of the Moon* tour in 1972.

For Pink Floyd Addicts

The eighth Pink Floyd album was re-named *Eclipse* after the members of the group became aware that the band Medicine Head had released its LP *Dark Side of the Moon* (1972) a few months earlier. They readopted their original title following the commercial failure of the Medicine Head album...

Storm Thorgerson took his inspiration for the cover of Rick Wright's *Broken China* album (1996) from the visuals for *The Dark Side of the Moon.*

within the overall concept emerged as follows: "Deadlines, travel, the stress of flying, the lure of money, a fear of dying, and problems of mental instability spilling over into madness...Armed with this list Roger went off to continue working on the lyrics."[5] David Gilmour remembers Roger saying: "...that he wanted to write it absolutely straight, clear and direct. To say exactly what he wanted to say for the first time and get away from psychedelic patter and strange and mysterious warblings."[1]

In terms of its themes and lyrics, *The Dark Side of the Moon* is clearly Roger Waters's album, because it was he alone who came up with them, conceiving of the work as a modern tragedy in three acts. The first act deals with the loss of childhood—apparently a reference to the bassist's early years in post–Second World War Britain, the second focuses on inhibiting factors within society (the politico-economic system, religion), and the third on the struggle—a battle lost in advance—against the death and nothingness that await us all at the end of the road..."The concept grabbed me,"[82] Gilmour would later declare.

The album's title is a metaphor for madness or, as the bassist himself has said, for everything that is capable of making people crazy: on the one hand the evils of the modern world (repetitive work, a lack of communication, greed, success...); on the other something that has always obsessed humankind: the passing of time, leading inexorably to death. The overriding mission of all rational beings must therefore be to find a way out of, to escape from, this "dark side" and to finally discover the light. "*The Dark Side of the Moon* was an expression of political, philosophical, humanitarian empathy that was desperate to get out,"[83] explains the songwriter. In an interview with *Uncut* magazine, he is even more specific: "If *The Dark Side of the Moon* is anything, it's an exhortation to join the flow of the river of natural

history in a way that's positive, and to embrace the positive and reject the negative, given that one might be able to identify with the things which seem to be a matter of great confusion to a lot of people."[81]

At first glance, then, there is more than just darkness in Waters's world. According to him, salvation is attained through having the courage to lead one's life free from harmful influences. *Don't be afraid to care*, he writes in "Breathe," for this is how we will get to see the light. Delving more deeply into the words of *The Dark Side of the Moon*, however, it is also possible to form a different impression, particularly from the closing track of the album, "Eclipse," in which the moon eclipses the sun and darkness reigns forevermore. "The ideas that Roger was exploring apply to every generation,"[83] reveals David Gilmour. A resounding triumph, the album was described by David Fricke, writing in the columns of *Rolling Stone*, as the ultimate concept album. "The concept is there, the songs are there, the spaces in the music are there. But it doesn't take away any of the imagination."[83]

A Break with the Past...

The Dark Side of the Moon revealed Roger Waters's creative strength as both a lyricist and a musician. "Compared to the rather piecemeal approach of our previous albums, which had often been conceived in an air of desperation rather than inspiration," reports Nick Mason, "this felt like a considerably more constructive way of working [...]. Using the specific lyrics that Roger devised, the music evolved in the rehearsal studio—and subsequently throughout the recording sessions. This gave Roger the opportunity to see any musical or lyrical gaps and to create pieces to fill them."[5]

This eighth album marks a clear break with the past. Peter Jenner shrewdly points out that "Though it was largely about him, that was the record where they escaped from

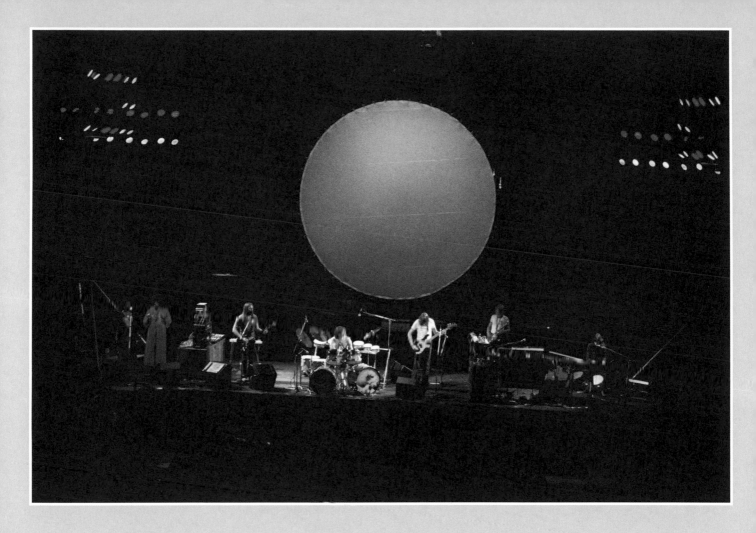

Syd."[53] The musical approach also differs from that of the previous albums. Epics of twenty minutes' or more duration, such as "Atom Heart Mother" and "Echoes," have been dropped in favor of a more "traditional" format. Thus the album is made up of ten songs, the longest of which, "Us and Them," is no more than eight minutes long. Some of these songs were sketched out well before the group started working on this concept album. "Breathe," for example, dates from the recording of *Music from the Body* (1970) by Roger Waters and Ron Geesin, while "Us and Them," originally named "The Violence Sequence," and "Brain Damage," go back to the movie *Zabriskie Point* and the album *Meddle* respectively. The new compositions are "Speak to Me," "On the Run," "Time," "The Great Gig in the Sky," "Money," "Any Colour You Like," and "Eclipse."

A Lengthy Gestation

The album would come together in various stages, starting with rehearsals at Decca Studios in Broadhurst Gardens (West Hampstead, London) between November 29 and December 10, 1971, when the Floyd started writing and making demos, although Roger Waters questions "[...] how much writing happened there. You know, let's play E minor or A for an hour or two and oh, that sounds alright, that'll take up five minutes or so."[83] New themes emerged out

of the many songs they worked on. The future "Breathe," "Us and Them," and "Brain Damage" already existed, but the group did not really know what to do with them. The breakthrough occurred when Roger Waters came up with the ingenious idea of linking all the songs together in order to turn each side of the (vinyl) album into a single track, creating a musical unit that embodied the unifying concept behind the album. In David Gilmour's words: "When Roger walked into Broadhurst Gardens with the idea of putting it all together as one piece with this linking theme he'd devised, that was a moment."[82]

From this time on, all the members of the group started to pull in the same direction. Between January 3 and 15, 1972, the songs continued to take shape in a rehearsal room in Bermondsey (London) belonging to the Rolling Stones. This also provided the London-based quartet with an opportunity to test their new equipment before going on tour: new lighting, designed by Arthur Marx, and above all an ultra-sophisticated WEM sound system with a twenty-four-channel Allen & Heath mixing desk and 360-degree quadraphonics. And then it was time for the tour, which kicked off in the United Kingdom (January 20 to February 20). From February 23 to 29, the Floyd was at the Château d'Hérouville, not far from Paris, recording the soundtrack to the movie *La Vallée* (*Obscured by*

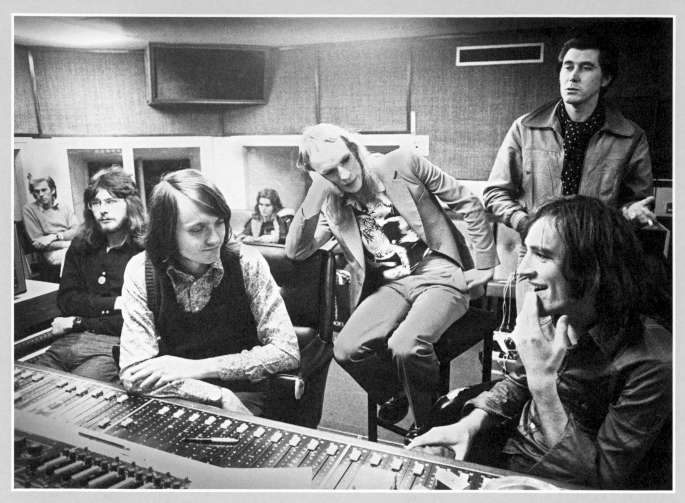

On the right, behind the console, the sound engineer Chris Thomas (shown here with the members of Roxy Music). Thomas would be at the controls for *The Dark Side of the Moon* alongside Alan Parsons and Peter James.

Clouds). They then flew off to Japan, where they toured between March 6 and 13. Another spell of a few more days at the Château d'Hérouville between March 23 and 27 in order to finish work on *Obscured by Clouds* was followed by the mixing of the soundtrack at Morgan Sound Studios in Willesden, London. The tour then moved to the United States from April 14 to May 4 and thereafter continued in Europe (West Germany and the Netherlands) from May 18 to 22.

The Album's Unsung Stars

To help them make *The Dark Side of the Moon*, Pink Floyd called upon the services of the very best studio technicians, and consequently the album's success owes an enormous amount to three engineers. Alan Parsons had been an assistant engineer at Abbey Road since the age of nineteen and had worked on the Beatles' last two albums. Chris Thomas, the mixing supervisor, had taken part in the sessions for the *White Album* (1968) and would go on to produce some of the major albums of the seventies, such as *For Your Pleasure* (1973) and *Siren* (1975) by Roxy Music, *Grand Hotel* (1973) by Procol Harum, *Paris 1919* (1973) by John Cale, and *Never Mind the Bollocks* (1977)

by the Sex Pistols. Peter James was the assistant sound engineer and would work with the Floyd again on *Wish You Were Here*.

One of the external musicians who contributed to the album was the saxophonist Dick Parry, an old friend of David Gilmour's. The two of them had played together during their Cambridge days, and Parry went on to play sax on albums such as J. J. Jackson's *Dilemma* (1970) by J. J. Jackson, *Bring It Back Home* (1971) by Mike Vernon, and *London Gumbo* (1972) by Lightnin' Slim. Then there were the backing singers Lesley Duncan, Doris Troy, Barry St. John, and Liza Strike, not to forget Clare Torry, the extraordinary voice on "The Great Gig in the Sky."

An Album of Superlatives

On February 27, 1973, EMI held a press reception at the London Planetarium on Marylebone Road for the launch of *The Dark Side of the Moon*. Rick Wright was the only member of Pink Floyd to attend. Roger Waters, David Gilmour, and Nick Mason boycotted the event for two reasons: firstly the quadraphonic mix was not yet ready, and secondly they judged the sound system

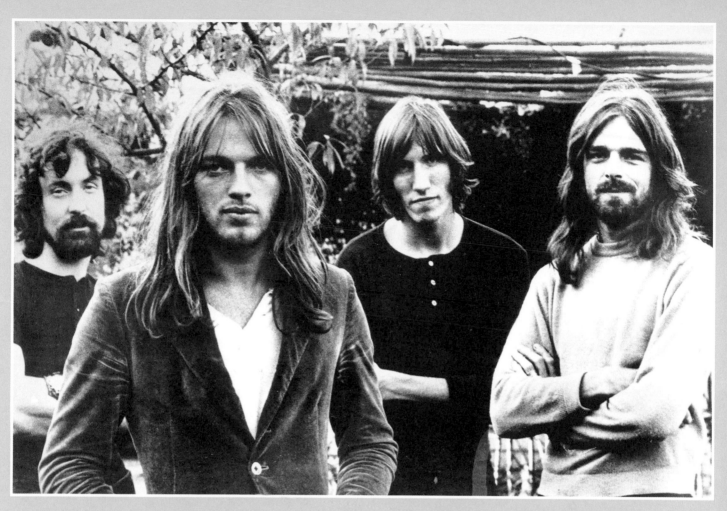

Publicity photo of Nick Mason, David Gilmour, Roger Waters, and Rick Wright taken in 1972 to promote *The Dark Side of the Moon*. The countdown had already started for their expedition to the Earth's satellite.

installed by the record company in the planetarium to be of inferior quality.

The group's eighth studio album went on sale in the United Kingdom on March 23, exactly thirteen days after its US release. Critics on both sides of the Atlantic gave it rave reviews. "It took nine months to make at Abbey Road and it is worth every second of studio time. A spacey trip, continuing the formula set by *Atom Heart Mother*," the *Melody Maker* reported on April 7, 1973; while the *NME* of March 17, 1973, called the album the "Floyd's most successful artistic venture"; and *Rolling Stone* claimed on May 24 that "There is a certain grandeur here that exceeds mere musical melodramatics and is rarely attempted in rock."

The Dark Side of the Moon rapidly became an album of superlatives, despite not doing quite as well in the United Kingdom as it did in the rest of the world. Pink Floyd's masterpiece would never get to number 1 in Britain, despite some seeing it as the musical embodiment of a nation that had started to doubt itself. Having risen to second place on the British charts by March 31, the album dropped back to number 5 the following week. In the United States it was a very different story. The album was an absolute sensation. Not only did it reach number 1 on the Billboard chart as

early as March 17, Saint Patrick's Day, it was to remain on and off the charts (that is to say for nonconsecutive periods) for a total of more than eight hundred weeks, the equivalent of more than fifteen years. It would also reach number 1 in Canada and Austria, and number 2 in West Germany and Norway. In France it would go on to achieve double platinum certification (400,000 copies). It is estimated that between forty-five million and fifty million copies of *Dark Side* have been sold to date (sixty-four million according to some sources), making it the third-best-selling album of all time (behind Michael Jackson's *Thriller* and AC/DC's *Back in Black*). *The Dark Side of the Moon* currently occupies forty-third place on the *Rolling Stone* list of the best five hundred albums.

The Sleeve

Ever since *A Saucerful of Secrets*, Pink Floyd's album sleeves had been designed by Hipgnosis. For *The Dark Side of the Moon*, the quartet persisted in not wanting to see the band's name on the cover, and now rejected the idea of a photographic montage as well. It was Rick Wright who steered Storm Thorgerson and Aubrey Powell in the right direction. "Richard Wright, the organist, said, 'Come up

Alan Parsons. After working with the Beatles, Parsons was to play a key part in the Pink Floyd sound at Abbey Road.

Alan Parsons was nominated for a Grammy Award for his work on *The Dark Side of the Moon*. Nominated only, more's the pity…

with something simple, a simple graphic, like a chocolate box,'" recalls Aubrey Powell. "This was insulting to us, but we said, 'Okay, we'll think about it.'"[84] Thorgerson and Powell would draw their inspiration from a French book of color photographs from the fifties. "In this book was a photo of a prism on a piece of sheet music and sunlight coming in through the glass window," explains Powell. "It was creating this rainbow effect."[84] Thorgerson explains that the sleeve design "comes from three basic ingredients, one of which is the light show that the band put on, so I was trying to represent that. Also, one of the themes of the lyrics, which was, I think, about ambition and greed, and thirdly was an answer to Rick Wright, who said that he wanted something simple and bold… and dramatic."[83] "Hence the prism, the triangle and the pyramids. It all connects, somehow, somewhere,"[65] adds the graphic designer in his book.

The final result is as striking as the music on the album. An equilateral triangle (or optical prism) is penetrated from the left by a white beam that disperses on the right into six colors of the spectrum (from top to bottom: red, orange, yellow, green, blue, violet). On the reverse of the cover we see the same diffracting prism, but this time inverted. Inside are the words to all the songs (for the first time on a Pink Floyd

album), through the middle of which the six spectral colors also run, with the difference that the green line now takes the form of a sinusoidal wave, which was Roger Waters's idea. As a bonus, the LP was accompanied by two posters, the first depicting the Pyramids of Giza (in blue or green depending on country), and the second portraying each of the members of the group in concert. Rounding off the package were two stickers (yellow and brown) featuring a deconstructed graphic of the same pyramids.

The Recording

The first recording session devoted to *The Dark Side of the Moon* was held on May 30. For this, Pink Floyd returned to the Abbey Road Studios, which they had more or less abandoned for their two previous albums, *Meddle* and *Obscured by Clouds*. Although the album was recorded over a period of nine months, due to the group's various commitments, it took only forty or so sessions (in Studios Two and Three, and Studio One for a single piano part!), not including various remixing, editing, and cross-fading sessions (which took place in Room Four). This is not a particularly large number for an album of such complexity. Recording was made easier as a result of the band having played the album live for

In 1972, the choreographer Roland Petit invited an English band he had seen in concert in London to Marseilles...and the *Pink Floyd Ballet* was born. A number of performances were given in the Salle Vallier in November, a few months before the release of the cult album *The Dark Side of the Moon*.

several months before entering the studio, as David Gilmour would later acknowledge: "When we went into the studio, we all knew the material. The playing was very good. It had a natural feel."[39] Roger Waters recalls, "It sounded special," adding that "When it was finished, I took the tape home and played it to my first wife, and I remember her bursting into tears when she'd finished listening to it. And I thought, 'Yeah, that's kind of what I expected,' because I think it's very moving emotionally and musically. Maybe its humanity has caused *Dark Side* to last as long as it has."[3]

However, this relative rapidity of execution is also explained by the perfect harmony that reigned within the group. "We were stuck in a small room for days on end and we did work very well together as a band,"[82] remembers David Gilmour. Mason concurs: "We approached the task assiduously, booking three-day sessions, sometimes whole weeks, and would all turn up for every session, everyone anxious to be involved in whatever was happening. There was an air of confidence in the studio. Since *Meddle* we had been our own producers, and so we could set our own schedule; at this point we were tending to work on the album track by track until we were happy with each piece."[5]

The atmosphere was so positive, in fact, that Alan Parsons was unable to distinguish any leader as such: "They produced each other—Roger would produce Dave playing guitar and singing and Dave would produce Roger doing his vocals."[82] And Waters would concede that he had been less dominant than he would later be: "We were pulling together pretty cohesively."[82]

By the time they recorded *The Dark Side of the Moon*, the members of Pink Floyd were leading more or less settled family lives, with the exception of David Gilmour, the only bachelor among them. Mason and Wright had even become fathers not long before. The sessions followed a relaxed rhythm, to such an extent, in fact, that they came to be organized around two important events: "Football League" soccer matches, which Waters did not want to miss at any price, and episodes of *Monty Python's Flying Circus* on television. On such occasions Alan Parsons found himself left to his own devices, tasked with doing a mix: "That was quite fulfilling for me. I got to put my own mark on what we were doing."[45]

However, the four members of Pink Floyd were no less perfectionists for this apparent calm, and spent as long as it took to come up with the right sound or idea. They

The famous EMI TG12345 MK IV console on which the record–breaking album was recorded.

dedicated hours to tracking down the perfect note, sonority, or sound effect and took an entire day over the loop for "Money." David Gilmour became famous for spending an eternity on his guitar settings, only to record his contributions very quickly once he had found the right sound. They were calm, highly reserved, and very British, as Alan Parsons has observed: "They would never be jumping up and down with joy when something was working. After an amazing take on a guitar solo, Roger would say something like, 'Oh, I think we might be able to get away with that one, Dave.' It was very low-key."[45]

The same observation was made by the backing singers, in particular Liza Strike, who was used to more of a fun atmosphere during recording: "This was very quiet; there was no interchange between us as people."[45] Nevertheless, the Floyd were able to get the best out of everyone, including themselves, and create a stunning album full of human warmth and emotion.

Alan Parsons, in Charge of Putting the Album into Orbit

As we have seen, the person responsible for recording the new Pink Floyd album was Alan Parsons. Nick Mason recalls that "At the beginning of the *Dark Side* recordings, we were assigned Alan Parsons, who had been assistant tape operator on *Atom Heart Mother*, as house engineer. […] He was a bloody good engineer. But he also had a very good ear and was a capable musician in his own right."[5] Parsons would have to cope with numerous technical constraints. Although

benefiting from sixteen tracks, this format was too limited for the group's ambitious music. He was therefore forced to transfer the sixteen tracks on the first tape recorder onto a second machine, premixing certain tracks, such as the drums and bass, in stereo, in order to create more space in the form of spare tracks. The drawback of this procedure was that it created a second generation of original takes, the signal inevitably being degraded each time. The final mixing of the album would therefore be done using the second or even third generation of recorded tracks. Parsons also had to come up with appropriate solutions for the group's numerous demands: "The Floyd were famous for using every machine in the studio, with wires trailing down the corridors and mangled tape strewn over the studio floor."[82] He even had to invent an original device to create a sufficiently long delay for the repetition of the words in "Us and Them."

The Mixing

Chris Thomas's services were called upon during the final stages of the album, that is to say the mixing. Although this is what he is credited for on the sleeve, it is a definition of his role that he disputes: "I was brought in at the end of the record, but as producer. It wasn't just mixing—it was mixing and recording."[45] He claims to have added new guitar parts to "Money" and helped to put "Speak to Me" together. Either way, his assistance was vital, although the underlying reason for his presence is interpreted differently by the different members of the group. David Gilmour has the most clear-cut views on the subject. According to him, Thomas's

On the right, Bhaskar Menon (pictured here in 2016), the former boss of Capitol Records, who helped to make *The Dark Side of the Moon* one of the best-selling records of all time. On the left is the current chairman of Capitol Records, Steve Barnett.

role was above all to arbitrate between the different visions for the mix that Gilmour and Waters now had. "I wanted *Dark Side* to be big and swampy and wet, with reverbs and things like that. And Roger was very keen on it being a very dry album. I think he was influenced a lot by John Lennon's first solo album [*Plastic Ono Band*], which was very dry."[29] This is also Nick Mason's recollection. Roger Waters, however, is not as categorical, the episode being less cut and dried in his memory. The bassist is more inclined to think that they were all exhausted and that what they most needed was a fresh pair of ears. Chris Thomas himself, the subject of contention, provides yet another version: "There was no difference of opinion between them. I don't remember Roger once saying that he wanted less echo. In fact, there were never any hints they were later going to fall out. It was a very creative atmosphere. A lot of fun."[45]

Ultimately, the mix would favor Gilmour's inclination toward an enormous sound with plenty of reverb. Although comprising ten numbers, the pieces that make up each side of the album are cross-faded to provide for uninterrupted listening. In order to achieve this, Alan Parsons and the group did their editing directly onto the two-inch master tape! And listening to the results, it is difficult to believe that this is the second—if not third—generation recording. So mind-blowing is the outcome that from the day of its release the album would serve as a test disc in hi-fi stores— and indeed still does. As it happens, the release of *The Dark Side of the Moon* coincided with a new affordability of music systems.

Martin Nelson, who worked in the promotions department at EMI and was given the task of carrying a copy of the master to Los Angeles, remembers the moment when everyone was able to savor the result of so many months of work: "Dave Gilmour was doing the editing with a razor blade and there were piles of tape all over the floor. Finally, at about 4 a.m., they turned the lights down in the studio and played the whole album. Unbelievable. Absolutely fantastic!"[85] David Gilmour has a similar recollection: "Eventually we'd finished mixing all the tracks, but until the very last day we'd never heard them as the continuous piece we'd been imagining for more than a year. [...] Finally you sit back and listen all the way through at enormous volume. I can remember it. It was absolutely...It was really exciting."[82] Years later, Roger Waters would ask himself whether he was happy when he heard it and he comes to the conclusion: "Yeah. I remember hearing it and thinking, 'Christ, that sounds really good.'"[45]

The Keys to Success

What is the reason for the phenomenal success of *The Dark Side of the Moon*? There are clearly a number of factors. The first is the outstanding quality of Roger Waters's lyrics. David Gilmour has declared that it was with this album that his partner came into his own as a writer. According to him, Waters's writing came from the heart, and it was this sincerity that gave his lyrics a universal dimension. The guitarist would also be hugely appreciative of the way in which Waters devoted himself to the task: "Roger worked all sorts of hours on the concept and the lyrics while the rest of us went home to enjoy

The Minimoog, one of the cult synthesizers in British rock music, which Rick Wright used for the first time on "Any Colour You Like."

The Decca Studios in West Hampstead, London, where the Floyd began writing and making demos for *Dark Side* toward the end of 1971, was where the Beatles had their famous Decca audition on January 1, 1962. Their performance met with a polite refusal from the company's managers, who could not believe that the Liverpool band had much of a future...

our suppers."[82] But Gilmour himself played no small part in the album's success. With his inspired guitar playing, his warm and immediately identifiable voice, he lent the music a particular character that would make it widely accessible. According to a Floyd insider, Gilmour gave people enjoyment, while Waters made them stop and think. But then, no discussion of *Dark Side* would be complete without mentioning Rick Wright's brilliant compositional work, Nick Mason's inimitable drumming (for example the sound of his Rototoms on "Time"), and all the sound effects and voices that are an integral part of the album. Then there is the extraordinary packaging by Storm Thorgerson and the Hipgnosis team, and Alan Parsons's and Chris Thomas's dazzling sound... All these elements conspired to make *The Dark Side of the Moon* one of the best-selling albums of all time.

Astronomical Sales

For the album to achieve such enormous commercial success, however, something extraordinary was required on the marketing front. And this something was made to happen by Bhaskar Menon, the chairman of Capitol, the record company that distributed the Pink Floyd catalog in the United States. Hitherto relegated to Tower Records, a sub-label of Capitol, the Floyd were unhappy with their US sales and complained of being treated no better than a minor group. With *Obscured by Clouds*, Menon had already sensed the winds of change and that it was time to devote more attention to Pink Floyd. Unfortunately, unknown to Menon, Steve O'Rourke had just signed a new deal with Columbia Records, whose president, Clive Davis, he admired. Upon learning of this deal, Menon was able to persuade O'Rourke to stay with him for *Dark Side*, to bring their collaboration to a close with it. One hundred percent convinced of the enormous potential of the record, Bhaskar Menon moved heaven and earth to mount a phenomenal media campaign. Once sales

of the album passed the million mark, he persuaded O'Rourke and his protégés to agree to release "Money" as a single. From this moment, not only did sales go through the roof, but the lives of Waters, Gilmour, Wright, and Mason were transformed for good.

It also has to be said that success and glory also brought their share of disappointment. Roger Waters gradually assumed leadership of Pink Floyd, which resulted in the group splitting up in the early eighties. Meanwhile the sessions for which Alan Parsons was paid only £35 per week would leave the engineer with a bitter taste in his mouth, although at the same time he would be forced to acknowledge that the album had brought him a worldwide reputation that more than compensated for his modest salary.

Technical Details

Studios Two and Three, where *Dark Side* was by and large recorded, were equipped with EMI TG12345 consoles, a Studer A80 sixteen-track, two-inch tape recorders, Fairchild 660/666 limiter-compressors, EMT 140 plate reverb, and in all probability Tannoy Gold (Lockwood) monitors. There was evidently a wide assortment of mics available, but Alan Parsons would later explain that he recorded Gilmour's guitar using a single Neumann U87, and that for voice or guitar overdubs he used a Neumann U47, positioned at a distance of at least eighteen inches from the amp in the case of the latter. Moreover, to record, Gilmour stood in the control room next to Parsons, his guitar connected to his amp (which was set up in Studio Three) via a long lead. Needless to say, Parsons had never before experienced a configuration of this kind.

The drums are one of the characteristic sounds of the album. Parsons explains why: "I totally hate compressing drums. So, although Chris Thomas wanted to compress everything, I talked him into compressing just the instruments and vocals, but not the drums."[86]

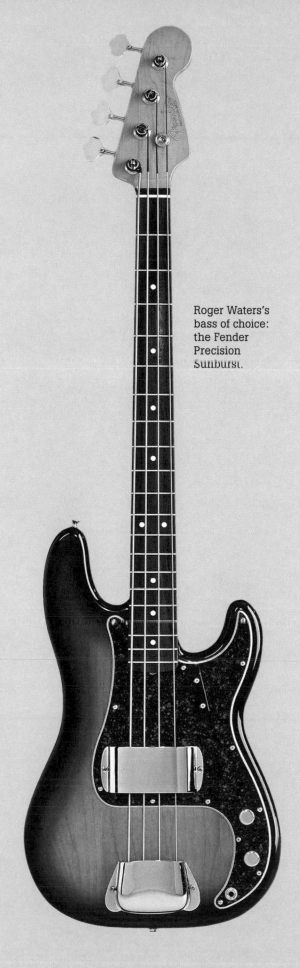

Roger Waters's bass of choice: the Fender Precision Sunburst.

The Instruments

Whereas Roger Waters remained faithful to his Fender Precision Sunburst bass, David Gilmour was continually experimenting and tinkering with his guitars. Around June 1972, for example, he swapped over the necks of his two Stratocasters, so that the "Black Strat" now had the rosewood neck of his Sunburst Strat and the latter had the maple neck of his "Black Strat." He also made striking use of his Fender 1000 double-neck pedal steel guitar in open-G and open-G6 (from lowest to highest string: D, G, D, G, B, E) tuning. Finally, for his third solo on "Money," Gilmour uses his twenty-four-fret Bill Lewis. He also added a Colorsound Power Boost to his collection of effects pedals (for its distortion) and, according to some observers, a Valley People Kepex for his tremolo on "Money," although he may also have achieved this with an EMS Hi-Fli guitar effects processor. Alan Parsons confirms his use of the latter: "And there was also a thing made by EMS called the HiFli, which was a sort of console device that had an early form of chorusing on it and some other effects. It was an interesting box."[86] As for amplification, Gilmour continued to use his Hiwatt DR-103 All Purpose 100-watt with WEM cabinets (Alan Parsons recalls him using Hiwatt enclosures), although he also seems to have used a Fender Twin Reverb.

Nick Mason, who would infuriate Alan Parsons during the first five days in the studio with his quest for the perfect sound for his Ludwig drum kit, used Rototoms for the first time on "Time," tuning them to the key changes on that track.

Rick Wright added a Hammond RT-3 (with Leslie 122 speaker), a Minimoog synthesizer, and a Wurlitzer EP-200 to his usual array of keyboards. Along with Gilmour and Waters, he also used EMS synthesizers, in particular the VCS3 Synthi A "Portabella," but also the new Synthi AKS model with integrated keyboard.

Alan Parsons with Scottish composer and member of the Alan Parsons Project Eric Woolfson.

Alan Parsons
and the Quest for Sound Perfection

By the time he took his place behind the console for the *Dark Side of the Moon* sessions, Alan Parsons, then just twenty-four years of age, possessed a résumé that seasoned engineers everywhere had good reason to envy him for. He initially won his spurs in 1969 working alongside George Martin and the four Beatles as assistant sound engineer on the legendary sessions for *Abbey Road*. Says Parsons: "They were a band that always were ready to experiment and push the limits of the recording studio to the boundaries that had never happened before. I think other groups from the 1960s and 1970s took advantage of what the Beatles had achieved, and many of them would say, 'if the Beatles can do it, we can do it too.' And I think Pink Floyd was one of those bands that did that."[94]

A Collaboration

Alan Parsons was born in London into an artistic family on December 20, 1948. He is the great-grandson of the famous actor and theater manager Sir Herbert Beerbohm Tree and the son of the pianist, flautist, man of letters, folk singer, and harpist Denys Parsons. He made his debut as a musician in London at the end of the sixties as a folk singer and a guitarist with a blues band called the Earth. In 1967 he was hired as assistant sound engineer at Abbey Road. The rest

is legend: collaboration with George Martin and the Beatles on the aforementioned *Abbey Road*, followed by more of the same on *Let It Be*.

Alan Parsons first entered the world of Floyd via the back door, as assistant on the sessions for the single "Point Me at the Sky" in autumn 1968 and then for *Umma-gumma* and *Atom Heart Mother*. Promoted to the role of sound engineer for *The Dark Side of the Moon* in 1972, he would contribute to one of the biggest albums in the history of rock music and play a part in the great technological revolution of the seventies. As a mixing desk specialist, and passionate about new technology, Parsons threw himself into the project body and soul, determined to obtain the best possible results at every stage of the recording process, and by whatever means. "I think it demonstrated the state of the art at the time and I am very proud of it. They would occasionally double-track guitars and I certainly multi-tracked guitars myself as Dave [Gilmour] would have as many as five or six parts going on and that was a demonstration of how the technology affected their creativity."[94] Nick Mason claims to have loved the drum sound Parsons was able to get for him on tape, and believes that "getting this right is still one of the great tests for any engineer"[5] in rock music. He adds: "Alan's full range of

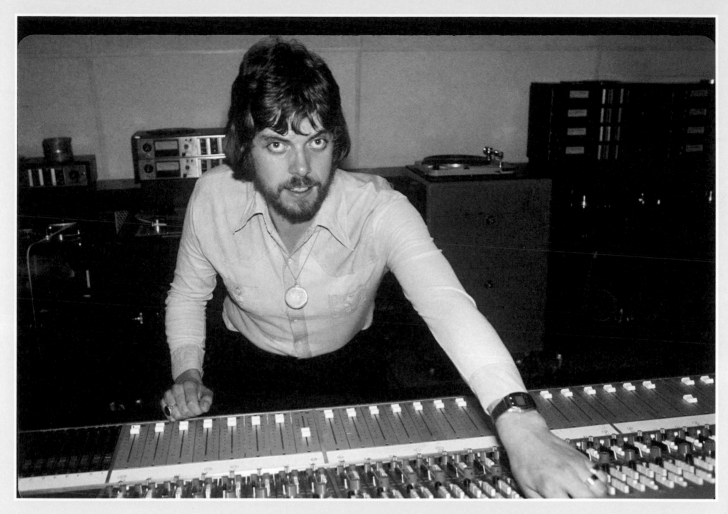

The sound engineer and producer at Media Sound Studios in New York in 1979.

engineering skills were self-evident as we began to construct the record."[5] Although the staggering richness of the album owed a great deal to Parsons, the Floyd drummer was nevertheless one of at most two members of the group to recognize the true scope of his exceptional contribution to *Dark Side*. Disparaged as much by David Gilmour as by Roger Waters, both of whom looked unfavorably on all the attention being paid to his role in the success of the album, Parsons decided not to continue his collaboration with Pink Floyd, who would add insult to injury in 2003 by failing to ask him to do the 5.1 and surround sound remix of the album.

The Alan Parsons Project

Having acquired considerable kudos with his work on the Pink Floyd album, Alan Parsons then pulled out all the stops. After reuniting with Paul McCartney for *Red Rose Speedway* (1973), he recorded the Hollies albums *Hollies* (1974) and *Another Night* (1975) and most importantly produced *Rebel* (1976) by John Miles, which yielded the enormous hit "Music," and *Year of the Cat* (1976) by Al Stewart, a magnum opus of British folk rock. These successes were followed up with Al Stewart's *Time Passages* (1978) and the London Philharmonic Orchestra's

Symphonic Music of Yes (1993). In 1976, Parsons had set himself another challenge when he decided to move around to the other side of the mixing desk and start a band. In partnership with Eric Woolfson, a Scottish composer, lyricist, singer, and multi instrumentalist who had been given his first studio break by Andrew Loog Oldham (then manager and producer of the Rolling Stones), he set up the Alan Parsons Project. This led to the highly successful *Tales of Mystery and Imagination* (1976), a setting to music of several short stories by Edgar Allan Poe, with the participation of Arthur Brown (vocals), John Miles (guitar and vocals), and others. After leaving Mercury for Arista (a label newly founded by Clive Davis), a dozen or so further albums followed, including *I Robot* (1977), *Eve* (1979), *Eye in the Sky* (1982), and *Gaudi* (1987). Beginning in the nineties, Alan Parsons pursued his career as a solo artist, and in this capacity has produced five studio albums over the years: *Try Anything Once* (1993), *On Air* (1996), *The Time Machine* (1999), *A Valid Path* (2004), and *Epilogue* (2013). He also engineered Steven Wilson's excellent concept album *The Raven That Refused to Sing* (2013). Currently living in California, Alan Parsons is regarded as one of the greatest sound engineers on planet Rock and one who is always prepared to explore new technology.

Speak To Me

Nick Mason / 1:07

Musicians
Rick Wright (?): piano, VCS3
Roger Waters: sound effects
Nick Mason: bass drum, sound effects
**Chris Adamson, Gerry O'Driscoll, Peter
Watts, Clare Torry:** voices
Recorded
Abbey Road Studios, London: June 23 and November 1 (?),
1972; January and February 1973 (Studios Two and Three)
Technical Team
Producer: Pink Floyd
Sound Engineers: Alan Parsons, Chris Thomas
Assistant Sound Engineer: Peter James

For Pink Floyd Addicts

Paul McCartney, who was at Abbey Road recording *Red Rose Speedway*, willingly submitted to Roger Waters's questioning. In the end, however, Waters decided not to include the former Beatle in the "Speak to Me" sound collage, judging him to be defensive, not sufficiently natural, and too "pro" in his answers.

David Gilmour confirms that Roger Waters gave "Speak to Me" to Nick Mason as a gift. This is a gesture the bassist would regret after leaving Pink Floyd due to the complex legal action in which the members of the Floyd became embroiled.

Genesis

"Speak to Me" serves as the overture to the concept album that is *The Dark Side of the Moon*. It presents a succession of sound effects that will be heard again at various points during the album, starting with a beating heart (which recurs in "Eclipse," the last track on the album) and continuing with the clocks from "Time," the laughter from "Brain Damage," the cash register from "Money," a helicopter noise generated on the VCS3, and an extract from Clare Torry's vocal performance in "The Great Gig in the Sky."

There are also two spoken phrases in this opening track: *I've been mad for fucking years, absolutely years, been over the edge for yonks, been working me buns off for bands*, which is attributed to Chris Adamson, the Pink Floyd roadie and technician who had also provided the inspiration for "When You're In" on *Obscured by Clouds*, and *I've always been mad, I know I've been mad, like the most of us are...very hard to explain why you're mad, even if you're not mad*, uttered by Gerry O'Driscoll, the Irish doorman at Abbey Road Studios, who also features in "The Great Gig in the Sky" and comes back again at the end of the album. Years later the group would agree to remunerate O'Driscoll by paying him for the studio session in which he did his bit.

With "Speak to Me," which symbolizes birth or awakening, we get straight to the heart of the matter. The message is clear: solitude and isolation are the path to madness, while communication alone enables us to maintain our mental health. Although this first track on *The Dark Side of the Moon* is credited to Nick Mason, it was actually Roger Waters's idea. It was Waters who, through the offices of sound engineer Alan Parsons, asked various people a series of fifteen questions relating to the themes of the album. These questions were written down on cards, and the respondents, Patricia "Puddie" Watts (wife of road manager Peter Watts), roadies Chris Adamson, Liverpool Bobby, and Roger "The Hat" Manifold, and various other persons present at Abbey Road at the time (notably Gerry O'Driscoll), were asked to answer the questions without beating around the bush. In order to put the respondents at ease, Waters started with innocent-sounding questions along the lines of "What is your favorite color/food?" before probing deeper with inquiries such as: "Do you fear death?" "When did you

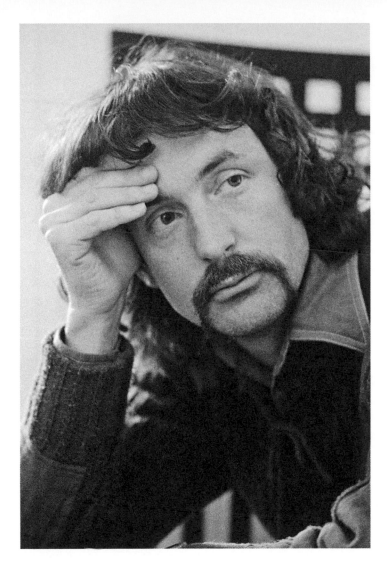

Nick Mason, who creates the heartbeat on "Speak to Me" by striking his bass drum with a mallet. This is the only piece on the album credited to Mason alone.

last hit someone?" "Were you in the right?" "Would you do it again if the same thing happened?" and even "What does the dark side of the moon mean to you?" All these questions would play a part in the development of the album.

Production

Alan Parsons was the first to be subjected to Roger Waters's questionnaire. However, the engineer was too nervous to do more than stammer out his responses, which were consequently not used. Back in the control room, in order to set the sound levels on his tape recorder, Parsons addressed the respondents using a particular phrase: "Speak to me." This phrase was retained as the title for the first track on *The Dark Side of the Moon*, a track whose almost hypnotic opening heartbeat would provide an ideal way to start Pink Floyd concerts. The heartbeat was not a new idea: it actually dated back to the *Zabriskie Point* era. Nick Mason explains that they had originally wanted to use a recording of a real heart, but the results were too stress inducing. In the end, they achieved the desired sound by padding out a bass drum and striking it with a mallet, an effect that sounds more realistic than the actual thing.

"That was bass drum Kepexed with a lot of EQ around 100 Hz,"[9] Alan Parsons would subsequently explain. However, 72 bpm—the average human heart rate—was too fast for the mood they wanted to create. They therefore reduced the speed, as Mason relates: "We slowed it down to a level that would have caused any cardiologist some concern."[5] Alan Parsons comments that the loop sounded horrible as a result of having been transferred from tape to tape and the signal therefore distorted, but the illusion is perfect. From the first seconds of "Speak to Me," when the heartbeat, to which a short reverb is applied, is heard, the tail end of a reversed piano chord, barely audible at first, grows progressively louder until it explodes into the beginning of "Breathe." In the meantime, various sounds and sound effects follow in succession: the sped-up ticking of a clock along with another clock running at normal speed; the "Money" loop; Gerry O'Driscoll's voice; the laughter of Pink Floyd tour manager Peter Watts; helicopter blades simulated on the VCS3; Clare Torry's screaming vocal, taken from "The Great Gig in the Sky"; and finally a cymbal, again reversed, merging with the piano chord that reaches its climax as the perfect transition to "Breathe."

Breathe

Roger Waters, David Gilmour, Richard Wright / 2:50

Musicians
David Gilmour: vocals, vocal harmonies,
electric rhythm guitar, pedal steel guitar
Rick Wright: keyboards
Roger Waters: bass
Nick Mason: drums

Recorded
Abbey Road Studios, London: May 30 and
31, June 22 and 23, October 31, 1972; January
18 and 27, 1973 (Studios Two and Three)

Technical Team
Producer: Pink Floyd
Sound Engineers: Alan Parsons, Chris Thomas
Assistant Sound Engineer: Peter James

For Pink Floyd Addicts

The original title of the piece on the vinyl album was "Breathe." For some inexplicable reason this was amended on the CD to "Breathe in the Air," and then "Breathe (In the Air)" on later versions.

COVERS

"Breathe" has been covered by various musicians, notably Sea of Green (on their album *Time to Fly*, 2001). The Flaming Lips performed a version during their set at the Glastonbury Festival in 2003.

Genesis

"Breathe" is the final incarnation of a song by the same name that Roger Waters composed and recorded for the 1970 album *Music from the Body*, a collaboration with Ron Geesin. Moreover, the different versions share a first line: *Breathe, breathe in the air*. This invitation to inhale is "an exhortation directed mainly at myself," explains Roger Waters, "but also at anybody else who cares to listen. It's about trying to be true to one's path."[82] In terms of the development of the highly conceptual *The Dark Side of the Moon*, "Breathe" may symbolize birth, the vocation of the newborn not necessarily being to adapt to the surrounding world, but to make its own life and value choices. This song can also be interpreted as a catalog of advice lavished by an adult (or elderly person) on a child or adolescent. It amounts to a philosophy of life, the phrase *Don't be afraid to care*, which can also be understood as "appreciate life as it is, for it is short," apparently looking forward to the closing line of the song: *You race towards an early grave*.

Finally, *Look around, choose your own ground* conveys the message: "You alone are responsible for your actions, no one can or should decide for you; never obey orders." Advice is easier to give than to receive, however, and every human being is torn between contradictory feelings. It is clearly this conflict that Roger Waters means to express when he writes: *Leave, but don't leave me*—conflict being a cause of inhibitions, which in turn can give rise to psychological problems. Hence another phrase that mercilessly points to the absurdity of life: *Dig that hole, forget the sun/ And when at last the work is done/Don't sit down, it's time to dig another one*. The myth of Sisyphus revisited, in a sense…In fact, Roger Waters puts words in David Gilmour's mouth that are almost the exact equivalent of what Albert Camus wrote in "The Myth of Sisyphus." Waters: *Forget the sun*; Camus: "There is no sun without shadow, and it is essential to know the night, the sun being the light that guides, that preserves us from derangement."

Production

"Breathe" is one of the pieces the Floyd had started rehearsing in Broadhurst Gardens back at the end of 1971. All the original version, written by Roger Waters for the soundtrack

of *Music from the Body*, and the one on *Dark Side* have in common are the title and first line. Everything else—words, ideas, melody—differs greatly. In the music, Roger Waters was inspired more by Neil Young's "Down by the River" (on the 1969 album *Everybody Knows This Is Nowhere*), and uses the same pivotal E-minor and A chords. The beginning of the refrain is also similar, although it continues differently thanks to a highly inspired contribution from Rick Wright, who brings an unexpected color to the piece. "The interesting thing about this song if we're talking about jazz," the keyboardist would later explain, "is that there's a certain chord [...] that I had heard, actually, on a Miles Davis album, *Kind of Blue*. [...] That chord I just love."[83] For those who know about such things, the chord in question is a D7 (+ 9).

"Breathe" is inseparable from "Speak to Me," whose gradual increase in volume, combined with the oppressive tension of the beating heart, finds its release in a sudden burst of adrenaline that propels "Breathe" toward the stars. The music explodes, generating a feeling of incredible fulfillment. The group is completely at one, the machinery well oiled following months of live performance. David Gilmour is omnipresent with his numerous guitar parts and lead vocals. His voice, whose texture has been enriched by his growing maturity, is just as gentle, intense, and emotional as before. He doubles himself in order to boost his power and improve his tuning, and harmonizes with himself in the refrains. Rick Wright would later describe Gilmour's double-tracking as no less than brilliant. And his achievement on guitar is equally remarkable. It is presumably with his Fender 1000 pedal steel guitar, one of the characteristic features of *The Dark Side of the Moon*, that he gives the piece its unique character. His soaring slide guitar, which he

controls with the volume pedal, is simply extraordinary. The notes seem to float in a sea of reverb, enhanced by delay. Gilmour harmonizes with himself to awe-inspiring effect on a second track. It is interesting to note that he uses open-G6 tuning, and that according to some witnesses, he was actually playing on a lap steel purchased just before the band entered the studio, or even, according to Waters, on his Strat (resting on his knees, and again in open tuning). From the very first bar, Gilmour also plays a rhythm guitar part on his "Black Strat," the sound of which, strongly colored by his Leslie speaker (or Uni-Vibe?) significantly reinforces the floating mood of the piece.

The various keyboard parts are another important element in "Breathe." In the first place, Rick Wright answers Gilmour's rhythm guitar with some superb electric piano—either his new Wurlitzer EP-200 or the Fender Rhodes—played through a Leslie speaker. He then records two Hammond RT-3 organ tracks: pads in the refrains, and orgasmic upward-thrusting runs drenched in Leslie and Binson Echorec II at each refrain-verse join. As for the rhythm section, Nick Mason delivers a superb floating drum part, supporting himself continually on ride cymbal and totally in sync with Waters's excellent bass.

"Eclipse Part 1," the working title of "Breathe," was recorded in seven sessions, with the January 27 session being reserved for the mixing. David Gilmour's vocal harmonies received special attention, for it seems they were recorded and finalized over the course of at least three sessions, a pretty generous allocation of time for a piece that is not especially complicated. The results, however, are extraordinary, and "Breathe" draws the listener straight into the heart of *The Dark Side of the Moon*.

Paul McCartney at the
time of "On the Run."

On The Run

David Gilmour, Roger Waters / 3:45

Musicians
David Gilmour: guitars, EMS Synthi AKS, VCS3 (?)
Rick Wright: keyboards
Roger Waters: EMS Synthi AKS, VCS3, effects, bass (?)
Nick Mason: drums, effects
Roger Manifold: voice

Recorded
Abbey Road Studios, London: May 31, June 13–15,
October 11, 12, 15, 16, 31, 1972; January 18–20, 24, 26, 27,
30, February 9, 1973 (Studios Two and Three, Room Four)

Technical Team
Producer: Pink Floyd
Sound Engineers: Alan Parsons, Chris Thomas
Assistant Sound Engineer: Peter James

COVERS
In addition to the Flaming Lips, 2009, the
Seatbelts have also recorded a version
of "On the Run"—for the soundtrack of
Cowboy Bebop (*Cowboy Bebop: Tengoku
no tobira*, 2001), a movie by Shinichiro
Watanabe.

Genesis

"On the Run" is characteristic of Pink Floyd's descriptive
music, and of David Gilmour and Roger Waters, who are
credited as its composers, in particular. It is an instrumental
that saw the light of day during the course of a long impro-
visation in the studio and was transformed into a sequence
of sonic effects that explicitly convey both the frantic life to
which the four members of the group were subjected and,
more specifically, the fear, if not paranoia (especially in Rick
Wright's case) inspired in them by flying. Moreover, "On the
Run" was called "The Travel Sequence" when *The Dark
Side of the Moon* was performed live by the group before
the start of recording.

An airport announcement can be heard, followed by the
noise of an aircraft engine. And already the machine is tak-
ing off, in a hellish cycle that will result in the plane crash at
the end of the piece. "On the Run" generates an atmosphere
of anxiety that is conveyed perfectly in a 1987 video...

Production

The initial live versions of "On the Run" differed from the
album version. The piece was more of a jam, foregrounding
David Gilmour on Echorec-laden guitar, answered by Rick
Wright with a jazzy improvisation on his Wurlitzer. Nobody
was happy with the piece in this form, however, and "Eclipse
Part 2" (its working title at the time) was totally remodeled
in the studio, starting on May 31, 1972 (the second session
devoted to the new album). The results were still not right
after the first day, and a new base track was cut on June 13,
the fifth take serving as the foundation for a huge number of
overdubs on which work would continue until the final mix-
ing on February 9, 1973. Throughout June, the Floyd would
record multiple sound effects, referred to in the session notes
as "Weird Noises" and even "More Weird Noises," but also
drum, guitar, bass, and electric piano overdubs. After the
summer, and following a series of North American concerts
in September, the Floyd returned to Abbey Road in October
and worked on the piece, now renamed "The Travel Sec-
tion," some more, adding further synthesizer, guitar, and
bass overdubs. It was eventually finished in January 1973
and its two distinct parts, "Wild Guitar" and "Big Crash,"
mixed and inserted into the final version on February 9.

Is it possible that Paul McCartney, who was working on *Red Rose Speedway* at Abbey Road at the same time that the Floyd were recording *Dark Side*, was influenced by the title "On the Run" when naming *Band On the Run*, released at the end of 1973?

"On the Run" opens with a rhythm tapped out on the hi-hat. The sound was derived fortuitously from the Synthi AKS sequence that serves as the main motif of the piece. But Nick Mason most likely doubles it with a hi-hat tape loop. Given the fast tempo (165 bpm), the tape is short but it works perfectly. Rick Wright's Hammond organ accompanies Mason before Roger Waters surges into the picture on the brand-new EMS Synthi A. Nick Mason explains that this "was in fact one of the last pieces added since it was only at this point we had access to an EMS Synthi A."[5] It was apparently on October 16, 1972, that the sequencer was recorded, entirely for real, because Adrian Maben was at the studio taking shots for his documentary *Pink Floyd: Live at Pompeii*, as Waters confirms: "[…] there's quite a long shot of me in the studio recording 'On the Run' with the VCS3."[82] Nevertheless, the band member at the origin of the sequencing idea is David Gilmour, because it is he who initially entered the eight notes into the Synthi AKS and then substantially increased the tempo: "I just plugged this up and started playing one sequence on it and Roger immediately pricked up his ears and said 'that sounded good.'"[83] The result wasn't quite to the bassist's taste, however, and so he reprogrammed the sequence. "He put in another, quite like mine, and I hate to say, it was marginally better."[45]

Other sounds made using the VCS3's voltage-controlled oscillator then enter the picture. These electronic noises travel across the stereo field in simulation of a Doppler effect, a phenomenon well known to electroacoustics experts.

At 0:28 a female airport announcer seems to be saying: …*Have your baggage and passport ready and then follow the green line to customs and immigration. BA 215 to Rome, Cairo, and Lagos. May I have your attention please, customs will be receiving passengers for Flight 215 to Rome, Cairo, and Lagos*…We then hear footsteps moving initially from left to right and then from right to left again. According to Nick Mason, this was a sound clip taken from the EMI sound library, but Alan Parsons offers a different explanation: "The footsteps were done by Peter James, the assistant engineer, running around Studio 2, breathing heavily and panting."[82] At around 1:00, the same heartbeat heard on "Speak to Me" re-emerges and anchors the tempo. The second spoken phrase (*Live for today, gone tomorrow, that's me*) is uttered by the roadie Roger "The Hat" Manifold, who underlines his answer to Waters's question "Do you fear death?" with a resounding laugh (1:53). This is followed by a reversed, Larsen-like distorted guitar effect, played by Gilmour with the leg of a mic stand! The tension gradually mounts, with the sound of an aircraft moving along the runway, the heartbeat growing more insistent, and then Manifold's laughter ringing out again before the airplane finally takes off and erupts in a mighty explosion. This explosion seems to be created partly from actual sound effects found in the studio's sound library, and partly from an effect realized on the VCS3s and by Gilmour on his Strat. The footsteps then emerge from the chaos before giving way to the ticking clocks that announce the beginning of the next track, "Time."

This was not an easy piece to mix. Because of its multiple sound sources and effects, each of the band members, in addition to Parsons and James, had to look after several tracks on the mixing desk, definitely helped to make "On the Run" even more vibrant than it would otherwise have been.

The expression *quiet desperation* in the last verse is borrowed from *Walden; or, Life in the Woods* by Henry David Thoreau, which was published in 1854: "The mass of men lead lives of quiet desperation." The addition *is the English way*, on the other hand, is typically Floydian.

David Gilmour and his "Black Strat." In "Time," the guitarist plays one of the most inspired solos of his career, bluesy and spacey at the same time.

Time

Nick Mason, Roger Waters, Richard Wright, David Gilmour / 6:53

Musicians
David Gilmour: vocals, vocal harmonies, electric rhythm and lead guitar, EMS Hi-Fli, VCS3 (?)
Rick Wright: vocals, keyboards, VCS3 (?)
Roger Waters: bass, VCS3 (?)
Nick Mason: drums, Rototoms
Doris Troy, Lesley Duncan, Liza Strike, Barry St. John: backing vocals
Recorded
Abbey Road Studios, London: June 8–10, 20, 22, October 17, 31, November 1, 1972; January 21, 24, 25, 1973 (Studios Two and Three)
Technical Team
Producer: Pink Floyd
Sound Engineers: Alan Parsons, Chris Thomas
Assistant Sound Engineer: Peter James

Ian Emes, who made the films shown during the live performances of *The Dark Side of the Moon*.

Genesis

"Time" is the only song on *The Dark Side of the Moon* whose musical composition is credited to all four members of the group. Roger Waters, by contrast, is the sole author of the lyrics, which constitute one of his most profound pieces of songwriting, from both a poetic and a philosophical point of view.

The clocks and bells that ring out by way of an intro are a metaphor: they are announcing some kind of realization or awakening of the spirit. *Fritter and waste the hours in an offhand way [...] Waiting for someone or something to show you the way*: what exactly is Waters trying to say here? Naturally the bassist is describing the inexorable passing of time, but he is also evoking our perception of it at the different stages of life (we have time to kill when we're young, and yet we run and [...] run to catch up with the sun as we grow older) as well as the urgent need for us to take in hand our own destinies. "I spent an awful lot of my life—until I was about twenty-eight—waiting for my life to start," explained Roger Waters to *Rolling Stone* in 1982. "I thought that at some point I would turn from a chrysalis into a butterfly, that my real life would begin. So if I had that bit of my life to live again, I would rather live the years between eighteen and twenty-eight knowing that that was it, that nothing was suddenly going to happen—that it was happening all the time. 'Time' passes, and you are what you are, you do what you do."[87] In *The Making of The Dark Side of the Moon*, Waters is even more specific: "[...] my mother was so obsessed with education, and the idea that childhood and adolescence and everything, really, was about preparing for a life that was going to start later. And I certainly realised that life wasn't going to start later, that it starts at dot and happens all the time. At any point you can grasp the reins and start guiding your own destiny. And that was a big revelation to me, it came as quite a shock."[83]

"Time" is thus an evocation of the songwriter's own experience, but it also conveys a tragically universal message: each passing day brings us closer to death, and all too often we are surprised to discover that already the song is over. Because we are going to die one day, it is important to relish even the simplest of pleasures, such as

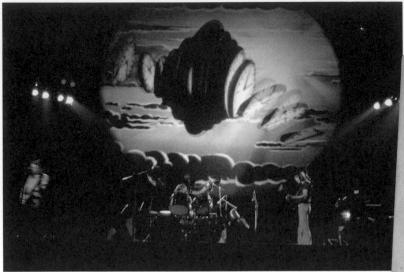

The clocks in "Time," which symbolize a coming to consciousness, an awakening of the spirit.

warming our bones beside the fire. Unless we believe in God, that is, whose church bell calls the faithful to their knees to hear the softly spoken magic spell. As for: *And you run and you run to catch up with the sun, but it's sinking*, a somewhat overhasty reading of this line could bring to mind the Gospel according to Saint John, chapter 1, verse 5: "And the light shineth in darkness; and the darkness comprehended it not," which would not be without a certain piquancy for a songwriter such as Waters! Musically, "Time" ends with a reprise of "Breathe," prompting listeners to ponder the eternal renewal of the world.

The Song of a Generation

Released (minus the reprise of "Breathe") as a double A-side single with "Us and Them," "Time" is also included on the live albums *Delicate Sound of Thunder* (1988) and *Pulse* (1995), on Roger Waters's live album *In the Flesh* (2000), and also on the compilation *Echoes: The Best of Pink Floyd* (2001). This song was a big influence on a whole generation of musicians, and reached far beyond the prog rock scene. Patterson Hood, guitarist-singer of the southern rock group Drive-By Truckers (and son of the renowned Muscle Shoals bassist David Hood), has revealed that *The Dark Side of the Moon* had been his "favourite album," adding: "'Time' was a really big deal when I was a kid. My stereo was down on my uncle's farm and I'd go stay with him on weekends. Out on the farm, I could play it as loud as I wanted to. So when I went to bed at night, that was my 'go-to-bed' record. I liked how dreamlike it was and I especially like the hypnotic quality of it. It was a very melodic record. I followed Pink Floyd through my teens, right up until punk rock started happening at junior high school. Listen to any of the Drive-By Truckers songs I play lead guitar on and Dave Gilmour is one the bigger influences on my playing."[81]

Production

The demo of "Time" that Roger Waters made prior to working on it in the studio presented the song almost fully formed, both musically and lyrically, except for the first line of the second verse, which differed (*Lying supine in the sunshine, let the grass grow in your brain* instead of *Tired of lying in the sunshine staying home to watch the rain*). However, the work done by the four members of Pink Floyd on creating the definitive version would raise the song to a new level, making it one of the most important pieces on the album. The first session took place on June 8 in Abbey Road's Studio Two, and the whole of the song, including the link with the "Breathe" reprise, would be recorded during the course of five further sessions that month. It was then completed in October and November, not least with the addition of the David Gilmour solo, before being mixed and edited in the New Year.

"Time Song," the working title by which this track was originally known, opens with the jangling and ticking of a multitude of clocks, which then explode at the same time in a sensational din of bells, chimes, and alarms. Alan Parsons had recorded these timepieces using a portable Uher tape recorder: "I had recorded them previously in a watchmaker's shop for a quadriphonic sound demonstration record,"[82] he would explain. Upon discovering what the subject of the song was, he himself offered his recording to the group. In order to fit in with the tempo of the piece, he had to calibrate the assorted ticking and ringing of the clocks. But the result is a triumph. One of the most famous effects on the album, it would be used for years to come to demonstrate hi-fi systems all over the world!

Roger Waters then enters on his Precision bass (from 0:28), simulating a kind of metronome, with, in the background, the heartbeat, which has been recurring periodically since the beginning of the album.

Before long, David Gilmour delivers a series of powerful, clear-toned chords on his "Black Strat," reinforced by deep reverb and the Binson Echorec II. He also uses a new guitar

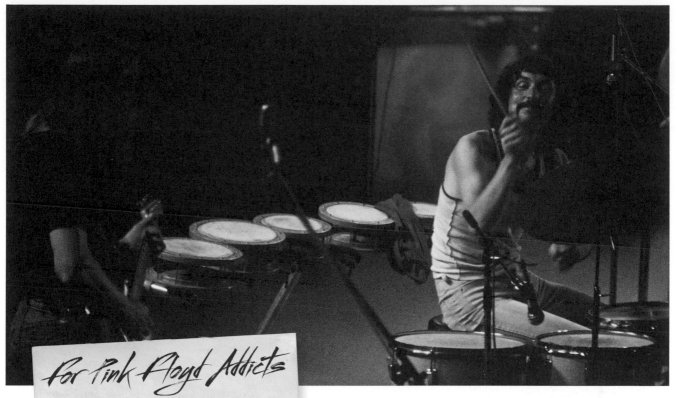

Nick Mason contributes an unusual color with his Rototoms, seen here arrayed behind him.

processor, the EMS Hi-Fli, which offered distortion effects, phasing, and ADT doubling. Rick Wright answers Gilmour with licks on his Wurlitzer EP-200 and pad sounds on his Farfisa organ. And it is over this intro that Nick Mason uses Rototoms for the first time. These were recorded on June 10. "The main intro for this song was devised because a set of Roto-Toms happened to be in the studio," explains the drummer, "and we completed it in just a few takes."[5] The sound of these drums is part and parcel of the special color of "Time," a sonority that was relatively unknown at the time.

Following this intro of more than two minutes' duration, the first verse eventually starts with Gilmour singing (doubled) lead vocal, this time with a hoarser timbre. Mason and Waters lay down a very good groove supported by Gilmour with a distorted rhythm part on his Strat (left-hand channel) and Wright, also playing a rhythm part on his Wurlitzer (right-hand channel). The keyboardist also sings lead vocal in the two bridges (in a softer voice), with Gilmour providing vocal harmonies and with superb support from Doris Troy, Lesley Duncan, Liza Strike, and Barry St. John on backing vocals, which were recorded on June 20. In order to modulate the sound of these backing singers, Alan Parsons found an alternative use for a frequency translator, whose original purpose had been to eliminate or attenuate feedback. He now fed the singers' voices through this device in order to obtain a flanger-like effect.

On November 1, David Gilmour recorded one of his best-ever solos on his "Black Strat." The sound is astonishing: bluesy, spacey, and with overtones of Hendrix. The notes literally leap from his guitar, and his playing, which makes abundant use of note bending and the whammy bar, overflows with feeling. Parsons recorded him with a single mic, presumably a Neumann U87, set up in front of his amp. The sound is enormous, the Hiwatt amp head, connected to WEM speakers, delivering extraordinary power. Although Gilmour is not, strictly speaking, one of the world's greatest guitar virtuosi, his touch is unique. He explains: "I don't have to have too much technique for it. I've developed the parts of my technique that are useful to me. I'll never be a very fast guitar player."[88] He doubles his solo and uses Fuzz Face and Echorec to obtain the desired color.

Following the return of the vocals with the second verse and bridge (with contributions from the VCS3), at 5:44 "Time" segues directly into the reprise of "Breathe," which was given the working title "Home Again." Other than the words, it is the very same version of the second half of "Breathe" that has been cut and pasted onto the end of "Time." The instrumentation is identical apart from the absence of the ride cymbal in the last refrain. It is interesting to note that this reprise is an integral part of "Time" in the sense that it is not listed as a separate track.

The Great Gig In The Sky

Richard Wright, vocal composition by Clare Torry / 4:44

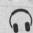
Musicians
David Gilmour: pedal steel guitar
Rick Wright: piano, Hammond organ
Roger Waters: bass
Nick Mason: drums
Clare Torry: vocals
Gerry O'Driscoll, Patricia Watts: voices

Recorded
Abbey Road Studios, London: June 20–22, October 25–26, 1972; January 21, 25–26, February 9, 1973 (Studios Two and Three, Room Four)

Technical Team
Producer: Pink Floyd
Sound Engineers: Alan Parsons, Chris Thomas
Assistant Sound Engineer: Peter James

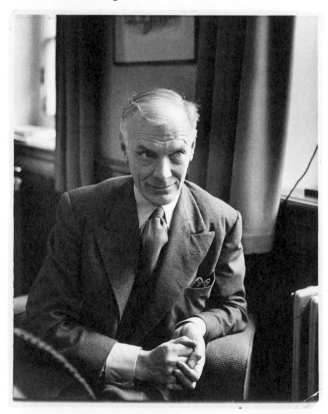

The British journalist and Catholic moralist Malcolm Muggeridge.

Genesis

This superb, moving track has its origins in another composition by Rick Wright, "The Mortality Sequence," written for the live version of *Eclipse: A Piece for Assorted Lunatics*. Performed on the organ (very much in the spirit of the finale of "A Saucerful of Secrets"), the point of the earlier piece had been to demonstrate that religions did not necessarily offer an optimistic message, but on the contrary could drive us to insanity. Hence the verses from Ecclesiastes and the extracts of speeches by Malcolm Muggeridge. This all-out attack on the church was subsequently abandoned because Pink Floyd feared they would attract the wrath of the substantial section of the American public that was still attached to Christian values. "The Great Gig in the Sky" was then transformed into a musical illustration of Rick Wright's fear of flying and his horror at the thought of dying mid-flight: "One of the pressures for me—and I'm sure all the others—is this constant fear of dying, because of all the travelling we're doing on the motorways of America and Europe, and the planes. That for me is a very real fear."[36]

"I think I just, as I always have done, sat at the piano. And those first two chords came,"[83] explains Rick Wright. Two chords of remarkable emotional power, it has to be said. "The Great Gig in the Sky" is an instrumental, albeit one that contains two highly meaningful spoken phrases. The first is uttered at 0:39 by Gerry O'Driscoll, the Abbey Road doorman: *And I am not frightened of dying. Any time will do, I don't mind. Why should I be frightened of dying? There's no reason for it, you've gotta go sometime.* The second occurs at 3:34 and is spoken by Patricia Watts (the wife of road manager Peter Watts): *I never said I was frightened of dying.* This is a possible reference to Thanatos and Moros (the personifications of death and fate in Greek mythology).

Thanks to Clare Torry's dazzling vocal performance, "The Great Gig in the Sky" is one of the crowning artistic moments on *The Dark Side of the Moon*. Also worthy of a special mention is the live version of "The Great Gig in the Sky" on the DVD *Delicate Sound of Thunder* (1989), featuring the backing singers Rachel Fury, Durga McBroom, and Margaret Taylor.

"The Great Gig in the Sky," a song born of Rick Wright's fear of flying.

Malcolm Muggeridge (1903–1990), an author and member of MI6 (the British Secret Intelligence Service) during the Second World War, was attracted to revolutionary ideas but rejected left-wing politics after experiencing life in the USSR. He then converted to Catholicism under the influence of Mother Teresa. He was also an ardent denigrator of the Swinging Sixties, and especially of the Beatles, whom he saw as "dummy figures with tousled heads [and] no talent."

For Pink Floyd Addicts

Thanks to an irony of fate, in the seventies this fantastic musical sequence of great emotional power was enthusiastically taken up by the sex shops of Amsterdam, which found that it set exactly the right tone! Similarly, two decades later it would be designated "the best music to make love to" by an Australian radio station. This has apparently been confirmed by David Gilmour, to whom numerous friends are supposed to have confided that the track has an extraordinary erotic power. A little like Maurice Ravel's *Boléro*, perhaps...Not bad for a number that started life as "The Mortality Sequence."

Production

It was under the title "Religious Theme" that the base track of "The Great Gig in the Sky" was recorded, on June 20, 1972. However, the Floyd were not satisfied with this initial version, and after rerecording it the following day, again without achieving the desired results, they eventually got the definitive base track down on June 22, with the third take selected for overdubbing. At this stage, Rick Wright recorded the piano and Hammond organ. However, after Nick Mason had recorded his excellent drum part, whose uncompressed sonority (exactly as Alan Parsons wanted) resounds powerfully, amply, and with no trace of aggressivity, on October 25 Wright found himself alone in Studio One, the immense recording studio at Abbey Road used mainly for movie soundtracks and classical music, to rerecord the piano part. Seated this time at a Steinway concert grand, he was under the impression that he was playing live with the others, who were holed up in Studio Two, but in fact Alan Parsons and the group had fooled him: "We put a little practical joke over on Rick, making him think the band were playing live when he was actually listening off tape, and when he looked up at the end of the song all of us were standing watching him from the [studio] door."[82] The next day, Roger Waters recorded a wonderful bass line that accompanies the piano throughout the piece, Wright recorded a new Hammond organ part, and David Gilmour worked on the track for the first time. His contribution consists of two extraordinary clear-toned pedal steel guitar parts played on his double-neck Fender 1000 in open-G6 tuning (D, G, D, G, B, E) with generous reverb added. Although this is a relatively short passage, as it is confined to the intro, Gilmour's guitar sound is one of the hallmarks of the piece. It possesses an expansive, emotional quality and also an irresistible power that paves the way for Clare Torry's stunning voice.

It was not until nearly three months later that Torry was called in to Abbey Road to take part in a session that would go down in Pink Floyd history. Although pleased with the piece at this stage, everyone felt that it was lacking a certain something. Alan Parsons tried to persuade the Floyd to use extracts of dialogue recorded during a NASA spacewalk, but this is not what they were looking for. According to David Gilmour, it was Roger Waters who suggested bringing in a singer. Parsons then told them about a female vocalist he knew: "They simply said, 'Who shall we get to sing this?' And I said, 'Well, I know a great singer…'"[36] That singer was Clare Torry: "She had done a covers album," he explains. "I can remember that she did a version of 'Light My Fire' [by the Doors—a cover she would later deny ever having done!]. I just thought she had a great voice."[89] Brought in on Sunday, January 21, Clare was not especially enthusiastic. She did not know Pink Floyd very well, and was not exactly a fan of their music. But it was a Sunday and she would get double the usual fee (£30 instead of £15). When she arrived at Abbey Road, the atmosphere was cool. "They didn't know what they wanted," she recalls, "just said it was a birth and death concept. I looked suitably baffled and just sang something off the top of my head."[36] It was mainly David Gilmour who took on the task of directing her, helped by Rick Wright. What they particularly wanted was for her to express emotion. Parsons remembers them saying: "'Sorry, we've got no words, no melody line, just a chord sequence—just see what you can do with it.'"[36] "I said 'Let me go into the studio, put some headphones on, and have a go,'" Torry continues. "I started going 'Ooh-aah, baby, baby—yeah, yeah.' They said, 'No, no. If we wanted that we'd have got Doris Troy.' They said, 'Try some longer notes,' and as this went on, I was getting more familiar with the backing track."[45] Torry still did not really understand what it was they were expecting of her, and even wondered whether the best course of action would be to leave. "That was when I thought, 'Maybe I should just pretend I'm an instrument.' So I said, 'Start the track again.'"[45] After the first take, Gilmour reassured her that she was getting closer to what they were

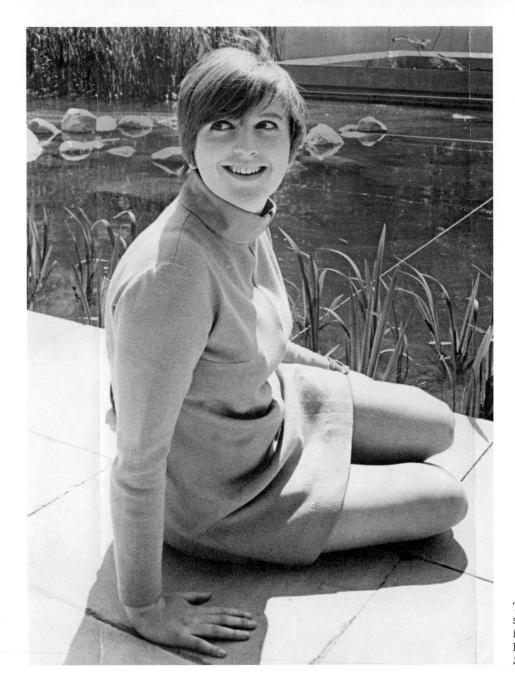

The singer Clare Torry, shown here in 1967. Her voice is one of the highlights of *The Dark Side of the Moon*.

looking for but that they wanted to try a second take with, if possible, even more emotion. Torry did not like what she was doing, finding her phrases repetitive: "It was beginning to sound contrived. I said: 'I think you've got enough.' I actually thought it sounded like caterwauling."[45] Rick Wright recalls that she seemed embarrassed upon joining them in the control room afterward but that her performance had sent shivers down his spine: "No words, just her wailing—but it's got something in it that's very seductive."[90] Torry nevertheless had the impression that everybody hated her performance, "and when I left I remember thinking to myself, 'That will never see the light of day.'"[82]

The ultimate version is a combination of two tracks performed by the singer, and represents one of the high points of the album, if not of the Floyd's entire output.

But the story of her performance does not end there. When she was passing a record store one day, Clare Torry spotted in the window an album featuring a prism and the name Pink Floyd on the cover. Wondering whether it could be the LP she had sung on, she went in and bought a copy. "I bought it and took it back home, and played it from the beginning. And I thought it was fantastic."[45]

Her collaboration with the group continued. She recorded with Roger Waters in 1987 and sang onstage with Pink Floyd in 1990. This would not prevent her from taking legal action against the group years later with the aim of gaining recognition for herself as co-composer of "The Great Gig in the Sky." The case was settled in 2005, since which time she has shared the composition credit with Rick Wright.

Roger Waters on his Fender Precision for one of the most famous riffs of the entire rock epic. Here he is playing his black model with white pickguard.

Money

Roger Waters / 6:23

Musicians
David Gilmour: vocals, electric rhythm and lead guitar
Rick Wright: keyboards
Roger Waters: bass, sound effects
Nick Mason: drums, sound effects
Dick Parry: tenor saxophone
Chris Adamson, Henry McCullough, Gerry O'Driscoll, Patricia Watts, Peter Watts: voices
Recorded
Abbey Road Studios, London: June 6–8, October 27, 30, November 2, 1972; January 21, 24, 29, February 6, 1973 (Studios Two and Three)
Technical Team
Producer: Pink Floyd
Sound Engineers: Alan Parsons, Chris Thomas
Assistant Sound Engineer: Peter James

The phrase *Money, so they say, is the root of all evil today* may be an allusion to the following passage in the New Testament (First Epistle of Saint Paul to Timothy, chapter 6, verse 10): "For the love of money is the root of all evil... "

Genesis

The second side of the LP *The Dark Side of the Moon* opens with "Money." David Gilmour recalls the day Roger turned up with the piece: "I've still got his demo of it lurking around somewhere, of him singing it with an acoustic guitar. It's very funny. And we did it pretty well the same as the demo, apart from the middle section with all the solos and stuff, which we wrote and put together in the studio or in rehearsal."[36] This demo can be heard on the DVD *The Making of The Dark Side of the Moon...*

New car, caviar, four-star daydream. Money makes everything possible, even owning a soccer club. In short, *Money, it's a gas.* Such is the message of the first few lines of "Money." Clearly the words to this song are to be understood as ironic, and the allusion to the football team is presumably a reference to the lyricist's well-known passion for that particular sport. With a strong feel for language that Bob Dylan or John Lennon would not have been ashamed of, Roger Waters denounces the unrestrained—and unrestrainable—power of money, of money as king, and the cynicism of those who have it, in short everything about the capitalist system that is unjust and appalling. "[I am] sure that the free market isn't the whole answer," Roger Waters would later reveal in an interview. "My hope is that mankind will evolve into a more cooperative and less competitive beast as the millennia pass. If he doesn't... [he will disappear] in a puff of smoke."[91] In the meantime, while waiting for the dawning of a new, humanitarian and fraternal, society, the songwriter lambasts all those who have elevated the consumer society to the rank of paramount social model—including exploiters of every hue, those in the *hi-fidelity first-class travelling set,* those who believe they *need a Learjet,* indeed all those who are disinclined to share what they have with others. There is something utterly irrevocable about the statement *I'm alright, Jack, keep your hands off my stack!*

A disturbing paradox is that it was thanks to this committed, resolutely anticapitalist song that Roger Waters joined the circle of superrich rock 'n' roll songwriters. Was his rock star status already making him experience a sense of guilt? This is not out of the question. In the last verse of "Money," at any rate, it is interesting to note that he abandons the

double entendre beloved of bluesmen and says exactly what he thinks, with no beating around the bush: *Money, it's a crime because it's the root of all evil today*. And he even addresses his closing line to those who work hard but are refused a pay raise.

The Single Effect

Although the album was a worldwide success, the global destiny of this title, originally a blues number very close to the heart of its creator, was simply astounding. Soon after the release of the album, Capitol Records in the US asked to release the song as a single. Rick Wright admits that nobody in the group had thought of this possibility or could possibly have imagined what would come of it. Selected as the A-side of a single (with "Any Colour You Like" as the flip side), "Money" was released in a number of countries (not the United Kingdom) in May 1973. It climbed the charts with lightning speed, beginning in France, where it reached number 1 that month. It got to number 13 on Billboard and number 10 in Austria. The success of this song would completely change the lives of all the members of the group, who saw themselves propelled into the ranks of international stars within a few weeks, experiencing everything that Waters denounces in his lyrics. Excess and adulation became a part of their everyday experience. "It moved us up into a super league,"[83] David Gilmour would later declare. The four of them were caught unawares. At concerts, fans started to demand "Money" and no longer observed the necessary

silence during the band's long instrumental pieces. The Floyd found themselves caught in a paradox situation of earning vast amounts of money with a song that denounces money's ill effects. Paranoia was lying in wait and would provide them with the subject of their next album, and then *The Wall*, leading eventually to the breakup of the group. *Money, so they say…*

"Money" became one of Pink Floyd's most-performed live numbers. Different versions can be enjoyed on *A Collection of Great Dance Songs* (1981), *Delicate Sound of Thunder* (1988), *Pulse* (1995), Roger Waters's *In the Flesh* (2000), and *Echoes: The Best of Pink Floyd* (2001).

The Return of the Questionnaire

In keeping with the process that loomed so large over the recording of *The Dark Side of the Moon*, in the coda to this song (from 5:55), various people can be heard giving their answers to Roger Waters's questions. Examples include Peter Watts: *Ha! Ha! I was in the right!*; Patricia Watts: *I was definitely in the right. That geezer was cruisin' for a bruisin'*; Gerry O'Driscoll: *Why does anyone do anything?*; Henry McCullough (guitarist with Paul McCartney's Wings): *I don't know, I was really drunk at the time!*; and the most garrulous of all, roadie Chris Adamson: *I was just telling him, he was in…he couldn't get into number two. He was asking why he wasn't coming up on freely eleven, so after, I yelling and screaming and telling him why he wasn't coming up on freely eleven…*

In the light of Capitol's refusal to license the song for inclusion on the album *A Collection of Great Dance Songs* (1981), "Money" was rerecorded, mainly by David Gilmour, although the differences are significant.

Production

Tearing paper (left)—uni-selector (right)—coins (right)—uni-selector (left)—coins on a string (right)—coins (left)—cash register (right): these are the sounds that make up the famous "Money" loop…Rarely has a sound clip consisting of some seven elements achieved such renown! The song begins with the sound of a cash register opening, out of which someone takes some change. The loop then begins and carries on playing until after the music has started. The idea came from Roger Waters, who was looking for the best way of illustrating in sound the lyrics he had written. "I had a two-track studio at home with a Revox recorder," he recalls. "[…] My first wife [Judy Trim] was a potter and she had a big industrial food mixer for mixing up clay. I threw handfuls of coins and wads of torn-up paper into it."[82] In the studio, however, this all had to be redone in order to improve the sound quality and precision. Alan Parsons remembers taking a whole day over this: "Each sound had its own loop which we had to measure, using a ruler, to keep in time."[82] Nick Mason contributed by drilling holes in coins and threading them onto a string: "They gave one sound on the loop of seven,"[5] he explains. Some of the sounds, including torn paper and coins thrown directly onto the studio floor, were recorded specially, while the uni-selector (a switching device used in telephony) and the cash register were taken from the EMI sound library.

The first session took place in Studio Two on June 6 and was devoted to making the "Money" loop. This was a complex procedure, not least because the various sounds were recorded not on quarter-inch tape, but on one-inch tape, with each of the different effects on a separate track. (It was originally thought that a quadraphonic version would be made.) The next day, this loop served as a click track from which the group took its timing, at least during the first few bars. The four members of Pink Floyd recorded a live take, each of them playing his instrument at the same time. Waters is on his Fender Precision, playing one of the most

famous riffs in the whole of rock music—in 7/4 time, pretty well unheard of on the rock scene! Wright is on his Wurlitzer, coloring his various solos with wah-wah pedal (right-hand channel), and Gilmour (according to Waters) is on his "Black Strat," playing a rhythm part with very pronounced tremolo (presumably using the Valley People Kepex or Hi-Fli processor), but it is more likely that he contributes a funky, slightly distorted rhythm guitar (in the left-hand channel) during this session. Finally, Mason lays down a superb groove for his bandmates on his Premier kit. Waters would quite rightly observe that "One of the ways you can tell that it was done live as a band is that the tempo changes so much from the beginning to the end. It speeds up fantastically."[82]

After the overdubbing of toms in the middle section (from 3:48) it was time for Gilmour's three different guitar solos. But information is lacking on the exact recording dates: the guitarist may have recorded one or all three during this same session or spread them out over the two subsequent sessions in October and November and the start of 1973. What is surely beyond dispute, however, is that they are some of the most successful of all his solos. The first begins at 3:05. Gilmour plays his "Black Strat" with Fuzz Face distortion, creating a floating sound similar to that on "Time," and further colored by the Binson Echorec and strong reverb. His playing is highly inspired and also extremely powerful, not least as a result of ADT doubling. At 3:48 he then moves into his second solo, this time very dry, without reverb or delay, which he plays on his Fender (in the left-hand channel). His phrases are short and edgy, and the tension is palpable. Mason and Waters support him with a very fast rhythm that is almost jazz-rock in feel. We then come to the third and last solo, recorded using the same effects as the first, with ample reverb, but this time played by Gilmour on his Lewis twenty-four-fret, on which higher notes can be reached than on the Strat. He double-tracks himself, and once again the results are outstanding. "I just wanted to make a dramatic effect with

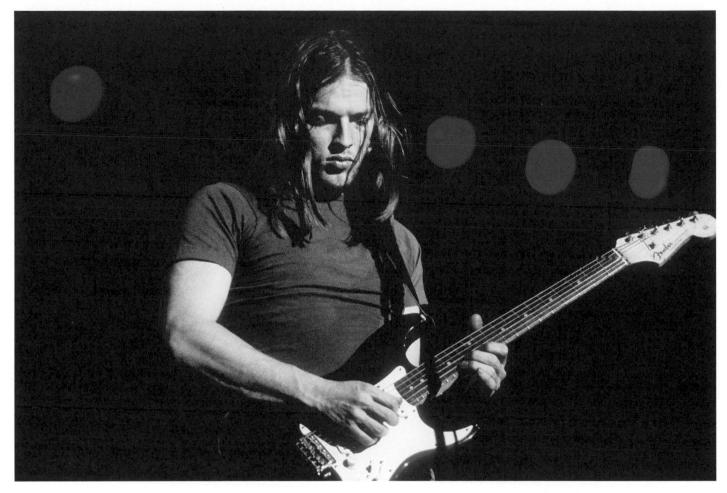

For "Money," David Gilmour recorded three different solos, two of them on his "Black Strat."

the three solos,"[29] Gilmour explains. He also reveals that it was from Elton John that he took the idea of alternating a reverb-drenched sound with a very dry sound.

Other guitar passages were also added, notably during the second solo, in which a second distorted rhythm guitar replaces Wright's Wurlitzer (on the right). Another guitar, this time clear-toned, doubles the bass in the two last lines of each verse (also on the right). Toward the end of the song, in the coda, Gilmour then improvises on guitar, singing scat-type answers to each of his guitar phrases (from 6:09). Chris Thomas would later claim to have contributed to the production of "Money," encouraging Gilmour to add numerous guitar parts, and it may well have been the engineer who came up with the inspired idea of getting Gilmour to double Waters's bass riff an octave higher in order to boost the impact of the riff and give it some extra bite.

On June 8, new Wurlitzer, piano, and drum overdubs were recorded. Glenn Povey reveals that the session

notes also list a trombone part as having been recorded that day. On October 27 Dick Parry came to the studio and recorded a superb saxophone part. David Gilmour explains this choice of instrumentalist: "Pink Floyd were so insular in some ways, thinking about it. We didn't know anyone; we really didn't know how to get hold of a sax player."[45] He therefore asked his old pal, who delivers a rhythm 'n' blues–style improvisation with an absolutely extraordinary rasping sonority. For a first, the solo is a triumph. It seems that in addition to "bathroom-style" reverb, the sound of Parry's instrument was also subjected to the same frequency translator used for the backing vocals on "Time."

Last but not least, "Money" also owes a large part of its success to David Gilmour's excellent voice with its rock timbre. He recorded this part in relatively few takes and double-tracks his singing, as he would start to do on a more regular basis from this point on.

"Us and Them" reveals the complex sensibility of Rick Wright, whose keyboard chords serve as a launch pad for David Gilmour's arpeggios.

Us And Them

Roger Waters, Richard Wright / 7:49

Musicians
David Gilmour: vocals, vocal harmonies, electric rhythm guitar
Rick Wright: keyboards, vocal harmonies
Roger Waters: bass
Nick Mason: drums
Dick Parry: tenor saxophone
Lesley Duncan, Doris Troy, Barry St. John, Liza Strike: backing vocals
Roger "The Hat" Manifold: voice

Recorded
Abbey Road Studios, London: June 1, 2, 16, 20, October 11–12, 16–17, 27, 1972; January 19, 30–31, February 2, 6, 1973 (Studios Two and Three, Room Four)

Technical Team
Producer: Pink Floyd
Sound Engineers: Alan Parsons, Chris Thomas
Assistant Sound Engineer: Peter James

For Pink Floyd Addicts

It was thanks to Doris Troy, who had released a single on Apple—the Beatles' label—in 1970 ("Ain't That Cute," produced by George Harrison), that Liza Strike and Barry St. John were given the opportunity to join her as backing vocalists on John Lennon's "Power to the People" in 1971.

Genesis

"Us and Them" was born out of the ashes, one might say, of "The Violence Sequence," a subtle, romantic melody on the piano that Rick Wright composed for the *Zabriskie Point* soundtrack. Rejected by Michelangelo Antonioni on the basis that it was "too sad" and made him think of church,[45] the piece resurfaced during *The Dark Side of the Moon* sessions. Rick Wright recalls playing it to the others in the studio one day and that they liked it. He remembers Waters then going into another room to start working on the lyrics.[83]

What the bassist came up with was a set of direct, linear lyrics about "those fundamental issues of whether or not the human race is capable of being humane."[83] He suggests an answer to his own question by setting the beginning of his tale in wartime, and specifically during the First World War with its catalog of horrors. "The first verse is about going to war, how in the front line we don't get much chance to communicate with each another, because someone else has decided that we shouldn't," explains Waters in an interview. "I was always taken with those stories of 'the First Christmas' in 1914, when [the soldiers] all wandered out into no-man's land, had a cigarette, shook hands and then carried on the next day."[82]

There is no hidden message behind the *Us and them*, the *Me and you*. The soldiers on both sides of the battlefield are *ordinary men*. They are fighting against their own will on the orders of the military hierarchy, which in turn obeys the government. Forward he cried, from the rear, and the front rank died...The songwriter is addressing all the little people, the minions, those who submit, victims of a deliberately destructive behavior, the simple pawns in a game of chess over which they have no control. The ultimate battle is one the general alone is waging, with little interest in those he is sending to the slaughterhouse.

In the second and third verses, Roger Waters widens his field of vision: "The second verse is about civil liberties, racism and colour prejudice. The last verse is about passing a tramp in the street and not helping."[82] Are we to make a connection between the war veteran and the beggar? One thing is grimly certain: lacking the

wherewithal to buy a cup of tea and something to drink, the old man dies.

At 5:05 we hear a short monologue from the roadie Roger "The Hat" Manifold, taken from a conversation led by Roger Waters, as the cards previously used for the questionnaire had by now been lost. In response to the question "When did you last hit someone?" Manifold tells the story of an altercation he had just had with a motorist who had unwisely opened the door of his vehicle at the moment the roadie was overtaking him. Faced with this display of arrogance, Roger "The Hat" lost his cool: *I mean, they're gonna kill ya, so like, if you give 'em a quick short, sharp, shock, they don't do it again, dig it? I mean he got off light, 'cos I could've given 'im a real thrashing—I only 'it 'im once! It was only a difference of opinion, but really...I mean good manners don't cost nothing, do they? Eh?*[40]

"Us and Them" is the longest song on *The Dark Side of the Moon*. It was chosen as the A-side of the second single to be taken from the album, but only reached numbers 72 and 85 in the US and Canada respectively. It can also be found on the live albums *Delicate Sound of Thunder* and *Pulse* as well as on the compilation *Echoes: The Best of Pink Floyd*.

Production

When the Floyd started work on Rick Wright's instrumental, the piece already possessed a clearly defined verse–chorus structure. However, the group's musical contributions would sublimate it into one of the album's totemic songs. Its working title was "Eclipse Part 3." After getting the base track down on June 1 and adding various guitar, keyboard, voice, and bass overdubs, Waters, Gilmour, Wright, and Mason then rerecorded it on June 16.

The track begins with wonderful pads played by Rick Wright on the Hammond RT-3 organ. Their warm sound is colored by a Leslie speaker. The group then joins him in a floating accompaniment, with David Gilmour playing arpeggios on his "Black Strat," presumably plugged into his Uni-Vibe, Nick Mason delivering a light, aqueous beat, and Roger Waters playing a bass line with a hypnotic rhythm. Waters would add more bass overdubs in October, including, most likely, the distorted bass in the refrains. Following the intro, Dick Parry enters with his first saxophone solo. His sound is soft and his phrasing redolent of Stan Getz, but in fact, Gilmour suggested that he could play like Gerry Mulligan on *Gandharva*, an album released in 1971 by the electronic–New Age duo Paul Beaver and Bernie

Dick Parry, whose saxophone sound, similar in some ways to
Stan Getz's, is a key aspect of "Us and Them."

Krause. The first session was held on October 16 and the second on October 27, the same day that Parry recorded his solo for "Money." When Gilmour launches into the first verse with his lead vocal, the intensity increases. Not only is his (double-tracked) voice sublime, the first and third syllables of each verse have an absolutely incredible echo. Alan Parsons would later explain that of all the effects on the album, this had been the most difficult to get right. In order to achieve it, the engineer required a remarkable degree of ingenuity. He used a modified eight-track 3M M23 to record the initial signal on every other track and then send it back to the console with the required delay. Needless to say the reality was far more complicated than this makes it sound, and one can only admire Parsons for

achieving this feat of technical wizardry! It is also interesting to note that combined with the floating, almost meditative mood of the piece, this emphatically spacey echo gives the notes a room to breathe that is worthy of Miles Davis. This is how the song is put together, Roger Waters would very aptly comment.[83]

The mood changes with the start of the first refrain. Gilmour ramps up the tension with distorted guitar passages, as does Waters on bass. Rick Wright harmonizes with Gilmour's vocal, and both are supported by the terrific backing vocals of Lesley Duncan, Doris Troy, Barry St. John, and Liza Strike, recorded on June 20. After the second refrain, Wright delivers a superb piano solo, presumably in conditions identical to those filmed by Adrian Maben for his

Doris Troy, discovered by James Brown at the beginning of the '60, sings backing vocals on "Us and Them."

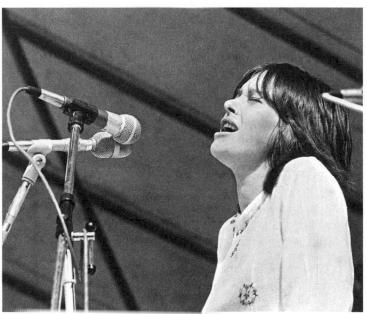

Lesley Duncan, who did a lot of work with Dusty Springfield, is also a backing singer on "Us and Them."

documentary *Pink Floyd: Live at Pompeii*. This solo is full of feeling and serves to demonstrate just how great a musician Rick Wright was. It is also over this passage that Roger "The Hat" Manifold adds a touch of both realism and surrealism to Waters's excellent lyrics (from 5:05). A second solo by Dick Parry follows, this one more tense and bluesy. After the final verse and refrain, "Us and Them" segues into "Any Colour You Like" by means of a cross-fade done on February 6.

This magnificent ballad combines the talents of Rick Wright and Roger Waters to marvelous effect and underlines the power of these four outstanding musicians. We should not forget the technical team, however, who helped to make "Us and Them" one of the highlights of the Floyd catalog.

COVERS

The Flaming Lips have recorded a highly successful version of "Us and Them." Also worth mentioning are versions by the German singer Nena (*Cover Me*, 2007), Mary Fahl (*From the Dark Side of the Moon*, 2011), and Gov't Mule (*Dark Side of the Mule*, 2014).

Any Colour You Like

David Gilmour, Nick Mason, Richard Wright / 3:26

<u>Musicians</u>
David Gilmour: electric rhythm and lead guitar, scat
Rick Wright: Minimoog, VCS3, organ
Roger Waters: bass
Nick Mason: drums
<u>Recorded</u>
Abbey Road Studios, London: June 17 and November 1, 1972;
January 31 and February 6, 1973 (Studio Two, Room Four)
<u>Technical Team</u>
Producer: Pink Floyd
Sound Engineers: Alan Parsons, Chris Thomas
Assistant Sound Engineer: Peter James

Genesis

"Any Colour You Like," credited to Gilmour-Mason-Wright, is an improvisation based on a dialogue between electric guitar and synthesizer. According to Nick Mason, the piece "really provides a touch of relief on a record so tightly arranged, contributing to the dynamic pacing, as a pause before 'Brain Damage.'"[5]

The title derives from an expression used by the roadie Chris Adamson, who, when asked for a guitar, would inevitably answer: "Choose any color you like, they're all blue." This touch of humor was probably inspired by the famous formula used by Henry Ford when launching the Model T Ford on the US market in 1908: "Any color he [the customer] wants as long as it's black." If this is the case, the song could be interpreted as a barely veiled criticism of capitalism, Henry Ford having not only created one of the most famous automobile brands of all time, but perhaps more significantly given his name to a labor model based on standardized mass production and the assembly line, a model denounced by some people as having transformed mankind into a machinelike slave of industrial "progress" (Fordism). Thus *Any colour you like* could also mean that the choice offered by society is no more than pure illusion, a non-choice in other words.

This explanation ties in with another given years later by Roger Waters. The bassist made a connection between the song and a traveling salesman he often used to come across during his youth in Cambridge, who, despite the limited choice of wares on offer, would invariably call out: "Whatever color you want," even if that color didn't exist; "[…] metaphorically, 'Any Colour You Like' is interesting, in that sense, because it denotes offering a choice where there is none."[92]

Other interpretations have also been suggested. Because it occurs between "Us and Them" and "Brain Damage," "Any Colour You Like" could be seen as signifying the relentless unfolding of war and the rejection of anyone remotely different as insane. Similarly, the psychedelic atmosphere of the piece (aided and abetted by David Gilmour's guitar) could perhaps be interpreted as evoking a trip under the influence of some hallucinogenic drug, thereby alluding indirectly to Syd Barrett, who had been such an influence on Waters, Gilmour, Wright, and Mason. Any explanation you like, the choice really is yours…

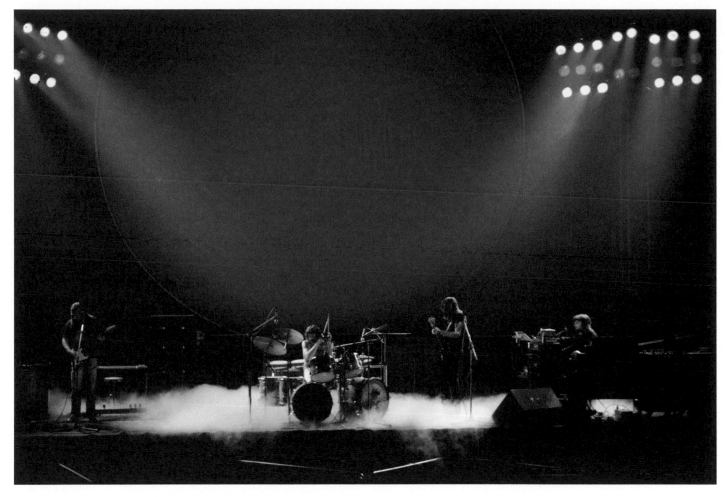

Pink Floyd in concert at the Palais des Sports in Paris in 1974. The magic of *Dark Side*.

Production

Rick Wright would later reveal that he had used the Minimoog for the very first time in the "Eclipse Scat Section," this being the working title of "Any Colour You Like." It is indeed the warm, resonant sound of this keyboard instrument that dominates the whole of the first section of the piece, with two superb Minimoog parts whose shifting sounds are reinforced by phenomenal echo from the Binson Echorec. The notes literally float out of the keyboard, and the effect is magnificent. Wright also plays a Hammond organ accompaniment that is difficult to discern other than at the end of the piece. Waters lays down an excellent groove on his Precision bass, supported by Nick Mason alternating snare drum and toms with metronomic regularity. Gilmour plays rhythm on his "Black Strat" with a lightly distorted sonority and also presumably colored by his Uni-Vibe. It is also possible, of course, that he uses his Hi-Fli processor to achieve this combination of effects. Constructed around the two chords of E-minor 7 and G, the instrumental shifts gears with Gilmour's solo intervention at 1:20. He plays with incredible feeling, bending his strings and also

modulating the notes with his whammy bar. Gilmour would later reveal that he took his inspiration from Eric Clapton in "Badge," in which the Cream guitarist uses a Leslie speaker to obtain his rich and swirling sonority. It is also after this particular passage that the working title "Eclipse Scat Section" is taken, for David Gilmour accompanies his solo with some scat singing. Although his voice is reasonably quiet, he can clearly be made out improvising in the style of George Benson, another famous guitarist who went in for this style of vocalization. Bass notes produced on the VCS3 are also heard throughout this section (from 1:45). Toward the end, the piece undergoes a final key change, creating a harmonic break that announces the following song, "Brain Damage."

Roger Waters would later comment on the joint composition credits for "Any Colour You Like." Although he is not among those credited, he explains that "'Breathe' and 'Any Colour You Like' are grey areas and so is 'Time,' because it was close to a real collaboration of all four members. [...]"[82] He goes on to explain that the group regarded itself as highly egalitarian at the time. "I gave away a lot of the publishing and I wish I hadn't."[82]

Brain Damage

Roger Waters / 3:47

Musicians
David Gilmour: electric rhythm and lead guitar
Rick Wright: keyboards
Roger Waters: vocals, vocal harmonies, bass
Nick Mason: drums
Doris Troy, Lesley Duncan, Liza Strike,
Barry St. John: backing vocals
Unidentified Musicians: tubular bells
Peter Watts: voice

Recorded
Abbey Road Studios, London: June 2–3, 6, 20, October
11–12, 17, November 2–3, 1972; February 1 and 9, 1973

Technical Team
Producer: Pink Floyd
Sound Engineers: Alan Parsons, Chris Thomas
Assistant Sound Engineer: Peter James

For Pink Floyd Addicts

The 2003 SACD 5.1 "surround sound" version of *The Dark Side of the Moon* led to the rediscovery of instruments that had been completely "buried" in the original mix. Notably the tubular bells, which were present in the "Brain Damage" instrumentation and are redis- covered in the documentary about the making of the new mix.

Genesis

Roger Waters wrote the words and music to this song while Pink Floyd was in the closing stages of recording *Meddle*. At that time the songwriter named it…"The Dark Side of the Moon," and it was under this title that the band performed the song within the framework of the concept *Eclipse: A Piece for Assorted Lunatics*. In an interview from March 1998, the bassist explains that for him the grass referred to in the first line (*The lunatic is on the grass*) evokes the "square in between the River Cam and Kings College chapel,"[82] a place he used to go to as a young adolescent growing up in Cambridge.

This lunatic on the grass can only be Syd Barrett, who continued to haunt the group for years after he and it pain- fully parted ways. This is revealed by the phrases *And if the dam breaks open many years too soon…And if your head explodes with dark forebodings too*. Furthermore, the first verse is an evocation of the friends' Cambridge childhood, which was for Waters and Barrett, and Gilmour too, a time of untroubled pleasures and dreams inspired by their reading of heroic fantasy literature: *The lunatic is on the grass/Remembering games and daisy chains and laughs*. Another pointer is that Barrett has influenced Waters to such an extent that he would remain forever inside him, no doubt serving him, symbolically at least, as some kind of guide: *The lunatic is in my head…You rear- range me 'til I'm sane*.

In the second verse, however, it is not just Syd Barrett who haunts Roger Waters's mind, for here the bassist speaks of lunatics in the plural. *The paper holds their folded faces to the floor*. Are we to understand here that all famous peo- ple, those who make the front pages—politicians, pop stars, and more—are insane? Here too it might be possible to haz- ard an interpretation. *There's someone in my head but it's not me*, sings Waters. Has he gone to join his former friend in insanity? The *dark side of the moon* is by definition something that other people cannot see (not immediately, at any rate), something that is hidden, although certainly exists. In other words, madness. Roger Waters explains: "The line 'I'll see you on the dark side of the moon' is me speaking to the listener, saying 'I know you have these bad feelings and impulses, because I do too; and one of the ways

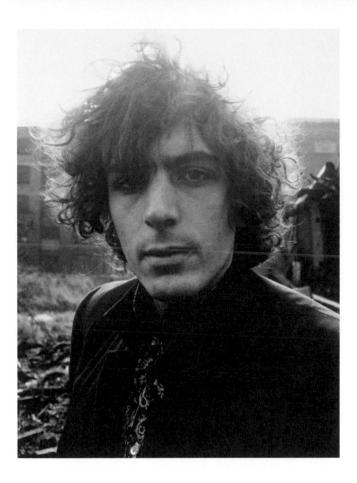

"Brain Damage," a composition by Roger Waters that alludes to Syd Barrett: *The lunatic is on the grass...*

I can make direct contact with you is to share the fact that I feel bad sometimes.'"[36]

Roger Waters is also, in a sense, reconnecting with the ancient belief that the moon could influence our mental state (not to mention the myths of human beings who metamorphose into werewolves or vampires during a full moon). Indeed the very term *lunatic* is derived from the Latin for moon.

Production

"Brain Damage" is a song that every self-respecting would-be guitarist felt compelled to learn when this LP came out. The two chords in the introduction (E and G7), which are relatively easy to play, offered even beginners—for whom the Pink Floyd repertoire was reputed to be difficult—a point of entry into the band's music. This apparent simplicity is also the key to the song's impact, and no doubt helped to get the album known all over the planet.

The making of this track is interlinked with that of "Eclipse," the last title on side one of the vinyl edition, because one segues into the other without any editing, unlike all the other titles on *Dark Side*.

Although the first session dedicated to this piece took place on June 2, the base track was not laid down until the next day, under the title "Eclipse Parts 5 & 6" ("Brain Damage" and "Eclipse"). It was the fifth take that was marked best. Roger Waters sings lead vocal for the first time on the album and is also responsible for the vocal harmonies.

David Gilmour recalls the songwriter's nervousness: "He'd rarely sung leads before and he was very shy about his voice. I encouraged him. On occasions, he would try to persuade me to sing for him and I wouldn't."[82] Waters is nevertheless a very good singer, different from Gilmour and Wright in that he is focused far more on the message than on the interpretation.

The piece opens with two "Black Strat" parts on opposite sides of the stereo field, each one arpeggiated and with a sound colored by a Leslie speaker. Gilmour also plays short solo phrases on his Bill Lewis, which enabled him to reach up higher than on his Strat (as can be seen in the documentary *Pink Floyd: Live at Pompeii*). For these he adopts a clear tone with reverb and delay. In October and November, Gilmour rerecorded his guitars, and Waters also recorded a new and very good bass line in October. At this stage the piece was renamed "Lunatic Song." From the first refrain, the texture is enriched by Rick Wright's Hammond organ, but also by the superb backing vocals of Doris Troy, Lesley Duncan, Liza Strike, and Barry St. John, who recorded their vocals on June 20. A Minimoog solo begins after the second refrain and is harmonized on a second track. The voice of Pink Floyd road manager Peter Watts, father of the actress Naomi Watts, can be heard at three points in the piece: firstly emitting a resounding laugh at 1:52, then uttering the phrase *I can't think of anything to say, ha ha ha!* at 3:20, and finally, just before the song transitions into "Eclipse," saying the words *I think it's nice, ha ha ha!*

Eclipse

Roger Waters / 2:13

Musicians
David Gilmour: electric rhythm and lead guitar, vocal harmonies (?)
Rick Wright: keyboards
Roger Waters: vocals, vocal harmonies (?), bass, sound effects
Nick Mason: drums, sound effects
Doris Troy, Lesley Duncan, Liza Strike, Barry St. John: backing vocals
Gerry O'Driscoll: voice

Recorded
Abbey Road Studios, London: June 3, 6, 20, October 11–12, 1972; February 1, 1973 (Studios Two and Three)

Technical Team
Producer: Pink Floyd
Sound Engineers: Alan Parsons, Chris Thomas
Assistant Sound Engineer: Peter James

 IN YOUR HEADPHONES

At the end of the song, from 1:38, just after Gerry O'Driscoll's voice starts up, an instrumental and orchestral version of the Beatles' "Ticket to Ride" can clearly be heard (when the volume is turned up!). It has been suggested that this music was playing in the background during O'Driscoll's interview, but the real explanation is probably a badly erased master or a technical error that occurred during the cutting of the disc.

Genesis

In a 1998 interview, Roger Waters reveals that he added this song after already leaving on tour. "It felt as if the piece needed an ending […]. In a strange way it re-attaches me to my adolescence, the dreams of youth. The lyric points back to what I was attempting to say at the beginning. It's a recitation of the ideas that preceded it saying, 'There you are, that's all there is to it.'"[82] Hence this long invocation (in reality lasting a mere two minutes) into which all the feelings and actions of a lifetime are concentrated: *All that you touch/And all that you see/All that you taste/All that you feel…*the words of "Eclipse" are the final words in a modern tragedy. They sound like the ultimate response to "Breathe" at the beginning of the album: *And all you touch and all you see/Is all your life will ever be.*

The spiritual, or even mystical, dimension is writ large here. A comparison suggests itself with the Book of Ecclesiastes, in which it is written: "To every thing there is a season, and a time to every purpose under heaven: A time to be born, and a time to die, a time to plant, and a time to pluck up that which is planted; A time to kill, and a time to heal, a time to break down, and a time to build up; A time to weep, and a time to laugh, a time to mourn, and a time to dance […]" (chapter 3, verses 1–4). Better still, Roger Waters himself is transformed into an ecclesiast, in other words a preacher, one who addresses the crowd, exposing and denouncing the absurdity of life given that every human being under the sun is destined one day to die, the futility of life if it really does end with the last breath we take.

Roger Waters purports to be a lucid thinker, and his perception of the world is severe and harrowing—just like life itself. In "Breathe," the sun is forgotten; in "Time," we race to catch up with it (before it sinks). In "Eclipse," the curtain finally falls: *And everything under the sun is in tune/But the sun is eclipsed by the moon*, the song concludes. The sun could therefore be seen as a metaphor for the nonexistence of a god as the grand orchestrator of the cosmic order. This interpretation is supported by the general lack of hope in the philosophy of the songwriter, who, in *The Dark Side of the Moon*, has invented a form of poetic realism in music. Unless…it is worth remembering that "Eclipse" ends with a

heartbeat, just as "Speak to Me" started. Plenty of food for thought here!

Production

Although announced on the album with a duration of 2:13, "Eclipse" is actually one of the shortest numbers on *Dark Side*, the song itself lasting just 1:30. The difference is accounted for by the forty-plus seconds reserved at the end for the beating heart and Gerry O'Driscoll's voice.

"The last track, 'Eclipse,' was a piece that had benefited enormously from live performance prior to recording,"[5] explains Nick Mason. The Floyd used it to conclude their live performances of *The Dark Side of the Moon*, but had not really found a way to transform it into a finale with the necessary energy and brio. It was in the studio that they would achieve this, coming up with the verve that had been missing. The base track was recorded, along with that of "Brain Damage," under the title "Eclipse Parts 5 & 6," on June 3. With various overdubs added on June 6, backing vocals on June 20, organ on October 11, and bass on October 12, "End," the new working title of "Eclipse," now possessed the power and panache that it had lacked in concert.

Roger Waters keeps the momentum going, and following on from "Brain Damage," delivers an excellent lead vocal, with David Gilmour most probably helping out on vocal harmonies. The four musicians are working in perfect symbiosis, Mason and Waters insistently pressing the rhythm, Wright making his Hammond organ roar, and Gilmour playing arpeggios on his "Black Strat" (colored by a Leslie speaker and almost certainly doubled) as well as solo passages most probably on his Lewis (with Fuzz Face distortion). But "Eclipse" would not have the impact it does without the incredible backing vocals of Doris Troy, Lesley Duncan, Liza Strike, and Barry St. John. Here, the main honors go to Doris Troy for her lesson in gospel that sets the piece on fire. Waters explains that "When Doris Troy did her wailing on 'Eclipse,' we knew it was the climactic ending we wanted. She did two passes and it was incredible. We knew we had the album in the bag."[64] After her performance, she went to see Waters and told him, no doubt with a glint in her eye: "I'm only going to charge you a hundred pounds for my thing on the end."[82]

"Eclipse" closes on a chord of E major before giving way to the same beating heart that can be heard on "Speak to Me" and from 1:37 to the final phrase spoken by the inimitable Gerry O'Driscoll by way of closing metaphor and conclusion: *There is no dark side of the moon, really. As a matter of fact it's all dark.* In reality, O'Driscoll's monologue continues: *And the thing that makes it look alight is the sun.* It is not difficult to see why Waters would not have wanted to include this last phrase on the LP, its message sounding altogether too positive to suit the concept of the album.

WISH YOU WERE HERE

ALBUM

WISH YOU WERE HERE

RELEASE DATE

United Kingdom: September 12, 1975 (September 15 according to some sources)

Label: Harvest Records
Record number: SHVL 814

Number 1 (United Kingdom), 104 weeks on the charts
Number 1 (France, United States, Netherlands)

Shine On You Crazy Diamond (Parts 1-5) /
Welcome To The Machine / Have A Cigar / Wish You Were Here /
Shine On You Crazy Diamond (Parts 6-9)

For Pink Floyd Addicts

Wish You Were Here is also the title of an album by Badfinger, produced by Chris Thomas and released in 1974, as well as being the name of a musical comedy by Arthur Kober, Joshua Logan, and Harold Rome, which debuted on Broadway in 1952.

Wish You Were Here, in the Shadow of Syd

The Dark Side of the Moon marked Pink Floyd's entry into the elite club of record industry superstars, along with the Rolling Stones, Led Zeppelin, and the Who, that were still active on the music scene. This was borne out by the 700,000 copies sold in the United Kingdom alone in the weeks following its release, as well as the sellout gigs, from the two shows at Earls Court Exhibition Hall in London in May 1973 (May 18 and 19) to the US tour from June 17 to 28, and the following year, the French tour (June 18 to 26), sponsored by a well-known soft drink brand (Gini).

A Time of Doubt

The financial rewards that accompanied this success were considerable. David Gilmour and Nick Mason each bought themselves a mansion in London, in Notting Hill and Highgate respectively, as well as a villa in the South of France (Gilmour) and on the island of Rhodes, Greece (Mason). Rick Wright, too, treated himself to a property on Rhodes, but also acquired a country house called the Old Rectory in Royston near Cambridge, where he had a recording studio installed. Roger Waters, meanwhile, spent a fortune on a fabulous villa in Volos, at the foot of Mount Pelion in Thessaly (Greece). "I have to accept, at that point, I became a capitalist," he acknowledges, not without humor, many years later. "I could no longer pretend that I was a true Socialist."[1] The group also founded its own publishing company, Pink Floyd Music Publishing, and discovered along the way that, over the last

three years, EMI had failed to collect a substantial sum of money from abroad!

The money, which from then on flowed freely, enabling them to realize their "wildest teenage dreams,"[102] also sowed the seeds of discontent within the Pink Floyd machine, which had been well-oiled up to that point. Nick Mason embarked on some projects of his own, producing the Principal Edwards album *Round One* (1974) and, notably, *Rock Bottom* (1974), a masterpiece of progressive rock by Robert Wyatt (former vocalist and drummer of Soft Machine), while David Gilmour, after producing for the group Unicorn, was poised to launch the career of the sixteen-year-old singer and composer Kate Bush. "We were at a watershed then, and we could easily have split up then. And we didn't, because we were frightened of the great out there," Roger Waters explains, "beyond the umbrella of this trade name—Pink Floyd,"[102] adding, "from my perspective now, to look back upon how I felt then, scared as I was of my own shadow, you know, never mind my relationship with audiences…"[102] There was probably also the worry of wanting to produce a worthy successor to the already legendary *The Dark Side of the Moon*.

Household Objects, the Comeback/ Orphans of the Moon

In their quest for this worthy successor, Pink Floyd decided in 1973 to revive their album project based entirely on everyday objects. They had attempted to get it off the ground in

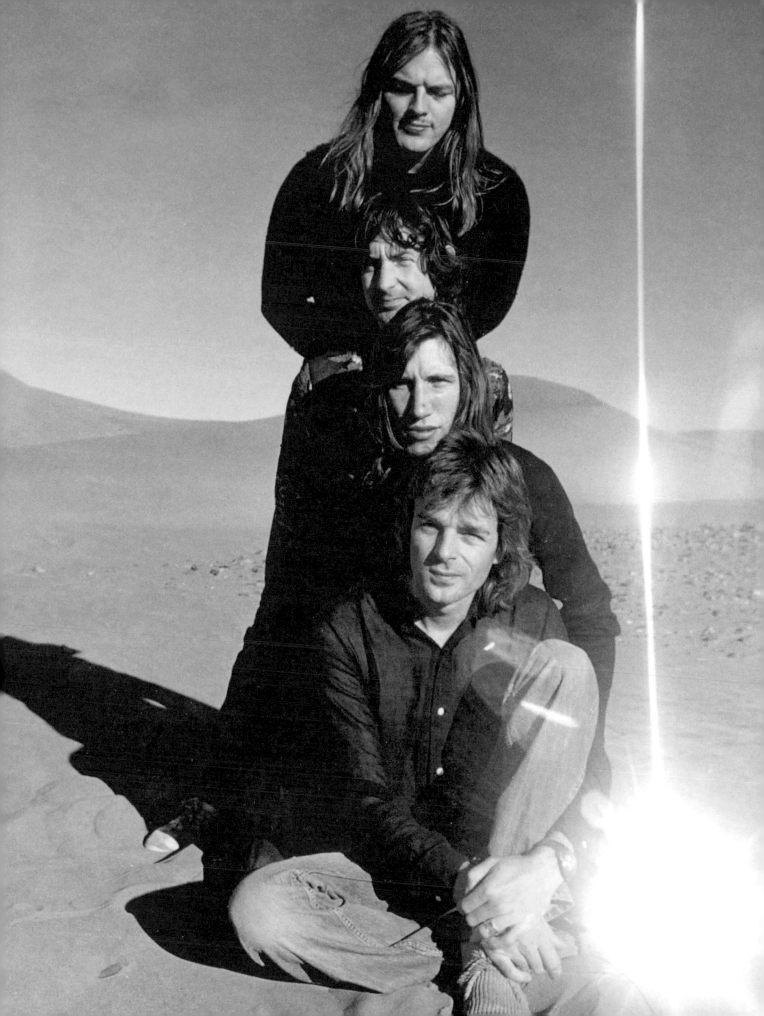

The rock critic Nick Kent. His vitriolic article in *NME* gave the band something to think about.

1971, at the start of the *Meddle* sessions, but without success. In October 1973, David Gilmour told *Sounds* magazine, "I think, strategically, our best thing to do next would be something weird, far out, and the kind of thing that nobody could possibly understand."[9] It was during that October and early November that the group tried to record several tracks in Studio Two at Abbey Road, including "The Hard Way" and "Papa Was a Rolling Floyd" (!), with Alan Parsons and Peter James at the mixing desk. There was no shortage of ideas: drinking glasses, knives, rolls of Scotch tape, the sound of footsteps, and bottles, among other things, were going to form the basis for what they hoped would be an all-new musical approach. Nick Mason was confident: "I think it will happen one day, because most of the ideas we've tried seem to work really very well so far."[9] Unfortunately, the group soon reached the limits of the project and gave up on it, for good this time, although "Wine Glasses" would later put in an appearance on "Shine On You Crazy Diamond." This impasse was to take Floyd to the brink of breakup: "Group momentum was pretty well non-existent," Nick Mason confided. "The early days of total commitment were beginning to dissipate."[5] Rick Wright then came up with the idea that each member of the band should spend six months of the year on personal projects, and the other six touring or recording with the Floyd. "Then there's no reason why we can't carry on for a long time."[9]

Back Down to Earth with the New Album...

At the end of 1974, the band seemed to have run out of steam. Commenting on their onstage performance, Nick Kent wrote in November 1974 in the columns of *NME*: "The Floyd in fact seem so incredibly tired and seemingly bereft of true creative ideas one wonders if they really care about their music anymore. [...] I mean, one can easily envisage a Floyd concert in the future consisting of the band simply wandering on stage, setting all their tapes into action, putting their instruments on remote control and then walking off behind the amps in order to talk about football or play billiards. I'd almost prefer to see them do that. At least it would be honest."[95] Although this vitriolic article by the legendary rock critic appeared several months after Waters, Gilmour, Wright, and Mason had abandoned the *Household Objects* project for good and laid the foundations of their new album in the course of several rehearsals at the King's Cross studio (January 1974), it would nevertheless play a part in bringing them down from cloud nine. "That review [by Kent] would have been one of the things which would have—once we'd got over our initial ire—we would have taken on board and realized that there was more than a germ of truth in it,"[102] David Gilmour admitted.

In January 1975, the four band members met at Abbey Road (in Studio Three, which had been completely refurbished) for the recording of what would become their ninth studio album. Roger Waters originally wanted to make a new concept album with, as its musical backbone, a suite entitled "Shine On You Crazy Diamond," a striking four-note phrase that Gilmour had hit upon, and a long poem by Waters about the absence of Syd Barrett. The theme itself was supposed to act as a kind of therapy, exposing everything that wasn't working within the band, in the hope of finding a lasting solution and setting the band back on the right track. But Gilmour was opposed to this artistic approach. He was keen to have side one of the new LP consist of the whole of "Shine On You Crazy Diamond," like the title song on *Atom Heart Mother* or "Echoes" on *Meddle*, and, on side two, to have two compositions the band had worked on at the King's Cross sessions, "Raving and Drooling" and "Gotta Be Crazy." "I had a legendary row with the rest of the band," he recalled in an interview in 1994. "After *Dark Side* we were really floundering around. I wanted to make the next

Roger Waters onstage at Knebworth Festival on July 5, 1975. The *Wish You Were Here* sessions were drawing to a close.

album more musical, because I felt some of these tracks had been just vehicles for the words. We were working in 1974 in this horrible little rehearsal room in King's Cross without windows, putting together what became the next two albums. There were three long tracks, including 'Shine On You Crazy Diamond,' which I wanted to record."[39]

After some fraught discussions, the guitarist-vocalist finally came around to Roger Waters's way of thinking, and in the meantime Rick Wright and Nick Mason had also been convinced. So "Shine On You Crazy Diamond" would be split into two parts, one at the beginning and one at the end of the album, which would also feature some new tracks. "There's one song that's about Syd, but the rest of it isn't. It's a much more universal expression of my feelings about absence. Because I felt that we weren't really there. We were very absent,"[102] Waters confessed. The other theme that emerges is the London foursome's total disillusionment with the record industry, which finds expression in "Welcome to the Machine" and "Have a Cigar."

Wish You Were Here really brought to a head the rift that was undoubtedly brewing within the group, as Waters explained: "I know that Dave and Rick, for example, don't think that the subject matter or theme of the record and the ideas developed are as important as I think they are. They're more interested in music, as abstract form as much as anything else."[9] It was this irreconcilable difference that would eventually lead to the breakup of the band.

The First Album with Columbia

Wish You Were Here came out on September 12, 1975, in the United Kingdom and continental Europe, and the following day in the United States. Stateside the album was distributed not by Capitol but by Columbia (in preference to Warner and Atlantic), after a contract was signed at the end of 1972 at the initiative of manager Steve O'Rourke. He would have

had no trouble convincing Columbia Records president Clive Davis, but the decision was a great disappointment to Bhaskar Menon, head of Capitol, who nevertheless managed to retain rights to *The Dark Side of the Moon.*

The new opus from the Floyd was a resounding success worldwide. It went to number 1 in the United Kingdom (spending 104 weeks on the charts and being certified double platinum), in the United States (six million copies sold, certified six times platinum), in Australia (seven times platinum), and in the Netherlands. In France it sold a million copies (diamond disc), twice as many as in Germany, and three times as many as in Canada. As for the critics, while some turned up their noses, such as Allan Jones of *Melody Maker*, who spoke of "a critical lack of imagination,"[96] a great many more were completely won over by this new record. "Where *The Dark Side Of The Moon* seemed flatulent, morose, aimless, positively numbskull, *Wish You Were Here* is concise, highly melodic and in a pleasingly simple fashion,"[97] wrote Peter Erskine in the columns of *NME*. In the United States, Robert Christgau noted in the *Village Voice*: "The music is not only simple and attractive, with the synthesizer used mostly for texture and the guitar breaks for comment, but it actually achieves some of the symphonic dignity (and cross-referencing) that *The Dark Side of the Moon* simulated so ponderously."[98]

The Sleeve

The sleeve for *Wish You Were* Here has legendary status among rock album covers. It was also one of the most complex ever produced by Hipgnosis. Having discussed it at length with the four band members and listened to "Shine On You Crazy Diamond," Storm Thorgerson set to work on the theme of absence, with the formidable challenge of coming up with something as good as—or even better than—the visual for *The Dark Side of the Moon*, yet different

from it. "It seemed therefore appropriate that, in the end, the cover should be absent," explained Thorgerson. "This is the end piece of the puzzle."[102] In his remarkable book, he writes: "But how do you represent absence? Especially with a presence, ie the presence of a design. We couldn't do a blank cover because the Beatles had done that with the *White Album*. Instead we devised a hidden cover. LPs in those days were often 'shrink' wrapped in clear, thin plastic, like cellophane, same as many CDs today. We suggested it was made black and opaque so the public could not see what was inside."[65] A sticker (designed by George Hardie) was affixed to the black plastic wrapper featuring two mechanical hands engaged in a handshake against a background of the four elements, as it was feared that, without this, the factory wouldn't pack the record properly. "I got very preoccupied with four, with the number four," Thorgerson explained in *The Story of Wish You Were Here*. "There were four words in the title, four members of the band, and four elements to life—air, fire, water and earth. So the first thing that was done was a postcard. The postcard said 'Wish you were here.'"[102] It's the same photo as on the inner sleeve—of a diver in a lake or a swimmer doing a headstand in the water—a photo that is all the more extraordinary as there are no ripples radiating out from him. The photo was taken by Aubrey Powell at Mono Lake in the Sierra Nevada, south of Death Valley in California. "The guy is doing a yoga position in a yoga chair locked into the mud," explains Powell. "Poor man, with a breathing apparatus on. And he had to hold his breath so I didn't get any bubbles."[102] The other photograph on the inner sleeve shows a windswept grove (in Norfolk) with, in the foreground, a red veil behind which one can make out the dark silhouette of a woman.

The cover photo is more enigmatic still: we see two men shaking hands, and the man on the right is on fire. A highly symbolic image: the burning man is the person conspicuous by his burning absence, or, if you prefer, the person whose shadow still hung over Waters, Gilmour, Wright, and Mason—Syd Barrett, of course (who incidentally was the composer of "Flaming" on *The Piper at the Gates of Dawn*). Storm Thorgerson thought it was a brilliant idea, "maybe because it was so outrageous."[102] The photo shoot took place in a studio lot at Warner Bros. studios in Burbank, California, with two stuntmen, Danny Rogers and Ronnie Rondell, the latter in the role of the burning man. "I was doing a lot of fire work in those days," Ronnie Rondell commented. "I had the special suits for full envelop fire. [...] The effects man will step out and he's got a wand with a fire on the end of it. And they go: 'We're ready, action,' and he just touches the three or four spots, steps out, everything is burning, and it's a still picture. Shaking hands. Nothing to it."[102] In fact, that's not quite the case. Aubrey Powell had to take at least fifteen shots because the wind kicked up in the Los Angeles region, eventually causing the fire to whip around Rondell's face. "He fell to the ground, absolutely smothered with foam and blankets," Powell recalls. "He got up and he said 'That's it, no more.'"[102]

On the back of the sleeve, a man dressed in a business suit is standing in the desert with a record in his hand, and one foot resting on a briefcase. On closer inspection, it becomes apparent that this man has no face, wrists, or ankles. It's a suit without a body that, in a way, is looking at us. Storm Thorgerson later spelled out the meaning of this mysterious image: "Our Floyd salesman is morally absent, lacks integrity, not really who he thinks he is, and is therefore absent, no face, faceless."[65] A dig at the record industry…

The Recording

While the birth of *Wish You Were Here* can be traced back to the King's Cross studio sessions in January 1974, during which the four musicians worked on "Shine On You Crazy Diamond," as well as "Raving and Drooling" and "Gotta Be Crazy," the sessions proper for the album got under way a year later, running from January 13 to March 3, 1975, in Abbey Road Studio Three.

Alan Parsons, who had a big hand in the success of *The Dark Side of the Moon*, naturally came to mind. "They offered me £10,000 a year to become their permanent sound engineer," said Parsons. "But I also wanted a royalty on the next album, and Steve O'Rourke said no."[1]

While Parsons launched himself into a career as an author-composer, setting up the Alan Parsons Project with producer, pianist, and vocalist Eric Woolfson (the album *Tales of Mystery and Imagination* would come out in 1976), Pink Floyd's choice fell on Brian Humphries, whose credits included having recorded the *Ummagumma* live record and

Lake Mono, in California, the location
for the famous sleeve photo.

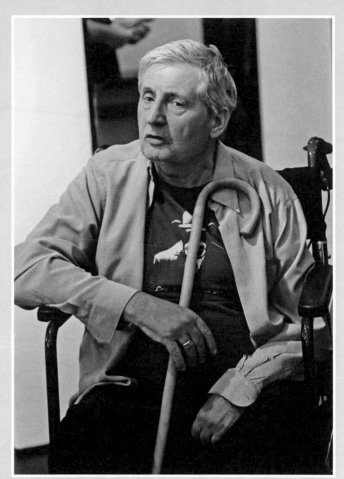

The brilliant designer Storm Thorgerson,
here in 2011.

Music from the Body by Roger Waters. He was brought on board initially to fill the gap left by the defection of their concert sound engineer: "I was asked to record the Floyd at the Empire Pool, which is now the Wembley Arena," explains Brian Humphries. "When I saw the Floyd before they went on, they said: 'Oh, do us a favour. Will you go and sit with our sound engineer?' And I said 'OK.'"[102] Humphries eventually took over from him and was in charge for the last three concerts at Wembley (from November 15 to 17, 1974). Then he was officially hired to record the next album. "Usually EMI does not allow outside engineers to work at Abbey Road," he later said, "but for the Floyd, they waived the ruling and I was allowed to work on the board."[101] Nevertheless it was John Leckie, who had worked on *Meddle* in 1971, who had the job of recording the first four sessions for the album (from January 13 to 16), assisted by Peter James. They were surprised to see Brian Humphries turn up on January 14 as an assistant. Three days later, Leckie handed it over to Humphries, and left to work on the next Roy Harper album.

A Difficult Labor

Wish You Were Here ended up taking some seventy sessions (mixing, cross-fades, and editing of various kinds), a record for the Floyd. "Shine On You Crazy Diamond" accounted for nearly fifty, while "Have a Cigar" alone needed fifty-six takes, an unprecedented feat by the band. These figures speak for themselves: Waters, Gilmour, Wright, and Mason certainly lacked concentration, if not inspiration. However, the finished product does not feel ponderous; indeed, the music is radiant. *Wish You Were Here* is David Gilmour and Rick Wright's favorite Pink Floyd album. Waters responded in a more nuanced fashion when asked by a journalist whether he was happy with it: "No. [But] I'm not unhappy with it. It's not bad."[9]

From January until the beginning of March, Pink Floyd spent four days a week recording at Abbey Road. But they were struggling, and couldn't seem to regain the creative energy of *Dark Side*. The unexpected and phenomenal success of their last album and the massive impact of their newfound glory literally numbed them. "Finding ourselves shut up in Abbey Road Studio Three felt like a real constraint," Waters relates. "Most of us didn't wish we were there at all; we wished we were somewhere else. I wasn't happy being there because I got the feeling we weren't together."[45] Humphries remembers that there were days when "[they] didn't do anything. They were thinking about ideas. It became a case of two would be in the studio, and two were running late. Or, as it was always known, they were out playing squash."[102] Rick Wright attributed this apathy partly to getting started too late. "It'll be a two-year gap between *Dark*

David Gilmour's famous "Black Strat," probably one of his finest guitars.

Side and the next one, and that's too long in my opinion,"[9] he declared during production.

Despite everything, they finally knuckled down to the task and in the end filled most of the twenty-four tracks of the Studer A80 in Studio Three. Nick Mason admitted to being somewhat discomfited by the new recording techniques: "The separation of each drum onto a different track meant it took even longer to get a result. This was part and parcel of general improvements in studio technology, but did nothing to help the sense that we were not a band playing together."[5] The harmony that had prevailed during the creation of *Dark Side* was no more. There was a change in the group dynamics. Waters slowly started to gain ascendancy over his colleagues. According to Humphries, Wright forced himself to stay in the studio to ensure he was credited on the record, even though he didn't agree with the approach that Waters was imposing on them, an attitude that got on David Gilmour's nerves. Conversely, when Wright was recording his keyboard overdubs, the other three would go out of the studio and leave him alone with the sound engineer. "Working in that atmosphere wasn't easy," [99] Humphries later said.

Intervening Tours

The London sessions were interrupted by an American tour, in which Brian Humphries participated. The first leg of this tour started at the Pacific National Exhibition Coliseum in Vancouver (Canada) on April 8, 1975, and ended on April 27 with a sixth show in the Los Angeles Memorial Sports Arena. The sessions resumed on May 5, and continued until June 5 (the day of the astonishing encounter between the members of Pink Floyd and an unrecognizable Syd Barrett). The band continued recording, spurred on mainly by Waters's energy, as Brian Humphries testifies: "I think of Roger actually being Pink Floyd, as much as I regard and respect the other three. He's really in control of the studio part of the group. After all, he does write all the songs."[9]

The second leg of the American tour took place between June 7 (Atlanta Stadium) and 28 (Ivor Wynne Stadium in Hamilton, Canada). Then, on July 5, the Floyd was on the bill at the big Knebworth Park rock festival, playing alongside the Steve Miller Band, Captain Beefheart, Roy Harper (and Trigger), Linda Lewis, and Graham Chapman. Finally, the last takes and the mixing were completed between July 7 and 28. This final stage, according to Brian Humphries, went better than for *Dark Side*, where the Floyd had had to call on Chris Thomas as an independent ear—and additionally, as a referee. In Humphries's words: "There are very few musical differences within the group framework. Insofar as mixing goes, there's never any bickering or anything of that sort. They all usually agree quite easily."[9] He ends on a critical note, though: "I could have mixed the album better than they did, but they are my bosses and they have the last say."[9] Yet David Gilmour would reveal in 1975 that after a week's work, the mixing had not been so easy: "We do get into a

1975

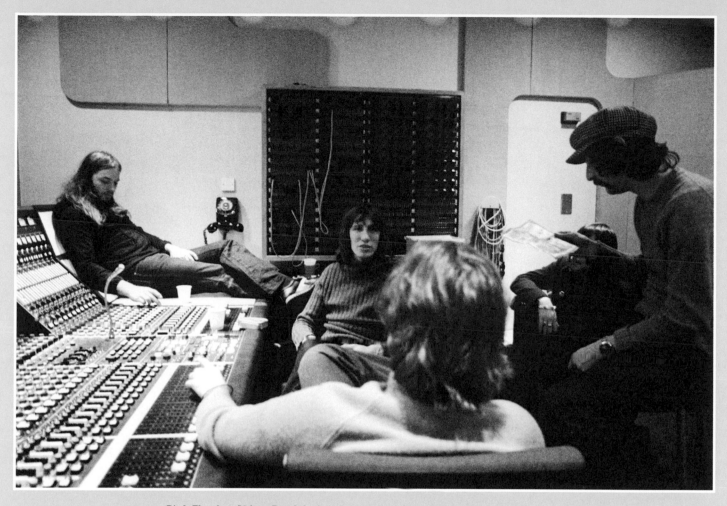

Pink Floyd at Abbey Road during the sessions for *Wish You Were Here*.

lot of arguments about the way things should be mixed and sometimes it comes down to two people mixing it differently and then we vote to see which mix to use."[100]

It was the first time Pink Floyd had brought in so many external musicians for an album. It features, on the saxophone, Dick Parry, who had really shone on *The Dark Side of the Moon*, but also some new contributors: Roy Harper, their longstanding friend, who performed the lead vocal in "Have a Cigar," Venetta Fields and Carlena Williams on backing vocals, and, more surprisingly, the extraordinary violinist Stéphane Grappelli, brilliant former partner of Django Reinhardt, whose contributions on "Wish You Were Here" unfortunately were omitted.

Technical Details

In 1974, two new mixing desks were installed in Abbey Road Studios One and Two. They were enormous EMI TG 44x16 consoles. Unfortunately, this model was too bulky for Studio Three, which was rather more modest in size. So, at the beginning of 1975, the old TG12345 was replaced with a Neve that was specially adapted for the studio and substantially modified by EMI. The setup was totally different from the TG, and Brian Humphries had trouble coming to grips with it, as he himself explained: "The main problem was that they had just installed a new console in [Studio Three],

and we were the very first ones to use it. It was a 24-track desk and though it's usually a fairly simple task to get accustomed to a new setup, this one was really difficult."[101] The tape recorder was a Studer A80 twenty-four track, while the monitors, effects, and microphones were largely the same as those used on *Dark Side*.

The Instruments

David Gilmour recorded predominantly with his faithful "Black Strat," its white pickguard replaced with a black one. For acoustic work he always used his Martin D-35, as well as an acoustic twelve-string bought from a friend, probably a Martin D12-28. On the effects side, he added an MXR Phase 90 to his collection.

Rick Wright opted for new keyboards, including an ARP Solina String Ensemble, a Hohner Clavinet, a Hammond C3, and a Moog Taurus.

Roger Waters still played a Fender Precision bass, but a black one with a maple neck and a white pickguard. In the *Melody Maker* from October 11, 1975, Nick Mason went through the exact setup of his Ludwig drum kit: bass drums; tom-toms; floor toms; Remo Rototoms; a snare drum; a Paiste hi-hat; Paiste cymbals; and Ginger Baker drumsticks. He also mentioned that, to dull the sound, he put pillows in his bass drums, which he tuned quite low.

Shine On You Crazy Diamond
(Parts 1-5)

Parts 1–4 (David Gilmour, Richard Wright, Roger Waters); Part 5 (Roger Waters) / 13:33

Musicians

David Gilmour: electric rhythm guitar, electric lead guitar, vocal harmonies (?)
Rick Wright: keyboards, vocal harmonies (?), vibraphone (?)
Roger Waters: voice, vocal harmonies (?), bass, VCS3
Nick Mason: drums
Dick Parry: baritone and tenor saxophones
Venetta Fields, Carlena Williams: backing vocals
Unidentified Musicians: singing glasses, sound effects

Recorded

Abbey Road Studios, London: January 13–16, 20–23, 27–30, February 3–6, 10–12, 14, 17–20, 24–26, March 3, May 5, 15, 19–21, 29, June 2, July 7, 8, 11, 14–19, 28, 1975 (Studios One, Two, and Three)

Technical Team

Producer: Pink Floyd
Sound Engineers: Brian Humphries, John Leckie (January 13–16)
Assistant Sound Engineer: Peter James

Genesis

It was in January 1974, when Pink Floyd got together to compose material for their next album, that the opening four notes of this vast symphony came to David Gilmour as he was playing his Stratocaster. Four notes that so inspired—or even moved—Roger Waters that he came up with some of his most beautiful lyrics. The "crazy diamond" is obviously Syd Barrett, who had not been a member of Pink Floyd for some years, who was no longer physically there, but who remained ever present in the minds of Waters, Gilmour, Wright, and Mason. "It's my homage to Syd and my heartfelt expression of my sadness," Roger Waters reflects in *The Story of Wish You Were Here*. "But also my admiration for the talent and my sadness for the loss of the friend."[102]

From the very first line of "Shine On You Crazy Diamond," Waters the songwriter travels back in time to the Cambridge of the early 1960s, a time when Barrett's intelligence, artistic eccentricity, and dreams bathed all who were around him in their light. Unfortunately, hallucinogenic drug abuse and the pressure of the music industry soon wiped out his magic. *Now there's a look in your eyes/Like black holes in the sky/You were caught in the cross fire/Of childhood and stardom*, sings Waters with tragic overtones. But at the same time, these words testify to a genuine admiration for someone who reached for the secret too soon, who lived—and was still living—threatened by shadows at night. "Shine On You Crazy Diamond" is effectively an ode to the "extraordinary" boy, in the original sense of the term, who enabled Pink Floyd to reach their dizzy heights, a gesture of recognition—in the form of poetry by turns luminous and desolate—of the one who had guided them along the path to the global success of *The Dark Side of the Moon*. "I think what was so important was to not try and write him out of history,"[102] Nick Mason comments in *The Story of Wish You Were Here*. And as Roger Waters adds in that same goldmine of a film: "There are no generalities, really, in that song. It's not about 'all the crazy diamonds,' it's about Syd." In 1976, Waters would re-examine his real motivation, telling Philippe Constantin, a journalist at the French magazine *Rock & Folk*: "In actual fact, I wrote that song, 'Shine On,' above all to see the reactions of people who reckon they know and understand Syd Barrett. I wrote and rewrote and rewrote and

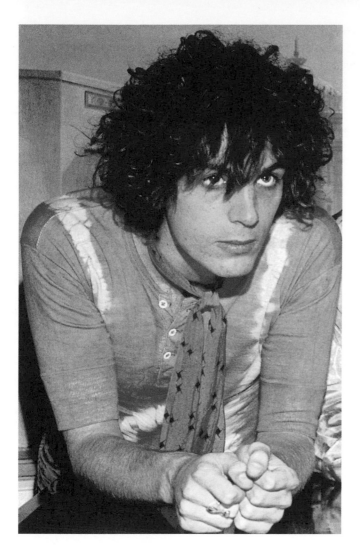

Syd Barrett is the "crazy diamond" in the song, the one whose absence continued to haunt its writer, Roger Waters.

rewrote the lyrics because I wanted it to be as close as possible to what I felt,"[9] adding that his words, though imperfect, conveyed a patent sincerity, "that sort of indefinable, inevitable melancholy about the disappearance of Syd."[9] However, Waters, not immune to the odd contradiction, claimed in the same interview: "I really don't know why I started writing 'Shine On.'"[9]

At the first recording sessions for the album in January 1975, Roger Waters convinced Rick Wright and Nick Mason, then David Gilmour, after long, heated discussions, to divide "Shine On You Crazy Diamond" into two movements, the first opening the opus, and the second concluding it. The first movement is in turn divided into four parts. The first part is a long keyboard introduction played by Rick Wright; the second, which also goes by the name "Syd's Theme," opens on David Gilmour's legendary four notes; the third is an instrumental with a solo by Wright followed by one by Gilmour; then the fourth is sung. The song and the guitar playing had a very big influence on Phil Manzanera (guitarist with Roxy Music, and later David Gilmour's accompanist): "That riff is like other great riffs—the minute you hear it, you know what it is. [...] When you're playing those songs, you marvel at the simplicity of it all, yet it's totally self-contained. It's quite minimalist, so each part is distinctive."[81]

The Evening Visitor

On June 5, the day before they were due to set off on their US tour, the four bandmates and their team gathered at Abbey Road for the final mix of "Shine On You Crazy Diamond." There was someone else in the studio as well, as Nick Mason and David Gilmour related in *The Story of Wish You Were Here*: "My memory is that I came in to the studio, and there was this guy standing there in a gabardine raincoat. A large, large bloke. And I had no idea who it was,"[102] Mason recalls. "And surprisingly," adds Gilmour, "no-one's saying 'Who's that person? What's he doing wandering around all our gear in the studio?' And then him coming into the control room and standing around. And how long it was before anyone woke up."[102] Because this visitor was none other than Syd Barrett (who, according to Mason, must have got wind that the band was recording at Abbey Road). An unrecognizable Syd Barrett, paunchy, bald, and with no eyebrows. "We just sort of stood there, just shellshocked," remembers Brian Humphries. Until somebody thought of something to say to him."[102] "It was pretty

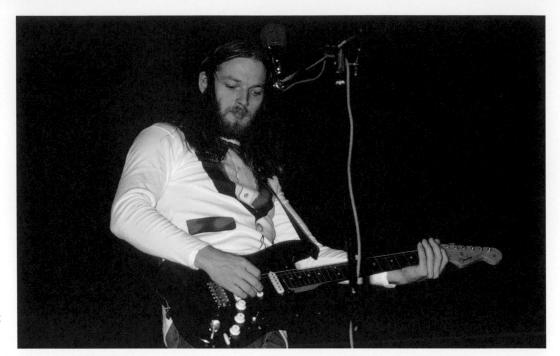

David Gilmour with his "Black Strat," playing a very bluesy solo in Part 1 of "Shine On You Crazy Diamond."

affecting, really," confirmed Storm Thorgerson, "Roger and Dave cried."[102] As for what piece the band were listening to when Barrett turned up in the studio, Nick Mason remains circumspect: "Legend has it that this was 'Shine On You Crazy Diamond'—the track most influenced by Syd's presence, or absence—although I'm not sure it actually was."[5]

Production

When the sessions for "Shine On" began on January 13, 1975, it was John Leckie who was in Studio Three at the fabulous Neve console modified by EMI's technicians. Leckie came on board, having been an assistant on *Meddle*. Now promoted to sound engineer, he was assisted by Peter James, who had worked with Alan Parsons on *Dark Side*. But the very next day the pair were astonished to discover that another sound engineer had been brought in to work alongside them, and what's more a freelance, though the use of these had hitherto been banned by EMI: Brian Humphries!

Humphries spent three days familiarizing himself with the premises and the equipment before finally taking over for Leckie on Monday, January 20. But he had the misfortune to be working with a new setup that was hard to come to grips with, even for the Abbey Road technicians. Soon after taking up his role, he made a mistake that could easily have cost him his job. Having spent several days recording the backing track for "Shine On You Crazy Diamond," the first track the band was working on (with an acoustic guitar, bass, synths, and drum kit), the Floyd wasn't happy with the result and decided to start over again. "So we did it again in one day flat and got it a lot better," David Gilmour recounts. "Unfortunately nobody understood the desk properly and when we played it back we found that someone had switched the echo returns from monitors to tracks one

and two."[99] The consequences were disastrous: the tom-toms, guitars, and keyboards were lost in the echo, which could not be got rid of. The only solution: to rerecord everything. "I was expecting to get fired on the Monday morning," Humphries admits. "Instead the band members just agreed to record both sections again because they felt they could do them better."[99]

The production of "Shine On" took a vast number of recording sessions and demanded an untold effort of everyone involved. The atmosphere was not ideal, as everyone was having trouble concentrating. Moreover, Waters, who was increasingly becoming the band's guiding force, took out his aggression on Rick Wright, but also on Nick Mason, himself in the midst of a personal crisis, who was fed up with Waters's telling him over and over to redo his drum takes. However, at the end of roughly seventy sessions there emerged this extraordinary piece of music split into two sections, "Shine On You Crazy Diamond (Parts 1–5)" and "(Parts 6–9)."

There were also two backing vocalists involved in the recording of the album: Venetta Fields and Carlena Williams. It was not the first time they had sung for Pink Floyd. Venetta had worked with them on The Dark Side of the Moon tour in October 1973 and Carlena on the French tour in June 1974. The two African American women had exceptional careers. Venetta Fields had been a member of the Ikettes, the Raelettes, and the Blackberries, and took part in numerous recording sessions, including for the Stones album *Exile on Main St.* (1972), and Steely Dan's *Aja* (1977). Carlena Williams, for her part, had been involved in collaborations with artists as diverse as Etta James, Roy Buchanan, and Donna Summer. The connection with Pink Floyd actually came about through Humble Pie, for whom the two singers were working in 1973. And it was David Gilmour, who was friends with the band's drummer Jerry Shirley (who also

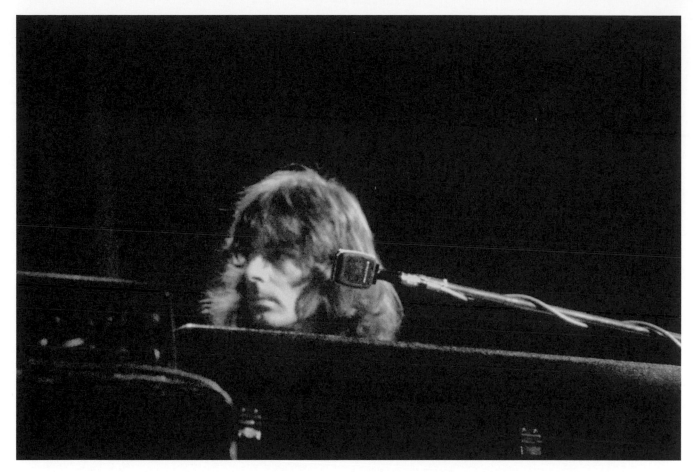

Rick Wright, who came up with the captivating introduction to the opening track on *Wish You Were Here*.

wielded the drumsticks on Syd Barrett's first two albums), who decided to poach them, contrary to the wishes of their bandleader Steve Marriott.

SHINE ON YOU CRAZY DIAMOND (Parts 1–5)

Part 1 (0:00–3:53)

The origins of this first part can be traced back to October 1973, when the Floyd was working on the *Household Objects* project. But the outcome was very disappointing; nothing really came out of the sessions, and there was nothing worth keeping. Except for one piece. Alan Parsons, who was still behind the desk at that time, explained: "[One of the instrumentals involved] compiling tapes of wine glasses varispeeded at different pitches so you could make up different chords by combining different tracks on the 24-tracks."[9] So glasses in fact formed the basis for this sequence: it was just a matter of running a damp finger around the rim of one of the glasses to make a sound, a well-known phenomenon called "singing glasses." It works on the principle that you have to fill them with liquid to different levels in order to vary the pitch of the notes, but Parsons later claimed they had done it with empty glasses: "It was a matter of scraping your finger on the edge and then varispeeding it from a loop,"[9] he explained.

Re-christened "Rick's Drone" at the first session on January 13, 1975, this instrumental sequence reappeared bearing the name "Wine Glasses" in 2011, on the CD *Wish You Were Here [Experience Edition]*. Confusingly, Glenn Povey—who had access to the session sheets—stated in his book *The Complete Pink Floyd* that the group added "Wine Glasses" by overdub on February 24 at the start of "Shine On," based on a sequence recorded on January 5, 1971, originally entitled "Nothing Part 5," one of the twenty-four pieces comprising *Nothing Parts 1–24*, a project that was partly abandoned by the Floyd at the time *Meddle* was being produced, and which was effectively the precursor to *Household Objects*. Is this a mistake? Does "Nothing Part 5" really have nothing in common with "Wine Glasses"?

This first part starts, then, on a G-minor chord that fades in as a kind of drone. Based entirely on "Wine Glasses," Rick Wright enriches it with overdubs of strings produced on the ARP Solina, bass produced by the Moog Taurus, effects almost certainly from an EMS VCS3, layers produced by the Hammond organ, and melodic phrases played on the Minimoog. It has a dense, rich texture, with multiple tracks combined to intensify the sound. One can also make out a ringing sound that is reminiscent of a vibraphone (example at 0:59), though it may also come from the Fender Rhodes or the Wurlitzer.

Toward the middle of this first part, David Gilmour comes in on his "Black Strat," playing a solo with a clean, very bluesy sound, very inspired and rather in the style of Peter

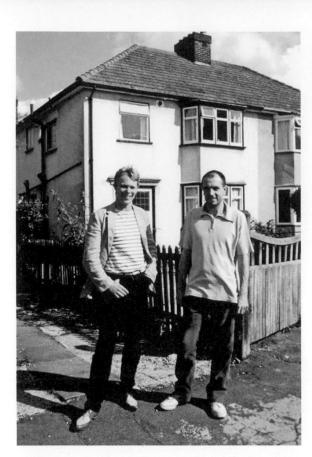

Syd Barrett (on the right, in front of his house in Cambridge) paid a visit to his former bandmates during the sessions for *Wish You Were Here*.

Note the strange handling of the credits for the fifth part, which is attributed to Roger Waters alone, whereas on the first edition of the original vinyl, the credit was shared by Waters, Gilmour, and Wright. Considering this sequence is all instrumental, it is surprising that Gilmour's and Wright's names have completely disappeared in the later editions (vinyl and CD).

Green (from 2:11 onward). His playing is brilliant and he picks his notes with feeling. The sound is compressed and amplified with generous, hovering reverb. The guitar-layer combination works like a dream, making this musical sequence a resounding success.

Part 2 (3:54–6:27)

B flat-F-G-E: so begins the second part, with these four sublime notes played by David Gilmour on his "Black Strat." They have such an emotional force that they will undoubtedly always be one of Pink Floyd's great signature phrases, along with the riff from "Money" or even the "ping" from "Echoes." These four notes, which inspired Roger Waters to write some of his finest lyrics, cost Gilmour a great deal of effort and research before he achieved the effect he was after. He decided to decamp from Studio Three, where the band was working, to the enormous Studio One, normally reserved for large classical ensembles, in order to capture the atmosphere of a hall. With the help of Phil Taylor, his guitar technician since 1974, he set up on his own in this huge room. Taylor was later able to give a full rundown of the equipment used: "He played the Black Strat through a Binson Echorec 2 delay unit amplified by a Fender Dual Showman amp with a 2 x 15 cabinet, a Hiwatt amp with a WEM 4 x 12 cabinet and a Leslie 760 rotating speaker cabinet."[104] Brian Humphries, meanwhile, placed the mics quite a long way from the amplifiers in order to capture the whole depth and resonance of the immense studio. And the result was everything they had hoped for: the riff rings out masterfully. It was added to the twenty-four-track master from Studio Three on January

21. Gilmour plays it four times before Nick Mason comes in with a rising crescendo played on the tom-toms, underpinned by Roger Waters on the bass. The two of them produce a groove both heavy and weightless, carried by the layers of Rick Wright's Hammond organ and Gilmour's rhythm guitar. The latter goes into a second solo every bit as powerful as the first, very bluesy, his "Black Strat" slightly distorted by his Colorsound Power Boost. If you had to sum up his playing in three words, you would have to say: an exceptional touch. Even Roger Waters, who is very sparing with his compliments, did acknowledge the outstanding quality of Gilmour's contributions on the album. This second part also goes by the title "Syd's Theme."

Part 3 (6:28–8:42)

The third part starts with quite a serene atmosphere, Rick Wright following on from Gilmour with a solo played with great subtlety on his Minimoog. The sound is warm and faintly resonant. He accompanies himself on a Steinway grand piano as well as on his Hammond organ. As for the drums, there is a palpable difference between the approach taken by Alan Parsons, who, on *The Dark Side of the Moon*, insisted they must not be compressed, and that of Brian Humphries, who doesn't hesitate to do this in quite an emphatic way. In particular the bass drum is much more percussive, but less natural. It's a matter of differing points of view. Waters plays a very good bass line, and Gilmour plays two rhythm guitars, opting mainly for chord licks on the second one. He then goes into a third solo after Wright's, this one much more aggressive than the two previous ones (at

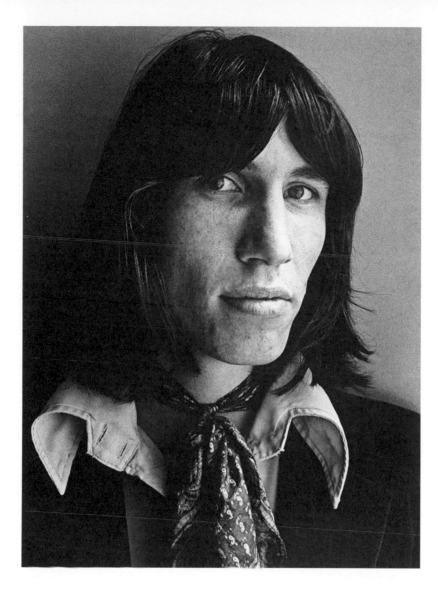

Roger Waters gave one of his most moving vocal performances in Part 4 of "Shine On You Crazy Diamond."

7:36). His "Black Strat" is distorted and colored by phasing from his MXR Phase 90, the whole thing enhanced with a slight delay from his Echorec.

Part 4 (8:43–11:08)

Roger Waters's vocal kicks off this fourth part. His singing is excellent, and very unexpected since, until that point, he had only ever adopted a more confidential or medium-loud register, as on "Eclipse." Now he stretches his vocal cords to their limits to express his emotions as precisely as possible. The result is superb; the lyrics come across as heartfelt. He later admitted that the recording of his vocal parts took a lot out of him, and that rings true because one senses Waters is close to the breaking point (for example at 9:25). His voice is doubled for greater assurance, and he seems to be supported by Gilmour and/or Wright on the vocal harmonies. And as on *Dark Side*, it is the female backing singers who provide the backing vocals. Venetta Fields and Carlena Williams bring a radiant gospel feel, accentuated by Rick Wright's Hammond organ. Gilmour most notably records two distorted guitar parts: the first (on the right), which he plays as a solo, and the second (on the left) as a rhythm part, which allows him to support the tune with power chords but also to deliver descants. He also performs a solo, or rather a line of melody, that he doubles (at around 9:46) and harmonizes with a third and even a fourth guitar.

Part 5 (11:09–13:33)

The fifth part, which completes this first section, starts with the return of Dick Parry and a remarkable baritone saxophone solo recorded on May 15. The playing is "on the breath," with rhythm 'n' blues and jazz influences. David Gilmour reprises his first riff, this time played clean and an octave higher, before providing an arpeggio accompaniment on his "Black Strat" (doubled in stereo). The sequence develops and the time signature moves from 6/8 into 12/8, which generates a sense of speed. Parry continues to improvise, but on a tenor saxophone. It is a shame that Nick Mason remains a bit too static on his drum kit; his hi-hat playing is distinctly lacking in groove and slows down the sequence somewhat. The sequence concludes with layers of strings from Wright's ARP, before Waters's VCS3 announces, *Welcome to the Machine*.

Welcome To The Machine

Roger Waters / 7:27

Musicians
David Gilmour: vocals, vocal harmonies, acoustic rhythm guitar, lead electric guitar, EMS VCS3 (?)
Rick Wright: keyboards
Roger Waters: bass, EMS VCS3
Nick Mason: timpani, cymbals
Recorded
Abbey Road Studios, London: February 25–27, May 8–9, 12–15, 27–28, June 2, July 9, 28, 1975 (Studios Two and Three)
Technical Team
Producer: Pink Floyd
Sound Engineer: Brian Humphries
Assistant Sound Engineer: Peter James

Gerald Scarfe (here with his wife, Jane Asher), who produced the music video for "Welcome to the Machine."

Genesis

The second song on *Wish You Were Here* was penned and composed by Roger Waters alone. In the DVD *The Story of Wish You Were Here*, he explains that this piece is not just the product of his own experience of the record industry, but "all of our [the musicians'] experience in the face of that monstrous, grinding thing that chews us up and spits us out."[102] Although inspired by a shared real-life experience, Waters's composition nevertheless seems to refer particularly to Syd Barrett, who once again finds himself the hero—or rather antihero—of a track on the album. In two verses and a chorus, Waters presents an imagined dialogue between two people. The first, symbolizing "power," takes a paternalistic tone as he addresses the second (Syd, presumably), who is there but doesn't say a word. The dual function of the latter is simple: to create and obey.

Welcome my son, welcome to the machine, Waters has the paternalistic figure say. The "machine" is the record industry, the entertainment industry in general—which makes kings as quickly as it destroys them. The songwriter then gets to the heart of the subject. He recalls the childhood of his friend, a Boy Scout who had bought a guitar to punish his mother with a demonstration of his insubordination. Then, in the second verse, it's the merciless law of the star system that is the focus of Waters's criticism—where dreams of glory, riches, and luxury are achievable, provided one toes the line laid down by the machine. It's not such a far cry from the totalitarian society and its "Big Brother is watching you" maxim evoked by George Orwell in his novel *1984*... In 1976, Roger Waters would analyze the lyrics in the following terms: "The idea is that the Machine is underground. Some subterranean and therefore evil power that is leading us towards our various bitter fates. The hero has been exposed to this power. Somehow he has gone down into the machinery and seen for himself, and the Machine (Power) has admitted this fact and it tells him that it is watching him because he knows. And it also tells him that all his actions are Pavlovian responses, that they are all just conditioned reflexes and that his responses do not come from himself. And in fact he doesn't exist, except in that he has a feeling inside of him that something is really not right. And that's the only reality."[105]

COVERS

"Welcome to the Machine" has been covered by several bands. The most famous version is the one by Queensrÿche on their album *Take Cover* (2007).

A Shocking Video

The first time Pink Floyd performed "Welcome to the Machine" in public was on the "In the Flesh Tour" in 1977. For the occasion, the illustrator and cartoonist Gerald Scarfe, whose collaboration with the band had started with *Wish You Were Here*, produced a music video for the song. We see a strange prehistoric creature, followed by rats running along steel girders and then steel towers that metamorphose into foul beasts, one of which decapitates a man; next a sea of blood engulfs a town and its inhabitants; a single tower at first escapes the apocalypse and flies up into the sky, before being swallowed up by an enormous bubble. "This particular creature I created, I remember showing it to the gang, who sort of went along with everything I said at that point," Gerald Scarfe revealed. "They didn't correct anything."[102]

Production

On February 25 the Floyd began the recording, under the title "The Machine Song," of Roger Waters's indictment of a "system" that manipulates and crushes all individuality. The opening of the song has a muffled, disturbing feel to it, conveying the atmosphere of the room that houses this frightening machine, and we hear the stealthy throbbing of its motor (produced on the VCS3). An electronic bell (at 0:03) is followed by the sound of a double door opening. Its presence has a metaphorical significance, as Roger Waters explains: "It's a phrase that gets used all the time in English, 'and the doors open to…,'" which is naturally associated with "the symbol of doors, keys, the symbol of discovery, of advancement, of progress, of agreement."[9] In this case, Waters had the door opening not to knowledge, but to the trap laid by the machine, that monster that tramples everyone's dreams.

The way "Welcome to the Machine" was produced was quite unusual for the group. There was no backing track laid down in advance as a guide for the overdubs; instead, it was created by a process of trial and error. As David Gilmour confirms: "It's very much a made-up-in-the-studio thing which was all built up from a basic throbbing made on a VCS 3."[100] This throbbing is not actually a machine motor; it is the sound of a bass synthesizer that we hear from 0:30 on the left of the stereo field, which is repeated on the right with a delay. The whole song consists of a buildup of sound effects and all kinds of instruments. "[It's] a form of collage using sound,"[100] Gilmour adds. The atmosphere of the piece is derived mainly from the many parts produced on the synthesizers: the VCS3s, of course (synthesizer models A and AKS synthesizer); the Minimoog, which Rick Wright uses for the solo parts at 5:09, for example; but also the strings of the ARP Solina, which have a strong presence and are one of the predominant keyboard effects. David Gilmour in fact talked about how difficult it was to record the synthesizers, and what technique to opt for, between a direct take on the console or a take via the amplifier: "Eventually what we decided to do was to use D.I. on synthesiser because that way you don't increase your [signal] losses and the final result sounds very much like a synthesizer through a stage amp."[100]

Roger Waters underpins the throbbing from the VCS3 with an overly quiet bass line, which is hard to make out amid the synthesizers. On May 13, Nick Mason recorded orchestral timpanis and cymbals to add to the tension of the piece (from 3:19 onward). David Gilmour, meanwhile, delivers not only an acoustic guitar part played on his Martin D-35, which is double-tracked starting from the verses, and a few phrases played clean on his "Black Strat" (which can be heard at 2:34), but also, notably, the lead vocal. It is pitched high. He double-tracks himself an octave lower. But he struggled with some notes that were too high for him. Whereas normally he would persevere until the result was to his liking, this time he decided to employ a trick whereby the tape recorder was noticeably slowed down: "It was a line I just couldn't reach," he admitted, "so we dropped the tape down half a semitone and then dropped the line in on the track."[100] The line in question could well be *It's alright we told you what to dream*, where you really hear his voice straining (at 4:17).

The track ends with the door closing and the sound of an oscillator rising then falling, before the mood changes to a lively atmosphere. "Yes, it's like a party. That was put in there because of the complete emptiness inherent in that way of behaving, celebrations, gatherings of people who talk and drink together. To me, that epitomizes the lack of contacts and of real feelings.

Have A Cigar

Roger Waters / 5:08

Musicians
David Gilmour: electric rhythm guitar, electric lead guitar, VCS3 (?)
Rick Wright: keyboards
Roger Waters: bass, VCS3 (?)
Nick Mason: drums
Roy Harper: vocals
Recorded
Abbey Road Studios, London: March 10–13, May 6–9, 16, 30–31, June 2, July 8–9 19, 28, 1975 (Studios Two and Three)
Technical Team
Producer: Pink Floyd
Sound Engineer: Brian Humphries
Assistant Sound Engineer: Peter James

For Pink Floyd Addicts

The trademark phrase *Which one's Pink?* is based on something the band had actually experienced. David Gilmour explained: "There were an awful lot of people who thought Pink Floyd was the name of the lead singer [...]. That's how it all came about, it was quite genuine."[107]

The Queen guitarist, Brian May, and the Foo Fighters recorded their own version of "Have a Cigar" for the soundtrack of *Mission: Impossible 2* (2000).

Genesis

"Have a Cigar" was born in the days following Pink Floyd's North American tour (April 1975). Roger Waters composed it as a logical follow-up to "Shine On You Crazy Diamond." "The verses (tune and words) were all written before I ever played it to the others," he confided to Nick Sedgwick. "Except the stuff before and after the vocal, that happened in the studio."[100]

In terms of the subject matter, "Have a Cigar" is a direct follow-up to "Welcome to the Machine"—it is another swipe at the record industry. And although, for once, there is a touch of humor in the tone: *Come in here, dear boy, have a cigar/You're gonna go far, you're gonna fly high…*the criticism is unambiguous. The head of the record label is on marvelous terms with the artist as long as the latter is a success. But when it comes down to it, he knows nothing of his protégé's artistic identity—or rather he doesn't care as long as the money comes pouring in. The record industry magnate doesn't even know the name of the artists. In his mind they are nothing more than consumer products to be exploited. In a nutshell, money prevails over everything. Everything else is trivial. As a result, the artist is gripped by feelings of incomprehension, disappointment, frustration, and loneliness. For Brian Humphries, "the lyrics so much sum up the recording business."[102] David Gilmour would often repeat that he thought Syd's madness had largely come about due to "the demands of the record industry."[102]

"Have a Cigar" was released as a single from *Wish You Were Here* (with "Shine On You Crazy Diamond" as its B-side in several European countries and with "Welcome to the Machine" in the United States). It reached only number 119 on the Cash Box magazine charts.

Production

"Have a Cigar" starts with an excellent riff played by Gilmour on his "Black Strat," distorted by his Colorsound and heavily colored above all by his MXR Phase 90. Waters supports him with his Fender Precision, which slots perfectly into his harmonic motif. The rhythm is heavy, with Mason really pounding his Ludwig kit; Wright assists with a funky Wurlitzer section before playing a melodic phrase on the Minimoog, double-tracked, which is underpinned by the Strat and the

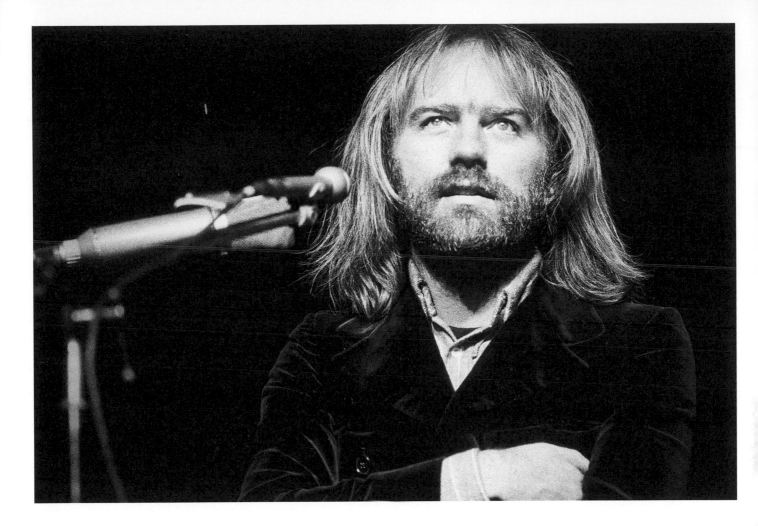

bass. He also provides an accompaniment on the Hammond organ, layers of strings on his ARP Solina, and a Clavinet part that comes in just before the first verse (probably double-tracked by ADT). Gilmour, for his part, delivers a number of overdubbed solo passages. Then comes the first verse.

At the initial recording sessions for "Have a Cigar," Roger Waters and then David Gilmour tried to record the lead vocals and sing together (session on May 8)—without much success. "With 'Have a Cigar' both of them knew that neither of them could sing it," comments Brian Humphries. "I always thought that Dave's voice was not deep enough."[102] After numerous attempts, by Gilmour and Waters, the Floyd ended up opting for Roy Harper, a folk singer who was a regular at big pop gatherings, particularly ones where Pink Floyd was headlining. Having made his name with the remarkable *Stormcock* (1971), Harper was in the middle of recording the album *HQ* (1975) in Studio Two at Abbey Road (with, on the console, the same John Leckie who had been involved in the early recording sessions for "Shine On You Crazy Diamond"). He offered to give it a go. "For a price," he joked. He would later admit how astonished he was at the huge success of the album and the song: "It was played around the world. That was my vocals on a number one selling single. Everybody thought it was Roger."[102] Although Humphries was enthusiastic about this performance and David Gilmour was also won

over, it was greeted with a certain reticence, to say the least, on the part of Roger Waters, who thought Harper's version was too much of a parody, "which I don't like. I never liked it. [...] I think if I'd sung it, it would be more vulnerable and less cynical than the way he did it."[102] He had to resign himself to his inability to sing this number, though, because the attempts he recorded after Harper's performance on May 9 proved no more conclusive than his previous attempts. So it was with a heavy heart that he finally threw in the towel, probably on May 31.

The song needed at least fifty-six takes, another band record! As for David Gilmour, his lack of interest was surprising. Some later said that he disapproved of the cynicism of the lyrics, which attacked a system that had made them all rich…

But he made up for it with a superb guitar solo with a strong rock vibe, funky, with phrasing still as blues-tinged as ever (from 3:17 onward). Mason intensifies the groove with some markedly more rhythmic hi-hat playing that gives an impression of speed. The piece is abruptly interrupted by an effect probably created on the VCS3 or the Minimoog (at 4:52). However, the music continues, but it has been equalized to simulate the sound of a radio and to link up with the introduction to "Wish You Were Here," which follows on from it with an identical feel.

Wish You Were Here

David Gilmour, Roger Waters / 5:40

Musicians

David Gilmour: vocals, vocal harmonies, twelve-string and six-string acoustic guitars, pedal steel guitar, electric lead guitar
Rick Wright: Steinway piano, Minimoog
Roger Waters: bass, VCS3 (?)
Nick Mason: drums
Stéphane Grappelli: violin (on the version on *Wish You Were Here [Experience Edition]*)

Recorded

Abbey Road Studios, London: May 16, 19, 21–23, 28–30, July 10, 24, 28, 1975 (Studios Two and Three)

Technical Team

Producer: Pink Floyd
Sound Engineer: Brian Humphries
Assistant Sound Engineer: Peter James

Virtuosos Stéphane Grappelli (on the left) and Yehudi Menuhin were recording at Abbey Road at the same time as the Floyd.

Genesis

In an interview with Nick Sedgwick, Roger Waters confided that he usually composed the music before writing the lyrics, but occasionally did both at the same time. "Only once have the lyrics been written down first—'Wish You Were Here,'" he said. "But this is unusual; it hasn't happened before."[106]

Indeed, the lyrics give us an insight into Waters's innermost thoughts and express the artist's clash of emotions. In an interview with Karl Dallas, he explained: "In a way it's a schizophrenic song. It's directed at my other half, if you like, the battling elements within myself. There's the bit that's concerned with other people, the bit that one applauds in oneself, then there's the grasping avaricious, selfish little kid who wants to get his hands on the sweets and have them all. The song slips in and out of both personae, so the bit that always wants to win is feeling upset and plaintively saying to the other side, wish you were here."[108] Does the dark side dominate over the bright side of Waters's personality? It seems that way. For the main character in the song can't necessarily distinguish between heaven and hell, blue skies and pain. The song proceeds via a series of questions: would *you trade your heroes for ghosts*, did you *exchange a walk on part in the war for a lead role in a cage*? "Most of the songs that I've ever written all pose similar questions," Roger Waters acknowledges in *The Story of Wish You Were Here*. "Can you free yourself enough to be able to experience the reality of life as it goes on before you and with you, and as you go on as part of it or not? Because if you can't, you stand on square one until you die."[102]

At the same time as he expresses this apparent mental confusion, struggling to tell the difference between the real and the illusory, the songwriter is also taking another swipe at the record industry, which—motivated solely by the lure of profit—tends to encourage its artists to pursue pipe dreams rather than appreciating what they've got. "Wish You Were Here" again—and throughout—refers implicitly to Syd Barrett when Waters mentions an artist locked up in the cage of his illusions, and slightly less implicitly when he extols the true meeting of minds: *We're just two lost souls swimming in a fish bowl*, and he admits to sharing *the same old fears*. So Barrett's absence is all the more painful, and it is with genuine sadness that he sings wish you were here.

But in the end, isn't "Wish You Were Here" purely and simply a love song? "Yes, that's true," the songwriter would admit to Philippe Constantin in 1976. "It's a love song, and still one on a very general and theoretical level. If I was undergoing psychoanalysis, my analyst would tell you why I don't write love songs. In fact, I've done one or two others, but always in a very impersonal way. If I haven't really spoken about love, perhaps it's because I've never really known what love was."[9]

Production

The "Wish You Were Here" recording sessions started on May 16. At that point, the song did not yet have a title. Initially known as "Untitled (An Afternoon at Home with the Duke of Royden)," it was then renamed more modestly "The Squire of Royden" (as Gilmour lived near Royden in Essex), before it acquired its definitive name on May 22. That same day the band returned to the backing track that had been recorded on May 16 and added different overdubs. The third take was the one they went with.

The introduction to the piece is rooted in the ending of "Have a Cigar," which simulated the sound of a radio. Someone then fiddles about with the frequencies. We catch snippets of conversation: *...and disciplinary remains mercifully...yes...now would you take this star nonsense? No, no...now, which is it?...I'm sure of it...* Further on, we hear a short excerpt from Tchaikovsky's Symphony No. 1. Then an acoustic twelve-string guitar rings out, the sound distorted by the radio effect that, curiously, gives it the tone of a Dobro. David Gilmour later explained that this effect was achieved by equalization, by cutting the instrument's high and low frequencies. "The interference was recorded on my car cassette radio, and all we did was to put that track on top of the original track [probably on May 28]. It's all meant to sound like the first track getting sucked into a radio, with one person sitting in the room playing guitar along with the radio."[100] That's why Gilmour takes up a six-string acoustic for a solo, played clean, which contrasts perfectly with the distorted tone of the twelve-string (at 0:58). He said he regretted not having been able to rerecord it, because each time he listens to it he can't help feeling that he didn't play it very well... He then accompanies himself with some strumming on his Martin D-35 before taking the lead vocal. The twelve-string gives way to a pedal steel guitar (Fender 1000 double neck), which he uses to color the harmony with plenty of reverb.

When the bass and drums come in (at 2:04), Rick Wright embarks on a lovely lyrical acoustic piano section with a folk-rock feel. He then performs a second solo on his D-35, which he seems to play with a slide, along with a scat accompaniment. In the course of this same passage he reprises the introductory riff on the twelve-string (doubled, probably a Martin D12-28), and Wright backs him up with resonant effects on his Minimoog. After singing the first verse, which he harmonizes himself, Gilmour takes up the main riff again—still with Wright on his Minimoog—before ending with a final slide solo on the acoustic, once again with a scat accompaniment. Then, as we move into the final fade-out, a synthetic wind noise produced on the VCS3 progressively dominates the whole end of the song. It is worth noting that, on May 30, Gilmour recorded an electric guitar part that was not used in the mix, though there is a fragment remaining at 3:12.

There is one surprising fact associated with the recording of "Wish You Were Here." Some people claim they can hear the sound of a violin in the dying seconds of the track, at the very end of the fade-out. To be honest, though, it is completely inaudible. It is true, however, that this instrument did play a part in the production of the song. On May 23, Stéphane Grappelli, the extraordinary former partner of Django Reinhardt, and Yehudi Menuhin, one of the greatest classical violinists, were themselves recording in Abbey Road's Studio One. Keen to give the title track a country feel, David Gilmour thought that a violin would be a good idea. "Both were pleased to be asked," Nick Mason recalls, "and Stéphane volunteered to take up the challenge. Yehudi preferred to stand listening to Stéphane's sinuous jazz violin."[5] But the band retained nothing of this recording, and listening to the 2011 version, one gets a better sense of the reason for this: Grappelli, one the best jazz violinists in the world, was unable to summon that touch of genius that he is known for. Perhaps this style of music was too far removed from his familiar universe.

Shine On You Crazy Diamond
(Parts 6-9)

Parts 6–8 (David Gilmour, Richard Wright, Roger Waters); Part 9 (Richard Wright) / 12:23

Musicians
David Gilmour: electric rhythm and lead guitars, pedal steel guitar, bass, vocal harmonies (?)
Rick Wright: keyboards, vocal harmonies (?)
Roger Waters: vocals, bass
Nick Mason: drums
Venetta Fields, Carlena Williams: backing singers
Unidentified Musicians: VCS3, singing glasses, sound effects
Recorded
Abbey Road Studios, London: January 13–16, 20–23, 27–30, February 3–6, 10–12, 14, 17–20, 24–26, March 3, May 5, 15, 19–21, 29, June 2, July 7, –8, 11, 14–19, 28, 1975 (Studios One, Two, and Three)
Technical Team
Producer: Pink Floyd
Sound Engineer: Brian Humphries
Assistant Sound Engineer: Peter James

Rick Wright wrote the last part of the title track, his last composition of the Waters era.

Genesis

The second movement of "Shine On You Crazy Diamond," which starts with the concluding wind of "Wish You Were Here," consists of four parts: a long introduction, a second sung part, then the third and the fourth, both instrumental parts. Once again Roger Waters's lyrics make direct reference to Syd Barrett: *Nobody knows where you are, how near or how far.* This line refers both to the mental confusion of the ex–Pink Floyd band member, and to the hermit-like life he has led since leaving the band, as well as the numerous questions raised by his absence (physical this time). Barrett, *seeker of the truth, brilliant mind*—especially for Waters, who would never forget the glorious past: *And we'll bask in the shadow of yesterday's triumph…*

Production

SHINE ON YOU CRAZY DIAMOND (Parts 6–9)

Part 6 (0:00–4:38)
This sixth part starts with the synthetic wind from the VCS3 that concludes the previous track, "Wish You Were Here." Two bass notes are heard, emerging seemingly from nothingness, probably played by David Gilmour, and are repeated three times before a second bass comes in, its sound highly colored by phasing (MXR Phase 90?). This time it seems to be Roger Waters who is playing. A short phrase added by overdub—still on the bass—reinforces the motif. Incidentally, this introduction with the wind and the two basses played by Gilmour and Waters is similar in spirit to that of "One of These Days" (*Meddle*). Then we hear layers of strings from Rick Wright's ARP Solina, with licks and rhythmic phrases played by Gilmour on his "Black Strat," and Mason comes in, opting for a plain approach with no hi-hat or cymbals. All this creates a rather unsettling ambiance for Wright's superb solo on the Minimoog, the sound generously echoed by his Binson Echorec II. He has said he prefers this album to the previous one as he feels his playing is superior; listening to this solo, one is tempted to agree with him. The time signature changes at 2:30, Mason brings in his cymbals, and Gilmour takes over from Wright, improvising on his pedal steel guitar, which is distorted and

For Pink Floyd Addicts

While Parts 1–5 of "Shine On You Crazy Diamond" would be played regularly in public after the band's split, Parts 6–9 were only rarely performed. However, Roger Waters would play them (almost) in their entirety, in particular on his 2002 tour, as did Gilmour in 2001. (Hear his surprising acoustic version—with Dick Parry on the saxophone—on the DVD *David Gilmour in Concert* released in 2003.)

open-tuned in G. He adds harmony to his lines at 4:18, and enhances the groove with two rhythm guitar parts opposite each other in the stereo picture.

Part 7 (4:39–6:02)

Part 7 marks a return to the main theme developed in the fourth part of the first movement. Wright returns to his Hammond organ and Gilmour to his "Black Strat" to play the melody line, before Waters comes in with the lead vocal, in a voice that is fragile and moving, yet still powerful. He is supported throughout with vocal harmonies provided by Wright and/or Gilmour, but also by the highly talented Venetta Fields and Carlena Williams. Gilmour later confessed that he and Waters struggled to record the lead vocals for the album: "I have trouble with the quality of my voice but I don't have much difficulty keeping in tune. On the other hand, Roger has no problem with vocal quality but he does have trouble keeping in tune."[100]

Part 8 (6:03–9:04)

This sequence starts with the same arpeggios as those played in Part 5 of the piece. Gilmour plays his Strat clean, and this part is double-tracked in stereo. He is accompanied by strings from Wright's ARP Solina. We hear him play a few harmonic notes on another track, before leading the band into a rhythm with funky jazz-rock accents. Mason gives the impression of being much more at ease, and seems less static than at the start of the second section. Waters supports him with a very good bass line, and Wright shines once again with an excellent accompaniment on the Wurlitzer, at times reminiscent of George Duke's phrasing. Gilmour introduces a funky rhythm guitar, colored by his MXR Phase 90, then Wright adds overdubs on the Hohner

Clavinet and the Minimoog (doubled, very likely by ADT, and still with Echorec added). The VCS3 appears from 8:41 with some typical passages, while layers of sound from the ARP rise in a crescendo.

Part 9 (9:05–12:23)

The final part of the monumental fresco that is "Shine On You Crazy Diamond" starts on a tom-tom break combined with inverted effects. Incidentally, this end section (whose working title was "End Sequence"), credited to Rick Wright alone, was the last piece from the Roger Waters era that he would compose for Pink Floyd. The tempo is relatively slow; Mason plays a heavy beat, and Waters's Precision bass imposes rhythmic phrasing that adds to the depth of the groove. Gilmour is virtually absent, apart from the odd slide passage from 10:43 onward. Wright is omnipresent, firstly on the Minimoog, from which he draws a very poignant, part-improvised melody line, but also on the Hammond organ, the Steinway grand piano, and probably the VCS3. This ninth part reaches its dénouement with a last chord of G major, this part having been in a minor key until that point. Again it is that idea of redemption, something that he certainly felt very strongly about. In the background we can again make out the singing glasses, already used in the first part of the song. And, as the coda draws to a close, Wright reprises the opening notes of the tune of "See Emily Play" on the Minimoog (at 12:11), a nod to his former bandmate, to whom this epic piece is dedicated. "I felt very close to Syd,"[72] he confessed in his last ever interview in 2007. And when the journalist asked him whether there was still something of Syd Barrett present in their music, he replied: "There clearly was."[72]

ANIMALS

ALBUM

ANIMALS

RELEASE DATE

United Kingdom: January 21, 1977

Label: Harvest Records

RECORD NUMBER: SHVL 815

Number 1 (France, Germany, Netherlands, Switzerland, Spain, Portugal)

Number 2 (United Kingdom)

Number 3 (United States)

Pigs On The Wing 1 / Dogs /

Pigs (Three Different Ones) / Sheep /

Pigs On The Wing 2

For Pink Floyd Addicts

In the mid-1970s, punk rocker John Lydon (aka Johnny Rotten of the Sex Pistols) was seen wearing a Pink Floyd T-shirt with the words *I hate* in front of the band name. That says a lot. Lydon's distaste didn't deter Nick Mason from later producing a punk band—*Music For Pleasure* (1977), the second album by the Damned. Interestingly, the punk outfit had originally wanted Syd Barrett to be their producer.

Animals, the *Punk* Floyd manifesto

In the mid-seventies, proud Britain was faltering. It was a time of inflation, record unemployment, and low growth. Edward Heath's Conservative government had taken a hard line that merely added to the discontent. This found its expression, for example, in the UK miners' strike (1974), which, besides triggering an early general election, pushed the country to the brink of bankruptcy. More worryingly, perhaps, the Labour governments of Harold Wilson (March 1974 to April 1976), then James Callaghan (April 1976 to May 1979) did no better than the Conservatives, and faced one industrial dispute after another, as well as continuing riots and attacks in Northern Ireland.

Increasingly the British people could see no future for themselves: some pinned their hopes on Margaret Thatcher, who became the leader of the Tories in February 1975; the younger generation, out of pure scorn or a loathing of a Victorian society in its death throes, would propel a new generation of bands to the forefront of the music scene, whose rallying cry was precisely that: "No future." As the Sex Pistols, the Clash, and the Damned belched out their hatred of everything that had gone before, their fans, in unity with them, pogo-danced, went around in torn T-shirts, wore garbage bags as skirts and—the ultimate provocation in the homeland of Churchill—adorned their leather jackets with vile swastikas.

A British society in total decline, plagued by social and race riots, teenagers burning their old idols…the changes were as brutal as they were radical.

For Roger Waters, who refused to conform to the image of an artist shut away in his ivory tower, a criticism leveled at the giants of rock by the young punks, the moment had come to step up his commitment, to wage war against every form of conservatism, and even warn crowds of the possibility of an authoritarian regime being established in Britain, that global bastion of parliamentary democracy. This, broadly speaking, is the theme of what would become Pink Floyd's tenth studio album. "I was always trying to push the band into more specific areas of subject matter, always trying to be more direct,"[109] he commented in 1987.

Album of the Animals

Animals, then, is first and foremost Roger Waters's work, the record with which he consolidated his influence and his authority over the other band members. "That was the first one I didn't write anything for," Rick Wright would say. "And it was the first album, for me, where the group was losing its unity as well. That's when it was beginning where Roger wanted to do everything."[110] However, Wright also acknowledged that he did not have any new compositions to offer at the time. So Waters wrote all the lyrics for *Animals*, composed four of the five tracks—both parts of "Pigs On the Wing," "Pigs," and "Sheep"—and co-composed the fifth, "Dogs," with David Gilmour. What's more, for the first time he performed nearly all the lead vocals, with the exception of "Dogs," which he sang as a duet with Gilmour.

1977

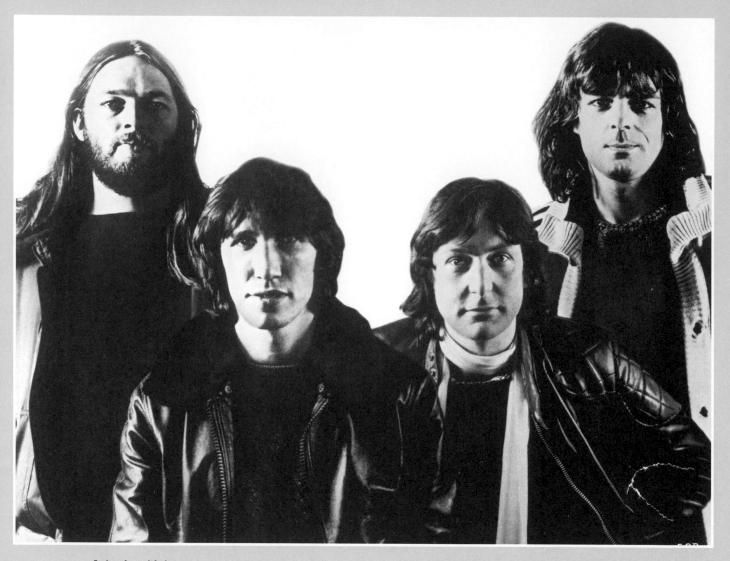

Animals, with its strong protest message, marked a new departure for Pink Floyd under Roger Waters's leadership.

A conceptual work following on from *The Dark Side of the Moon* and *Wish You Were Here*, which deal respectively with madness and absence, *Animals* is not a straight adaptation of George Orwell's *Animal Farm*, published in 1945, unlike David Bowie's album *Diamond Dogs* (1974), which is a kind of musical illustration of the novel *1984*. *Animals* is a much looser adaptation. In his novel, Orwell delivers a hard-hitting satire on the Bolshevik revolution, then on the Stalinist regime, by describing how the animals seize control of a farm hitherto run by men (all the more genuine since he himself was a passionate socialist activist). The revolutionaries are the pigs, commanded by old Major, who is modeled on both Marx and Lenin, and by Napoleon, who bears a strong resemblance to Stalin, these two having ousted Snowball, who is none other than Trotsky. There are other animals—horses, donkeys, sheep, and cows—and of course men, like Mr. Jones and Mr. Frederick, modeled on Nicolas II and Hitler respectively. One line alone sums up Orwell's masterpiece. It is one of the commandments laid down by the pigs: "All animals are equal but some animals are more equal than others."

Roger Waters borrows George Orwell's anthropomorphic approach, not to criticize Marxism-Leninism, but to launch an all-out attack on capitalist society, which he holds responsible for all society's ills—injustice, exploitation, inhibition, oppression. He espouses the theory developed by Pierre Bourdieu in Reproduction in Education, Society and Culture (La Reproduction) in 1970, which proposes that it is a characteristic of ideology that it sets out obvious facts as obvious facts. Waters divides liberal society into three classes: the pigs, which represent the capitalists, the corrupt ruling class that owns the means of production and embodies social success; the dogs, symbols of the middle and lower middle classes, which aspire to one day advance to the next level up—the dog dreaming of becoming a pig, so to speak; then there are the sheep, naturally the most numerous group, the vast proletarian masses who have no choice but to obey the pigs and the dogs. David Gilmour would remain rather doubtful about his bandmate's uncompromising view of society: "*Animals* I could see the truth of, though I don't paint people as black as that,"[9] he said.

David Gilmour, the musical force behind the album.

A Raw, No-Frills Brand of Rock

The music on the album matches the seriousness of the subject matter from which Roger Waters drew his inspiration and reflects the anger he felt in the face of his social observations. The change in musical style compared to the previous albums is striking. The psychedelic flavor of *The Piper at the Gates of Dawn*, the symphonic epic style of *Atom Heart Mother*, the mind-blowing soundscapes of *Meddle*, the pop aestheticism and prog rock of *The Dark Side of the Moon* and *Wish You Were Here*: these different musical facets that propelled Pink Floyd to the pinnacle of the rock hierarchy have been dispensed with in favor of a raw, no-frills brand of rock. Could it be the influence of punk? A new interest in heavy metal? Perhaps. But more than that it is the expression of a sense of outrage at what Britain had become—and of a frustration stemming from the troubled state of his private life. "I think I played well but I remember feeling not very happy or creative, partly because of problems with my marriage," Waters told a *Mojo* journalist in 1994. "It was the beginning of my writer's block."[39] In the

same magazine, David Gilmour stated that he himself was "the prime musical force" on *Animals*, whereas "Roger was the motivator and lyric writer."[39]

Although according to Nick Mason there was a better cohesion among the band members during the production of this new album, compared to the recording sessions for *Wish You Were Here*, there was also a growing sense of discord. Wright, who freely admitted to his own failings and his lack of involvement, for personal reasons, was critical of Waters's rigidity and his increasingly relentless autocratic style: "I think Roger was deciding, 'I'm gonna be the writer of Pink Floyd. I'm gonna write everything, and these guys are gonna be the musicians to play my stuff.' If you're thinking like that, you're gonna reject things. It's very sad that's the way it happened."[72] Gilmour, too, felt frustrated at the way the credits were allocated. Toward the end of recording, Waters proposed an addition: "Pigs On the Wing," a piece about three minutes long, which he decided to split in two and have it bookending the album. So in terms of royalties, he was adding two relatively short songs, and the royalties'

For Pink Floyd Addicts

Peter Watts, Pink Floyd's former road manager, immortalized both on the back of the sleeve of *Ummagumma* and by his various phrases and laughs on *The Dark Side of the Moon*, was found dead in Notting Hill, London, on August 2, 1976, following a fatal heroin overdose. Drawing lessons from their sad experience with Syd Barrett, the band members had checked him into a clinic to undergo treatment for drug addiction. But in vain.

split was based on the number of titles, not on their length. Gilmour protested on the grounds that "Dogs," the only song that he co-wrote but which is over seventeen minutes long, deserved to count for more than "Pigs On the Wing." "This was the kind of issue that would later prove contentious,"[5] Nick Mason commented.

Success this Side of the Sun

Pink Floyd's tenth studio album was released in the United Kingdom (and in continental Europe) on January 21, 1977, and then in the United States on February 10. On February 12, Angus MacKinnon, writing in *NME*, called it: "One of the most extreme, relentless, harrowing, downright iconoclastic hunks of music this side of the sun."[61] Karl Dallas, in *Melody Maker*, preferred to play the offbeat humor card, declaring: "Perhaps they should rename themselves Punk Floyd."[111] *Rolling Stone*, meanwhile, highlighted how the London foursome's music had evolved over time, and now had little in common with what they were playing in the good old days of the sixties (which reviewer Frank Rose thought was a shame): "In 1968 Floyd was chanting lines like: 'Why can't we reach the sun? / Why can't we throw the years away?' This kind of stuff may seem silly, but at least it wasn't self-pitying. The 1977 Floyd has turned bitter and morose."[112]

Despite the reservations expressed by *Rolling Stone* and a number of other rock magazines, *Animals* made it to number 2 in the United Kingdom and number 3 in the United States. It even reached the number 1 spot in several countries, including France, West Germany, Spain, and the Netherlands. In France, 800,000 copies were sold (200,000 more than in the United Kingdom!). David Gilmour later said that this record, from the outset, was aimed at a much narrower audience than their last two albums. "There's not a lot of sweet, sing-along stuff on it! But I think it's just as good, the quality is just as high."[9]

A mere two days after *Animals* came out, Pink Floyd set off on a long European tour, from January 23 to March 31 including West Germany, the Netherlands, Belgium, France, and the United Kingdom. That was followed by the North American tour (called "In the Flesh"), from April 22 to May 12, and then from June 15 to July 6.

The Sleeve: Algie in the Sky with Helium...

For the sleeve artwork, Storm Thorgerson and Aubrey Powell initially came up with two highly provocative illustrations. The first showed a child (seen from behind) watching his parents engaged in sexual intercourse ("copulating… like animals,"[1] as Thorgerson later put it). The second was a twisted version of an old British custom of hanging ceramic flying ducks on one's wall: in place of decorative birds, the two iconic figures from the Hipgnosis studio imagined real ducks, bought from the butcher's shop, nailed above a fireplace. These two proposals were immediately rejected by the four band members, and especially Roger Waters, who already had a very specific idea of what he wanted: Battersea Power Station, a power station built on the banks of the River Thames in the 1930s, already partially decommissioned at that time. "I like the four phallic towers,"[53] he said. For the songwriter, these four highly symbolic towers were synonymous with power and domination. He added later on that they also reminded him of a tortoise lying on its back with its four legs in the air, unable to move, and at everyone's mercy. According to Mason, the idea simply came to him as he passed the power station each day on his way to the studios.

Waters took his concept one step further: he imagined having a balloon in the shape of a pig flying above the power station as a "symbol of hope,"[1] as he later called it, in the sense that the kindly pig would appear to observe from a great height—and hence with detachment—the

1977

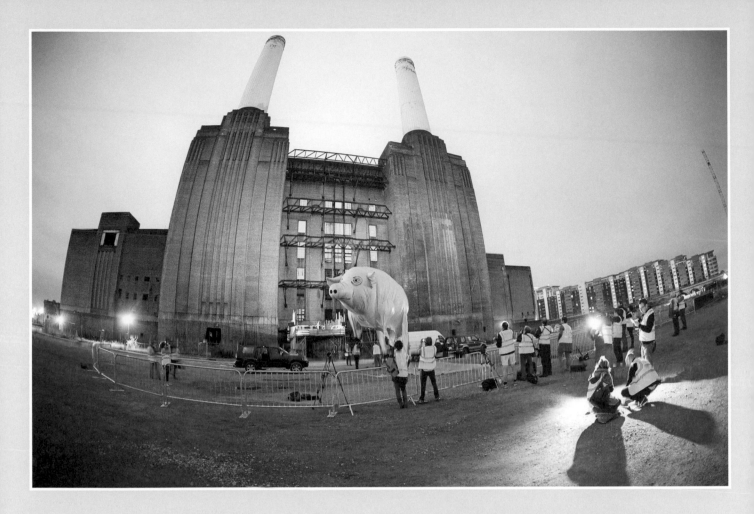

contradictions of the modern world, of capitalist society. So he asked the company ERG in Amsterdam to design an inflatable pig 30 feet long and 20 feet high, with the idea of shooting some cover images that would stick in people's minds. It was a German company, Ballon Fabrik, that was commissioned to make the pig, which very soon acquired the nickname Algie. Apparently, according to Nick Mason, this firm "had learnt their craft constructing the original Zeppelins!"[5]

The shooting turned out to be a lot more complex than anticipated, and did not go entirely smoothly. "Po and I had organised a veritable army of photographers (at least eleven of them)," Storm Thorgerson explained, "and had deployed them at key positions round the power station, covering nearly every conceivable angle, including the roof."[80] On the first day various technical problems prevented the balloon from being fully inflated. The following day poor Algie broke free due to a strong gust of wind and disappeared into the sky, where he sailed up to an altitude of 30,000 feet. Panic ensued! All flights at Heathrow Airport had to be canceled for several hours, and the inflatable was eventually recovered after it came down in a field near Godmersham in Kent. Pink Floyd's roadies were dispatched to collect it and brought it straight back to London. The third day brought a different problem: the cloudless blue sky over the Thames was not the backdrop Waters had in mind. So the decision

was taken to get around this problem by superimposing images from the third day (the inflatable pig above Battersea Power Station) onto images from the first day (cloudy sky).

Recording at Britannia Row

Animals was recorded between April and December 1976, not at the Abbey Road studios this time, but at Pink Floyd's own studio at 35 Britannia Row, Islington, North London. The three-story building bought by the band in 1975 was a former chapel that they converted for use as warehouses for their tour equipment (PA system, light shows), offices (with a billiards room) and, in particular, a fully-fledged recording studio (one that could bear comparison with the Abbey Road studio). So after the release of *Wish You Were Here*, Waters, Gilmour, Wright, and Mason had new premises at their disposal. They acquired state-of-the-art equipment and decided, having learned from their own experience, to make it intelligible to all who wished to use it. All the machines came with simple instructions in terminology accessible to anyone. No need now to spend hours searching for a headphone socket, as Nick Mason put it. The job of designing the studio went to Jon Corpe, a former friend from London Polytechnic on Regent Street. The design was quite stark: the control room was fairly cramped and not that inviting. The structure had been built from cinder blocks made of Lignacite, a composite of sawdust, sand, and cement that

The Korg VC-10 vocoder, the model probably used on *Animals*.

Brian Humphries, the sound engineer, had a foible that wound everyone up: he spent his time dusting the mixing console with an old cloth that he kept with him at all times like a comfort blanket. "Roger later had it framed," Nick Mason recounted, "and presented it to Brian after the completion of recording."[5]

is less reflective than brick. When he saw the final result, Roger Waters apparently exclaimed: "It looks like a fucking prison." Adding, "That's appropriate, I suppose…"[5]

There were multiple reasons for this move. Firstly there was the contract with EMI, which stipulated reduced percentages in exchange for unlimited time in their studios. Then there was the fact that the band wanted to own its own premises where it could record without time constraints, in the same way as artists like Pete Townsend or the Kinks. There were also personnel considerations, as Robbie Williams, one of the members of the management team, explained: "Brit Row was really started to give a reason to not fire the crew."[25] After all, Pink Floyd was an organization that employed a considerable number of people. Up until 1975 the band had toured for around nine months of the year. From now on it would be six months every two years. So Britannia Row was, to a certain extent, a way of making up for this lack of activity. The group was also hoping to turn this complex into a flourishing stage equipment company, whereby they would rent out their own equipment, which had been extremely expensive, allowing them to recoup the cost. But the project was not profitable, and the band members all ended up selling their shares, before Brian Grant and Robbie Williams took over the business in 1986 and made a success of it.

The sound engineer on the album—and in the studio—was Brian Humphries, who had already been heavily involved in the recording sessions for *Wish You Were Here*. But relations between him and the Floyd were becoming strained. It seems that Humphries found it hard to deal with the cramped confines of Britannia Row and the pressure of touring. Moreover his political opinions clashed with the band's more center-left stance, and he tended to express his views openly in Roger Waters's

presence, which only added to the awkward atmosphere. This would be the last studio album he would record with them. Nick Griffiths assumed the role of assistant sound engineer, but only toward the end of the sessions. A former BBC engineer, he would continue his collaboration with the band, working on *The Wall*, especially, but also on Gilmour's and Waters's solo albums.

When the band assembled at Britannia Row, Roger Waters had not yet decided on the concept for the album. The group started by reworking two songs they had composed nearly two years earlier during rehearsals in King's Cross in January 1974: "Raving and Drooling," which was to become the song "Sheep"; and "You've Gotta Be Crazy," which ended up as "Dogs"[1]; as well as a recent Waters composition entitled "Pigs On the Wing," which he presented to the band toward the end of the recording sessions, and which, in the end, he decided to split in two. The recording of *Animals* left Nick Mason with better memories than that of *Wish You Were Here*. Rick Wright was happy with the quality of his keyboard playing, despite the feeling of having been excluded from the creative process by Roger Waters and the fact, he eventually admitted, that he "didn't really like a lot of the music on the album."[25]

This time there were no outside musicians involved in the sessions. The sax parts by Dick Parry and the backing vocals by the fantastic backing singers, which had lit up the last two opuses, would not be making a return. However, a new guitarist was recruited to assist David Gilmour in their concerts, which were increasingly turning into mammoth events. This was Terence "Snowy" White, a talented musician who would tour with the Floyd until the eighties before joining Thin Lizzy. He went on to work on Richard Wright's *Wet Dream* album in 1978, and accompanied Roger Waters on numerous solo tours.

Technical Details

The recording equipment at Britannia Row marked a break from what they had been used to at Abbey Road. No more EMI or Neve consoles or Studer tape recorders. The band decided to go with an MCI JH-440 custom console (with equalization specifically requested by Roger Waters), an MCI twenty-four-track tape recorder (with DBX N/Rs), but also a four-track and a two-track (again MCI), three Revoxes (presumably A77s), a Nakamichi cassette recorder (1000 or 700), together with UREI 1176 compressors, Lexicon 102 digital delays (coupled together), Eventide H910 harmonizers, and four powerful JBL 4350 speaker cabinets. It seems the decision to opt for an MCI console instead of a Neve was prompted by a lack of funds at the time, since firstly the band had made some bad investments, and secondly it was still waiting to collect its royalties from *The Dark Side of the Moon*.

The Instruments

Roger Waters still played his Fender Precision basses, particularly the black one, having replaced its white pickguard with a black one as Gilmour had done on his "Black Strat." For the first time he also used an Ovation Legend acoustic guitar, just like Gilmour, incidentally. The latter still favored his "Black Strat" fitted with DiMarzio pickups. He also used a Heil Sound Talk Box from Dunlop, and probably the guitar effects pedal board made by Pete Cornish (which enabled all the effects pedals to be brought together in one place with one central connection) with, among other things, a Big Muff V2 "Ram's Head." Although this pedal board proved useful in concerts, it was less so in the studio. Gilmour also recorded with a 1959 Fender Custom Telecaster, plugged in to a Hiwatt DR-103 amp and a Yamaha RA-200 rotating speaker (similar to a Leslie cabinet). Rick Wright, meanwhile, continued to add new instruments to his keyboard collection, including a Hammond B-3 organ and a Yamaha C7 grand piano. There was one synthesizer that particularly made its mark: the vocoder. This piece of equipment, generally used for voice, allows you to achieve a robotic effect. The model the band used may have been the Korg VC-10 vocoder or the EMS Synthi Vocoder 5000, although various people have claimed that there was a Korg at the sessions, despite the fact that these weren't produced until a later date (1978). Could this have been a prototype?

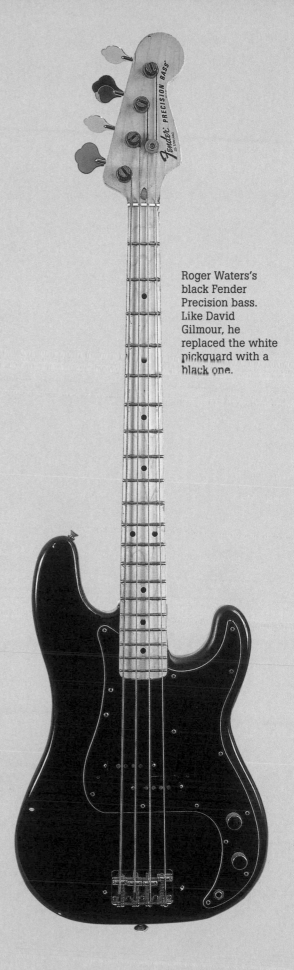

Roger Waters's black Fender Precision bass. Like David Gilmour, he replaced the white pickguard with a black one.

Pigs On The Wing 1

Roger Waters / 1:26

Musician
Roger Waters: vocals, acoustic guitar
Recorded
Britannia Row, Islington, London: April–December 1976
Technical Team
Producer: Pink Floyd
Sound Engineer: Brian Humphries
Assistant Sound Engineer: Nick Griffiths

The song's title comes from an expression used by fighter pilots to refer to an enemy, which has since entered into common parlance, referring to a hidden enemy or an undesirable.

The guitarist Snowy White, whose solo was dropped when "Pigs On The Wing" was split into two parts.

Genesis

Roger Waters composed "Pigs On the Wing" several months prior to the start of the *Animals* sessions, but it was only at the end of the sessions that he decided to record it, then to divide it into two parts (as had been done previously with "Shine On You Crazy Diamond"), with one part placed at the beginning of the album (part one) and the other at the end (part two). This acoustic ballad added at the last minute breathes a small dose of optimism into this unapologetically somber, even depressing album. "A touch of romanticism in a world of brutes" might have made a good subtitle for this song, an ode to Waters's new wife Carolyne Christie, who came into his life and into his heart after the torments of his separation from his first wife, Judy Trim.

The granddaughter of Lawrence John Lumley Dundas, the 2nd Marquess of Zetland, Carolyne Christie was a member of the British aristocracy, a world until then totally foreign to Pink Floyd's songwriter. She was also a dedicated fan of rock music who had worked for Atlantic Records and for producer Bob Ezrin. When she met Roger Waters, Carolyne was still married to Rock Scully, the manager of the Grateful Dead. It all happened very quickly after that, and Harry (Waters's first child) was born on November 16, 1976.

Not only had Roger Waters found love again—"Pigs On the Wing" is in fact one of Pink Floyd's first real love songs—Carolyne Christie also above all brought a sense of balance. In a way, she prevented him from straying from his chosen path by abandoning himself to all the *excesses* of rock stardom, from betraying himself, from lapsing into the kind of behaviors he used to criticize, starting with consumerism. Essentially, from turning into a "pig" himself. She is *a shelter from pigs on the wing*, his defense against *boredom and pain*, a sister soul who would enable him to overcome adversity and tolerate society's ills.

Production

The piece begins with Roger Waters on his own. He sings with simplicity, accompanying himself with strumming on his acoustic guitar, an Ovation Legend. It has something of Bob Dylan, or John Lennon (Plastic Ono Band) feel about it. The guitar and vocal are recorded in mono, and only the reverb is in stereo.

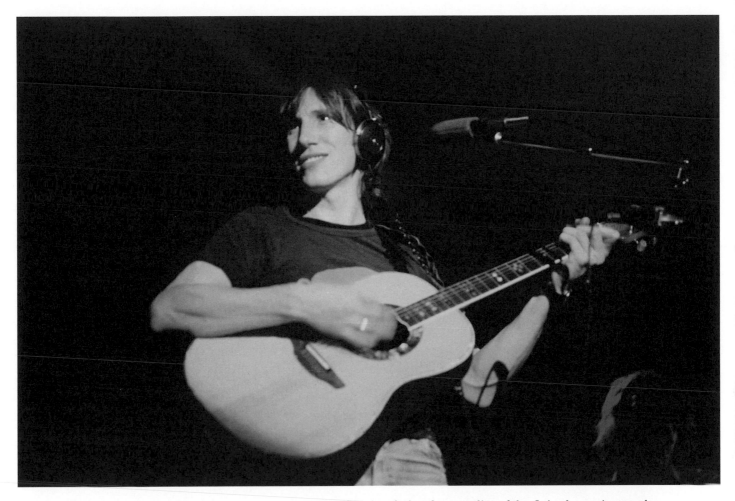

Roger Waters swapped his Fender bass for an Ovation acoustic guitar during the recording of the *Animals* opening number.

"Pigs On the Wing," the first track on *Animals*, was recorded as a single piece, and it was only afterward, at the very end of the sessions, that it was decided to split it in two. The piece initially included a guitar solo that formed a bridge between the first and the second parts. Unfortunately, while Brian Humphries was taking a break from recording, Waters and Mason, who were sitting at the console, inadvertently deleted this solo that Gilmour had just put down. Realizing their mistake, the musicians decided to ask Snowy White, who had just entered the control room, whether he would be able to rerecord it. White was a guitarist who had been engaged by Steve O'Rourke to assist Gilmour onstage. As Nick Mason related: "Snowy was given a cursory interview by David ('You wouldn't be here if you couldn't play, would you?') and later Roger ('Since you're here you might as well play something'), who gave Snowy a shot at a solo on

"Pigs On The Wing," a part [unfortunately] made redundant when the track was split in two for the final album."[5] Snowy White's very good solo (forty-nine seconds!), played on his 1957 Gibson Les Paul Goldtop through his Vox AC30 amp, can be heard in its entirety in the initial, untruncated version of "Pigs On the Wing," which was released as an eight-track cartridge in February 1977 (Harvest/EMI Records 8X-SHVL 815).

One small technical detail: since the two parts were originally one, how can it be, one wonders, that Roger Waters ends the section "Pigs On the Wing 1" with a final chord? One would expect this section to end on a guitar fade-out. Probably what happened was that the ending of the second part, which finishes cleanly, was copied and added at this precise point. Unless Waters replayed that concluding chord to round off the album's opening number.

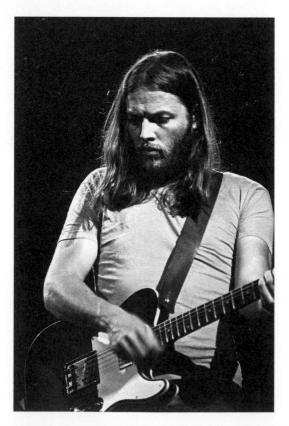

IN YOUR HEADPHONES

During Gilmour's first guitar solo, at 2:19, we hear jubilant cries and laughs, which seem to come from Waters.

Dogs

David Gilmour, Roger Waters / 17:05

Musicians
David Gilmour: vocals, vocal harmonies, acoustic guitars, electric rhythm and lead guitars
Rick Wright: keyboards
Roger Waters: vocals, vocal harmonies, bass
Nick Mason: drums
Unidentified Musicians: VCS3, vocoder, sound effects
Recorded
Britannia Row, Islington, London: April–December 1976
Technical Team
Producer: Pink Floyd
Sound Engineer: Brian Humphries
Assistant Sound Engineer: Nick Griffiths

David Gilmour, on his 1959 Fender Telecaster Custom, composer of this new version of "You've Gotta Be Crazy" from 1974.

Genesis

"Dogs" is the only song on *Animals* not credited solely to Roger Waters. It was actually composed mainly by David Gilmour: "I basically wrote all the chords—the main music part of it," he told a journalist in 1993. "And we [Roger and I] wrote some other bits together at the end."[29] This second track, the album's real pièce de résistance, is actually a new version of "You've Gotta Be Crazy," a piece dating from the January 1974 sessions in the King's Cross studios, which Gilmour had wanted to record for *Wish You Were Here*, though it didn't work out at the time. The bassist modified the lyrics to make them fit his new conceptual approach, turning them into a biting satire on capitalism.

The dogs, as mentioned earlier, symbolize the middle- and lower-middle classes. You could say there are two kinds of dogs in this song: the first in the section played by David Gilmour at the beginning, and the second in the section played by Roger Waters. The first kind that Waters targets is the opportunist class, those prepared to do anything to scale the social ladder and haul themselves up to the level of the pigs; those that can pick out the *easy meat*, and *strike when the moment is right without thinking*, and who lie to those who trust them, but whose lives end in loneliness or illness.

The second category, to which the narrator of "Pigs On the Wing" seems to belong, is that of the dogs that have turned into pigs. Again they are described in uncompromising terms: *broken by trained personnel, a stranger at home, found dead on the phone, dragged down by the stone.* The stone being the burden of life? Or the burden of remorse? One thing is for sure: Waters adopts a venomous tone as he savages a political and economic system, a dominant ideology, which, as he sees it, invariably leads to repudiation and alienation. He calls for some kind of awakening, for the mind to triumph over the forces of profit.

Production

The difference between "You've Gotta Be Crazy" and "Dogs" is not as striking as one might imagine, except for the end of the piece, which has been extensively reworked, and the key, which is a tone lower. The song has been taken down from E minor to D minor, forcing Gilmour to tune his

The Beat Generation writer Allen Ginsberg, from whom Roger Waters would take inspiration on "Dogs."

acoustic and electric guitars a tone lower. "It was fundamentally the same song, but the lyrics changed a little to suit the 'Animals' concept," he later said. "I did one or two very nice, slightly different, guitar solos on it that I was quite pleased with."[29] The live version from 1974 (which can be found on the CD *Wish You Were Here [Experience Edition]*, released in 2011) feels generally much closer in style to *Wish You Were Here*, or even *The Dark Side of the Moon*. The *Animals* version is colder, harder, but just as remarkable. The Pink Floyd sound was evolving, probably due in part to technological advances, but also to the punk wave, which had an undeniable influence. The internal strife that was brewing at Britannia Row also contributed to their new musical approach, which was sharper and more cutting. This epic lasting over seventeen minutes—this would be the last piece of that kind of length in the Waters era—is quite unusual in terms of harmonics, with a chord progression more reminiscent of progressive bands like Yes or Genesis.

"Dogs" opens with the sound of David Gilmour's acoustic guitar, his Ovation Legend (taken down a tone). It is double-tracked, laid down in stereo, and is faded in. Rick Wright comes in with his organ playing chord tones, rather in the style of "One of these Days." The sound, which switches from left to right, resembles the Farfisa, but is more likely to come from his Hammond B-3. Then Gilmour takes the lead vocal. His singing is as excellent as usual, the key still rather high for him (despite it having been lowered by a tone), but it enables him to express himself with both power and fragility, in the very same way Waters does. The sound is clean, with only a slight delay audible. Cymbals (with inverted effects), bass, and electric rhythm guitar put in an appearance, marking the end of the first verse, before Nick Mason comes in on the drums. His playing has much more of a groove to it than on *Wish You Were Here*; we sense he is enjoying his playing, despite the fact that the sound recording is perhaps not as good as on the previous albums.

David Gilmour performs an initial guitar solo at the end of the second verse (from 1:50 onward). In his own words: "[it was] a custom Telecaster. I was coming through some Hiwatt amps and a couple of Yamaha rotating speaker cabinets—Leslie style cabinets that they used to make."[29] His playing is markedly different from previous recordings: it is more aggressive, more jazz-rock, distorted by his Big Muff and heavily tinged by his Yamahas. And, as ever, his touch is what makes all the difference. The solo is a success, demonstrating his absolute mastery of his instrument. His bandmates won't be outdone, though: Waters provides a very good bass line that feels taut and sinewy (and is slightly undermixed), Mason adds some overdubs of tom-toms and crash cymbals, and Wright sustains the harmony with a generous B-3 part.

The third verse (at 3:00) is followed by the first instrumental sequence. Wright plays a solo on the Minimoog, and Gilmour's electric rhythm guitar (his Strat?) comes more to the fore, with a very pronounced Leslie effect from his Yamahas. Gilmour then launches into a melodic motif on his Telecaster, which he harmonizes on a second track (from 3:42). Responding to these two guitars is a third guitar (with reverb and with some Binson Echorec), played in descant. Wright brings in his Fender Rhodes piano and his ARP Solina to support Gilmour with layers of strings.

Rick Wright on a Hammond organ B-3, about to launch into a solo on a Minimoog for the third verse of "Dogs."

IN YOUR HEADPHONES
Between 5:17 and 5:24, some electronic interference is audible, probably coming from Gilmour's Ovation.

This part then gives way to the acoustic guitars, doubled in stereo as in the introduction, and fully foregrounded. Gilmour is strumming chords, Wright is still on the Rhodes, and Waters is on the bass. The sound of dogs barking can be heard (from 4:50), sinister and desolate. Now comes the second Telecaster solo, Gilmour as brilliant as before, proving himself once again as one of the best guitarists of his generation. It is interesting to note, though, that he places less emphasis on the melodic aspect of his lines than in the past, focusing rather on technique and energy.

Then it's back to vocals, with Gilmour, who sings the whole of the fourth verse and harmonizes with himself. He adds rhythmic power chords, and ends his lead vocal on the word *stone*, which is repeated about fifty-six times before finally fading away. These repetitions are not perfectly matched to the tempo. This central section, which is purely instrumental, is one of the strengths of "Dogs." The atmosphere is oppressive, partly due to the constant repetition, but also because of the multiple string tracks from the ARP, which produce a swirling effect (Leslie cabinet), and the percussion, which emphasizes the rhythm with a ride cymbal and a bass drum with reverb marking the start of each bar (it's in 6/4). The sound of the bass drum is very compressed, perhaps a little too much, producing a less-well-rounded overall effect. At 9:18 the barking of dogs is heard again before being repeated by a vocoder and fed through a Leslie (or the Yamaha rotating cabinets). The effect is supposed to lend the signal a "robotic" character, but the execution on the record is not particularly spectacular. (Some thought that it was Wright's keyboards that are repeated by the vocoder, but it definitely is the dogs.) This sequence is followed by a solo part on the Minimoog, featuring effects produced by a VCS3. Someone whistles to the dogs at 10:50, and they reply, still through the vocoder.

The piece moves on into the last two verses. Waters's lead vocal is excellent. His voice is taut, charged with emotion, and the message is clear: sooner or later the dogs will be forced to pay for the choices they have made, and will have to fight to survive. Gilmour follows him with a very impressive last solo, not unlike Steve Howe's in its phrasing and sound, which he concludes by harmonizing his guitar with various parts (listen at 13:55). He explains: "The last line of the first solo, I believe, [Wrong! It's the third line!] is a three-part descending augmented chord. Which is quite nice, and I was very proud of it; I thought it was very clever."[29] But before he arrived at this definitive version, Waters had had the unfortunate idea of putting himself behind the console, and, as had happened with the solo for "Pigs On the Wing," he deleted what Gilmour had just recorded. "I had to re-create it,"[29] Gilmour later commented… But asked whether it had been done deliberately, he replied without hesitation: "By mistake, by mistake."[29]

After a repeat of the melodic theme harmonized on two guitars, the final sequence of "Dogs" is sung by Roger Waters, who takes a moralizing tone similar to that of "Eclipse" on *Dark Side* (from 15:20). This final section is colder and more violent than in the "You've Gotta Be Crazy" version. In the 1974 version, there were backing vocals sung by Gilmour and Wright in answer to Waters, giving the piece a spiritual quality that it no longer has, which is a shame.

"Dogs" is certainly one of the standout tracks on *Animals,* illustrating a noticeably different musical approach that is more aggressive than before. We sense a shift toward a more Waters-led feel, even though Gilmour composed the majority of the music. The latter delivers a convincing demonstration of his talents as a first-rate guitarist, at the same time revealing a more rugged side to his playing. Wright's and Mason's contributions are still just as essential to the Pink Floyd sound.

1977

Pigs
(Three Different Ones)

Roger Waters / 11:26

Musicians
David Gilmour: electric rhythm and lead guitars, bass guitar, sound effects
Rick Wright: Hammond organ, ARP Solina, piano, clavinet (?), Minimoog (?) VCS3 (?)
Roger Waters: vocals, vocal harmonies, VCS3 (?)
Nick Mason: drums, cowbell

Recorded
Britannia Row, Islington, London: April–December 1976

Technical Team
Producer: Pink Floyd
Sound Engineer: Brian Humphries
Assistant Sound Engineer: Nick Griffiths

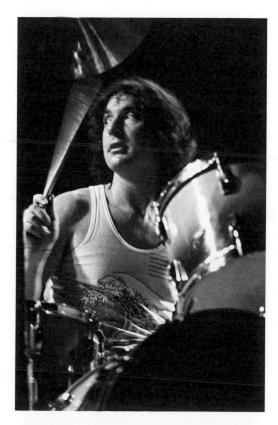

Nick Mason. His drumming is a key part of the Pink Floyd sound, particularly on "Dogs."

Genesis

In this song Roger Waters continues his attack on liberal society. Three verses—presenting three types of pigs he loathes. The first is the businessman, whom we imagine all buttoned up in his three-piece suit, smoking a cigar, and drinking a well matured whiskey while checking the share prices in the newspaper. *When your hand is on your heart/ You're nearly a good laugh/Almost a joker*, Waters writes. But in reality, these kinds of people make him want to weep.

In the second verse the songwriter targets not a social class, but a person—a woman he has seen at the bus stop. A *fucked up old hag* who likes *the feel of steel* and who is *good fun with a hand gun*—in other words a woman devoid of all humanity. Did he have someone particular in mind? The figure that springs to mind is Margaret Thatcher, who, although not yet prime minister when Waters wrote this song, had already been elected leader of the Conservative party and, in particular, had been nicknamed the "Iron Lady" by the Soviets on account of her anticommunist stance, not to mention her fierce determination to crush the power of the trade unions, which she claimed were guilty of stifling growth in the United Kingdom.

In the third and final verse, which is just as vitriolic, there is no doubt this time as to the person being accused, as Roger Waters names her outright: the *house proud town mouse* is none other than Mary Whitehouse, an impassioned campaigner for a return to the puritan values of old England, bitterly contemptuous of homosexual minorities and so lacking in humor, or any sense of proportion, that in one fiery outburst she condemned the violence of the *Doctor Who* series and of the film *A Clockwork Orange* (1971) by Stanley Kubrick and the pornography of *Last Tango in Paris* (1972) by Bernardo Bertolucci. Mary Whitehouse was someone who had made it her mission to ward off the forces of evil, and who would not have been opposed to the establishment of a theocracy on British soil. Which was why she became the object of Waters's bile!

Production

"Pigs (Three Different Ones)" was the only song, other than "Pigs On the Wing" (parts one and two) written specifically for the new album, as the two others dated from the

Wish You Were Here period. Roger Waters was the sole writer-composer of this piece lasting more than eleven minutes. But the contributions of the other band members were vitally important in creating the alchemy necessary to the wholly unique language they had jointly developed.

The piece opens with the grunt of a pig, produced by David Gilmour's Heil Sound Talk Box. This effect, which was popularized in the early seventies by musicians such as Stevie Wonder and Peter Frampton, allows a performer to modulate the notes of an instrument such as a keyboard or guitar using his mouth and a pipe connected to the box and the amplifier. So it is an imitation of a pig's grunt—repeated over and over by a delay with a very long feedback—that marks the start of "Pigs (Three Different Ones)." This is followed by a sound produced by a synthesizer (Minimoog or VCS3) with an identical delay. Rick Wright on the Hammond organ gets the piece properly under way with two arpeggio parts opposite each other in the stereo picture. Then comes a bass solo, the phrasing giving away the fact that it is definitely not Roger Waters playing, but a guitarist, in this case David Gilmour. It was he who wrote this part, even though he doesn't get a mention in the record credits. His bass line is very melodic and his playing is technically superior to Waters's. It is hard to pin down what type of bass it is played on; it is most likely the Fender Precision, but certain tones are also reminiscent of a fretless (such as a Charvel P-Bass). Gilmour has various guitar parts elsewhere, notably in the introduction, where he comes in with some almighty chords on his "Black Strat," distorted by his Colorsound (doubled by ADT).

It is Roger Waters who takes the lead vocal. His confidence is such, since *Wish You Were Here*, that he automatically awards himself the lead vocal in the bulk of the songs where he is the main writer. His singing is different from Gilmour's, more highly sensitive, more urgent. He sings four of the five tracks on *Animals*, and on the next two albums

Gilmour concedes this role, which had previously been his own, to Waters almost entirely. Pink Floyd has a different view of things now; their music has a very different feel about it than at the start of their career. Waters is supported by an excellent rhythmic section performed by Nick Mason, who is in top form; by Gilmour's Strat and bass; and probably by Wright on the Clavinet. After the first three lines of the verse, Mason—for the first time in the band's history (in such an obvious manner)—brings in a cowbell, the effect of which is absolutely superb. Wright backs him up on the grand piano, the Yamaha C7, with a boogie-style passage; Gilmour adds a second rhythm guitar, and Waters performs a very good vocal, his voice equalized and fed through most probably a Leslie (or the rotating Yamahas) with very short reverb (not done with a vocoder). Then comes an interlude in which Gilmour plays some very high notes that he introduces with his volume pedal (or the volume dial on his Strat), featuring a delay and very long reverb (from 2:29).

After the second verse a rhythm guitar played clean and heavily colored by the Yamaha rotating speakers launches into the first instrumental part. Again grunting noises can be heard. Then Gilmour embarks on an unbelievable solo, performed on his Heil Talk Box (from 5:13). He also contributes other rhythm guitar parts, while Mason pounds his Ludwig, with Wright supporting on the Hammond organ and the ARP Solina. The effectiveness of Gilmour's bass line is striking, his playing so different from that of Waters (listen at 6:45, for example).

At the end of the solo we hear a repeat of the introduction, Wright's Hammond organ not double-tracked this time. Waters resumes the lead vocal in the last verse, with voice effects added, Mason is back on his cowbell (as superb as ever!), Wright is on his grand piano, and Gilmour is on his various rhythm guitars and the bass all at once. Finally Gilmour plays a truly magnificent chorus on his "Black

1977

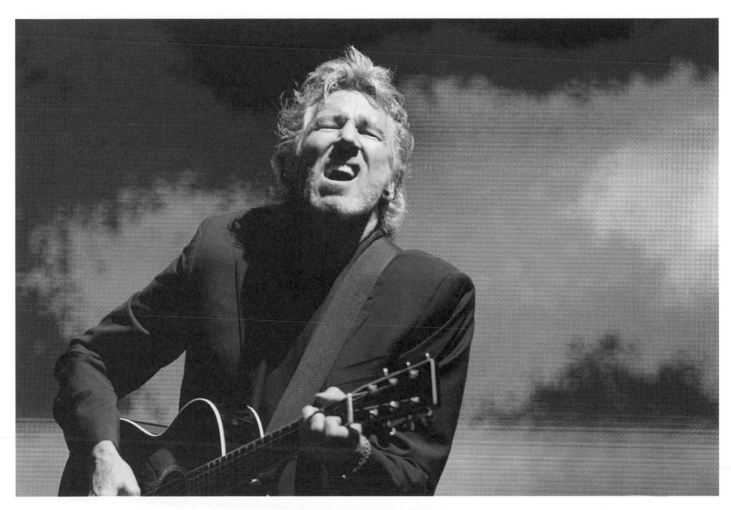

Roger Waters at the Coachella Festival in 2008, where he performed a version of "Pigs."

Strat," distorted by his Big Muff. He has now abandoned for good the soaring pedal steel guitar passages that had graced *Meddle* and *The Dark Side of the Moon*, especially, in favor of a hard, aggressive playing style. In fact he acknowledged this later, in 1978, commenting that "that seemed to work at the time and appeared a reasonable thing to do."[9] His bass playing is once again beautifully done, going up and down the scale to great effect (listen at 10:12). The piece ends on a fade-out, gradually giving way to the sound of birds and sheep, which usher in the next song, "Sheep."

"Pigs (Three Different Ones)" is interesting in that it clearly demonstrates the role of each band member at this stage in the group's career. Waters had indisputably appointed himself the band's leader, his bandmates reduced to the role of accompanists. With one exception: Gilmour, who stood up for himself, managing to get his name on one piece ("Dogs") and to hold his own with his brilliant instrumental contributions. Waters, unlike his bandmates, always considered the lyrics to be paramount. Indeed he made this point in numerous interviews, as in 2004: "I think [Rick] liked to think of himself as a kind of musical purist. As did Dave."[113] "Pigs (Three Different Ones)" is a good example of this: he had no qualms about abandoning his bass, to Gilmour's benefit, but he was determined to perform his lyrics. Ideas above all else.

Sheep

Roger Waters / 10:19

Musicians
David Gilmour: rhythm and lead guitars, bass
Rick Wright: keyboards, VCS3 (?)
Roger Waters: vocals, rhythm guitar, VCS3 (?)
Nick Mason: drums
Unidentified: vocoder voice

Recorded
Britannia Row, Islington, London: April–December 1976

Technical Team
Producer: Pink Floyd
Sound Engineer: Brian Humphries
Assistant Sound Engineer: Nick Griffiths

This was the first time Waters had recorded a rhythm guitar part. He probably played a Fender Stratocaster.

Genesis

The original version of "Sheep," like that of "Dogs," dates back to January 1974. At the time it was entitled "Raving and Drooling." A song with a rather hazy message, perhaps about insanity, with the character caught in a trap between *the illusion of safety in numbers/And the fist in your face.* It was performed for the first time on the French tour for *The Dark Side of the Moon* in 1974. Abandoned even before the recording of *Wish You Were Here*, this composition resurfaced during the *Animals* recording sessions at Britannia Row in Islington, this time entitled "Sheep."

Waters talks about sheep, the working classes, the followers, described as meek, fearful animals under the influence of the so-called higher classes, the pigs and the dogs. *You better watch out/There may be dogs about*, he sings. The criticism evidently has no other aim than to rouse these working classes, to incite them to rebel against something that is by no means inexorable, *to get out of the road if you want to grow old.* "It was my sense," Roger Waters explained to Karl Dallas, "of what was to come down in England, and it did last summer with the riots in England, in Brixton and Toxteth…Probably that it had happened before in Notting Hill in the early sixties. And it will happen again. It will always happen. There are too many of us in the world and we treat each other badly. We get obsessed with things and there aren't enough things, products, to go round. If we're persuaded it's important to have them, that we're nothing without them, and there aren't enough of them to go round, the people without them are going to get angry."[104] For the songwriter, the sheep are oppressed perhaps not just by economic and political forces, but by religious forces as well. Why else, in the middle of the song, would he have a robotic voice recite this parody—not without humor—of Psalm 23: *The Lord is my shepherd, I shall not want/He makes me down to lie […] With bright knives He releaseth my soul […] He converteth me to lamb cutlets.* Why else would he again evoke the inevitable revolt that is brewing: *When cometh the day we lowly ones,/Through quiet reflection, and great dedication/Master the art of karate,/Lo, we shall rise up/And then we'll make the bugger's eyes water.* Roger Waters sees himself as belonging to the class of the sheep: like a lost sheep, one might add…

Production

"Sheep" opens with a fantastic solo by Rick Wright on the Fender Rhodes lasting more than ninety seconds. His notes seem to float above a rural ambiance composed of birdsong and the baaing of sheep, continued from the end of "Pigs (Three Different Ones)." The phrasing is bluesy and his playing is supported by a hypnotic tremolo. David Gilmour would later say that *Animals*, with its harder, more aggressive edge than the previous albums, had probably left Wright, who "didn't feel it suited so well,"[9] struggling to express himself. However, this introduction is delightful and reminds us what an inspired musician Wright was. A bass accompanies him from the sixth bar onward. The motif contains a hint of the *Doctor Who* theme tune, the British cult TV series having already been a source of inspiration on "One of These Days" (*Meddle*). It is David Gilmour's playing we hear, as on "Pigs (Three Different Ones)." And he is most probably on his Fender Precision, the sound colored by an MXR Phase 90. But, unlike in the previous piece, his playing bears a strong resemblance to Waters's. Gilmour would later explain that he had in fact partly copied the bass line that Waters used to play onstage for "Raving and Drooling." This can be heard on the live recording from 1974, which features on the CD *Wish You Were Here [Experience Edition]*, released in 2011. Incidentally, for the concerts on the British Winter Tour that same year (November 4 to December 14), Waters took a recording of Jimmy Young, the famous BBC radio DJ, cut it up and randomly reassembled it, and played this at the shows to represent his idea of a man "raving and drooling"—a madman, in other words.

Nick Mason comes in with some inverted drum effects that lead into the first verse, sung by Roger Waters. His voice is taut, aggressive, and the tempo is very dynamic, contrasting with the serenity of the introduction. The last words of some lines of the verses are mixed and drawn out with a note on the Minimoog (or the VCS3?), adding an artificial emphasis. Wright has switched to the Hammond organ, and Gilmour is on the rhythm guitar, probably his Telecaster (as on "Dogs"). What's new here is Waters on electric rhythm guitar ("Black Strat"?), which he double-tracks with the two guitars in stereo. He mirrors the bass line, and the two instruments slot effectively into Mason's very good drum part.

The first instrumental break comes at 3:47, against a background of sound effects, probably slowed down, which suggests the sound of chains or a spinning cylinder. The bass creates tension with a repeated F note alternating with an E an octave higher, which rises in a crescendo, while chords on the guitar and Hammond organ ring out in this almost surreal atmosphere. The word *stone*, which was repeated over and over in "Dogs," makes a brief, ghostly appearance (between 4:06 and 4:20), before giving way to a synthesized bass sound produced almost certainly on the VCS3. This sequence continues with the Minimoog coming more to the fore, and a repeat of the rhythmic section led by Mason.

Then comes a second instrumental break (at 5:33). The tension mounts a notch. Gilmour's bass is increasingly foregrounded. Wright plays a motif on the Minimoog, which he harmonizes on two tracks opposite each other in the stereo picture, with strings from the ARP Solina forming the background soundscape. Next we have a series of organ chords that seem to pre-echo "Don't Leave Me Now" from the album *The Wall* (from 6:10). Eventually, as if rising out of the darkness, comes a monotone voice distorted by a vocoder, reciting a parody of Psalm 23. It works well, with the baaing effect adding to the caricature. At concerts it was Nick Mason's voice that was heard here, but on the album it would definitely have been a roadie or a studio technician who, unfortunately, is not identified.

The piece carries on with a repeat of the third verse and some excellent singing by Waters, who isn't afraid to let it rip with a demonic scream and laugh (at 7:24). "Sheep" then concludes with a final sequence led by Gilmour on his Telecaster. He delivers a superb chord-based melodic motif (doubled) with an epic quality to it, not unlike that of some of Jimmy Page's guitar parts (for example, on "The Song Remains the Same"). The piece ends on a fade-out, as the pastoral flavor of the introduction returns with the sounds of birds and sheep, bringing us to "Pigs On the Wing 2," the last song on the album.

Pigs On The Wing 2

Roger Waters / 1:29

Musician
Roger Waters: vocals, acoustic guitars
Recorded
Britannia Row, Islington, London: April–December 1976
Technical Team
Producer: Pink Floyd
Sound Engineer: Brian Humphries
Assistant Sound Engineer: Nick Griffiths

Genesis

The second part of "Pigs On the Wing" provides some answers to the questions posed by Waters in the first part. His partner—in this case his second wife Carolyne Christie—is there to guide him and keep him on the right track. Interviewed by Karl Dallas, Waters explained that the first verse amounts to a contemplation of the question "Where would I be without you?" while the second verse says, "In the face of all this other shit—confusion, sidetracks, difficulties—you care, and that makes it possible to survive."[104] So thanks to Carolyne, Waters will not become a dog or a pig, nor will he be submissive in the way so many sheep are. This ballad that rounds off the album is therefore the simple, powerful story of a mutual love that enables Waters and his wife—like all couples who love and respect each other—to avoid loneliness, of course, but also boredom and pain. It is from this love that he draws all his strength and which protects him from the "pigs on the wing."

Production

This second part follows on from the pastoral sounds of sheep and birds at the end of "Sheep." Roger Waters adds a second guitar, with the two instruments positioned to give panoramic sound. His voice is noticeably more foregrounded than in the first part, probably to draw more attention to the meaning of his words, to reveal his feelings a little more. He seems to be doubling himself, although the effect is hard to pick out. The reverb is shorter, emphasizing the presence of his vocal. And the last track of *Animals* ends as it began: simply, and with feeling.

For Pink Floyd Addicts

It was Carolyne Christie's suggestion that Roger Waters approach Bob Ezrin to produce Pink Floyd's next album, *The Wall*.

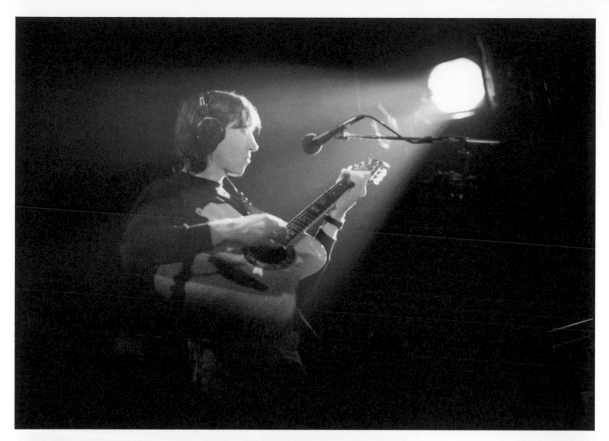

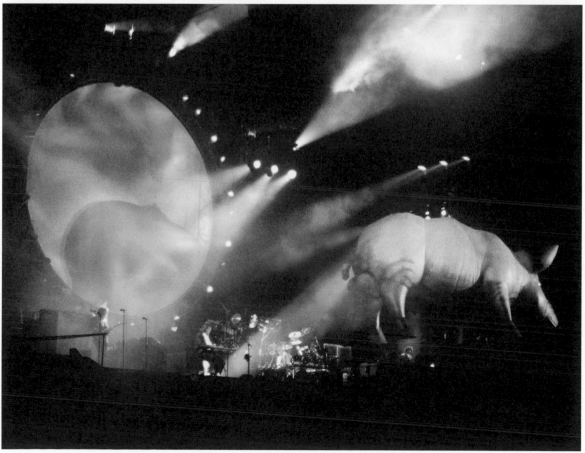

Top: Roger Waters on the acoustic guitar for "Pigs On the Wing (Part 2)."
Bottom: The flying pig, an iconic feature of Pink Floyd concerts in the '70s and '80s.

THE WALL

ALBUM

THE WALL

RELEASE DATE

United Kingdom: November 30, 1979

Label: Harvest Records
RECORD NUMBER: SHDW 411

Number 3 (United Kingdom), on the charts for 67 weeks
Number 1 (France, United States, Canada, the Netherlands, West Germany, Sweden, Norway)

In The Flesh ? / The Thin Ice / Another Brick In The Wall, Part 1 / The Happiest Days Of Our Lives / Another Brick In The Wall, Part 2 / Mother / Goodbye Blue Sky / Empty Spaces / Young Lust / One Of My Turns / Don't Leave Me Now / Another Brick In The Wall, Part 3 / Goodbye Cruel World / Hey You / Is There Anybody Out There ? / Nobody Home / Vera / Bring The Boys Back Home / Comfortably Numb / The Show Must Go On / In The Flesh / Run Like Hell / Waiting For The Worms / Stop / The Trial / Outside The Wall
OUTTAKES What Shall We Do Now ? / Sexual Revolution

The movie *The Wall* was directed by Alan Parker and featured Bob Geldof in the role of Pink. It was screened "out of competition" at the Cannes Film Festival on May 22, 1982, and was released in France and the United Kingdom on July 14 and in the United States on August 6. Some of the songs from the album were specially rerecorded for the movie.

The Wall, Roger Waters's Epic Psychological Journey

Coming off the 1977 promotional tour for *Animals* (christened the "In the Flesh Tour") that had begun in Europe (January 23 to March 31) before moving to North America (April 22 to July 6), the four members of Pink Floyd were completely exhausted. Upon returning home, all they wanted was a little rest before turning their attention to various personal projects. Unfortunately they had not bargained for the harsh realities of the business world.

Financial Setbacks and Tax Exile

In 1976, Pink Floyd had placed their financial future in the hands of the investment company Norton Warburg. When James Callaghan's Labour party raised the top rate of income tax to over 80 percent, Norton Warburg persuaded the four musicians to invest in a range of ventures which proved disastrous. As a result, despite the commercial success of their recent albums and sold-out concerts, Pink Floyd was effectively ruined. More than two million pounds had gone up in smoke, and Andrew Warburg, the founder of the investment company, had absconded to Spain! Pink Floyd was by no means his only victim, and Warburg would serve three years in prison after returning to England in 1982.

For the time being, however, not only did the Floyd discover that they had nothing left (having lost, they reckoned, the equivalent of their entire royalties from sales of *The Dark Side of the Moon*), they also learned that the state was entitled to a further 83 percent of the vanished sums in tax—money they clearly did not have! A double solution

presented itself to the band: releasing a new album and going into tax exile. Like the Rolling Stones, the Floyd had no other choice but to quit perfidious Albion for a period of one year, from April 6, 1979, to April 5, 1980. Their chosen destination was the South of France, where the recording sessions for *The Wall* would begin in earnest at Berre-les-Alpes and Correns before continuing in the United States.

Waters's New Concept

In July 1978, once the band members had finished working on their various personal projects (solo albums from Gilmour [*David Gilmour*, 1978] and Wright [*Wet Dream*, 1978]; Nick Mason's collaboration with Steve Hillage on *Green* [1978]), Roger Waters unveiled a new concept to Gilmour, Wright, Mason, and Steve O'Rourke. More accurately, he presented them with a choice of two projects that he had recorded at his home in the South of England. "I'd bought this weird [MCI] mixing console from a famous studio in Florida, Criteria," explains Waters. "I wrote *The Wall* using that board, playing acoustic guitar, electric guitar, electric piano and synthesizers."[37] The other project was called *The Pros and Cons of Hitch Hiking*, a concept based on the dreams experienced by one man during the course of a single night. This idea would later give rise to Waters's second solo album.

While Steve O'Rourke's ears pricked up at *The Pros and Cons of Hitch Hiking*, David Gilmour, Rick Wright, and Nick Mason declared themselves in favor of *The Wall*, at that time called *Bricks in the Wall*. To call their reaction enthusiastic

1979

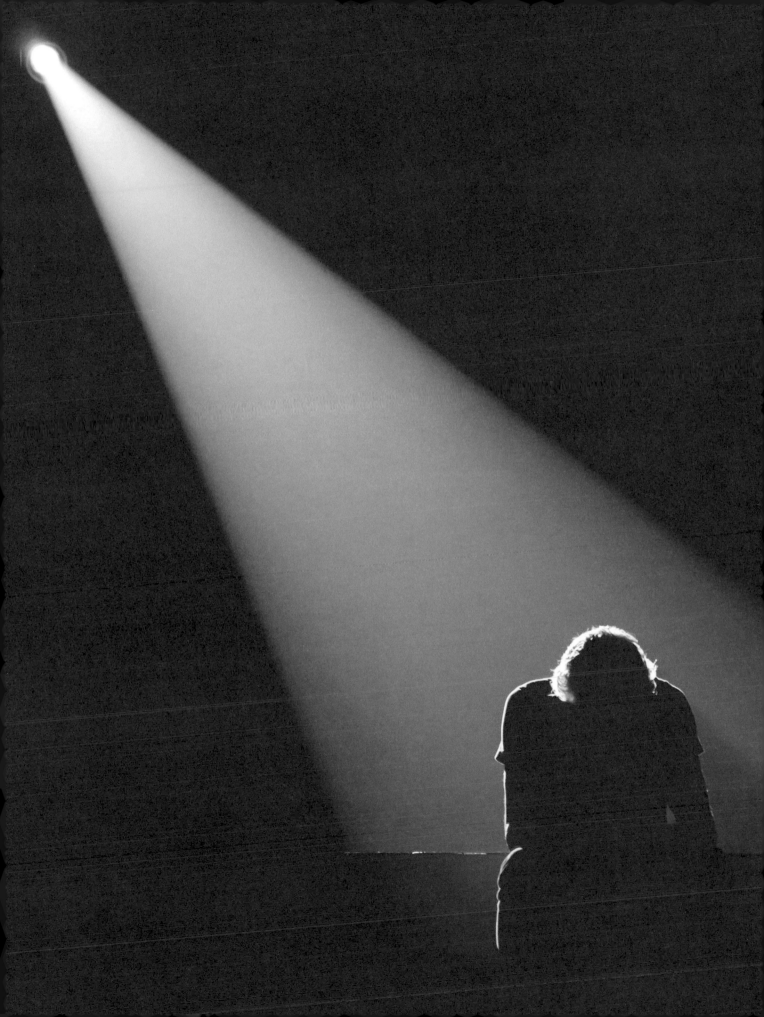

Bob Ezrin, who performed a Herculean task in producing *The Wall*.

would be going too far. Wright was wary of once more having to work on an obsession of Waters's, while Gilmour, after listening to the music for the first time, judged it to be too weak. "It was too depressing, and too boring in lots of places. But I liked the basic idea."[64] Nick Griffiths, the sound engineer at Britannia Row, also had reservations: "I heard the *Wall* demos. They were seriously rough, but the songs were there."[53] Rick Wright has freely admitted that had their financial situation been different, they would probably have replied that they did not like the songs: "But Roger had this material, Dave and I didn't have any, so [*we figured*] we'll do it."[116]

Montreal: The Foundations of *The Wall*

The origins of *The Wall* go back to the extended tour that followed the release of *Animals*, and more specifically to a succession of concerts the group gave to crowds who were becoming more unruly, for example in Montreal, which was the closing concert of the tour and clearly a gig too far. On that July 6, more than 80,000 people had started to gather in the city's brand-new Olympic Stadium in the late afternoon even though the performance was not due to start until 8:30 p.m. By the time the show kicked off, some fans were drunk, high, and unruly. The music was being drowned out by yelling and exploding firecrackers—to such an extent that the four members of Pink Floyd were finding it difficult to play. Waters asked the crowd to calm down, but to no avail. Before long, the bassist-singer's astonishment gave way to rage, causing him to react in a manner as inappropriate as it was unexpected: "I was on stage in Montreal in 1977 on the final night of a tour," relates Waters, "and there was one guy in the front row who was shouting and screaming all the way through everything. In the end, I called him over and, when he got close enough, I spat in his face. I shocked myself with that incident, enough to think, 'Hold on a minute. This is all wrong. I'm hating all this.' Then I began to think what it was all about."[9] The other members of the group had not grasped the extent of the nervous exhaustion from which their bassist was suffering: "None of us were aware of it at the time," explains David Gilmour, "I just thought it was a great shame to end up a six-month tour with a rotten show."[9]

As inglorious as the incident was, it effectively laid the foundations for *The Wall*, as Nick Mason confirms: "This incident just indicated that establishing any kind of bond with the audience was becoming increasingly difficult."[9] He explains: "Although the spitting incident was unnerving at the time, it did serve to set Roger's creative wheels spinning, and he developed the outline for a show based around the concept of an audience both physically and mentally separated from their idols."[5] Hence the idea of erecting a wall along the front of the stage while the group was performing.

In Roger Waters's fertile mind, the *Wall* concept was to be far more than just another recording in the career of Pink Floyd. He wanted to present the public with a multimedia project, in other words not only a double album, but also a movie and a full-blown show. Having obtained a £4 million advance from EMI and CBS, the four members of the Floyd and their team (including James Guthrie) started working on a number of songs at Britannia Row Studios in autumn 1978.

Bob Ezrin in the Structuring Role

Waters was aware that the goal he had set himself was too ambitious for one individual: "I could see it was going to be a complex process, and I needed a collaborator who I could talk to."[116] No longer able to count on his band mates, Waters decided to call upon the services of an outside producer, the Canadian Bob Ezrin. In addition to having worked with Roger Waters's wife Carolyne, Ezrin was able to pride himself on having produced Alice Cooper's albums starting with *Love It to Death* (1971) as well as Lou Reed's *Berlin* (1973), Aerosmith's *Get Your Wings* (1974) and *Peter Gabriel* (1977) by the former lead singer of Genesis. Bob Ezrin remembers an almost premonitory conversation with the bassist-singer-songwriter during the 1977 tour. "I met Roger through his then wife Carolyne, who once worked for me. On the *Animals* tour, they stopped in Toronto where I was living, and on the limousine ride out to the gig Roger told me about his feeling of alienation from the audience and his desire sometimes to put a wall between him and them. I recall saying flippantly, 'Well why don't you?' A year, 18 months later I got a call asking me to come to his home to talk to him about the possibility of working together on this project called *The Wall*."[117]

Bob Ezrin duly visited Waters at his house in the South of England: "He proceeded to play me a tape of music all

Roger Waters onstage in Berlin on July 21, 1990, playing the tortured, agoraphobic rock star.

strung together, almost like one song 90 minutes long, called *The Wall*, then some bits and bobs of other ideas that he hoped to incorporate in some way, which never made it to the album but resurfaced later on some of his solo work."[117] Ezrin was interested, intrigued even, by Waters's music, but was aware that a long, hard road lay ahead. After visiting Britannia Row, where he met Gilmour, Wright, and Mason for the first time, and listened once more to the compositions (which could have filled a triple album), he got down to work. He ruled out certain songs and retained others with the initial aim of respecting the timing of a double vinyl album—twenty minutes per side. In order to ensure that the story obeyed a coherent scenario, he then set down on paper as precise a storyline as possible. "In an all-night session, I rewrote the record. I used all of Roger's elements, but I rearranged their order and put them in a different form. I wrote *The Wall* out in forty pages, like a book."[118] However, Ezrin's role would not be confined to helping Waters manage his material. He would also serve as a safety valve and referee in the numerous conflicts that would not be long in breaking out between all those involved.

A Rock Opera Starring Pink

Pink Floyd had already recorded some long suites that take up a whole side of an album ("Atom Heart Mother" and "Echoes") as well as three concept albums (*The Dark Side of the Moon*, *Wish You Were Here*, and *Animals*), but with *The Wall*, the group threw itself into a concept album of a different kind: a narrative rock-opera-style work with multiple characters along the lines of *Tommy* (1969) by the Who and *The Lamb Lies Down on Broadway* (1974) by Genesis.

The main character in the *Wall* scenario, imagined by Roger Waters and structured by Bob Ezrin, is a rock star called Pink. Shut away in his hotel room watching a war film, Pink remembers the death of his father in the Second World War, his upbringing by a protective (if not suffocating) mother, being shamed by a teacher (who was in turn humiliated by his despicable wife)…By the time he has become a teenager and then made a name for himself fame, Pink is pathologically agoraphobic and has constructed a wall with which to shut himself off from the world. Although he has married, he neglects and even despises his wife, who eventually gets gets her revenge by taking a lover. While in the company of a groupie, Pink suffers a new mental crisis. Under the panic-stricken gaze of the young woman, he trashes his room, starting with his guitars. He then shaves his face, eyebrows, and body. His manager, the director of the hotel, and a physician, surrounded by a pack of photographers, try to get him back on his feet despite (or thanks to) the drugs he has been given, and manage somehow to get him onto the stage. Transformed into a neo-Nazi leader, he is hailed by the crowd. Subsequently arrested and thrown in prison, he is then judged at a court hearing in which his mother, his wife, and his former teacher are called as witnesses. The verdict is eventually handed down: Pink has to demolish the wall behind which he had mistakenly thought he was safe.

David Gilmour and his wife Ginger, at the preview of the movie *Pink Floyd: The Wall* in London in 1982.

A Personal Work

In many respects this is an autobiographical story, not least in its examination of the trauma caused by the death of a father in the Second World War (the first brick in the wall) and the iron discipline that prevailed in British schools in the fifties. It also, once again, alludes to Syd Barrett in the figure of the brilliant but fragile artist who falls victim to the star system and drugs. Finally, the dramatic development of the work involves several themes that are perennial obsessions of Roger Waters's: the inability to communicate, insanity, and the almost esoteric power exercised by a totalitarian leader over his people.

In terms of form, *The Wall* has more in common with *The Dark Side of the Moon* than with *Atom Heart Mother*, *Meddle*, *Wish You Were Here*, or *Animals*, Roger Waters having favored a series of short tracks over the suite format. This enables the listener (and, of course, viewer) to accompany Pink on his chaotic progress, or more accurately to experience it alongside him.

The Wall is effectively a double album comprising twenty-six songs. Of these, twenty-two are credited to Roger Waters, three to Roger Waters and David Gilmour ("Young Lust," "Comfortably Numb," and "Run Like Hell"), and one to Roger Waters and Bob Ezrin ("The Trial"). Musically, the album presents a cross-section of the musical sensibilities that had helped Pink Floyd to make its name (leaving out the space rock of *A Saucerful of Secrets* and the mellow, floating moods on *Meddle*): the tuneful acoustic ballad ("Mother," "Goodbye Blue Sky"), the somber, anguished outpouring ("Don't Leave Me Now," "Is There Anybody Out There?"), and the rock number with more than a little in common with heavy metal ("Young Lust"). Added to these are a completely unexpected incursion into disco or funk ("Another Brick in the Wall (Part 2)") and Broadway-style musical comedy ("The Trial"). Moreover, a number of the songs are enhanced by sound effects, some of which had admittedly been a part of the group's musical world since its earliest days, for example birdsong, while others relate directly to the unfolding story, such as dive-bombing Stukas, a war movie being shown on television, the trashing of a hotel room, the voice of a telephone operator, and so on…

The Ogre Waters

All in all, the album demonstrates the multifaceted compositional talent of Roger Waters, who in addition to doing his own thing, has ventured into the terrain of songwriters as important and yet dissimilar as Bob Dylan, Hoagy Carmichael, and Kurt Weill. Alongside him—and, it has to be admitted, in stark contrast to Rick Wright and Nick Mason—David Gilmour is far from merely playing second fiddle. Moreover, Bob Ezrin got along with Gilmour from their very first meeting, and would try to assert the guitarist's position more vis-à-vis the ogre Waters, who, right from the outset, Ezrin claims, had had no intention of involving him in the songwriting. After all, having reformulated the script in some forty pages,

In highly symbolic fashion, Pink Floyd's conceptual work was performed in
Berlin in July 1990, a few months after the fall of the Berlin Wall.

Ezrin was in a good position to identify the weaknesses that had to be overcome and the gaps that needed to be filled. Taken as a whole, the songs—all, at that early stage, composed by Waters—were guilty of uniformity, of a lack of variety. "We were really missing the Gilmour influence and his heart," explains Ezrin. "We had a lot of Roger's angst and intellect, but we were missing the visceral Gilmour heart and swing. So then we started filling in the holes with Gilmour's stuff. When there were certain holes left in the script, it would say, 'To be written.'"[119] In addition to composing the music for three major songs, David Gilmour also came up with a number of radiant solos, on "Comfortably Numb," on "Mother," and on the three parts of "Another Brick in the Wall." He also gives a brilliant demonstration of the diversity of his style—as a musician, but also as an alchemist of sounds, the sonority of his guitar on "Run Like Hell," for example, having influenced many guitarists, not least U2's The Edge, since the album came out.

The double album *The Wall* was released in the United Kingdom on November 30, 1979, and in North America on December 10. Although only getting as high as third place in Pink Floyd's native country, it reached the number one spot in many other countries including the United States (where it would eventually be certified 23x Platinum, with more than 11.5 million copies sold), France (1.7 million), Australia, Canada, West Germany, the Scandinavian countries, and the Netherlands. To date, some 30 million copies

have been sold, making *The Wall* the biggest-selling double album in the history of the recording industry.

Most critics were as one in praising not only the talent and creativity of Waters and the other members of Pink Floyd, but also of everyone else who had supported them in this enormous adventure, not least Bob Ezrin and James Guthrie. Chris Brazier wrote in *Melody Maker*: "Quite obviously, *The Wall* is an extraordinary record. I'm not sure whether it's brilliant or terrible, but I find it utterly compelling."[125] Kurt Loder, in *Rolling Stone*, called the album the Floyd's "most startling rhetorical achievement" and underlined the work of Roger Waters in projecting "a dark, multilayered vision of post-World War II Western (and especially British) society so unremittingly dismal and acidulous that it makes contemporary gloom-mongers such as Randy Newman or, say, Nico seem like Peter Pan and Tinker Bell."[121] Finally, in France, Xavier Chatagnon has noted that the album *The Wall* "would profoundly affect an entire generation, even to the extent of provoking many cases of suicide."[122]

Recording the "Wall of Sound"

Unlike *Animals*, *The Wall* was hardly a group album, not a single track having been recorded with all four members of Pink Floyd present at the same time. With each band member recording his parts independently of the others, overdubbing was the preferred technique. In spite of this, the album possesses an astonishing homogeneity that betrays

On the original sleeve of *The Wall*, the name of Jacques Loussier's studio is misspelled—Miravel instead of Miraval.

The French pianist Jacques Loussier, founder of Studio Miraval, where Pink Floyd recorded parts of *The Wall*.

nothing of the way it was made. On the contrary, the album is dense and rich and possesses a remarkable energy.

The initial sessions, at Britannia Row, Islington, ran from September to December 1978. The group was in preproduction mode during this phase, only recorded demos.

Roger Waters had already asked Gerald Scarfe to do the illustrations for his conceptual project. "He came round to my place in Chelsea, and played me the demos," recalls Scarfe. "It was all very rough, but he told me *The Wall* was going to be a record, a show and a movie. He obviously had the whole thing mapped out in his head."[1]

While Gerald Scarfe was working on the illustrations, the studio team organized itself around the four members of the group. Brian Humphries, with whom relations had deteriorated, and who was probably worn out after five years of working with the quartet, was not on board for the new project. Logically, Nick Griffiths, the assistant engineer at Britannia Row, who had already worked on *Animals*, should have been the one to replace him, but although Griffiths would work on the album, the job went to James Guthrie at the instigation of Alan Parsons. Aged only twenty-five, Guthrie had already recorded and produced the Bay City Rollers, Heatwave, and Runner. He was also proposed by Steve O'Rourke for the role of co-producer. "James's track record [...] suggested that he could add a fresh, brighter feel to our work,"[5] explains Nick Mason. Part of the idea was also to have a counterbalance to Bob Ezrin, who had arrived in London in the meantime (December 1978)…"There was confusion when we first began," concedes Ezrin. "As you can imagine, there were three of us—myself, James and Roger—all with these very strong ideas about how this album should be made."[117]

The preproduction work continued throughout the first three months of 1979. Some of the drum and bass parts laid down during this period would be conserved in a pristine state for the final mix. For some takes, Nick Mason set himself up on the top floor in search of a live sound. In reality this was a large glass-roofed room with a parquet floor that housed the snooker table reserved for Roger Waters's use. "For the first time the drum sound on *The Wall* was kept intact throughout the recording process," explains Mason. "The drums and bass were initially recorded on an analogue 16-track machine, and mixed down to two tracks on a 24-track machine for the overdubs, retaining the original recording for the final mix."[5] This idea came from Bob Ezrin. From the very start of the project, Ezrin had planned to record some of the musical elements (notably the drums, which require maximum dynamics) on a sixteen-track, which he would synchronize with the twenty-four-track when it came to doing the final mix. The advantage of this way of doing things was that it preserved the freshness of the sixteen-track takes, by contrast with the twenty-four-track master tape, which would be used repeatedly for overdubs throughout the months of recording. The system clearly involved a certain risk, however, and the closer it came to synchronizing the two machines, the more nervous the team became. Ezrin testifies to this: "I remember as we were finishing up one song it was necessary to erase the copy-drums from the 24-track, which meant that if the two tapes didn't sync up there would be no drums at all. James (Guthrie) blanched when I made him press the erase button [...] When it worked, you've never seen such a look of relief on the faces of so many people. That process has a tremendous amount to do with why that album has got that incredible presence and such a density of sound."[117]

Exile in France

Forced into exile by its financial difficulties, the group initially chose to settle in the South of France and to record at Super Bear Studios at Berre-les-Alpes, in the département

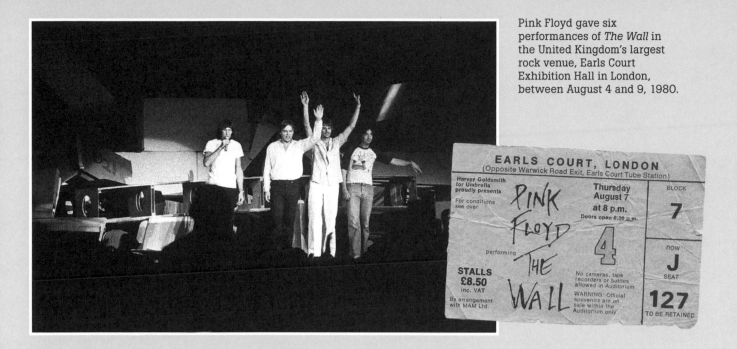

Pink Floyd gave six performances of *The Wall* in the United Kingdom's largest rock venue, Earls Court Exhibition Hall in London, between August 4 and 9, 1980.

of Alpes-Maritimes, some twenty kilometers (twelve miles) north of Nice. Super Bear was housed in a former restaurant that had been transformed into a recording studio by Britons Tom Hidley and David Hawkins in 1977 at the request of the musician Damon Metrebian. It was here that David Gilmour and Rick Wright had recorded their debut solo albums (*David Gilmour* and *Wet Dream* respectively) the year before. (Before being destroyed by fire in 1986, Super Bear would see an impressive number of artists pass through its doors, including Paul McCartney, Ringo Starr, Elton John, Queen, Kate Bush, and the Alan Parsons Project.) The Floyd would record most of *The Wall* there, occupying the studio from April to July 1979 to work on definitive takes, rather than demos. However, one peculiarity relating to Super Bear's geographical situation would lead the group to divide its time between Berre-les-Alpes and another studio 150 kilometers (ninety-three miles) away. This was Studio Miraval, located at Le Val in the commune of Correns (Var département). Miraval had also been founded in 1977, in this case by the French jazz musician Jacques Loussier and the sound engineer Patrice Quef. David Gilmour explains the reasons for this choice: "Superbear, the studio we were mostly at, was high in the mountains, and it's notorious for being difficult to sing there [due to reduced oxygen levels at high altitudes], and Roger had a lot of difficulty singing in tune—he always did. [laughs] So we found another studio, Miraval, and Roger would go there with Bob to do vocals."[116]

After having some of the Britannia Row equipment brought over from London, Roger Waters decided on working hours of 10 a.m. to 6 p.m. (leaving himself, as well as the other members of the group and the technical team, time to spend with their families or partying on the Côte d'Azur). Only Rick Wright would record in the evenings (with James Guthrie), from 7 p.m. to 1 a.m. But the mood was suffocating. "The atmosphere in the studio was war," Bob Ezrin would reveal.

"But, you know, a very gentlemanly war, because they're British."[81] Not only did Roger Waters want to be personally in charge of everything, the four musicians hardly ever played together, which did not exactly have a motivating effect on the other members of the group (with the exception of Gilmour). Nick Mason recorded most of his drum parts at the beginning of the sessions and would then entrust them to Ezrin and Guthrie. This enabled the racing car enthusiast to enter the Le Mans 24 Hours (in which he would come second!). James Guthrie would select the best takes in the evening, ready to present them to Waters and Gilmour the next day.

The Ousting of Rick Wright

Rick Wright, who had never regarded the hiring of Bob Ezrin as particularly helpful, and even saw his presence as detracting from the homogeneity of the group (although he would later come to appreciate his arbitration skills!), was unable to get himself credited as co-producer and therefore felt excluded. Or had he excluded himself? "Rick's relationship with all of us, but certainly Roger, did become impossible during the making of *The Wall*," reveals David Gilmour. "He had been asked if he had any ideas or anything that he wanted to do. We would leave the studio in the evening and he would have the whole night to come up with stuff, but he didn't contribute anything. He just sat there and it was driving us all mad."[81]

At the heart of Wright's conflict with Waters was a fundamental lack of closeness: "Roger and I were never the best of friends,"[116] the keyboard player would later admit. Up to— and especially during—the making of *The Dark Side of the Moon*, there had been no sign of any tension in their relationship, which had, on the contrary, been perfectly cordial, a relationship in which each of them had his natural place. This was to change with the recording of *Wish You Were Here*. Wright could no longer abide what he used to describe

It was during the sessions for *The Wall* that the breach between Rick Wright and Roger Waters reached the point of no return.

For Pink Floyd Addicts

Inside the gatefold of *The Wall* is the image of a gigantic stadium: this is a caricature of the Olympic Stadium in Montreal, which was the starting point for Roger Waters's concept…

IRONY OF FATE

Rick Wright took part in *The Wall* tour despite the difficulties, but only as a salaried musician. Ironically, he was the only one of the four to make any money out of it, as the other three were obliged to absorb debts arising from their earlier financial difficulties.

as Waters's "ego trip," which offended his introverted sensibility. By the time production started on *The Wall,* Wright was in mid divorce. On top of this, he did not really like the project or the music. However, the keyboard player was undergoing a severe creative drought at the time, and had nothing of his own to propose, which infuriated Waters. "He might have seen my situation as not having contributed everything," emphasizes Wright, "but he wouldn't allow me to contribute anything."[116] Wright took the decision to put up with Waters's wrath, to attend all the sessions in order to be seen to be putting in an appearance, and to try to contribute as many keyboard parts as possible. Gilmour would later claim that along with help from Waters, Ezrin, Michael Kamen, and Freddie Mandel, he himself had had to record a fair few keyboard parts. However, this is contested by James Guthrie, who worked alone with Wright and maintains that a large number of keyboard parts were indeed of Wright's making. The misunderstanding no doubt derives from the isolation in which Rick Wright was recording his parts, with no other member of the team (only Guthrie) present to vouch for him.

The incident that was to provoke the definitive clash between Wright and Waters occurred in the summer. Dick Asher, an executive at CBS Records, offered Pink Floyd an additional percentage if they could complete the album in October. Given their precarious financial situation, Waters had no hesitation in accepting. It seemed a foregone conclusion that they would say yes. Although they had all decided to take their vacation in August before continuing the sessions in Los Angeles, this development obviously forced them to reconsider their schedule. Waters immediately called Ezrin to ask if he would be prepared to start recording the keyboard parts with Rick in Los Angeles a week earlier than anticipated.[116] The producer having agreed, Waters then suggested, while he was at it, that Ezrin hire a second keyboard player in order to speed up the sessions if

necessary. "If you get all that keyboard overdubbing done before the rest of us arrive we can just about make the end of the schedule," [116] he argued. Waters asked O'Rourke to call Rick and ask him to cut short his vacation. Wright, who was spending a few days with his family in Rhodes, categorically refused, saying, "I haven't seen my young kids for months and months. I'll come on the agreed date,"[116] and closing the conversation with the request: "Tell Roger to fuck off."[1] O'Rourke accepted Wright's reasoning but Waters couldn't. While he had been battling for months to move the project forward, Wright, who in his eyes was the only one to have done practically nothing, was refusing to break off his vacation in order to save the group's skin! Waters's response was not long in coming: "I made the suggestion that O'Rourke gave to Rick: either you can have a long battle or you can agree to this, and 'this' was 'You finish making the album, keep your full share of the album, but at the end of it you leave quietly.' Rick agreed."[116]

Whatever the motives, the harshness and injustice of Waters's reaction would leave an indelible impression on each member of the group. The others would later voice their regrets: "We were under a lot of pressure," Mason would explain. "I felt guilty. Still do really."[116] While Gilmour and Mason would in turn abandon Waters in the early eighties, Wright would reveal in an interview: "Hopefully one day I'll sit down with Roger and he might say, 'Yes, it was unfair.' "[116] To which Waters, through the columns of *Sounds*, would retort: "Our paths were not parallel enough."[9]

The Beginning of the End

While *The Wall* marked the end of any real cooperation between Rick Wright and Roger Waters, work on the recording of the album continued apace, at the CBS Studios in New York City (in August) for sessions with the New York City Opera, the New York Symphony, and

the New York Philharmonic Orchestra; at Cherokee Studios in Los Angeles (September 6–8); and at the Producers Workshop in Los Angeles (September 12–November 6) for the final takes and mixing. In the final stages, the Floyd realized to their horror that the songs they had were far too long for the four sides of the album. They therefore had to reorganize parts of the track listing and come up with some technical solutions in a hurry. They also had to push back the recording deadline to November.

Nevertheless, the firing of Rick Wright marked a major turning point in Pink Floyd's career, and the band could no longer return to the way things had been before. This was the beginning of the end, and The Wall was to be the penultimate album with the original lineup (that is to say following the ejection of Syd Barrett). Roger Waters had succeeded in establishing himself as the undisputed captain of the ship. Fortunately, his talent was in proportion to his appetite for domination, as the following opinion expressed in 1999 demonstrates: "They would like to believe that the making of The Wall was a group collaboration—well, okay, they collaborated on it, but we were not collaborators. This was not a co-operative; it was in no sense a democratic process. If somebody had a good idea I would accept it and maybe use it, in the same sense that if someone writes and directs a movie he will often listen to what the actors have to say."[117]

Whereas the contributions of Rick Wright and Nick Mason clearly carried no weight in Waters's eyes, the same was not true of those of David Gilmour, whom he recognized as having written the music for three songs, albeit judging necessary to add that "he didn't have any input into anything else really. The collaboration with Ezrin was a fertile one; his input was big. And Dave got a production credit—I'm sure he had something to do with the record production; he had very different ideas about that sort of thing. But there was really only one chief, and that was me."[117] Waters would confirm his seizure of power by firing Wright, admittedly after consulting his bandmates, who, in the light of the keyboard player's failings, could do nothing but give in. Gilmour would try to convince Wright to defend himself, promising him his support should he decide to remain within the group—but without neglecting to emphasize the keyboardist's catastrophic apathy. For Gilmour, being a member of Pink Floyd was sacrosanct: "If people didn't like the way it was going, it was their option to leave. I didn't consider that it was their option to throw people out."[116] Nevertheless, Gilmour had approved Waters's decision, as had Mason, who was now expecting to suffer the same fate as Wright: "I think in real terms it would have been highly likely that I would have been next. And then after that I think it would have been Dave."[116] Just to add to the confusion, Waters would claim that Gilmour said to him: "'Let's get rid of Nick too.' I bet he doesn't remember that. How inconvenient would that be? I went 'Ooh, Dave, Nick's my friend. Steady!'"[123]

The Wall is the second collaboration between the illustrator Gerald Scarfe (seen here with his sculpture of Ronald Reagan) and the Floyd.

Even Ezrin was not spared by the infighting. He too feared confrontation with Waters, particularly during the sessions in France, which were the most fraught ones, as he explains: "During that period I went a little bit mad and really dreaded going in [to the studio], so I would find any excuse to come in late the next morning. I preferred not to be there while Roger was there. A lot of the time it was so tense. And a lot of it was directed at me."[116] Ezrin eventually fell foul of Waters when he ill-advisedly revealed the content of the first *Wall* show to a journalist friend. Bound by a confidentiality clause, to which Waters attached great importance, Ezrin found that he had committed an unpardonable sin. Such was Waters's fury that he was forced to pay for his own ticket to see the show.

Outside Musicians

For *The Wall*, Pink Floyd called upon the services of more outside musicians than for any of their previous albums. The most important of these was Michael Kamen, a hugely talented composer and arranger and sometime collaborator of Eric Clapton, David Bowie, Sting, Queen, Metallica, and Kate Bush, to name a few. Kamen would compose a considerable number of movie scores, notably for *Lethal Weapon* and *X-Men*, and with this talent was given responsibility for *The Wall*'s orchestral arrangements.

Six singers were used for the backing vocals: Bruce Johnston (the Beach Boys), Toni Tennille (the female voice in the duo Captain & Tennille), Joe Chemay (Dennis Wilson, Elton John, Christopher Cross), Jon Joyce (Dennis Wilson, Roger Waters, Chicago), Stan Farber (Sparks, Barbra Streisand, Jerry Lee Lewis), and Jim Haas (Bruce Johnston, Roy Orbison, Donna Summer). Another important vocal contributor, of course, was the children's choir of Islington Green School, which sings on "Another Brick in the Wall (Part 2)."

Various other musicians were also used who are not credited on the sleeve: on the guitar Joe DiBlasi (Lalo Schifrin, Danny Elfman) and Lee Ritenour (who has played on some three thousand sessions, not least for B. B. King, Steely Dan, and Jaco Pastorius), on the congas Bobbye Hall (Stevie Wonder, Lynyrd Skynyrd, Marvin Gaye), on the keyboards Fred Mandel (Alice Cooper, Queen, Elton John), on the concertina Frank Marocco (the Beach Boys [*Pet Sounds*], Phil Collins, Hans Zimmer), on drums Bleu Ocean (who directed thirty-five snare drummers in the studio!), Jeff Porcaro (the drummer of Toto and one of the greatest of all session musicians) and his father Joe Porcaro (Frank Sinatra, Stan Getz, Steve Vai), on mandolin Trevor Veitch (Tom Rush, Emmylou Harris, Carl Wilson), and on clarinet Larry Williams (Michael Jackson [*Thriller*], Al Jarreau, George Benson).

The Sleeve

Ever since *A Saucerful of Secrets* in 1968, Pink Floyd's album covers had been designed by Storm Thorgerson and Hipgnosis. For *The Wall*, Roger Waters turned to Gerald

Michael Kamen, a valuable collaborator of Pink Floyd, and Bob Ezrin, who did the orchestrations for the conceptual work.

Scarfe and...none other but himself, Scarfe, and Waters having previously collaborated within the context of *Wish You Were Here*. "From my point of view, it was a happy arrangement [...]," says Scarfe of his work on the sleeve, "because Roger in no way tried to impose himself on my work."[115] The cartoonist and illustrator adds that "We were working in separate fields—music and art—and yet the two helped one another. He saw the whole sleeve as being designed by me, but it was Roger's idea from the beginning that it should be a blank wall."[115]

On the front and back, then, a simple wall with gray mortar. (Scarfe drew a number of different versions: one with small bricks, another with larger bricks, one with black mortar, another with light gray mortar.) Neither the name of the group nor the title of the album appears on the cover: "the commercial decision was that nobody would know what the album was, so the logo was put on a separate piece of cellophane inside the shrink-wrap,"[115] explains Gerald Scarfe.

The vinyl album's interior gatefold continues the wall idea, enhanced this time by Scarfe illustrations designed to help listeners understand the story devised by Waters: on the left-hand side a judge (whose face resembles a pair of buttocks) looming over a stadium, with parading hammers and an aircraft nose-diving toward the crowd; on the right-hand side the teacher, the mother, the wife, and some revolting worms..."I had to think, 'what would be the most obvious symbol of oppression,' and the most unrelenting, crushing,

unthinking thing that I could think of was a hammer. The violence of a hammer when it comes down is horrific."[124] Finally the credits are written by hand and printed in different colors. Rick Wright and Nick Mason are not mentioned at all, and David Gilmour is mentioned only in his capacity as one of the producers and composers.

Technical Details

The main effects used in the recording and mixing of *The Wall* are relatively limited, which seems incredible when one listens to the final results. James Guthrie mentions "tape delay," a couple of digital delays, the famous Eventide H910 Harmonizer, and that's about it. Far more impressive is the number of studios used: no less than six (and they are just the main ones). The first, which was used mainly for preproduction, was Pink Floyd's own London studio, Britannia Row, where they had recorded *Animals* in 1976. This time they were in residence from September 1978 to March 1979, preparing demos of the whole album. Bob Ezrin brought in a sixteen-track Stephens, which he considered better than the Floyd's MCI multitrack. However, this machine was to prove relatively unstable, and for the French sessions the team favored a sixteen-track Studer A80 with the intention of synchronizing it (by means of an API MagLink synchronizer) with a twenty-four-track Studer during the final mix. According to Nick Mason, Ezrin, like James Guthrie, would find the particular combination of the Britannia Row location and equipment

The Prophet-5, an extraordinary synthesizer that plays a special role in *The Wall*.

inadequate for the definitive recording, not least the MCI 400 console that was used only for monitoring, Guthrie preferring to input straight into the multitrack via preamps. And as the Floyd had to go into tax exile no later than April 6, 1979, they took off for Super Bear in the Gerps district of Berre-les-Alpes, near Nice, France. This place had charmed both Gilmour and Wright when they chose to record their respective solo albums at the studio in 1978, and they would remain there from April until June. The control room at Super Bear was equipped with an MCI JH-500 console with four Eastlake TM3 monitors, and the tape recorder was none other than the sixteen-track Studer A80. As at Britannia Row, however, Guthrie preferred to input straight onto tape with the help of Klein & Hummel equalizers. To record Roger Waters's voice they went to Studio Miraval, where Ezrin discovered a facet of the singer-songwriter-bassist hitherto unknown to him: "Actually, you'd be surprised. Some of the stuff that musicians drive themselves crazy over, like a harmony part, he'd sing it, and say, 'Close enough! Great! Next!' But if you wanted a sound effect, you went for the real thing. If you wanted the sound of English school kids, you went to an English school."[119] The console at Studio Miraval was a Neve 32x24, and the monitors Lockwood.

The mics available at the two French studios were mainly Neumann U87s and U47s with a few Neumann KM84s and 86s thrown in for good measure. However, all the voices on the album were recorded using Neumann U67s.

After France, work continued in August in New York City, specifically at CBS Studios, the former Columbia 30th Street Studios (located at 207 East Thirtieth Street), nicknamed "The Church." This is where Michael Kamen recorded his orchestral parts with the New York Philharmonic and Symphony orchestras, and also the New York City Opera. It was also here that Bleu Ocean directed his thirty-five snare drummers. The main studio, which boasted gigantic proportions (including a ceiling height of a hundred feet!), was thought to possess some of the best acoustics in the world. Having witnessed the birth of Leonard Bernstein's *West Side Story*, Miles Davis's *Kind of Blue*, and a host of other masterpieces, these historic studios sadly closed for good in 1981.

Production of *The Wall* then moved to Cherokee Studios, located at 751 North Fairfax Avenue, Los Angeles, between September 6 and 8. Opened by the Robb brothers in 1972, Cherokee would see artists of the caliber of Steely Dan, Aerosmith, Devo, Lenny Kravitz, Al Green, and Michael Jackson pass through its doors.

The project was finalized at the Producers Workshop at 6035 Hollywood Boulevard, where the Floyd held a total of fifty-two sessions in the virtually two-month period from September 12 to November 1. The mixing desk there was a Quantum Custom. A quirky detail is that the studio's two two-track tape machines were nicknamed Mork and Mindy! In the meantime, David Gilmour made a brief appearance at yet another Los Angeles studio, the Village Recorder, on September 21, but only to transfer tapes.

It is worth emphasizing the extraordinary editing task (on both two-inch and quarter-inch tape) facing James Guthrie. Between cross-fades and insertions of one kind and another, the master tapes ended up as a patchwork of edits, according to the engineer. The finished results betray nothing of this, however, only craftsmanship of the highest order.

Among the sound engineers who worked alongside Guthrie were Patrice Quef at Studio Miraval, Nick Griffiths at Britannia Row—where he too would accomplish a remarkable task, not least in his recording of multiple sound effects and also the children's choir—and Brian Christian, who would work both with John McClure at CBS Studios and Rick Hart at the Producers Workshop. The list would certainly have been longer than this, but the credits on the album are sadly incomplete.

The Instruments

There is some debate over which tracks Rick Wright actually plays on. Most people seem to think that these are few in number, Ezrin and Waters calling upon other musicians to make up for his absence. As already mentioned, James Guthrie contradicts this version of events, rehabilitating Wright by suggesting that he recorded far more keyboard parts than rumor would have us believe. His presence can definitely be felt on the album, and in

The Ovation Legend 1619, which Gilmour and Waters had been using since *Animals*.

addition to his earlier equipment, the new instruments played by Wright on *The Wall* are an SCI Sequential Circuits Prophet-5, the first truly polyphonic synthesizer, and an ARP Quadra.

Roger Waters seems to have gone back to his Fender Precision Sunburst, which he had last recorded with on *The Dark Side of the Moon*. His Black Precision was adopted by Gilmour. In addition to his usual Hiwatt DR-103 amplifier, Waters would use a Fender Bassman 50 amp (with 2x15 speakers) for the Britannia Row sessions and an Ampeg B-18N Portaflex for the Los Angeles ones.

On the drum platform, Nick Mason remained faithful to his usual Ludwig kit with 12x8, 13x9, 14x14, and 16x16 toms, a Ludwig Black Beauty snare drum, Paiste cymbals, mainly Remo Ambassador drumheads, and a Japanese stool.

Finally, David Gilmour continued with his guitar experimentation and added further to his collection. He swapped the neck of his "Black Strat" for a Charvel Custom and in turn fitted the rosewood neck of his "Black Strat" to his Stratocaster Sunburst. Gilmour also used various Fenders for recording, supplementing his 1955 Fender Esquire and 1959 Telecaster with a Fender Baritone VI. He also plays a superb 1955 Gibson Les Paul Goldtop for the first time as well as (in all probability) a ZB (Zane Beck) Custom pedal steel guitar. (The precise model has not been identified.) In terms of acoustic guitars, his Ovation Legend was still on the scene, as were his Martin D-35 and twelve-string Martin D12-28. For the more classical passages on acoustic guitar, Gilmour opted for an Ovation 1613-4 with nylon strings. As far as effects are concerned, the Binson Echorec has been replaced once and for all with an MXR Digital Delay, while additions to his Pete Cornish pedal board, alongside other effects manufactured by Cornish himself, are an Electric Mistress and an MXR Dyna Comp. As for amplifiers, Gilmour remained faithful to his Hiwatt DR-103s, his rotating Yamaha RA-200s, and his WEM Super Starfinder 200s, but innovated with a 60 W Mesa Boogie Mark I amp and an Alembic F-2B tube preamp. It is also interesting to note that he recorded certain guitar parts straight into the console.

Bob Geldof, the singer for the Boomtown Rats, was chosen to play Pink in the film.

Pink Floyd The Wall, the Movie

The promotional tour that followed the release of the album *The Wall* in the United Kingdom on November 30, 1979, began with a series of seven concerts at the Los Angeles Memorial Sports Arena between February 7 and 13, 1980. Wanting to transfer his conceptual work to the big screen in order to complete the multimedia trilogy he had had in mind from the very outset (album, show, movie), Roger Waters made contact after contact. Several possible collaborations were envisaged, and the project went into preproduction at the beginning of 1981. Roger Waters and the renowned British satirical cartoonist Gerald Scarfe developed and then honed the storyboard together. A few months later, having abandoned the idea of calling upon the authorial talent of Roald Dahl, Waters and Scarfe worked together for some time at the cartoonist's house in Cheyne Walk, London, explains Scarfe in *The Making of Pink Floyd The Wall*. "I made notes as we talked and I thought it would be a good idea to write it into some semblance of a script and had my secretary transcribe my notes, titling it 'The Wall—Screenplay by Roger Waters and Gerald Scarfe.'"[80]

The Choice of Parker and Geldof

The next decision that needed to be made was who to get to direct the movie. Roger Waters and producer Alan Marshall initially thought of Ridley Scott, who had been surrounded by an aura of great prestige since the success of *Alien* (1979), but in the end they went with another renowned filmmaker, Alan Parker (*Bugsy Malone*, 1976; *Midnight Express*, 1978).

Parker, British and a Pink Floyd fan into the bargain, accepted the challenge after managing to get in to see one of *The Wall* shows given by Pink Floyd in February 1980 and being won over by the theatrical side of the concept. In April 1981, the director began reworking the initial script in close collaboration with Waters and Scarfe (albeit punctuated by notorious clashes) with the aim of adapting it into a style of narration suited to the cinema. After convincing MGM to finance the project, he managed to secure Roger Waters's agreement not to include live concert scenes in the movie and, most importantly, not to play the role of Pink himself—mainly due to his age, but also because of his lack of experience as an actor. To play the part of the rock star, Parker had in mind Bob Geldof, the singer with the Irish punk band the Boomtown Rats, one of whose music videos, "I Don't Like Mondays," the director had recently seen. Convinced that Geldof would make a perfect Pink, the filmmaker found a way of getting the initially reluctant musician to agree. The supporting roles went to Christine Hargreaves (the mother), James Laurenson (the father), Bob Hoskins (the manager), and Jenny Wright (the young groupie)…

The Making Of

The filming of *The Wall* began in early September 1981 at a manor house that had once belonged to an admiral and at Pinewood Studios in Iver Heath, Buckinghamshire. The outdoor scenes were shot in Somerset and Devon (the Battle of Anzio), and Pink's neo-Nazi rally, which occurs in

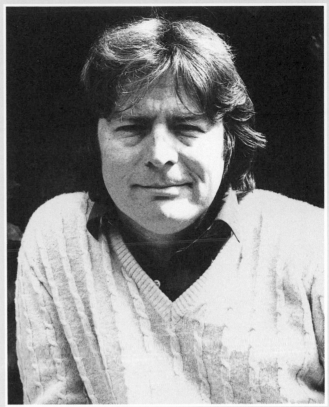

Left: The poster for the movie, which was screened at the Cannes Film Festival on May 22, 1982.

Above: Alan Parker, the director of *Pink Floyd The Wall*. A filmmaker with a passion for Pink Floyd's music.

the second half of the movie and for which a gang of skinheads was hired, at the Royal Horticultural Halls in Westminster… At the same time, Gerald Scarfe and his team had set to work on some ten thousand color illustrations for the total of fifteen minutes of animation in the movie. Sixty-one days of shooting, sixty hours of rushes, and eight months of editing later, the movie *Pink Floyd The Wall*, in which filmed scenes without dialogue alternated with animated sequences, was finished. It was shown out of competition at the Cannes Film Festival on May 23, 1982, and opened in the United Kingdom and France on July 14 and in the United States on August 8.

The soundtrack differs from the double studio album in several ways. "Is There Anybody Out There?" "Bring the Boys Back Home," "Mother," "In the Flesh?" and "In the Flesh" were rerecorded (the last two with Bob Geldof singing the lead vocal), "Run Like Hell" and "Another Brick in the Wall, Part 2" were remixed, two songs ("Hey You" and "The Show Must Go On") were cut, and two others were added ("What Shall We Do Now?" and "When the Tigers Broke Free," released as a single ten days or so after the opening of the movie). Another addition is Vera Lynn's "It's the Little Boy That Santa Claus Forgot" (instead of "We'll Meet Again").

With its kaleidoscope of extreme and even violent images, Alan Parker's movie instantly plunges the viewer into the labyrinthine nightmare of Pink's world. The filmmaker succeeds so well in fusing image and sound without either ever dominating the other that it is difficult to listen to the album today without his visual transcriptions of the music coming immediately to mind. However, Roger Waters would judge the movie to be very different to what he had originally imagined, finding it excessively violent and lacking in subtlety. He even went so far as to claim that he felt little empathy for the character of Pink that the director had molded. As a result, Alan Parker fell into disgrace with the Floyd bassist and would never work with him again.

To start with, Bob Geldof rejected the idea of playing Pink on screen—for the simple reason that he did not like the music of Pink Floyd. His agent insisted that he read the script, however. This exchange reportedly took place in a taxi driven by none other than Roger Waters's brother!

In The Flesh ?

Roger Waters / 3:20

Musicians
David Gilmour: electric lead guitar
Rick Wright: keyboards
Roger Waters: vocals, bass, VCS3
Nick Mason: drums
Fred Mandel: Hammond organ
Bruce Johnston, Toni Tennille, Joe Chemay, Stan Farber, Jim Haas, Jon Joyce: backing vocals

Recorded
Britannia Row, Islington, London:
September 1978–March 1979
Super Bear Studios, Berre-les-Alpes, Alpes-Maritimes (France): April–July 1979
Studio Miraval, Domaine de Miraval, Le Val, Var (France): April–July 1979
Producers Workshop, Hollywood:
September 12–November 1, 1979

Technical Team
Producers: Bob Ezrin, David Gilmour, Roger Waters
Co-producer: James Guthrie
Sound Engineers: James Guthrie, Nick Griffiths, Patrice Quef, Brian Christian, Rick Hart

Genesis

It was by no means mere chance that the opening song of *The Wall* shares its title with the name of Pink Floyd's previous tour ("In the Flesh"). After all, it was an incident that occurred at the closing concert in Montreal on July 6, 1977, that gave Roger Waters the idea of a wall separating the musicians from their audience, and by extension the extraordinary story of Pink, whose life *The Wall* tells. The question mark is there to remind us that nothing can ever be absolutely certain, and that appearances are not to be trusted…In a sense it is the perfect symbol of a key phrase in the song: *If you'd like to find out what's behind these cold eyes? You'll just have to clear your way through the disguise.* Waters would later reveal that this song was originally destined for the second project he was developing in 1978, *The Pros and Cons of Hitch Hiking*, and that he had remodeled it to fit into the theatrical context he wanted for the intro to *The Wall*.

It is in this song, then, that we first encounter the main character of *The Wall*: Pink, a rock star traumatized since childhood by the death of his father, a performer who has descended into decadence and depression as a result of his success. Paradoxically, we begin Pink's story at the end, for this song evokes an incident that occurs in the closing stages of the rock star's narrative. Preparing to go onstage, Pink accuses his audience of having come to the show not to listen to his music but to take part in a kind of pagan high mass. And as the curtain rises and the spotlights catch him in their beam, he remembers the death of his father in the Second World War.

Production

"In the Flesh?" whose working title was "The Show," begins enigmatically with some soft music strangely reminiscent of Berlin in the war years and Lili Marlene…Roger Waters's voice emerges from nowhere to deliver a sort of coded message: *…we came in?* In reality—and this reveals Waters's brilliance as the originator of the concept—this opening atmosphere of the first track on *The Wall* is nothing other than the continuation of "Outside the Wall," the very last song on the album. During the final few seconds of the closing track, Waters can be heard saying, *Isn't this where…* Joining the two part-phrases together yields the question:

1979

Nick Mason, whose explosive drumming throughout the sessions for *The Wall* was shown off to its best advantage by the talented James Guthrie.

Isn't this where we came in? Waters is clearly indicating that "In The Flesh?" is an invitation to go back in time. "So it's a flashback," Waters would explain to Tommy Vance in 1979, "we start telling the story..."[126]

After twenty or so seconds of relatively tranquility, the group brutally makes its presence felt in all-out rock mode, launching into an ideal concert opener. Nick Mason's drums, recorded on the top floor of Britannia Row, explode with live sound. "I think the playing on the record is far tighter and better, and sounds better, than anything before,"[9] Mason would claim.

And David Gilmour's "Black Strat" is up there with him. Gilmour's guitar, distorted through the Big Muff, has an aggressive edge thanks to highly effective reverb and short delay, and is harmonized in places by Gilmour on a second guitar, albeit recessed in the mix. His guitar phrases are answered by a Hammond organ played by Fred Mandel, a session musician who makes prolific use of the Leslie speaker in making his B-3 roar. Waters's Fender Precision supports the group powerfully and insistently. Pink Floyd sounds like a garage band! In this it is possible to detect the influence of Bob Ezrin, the distinguished producer who had brilliantly overseen LPs from Alice Cooper, Aerosmith, and Lou Reed. The sound is American and far removed from progressive English pop.

In the bridge of this initial instrumental section (between 0:37 and 0:56), we can hear a synthesizer that may well be Rick Wright's newly acquired Prophet-5. On the other hand, it could be the ARP Quadra or even the VCS3.

Roger Waters then launches into his lead vocal. His voice fits the bill perfectly, carried by a reasonably long stereo delay and exhibiting exactly the right degree of cynicism. Beach Boys–style backing vocals envelop him in saccharine harmonies. It is worth mentioning that one of the backing vocalists was a certain Bruce Johnston, who had been engaged by the Californian band in 1965 to replace Brian Wilson in concerts after Wilson had decided he no longer wanted to sing in public. Surrounded by brilliant colleagues, Johnston delivers an exhilarating performance that is light-years away from the tormented universe of Pink Floyd. Waters can be felt taking delight in the midst of these singers, thrilling to the power of the work he is performing and has created, and supported by rhythmic chords on the organ (played by Wright?) and Mason's bass drum, which marks the beat in similar fashion to the heartbeat in "Speak to Me" on *The Dark Side of the Moon*.

The band then reasserts itself, Mason once again smacking his drums with explosive power, supported by Gilmour's aggressive-sounding Strat, Mandel's bellowing B-3, and Waters's muscular bass. Before long Waters starts barking out orders like some kind of demented movie director: *Lights! Roll the sound effects!* (2:23) At this point, the throbbing engines of bomber aircraft can be heard followed by the noise of a Stuka, that fighter plane that once terrorized populations with its dive-bombing attacks, stoking up the fear even further with its wailing sirens. *Action! Drop it, drop it on them! DROP IT ON THEEEM!* he raves. The other musicians work their instruments furiously in a hellish finale, Mason's snare drum accompanying the Stuka to the bitter end. Instead of the anticipated explosion, however, we hear the crying of a baby, which has been skillfully substituted for the blast. Waters's time machine has been set.

The Thin Ice

Roger Waters / 2:27

Musicians
David Gilmour: vocals, electric rhythm and lead guitar, Prophet-5
Rick Wright: organ, piano
Roger Waters: vocals, bass
Nick Mason: drums

Recorded
Britannia Row, Islington, London: September 1978–March 1979
Super Bear Studios, Berre-les-Alpes, Alpes-Maritimes (France): April–July 1979
Studio Miraval, Domaine de Miraval, Le Val, Var, (France): April–July 1979
Cherokee Recording Studios, Los Angeles: September 6–8, 1979
Producers Workshop, Hollywood: September 12–November 1, 1979

Technical Team
Producers: Bob Ezrin, David Gilmour, Roger Waters
Co-producer: James Guthrie
Sound Engineers: James Guthrie, Nick Griffiths, Patrice Quef, Brian Christian, Rick Hart

Allied forces landing on Anzio Beach, Italy, in 1944.

Genesis

"The Thin Ice" begins as "In the Flesh?" ends: with a baby crying. This innocent *baby blue*, whom *mama* so loves, is Pink. Before long, however, disaster strikes when Pink's father is killed in the war. The valiant freedom fighter never got to see his son, and the newborn boy will never know his father. We are given to understand that Pink's existence will be strewn with trials, because modern life is nothing but thin ice that can give way at any moment, leaving us to founder. It is actually his own past that Roger Waters is describing via the sorrows of Pink, his own father, Eric Fletcher Waters, having been killed at the Battle of Anzio in January 1944. Syd Barrett, who lost his father at twelve years of age, also comes to mind…The loss of their fathers by two future members of Pink Floyd opened up wounds that would never fully heal. Waters was nevertheless to claim a more general applicability: "After 'In the Flesh?' we start telling a story which is about my generation,"[126] he explained to Tommy Vance a few years later, his generation being the "war babies." "But it can be about anybody who gets left by anybody,"[9] he has stressed.

Production

The second song on the album begins after seven seconds of a baby crying. The music is gentle, bringing to mind a lullaby. The soft voice singing belongs to David Gilmour, who simultaneously adopts the role of Pink's mother. In the last three lines of his section, the notes get higher, and Gilmour can be heard struggling to reach the final *babe*, which seems to have been manipulated somewhat during mixing (listen at 0:59). The instrumental accompaniment consists mainly of keyboard, played most likely by Rick Wright: organ pads and a highly lyrical acoustic piano. There is also a low-register Prophet-5 part played by David Gilmour. The other essential—and very present—instrument in this section is Roger Waters's bass. His playing is restrained, and the register low. By means of a short and highly intelligent rhythmic counterpoint that looks forward to the second verse, Waters creates an insidious tension on his Precision bass following Gilmour's *baby blue* (listen at 0:47).

Following this, the roles and atmosphere change. Waters takes over the lead vocal, which is sung to a cheerful-sounding

For Pink Floyd Addicts

In Alan Parker's movie, the scene that corresponds to "The Thin Ice" (Pink's childhood) was shot at East Molesey in Surrey, not far from Great Bookham, Roger Waters's place of birth.

Still from the scenes in Alan Parker's movie depicting Operation Shingle, during which Roger Waters's father was killed.

doo-wop-style melody, but in a caustic and caricatural voice that is the very opposite of Gilmour's. The piano plays eighth-note chords, supported by organ pads and a bass that purrs along in the lower reaches of the harmonic structure. It also sounds as if there is a second piano emphasizing the lowest notes.

Once Waters reaches the end of the lyrics, Mason thumps out a forceful drum break that launches the group into a short rock instrumental similar in spirit to that of "In the Flesh?" Mason's Ludwig kit is sounding just as powerful as before. Its particular sonority is that of Britannia Row: "live" and airy, and brilliantly recorded by James Guthrie. Wright is on the Hammond organ played through the Leslie, his style quite different from Fred Mandel's on the previous track. Guthrie would later testify to the quality of Wright's performances on the album: "Rick did some great playing on that album, whether or not people remember it. Some fantastic Hammond parts."[116] David Gilmour delivers two rhythm parts with Big Muff distortion on his "Black Strat" as well as a highly spirited solo part incorporating examples of his legendary phrasing. "The Thin Ice" ends on a chord of C whose resonance connects this track with the next: "Another Brick in the Wall (Part 1)."

Another Brick In The Wall, Part 1

Roger Waters / 3:10

Musicians
David Gilmour: electric rhythm and lead guitar, vocal harmonies
Rick Wright: Minimoog, Prophet-5, Fender Rhodes
Roger Waters: vocals, vocal harmonies, bass

Recorded
Britannia Row, Islington, London: September 1978–March 1979
Super Bear Studios, Berre-les-Alpes, Alpes-Maritimes (France): April–July 1979
Studio Miraval, Domaine de Miraval, Le Val, Var (France): April–July 1979
Cherokee Recording Studios, Los Angeles: September 6–8, 1979
Producers Workshop, Hollywood: September 12–November 1, 1979

Technical Team
Producers: Bob Ezrin, David Gilmour, Roger Waters
Co-producer: James Guthrie
Sound Engineers: James Guthrie, Nick Griffiths, Patrice Quef, Brian Christian, Rick Hart

James Guthrie (on the left, in 2016), a sound engineer on *The Wall*, contributed to the success of the album.

Genesis

"Another Brick in the Wall (Part 1)" follows on logically from "The Thin Ice." Here, Waters/Pink returns to the deep-seated trauma caused by the death of his father, who is now no more than a memory, a mere *snapshot in the family album.* His death in combat is the first brick in the wall constructed by Pink as a way of isolating himself from other people.

In his cinematographic adaptation of this conceptual work, Alan Parker creates a very moving scene for "Another Brick in the Wall (Part 1)." After being left alone by his mother in a children's playground for a few minutes, Pink unsuccessfully tries to take hold of the hand of a man—a kind of substitute father—who happens to be there keeping an eye on his own son. This makes it clear that in the mind of the songwriter, the song is addressed not only to those who have lost a father in war, but to all orphans and more generally to all children anywhere in the world who are forced to endure the absence of a parent. As Roger Waters explains: "It is personal for me, but it's also meant to be about any family where either parent goes away for whatever reason; whether it's to go and fight someone or go and work somewhere. In a way, it's about stars leaving home for a long time to go on tour… and maybe coming home dead, or more dead than alive."[36] The song ends with the hubbub of children…

Production

Pink Floyd recorded this first part of *The Wall*'s key triptych under the working title "Reminiscing." If Roger Waters's lyrics and composition are the soul of this piece, David Gilmour's guitar playing is its heart. Gilmour gives a brilliant demonstration of his outstanding talent as a guitarist, a master not only of his instrument, but of technology of the delay as well. The track begins with the resounding closing chord of "The Thin Ice." Gilmour's "Black Strat" is immediately heard, playing a (doubled) palm-mute rhythm part on one note, a D that rapidly acquires a haunting quality. He then plays a number of short licks on a second guitar whose sound is strongly colored by a very present delay. Gilmour is most probably using his MXR Digital Delay at 440 ms with five feedback repeats and a tempo of 100 bpm. This produces superbly hypnotic and awe-inspiring results. He plays a clear-toned Strat colored by a light chorus, and although

1979

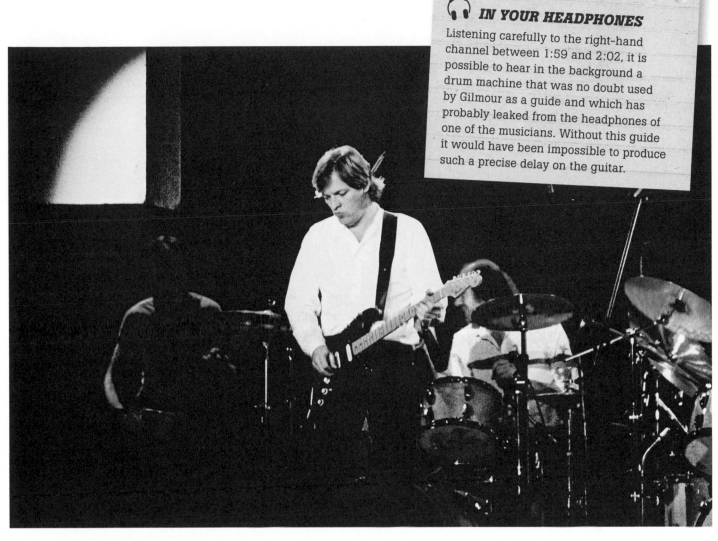

David Gilmour and his "Black Strat," responsible for the haunting sound in "Another Brick in the Wall (Part 1)."

subjected to long, deep reverb, the sound remains extremely present as a result of being plugged directly into the console in accordance with Bob Ezrin's wishes. This recording betrays a real technical prowess, and it seems likely that special attention was lavished on it. James Guthrie would later claim it as his favorite track on the whole album, not only for its musicality, but also for its successful evocation of the atmosphere of the 1940s that is associated here with Pink's childhood memories.

The lead vocal is again sung by Roger Waters. His delivery is convincing, and he can be felt intensely reliving the words, his emotion captured by the mic. In certain phrases he doubles and even triples himself, particularly in the refrain (with Gilmour singing vocal harmonies). Waters is also playing bass, following Gilmour's guitar like a shadow. He plays his Precision in standard tuning rather than in drop D, as he would do on "Brick 2."

Following the last sung phrase, Gilmour plays two harmonized solo guitar parts that answer each other with the same impressive delay as before. Here and there he also throws in a power chord distorted by Big Muff and colored by Electric Mistress.

Right from the opening bars, we hear bass notes produced on a synthesizer, most likely played by Rick Wright on a Minimoog and sustained by pads on the Prophet-5. The Prophet-5 can also clearly be heard producing brass-like sounds toward the end of the song (listen from 2:42). A number of Fender Rhodes passages were also recorded, although these are difficult to make out.

Finally, the track is punctuated by various sound effects: a reversed keyboard (at 0:59), a disturbing-sounding voice (from 1:40), which goes on to whistle and utter the phrase: *Hup, two, three…hey!* (1:59), and the slowly faded-in sounds of a children's playground (recorded both by Phil Taylor at a school in Beverly Hills and Brian Christian at his own son's school in West Covina). Although rhythmically complex, it is interesting to note the total absence of drums and other percussion in "Another Brick in the Wall (Part 1)."

The Happiest Days
Of Our Lives

Roger Waters / 1:51

Musicians
David Gilmour: electric rhythm and lead guitar, backing vocals
Rick Wright: organ
Roger Waters: vocals, bass, backing vocals
Nick Mason: drums
James Guthrie: hi-hat, choke cymbal
Bob Ezrin (?): percussion

Recorded
Britannia Row, Islington, London:
September 1978–March 1979
Super Bear Studios, Berre-les-Alpes, Alpes-Maritimes (France): April–July 1979
Studio Miraval, Domaine de Miraval, Le Val, Var (France): April–July 1979
Producers Workshop, Hollywood:
September 12–November 1, 1979

Technical Team
Producers: Bob Ezrin, David Gilmour, Roger Waters
Co-producer: James Guthrie
Sound Engineers: James Guthrie, Nick Griffiths, Patrice Quef, Brian Christian, Rick Hart

Roger Waters's description of school life is the mirror image of the happy schooldays evoked in Launder's comedy.

Genesis

This song opens with the whirr of helicopter blades and the military-sounding voice of a school principal. The scene is set. Roger Waters uses irony (*the happiest days of our lives*) to denounce the teaching in British schools in the aftermath of the Second World War, characterized by iron discipline and even physical abuse. The songwriter targets *those teachers who would hurt the children any way they could*. The only attenuating circumstance offered in explanation of the sadistic behavior of these teachers is that when they got home they would in turn be beaten by their *fat and psychopathic wives*. This song includes Waters's first misogynistic attack on *The Wall*—the first in a long series, it has to be said...Once again, Waters's own experience and the story of Pink coincide here: "My school life was very like that. Oh, it was awful, it was really terrible," claims Waters, but at least he has the discernment to put things into perspective: "I want to make it plain that some of the men who taught (it was a boys school) some of the men who taught there were very nice guys, you know I'm not...it's not meant to be a blanket condemnation of teachers everywhere, but the bad ones can really do people in—and there were some at my school who were just incredibly bad and treated the children so badly, just putting them down, putting them down, you know, all the time."[126]

Waters's attack is also aimed at the teachers' "higher" purpose—either conferred on them by the government or self-conferred—that of educating young people in such a way as to force them into the mold, to make docile citizens out of them, incapable of revolt or even critical thought.

Production

This song, musically a continuation of "Another Brick in the Wall (Part 1)," begins with the fade-out of that track against the background noise of a schoolyard. Suddenly a helicopter approaches. Bob Ezrin remembers recording it at Edwards Air Force Base in California: "We put a couple of pzm mikes out on the tarmac and got some seriously good stereo! I think it's the best helicopter that's ever been on record."[119] Strangely enough, Brian Christian would give a completely different account, claiming that he had personally recorded it with Sennheiser mics and a portable Nagra at Van Nuys

For Pink Floyd Addicts

The Happiest Days of Your Life is a British comedy directed by Frank Launder in 1950. The movie tells the story of the joyful anarchy that ensues when a boys' school merges with a girls' school just after the London Blitz. It may be that Roger Waters was thinking of this movie when he wrote his song. Another layer of irony…

Scene from *The Happiest Days of Your Life*, Frank Launder's movie to which Waters alludes ironically.

Heliport in Los Angeles…A withering voice can then be heard issuing a command through some sort of megaphone: *You, yes you! Stand still, laddie!* The effect is achieved with equalization and a delay, helping to convey the patently traumatic nature of Waters's memories of his schooldays. Suddenly the band enters, a bass drum/hi-hat combination on the first beat of the bar supporting Waters's bass, played with delay, and Gilmour's Strat, on which the guitarist resumes his palm mute. The sonority of the bass gives the impression that it was plugged straight into the console, just like the guitar. The interaction between the musicians is just as impressive as before, with Guthrie varying the effect of the delay on Waters's Precision in order to avoid the sound becoming muddy. Waters comes in on lead vocal, his voice initially compassionate and intimate before rising in intensity as he describes the sad lives of the tyrannical teachers. It sounds as if a reverse reverb has been applied to his voice. The piece then moves into a short instrumental section consisting of vocal harmonies from Gilmour and Waters, a distorted sound that could be fuzz bass or fuzz keyboard, or even just a guitar, pad sounds from the Hammond organ, Mason on drums, and various percussion instruments played most probably by Bob Ezrin. According to Vernon Fitch, James Guthrie was responsible for the hi-hat and choke cymbal.

Another Brick In The Wall, Part 2

Roger Waters / 4:00

Musicians
David Gilmour: vocals, electric rhythm and lead guitar
Rick Wright: organ, Prophet-5, Minimoog (?)
Roger Waters: vocals, bass
Nick Mason: drums
Bob Ezrin (?): tambourine
Islington Green School students: choir

Recorded
Britannia Row, Islington, London: September 1978–March 1979
Super Bear Studios, Berre-les-Alpes, Alpes-Maritimes (France): April–July 1979
Studio Miraval, Domaine de Miraval, Le Val, Var (France): April–July 1979
Cherokee Recording Studios, Los Angeles: September 6–8, 1979
Producers Workshop, Hollywood: September 12–November 1, 1979

Technical Team
Producers: Bob Ezrin, David Gilmour, Roger Waters
Co-producer: James Guthrie
Sound Engineers: James Guthrie, Nick Griffiths, Patrice Quef, Brian Christian, Rick Hart

Alex McAvoy plays the teacher who destroys his students' personalities in *The Wall*.

Genesis

This second part of "Another Brick in the Wall" continues the idea of "The Happiest Days of Our Lives" with a new attack on the British education system. When Roger Waters writes and sings *We don't need no education*, he is clearly not expressing a complete rejection of learning. What he is condemning is the way in which children are taught in the classroom, specifically the *thought control* implemented by means of *dark sarcasm*. And his shout of protest (*Teachers leave the kids alone!*) is utterly sincere. It is a protest against discipline verging on cruelty, the admonishments of the teacher at the end of the song speaking volumes: *Wrong! Do it again! If you don't eat yer meat, you can't have any pudding. How can you have any pudding if you don't eat yer meat?*

This all-out condemnation of the British education system makes even more sense in light of Roger Waters's own suffering in elementary and secondary schools, but in higher education too, where it took the form of his strong opposition to the conservatism of his lecturers after embarking on architectural studies in London. "Another Brick in the Wall (Part 2)" should also be seen as a protest against the establishment in the wider sense, an establishment that exercises its power over the masses without compunction. This is a recurring theme with Roger Waters and one with which the rapper Ice Cube is able to sympathize: "It was a big hit, it was getting a lot of airplay at the time, even on black stations. It's a seriously funky track, it's got a tight drum and a killer bass line. I remember we used to march around the playground singing the lyrics from this song […]. Ha! When you're a kid at school, of course you're going to love a lyric like that! The idea that we're all just bricks in the wall, just identikit packages that the system requires. That's the shit. It's real. And it's true. It's still true now."[81]

A Hit Single

After having been thoroughly reworked by Bob Ezrin (with, in particular, the recording of the school choir as the second verse), "Another Brick in the Wall (Part 2)" was released as a single on November 16, 1979 (with "One of My Turns" as the B-side), against the advice of the band members. "That 'Another Brick' appeared as a single," recalls Nick Mason, "was partly due to the influence of Bob Ezrin, who curiously

Choosing faceless pupils as the image accompanying this song in the movie is a blatant condemnation of the British educational system.

had always wanted to produce a disco single. [...]. Bob maintains that such was the lack of enthusiasm to make a single that it was only at the last minute that the piece was tailored to the requisite length."[5] And he concludes: "a bemusement made even stronger when we ended up as the UK Christmas Number One for 1979."[5]

The single would also top the charts in many other countries, including the United States, France (for five weeks at the beginning of February 1980), West Germany, Canada, Switzerland, Norway, and Sweden. Roger Waters would make the following disapproving comment: "'Another Brick in the Wall' really was another nail in my heart [...] imagine people buying like sheep a record telling them not to let themselves be rounded up by collies."[36] "Another Brick in the Wall (Part 2)" is currently at number 375 in *Rolling Stone*'s list of the 500 greatest songs of all time.

Production

The second installment in *The Wall*'s "Another Brick" triptych was initially called "Education." The song starts with a strange shriek of equally curious origins. After recording had finished at Super Bear and Miraval in the South of France, the group decided to take a break in August. James Guthrie took advantage of this to return to London alone in order to do a rough mix of the various songs at Utopia, one of his favorite studios. Upon listening to "Brick 2," he realized that the scream recorded by Roger Waters—with some difficulty—to link this song to the previous one, "The Happiest Days of Our Lives," was nowhere to be found. He searched through all his tapes but could not lay his hands on it. Guthrie then phoned Waters, who was still in France, and asked him to do it again over the phone. After screaming like a banshee

in a number of different ways, Waters told him he needed to stop because the people around him were eying him nervously! Guthrie then inserted the new scream into the song with the intention of finding the original and swapping them over during the mixing stage. The exchange was never made, however, and it is therefore the shriek recorded on the phone from France that can be heard on the record.

In reality, "Another Brick in the Wall (Part 2)" is completely atypical of Pink Floyd's world, and for two main reasons: firstly the rhythm, which is light-years away from the group's musical orientation, and secondly the children's choir. Regarding the rhythm, the bass drum stresses every beat of the bar. This is the defining feature of disco music, a genre Pink Floyd would never have dreamed of attempting, not even in their worst nightmares. It was Bob Ezrin who forced the group to cross this particular Rubicon: as soon as he heard Roger Waters singing the song and accompanying himself on acoustic guitar, the tune lodged itself inside his head and he could not get it out. From this moment he knew they had a hit on their hands! The first decision was to adapt the rhythm to the taste of the day. Gilmour remembers: "It wasn't my idea to do disco music, it was Bob's. He said to me, 'Go to a couple of clubs and listen to what's happening with disco music,' so I forced myself out and listened to loud, four-to-the-bar bass drums and stuff and thought, Gawd, awful!"[116] Nevertheless, the group followed the advice of its producer and recorded an initial version. Waters had written only one verse and one chorus, however, and the whole thing lasted no more than 1:20. This was a bit short for a hit record—in fact out of the question. Ezrin wanted to pad it out by adding two verses and two refrains. But he met with a categorical refusal from the four members of the band,

Alice Cooper would pay homage to the Floyd song in his own unique way by incorporating the first part of "Another Brick in the Wall (Part 2)" into "School's Out" at his concerts.

Roger Waters and
David Gilmour
share the vocals.

who, in light of their humiliating 1968 flop "Point Me at the Sky," gave him the following uncompromising answer: "We don't do singles, so fuck you."[116] The American was undeterred. Faced with Waters's stubbornness, Ezrin decided to copy the instrumental parts for the verse and chorus onto a second twenty-four-track machine when the band members were not around, and edit them onto the original version: "[...] if you listen," he explains, "you'll realize it's the same verse and chorus twice."[119] Having solved the issue of length, a new problem presented itself: how to fill the second verse. Ezrin then had the idea of bringing in a children's choir, as he had on Alice Cooper's 1972 hit "School's Out."

An Unforeseen Controversy

Nick Griffiths, in London, received a telephone call from Los Angeles asking him to record children from a school near Britannia Row in Islington. Strangely, Ezrin and Gilmour would both claim to have issued this request! Ezrin is categorical: "I said, 'Give me 24 tracks of kids singing this thing. I want Cockney, I want posh, fill 'em up."[116] For his part, Gilmour claims to have given Griffiths "a lot of instructions, ten-to-fifteen-year-olds from North London, mostly boys, and I said, 'get them to sing this song in as many ways as you like,' and he filled up all the tracks on a 24-track machine with stereo pairs."[9] Whoever made the request, Griffiths got straight down to work. He went to Islington Green School, in the vicinity of Britannia Row Studios, and succeeded in convincing the music teacher, Alun Renshaw (who was "extremely receptive" according to Mason[5]) to take part in the project. Seizing with both hands the opportunity to show his pupils how a real recording studio works, the teacher brought twenty-three schoolchildren along to Britannia Row without bothering to secure prior authorization from his superiors. "I was a naughty boy," he told the *Daily Telegraph* in a 2013

interview, but "we didn't expect it to be that big."[129] The children positioned themselves on the wooden drum rostrum, and one of the technicians set up a couple of Neumann U87 mics in front of them. The rough mix was then played back on a pair of JBLs installed behind the two mics, which were connected to a Neve compressor. "We sang like the school choir," says Caroline Greeves, a member of the improvised group of singers, "They said: 'No, we don't want you to do that, we want you to sing like you're in the playground.'"[130] According to the technician in charge of the session, eleven stereo takes were recorded, with the last two tracks reserved for the rough mix and the synchro. The session took only half an hour, which meant the teacher was able to get his students back to school in time for their next class!

Once the twenty-four-track tape had been sent back to Los Angeles, Bob Ezrin lost no time in transferring it and preparing the new version of the song. "I played it for Roger as a surprise," he explains," "and the grin on his face was unbelievable. From that point on, not only did he get it, but I think he probably believed it was his idea in the first place!"[119] Years later, Waters would claim that the memory of the sound at the moment he heard the children singing had made his hair stand on end.[130]

The success of the record caused some issues. In the press, the educational "powers that be" in Great Britain vigorously criticized the children's media exposure, and above all the video of the single that was shown on television. In actual fact, extras appeared in this video rather than the Islington children, who lacked Actors Equity cards and were therefore unable to take part. Patricia Kirwan, a member of the London Education Authority, declared that "It is scandalous that it should be allowed to happen in school time, and it can only lead other children who hear the record to emulate the attitudes expressed in it."[9] Meanwhile Margaret

The wall, a symbol of alienation, is constructed brick by brick to the sound of Gilmour playing rhythm on his "Black Strat."

Maden, the principal of Islington Green School, became the target of vehement attacks, and had to change jobs. Alun Renshaw, the music teacher, emigrated to Australia in disgust at the British educational system. The school was eventually paid £1,000 in compensation and presented with a platinum disc. The children were given concert tickets and copies of both the album and the single. However, this did not prevent them bringing legal action against Pink Floyd for unpaid royalties in 2004.

A Gold-Plated Brick

Musically, in addition to Mason's disco drums, the song also provides an opportunity to hear Waters and Gilmour singing together. Waters's Precision sounds powerful and funky, and provides the perfect support for the bass drum. The bass is tuned in drop D (in other words the bottom string tuned down from E to D). It seems to have been recorded on October 6, in the closing stages of production, according to the Producers Workshop recording notes. Once again, however, it is Gilmour who excels with his various guitar parts. First of all he lays down an excellent clear-toned, funky rhythm part on his "Black Strat," which he doubles, recording directly into the console. He also adds overdubs of distorted guitar, initially underlining the vocal line and later playing power chords. The sound is probably enhanced with MXR Phase 90 or Electric Mistress. But his key moment is the superb solo he plays after the children's singing (from 2:09). For this

he uses his 1955 Gibson Les Paul Goldtop, again plugged straight into the console. He would later explain that although Bob Ezrin was completely happy with the solo, he himself felt that it lacked substance. He therefore persuaded the producer to replay what he had just played through his Mesa Boogie Mark I and record it on a new track, thereby giving his guitar a more aggressive rock sound. A tambourine can be heard during this solo, which was added (by Bob Ezrin?) at the Producers Workshop on September 15. There are also various keyboard parts played by Rick Wright and this time recorded at Cherokee Studios on September 7: a Hammond, pad sounds on the Prophet-5, and probably, as James Guthrie would claim, a Minimoog.

Following this solo section, Mason's drums alone serve as the guide for the various different spoken phrases and effects that conclude the song (from 3:21): the sadistic voice of the teachers (*Wrong, do it again!—If you don't eat yer meat, you can't have any pudding!—How can you have any pudding in you don't eat yer meat?—You! Yes, you behind the bike sheds! Stand still, laddie!*), the school playground and, finally, a ringing telephone.

The single version does not include this closing sound effects section, ending instead with a fade-out of Gilmour's solo, and that the intro begins with four bars of Mason's drumming and Gilmour's two rhythm guitars, unlike the album version, which opens with Waters's scream and the lead vocal.

Mother

Roger Waters / 5:32

Musicians

David Gilmour: vocals, acoustic guitar, electric lead guitar, bass
Roger Waters: vocals, acoustic guitar
Bob Ezrin: keyboards
Jeff Porcaro: drums

Recorded

Britannia Row, Islington, London: September 1978–March 1979
Super Bear Studios, Berre-les-Alpes, Alpes-Maritimes (France): April–July 1979
Studio Miraval, Domaine de Miraval, Le Val, Var (France): April–July 1979
Cherokee Recording Studios, Los Angeles: September 6–8, 1979
Producers Workshop, Hollywood: September 12–November 1, 1979

Technical Team

Producers: Bob Ezrin, David Gilmour, Roger Waters
Co-producer: James Guthrie
Sound Engineers: James Guthrie, Nick Griffiths, Patrice Quef, Brian Christian, Rick Hart

1979

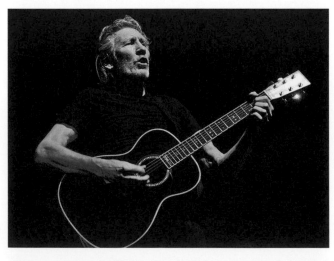

Waters performing "Mother," the mother in question being the very opposite of John Lennon's in his song of the same title.

Genesis

The third brick in the wall concerns Pink's relationship with his mother, a mother who tries to make up for her son's lack of a father with overprotective love that becomes suffocating. As in "Dogs" (on the album *Animals*), Roger Waters resorts to the technique of anaphora in writing of his mother, wherein each question he asks her begins with the same word: *Mother do you think they'll drop the bomb?...Mother should I build a wall?* This hints at the state of extreme anxiety of the young Pink, for whom the world, both the external and the internal, seems to represent a permanent danger.

In the second section, Pink's mother tries to answer all her son's questions and soothe his anxieties: *Mama's gonna keep you right here under her wing/She won't let you fly but she might let you sing.* And then: *Of course mama'll help you build the wall.* She is clearly seeking to reassure Pink (while reassuring herself?), but all she does is add to his fears by projecting her own frustrations onto him. Worst of all, she says she wants to help him construct the wall that is designed to protect him, but in reality is the main symptom of her son's confusion.

In the final section of the song, years have elapsed and Pink has grown up. His apprehensions remain or have even intensified, for he asks his mother if *she's good enough...*if *she's dangerous* ("she" being his wife or rather future wife). Thus Pink is unsure of his feelings, just as he is unsure of himself. In any case, he still needs his mother's advice—which she does not hold back on: *Mama's gonna check out all your girlfriends for you/Mama won't let anyone dirty get through.* In short, Pink will always be her *baby blue...* The last line of the song is a painful acknowledgment of the dimensions of the metaphorical wall: *Mother, did it need to be so high?* Presumably not. But isn't this how some human relationships work? On the one side oppression; on the other, submission. This suffocating mother is the very opposite of Lennon's on the 1970 album *John Lennon/ Plastic Ono Band*, who was absent. Are we to conclude that well-balanced mothers would not have enabled Waters and Lennon to develop into such talented and successful song-writers? It is certainly a question worth asking.

Was Roger Waters inspired to write the song by his own mother? The songwriter denied it in the radio interview he

Jeff Porcaro, shown here in Rotterdam in 1988, who plays drums on "Mother."

gave to Tommy Vance in 1979: "This isn't a portrait of my mother, although some of the, you know, one or two of the things in there apply to her as well as to I'm sure lots of other people's mothers. Funnily enough, lots of people recognize that and in fact, a woman that I know the other day who'd heard the album, called me up and said she'd liked it. And she said that listening to that track made her feel very guilty and she's got herself three kids, and I wouldn't have said she was particularly over-protective towards her children."[126] Subsequently, Waters would be quick to acknowledge that "it's a very crude portrayal. It's a cliché."[9]

Production

"Mother" is one of the few songs that underwent very few changes between Waters's demo and the final version. This is a typical lyricist's song, in which greater importance is given to the meaning of the words than to the rhythmic structure. As a result, the time signatures vary between 6/8, 4/4, and 12/8 (with a few exceptions).

Waters begins the song with an inhalation and an exhalation in an apparent effort to summon the courage to broach this painful subject. He then sings (double-tracked) and accompanies himself on the guitar in a performance that is presumably "live" rather than overdubbed. His voice is drawling and submissive, with emotion flooding in when he evokes the threat of one day being sent to the front line (1:34). Again this fear of war being forced on the population. A synth pad joins in from the second verse, although it is difficult to identify the instrument. After Waters has sung the opening verses, David Gilmour takes over, adopting a gentle tone and assuming once more the role of mother that he had already played in "The Thin Ice." He is accompanied by two acoustic guitar parts, positioned in stereo, which are in turn supported by a bass he plays himself (as he does the two acoustics) and organ. The keyboards are all thought to be played by Bob Ezrin. The first two acoustic guitars are reinforced by two more, before Gilmour plays a doubled solo on a distorted "Black Strat," giving a performance that is every bit as lyrical and successful as usual. In this he is supported by an excellent drum part played not by Nick Mason but by Jeff Porcaro, one of the best drummers of his generation, who sadly passed away in 1992. The reason for Porcaro's involvement? Nick Mason was having a lot of trouble with the different time signatures, and David Gilmour therefore made the decision to replace him. Furthermore the drums were recorded along with the bass at the Producers Workshop on October 20, shortly before the end of production, which seems to indicate that the decision was made at the last moment. After returning for another verse and refrain, Waters concludes the song alone, accompanying himself on acoustic guitar for the final line.

Goodbye Blue Sky

Roger Waters / 2:48

Musicians
David Gilmour: vocals, vocal harmonies and backing vocals, acoustic guitars, bass, synthesizers
Rick Wright: Prophet-5, Minimoog (?)
Roger Waters: VCS3 (?)
Harry Waters: child's voice
Recorded
Britannia Row, Islington, London: September 1978–March 1979
Super Bear Studios, Berre-les-Alpes, Alpes-Maritimes (France): April–July 1979
Studio Miraval, Domaine de Miraval, Le Val, Var (France): April–July 1979
Cherokee Recording Studios, Los Angeles: September 6–8, 1979
Producers Workshop, Hollywood: September 12–November 1, 1979
Technical Team
Producers: Bob Ezrin, David Gilmour, Roger Waters
Co-producer: James Guthrie
Sound Engineers: James Guthrie, Nick Griffiths, Patrice Quef, Brian Christian, Rick Hart

Roger Waters and his son Harry in 2015. Harry provided the child's voice in this song.

Genesis

The second act of *The Wall* (the second side of the double LP) opens with "Goodbye Blue Sky," which amounts to a kind of summary of the first side, evoking Pink's childhood and his many psychological wounds. *Look, Mummy, there's an aeroplane up in the sky*, says the young Pink right at the beginning of the song. Although the war is over, it continues to fill the boy with indescribable fear. *The flames are all long gone, but the pain lingers on*, sings Waters, after asking himself why *we had to run for shelter when the promise of a brave new world unfurled beneath a clear blue sky.*

The blue sky is a metaphor for purity and innocence. "Goodbye Blue Sky" therefore marks a stage in Pink's development: the transition from adolescence to adulthood, with the loss of innocence. This probably explains the musical ambiance reminiscent of "Grantchester Meadows" on *Ummagumma*: the chirruping birds at the beginning of the song, followed by a moving ballad sung to acoustic guitar, both of which take us back to that gentle Cambridge childhood.

Production

After ten seconds or so of nothing but birdsong, we hear the muffled drone of bombers. And it is in this lugubrious, menacing atmosphere that the small child pipes up, calling his mother's attention to the aircraft (at 0:20). The voice belongs to Roger Waters's son Harry, then aged two years. Innocence confronting the monstrous. The music begins with two arpeggiated parts played on acoustic guitar (with nylon strings) plus a third acoustic in the center of the stereo field that supports the melody and interjects short phrases throughout the song. David Gilmour plays all these parts on his classical Ovation 1613-4. His playing creates an impression of nostalgia and anxiety at the same time. The bass, in drop-D tuning, is also Gilmour's work. In addition to bass guitar, there are also bass notes produced by a synthesizer whose sonorities are characteristic of the Minimoog (or VCS3 according to certain sources), and also a Prophet-5. Gilmour sings the extremely beautiful backing vocals as well as the lead vocal. The refrain comes at the end of the song. By this time the bass guitar has stopped playing and the voice, which is doubled and positioned in

In Alan Parker's movie, "Goodbye Blue Sky" is positioned between "When the Tigers Broke Free (Part 2)," a song not included on the album, although released as a single, and "The Happiest Days of Our Lives." The scene is a flashback to Pink's childhood, and is followed by Gerald Scarfe's animations on war and death.

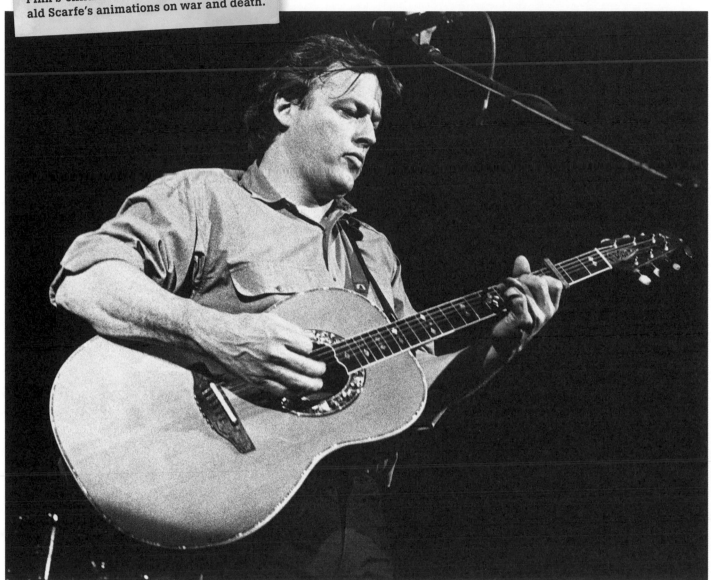

David Gilmour playing his acoustic Ovation guitar in "Goodbye Blue Sky."

stereo, is accompanied by the Prophet-5 and the Ovation alone. Toward the end, a train station soundscape gradually merges with the music, and through a loudspeaker a voice can be heard announcing that the *11:15 arrival from Newcastle is now approaching...*

The intro to Metallica's song "Fade to Black," on the band's 1984 album *Ride the Lightning,* seems to have been partly inspired by "Goodbye Blue Sky."

Empty Spaces

Roger Waters / 2:08

Musicians
David Gilmour: electric rhythm and lead guitar, keyboards
Rick Wright: piano
Roger Waters: vocals, bass, VCS3
Nick Mason: drums

Recorded
Britannia Row, Islington, London:
September 1978–March 1979
Super Bear Studios, Berre-les-Alpes, Alpes-Maritimes (France): April–July 1979
Studio Miraval, Domaine de Miraval, Le Val, Var (France): April–July 1979
Cherokee Recording Studios, Los Angeles: September 6–8, 1979
Village Recorder, Los Angeles: September 21, 1979
Producers Workshop, Hollywood:
September 12–November 1, 1979

Technical Team
Producers: Bob Ezrin, David Gilmour, Roger Waters
Co-producer: James Guthrie
Sound Engineers: James Guthrie, Nick Griffiths, Patrice Quef, Brian Christian, Rick Hart

Genesis

In the original scheme, "Empty Spaces" was positioned not where it has ended up on the album, but between "Don't Leave Me Now" and "Another Brick in the Wall (Part 3)." Its eventual place was initially to have been occupied by a different song, "What Shall We Do Now," which had different words but similar music. Roger Waters explained to Tommy Vance that the substitution was made for reasons of length. During production the group realized that the second side of the album would exceed the maximum length permitted by the vinyl engraving process. Waters therefore took the decision to replace the song with the significantly shorter "Empty Spaces" (2:08 compared to 3:15). On the other hand, the original song, "What Shall We Do Now," is very much a part of Alan Parker's movie, coming after "Mother" and contributing to the dramatic development. This last-minute change to the album presented another problem in that the album covers had already been printed in order to adhere to what was a very tight marketing schedule. The fans were somewhat confused to come across the lyrics to a song that did not exist and to find another song in the wrong place. Fortunately, everything was sorted out in the subsequent versions.

To start with, we hear a distant, reversed voice. It is that of Roger Waters, saying: *Hello, punter...congratulations. You have just discovered the hidden message. Please send your answer to Ol' Pink, care of the Funny Farm, Chalfont...*The next voice is James Guthrie on the intercom (again reversed): *Roger, Carolyne's on the phone—okay.* After all, where's the harm in a little humor? Carolyne, of course, was Roger Waters's wife...Later on we hear: *There's a little secret message hidden. See if you understand.* Nick Mason would explain that this bit of fun was aimed at the many fans who were forever scanning the group's records for subliminal messages. A private joke, in a sense.

And then Pink enters onto the scene, pondering his relationship with his wife and their lack of communication. This culminates in the billion-dollar question: *How shall I complete the wall?* "Empty Spaces" is a transitional song, albeit one that shows the main character losing touch with reality.

At this stage in the album and show (performed here at the Los Angeles Memorial Sports Arena in 1980), the wall is not yet finished and some gaps remain.

Production

As the last few notes of "Goodbye Blue Sky" are fading away, two sequencer (more specifically VCS3) parts, emerge as if from nowhere. These sequencer parts answer each other in stereo against the background of infernal noises. They are drenched in reverb and supported by some kind of percussion instrument that is powerful but muffled. Gilmour contributes to this disquieting atmosphere with a melody on his "Black Strat" colored by abundant distortion, Electric Mistress, and, again, reverb. The nightmarish atmosphere gives way to a second instrumental section (from 0:51). Here, Roger Waters is on bass colored by MXR Phase 90,

Rick Wright is on acoustic piano, and David Gilmour plays a melody on his Strat (high up on the fingerboard) with added stereo delay before switching to very distorted power chords (stereo left). There is also a harmonic pattern produced with the arpeggiator on either the Prophet-5 or the VCS3 Synthi AKS. The mysterious backward message begins suddenly at 1:13, after which Waters's plaintive voice comes to the fore. Waters enables the listener to feel the full weight of his anguish, all the more so as a kind of phasing (Eventide H910?) reinforces the sense of sadness and paranoia. Gilmour accompanies the vocal line with distorted guitar parts positioned on opposite sides of the stereo field.

Young Lust

Roger Waters, David Gilmour / 3:31

Musicians
David Gilmour: vocals, vocal harmonies, electric rhythm and lead guitar, bass
Rick Wright: organ, Wurlitzer, piano (?)
Roger Waters: vocal harmonies
Nick Mason: drums, tambourine
Chris Fitzmorris: voice on the telephone

Recorded
Britannia Row, Islington, London: September 1978–March 1979
Super Bear Studios, Berre-les-Alpes, Alpes-Maritimes (France): April–July 1979
Studio Miraval, Domaine de Miraval, Le Val, Var (France): April–July 1979
Cherokee Recording Studios, Los Angeles: September 6–8, 1979
Producers Workshop, Hollywood: September 12–November 1, 1979

Technical Team
Producers: Bob Ezrin, David Gilmour, Roger Waters
Co-producer: James Guthrie
Sound Engineers: James Guthrie, Nick Griffiths, Patrice Quef, Brian Christian, Rick Hart

On "Young Lust," Nick Mason (here playing on Long Island in 1980) shows just how powerfully he can pound those skins.

Genesis

"Young Lust" presents a new twist in Pink's convoluted tale. Having made the transition from adolescence to adulthood, here he is elevated to the status of rock star, and the clichés come thick and fast. While on tour in an unfamiliar city—*a desert land*, in his own words—he looks forward to having a good time after the show. In Alan Parker's movie, there is no shortage of seductive young women thrusting themselves forward. Pink is on cloud nine. *I need a dirty woman*, he gushes. To make him feel like a real man, that is…"When I wrote this song 'Young Lust,'" explains Roger Waters to Tommy Vance, "the words were all quite different, it was about leaving school and wandering around town and hanging around outside porno movies and dirty bookshops and being very interested in sex (…)."[126] And on a musical level, Waters explains: "It reminds me very much of a song we recorded years and years ago called 'The Nile Song' [*More*]. It's very similar, Dave sings it in a very similar way. I think he sings 'Young Lust' terrific, I love the vocals. But it's meant to be a pastiche of any young rock and roll band out on the road."[126]

Before long, however, the raunchy, testosterone-charged atmosphere is completely transformed. When Pink calls his wife, a man answers the phone. And with that he is caught in his own trap: in the company of a groupie and cheated on by his neglected, humiliated wife.

Production

As David Gilmour did not like certain chords in the original demo, Roger Waters consented to various changes. The first of these gave rise to the riff and the second to a significant proportion of the harmonic structure. The collaboration between Gilmour and Waters works perfectly here and has transformed "Young Lust" into an excellent, indeed archetypal rock song, just as Waters had wanted.

The song therefore opens with a very catchy riff. Playing his 1955 Fender Esquire with Big Muff distortion, Gilmour distinguishes himself once again with his guitar playing. And as he likes to have a bass provide the ideal support for his guitar when playing this kind of rhythm, he simply takes care of it himself. It is worth emphasizing that he has a very good feel for the instrument, and unlike most guitarists

Roger Waters and his wife Judy Trim, in 1974. Happy days!

when they play bass, does not simply try to transpose his six-string technique onto four strings.

On the percussion front, Nick Mason lays down a very good groove, working his kit with considerable power. Unlike his drumming on "In the Flesh?" there is nothing of the garage band about the sound of his Ludwig kit here. On the contrary, the drum sound is very "studio," but for this song in particular, that is perhaps a mistake. A tambourine can be heard, reasonably discreet in the verses and louder in the refrains, which was added at the Producers Workshop on September 15. The various keyboards on this track are quite definitely played by Rick Wright, as James Guthrie has confirmed. Wright can be heard on the Hammond organ, with Big Muff distortion to lend his playing the desired rock sound, on the Wurlitzer, particularly during Gilmour's solo, and also, it seems, on acoustic piano during the second refrain (around 1:21). As for Gilmour's lead vocal, with harmonies from Waters in the refrains, it is simply excellent. His raucous timbre provides a stark contrast to his usual gentler tone, demonstrating his wide range of vocal skills. It is also Gilmour who plays the song's one and only—very good—solo, with plenty of distortion and above all highly colored by flanging from his Electric Mistress. Wright's accompaniment on the Wurlitzer is also excellent.

The Idea of the Collect Call

"Young Lust" ends in a surrealistic and unexpected fashion (from 2:47). Waters wanted to illustrate the feeling of solitude and disconnectedness that sometimes overcomes artists on the road. It was James Guthrie who came up with a way of bringing this about. He had the idea of phoning his neighbor

in London, one Chris Fitzmorris (who had the keys to Guthrie's flat). He asked him to go to his apartment and answer the phone every time it rang, explaining that after answering, he was to let the operator speak and then hang up without saying another word. After connecting his handset to a tape recorder, Guthrie was ready to capture any conversation that resulted from his call to London on quarter-inch tape. The first two attempts came to nothing as the operators' reactions were disappointing. The third attempt, however, was a charm. Guthrie told the operator he wished to make a collect call to his wife, Mrs. Floyd. Fitzmorris plays his part to perfection. He answers the operator's call with a "Hello?" "Yes," answers the operator, "a collect call for Mrs. Floyd from Mr. Floyd. Will you accept the charges from United States?" Fitzmorris hangs up. And then the same thing happens again. After a moment, the operator starts to feel genuinely concerned about this difficult situation in which the poor Mr. Floyd finds himself: "Oh! He hung up! That's your residence, right? I wonder why he hung up! Is there supposed to be someone else there besides your wife there to answer?" Guthrie replies in the negative. She tries again: "Hello?" replies Fitzmorris. "This is United States calling, are we reaching...See, he keeps hanging up! It's a man answering!" This gave Guthrie exactly what he was looking for. He hurriedly did the edit and played the results to Waters: "I think it's great," Waters would comment in November 1979, "I love that operator on it. [...] She didn't know what was happening at all, the way she picks up on [...] I think is amazing, she really clicked into it straight away. She's terrific!"[126] James Guthrie continues to wonder whether the charming operator has had the opportunity to hear her own voice on Pink Floyd's album *The Wall*.

One Of My Turns

Roger Waters / 3:38

Musicians

David Gilmour: electric lead guitar
Rick Wright: piano
Roger Waters: vocals, bass
Nick Mason: drums, tambourine
Bob Ezrin: organ, Prophet-5
Lee Ritenour: electric rhythm guitar
Trudy Young: groupie's voice

Recorded

Britannia Row, Islington, London: September 1978–March 1979
Super Bear Studios, Berre-les-Alpes, Alpes-Maritimes (France): April–July 1979
Studio Miraval, Domaine de Miraval, Le Val, Var (France): April–July 1979
Cherokee Recording Studios, Los Angeles: September 6–8, 1979
Producers Workshop, Hollywood: September 12–November 1, 1979
Nimbus 9's Soundstage Studios: August 1979 (?)

Technical Team

Producers: Bob Ezrin, David Gilmour, Roger Waters
Co-producer: James Guthrie
Sound Engineers: James Guthrie, Nick Griffiths, Patrice Quef, Brian Christian, Rick Hart, Michael McCarty, and Robert "Ringo" Hrycyna (at Nimbus 9)

Pink (Bob Geldof) seeks illusory comfort from a groupie (Jenny Wright).

1979

Genesis

As its title suggests, this song tells of one of Pink's existential crises. Pink invites a groupie he has met at the after-party back to his hotel room and learns his wife is unfaithful. While the young woman goes into raptures at the luxuriousness of the room, which, she says, is *bigger than our apartment*, Pink collapses in an armchair in front of the television. The woman's attempts to attract his attention and seduce him come to nothing. The rock star's eyes are riveted to the screen, and he is lost in his own dark thoughts as he watches a war movie that stirs up memories of his father. Pink's mind turns to his sorrows both past and present: his father's premature death, his unfaithful wife…Sadness. Humiliation. Despair. *Day after day, love turns grey like the skin of a dying man*, sings Waters/Pink. All of a sudden, Pink is seized by a fit of madness and completely loses it in front of the alarmed groupie. *I feel cold as a razor blade*, declares the enraged narrator before setting about trashing his hotel room, throwing the television set through the window ("classic" rock-star-on-tour behavior!), and even smashing up all his guitars (the ultimate symbol of his desperation). In terms of both words and music, this is a caustic song. It testifies to a deterioration in Pink's mental state and to a simultaneous intensification of his feelings of guilt. It is difficult not to be reminded of Syd Barrett's decline a few years before… another gaping wound for Roger Waters.

Looking beyond the hero of *The Wall*, the song also offers a horrifying insight into the violent relationships in which some couples find themselves—often as a result of immaturity or frustration: "If you skip back from there," explains Roger Waters to Tommy Vance, "my theory is that they do that because they've never really been able to become themselves and there is a lot of pressure on people to get married, at least when they're in their late twenties, not earlier. I think a lot of people shouldn't really get married until they are strong enough in themselves to be themselves."[126]

Production

"One of My Turns" opens with the sounds of a telephone dial tone and a door opening and shutting, followed by an E emanating from a Prophet-5 and the voice of a groupie. The

The actress Trudy Young plays the part of the American groupie in Alan Parker's *Pink Floyd: The Wall.*

voice belongs to the Canadian actress Trudy Young, who was directed and recorded by Bob Ezrin at Nimbus 9's Soundstage Studios in Toronto, Canada, and who, it has to be said, gives a memorable performance, undeniably one of the highlights of *The Wall*: *Oh my God! What a fabulous room! Are all these your guitars? This place is bigger than our apartment! Uh, can I get a drink of water? You want some, huh? Oh, wow, look at this tub! You wanna take a bath? What are you watching? Hello? Are you feeling okay?* Such was the attention to detail that different degrees of reverb were even created in the studio: nonexistent in the bedroom, short in the kitchen, and longer in the bathroom! During the monologue, a television can be heard in the background, while Bob Ezrin continues to play the Prophet-5, picking out more or less dissonant harmonies. The atmosphere is one of heartbreaking emptiness and loneliness. This passage is followed by Roger Waters in one of his best vocal performances. His tone is resigned and anguished. During this section, he is accompanied starkly by Bob Ezrin on the Prophet-5. Introduced by a reverse effect, the group then launches all together into a lively rock sequence. Here, Waters pushes his voice to the breaking point, lending it a simultaneously powerful and fragile air. He gives a fantastic performance that really breathes life into his character. Also playing bass, Waters is supported

by Nick Mason on drums (and tambourine), Bob Ezrin on the Prophet-5 and Hammond organ (during the guitar solo), and Rick Wright on acoustic piano. This time there are two guitarists. The talented and highly jazz-oriented Lee Ritenour contributes rhythm guitar, playing with distortion and wah-wah. Ritenour tells a very nice anecdote about this recording. As a session guitarist at the time, he used to turn up at whatever studio he was working at with an enormous case containing fifteen or so guitars of every kind. Keen to impress Pink Floyd, he arrived for the session with all his equipment as well as a pedal board and a rack of effects, confident of causing a stir. "So, I walk in the door of the studio and Gilmour must have had 75 guitars lined up," explains Ritenour. "The most vintage, best guitars I've ever seen, all sitting on stands around the studio along with an equal amount of amps and everything else you can imagine. Needless to say, my system didn't look quite as impressive after that! [Laughs]"[131] Throughout the sequence, various sound effects can be heard—for example shattering dishes and the noise of traffic on a freeway—all recorded by Nick Griffiths in London. Gilmour contributes a guitar solo on his "Black Strat." In actual fact, he recorded two answering parts on opposite sides of the stereo field. The song ends with Waters desperately emitting a kind of pained and poignant wail. A masterpiece.

Don't Leave Me Now

Roger Waters / 4:17

Musicians
David Gilmour: vocals, vocal harmonies, breathing, electric rhythm and lead guitar, bass
Rick Wright: piano, organ, organ pedal board, Prophet-5 (?)
Roger Waters: vocals, VCS3, rhythm guitar (?)
Nick Mason: drums

Recorded
Britannia Row, Islington, London: September 1978–March 1979
Super Bear Studios, Berre-les-Alpes, Alpes-Maritimes (France): April–July 1979
Studio Miraval, Domaine de Miraval, Le Val, Var (France): April–July 1979
Cherokee Recording Studios, Los Angeles: September 6–8, 1979
Producers Workshop, Hollywood: September 12–November 1, 1979

Technical Team
Producers: Bob Ezrin, David Gilmour, Roger Waters
Co-producer: James Guthrie
Sound Engineers: James Guthrie, Nick Griffiths, Patrice Quef, Brian Christian, Rick Hart

Roger Waters, the heart and soul of *The Wall*, in concert at the Nassau Coliseum on Long Island on February 27, 1980.

Genesis

Roger Waters explains the sentiments that led him to write "Don't Leave Me Now": "Well a lot of men and women do get involved with each other for lots of wrong reasons and they do get aggressive towards each other and do each other a lot of damage."[126] And he adds: "But yes it is a very depressing song. I love it! I really love it."[126] Within the context of the *Wall* storyline, has the time for regrets and repentance finally come for Pink? Despite his shortcomings, he seems to love his wife deeply, and does not want her to leave him. The rock star's voice is virtually at the breaking point, presumably as a way of conveying his sincerity. He even tries to play the guilt card: *How could you go when you know how I need you?* Is this one last attempt to convince her? If it is, the stratagem can only fail, because his demons and paranoia immediately resurface. He needs her, sings Pink/Waters, *To beat to a pulp on a Saturday night.* This is an example of verbal violence—preceding physical violence—that the rock star is becoming less and less capable of holding back now that there are no more obstacles in the way of his insanity. "Don't Leave Me Now" was released in the United States and Europe (but not the United Kingdom) as the B-side of "Run Like Hell" in April 1980.

Production

There are few differences between Waters's demo of this song and the album version. It has lost none of its power; in fact, this has been intensified by the group. "Don't Leave Me Now" is one of *The Wall*'s gems, a song of extraordinary emotional power, underlining Roger Waters's exceptional talent. It opens with low notes on the piano, sustained bass played on a Hammond B-3 pedal board, the mournful sound of a VCS3 (or a Prophet-5?), organ chords, and a rhythm guitar (Waters?) with impressive, hypnotic delay. The atmosphere is lugubrious and stress inducing, dragging the listener down into a very somber world. The resolutely depressing atmosphere is intensified by some disturbing breathing for which David Gilmour was responsible. After a few bars, Waters enters with the lead vocal, pushing his voice to extremes as he tests the limits of his vocal capacities, and in doing so creates a sense of intense vulnerability. Waters offers up his soul; he is suffering for his art. There is no cheating here; he puts his feelings

The very image of the dysfunctional couple in Alan Parker's movie. The woman is about to metamorphose into a monstrous flower.

into song without a shred of modesty, a little like Jacques Brel, who wrote "Ne Me Quitte Pas" in 1959. Naturally the two approaches differ: Brel's has a more poetic vision of life, while Waters's is bleaker and more paranoid. It is also possible to discern the influence of *John Lennon/Plastic Ono Band*, the album Waters admired for the way in which the artist lays bare his emotions.

In the third verse (from 2:20), Gilmour's breathing grows heavier, more intense, and more invasive. Waters's performance becomes unbearably agonizing before tailing off in a final, heartrending wail. Rick Wright announces the last section of the song with furious glissandi on his B-3, launching the musicians into a rockier sequence, with Mason picking up his sticks again to work his Ludwig, and Gilmour taking over the lead vocal. Gilmour also plays a stereo rhythm guitar part, most likely through his Yamaha rotary speakers, a distorted rhythm part in support of the drums, and a lead part that underlines his sung melody.

"Don't Leave Me Now" eventually closes with a return to the background television noises (from 4:00) as Pink compulsively changes channels, before ending on a dreadful cry of rage.

Another Brick
In The Wall, Part 3

Roger Waters / 1:15

Musicians

David Gilmour: electric rhythm and lead guitar, vocal harmonies (?)
Rick Wright: Prophet-5
Roger Waters: vocals, vocal harmonies, bass, electric rhythm guitar
Nick Mason: drums

Recorded

Britannia Row, Islington, London: September 1978–March 1979
Super Bear Studios, Berre-les-Alpes, Alpes-Maritimes (France): April–July 1979
Studio Miraval, Domaine de Miraval, Le Val, Var (France): April–July 1979
Producers Workshop, Hollywood: September 12–November 1, 1979

Technical Team

Producers: Bob Ezrin, David Gilmour, Roger Waters
Co-producer: James Guthrie
Sound Engineers: James Guthrie, Nick Griffiths, Patrice Quef, Brian Christian, Rick Hart

For Pink Floyd Addicts

Originally, Roger Waters's opening line was *I don't need your drugs to bring me down, down, down.* He was asked to change the words by Bob Ezrin, probably because of the overexplicit reference to illegal substances...

Genesis

In the third and final installment of the "Wall" triptych, Pink's schizophrenia reaches a new stage. The wall he believes will protect him from other people and enable him to live at ease within his inner world is almost finished. He comes straight to the point, expressing his desire for solitude, which involves contempt for, and the rejection of, those he has shared his life with hitherto: his wife, his manager, and perhaps even his mother: *I don't need no arms around me/I don't need no drugs to calm me…No, don't think I'll need anything at all…*and the killer line, sounding like an ode to isolation and his only response to the world he has grown to detest: *All in all, you were all just bricks in the wall.* He could not be more direct. Pink is "convincing himself really that his isolation is a desirable thing, that's all,"[126] Roger Waters would reveal in his interview with Tommy Vance in 1979. "That's the moment of catharsis."[36] Again according to Waters, this self-persuasion involves rejecting all that the world offers in terms of ways of easing the pain of existence, in other words pharmaceutical or recreational drugs (in fact the working title of the song was "Drugs"), but also empathetic human relationships. For Pink, the consumption of narcotics has only widened the gulf between him and the rest of the world, while the loving arms that have embraced him, whether the overprotective arms of a mother or the sensual arms of a wife, have proved suffocating in the case of the first and treacherous in that of the second. Arms that either imprison or deceive!

Pink is aware of the harm the world can inflict on human beings. He has seen the "writing on the wall." This expression signifying an omen of impending doom or misfortune goes all the way back to the Old Testament book of Daniel, in which an otherworldly inscription portending the fall of Babylon appears to King Belshazzar. Could Waters be relating the expression to himself in this instance? By the end of the song, Pink has completed his self-immurement with the addition of the last brick.

Production

The early versions of this song were appreciably different from the album version—in the first part of the song at least. Early on, Waters was singing in almost folk-rock mode in a

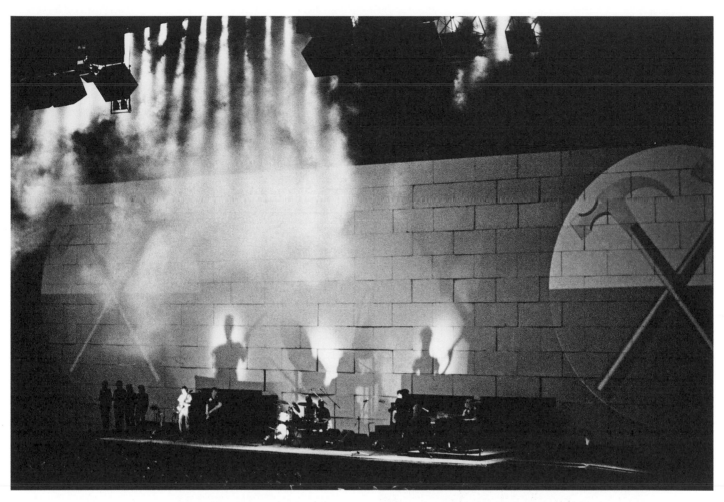
The wall is almost finished. Pink has reached a new stage in his isolation.

gentle voice with vocal harmonies and no drums. On the album, the intro takes the form of an exploding television that follows on from the cry of rage emitted by Waters/Pink at the end of "Don't Leave Me Now." In fact there is a total of six explosions, the last of which launches the group into a muscular version of "Another Brick in the Wall." Mason is on drums, marking each beat of the bar on the bass drum, Waters is on the bass guitar and singing lead vocal—this time very tensely and aggressively, and Gilmour plays palm mute on his now clear-toned "Black Strat." He also contributes further guitar parts with Big Muff distortion and strongly colored by the Electric Mistress. At the end of the fourth line, Rick Wright comes in on the Prophet-5 doubled by a guitar played, this time, by Waters in a rhythmic loop

with very prominent delay. In the refrain, Waters multitracks his voice, with Gilmour possibly coming to his aid as well.

The exploding television required a considerable amount of preparation before it could be recorded. First of all, Phil Taylor was given the task of procuring an enormous set from a Los Angeles store. He also took the sensible precaution of bringing back two smaller sets so that James Guthrie could set his sound levels. Once they were positioned in the Producers Workshop parking lot, Guthrie used a pair of shotgun mics connected to limiters, and Brian Christian was chosen to smash the television set with a sledgehammer wrapped in a T-shirt to dampen the blow. It worked perfectly, and the results were used numerous times on the album!

Goodbye Cruel World is also the title of the eighth album by Elvis Costello and the Attractions, which was released in 1984.

Goodbye Cruel World

Roger Waters / 1:17

Musicians
Rick Wright: Prophet-5
Roger Waters: vocals, bass

Recorded
Britannia Row, Islington, London: September 1978–March 1979
Super Bear Studios, Berre-les-Alpes, Alpes-Maritimes (France): April–July 1979
Studio Miraval, Domaine de Miraval, Le Val, Var (France): April–July 1979
Producers Workshop, Hollywood: September 12–November 1, 1979

Technical Team
Producers: Bob Ezrin, David Gilmour, Roger Waters
Co-producer: James Guthrie
Sound Engineers: James Guthrie, Nick Griffiths, Patrice Quef, Brian Christian, Rick Hart

Roger Waters singing and playing his Fender Precision "all black" on this song.

Genesis

The second side of the vinyl edition of *The Wall* ends with this short song (in the CD versions, it concludes the first of the two discs). The final farewells addressed by the rock star to the real world in "Another Brick in the Wall (Part 3)" are confirmed here: *Goodbye cruel world, I'm leaving you today.* Is Pink planning to do the unthinkable? No! "Goodbye Cruel World" is not a suicide note, it is the rock star bricking himself up within his own space, behind the wall he has just finished constructing. "That's him going catatonic if you like," explains Roger Waters to Tommy Vance, "that's final and he's going back and he's just curling up and he's not going to move. That's it, he's had enough, that's the end."[126] And this is exactly what we see in Alan Parker's movie: Pink in his hotel room, a cigarette between his fingers, his eyes glazed over, lost in his own unfathomable thoughts. End of the second act! However, behind Pink, once again, is Waters, and he has been building his wall, metaphorically speaking, since the Second World War, since the childhood from which his father was absent.

Production

"Goodbye Cruel World" is faded in over the end of "Another Brick in the Wall (Part 3)." Roger Waters rocks very slowly between octave Ds on his bass (tuned in drop D). The sound brings to mind the swinging of a clock pendulum, and, inevitably, the inexorable passing of time. Moreover, this idea is reinforced by two chimes (at 0:16 and 0:26). Rick Wright provides the only harmonic support, with synth pads produced on his Prophet-5. It is over this that Waters launches into his lead vocal after thirty-five seconds of intro. His voice is simultaneously solemn, resigned, and relieved. No sooner has he has uttered his last "goodbye" than a glacial silence prevails. In the live show, it is on this final word that the last brick is inserted into the wall.

Hey You

Roger Waters / 4:42

Musicians
David Gilmour: vocals, vocal harmonies, six- and twelve-string acoustic guitars, electric rhythm and lead guitar, fretless bass
Rick Wright: organ, Rhodes Fender, Prophet-5
Roger Waters: vocals
Nick Mason: drums
James Guthrie: drill

Recorded
Britannia Row, Islington, London: September 1978–March 1979
Super Bear Studios, Berre-les-Alpes, Alpes-Maritimes (France): April–July 1979
Studio Miraval, Domaine de Miraval, Le Val, Var (France): April–July 1979
Producers Workshop, Hollywood: September 12–November 1, 1979

Technical Team
Producers: Bob Ezrin, David Gilmour, Roger Waters
Co-producer: James Guthrie
Sound Engineers: James Guthrie, Nick Griffiths, Patrice Quef, Brian Christian, Rick Hart

"Hey You" was left off the movie soundtrack of *The Wall* when it was decided the accompanying footage was redundant.

Genesis

Roger Waters had originally conceived of *The Wall* with "Is There Anybody Out There?" as the opening song of the third act. After Bob Ezrin pointed out to him that side three would not really work with that structure, the decision was made to start the side with "Hey You," and this explains why the lyrics for the song were printed in the wrong place on the inner sleeve, that is to say at the end of the third side, after "Comfortably Numb." "In fact," explains Waters, "I think I'd been feeling uncomfortable about it anyway. I thought about it and in a couple of minutes I realised that 'Hey You' could conceptually go anywhere."[126] Thus the song opens the third act of the concept album, as Pink lies prostrate in his hotel room (until "Comfortably Numb"), sheltered by the wall he has erected, his only contact with the outside world now the sound of the freeway that reaches him through the broken window. The rock star wanted to cut himself off from the world, but now that he has achieved that aim, the solitude is weighing on him. This song, one of the most remarkable on the whole album—and one of the most important in terms of the storyline devised by Waters and Ezrin—is actually an appeal for help directed to anyone capable of understanding him and with the strength to battle to help him. Or is it simply Pink calling out to the world without any expectation of help (*Hey you, don't help them to bury the light, don't give in without a fight*)? In any case he cannot be heard because of the thickness and height of the wall he has erected. Another theory is that a part of Pink wants to be helped while another part of him does not. This schizophrenia becomes painfully obvious from this point forward, and the wall itself is a metaphor of the schizophrenic incarceration of the self. *And the worms ate into his brain*, writes Roger Waters. For the songwriter, worms, to which this is the first reference in the conceptual work, symbolize decay.

Roger Waters would also explain that "Hey You" was not merely a bottle desperately cast into the sea by Pink, but "a cry to the rest of the world,"[126] a message of unity and harmony of more universal significance. Pink concludes the song with a flash of lucidity: *Together we stand, divided we fall*, but he very quickly sinks back into pessimism, and the song ends with the multiple repetition of the last two words:

Above: Pink supine in his hotel room. "Hey You" opens the third act of Pink Floyd's conceptual work.
Right: David Gilmour (seen here in London on August 7, 1980) delivers an excellent solo on his "Black Strat" in "Hey You."

we fall. As Waters would explain: "At the end of 'Hey You,' he makes this cry for help, but it's too late."[9]

Production

"Hey You" is a real showcase for David Gilmour's musical talent. As well as singing one of the lead vocal parts, he plays no fewer than five different types of guitar, including bass. He begins with arpeggios on his Ovation Custom Legend 1619-4, played in nonstandard "Nashville" tuning, which is often used by country musicians. Nashville tuning is also used in "Wild Horses," the superb Rolling Stones song on the album *Sticky Fingers* (1971). The four lowest strings (E, A, D, G) are replaced by the corresponding strings (the finer-gauge ones) of a twelve-string guitar. Gilmour introduces a further variation, however, in which the bottom E (the sixth string) is identical to the top E (the first string). In order to reinforce the resulting crystalline sound, his Ovation was recorded by a Neumann U67 mic connected to an Alembic F-2B preamp and then played through Yamaha rotary speakers whose output James Guthrie captured by means of three mics positioned in front of each of the three individual speakers! Hence the incredible whirling sound. In the second verse (1:20), Gilmour introduces a Martin D12-28 twelve-string acoustic (doubled). He also plays various rhythm parts with Big Muff distortion on his "Black Strat." Finally (from 1:58), he plays an excellent solo in which his use of string bending and the whammy bar lends his playing a unique character. An unusual thing about this solo is that it is based on the melodic motif of "Another Brick in the Wall," as is the accompaniment played on two distorted rhythm guitars. Also, right from the intro (end of the fourth bar), Gilmour can be heard playing a good bass line on a Charvel fretless red sunburst P-bass, as he had previously done in "Pigs (Three Different Ones)" on *Animals.* When asked in 1992 if it really was him playing this part, he replied: "Yeah. Hmm. Roger playing fretless bass? Please! [laughs]"[132] On top of all this, Gilmour also sings lead vocal in the first two verses, harmonizing with himself in the second.

Rick Wright contributes some good keyboard parts, firstly on the Fender Rhodes, with unmistakable phrasing, and then on the Hammond and Prophet-5. Meanwhile Nick Mason supports his bandmates from the second verse on with some powerful drumming with a clear sonority.

Roger Waters takes over the lead vocal in the bridge of "Hey You" (from 2:57) and in the final verse, singing in a strained and high-pitched voice. Separating the bridge from the final verse, however, is a short and curious instrumental section (from 3:21). We hear the famous "ping" from "Echoes" on the album *Meddle,* which resounds, ghost-like, six times, and the Prophet-5 is used to create a kind of swarming noise, reinforced by James Guthrie with an electric drill, in order to illustrate the last phrase of the bridge: *And the worms ate into his brain.*

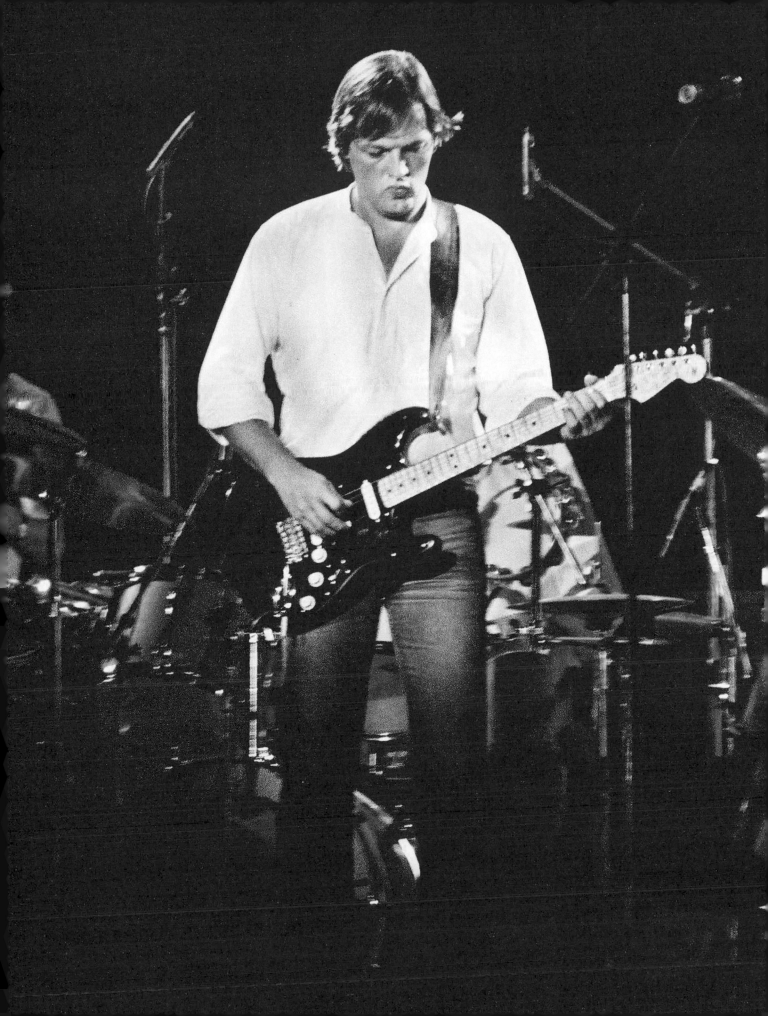

Is There Anybody Out There ?

Roger Waters / 2:41

Musicians

David Gilmour: backing vocals, electric lead guitar (with wah-wah)
Rick Wright: Prophet-5
Roger Waters: vocals, bass
Bob Ezrin: synthesizers
Joe DiBlasi: classical guitar
Unidentified Musician: violin

Recorded

Britannia Row, Islington, London: September 1978–March 1979
Super Bear Studios, Berre-les-Alpes, Alpes-Maritimes (France): April–July 1979
Studio Miraval, Domaine de Miraval, Le Val, Var (France): April–July 1979
Producers Workshop, Hollywood: September 12–November 1, 1979

Technical Team

Producers: Bob Ezrin, David Gilmour, Roger Waters
Co-producer: James Guthrie
Sound Engineers: James Guthrie, Nick Griffiths, Patrice Quef, Brian Christian, Rick Hart

Genesis

This song might just as well be called "Pink's Agony." As in the preceding song, Pink is calling for help, and repeats the same phrase four times: *Is there anybody out there?* A question to which the answer, for the time being, is "no." Pink is alone, and is going to remain so…

Musically, this second track in the third act of *The Wall* is a real triumph thanks to the way it creates an oppressive atmosphere that compellingly reflects the feelings of alienation overcoming the rock star. Roger Waters has described this as a transitional piece.

Production

The track opens with the sound of a television channel being selected and dialogue from an episode of *Gunsmoke* ("Fandango," to be exact). We also hear traffic noises that were recorded from the roof of the Producers Workshop by Rick Hart. These are the very same sound effects that can be heard in "One of My Turns," establishing the same American motel atmosphere as the backdrop to Pink's unfolding drama. A Prophet-5 synth pad is faded in, followed by chords almost certainly played on the ARP Solina, before Roger Waters's lugubrious voice (doubled for the last words of the phrase, and with shortish reverb) asks the question: *Is there anybody out there?* The harmonies are dominated by spacious, crystalline sonorities from the Prophet-5, blending with a kind of extraterrestrial siren. Waters poses his question a second time, giving rise to the astonishing sound of seagull cries, the same ones that are heard on "Echoes." Following the "ping" on "Hey You," this is the second time the group has harked back to the masterly second side of *Meddle*. These birdcalls were created by Gilmour on a "Black Strat" plugged into his wah-wah with the connections reversed. The swarming noises heard on the bridge of "Hey You" then resurface, leaving Waters to repeat his question a third time. After this, the tension is suddenly dissipated by a change of key, giving way to some very fine backing vocals sung most probably by Gilmour alone. The seagull cries return furtively and Waters's voice then rings out for one last time with, *Is there anybody out there?*

Pink has smashed everything, including the television set and his musical instruments, in a frenzy resembling a kind of ritual.

The second section differs radically from the first. Roger Waters came up with a subtle and melancholy arpeggiated part for classical guitar that should, of course, have been played by Gilmour. Gilmour's attempt to play it having proved less than convincing, a classical guitar player named Joe DiBlasi was brought in under Michael Kamen's supervision. "There's a guy playing the Spanish guitar on 'Is There Anybody out There'; I could play it with a leather pick but couldn't play it properly fingerstyle."[133] This beautiful classical guitar passage is accompanied by the Prophet-5 and a violin sound presumably produced on the ARP. A bass joins in for eight bars from 2:07, and Joe DiBlasi ends the song with a real violinist playing a particularly melancholy tune (from 2:24). Flute sounds (produced on the Mellotron?) can also be made out at the back of the mix. The traffic noises then come to the

fore again, and the sound of a sixties sitcom, *Gomer Pyle, U.S.M.C.*, playing on the television in the background, brings "Is There Anybody Out There?" to a close.

Nobody Home

Roger Waters / 3:25

Musicians
David Gilmour: bass
Rick Wright: Prophet-5
Roger Waters: chant, VCS3
Bob Ezrin: piano
Michael Kamen: orchestration and conducting
New York Symphony: orchestra

Recorded
Britannia Row, Islington, London:
September 1978–March 1979
**Super Bear Studios, Berre-les-Alpes, Alpes-
Maritimes (France):** April–July 1979
**Studio Miraval, Domaine de Miraval,
Le Val, Var (France):** April–July 1979
CBS Studios, New York City: August 1979
Producers Workshop, Hollywood:
September 12–November 1, 1979

Technical Team
Producers: Bob Ezrin, David Gilmour, Roger Waters
Co-producer: James Guthrie
Sound Engineers: James Guthrie, Nick Griffiths, Patrice
Quef, Brian Christian, Rick Hart, John McClure

Roger Waters and Michael Kamen, shown here in around 1970, would collaborate a few years later on *The Wall*.

Genesis

In a state of utter isolation and abandonment, Pink is reminded to make a kind of Jacques Prévert–like inventory of all the items he has at hand: a black book in which he writes poems, a toothbrush and comb…*thirteen channels of shit on the TV to choose from*, and a telephone that only adds to his suffering because there is *never anybody to talk to on the other end*. This idea of a nonexistent phone conversation is really a grim reflection on his wife, who has abandoned him for another man and is ignoring him. There is nothing, in other words, to stave off his boredom or help him out of his despair. At the end of the song, Roger Waters refers to *fading roots*. This is a new source of anguish given that Pink wants to reconnect with his roots at this point. "If you like," explains Waters, "he's getting ready here to start getting back to side one [of the album]."[126]

In this song, Roger Waters has projected onto Pink part of the experience and soul of Pink Floyd. "There are some lines in here that hark back to the halcyon days of Syd Barrett," explains Waters to Tommy Vance, "it's partly about all kinds of people I've known, but Syd was the only person I used to know who used elastic bands to keep his boots together, which is where that line comes from, in fact the 'obligatory Hendrix perm,' you have to go back ten years before you understand what all that's about."[126] Roger Waters is referring here to Jimi Hendrix's Afro, which was copied by numerous guitar heroes at the end of the sixties, including Eric Clapton and…Syd Barrett. Other references pepper the song, not least the small silver spoon on a chain, a utensil from which many a cocaine-loving rock star (including a certain Rick Wright) would not be separated for the world. There are also various other, reasonably precise, allusions to the Floyd keyboard player, notably the phrase *Got a grand piano to prop up my mortal remains*; this inevitably brings to mind "The Mortality Sequence," Wright's sublime composition renamed by the group "The Great Gig in the Sky (on the album *The Dark Side of the Moon*), featuring Mr. Rick Wright on the grand piano!

Production

This very beautiful Roger Waters ballad is another song that opens with television sounds, with the inevitable

An allegory of Pink's solitude and insanity, as seen through Alan Parker's lens.

traffic noise in the background. The show we can hear is the continuation of the extract from *Gomer Pyle, U.S.M.C.* that began at the end of the previous track, "Is There Anybody Out There?" The particular episode being broadcast is called "Gomer Says 'Hey' to the President"! James Guthrie has explained that most of these extracts were recorded on quarter-inch tape, with a few exceptions that were captured direct on the twenty-four-track. "Nobody Home" is one of these exceptions. A little later, we hear a girl (or possibly a woman) screaming. And then a man shouting: *Shut up!...I've got a little black book with my poems in!*

Finally, after six seconds of dialogue, the music begins with grand piano played by the talented Bob Ezrin, accompanied by a weak rhythmic pulse that moves around the stereo field, probably a sequence programmed into the VCS3. Roger Waters comes in on lead vocal in the sixth bar and gives a superb performance. His voice is doubled by a soft mono delay that is present enough for the repetition of each word to be clearly distinguishable without becoming muddied. The strings of the New York Symphony, orchestrated and conducted by the excellent Michael Kamen at the CBS Studios in New York

City in August, then make their magnificent entrance. The brass comes in soon after, supplementing the strings to create a rich and superbly rounded orchestral sound. Waters gives a very fine performance, adapting his emotions to the words. David Gilmour plays a reasonably discreet bass part (from 1:48), and in the third verse Rick Wright comes in with pad sounds on the Prophet-5, thickening the texture even further. Waters's vocal reaches a climax at 2:51, his intense voice betraying extraordinary emotion, before sinking back into resignation with "There's still nobody home," a phrase to which, by some strange coincidence, one of the actors in the television series (which is still playing in the background) replies: *Surprise, surprise, surprise!*

In a 2009 interview, David Gilmour recalled that during preproduction for *The Wall*, Roger Waters would submit his demos to the rest of the band for approval. In the event of rejection, he would come back the next day with an improved and often brilliant version. "Some of the songs—I remember 'Nobody Home'—came along when we were well into the thing and he'd gone off in a sulk the night before and came in the next day with something fantastic."[116]

Vera

Roger Waters / 1:34

Musicians
David Gilmour: bass, acoustic guitar
Rick Wright: Prophet-5
Roger Waters: vocals
Michael Kamen: orchestration and conducting
New York Symphony: orchestra

Recorded
Britannia Row, Islington, London:
September 1978–March 1979
Super Bear Studios, Berre-les-Alpes, Alpes-Maritimes (France): April–July 1979
Studio Miraval, Domaine de Miraval, Le Val, Var (France): April–July 1979
CBS Studios, New York City: August 1979
Producers Workshop, Hollywood:
September 12–November 1, 1979

Technical Team
Producers: Bob Ezrin, David Gilmour, Roger Waters
Co-producer: James Guthrie
Sound Engineers: James Guthrie, Nick Griffiths, Patrice Quef, Brian Christian, Rick Hart, John McClure

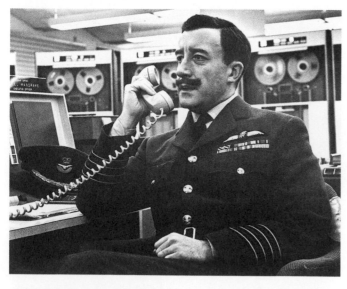

Peter Sellers in *Dr. Strangelove* by Stanley Kubrick, who used "We'll Meet Again" in the soundtrack.

Genesis

Roger Waters had originally envisaged opening *The Wall* with "We'll Meet Again," a composition by Ross Parker and Hughie Charles that was a huge success for the British singer Vera Lynn on the eve of the Second World War. The performer from London, who presented a radio show called *Sincerely Yours* and gave concert after concert in order to boost the morale of the troops, became a big star during these anxious, uncertain years. "We'll Meet Again" also became the emblematic song of RAF pilots during the Battle of Britain.

Although the idea of using "We'll Meet Again" was abandoned, possibly for rights reasons, Roger Waters decided to pay homage to Vera Lynn in this song appropriately entitled "Vera." *Does anybody here remember Vera Lynn?* he sings, before repeating almost word by word the line *But I know we'll meet again some sunny day* from "We'll Meet Again," changing it to: *…we would meet again/Some sunny day.*

At the beginning of the song, a snatch of dialogue from the movie *Battle of Britain* (1969), directed by Guy Hamilton, takes Pink/Waters back to his childhood and the death of his father. This sequence was clearly carefully chosen to illustrate Pink returning to his origins, a process initiated at the end of "Nobody Home." "This is supposed to be brought on by the fact that a war movie comes on the TV,"[126] confirms Waters. The dialogue from the movie merges with the voice of a television announcer, followed by the sound of fighter aircraft and an explosion.

Production

It is at the precise moment of the explosion that Roger Waters launches into the first verse of this melancholy song, his voice colored by a slight delay. He is accompanied by David Gilmour playing arpeggios on his classical Ovation 1613-4 in the midst of a string ensemble brilliantly orchestrated and conducted by Michael Kamen and recorded by the New York Symphony at the CBS Studios in New York City in August. A short instrumental bridge follows in which Gilmour comes in on bass and Rick Wright produces synth pads and crystalline sounds (with delay) on his Prophet-5 (from 0:43), before Waters ends his song in a nostalgic atmosphere reminiscent of the wartime cabaret style.

1979

Singer Vera Lynn, the muse of British soldiers during the Second World War, and an inspiration for Roger Waters.

Bring The Boys Back Home

Roger Waters / 1:27

Musicians
David Gilmour: vocals (reprise of "Is There Anybody Out There?")
Roger Waters: vocals
Joe Porcaro: snare drum
Bleu Ocean: direction of snare drummers
Thirty-five New York drummers: snare drum
Michael Kamen: orchestration and conducting
New York Symphony: orchestra
New York City Opera: backing vocals

Recorded
Britannia Row, Islington, London:
September 1978–March 1979
Super Bear Studios, Berre-les-Alpes, Alpes-Maritimes (France): April–July 1979
Studio Miraval, Domaine de Miraval, Le Val, Var (France): April–July 1979
CBS Studios, New York City: August 1979
Producers Workshop, Hollywood:
September 12–November 1, 1979

Technical Team
Producers: Bob Ezrin, David Gilmour, Roger Waters
Co-producer: James Guthrie
Sound Engineers: James Guthrie, Nick Griffiths, Patrice Quef, Brian Christian, Rick Hart, John McClure

Joe Porcaro (on the right, in 1998) plays the snare drum in "Bring the Boys Back Home."

Genesis

Roger Waters has revealed to Tommy Vance that for him, "Bring the Boys Back Home" was the "central song on the whole album."[126] It is "partly about not letting people go off and be killed in wars, but it's also partly about not allowing rock and roll, or making cars or selling soap or getting involved in biological research or anything that anybody might do, not letting that become such an important and 'jolly boys game' that it becomes more important than friends, wives, children, other people."[126] In other words, Waters is attributing Pink's pathological isolation to his career and the obligations that go hand in hand with being a rock star. Representative of these pressures is the manager who knocks on his door and tells him: *Time to go.*

Nevertheless, "Bring the Boys Back Home" remains first and foremost an antiwar song. *Bring the boys back home/ Don't leave the children on their own*, sings Waters. In the same surge of patriotism, the drums celebrate the homecoming of the lucky ones who have returned from the battlefield and commemorate the fallen. But what about the children who, like Pink, will never experience the joy of welcoming home a revered father…As another flashback, this song also sums up the action of *The Wall* from the very beginning, which explains why we successively hear the voices of the schoolmaster, the phone operator, the groupie, and finally Pink himself, asking, *Is there anybody out there?* The only newcomer in Pink's confined world is his manager.

Production

"Bring the Boys Back Home" occupies a unique place in the history of Pink Floyd. It was the first time one of their songs was treated more like a piece of musical theater than rock music—even of the progressive variety! The track starts with a group of thirty-five snare drummers assembled at Bob Ezrin's request by Bleu Ocean, a professional drummer said to have played for the Monkees without ever being credited. The session was held at the CBS Studios in New York City in August. Jordan Rudess, the keyboard player with Dream Theater, recalls having been invited along by Bleu Ocean despite having only a rudimentary grasp of the snare drum. He turned up to record at the studio and duly started to play, along with the other thirty-five musicians. "But as I'm doing

1979

A scene from Alan Parker's film showing Pink, as a boy, coming face to face with his father, who was killed in combat, a central theme of *The Wall*...

so," explains Rudess, "I become aware that Bob Ezrin is looking at me across the room, eyebrow slightly askew and finally he says: 'I don't think so.'"[134] He followed the proceedings from the control room, and clearly remembers the team wondering where to position the piece on the album! On October 4, Joe Porcaro, the father of Jeff Porcaro, recorded a military drum at the Producers Workshop in Los Angeles. This was the final element in the rhythm section. Following fifteen seconds of massed snare drums, the New York Symphony and the impressive chorus of the New York City Opera explode into a powerful lyrical passage masterfully orchestrated and conducted by Michael Kamen with the help of Bob Ezrin. Roger Waters's lead vocal blends with the voices of

the chorus, emerging at certain points, where it sounds close to the breaking point, and transforming the last word of the song into a howl of pain (0:49). The snare drums continue to beat out their martial rhythm after the other musicians have fallen silent. This is when the procession of sound effects and voices begins, most of which have already been repeated since the beginning of the album: *Wrong, do it again!*—the desolate ringing of a telephone—*Time to go!*—the sound of the television—*Are you feeling okay?—There's a man answering, see he keeps hanging up!*—crowd noises, laughter—the backing vocals of "Is There Anybody Out There?"—and finally Waters/Pink ending the song with that recurring question: *Is there anybody out there?*

Comfortably Numb

David Gilmour, Roger Waters / 6:24

Musicians

David Gilmour: vocals, vocal harmonies, acoustic rhythm guitar, electric rhythm and lead guitar, pedal steel guitar, bass, Prophet-5
Rick Wright: organ
Roger Waters: vocals, bass
Nick Mason: drums
Lee Ritenour: acoustic guitar
Michael Kamen: orchestration and conducting
New York Symphony: orchestra

Recorded

Britannia Row, Islington, London:
September 1978–March 1979
Super Bear Studios, Berre-les-Alpes, Alpes-Maritimes (France): April–July 1979
Studio Miraval, Domaine de Miraval, Le Val, Var (France): April–July 1979
CBS Studios, New York City: August 1979
Producers Workshop, Hollywood:
September 12–November 1, 1979

Technical Team

Producers: Bob Ezrin, David Gilmour, Roger Waters
Co-producer: James Guthrie
Sound Engineers: James Guthrie, Nick Griffiths, Patrice Quef, Brian Christian, Rick Hart, John McClure

Genesis

"Comfortably Numb" represents a climax both within the narrative of *The Wall* and in terms of the artistic collaboration between Roger Waters and David Gilmour. Concluding the third act of this conceptual work, this song plays a decisive role in the album's storyline. It is here that Pink's metamorphosis takes place, under the influence of an unknown substance with strange powers, which is injected into him by a physician. This is his "confrontation with the doctor,"[126] as Roger Waters puts it to Tommy Vance, and indeed "The Doctor" was the song's working title. Shut away in his hotel room, Pink has failed to respond to either the repeated banging on his door at the end of the previous song ("Bring the Boys Back Home") or his manager's persistent attempts to make him see sense, given that the concert is fast approaching: *Time to go!* All to no avail. Enter a physician who asks: *Hello, is there anybody in there?* a question that echoes the song "Is There Anybody Out There?" His offer to ease the rock star's pain is clearly full of significance.

It seems that Roger Waters's description of Pink's mental deterioration in this song was inspired by a real-life incident that occurred in the summer of 1967. During the International Love-In Festival, Marc Bolan's wife discovered Syd Barrett in such a serious cataleptic state that he was unable to recognize her. Aware of the seconds ticking away, the stage manager started panicking and shouting "Time to go! Time to go!" exactly as Pink's manager (who also bangs on the hotel room door) does at the end of "Bring the Boys Back Home." Although Barrett was eventually led onto the stage, he was present in body only that evening and was unable to support the other three members of the group…

Roger Waters and David Gilmour share the lead vocal in "Comfortably Numb." The verses are sung by Roger Waters, playing the part of the physician, and the refrain by David Gilmour in the role of Pink. In Waters's sections, his voice is so fragile and dreamlike that one wonders whether he is trying to embody the drug and its effect on Pink's neurons. In the first refrain, Pink addresses the following words to the physician: *Your lips move, but I can't hear what you're saying.* He is then plunged deep into his past and the memory of a fever that makes him feel "comfortably numb." Is this an expression of the sense of paralysis we feel when

David Gilmour's guitar solo on "Comfortably Numb" remains one of the best he has ever recorded.

we suddenly discover that our childhood has disappeared for good? Or is it a reference to Pink's possessive mother (as Alan Parker gives us to think in his movie, in which we see Pink marrying a "rock chick"—out of love perhaps, but more likely to escape from the web his mother has woven around him in order to protect him from the outside world)?

The physician then administers an injection with the aim of getting Pink through the show. Pink's plunge into the past continues until the end of the last refrain. Waters has revealed that this passage derives from an experience he had had a few years before: "I was in Philadelphia; I had terrible stomach pains. I can't remember exactly when it was, but this idiot said, 'Oh, I can deal with that,' and gave me an injection of some kind. God knows what it was, but I went (*sound of hitting floor*)."[36] He adds that the two hours that followed were the longest two hours in his life as he was incapable of playing or moving his arms during the concert.

The message is clear: Waters is targeting the world of entertainment, and rock 'n' roll in particular, where money takes precedence over everything else—with no regard to the physical or mental health of those paid to go onstage. It is also a frontal attack on an economic

model based on profit. Open season on the moneymen, in a sense…From a musical point of view, "Comfortably Numb" is universally recognized as a Pink Floyd masterpiece and as a perfect example of Gilmour's melodic subtlety combined with Waters's dark poetry. This song is David Gilmour's main contribution to *The Wall*—in the capacity of composer at least.

Production

"Comfortably Numb" is one of the rare tracks on the album that starts with neither sound effect nor segue. David Gilmour explains the genesis of the song: "I actually recorded a demo of 'Comfortably Numb' at Berre Les Alpes while I was doing my first solo album [*David Gilmour*, 1978], but it was only a basic little chord pattern which was really not much else,"[36] he explains. In the end, the guitarist did not have time to include it on his solo album, and put it to one side. It was only much later, at the insistence of Bob Ezrin, who was extremely keen for Gilmour to contribute to the writing of *The Wall*, that he returned to it. James Guthrie remembers: "The day that he turned up with 'Comfortably Numb,' sang a '*la-la*' melody over the top of these

chords, was fantastic."[116] Ezrin then asked Waters to write the words. Waters did so, but with little enthusiasm, according to Ezrin. When he reappeared with the finished lyric, the producer was full of admiration, and has called the song text "one of the greatest ever written."[116]

Although there was no dispute about the authorship of the words, the same cannot be said of the music. Gilmour has subsequently maintained throughout many an interview that his collaboration with Waters on this track amounted to "my music, his words,"[116] claiming that Waters had asked him to adapt his music to the length of his lines, thereby forcing him to change the structure of the piece. However, Roger Waters would dispute this version of events, which in his opinion is too black and white: "What happened is Dave gave me a chord sequence, so if you wanted to fight about it I could say that I wrote the melody and the lyrics, obviously. I think in the choruses he actually hummed a bit of the melody, but in the verses he certainly didn't."[116] Listening to Gilmour's demo, it seems that Waters's memory had played tricks on him because the refrain and its melody were fully formed and only the verses remained vague. But as he himself would say, "Arguing about who did what at this point is kind of futile."[116]

Ego Problems

Unfortunately, the disagreements between the two men were not confined to the songwriting. Other major bones of contention were the arrangements and mixing. Gilmour and Waters failed to see eye to eye on two main points. Firstly the strings that Bob Ezrin had Michael Kamen arrange and record in New York City were judged by David Gilmour to be excessively syrupy. He wanted a more pared-down rock sound. However, the producer fought his corner and Roger Waters supported him: "They sounded fantastic, almost the best thing that Michael ever did in my view. I loved it."[135]

The second area of dispute concerned the drum part recorded by Nick Mason, which the guitarist considered slapdash. "We had another go at it and I thought that the second take was better."[29] Gilmour then reworked the song and took it upon himself to present a new version that he now considered perfect, but Waters did not like it at all, and "That was the big argument."[135] Each of them justified his own vision of the song forcefully, conceding nothing, Gilmour, for his part, wanting to defend at all costs one of the very few titles he had written for the album. They would describe this sparring as no less than a battle. Finally, in the light of their respective stubbornness, they reached a compromise: "So the song ended up with 4 bars of his and 4 bars of mine...the whole track is like that. It was a weird sort of bargaining thing between he and I."[135] The most distressing thing about this whole episode is that both Gilmour and Waters have since admitted that they are unable to hear the difference between the rejected versions and the version used in the end. "It was more an ego thing than anything else,"[29] Gilmour would admit in 1993...

Musically, "Comfortably Numb" opens with four bars consisting of the brass conducted by Michael Kamen, a pedal steel guitar played by David Gilmour (a sonority that had been absent in Pink Floyd's music since *Wish You Were Here*), Rick Wright's Hammond organ, Roger Waters's bass, and Nick Mason's drumming. Roger Waters has awarded himself the lead vocal in all the verses, singing in a drawling voice and a patronizing, paternalistic tone in keeping with the character of the shady Dr. Feelgood. The first syllables of each verse are repeated by a very present echo, creating the impression that they are reverberating in Pink's befuddled head. David Gilmour in turn takes the lead vocal in the refrains, supported by his Ovation Custom Legend, in "Nashville" tuning (as on "Hey You"), a second acoustic rhythm part, this time played by Lee Ritenour, and

Waters and Gilmour in reconciliatory mood in 2005 after falling out so ferociously over "Comfortably Numb."

the superb strings orchestrated and conducted by Michael Kamen—one of the areas of disagreement.

A Landmark Solo

At the end of the first refrain, Gilmour plays one of the song's two guitar solos on his "Black Strat," with Big Muff distortion and colored by Yamaha rotary speaker. His touch is as brilliant, and his performance as inspired, as ever. Roger Waters sings lead vocal in three more verses before Gilmour returns for the final refrain. After his last phrase he launches into his second solo, which remains one of the highlights of his career as a guitarist. He would explain that he recorded it relatively quickly, in five or six takes: "From there I just followed my usual procedure, which is to listen back to each solo and mark out bar lines, saying which bits are good."[29] Having identified the most successful passages, all that remained to do was to bring the faders up and down for each of the tracks used in order to arrive at a single, polished solo. "That's the way we did it on 'Comfortably Numb.' It wasn't that difficult,"[29] he would conclude. The results are breathtaking. Gilmour surpasses himself in the intensity of his performance, his "Black Strat" thundering through his

Hiwatt amp, colored by Yamaha rotary speaker and Big Muff. This solo would go down in the annals of music history, among other things being voted fourth-best rock solo of all time by the magazine *Guitar World*. Supporting the guitarist are Mason with a very good drum part and Wright on organ. It is highly likely that Gilmour is also playing bass in this section, given that the style is substantially more aggressive than that of Waters. He is also on the Prophet-5 and playing distorted rhythm guitar.

Guthrie has explained that during mixing there was a Nick Mason drum fill he wanted to change. As the Ludwig had been recorded on a sixteen-track machine that was synchronized with the twenty-four-track, there was no question of tampering with the master tape. He therefore decided to perform a window edit, a trick he had heard about, although never actually tried himself. This involved cutting out the top part of the sixteen-track tape corresponding to the eight drum tracks, and replacing it with another section pulled from a satisfactory take. Armed with a razor blade, he performed the maneuver skillfully, carefully inserted the section of tape in question, and switched on the two machines: the operation was a complete success!

The Show Must Go On

Roger Waters / 1:36

Musicians
David Gilmour: vocals, acoustic rhythm guitar, bass
Rick Wright: Prophet-5
Nick Mason: drums, Rototoms
Bob Ezrin: piano, Prophet-5
Bruce Johnston, Toni Tennille, Joe Chemay, Stan Farber, Jim Haas, Jon Joyce: backing vocals

Recorded
Britannia Row, Islington, London:
September 1978–March 1979
Super Bear Studios, Berre-les-Alpes, Alpes-Maritimes (France): April–July 1979
Studio Miraval, Domaine de Miraval, Le Val, Var (France): April–July 1979
Cherokee Recording Studios, Los Angeles: September 6–8, 1979
Producers Workshop, Hollywood:
September 12–November 1, 1979

Technical Team
Producers: Bob Ezrin, David Gilmour, Roger Waters
Co-producer: James Guthrie
Sound Engineers: James Guthrie, Nick Griffiths, Patrice Quef, Brian Christian, Rick Hart

Genesis

The fourth and last act in Roger Waters's conceptual work opens with "The Show Must Go On," known during production by the working titles "Who's Sorry Now" and "(It's) Never Too Late." Thanks to the injection from "Dr. Feelgood," Pink is back on his feet—more or less—and the show can go ahead. This is all that matters to everyone concerned, from Pink's manager to the fans. But the questioning continues. The rock star turns metaphorically to his father (whom he has never seen) and asks him to take him home. Then he addresses his mother, asking her to *let me go.* The most important phrase, however, falls like an axe at the beginning of the second act: *I didn't mean to let them take away my soul.* This gives rise to speculation that the show in question may be, in reality, Pink's life.

This song is clearly another attack from Roger Waters on the star system and the recording industry. Waters explains that "they're [Pink's managers] not interested in any of these problems, all they're interested in is how many people there are and tickets have been sold and the show must go on, at any cost, to anybody."[126]

Production

Wanting originally to make "The Show Must Go On" a Beach Boys–like number, Roger Waters went as far as asking the Beach Boys to take part in the recording. "Mike Love and I went over to Roger Waters's house. He and David Gilmour were there. They said, 'We started singing high parts, trying to sound like the Beach Boys, and then we decided, why don't we ask them?'" [9] After leaving with cassette tapes of various songs to work on with the rest of the group, and booking Sundance Productions, Inc., of Dallas, Texas, for a recording session on October 2, Mike Love politely declined the offer the same day, judging that the dark-hued concept of *The Wall* would not sit well with the Beach Boys' image. Only Bruce Johnston accepted Waters's invitation, and on October 11 he turned up at the Producers Workshop in Los Angeles in the company of Toni Tennille, one half of the duo Captain & Tennille, in order to make up for his group's defection. It should be pointed out that he is also supported by Joe Chemay, Stan Farber, Jim Haas, and Jon Joyce, well-known "names" who had all orbited planet Beach Boys. It was therefore in a spirit

The "Show Must Go On" does not feature on the soundtrack to Alan Parker's movie.

The Beach Boys—during the Bruce Johnston era—were Roger Waters's inspiration for "The Show Must Go On."

of complete confidence that Johnston recorded the backing vocals to "The Show Must Go On" with them, and the results are superb to say the least.

The song opens with their vocal harmonies. The mood is light and serene, and the instrumentation includes piano, Prophet-5, two six-string acoustic guitars, drums, and bass. The keyboards are split between Bob Ezrin and Rick Wright, the guitars and bass are played by David Gilmour, and Nick Mason is on drums. It is interesting to note that this is the only piece on the album in which Roger Waters does not play any part (other than that of songwriter). The lead vocal is taken by Gilmour, whose performance and vocal color blend perfectly with those of the "nearly" Beach Boys.

The musical material of this song is surprising in that it is reminiscent more of Gilmour's writing style than

Waters's, especially in the section following the refrain (from 0:37), which is nothing less than a homage to the Californian band with, what's more, Queen-like touches on the repeated phrase *take me home*, and descending Rototoms. Preceding the first verse (at 0:52), there was originally another that was printed and included with the other lyrics but eliminated from the recording at the mixing stage.

Listening to the refrains, it is difficult not to notice a similarity with those of "Mother." Furthermore the key is the same, as are certain chord sequences. But the song is no less a triumph for this, Bruce Johnston and his colleagues blending wonderfully well with the Floyd. There is only one cause for regret: that the brilliant Brian Wilson did not have a hand in writing the vocal harmonies!

In The Flesh

Roger Waters / 4:18

Musicians
David Gilmour: electric rhythm and lead guitar, ARP Quadra
Roger Waters: vocals, bass, VCS3
Nick Mason: drums
James Guthrie: ARP Quadra
Fred Mandel: Hammond organ
Bob Ezrin: Prophet-5
Bruce Johnston, Toni Tennille, Joe Chemay, Stan Farber, Jim Haas, Jon Joyce: backing vocals

Recorded
Britannia Row, Islington, London:
September 1978–March 1979
Super Bear Studios, Berre-les-Alpes, Alpes-Maritimes (France): April–July 1979
Studio Miraval, Domaine de Miraval, Le Val, Var (France): April–July 1979
Producers Workshop, Hollywood:
September 12–November 1, 1979

Technical Team
Producers: Bob Ezrin, David Gilmour, Roger Waters
Co-producer: James Guthrie
Sound Engineers: James Guthrie, Nick Griffiths, Patrice Quef, Brian Christian, Rick Hart

Toni Tennille sings backing vocals for Pink Floyd, alongside Bruce Johnston and his gang, on "In the Flesh."

Genesis

Back to square one, it seems, with this song that shares its title with the opening number, the only difference being the absence of the question mark. "In the Flesh" begins the album's cycle of three so-called totalitarian songs, the other two being "Run Like Hell" and "Waiting for the Worms." As a consequence of his isolation behind the wall and his schizophrenia, Pink is transformed into a fascist leader. His show resembles the Nazi rallies of the thirties, choreographed by Albert Speer and brilliantly filmed by Leni Riefenstahl (*Triumph of the Will*, 1935), and although the swastika has been replaced by a hammer symbol, the rock star's hold over the crowds recalls the diabolical spell cast by the Third Reich dictator over the Nuremberg crowds. The rhetoric, moreover, is very similar: *Are there any queers in the theatre tonight? Get 'em up against the wall…That one looks Jewish/And that one's a coon/Who let all this riffraff into the room?* In his racist frenzy, Pink lays into a member of the audience who is smoking a joint and another who has acne…"I've picked on queers and Jews and blacks simply because they're the most easily identifiable minorities where I come from, which is England," explains Roger Waters to Tommy Vance. "In fact, they are the most easily identifiable minorities in America, as well."[126] And he adds: "So the obnoxiousness of 'In the Flesh,' and it is meant to be obnoxious, you know? This is the end result of that much isolation and decay."[126] Roger Waters also tells Tommy Vance that the idea for the song and indeed the overall concept of *The Wall* came to him after the Montreal concert, where, unable to control himself when confronted by an unruly crowd, he spat at a fan. He explains: "They were pushing against the barrier and what he wanted was a good riot, and what I wanted was to do a good rock and roll show,"[126] adding: "Anyway, the idea is that these kinds of fascist feelings develop from isolation."[126]

The second incarnation of "In the Flesh" was rerecorded for the movie *The Wall*.

Production

A concert atmosphere. The crowd is excited. Nick Mason counts the band in with his sticks, and "In the Flesh" explodes with the same live sound that we hear at the beginning of the album. The rock part of the song is identical,

"In the Flesh": Roger Waters's Precision in the service of an ambitious piece.

Pink's self-destructive madness has transformed him into a neo-Nazi leader.

the musicians the same: Mason on drums, Waters on bass, Gilmour on his Strat, and Fred Mandel on Hammond organ. This lively sequence is followed by vocal harmonies of the kind heard on the previous song, "The Show Must Go On," led by the talented Bruce Johnston and his troops. The contrast is striking, very much the calm after the storm. Gilmour accompanies the singers with an arpeggiated guitar part played with a pick on a "Black Strat" strongly colored by his Yamaha rotary speakers. Underpinning the ensemble are synth pads apparently played by Bob Ezrin on the Prophet-5. The resulting sonority recalls the doowop groups of the fifties, and it is in this "good-natured"

atmosphere that Roger Waters chooses to declaim his poisonous verses. His voice is emphasized by a very present delay, and he gives an excellent performance. Drum fills and a rhythm part on the organ round off the accompaniment. In the second verse (from 2:35), the backing vocalists answer his phrases, and it has to be said that his lead vocal is absolutely masterful. The band follows up the closing words of his rant with the rock motif from the intro, Fred Mandel distinguishing himself in particular on organ. Crown noises return after the song's finale is brought to a conclusion by Nick Mason on snare drum, providing the perfect transition to the following piece, "Run Like Hell"...

Run Like Hell

David Gilmour, Roger Waters / 4:25

Musicians
David Gilmour: vocals, vocal harmonies, electric rhythm and lead guitar, bass
Rick Wright: Prophet-5, Minimoog (?)
Roger Waters: vocals
Nick Mason: drums
Bobbye Hall: congas, bongos

Recorded
Britannia Row, Islington, London: September 1978–March 1979
Super Bear Studios, Berre-les-Alpes, Alpes-Maritimes (France): April–July 1979
Studio Miraval, Domaine de Miraval, Le Val, Var (France): April–July 1979
Producers Workshop, Hollywood: September 12–November 1, 1979

Technical Team
Producers: Bob Ezrin, David Gilmour, Roger Waters
Co-producer: James Guthrie
Sound Engineers: James Guthrie, Nick Griffiths, Patrice Quef, Brian Christian, Rick Hart

David Gilmour in concert, playing an extraordinary guitar part on his superb 1955 Fender Esquire.

Genesis

"Run Like Hell" is the third song on *The Wall* to have been composed by David Gilmour. Like "Comfortably Numb," it had originally been earmarked by Gilmour for his first solo album. Waters's words, on the other hand, are in a similar vein to "In the Flesh." As a fascist leader, Pink addresses the crowd that has come to see him and worship at his feet. But for anyone who does not toe the line, *with your empty smile* and *a hungry heart*, Pink's words are ruthless and menacing. *Hammers*, he warns, can *batter down your door* and so these people had better *run like hell*. "Here is a tune for all paranoids in the audience,"[126] Waters would tell Tommy Vance. Waters has always been interested in the Second World War, and especially in the psychological hold of dictators over the masses. This led the songwriter to draw a parallel between the Nazi rallies of the thirties and rock concerts. "Run Like Hell" is thus the manifestation of a fear or phobia: the elevation of intolerance and racism to supreme values accompanied by the suppression of individual rights and liberties. This idea can also be found in the movie *Privilege* (1967), directed by Peter Watkins, in which a rock star (played by Paul Jones, the singer with Manfred Mann) exercises such an influence over teenagers that he is used by the authorities, despite himself, to nip in the bud any hint of rebellion from that section of society.

Production

"Run Like Hell" opens with the crowd atmosphere from the end of "In the Flesh" and chants of *Pink Floyd! Pink Floyd!* We immediately hear notes ringing out on the guitar, colored by a very prominent delay. The impression created is of a racing car starting up because as soon as these initial sonorities have dissipated, Gilmour reattacks the strings of his 1955 Fender Esquire with a palm-mute rhythm part. The effect is extraordinary, all the more so as he uses an initial delay of 4/4 and a second of 3/4. His Fender is tuned in drop D (in other words with the bottom E string lowered a tone, to D) and the sound is slightly distorted and colored by his customary Electric Mistress. Nick Mason supports him with bass drum on each beat of the bar, the same disco style with which the group had flirted on "Another Brick in the Wall (Part 2)." "We did the same exercise on 'Run Like

1979

A faceless crowd ready to heed the totalitarian ravings of its idol.

Hell,'"[116] Gilmour would confirm. And to reinforce the beat in this song, Gilmour also plays a bass line on a Fender VI Baritone, enabling him to reach lower notes (although it is also possible that the Fender VI Baritone was used to double his Esquire in the intro, and that his bass line was played on a Precision). He then executes a superb, highly melodic triad (three-note chord) motif on his Fender Esquire, again with Electric Mistress and the same delay. In 1992 he confessed to having been inspired to some extent by "Short and Sweet," a track written and recorded for his first solo album, released in 1978. Meanwhile Rick Wright supports his bandmates on the Prophet-5. This long intro then gives way to a new section introduced by reversed cymbal (as was the triad motif). Gilmour sings and harmonizes sixteen repeats of the word *run*, leading into the first verse, which has Roger Waters on lead vocal. What is unusual about his performance is that his phrases alternate between one side of the stereo field and the other, reinforced by a delay with impressive feedback. In concert, David Gilmour would sing every other phrase. Once again, Waters is excellent in the way he unreservedly gets under the skin of his character. Gilmour's triad motif then returns, reinforced by percussion played by Bobbye Hall. At the end of the second verse, Rick

Wright plays a very impressive solo that could have been recorded on his Minimoog, although it is generally acknowledged to be the Prophet-5. Finally, the last section of "Run Like Hell" gives way to a sequence of sounds: the percussion becomes more prominent (from 3:15), the crowd atmosphere comes back, somebody can be heard running and panting with deep reverb (James Guthrie in fact, using a Nagra to record himself running in a corridor of the London Underground), Waters speaking and laughing dementedly (around 3:33), and the squealing of a car's tires. Nick Mason recalls the creation of this particular sound effect at the Producers Workshop: "This involved Phil Taylor [the guitar technician] slewing a Ford LTD van around the car park with Roger inside, screaming at full volume."[5]

Finally, following the return of Gilmour's riff, led in by a piercing scream from Waters (at 3:59), the music comes to a definitive end, leaving the crowd screaming *Pink Floyd! Pink Floyd!* from stereo left and *Hammer! Hammer!* from stereo right, the latter having been recorded in the studio.

It is interesting to note that although a session was held at the Producers Workshop on October 17 to record hand claps, these are inaudible, or were perhaps included right at the back of the crowd noise mix.

Waiting For The Worms

Roger Waters / 3:58

Bruce Johnston was surprised to find himself singing a song entitled "Waiting for the Worms," given that in 1966 the Beach Boys' brilliant composer Brian Wilson, in collaboration with his lyricist Van Dyke Parks, had written a song "Do You Like Worms?" Initially intended for the album *Smile*, the song never saw the light of day under the band's name.

Musicians

David Gilmour: vocals, backing vocals, electric rhythm and lead guitar, bass, Prophet-5
Rick Wright: organ
Roger Waters: vocals, backing vocal, VCS3
Nick Mason: drums
Bob Ezrin: piano, backing vocal
Bruce Johnston, Toni Tennille, Joe Chemay, Stan Farber, Jim Haas, Jon Joyce: backing vocals

Recorded

Britannia Row, Islington, London: September 1978–March 1979
Super Bear Studios, Berre-les-Alpes, Alpes-Maritimes (France): April–July 1979
Studio Miraval, Domaine de Miraval, Le Val, Var (France): April–July 1979
Producers Workshop, Hollywood: September 12–November 1, 1979

Technical Team

Producers: Bob Ezrin, David Gilmour, Roger Waters
Co-producer: James Guthrie
Sound Engineers: James Guthrie, Nick Griffiths, Patrice Quef, Brian Christian, Rick Hart

Bruce Johnston, who sings backing vocals on "Waiting for the Worms."

Genesis

"Waiting for the Worms" concludes the "totalitarian cycle" of three songs that began with "In the Flesh." Behind the wall, lying low in his bunker, Pink awaits the arrival of the worms, in other words his henchmen, the hammers. The rock star's ramblings have taken an unsuspected and even more disturbing turn. At the head of nothing less than an army, whose soldiers have been asked to wear black shirts, he has taken it upon himself to *clean up the city*, that is to say to implement the *final solution*, to *turn on the showers* and *fire the ovens* ready to receive the *queers*, the *reds*, and the *Jews* so that Britannia can once again rule the world. The ultimate horror, in other words…In order to describe these monstrous "cleaners," Waters uses the phrase *waiting for the worms*, "in theatrical terms […] an expression of what happens in the show when the drugs start wearing off and his real feelings of what he's got left start taking over again."[126]

Although Roger Waters is clearly describing the dark years of the Second World War, the countless martyrs of Nazism and the "Blackshirts" of Oswald Mosley's British Union of Fascists, he is also referencing the situation in contemporary Britain: the growing influence of the National Front and the race riots that were starting to shake the multicultural district of Brixton in London, accompanied by police violence. (These riots would grow steadily worse, eventually making news headlines all over the world in 1981.) Here too, Roger Waters draws a parallel between fascist rallies and rock 'n' roll concerts and creates a particular, highly symbolic effect, as he explains to Tommy Vance: "After 'Run Like Hell' you can hear an audience shouting 'Pink Floyd' on the left-hand side of the stereo, if you're listening in cans, and on the right-hand side or in the middle, you can hear voices going 'hammer,' they're saying 'hammer, ham-mer'…This is the Pink Floyd audience, if you like, turning into a rally."[126]

Production

Eins, zwei, drei, alle! (one, two, three, everyone!): it is with this count-in in the language of Goethe that Roger Waters launches the song, whose intro takes the form of yet another fantastic homage to the Beach Boys, with Bruce Johnston and his cohort providing an indispensable authentic touch.

1979

The hammers, symbolizing power and violence, in action. Is the totalitarian terror about to rain down on Old England?

"Musically, I've gotta represent a vast amount of saccharine. Toni's gotta represent a lot of fluff. There we are, singing songs about worms on this album that certainly has to be 180 degrees from what the Beach Boys do."[9] Johnston is probably right, but the blend of the two musical worlds is one of the triumphs of *The Wall*, the saccharine and the sardonic proving an unexpected recipe for success. Before long, Gilmour, Ezrin, and Waters add their own backing vocals to those of the Californian gang. The accompaniment consists of two rhythm guitar parts played by David Gilmour on the "Black Strat," colored by the Electric Mistress and heavily distorted. Gilmour also plays the Prophet-5 and the bass. Ezrin is on piano and Mason on drums (recorded on the upper floor at Britannia Row). Gilmour begins the lead vocal in a gentle, reassuring voice. This is immediately counterbalanced by Waters, who is aggressive and cynical. Mason marks the beat with what sounds like a combination of bass drum and toms, recorded close to the drumheads and with significant compression. Moreover, his beat is almost certainly reinforced by VCS3. After the first two verses, the rhythm hardens, and Waters takes to declaiming his extremely poisonous text in a theatrical tone and apparently through a megaphone, an effect obtained by means of equalization and a delay (from 1:20). Written using the technique of anaphora (the repetition of the same word or phrase in successive clauses), the start of each line, that is to say the word *waiting*, is picked out by the backing vocalists, with Waters answering in his sentential voice. The rhythm is heavy and very basic, with distorted guitars to the fore and a lead guitar in the background, the whole thing forming a strong contrast with the calmer sections of the song. In the following sequence, Gilmour resumes lead vocal (from 2:09), accompanied by vocal harmonies from Johnston and his gang. Mason plays a highly compressed ride cymbal, creating a curious but interesting pumping effect.

For the outro, Waters picks up his "megaphone" again, the rhythm once more becomes heavy and basic, the distorted Strats are to the fore, Wright's Hammond organ boosts the overcharged atmosphere a little further, and we hear the crowd's chilling *Hammer!* chants, with Waters delirious in their midst, gradually rising in intensity.

In addition to its musical and narrative qualities, "Waiting for the Worms" is the result of an incredible feat of production by the talented Bob Ezrin, who has succeeded in alternating diametrically opposed atmospheres, to amazing effect, within one and the same song.

Stop

Roger Waters / 0:30

Musicians
Roger Waters: vocals
Bob Ezrin: piano
Michael Kamen: orchestration and conducting
New York Symphony: orchestra
Recorded
Britannia Row, Islington, London:
September 1978–March 1979
Super Bear Studios, Berre-les-Alpes, Alpes-Maritimes (France): April–July 1979
Studio Miraval, Domaine de Miraval, Le Val, Var (France): April–July 1979
CBS Studios, New York City: August 1979
Producers Workshop, Hollywood:
September 12–November 1, 1979
Technical Team
Producers: Bob Ezrin, David Gilmour, Roger Waters
Co-producer: James Guthrie
Sound Engineers: James Guthrie, Nick Griffiths, Patrice Quef, Brian Christian, Rick Hart, John McClure

1979

Genesis

"Stop" seems to be the song that marks a return to reality—a certain kind of reality, at any rate. Following the powerful effects of the drug and his totalitarian ravings in front of a bewitched crowd, Pink finally awakens from his long nightmare. He claims to want to go home, take off his uniform, and *leave the show*.

Have his eyes been opened? This is by no means certain, as he still finds it necessary to ask whether he has been guilty all this time. Guilty of having constructed the wall that has isolated him from the world? Guilty of having advocated violence and oppression? Whichever it is, it is too late, as Pink has now been locked up. In Alan Parker's movie we see him sitting in the bathroom of the cells reading his book of poems. He is awaiting trial. "So the judge is part of him just as much as all the other characters and things he remembers…," explains Roger Waters to Tommy Vance, "they're all in his mind, they're all memories."[126]

Production

At the end of "Waiting for the Worms," we hear Roger Waters holding forth through his megaphone in the midst of a delirious crowd. Suddenly a resounding *Stop!* supported by orchestra (the New York Symphony) puts an end to his verbal diarrhea. It is accompanied by grand piano alone, played by Bob Ezrin, that Waters then performs the shortest song on the album. Theatrical, strained, and plaintive in tone, Waters sings in a high vocal register, needing this physical tension in order to give full expression to his emotions. He has come a long way from his early lead vocals, such as "Set the Controls for the Heart of the Sun," "Grantchester Meadows," and "If," which were virtually whispered. Since that time he has asserted himself to the full, wholeheartedly taken on the role of lead singer, and with *The Wall* achieved a major feat. The final words of the two last lines of the song are colored by a delay with abundant feedback, an effect of which the group—and apparently Ezrin too—was very fond. Finally (from 0:25) the first, disquieting notes of "The Trial," the denouement of this conceptual work by the highly talented Pink Floyd bassist, emerge as if out of nowhere.

The Trial

Roger Waters, Bob Ezrin / 5:20

Musicians
David Gilmour: electric lead guitar, bass
Roger Waters: vocals
Nick Mason: bass drum, cymbals
Bob Ezrin: piano
Unidentified Los Angeles–based Actresses: backing vocals
Michael Kamen: orchestral conducting
New York Symphony: orchestra

Recorded
Britannia Row, Islington, London:
September 1978–March 1979
Super Bear Studios, Berre-les-Alpes, Alpes-Maritimes (France): April–July 1979
Studio Miraval, Domaine de Miraval, Le Val, Var (France): April–July 1979
CBS Studios, New York City: August 1979
Cherokee Recording Studios, Los Angeles: September 6–8, 1979
The Village Recorder, Los Angeles: September 21, 1979
Producers Workshop, Hollywood:
September 12–November 1, 1979

Technical Team
Producers: Bob Ezrin, David Gilmour, Roger Waters
Co-producer: James Guthrie
Sound Engineers: James Guthrie, Nick Griffiths, Patrice Quef, Brian Christian, Rick Hart, John McClure

Genesis
Like that of any well-constructed storyline, the ending of *The Wall* has a few surprises in store. Just as we think Pink is on the road to recovery, here he is at the height of his insanity, organizing his own trial. This is a trial that takes place within his own mind, crazed by the drug the physician has injected into him and above all by the frustrations to which he has been subjected since early childhood. In the spirit of Kafka's novel of the same name, all the characters in the trial are a part of himself: the judge, his mother, and all the facts of the case are drawn from his febrile memory.

This surreal trial opens with a preamble from the prosecuting attorney that itself defies common sense, as the rock star is said to have shown *feelings of an almost human nature.* The witnesses are then called one by one. First of all Pink's schoolmaster, who had always known that the boy would *come to no good* and that had he been allowed to, he could have *flayed him into shape.* Pink's wife then addresses him directly, calling him a *little shit* and asking if he has *broken any homes up lately.* Next it is Pink's mother who is called to the witness-box. She pleads with the judge to let her *take him home.* "She is only being over-protective," explains Roger Waters to Tommy Vance. "She's not attacking him in the way that the teacher and his wife do."[126]

The verdict is delivered. *There's no need for the jury to retire,* announces the judge (who has been transformed into a rear end and is literally talking through his backside). Pink is found guilty. Pink is sentenced to tearing down the wall he has constructed, which for the rock star amounts to exposing himself in his state of extreme distress to the eyes of the whole world! A sentence that is utterly comical, as it will have the effect of enabling the "culpable party" to free himself...It is worth reiterating here that the court and all those who participate in it exist only in Pink's mind, thus the sentence he imposes upon himself reveals the feelings of guilt that have tormented him since the effects of the drug have faded and reality has started to dawn once again. The song ends with the destruction of the wall.

Production
A key turns in a lock, a door opens, and footsteps resonate on a hard floor: the intro to "The Trial" (whose working title

The orchestration of "The Trial" is credited to Michael Kamen. He has created a musical atmosphere that harks back to the musical collaborations of Kurt Weill and Bertolt Brecht.

was "Trial by Puppet") depicts Pink leaving prison and making his way to the courtroom. The accompaniment to this incredible piece of music, like "Bring the Boys Back Home" very much an exception in the Pink Floyd catalog, is provided by the fifty-five musicians of the New York Symphony under the baton of Michael Kamen. "That's largely Roger and Bob Ezrin collaborating,"[9] David Gilmour would explain. In truth it is to a score composed by the brilliant producer of *The Wall* that Waters sings the words of this key song in his conceptual work. Although Bob Ezrin was credited for his contribution, this was by no means a foregone conclusion: "You can write anything you want," Waters is supposed to have told him, "just don't expect any credit or money for it."[9] However, Ezrin, obstinate to the end, caused Waters to relent and succeeded in imposing his own original idea on the songwriter. "I think it was written by Bob with the immediate intention to do that with an orchestra, although we did demos of it with synthesizers and stuff,"[9] explains Gilmour. It is certainly true that Ezrin had always envisaged an orchestra for this piece, having figured out how important it was. His musical choices would turn out to center largely on Kurt Weill, the German composer who had succeeded in blending the European operatic tradition with the American musical. It also seems possible that this choice of model was influenced by Weill's own bitter experience. Faced with the rise of Nazism, the Jewish composer quit his home country in 1933 after the performance of his works had been banned. Moreover, Waters would reveal that the specific musical source was the *Rise and Fall of the City of Mahagonny*, an opera with libretto by Bertolt Brecht and music by Kurt Weill that was premiered in 1930 (and which includes the famous "Alabama Song" covered by the Doors in 1967).

"The Trial" is therefore dominated by a big orchestral sound conducted by the extraordinary Michael Kamen. Roger Waters gives a brilliant performance as each of the protagonists in turn. One by one, the various characters take the stand: the prosecutor (with his upper-class accent), the schoolmaster (with his Scottish accent), Pink's wife (with a southern English accent), his mother (with a northern English accent), and finally the judge (again with an upper-class accent). There are also two refrains sung in a normal voice, supported by Bob Ezrin's lyrical piano playing and backing vocals by a group of Los Angeles actresses hired by the Canadian producer. Significantly it is in the final verse, in which the sentence is pronounced, that David Gilmour enters on his "Black Strat," playing a distorted motif (with Big Muff and Electric Mistress) that is doubled for extra power. Gilmour also plays bass guitar, while Nick Mason works his cymbals and supports the rhythm with a very present bass drum. Finally, as soon as the sentence is passed down, an impressive crowd starts to chant, *Tear down the wall!* Before long we hear the beginnings of a rumbling noise that gradually builds in volume, culminating in the collapse of an enormous wall (at 5:00).

Two teams were needed to create this final sound effect. To start with, Nick Griffiths was given the task of recording the demolition of a building. As Nick Mason has observed, this kind of operation carried out by experts using only small explosive charges is relatively quiet and therefore failed to produce the anticipated effect. So a second team was sent into action. Nigel Taylor, the technical manager at Britannia Row, traveled down to Somerset with a couple of technicians, armed with a rented Nagra and a pair of mics, to record a real explosion in a quarry. As this procedure was performed only once a day, they did not have the opportunity to set their sound levels before the daily explosion. Fortunately the sound was captured perfectly. Ultimately, James Guthrie filled a twenty-four-track tape with all these takes. He slowed them down, doubled them, and supplemented them with other available sources.

Outside The Wall

Roger Waters / 1:46

Musicians
David Gilmour: backing vocals
Roger Waters: vocals
Frank Marocco: concertina
Trevor Veitch: mandolin
Larry Williams: clarinet
Children's choir (unidentified): backing vocals

Recorded
Britannia Row, Islington, London:
September 1978–March 1979
Super Bear Studios, Berre-les-Alpes, Alpes-Maritimes (France): April–July 1979
Studio Miraval, Domaine de Miraval, Le Val, Var (France): April–July 1979
Producers Workshop, Hollywood:
September 12–November 1, 1979

Technical Team
Producers: Bob Ezrin, David Gilmour, Roger Waters
Co-producer: James Guthrie
Sound Engineers: James Guthrie, Nick Griffiths, Patrice Quef, Brian Christian, Rick Hart

1979

Genesis

Roger Waters's conceptual work concludes with "Outside the Wall." Now that the wall is no more, is Pink's true personality revealed? Roger Waters leaves this question shrouded in doubt. Is Pink now cured? Or has his mental confusion reached the point of no return? It remains a mystery. The final song on *The Wall* is all about those who have loved Pink, for want of understanding him, perhaps, who are walking *up and down outside the wall* waiting for him, even if *after all it's not easy banging your heart against some mad bugger's wall.*

In Alan Parker's movie, "Outside the Wall" has been relegated to the credit sequence, following on from the destruction of the wall. We see women and children clearing away debris (including a Molotov cocktail) from the wall. According to Roger Waters, this closing scene is an illustration of mankind's natural aversion to violence.

Production

As the wall continues to collapse, Larry Williams plays a solitary, melancholy melody on the clarinet. After twenty seconds or so, Roger Waters starts to sing, or rather recite, the final lyric of *The Wall*. He is accompanied by a children's choir (with the participation of David Gilmour singing falsetto!), by the mandolin of Trevor Veitch (at the back of the mix), and by the concertina (an instrument of the accordion family) of Frank Marocco. It is interesting to note that Veitch and Marocco were regular Beach Boys sidemen, Marocco even having taken part in the sessions for *Pet Sounds*. After three verses, the three musicians continue their accompaniment alone, Waters and the choir having fallen silent. The atmosphere is distinctly forlorn and recalls the Berlin of the war years. Suddenly we hear Waters's voice saying: *Isn't this where…*And then his words and the music are brutally silenced. Thus ends the fourth and last side of the album. To discover what comes next, all we have to do is return to the first song of the album, "In the Flesh?" because the opening song of *The Wall* begins with the end of "Outside the Wall," clearly symbolizing that life eternally repeats itself, bringing not redemption, but a path of sorrows that has to be traveled until the end of time.

In 2015, Bob Ezrin made the following statement about this work that played such a big part in his career:

The spectacular stage set for the Berlin production of *The Wall* on July 21, 1990.

"Making that album was a very difficult job, but it was thrilling because it was such a pure vision. When I finally got all four sides of the record done and I could play them 1, 2, 3, 4 in order, I broke down and cried because it was such a release. So many months in construction, pounding away and fighting with things, bending, adapting, and going without to get that final product."[119]

For Pink Floyd Addicts

For his famous performance of *The Wall* in Berlin in 1990, Roger Waters chose to replace "Outside the Wall" with "The Tide Is Turning" (from his album *Radio K.A.O.S.*, 1987), a song of hope for a better world and the end of the Cold War.

What Shall We Do Now ?

Roger Waters / 3:20

Musicians: **David Gilmour:** electric rhythm and lead guitar, Prophet-5 / **Rick Wright:** keyboards / **Roger Waters:** vocals, vocal harmonies, bass, VCS3 / **Nick Mason:** drums / **Recorded**: **Britannia Row, Islington, London:** September 1978–March 1979 / **Super Bear Studios, Berre-les-Alpes, Alpes-Maritimes (France):** April–July 1979 / **Studio Miraval, Domaine de Miraval, Le Val, Var (France):** April–July 1979 / **Producers Workshop, Hollywood:** September 12–November 1, 1979 / **Technical Team**: **Producers:** Bob Ezrin, David Gilmour, Roger Waters / **Co-producer:** James Guthrie / **Sound Engineers:** James Guthrie, Nick Griffiths, Patrice Quef, Brian Christian, Rick Hart

Genesis

"What Shall We Do Now?" (sometimes abbreviated to "Do Now?") was removed from *The Wall* at the last moment due to a shortage of space on side two of the album. It was replaced by a shorter version named "Empty Spaces." Because the album cover was already in production, however, it was too late to remove the lyrics to "What Shall We Do Now?," which therefore remained in place, printed on the relevant inner sleeve between "Goodbye Blue Sky" and "Young Lust."

Roger Waters's initial idea for "What Shall We Do Now?" was to show the adult Pink wondering how to give his life meaning and taking an almost obsessive interest in other people's uncertainties as a way of dealing with his own isolation. Hence the numerous questions that punctuate the song: *Shall we buy a new guitar? Shall we…leave the lights on?…Drop bombs?…Break up homes?…Send flowers by phone?…Race rats?* etc. Waters would explain to Tommy Vance that this song was an out-and-out attack on consumer society, in which people are judged on the basis of what they possess and the social connections of which they can boast. For Waters, the danger that lies in wait for all those who seek to define themselves entirely in terms of external factors, notably a permanent quest for recognition and an insatiable desire for material things, is frustration and a loss of individuality. "What Shall We Do Now?" went on to become a kind of transitional song in the dramatic development of Waters's conceptual work.

Although absent from the album, "What Shall We Do Now?" was included in place of "Empty Spaces" (just after "Mother") in the live show and in Alan Parker's movie, where it is enhanced by Gerald Scarfe's animations.

Production

"What Shall We Do Now?" shares the same musical basis as "Empty Spaces," although the key is a tone lower. The intro is similar, with the same sequences played on the VCS3 (on which the wind noises and mighty percussion sounds are also created), the same distorted melodic line on the "Black Strat," and the same bass and Prophet-5 pads. The next section is harmonically identical, with added string sounds from the ARP Solina and a motif also, presumably, played on the ARP Quadra. There is no Rick Wright piano, however. When Roger Waters subsequently launches into his lead vocal, a strong delay is applied to his voice, creating an even more unreal atmosphere. The following section is different, taking the form of an instrumental break opening with a lugubrious scream and based on a very good drum part from Nick Mason, who executes some impressive fills with reverse reverb. This is followed by a final rock sequence, in double time, sung by Waters, who also delivers a very good bass part; with Rick Wright on Hammond Organ; David Gilmour playing a rhythm part on his "Black Strat" with Big Muff distortion and colored by Electric Mistress; and Mason, who is particularly good on this track, on drums.

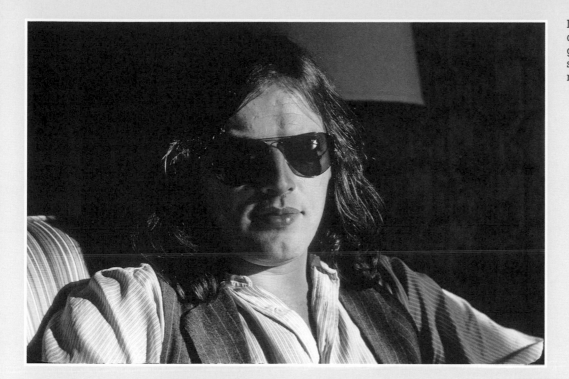

David Gilmour, composer, singer, guitarist, and... sex symbol, during the recording of *The Wall*.

Sexual Revolution
Roger Waters / 4:50

Musicians: **David Gilmour:** electric rhythm and lead guitar / **Rick Wright:** organ, Minimoog (?) / **Roger Waters:** vocals, bass / **Nick Mason:** drums / **Recorded:** **Britannia Row, Islington, London:** September 1978–March 1979 / **Technical Team:** **Producers:** Bob Ezrin, David Gilmour, Roger Waters / **Co-producer:** James Guthrie / **Sound Engineers:** James Guthrie, Nick Griffiths

Genesis

Like "Teacher Teacher" (which would be resurrected on *The Final Cut* under the title "The Hero's Return"), "Sexual Revolution" did not get past the initial rehearsal stage for *The Wall*. *Hey girl, as I've always said, I prefer your lips red, not [...], Hey girl, look in the mirror, can you see what you are?* The message was perhaps thought to be too cliché... And perhaps the music owed a little too much to "Corporal Clegg" on *A Saucerful of Secrets*.

Although not used in his conceptual work, this song in the form of a manifesto for sexual liberation was by no means abandoned by Roger Waters. Renamed "4.41 AM. (Sexual Revolution)," it reappears as the fifth track on his solo album *The Pros and Cons of Hitch Hiking*, a project Waters had developed in parallel with *The Wall*.

Production

It is David Gilmour who opens "Sexual Revolution" with an excellent, Hendrix-like riff played on a clear-toned "Black Strat" and supported by Rick Wright on Hammond organ. Initially bringing to mind "Corporal Clegg," the song's development makes it clear that only the intro retains traces of that earlier work. Nick Mason works his Ludwig with some power, Roger Waters supporting him on his Precision, the strange sonority of the bass suggesting that wah-wah is being used. It is also Waters who sings the lead vocal, in a very high voice at the limit of his range. After two verses, he can be heard counting in an instrumental section in a novel way: *4, 1, 2, 3!* This is followed by a playback consisting of group accompaniment but no lead vocal, Waters simply giving a regular count in order to help the musicians get their bearings. The plan for this section was probably to overdub a Strat or B-3 solo. After the reprise of the verse (around 3:26), Waters can be heard singing *la la las* instead of words, which he had clearly either forgotten or not yet written! Finally, the song ends with an instrumental coda in which Gilmour and Wright play the same melodic motif in unison, the former on his Strat and the second almost certainly on the Minimoog. The later "cover" by Roger Waters is very good, slower but also more "soul." Nevertheless, the Floyd demo of "Sexual Revolution" possesses a certain charm that gives a hint of what the group could have done with the song for *The Wall*.

1982

When The Tigers Broke Free / Bring The Boys Back Home

SINGLE

RELEASE DATE

UNITED KINGDOM: JULY 26, 1982

Label: Harvest Records

RECORD NUMBER: HAR 5222

In February 2014, seventy years after his father was killed at Anzio, Roger Waters inaugurated a monument near the site of the battle in memory of Z Company.

For Pink Floyd Addicts

The sleeve of "When the Tigers Broke Free" bears the wording, "Taken from the album *The Final Cut*," which is a mistake. The song would be added to the album for the CD reissue in 2004.

When The Tigers Broke Free

Roger Waters / 2:55

Musicians
Roger Waters: vocals, VCS3 (?)
Michael Kamen: orchestral conducting and arrangements, keyboards (?)
New York Symphony : orchestra
Noel Davies: choir conductor
The Pontarddulais Male Choir: backing vocals

Recorded
Britannia Row, Islington, London:
September 1978–March 1979
Super Bear Studios, Berre-les-Alpes, Alpes-Maritimes (France): April–July 1979
Studio Miraval, domaine de Miraval, Le Val, Var (France): April–July 1979
CBS Studios, New York: August 1979
Producers Workshop, Hollywood:
September 12–November 1, 1979
Mayfair Recording Studios, London:
June 17–19, June 24, 1982

Technical Team
Producers: Roger Waters, David Gilmour, James Guthrie, Michael Kamen
Sound Engineers: James Guthrie, Nick Griffiths, Patrice Quef, Brian Christian, Rick Hart, John McClure

The "Tigers" referred to are the notorious German Tiger I tanks.

Genesis

Roger Waters composed "When the Tigers Broke Free" for *The Wall*. But once the recording sessions got under way, it had been decided not to include this song in the concept album (unlike "What Shall We Do Now?") on the grounds that it was too personal. In the song, which is around three minutes long, Roger Waters relates with unflinching precision the circumstances surrounding the death of his father, a soldier in the Eighth Battalion of the Royal Fusiliers. First the dawn setting (*one miserable morning in black Forty-Four*), then the orders of the forward commander, the assault by enemy forces, and the high price paid for their victory. *And the Anzio bridgehead was held for the price/Of a few hundred ordinary lives…*Waters's second verse comes from the heart, a heart forever broken: a letter from *kind old King George* to his mother saying that his father was dead—a letter *in the form of a scroll/With gold leaf and all* which the songwriter discovered many years later, *In a drawer of old photographs, hidden away*. The third and final verse takes us back to the battlefield: […] *When the Tigers broke free/And no one survived from the Royal Fusiliers, Company Z* […] *And that's how the high command/Took my daddy from me*, sings Waters in a choked voice.

Omitted from the double album, "When the Tigers Broke Free" was instead issued as a single (with "Bring the Boys Back Home" in the version from *The Wall* movie as the B-side), on July 26, 1982. The song got to number 39 on the UK singles charts, and stayed on the charts for five weeks. The version used in the Alan Parker movie is slightly longer (3:17) than the version on the single, and is divided

January 22, 1944, the American fleet just prior to the amphibious landing at Anzio, an offensive that has bleak associations for Roger Waters...

into two parts: during the first verse Pink's father cleans and then loads his gun, while in the second and third verses, Pink discovers the official letter announcing the death of his father, and then puts on his father's uniform.

Production

The wind is blowing (an effect probably produced on the VCS3). The mood is solemn with, in the background, a very discreet layer of sound in a low register (Prophet-5?). We hear an orchestral timpani ring out at regular intervals with deep reverb. French horns combined with the humming of a male voice choir create a poignant atmosphere that inevitably calls to mind the appalling sight of a battlefield after the battle. The music slowly swells, before Roger Waters sings his first two verses in a quiet, almost resigned voice. Then, in the third verse, he summons the full power of his voice, taking it to the limit, as he often does. (He double-tracks

himself.) It is a moving performance, enhanced by Michael Kamen's orchestration and the singing of the Pontarddulais Male Choir, conducted by Noel Davies—who also worked with Roger Waters on his solo album *Radio K.A.O.S.* in 1987. Finally, as we reach the concluding words of the song, the musicians and Roger Waters come to an abrupt halt, and Waters's voice fades away into the reverb and the icy whistling of the wind.

Although David Gilmour's name figures as one of the producers of this single, there is some doubt over whether he really was involved. Despite the evident qualities of "When the Tigers Broke Free," this song has nothing in common with the musical universe created by the Floyd over the years. This is a Roger Waters song, not a Pink Floyd work. The single version was recorded at Mayfair Studios in London between June 17 and 19, 1982, then mixed in the same studios on June 24.

THE FINAL CUT

ALBUM
THE FINAL CUT

RELEASE DATE
United Kingdom: March 21, 1983

Label: Harvest Records
RECORD NUMBER: SHPF 1983

Number 1 (United Kingdom), on the charts for 25 weeks
Number 1 (France, West Germany, Sweden, Norway, New Zealand)
Number 6 (United States)

The Post War Dream / Your Possible Pasts / One Of The Few /
The Hero's Return / The Gunners Dream / Paranoid Eyes /
Get Your Filthy Hands Off My Desert / The Fletcher Memorial Home /
Southampton Dock / The Final Cut / Not Now John /

The Final Cut, which was more like a Waters solo album than a Pink Floyd collective project, would be the first and last opus by Pink Floyd mark two, and the last of the "Waters era."

For Pink Floyd Addicts

The Final Cut is the only Pink Floyd album not to have been followed by a tour. What's more, Pink Floyd never played a single song from the album live (although Roger Waters did).

The Final Cut, an Album by Roger Waters, Performed by Pink Floyd

After the worldwide success of *The Wall* and the release of its movie adaptation, Pink Floyd, now reduced to a trio, was required, under their contract with the record company, to bring out an album which had to include certain songs that had been rerecorded for the movie (both versions of "In the Flesh" performed by Bob Geldof, and "Bring the Boys Back Home"), as well as "When the Tigers Broke Free" and "What Shall We Do Now?" (omitted from the original album but released as a single, in the case of the former) along with a number of brand-new songs intended to bolster the narrative—in actual fact titles composed for *The Wall* but not included. Waters, who thought that "there really wasn't enough new material in the movie to make a record that [he] thought was interesting,"[25] eventually had a change of heart, suddenly spurred into action by events on the international stage, and found a purpose for this work provisionally entitled *Spare Bricks*, turning it into something altogether different from the movie soundtrack of *The Wall*.

A Pacifist Manifesto

It was the events of the Falklands War that so troubled Roger Waters. On March 26, 1982, Leopoldo Galtieri, the head of the military junta in Argentina, decided to invade the island of South Georgia, part of the Falkland Islands Dependencies, a British overseas territory (since 1833) over which Argentina claimed sovereignty (with the backing of the Organization of American States [OAS]). April 2 marked the start of Operation Rosario, which led to Argentina seizing control of the Falkland Islands and their capital, Port Stanley, and, consequently, the surrender by the British governor Rex Hunt.

In fact the Falklands War was only just beginning. In London, Prime Minister Margaret Thatcher had no intention of relinquishing the islands. On the contrary, despite attempts at a negotiated solution mediated by the United Nations Security Council and the United States, the "Iron Lady" proceeded to launch a major operation. On April 25, the British Navy landed on South Georgia and took two hundred Argentine prisoners. On May 1, the war intensified. The following day, a British submarine sank the Argentine cruiser, the *General Belgrano*. On May 5, the British destroyer, the *Sheffield*, was hit by an Exocet missile and sank in the Atlantic. On land, too, the fighting was extremely fierce. Then, on June 11, the British launched an attack on Port Stanley and, three days later, the Argentines surrendered. The Falklands War resulted in the loss of 907 lives.

In late spring 1982, Margaret Thatcher, whose hardline economic and social policies had made her unpopular, basked in the victory of the British troops. The United Kingdom had restored its image, and many people credited the resident of 10 Downing Street. However, not all Her Majesty's subjects shared this patriotic fervor. Roger Waters was one of them. "I'm not a pacifist," he said, "I think there are wars that have to be fought, unfortunately. I just happen to think that the Falklands was not one of them."[1] Furthermore, the songwriter was a fierce opponent of the Conservatives,

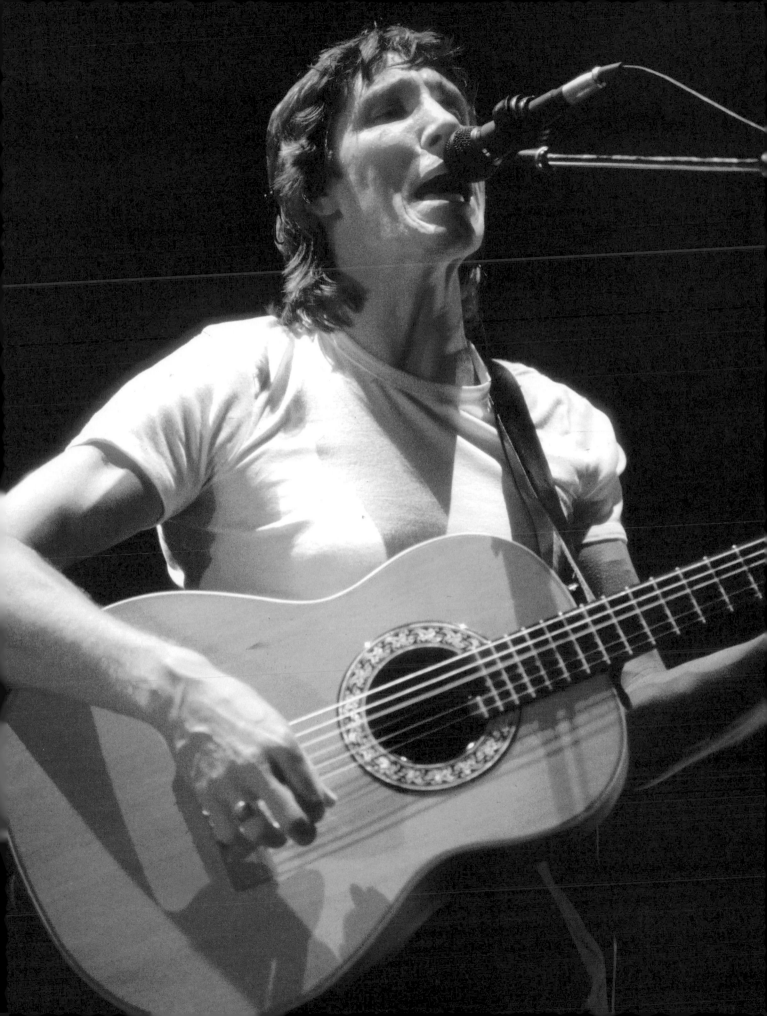

and Margaret Thatcher in particular, whom he saw not as the architect of Britain's recovery, but as the person responsible for an explosion in poverty. "We experienced the beginning of the Welfare State in 1946," he explained in an interview in June 2004. "The government introduced all that new [postwar] legislation. At the point where I wrote *The Final Cut*, I'd seen all that chiseled away, and I'd seen a return to an almost Dickensian view of society under Margaret Thatcher."[119]

The idea for the new album was taking shape…Its central character (the narrator) would be an ex-serviceman who had returned from the war profoundly traumatized. (The ex-serviceman was none other than the schoolteacher in "The Happiest Days of Our Lives" from *The Wall*.) *The Final Cut* would be a strongly antiwar album with two key concepts: the sacrifice made by the soldiers—in this case the British soldiers who fought in the Second World War—for the vain promise of a better world, and the betrayal perpetrated by a political class that triggered armed conflicts purely for its own profit.

So this twelfth album would be another homage to Waters's father, as well as a scathing attack on Thatcher, the typical warmongering, neocolonialist politician, and, more generally, a targeted attack on the world leaders of the time, from Ronald Reagan to Leonid Brezhnev, not to mention Menachem Begin and Ian Paisley.

Requiem for a Band

The back of the sleeve of *The Final Cut* carries the subtitle, *A Requiem for the Post War Dream by Roger Waters*, and on the line below, *performed by Pink Floyd*. That says it all. The album, more than just a requiem for a dream, becomes something of a requiem for a band (now no more than a trio), for which it sounds an unmistakable death knell. The band's first album without Rick Wright—who was replaced on the keyboards by Michael Kamen and Andy Bown—was

also the last that Roger Waters, David Gilmour, and Nick Mason worked on together. *The Final Cut* is no longer a collective work, but the product of a personal initiative by Waters, almost a solo album. The bassist-singer-songwriter composed all thirteen of the songs and sang them all himself (with the exception of most of the verses of "Not Now John," performed by David Gilmour). "I could hardly fail to sympathise with these political sentiments," Nick Mason wrote in his book, "but I think David's view was that it was becoming unsuitable as a band album. David wanted time to produce some material of his own. Roger, now totally motivated [by his project], was not interested in waiting."[5]

Even more revealing of the discord that reigned from that point on within the band was Waters's announcement to Nick Mason, before the recording sessions got started, that the latter, as merely the drummer, could not expect to claim any extra credits or royalties. And indeed, Gilmour and Mason were relegated to mere accompanists supporting Waters, on a par with Andy Bown and Ray Cooper. David Gilmour later commented with a touch of irony that if Waters ever needed a guitarist, to give him a call.

Gilmour was also unhappy at the new direction in which Waters had been driving Pink Floyd since *The Wall*, or even since *Animals*, putting the lyrics—highly politicized ones at that—above all else, to the detriment of the music. And at the way Waters was systematically resurrecting the pieces he had composed that had been rejected by the group. "Songs that we threw off *The Wall*, he brought them back for *The Final Cut*—same songs," David Gilmour complained. "Nobody thought they were that good then; what makes them so good now? I bet he thought I was just being obstructive."[53] Roger Waters, meanwhile, seemed to have already moved on to the time after Pink Floyd: "By the time we had gotten a quarter of the way through making *The Final Cut*, I knew that I would never make another record

Send-off for the British troops bound for the South Atlantic on board the *Queen Elizabeth II, in a* war that Roger Waters found abhorrent.

with Dave Gilmour and Nick Mason. We just didn't agree on anything anymore."[137] In an interview with the *Guardian* in 2002, Gilmour would sum up the situation with a touch of humor, declaring that the album should have been called not *The Final Cut*, but *The Final Straw*...And for the first time in the band's history, they had no plans whatsoever for a tour to promote the album.

In the end, three producers shared the credits for *The Final Cut*: Roger Waters, James Guthrie, and Michael Kamen. Bob Ezrin and David Gilmour didn't feature. The former was already in disgrace after he clumsily disclosed confidential information to the press ahead of the tour for *The Wall*. Waters had had no qualms in sweeping aside an exceptional collaboration, even though this was what had enabled him to get the concept for *The Wall* off the ground. The latter, David Gilmour, would himself ask for his name to be removed from the credits. In 1983 he explained it this way: "It's very very much Roger's baby, more than any one [of the band's albums] has been before and I didn't...it's not the way I'd have produced it and we did have an argument about the production on this record—several arguments, and I came off the production credits because my ideas of production weren't the way that Roger saw it being."[138] Although Gilmour still received his production royalties, his radical attitude was a sign that they had reached the point of no return.

Only the highly talented Michael Kamen succeeded in earning his stripes as a producer. Obviously he played a vital role, though he would never erase the memory of Bob Ezrin. At one point the tensions in the recording studio were

getting to him, and he became involved in quite a funny altercation related by Nick Mason. During a recording session where Roger Waters was having some difficulty with his lead vocal and needed repeated takes, Michael Kamen, sitting in the control room and visibly paying little attention to Waters's efforts, started scribbling incessantly in a notebook. After a while, Mason reports, Roger, distracted by Michael's apparent lack of interest, "stormed into the control room and demanded to know what Michael was writing. Michael had decided that he must have done something unspeakable in a past life, something he was now karmically paying for by having to endure take after take of the same vocal performance. So he had written over and over on his legal pad, page after page, line after line, 'I must not fuck sheep.'"[5]

A Qualified Success with a Bitter Taste

Roger Waters's requiem, his final legacy as part of the band, came out in the United Kingdom and continental Europe on March 21, 1983, and then in the United States on April 2. Regardless of the criticism, notably the comments by critic Lynden Barber, who regarded this opus as nothing but "a series of outtakes from an Alan Price LP" and "a milestone in the history of awfulness,"[139] the British public gave *The Final Cut* a very favorable reception, and it reached number 1 on the charts, something that both *The Dark Side of the Moon* and *The Wall* had failed to do. The album likewise made it to number 1 in several other European countries including France, the West Germany, Sweden, and Norway. In the United States, on the other hand, it peaked at only

After the monumental album *The Wall*, Michael Kamen teamed up with the Floyd again for *The Final Cut* sessions.

The giant pig used to promote the *Animals* album was stored in one of the annexes of the Hook End Studios, owned by David Gilmour.

sixth place, despite the fact it was certified Platinum in May, and despite the fact that the rock critic Kurt Loder of *Rolling Stone* gave it a five-star review, hailing it as a masterpiece of art rock and elevating Roger Waters to the status of Bob Dylan, the great poetic observer of the world's political order.

Internationally, Pink Floyd's twelfth album remains their lowest-selling album since *Meddle* in 1971, at three million copies. David Gilmour took the chance to comment on this outcome with some irony, to Roger Waters's annoyance: "Dave Gilmour went on record as saying, 'There you go: I knew he was doing it wrong all along.' But it's absolutely ridiculous to judge a record solely on sales. If you're going to use sales as the sole criterion, it makes *Grease* a better record than *Graceland* [by Paul Simon]."[140] However, Waters himself was not completely happy with it. The homage to his father was not as successful as he had hoped, and he had "...a sense that I might have betrayed him, because we haven't managed to improve things very much."[9]

The Sleeve

For *The Final Cut*, as for *The Wall*, Storm Thorgerson was passed over for the cover design. The Hipgnosis studio had, it is true, been booked during the recording of the album, but Waters's decision was above all prompted by a desire to break with the past. So it was Roger Waters himself, helped by his brother-in-law Willie Christie (who took the photos), who took charge of the sleeve artwork for this new opus, an austere design on a remembrance theme. On a black background (the color of mourning?) we see, on the top left, a Remembrance Day poppy, traditionally worn in the United Kingdom on November 11 in remembrance of servicemen killed in combat. At the bottom is a row of four medal ribbons from the Second World War: from left to right, the 1939–1945 Star (awarded for six months' service or more), the Africa Star (awarded to those who had fought in the African campaigns), the Defence Medal (for those who had contributed to the defense of the country in a nonoperational capacity), and the Distinguished Flying Cross (a decoration awarded to air force personnel).

On the back cover, also on a black background, we find the track listing and various credits, as well as a photograph of a soldier standing in a field of poppies with a knife protruding from his back and a reel of film under his arm. The interior gatefold features three more photographs: on the left, a hand holding three poppies and, in the background, a soldier in a field (seemingly standing at attention); in the middle, a welder's mask emblazoned with the imperial flag of Japan; and on the right, a (nuclear) explosion seen from inside a car with poppies in front of the windscreen.

The Recording

The time when Pink Floyd used to record all their albums entirely at Abbey Road Studios was long past. Although the band returned there for *The Final Cut*, seven other studios were also involved in the production of the new album: the Billiard Room, the Hook End Studios, Mayfair Studios, Olympic Studios, Eel Pie Studios, RAK Studios, and Audio International Studios, all of them located in London itself or on the outskirts. The recording sessions took place between May 1982 and February 1983. This fragmented approach was testament to the lack of unity, each member very often recording separately to avoid confrontation, particularly between Roger Waters and David Gilmour. Andy Jackson, one of the two sound engineers (the other being James Guthrie), recalls: "So the time that Dave—Dave in particular—and Roger were in the studio together, it was frosty. There's no question about it."[141] The two sound engineers each tended to work for one of the musicians: Andy Jackson worked with Waters, recording his vocals, while James Guthrie assisted Gilmour, capturing the guitar parts. "And we'd occasionally meet up again," Jackson would chuckle, "and swap what we'd done!"[141] But this lack of communication in no way hindered the effective production of the album, as the multitrack techniques made up for this physical absence, with Waters and Gilmour each having their own personal recording studio. All the same, Waters was not very happy with his vocals: "I don't like my singing on it. You can hear the mad tension running through it all. If you're trying to express something and being prevented

In 1983, David Gilmour bought Hook End Manor and the eponymous studios from Alvin Lee (left). Part of the album would be recorded here.

from doing it because you're so uptight…It was a horrible time. We were all fighting like cats and dogs."[140]

Eight Studios for the Final Cut

So work kicked off in May 1982 in Roger Waters's own studio, the Billiard Room, its name chosen due to his passion for the game. It was here, in Sheen, in the London suburbs, that many of the songs were knocked into shape. Recording took place from June to October, with other sessions held, in the meantime, in different studios, such as the Hook End Recording Studios. Located near Checkendon in Oxfordshire, these had been set up by Alvin Lee, the leader of Ten Years After, who in the early seventies bought this magnificent country house, where he would go on to record *On the Road to Freedom* (1973) and *Rocket Fuel* (1978). He then sold it to David Gilmour—which is why part of *The Final Cut* was produced there in June and October (before Trevor Horn eventually acquired it). It was partly here that Gilmour recorded his guitar parts for the album (as well as at Mayfair and RAK Studios).

After that, the production of the album continued mainly at Mayfair Studios in Primrose Hill, London, the internationally renowned studios where artists such as the Clash, the Bee Gees, and the Smiths would record their respective works. The Floyd booked the studios for June and October 1982 and then for January and February 1983 (for final mixing and mastering).

In June, September, and October, the legendary Olympic Studios in London (117 Church Road, Richmond upon Thames) also played host to the band, and it is here that the majority of Nick Mason's drum parts were thrashed out.

These studios are among the most famous in the history of rock, with not only the Rolling Stones, but also David Bowie, Elvis Costello, Jimi Hendrix, Jethro Tull, the Beatles, and Queen having recorded some of their most famous albums here.

On July 22 and 23, Pink Floyd returned to Abbey Road Studios for the first time since *Wish You Were Here* in 1975. This is where the National Philharmonic Orchestra, conducted by Michael Kamen, recorded all the orchestral parts.

In September, it was the turn of Eel Pie Studios, which became the venue for the recording of Michael Kamen's piano parts (which took one or two days). The studios were owned by Pete Townshend, the Who's songwriter and guitarist. It was here that the Who recorded *Quadrophenia* (1973), *The Who by Numbers* (1975), and *Endless Wire* (2006), and Pete Townshend his solo albums, from *Who Came First* (1972) to *White City: A Novel* (1985). Also worth mentioning are Graham Parker (*The Real Macaw*, 1983), Siouxsie and the Banshees (*Hyæna*, 1984), the Damned (*Phantasmagoria*, 1985), and a certain Roger Waters (*The Pros And Cons of Hitch Hiking*, 1984).

Production continued at RAK Studios (42-48 Charlbert Street, near Regent's Park in London), founded by the producer Mickie Most in 1976. Andy Bown recorded his Hammond organ parts there. The four studios housed in this Victorian former school building has been a studio of choice and place of inspiration for the likes of Yes and the Cure, Michael Jackson and Radiohead.

The final leg of Pink Floyd's journey took them to Audio International Studios (18 Rodmarton Street, London),

A 1957 Gibson Les Paul Goldtop belonging to Steve Hackett, similar to Gilmour's, which dates from 1956 and has a Bigsby vibrato.

A video of *The Final Cut*, nineteen minutes long, was shot by Willie Christie, featuring the actor Alex McAvoy (who plays the teacher in *The Wall*). It has four songs on it: "The Gunner's Dream," "The Final Cut," "Not Now John," and "The Fletcher Memorial Home."

from January 26 to 30, 1983. These studios, dating back to 1937, are where Radio Luxembourg's public broadcasts were recorded. From the seventies, rock artists were also drawn there by the studios' special relationship with the record company Chrysalis Records, from Gilbert O'Sullivan (the single "Nothing Rhymed," 1970) to Japan (*Adolescent Sex*, 1978) to Suzi Quatro (*Quatro*, 1974). James Guthrie had been the assistant sound engineer there (just after his apprenticeship at Mayfair Studios).

The Musicians and the Technical Team

Eight studios, then, and an extended team supporting the three Pink Floyd band members. Michael Kamen, who had already been part of the team for *The Wall*, provided various arrangements and, as Rick Wright's replacement, played the keyboards on several songs, as did Andy Bown, who had begun his career working with Peter Frampton, before joining Status Quo, after which he spent some time as a session musician (and took part in *The Wall* tour). The drummer and percussionist Ray Cooper, who became part of the Rolling Stones' inner circle (*It's Only Rock'n'Roll* [1974] and *She's the Boss* [1985] by Mick Jagger, *Willie and the Poor Boys* [1985] by Bill Wyman) and who collaborated with other giants of the rock scene, like George Harrison, Eric Clapton, and Elton John, played a part in many of the songs. Andy Newmark, who had the delicate task of standing in for Nick Mason on "Two Suns in the Sunset," also deserves a special mention, as does the tenor saxophonist Raphael Ravenscroft, whose name will forever remain associated with Gerry Rafferty (the album *City to City* [1978], from which the hit "Baker Street" is taken), but also with Pink Floyd, as well as Marvin Gaye and Robert Plant. Finally, two female singers provided the backing vocals on "Not Now John"—the only track that would be released as a single. These were probably Doreen and Irene Chanter.

On the technical side, James Guthrie was still in charge of the recording, but he had a second sound engineer helping out (although, strangely, he was not credited on some CD versions). This was Andy Jackson, who worked on projects for artists as diverse as Spandau Ballet and Humble Pie, but

Hook End Studios (here in 2011), where David Gilmour recorded many of the guitar parts for *The Final Cut.*

also on the Roger Waters and David Gilmour solo albums and the future Pink Floyd albums. There were three assistant sound engineers: Andy Canelle, Mike Nocito (the Cure, XTC), and Jules Bowen (Naked Eyes, Pete Townshend),

Technical Details

Eight studios, eight different setups! Here is a summary of the equipment available in each:

The Billiard Room, Roger Waters's own studio, was equipped with a custom Trident Series 80 console and a twenty-four-track Studer A80 tape recorder. Apparently Waters was no longer using the MCI console from Criteria that had been used for the recording of *The Wall.*

We don't have any information for Hook End Studios, owned by David Gilmour, but chances are he also possessed a twenty-four-track Studer A80, which was standard at the time.

The Mayfair Studios were equipped with an AMEK M3000 console and the inevitable twenty-four-track Studer A80, with JBL monitors.

Olympic Studios (comprising three independent studios) offered Raindirk Series 3 consoles, and the one in Studio Three was equipped with EQ from the much-vaunted Helios consoles designed by Dick Swettenham. The monitors were Tannoy/Lockwoods, except in Studio Three, which had Tannoy Super Reds.

Eel Pie Studios featured all-new equipment: an SSL 4048E console and a twenty-four-track Studer A800, a DeltaLab DDL delay, a Lexicon 224 reverb, UREI 1176 compressors, and instruments including a Bösendorfer grand piano.

RAK Studios were set up with thirty-two-channel API consoles and Lyrec TR532 twenty-four-tracks.

Audio International Studios, meanwhile, came with a Neve A210 console with Cadac modules and a twenty-four-track Studer A80.

And finally, Abbey Road Studios were also equipped with a custom Neve console, a twenty-four-track Studer A80, and JBL monitors.

The Holophonics Story

Another interesting feature of *The Final Cut* was that a holophonic recording system was used. This was a revolutionary method invented by the Argentinian Hugo Zuccarelli in 1980, and Pink Floyd, always keen to make use of the very latest recording and audio transmission technology (remember their experiments with quadraphonics, for example), were quick to adopt it when approached by the Argentinian. The main benefit of this technique is that it gives the listener the impression of an object moving all around him—it works best when wearing headphones. David Gilmour tried to explain: "The secret of this Holophonic thing is that it actually fools your brain; it's not what is actually on the tape or on the record, that isn't all of it—it's actually making a reaction with your brain; it's very hard to explain but it alters how you perceive the sound."[138] It was Nick Mason who got to try out the new equipment for the first time: "We immediately decided to use the system for all the sound effects on the album, and I was volunteered to escort the holophonic head (which answered to the name of Ringo) to various locations to capture the sound of church bells or footsteps."[5] It has to be said that the quality of the various recordings is remarkable, thanks to the skilled use of the technique on each of the songs on the album. This process would be used again by Roger Waters on his 1984 solo album, *The Pros and Cons of Hitch Hiking.*

The Instruments

The Floyd, now reduced to a trio, did not try anything particularly new in terms of instruments. Roger Waters played his Fender Precision Sunburst mostly, Nick Mason his Ludwig kit, and David Gilmour his "Black Strat." However, Gilmour changed its neck, replacing it with a Charvel twenty-two fret, which gained him a semitone. He also later mentioned having used a Gibson Les Paul with a vibrato bar, probably a 1956 Gibson Les Paul Goldtop equipped with a Bigsby. In terms of his other guitars, effects and amps, he, like Waters, used essentially the same equipment as for *The Wall.*

The Post War Dream

Roger Waters / 3:01

The British merchant vessel *Atlantic Conveyor*, which was carrying several helicopters, was hit by two Exocet AM39 missiles fired from Argentinian Navy Super Étendard jet fighters on May 25, 1982. Twelve men lost their lives in the ensuing fire. The ship that replaced it was also christened the *Atlantic Conveyor*.

Musicians

David Gilmour: electric lead guitar
Roger Waters: vocals, bass
Nick Mason: drums
Andy Bown: Hammond organ
Ray Cooper: tambourine
Michael Kamen: harmonium and orchestral conducting
National Philharmonic Orchestra: orchestra
Richard Millard: one of the voices on the radio

Recorded

The Billiard Room, London: May–October 1982
Hook End Recording Studios, Checkendon: June, October 1982
Mayfair Recording Studios, London: June, October–November 1982; January 19, February 1983
Olympic Studios, London: June, September–October 1982
Abbey Road Studios, London: July 22 and 23, 1982
Eel Pie Studios, Twickenham: September 1982
RAK Studios, London: October 1982
Audio International Studios, London: January 26–30, 1983

Technical Team

Producers: Roger Waters, James Guthrie, Michael Kamen
Sound Engineers: James Guthrie, Andy Jackson
Assistant Sound Engineers: Andy Canelle, Mike Nocito, Jules Bowen

The *Atlantic Conveyor*, a Merchant Navy ship requisitioned during the Falklands Conflict.

Genesis

We hear a car radio being tuned in and out of different stations, and catch snatches of news broadcasts, one after the other, which together seem to give a snapshot of the state of the world: "a group of businessmen announced plans to build a nuclear fallout shelter at Peterborough in Cambridgeshire…"; "three high court judges have cleared the way…"; "it was announced today that the replacement for the *Atlantic Conveyor*, the container ship lost in the Falklands conflict, would be built in Japan, a spokesman for…"; "…moving in. They say the third world countries like Bolivia which produce the drug are suffering from rising violence…" Then Roger Waters sings: *Tell me true, tell me why was Jesus crucified/Is it for this that daddy died?*

"The Post War Dream" is the opening salvo in the songwriter's indictment of Margaret Thatcher, Britain's prime minister at the time, whom he addresses directly in the penultimate and the final verse: *What have we done, Maggie […] / What have we done to England?* He accuses her of having put an end to the "postwar dream"—the dream of the welfare state and of a lasting peace—by dragging the United Kingdom into a conflict (the Falklands War) reeking of neocolonialism. On the domestic front, his attack is equally bitter: *If it wasn't for the Nips/Being so good at building ships/The yards would still be open on the Clyde.* Waters is alluding here to the controversial decision by the Thatcher government to award the contract to construct a new container ship to replace the Atlantic Conveyor to the Japanese rather than to the Glasgow shipyards. (The Clyde is the river that flows through the Scottish city.) Putting an end to peace, and to the welfare state, ushering in an explosion in economic liberalism: these are the crimes of which the "Iron Lady" stands accused.

Production

So *The Final Cut* opens to traffic sounds from a relatively quiet road with only a few vehicles passing. The traffic noises are succeeded by scraps of radio broadcasts. One of the male voices coming from the radio was recorded by Richard Millard, the owner of Audio International Studios in Marylebone, London, in January 1983. Then in the distance we discern the sound of a harmonium, played by

Prime Minister Margaret Thatcher, Roger Waters's high-profile target in "The Post War Dream."

Michael Kamen, which calls to mind the Salvation Army. The metallic noises of coins, which flit about in the stereo picture, also add to this notion of charity. The sound effects, as in all Pink Floyd productions, are subtle and of a high quality. And there is a good reason for that, as they were recorded using Zuccarelli's holophonic process, yielding a three-dimensional effect better than anything that had gone before. The effect is remarkable. The harmonium gets louder, and after fifty seconds of introduction, Roger Waters takes the lead vocal. His voice is soft and melancholic. Listening to the tune, one can't help wondering whether it drew its inspiration from "Sam Stone" (1971), a song by John Prine that tells the tragic story of a Vietnam veteran decorated with the Purple Heart who died of an overdose. There is certainly an uncanny resemblance…

In the first line of the first verse (at 1:07), the words *daddy died* are echoed over and over—a technique that was used in abundance on *The Wall*—highlighting Waters's preoccupations. In the third verse, French horns played by the National Philharmonic Orchestra, conducted by Michael

Kamen, provide a harmonious accompaniment. In the chorus, Waters double-tracks his voice against a lovely background of orchestral strings. Then a drum fill announces a rock section. Nick Mason pounds his Ludwig energetically, a tambourine played by Ray Cooper emphasizing his beats on the snare drum. The sound is live, and reminiscent of "In the Flesh" on *The Wall*, especially as Mason is accompanied on lead guitar by David Gilmour, the sound of his "Black Strat" heavily distorted by his Big Muff. Andy Bown has replaced Rick Wright on the Hammond organ. Waters plays the bass and performs the lead vocal. His voice comes across as rather strained, very intense and high-pitched. The piece ends with just the French horns, which immediately mingle with the sound of a moving train car grinding to a halt with a squeal of brakes.

"The Post War Dream" is a really good song, definitely in the same vein as *The Wall*. The production is particularly slick, and Waters's performance is excellent. But this opening number confirms what the album cover tells us: this is indeed Roger Waters accompanied by Pink Floyd.

Your Possible Pasts

Roger Waters / 4:26

Musicians
David Gilmour: acoustic rhythm guitar, electric rhythm and lead guitar
Roger Waters: vocals, bass
Nick Mason: drums
Michael Kamen: electric piano
Andy Bown: Hammond organ
Ray Cooper: tambourine

Recorded
The Billiard Room, London: May–October 1982
Hook End Recording Studios, Checkendon: June, October 1982
Mayfair Recording Studios, London: June, October–November 1982; January 19, February 1983
Olympic Studios, London: June, September–October 1982
Abbey Road Studios, London: July 22 and 23, 1982
Eel Pie Studios, Twickenham: September 1982
RAK Studios, London: October 1982
Audio International Studios, London: January 26–30, 1983

Technical Team
Producers: Roger Waters, James Guthrie, Michael Kamen
Sound Engineers: James Guthrie, Andy Jackson
Assistant Sound Engineers: Andy Canelle, Mike Nocito, Jules Bowen

For Pink Floyd Addicts

For some unknown reason, Roger Waters does not sing two of the lines of the third verse that are printed on the booklet accompanying the LP and the CDs: *Tongue tied and terrified we learned how to pray/Now our feelings run deep and cold as the clay.* This was only rectified on the remastered versions.

Genesis

This song was one of the ones rejected by David Gilmour, Rick Wright, and Nick Mason at the time of the recording of *The Wall.* The reworked version of "Your Possible Pasts" was to become one of the best protest songs ever written by Roger Waters, and is one of the main reasons that prompted Kurt Loder of *Rolling Stone* magazine to compare the British songwriter to Bob Dylan as "Masters of War."

The song takes a rather dark, uneasy journey into the past, or more precisely the pasts, according to the song's title. The narrator bears the painful and permanent scars of the Second World War, judging by the mention here of poppies (a symbol used by the British to commemorate fallen soldiers), which are entwined with the fateful *cattle trucks lying in wait for the next time.* However, his resentment seems to be directed not only at the authorities who forced him to fight and stole his youth (*I was just a child then…*). It is also aimed at religion, whose icy clutches he evokes: *By the cold and religious we were taken in hand/Shown how to feel good and told to feel bad.* Waters seems obsessed with ideas of repression, and the memories of a woman *stood in the doorway, the ghost of a smile/Haunting her face* are not enough to dispel in any way the gloom that hangs over him. That's because this woman is engaged in a morbid waiting game, waiting on the one hand for her next customer and on the other for the executioner who will stab her with the knife he has hidden behind his back. Several pasts are possible, Waters sings.

Production

We hear again the train car that drew to a halt at the end of "The Post War Dream," the previous song, and the sudden, sinister sounds of the doors opening, their creaking obviously bringing back terrifying memories. But only an icy wind emanates from the gaping opening. Gilmour's "Black Strat" interrupts this somber atmosphere with arpeggios heavily colored by his Electric Mistress. Waters immediately follows with the lead vocal, in what is a very moving rendition. He accompanies himself on his Fender Precision, and it has to be said that his bass playing—on this piece particularly—is excellent, displaying an exceptional

Andy Bown (here in 1975), a member of Status Quo, was on the Hammond organ on "Your Possible Pasts."

roundness and presence of tone. Once again it is Andy Bown we hear on the Hammond organ, his parts having been recorded at RAK Studios in October. The piece gathers in intensity, and a single beat of the snare drum reinforced by Gilmour's distorted Strat emphasizes the words *still in command*, to which we hear the distant reply, *Ranks! Fire!* (at 0:30). A particular feature of the verses is the way they include a bar in 2/4 whereas for the rest of the piece the time signature is 3/4, which produces a rather unexpected hiatus. In the first chorus Waters injects more power into his voice, but his singing is somewhat bland and lacking in warmth, unlike on the previous track. This could well be due to the tensions within the band, which prevented him from giving himself entirely to the music. He again uses the same echo technique for the last words of certain lines, and in this case at the end of every chorus (for example at 1:14). The effect, though attractive, has been overused since *Animals* and at times feels intrusive. In this chorus, he is supported by Mason on the drums, along with Bown on the organ, and Gilmour's clean-played rhythm guitar is underpinned with a distorted guitar line. For the next verse

Michael Kamen is on the electric piano, and Gilmour plays an acoustic rhythm guitar with a tinge of what is probably a harmonizer. Faintly we hear the cries of children playing (at around 1:38), before Waters pronounces the word *hand* with force (at 2:04), once again reinforced by a violent crash of the snare drum and a distorted chord on the Strat. The next chorus ends with a sustained Hammond organ passage, and an excellent guitar solo by Gilmour. The moment he comes in, we are of course back to the old familiar Floyd sound. His handling of the instrument is as inspired as ever, and Waters was full of praise in this regard: "His guitar playing is fantastic. He's a very underrated guitar player, in my opinion,"[9] he would say in 1983. Gilmour plays his Black Strat distorted by his Big Muff and uses fantastic bends as well as his vibrato bar to add expression to his lines. At the end of his solo, we hear the sound of a tambourine, masterfully handled by the talented Ray Cooper. After a final verse and chorus, "Your Possible Pasts" finishes with a repetition of the last word of the song, *closer*, which gradually fades away to the sound of clocks ticking, calling to mind "Time" on *The Dark Side of the Moon*.

One Of The Few

Roger Waters / 1:14

Musicians
Roger Waters: vocals, acoustic guitar (?), synthesizer (?)
Michael Kamen: synthesizer (?), orchestral conducting
National Philharmonic Orchestra: orchestra
Unidentified Musician: vocal harmonies
Recorded
The Billiard Room, London: May–October 1982
Hook End Recording Studios,
Checkendon: June, October 1982
Mayfair Recording Studios, London: June, October–November 1982; January 19, February 1983
Olympic Studios, London: June, September–October 1982
Abbey Road Studios, London: July 22 and 23, 1982
Eel Pie Studios, Twickenham: September 1982
RAK Studios, London: October 1982
Audio International Studios, London: January 26–30, 1983
Technical Team
Producers: Roger Waters, James Guthrie, Michael Kamen
Sound Engineers: James Guthrie, Andy Jackson
Assistant Sound Engineers: Andy
Canelle, Mike Nocito, Jules Bowen

The word *few* has another association here: it is the term used by Prime Minister Winston Churchill in his speech of August 20, 1940, to refer to the victorious RAF pilots of the Battle of Britain: "Never was so much owed by so many to so few."

Genesis

Waters's new concept album continues with "One of the Few," another song that *was rejected* during the recording sessions for *The Wall*. Its working title at the time was "Teach," and indeed its central character is none other than the schoolteacher from "The Happiest Days of Our Lives," the one who bullied his pupils because he himself was humiliated by his wife. We learn that he had fought in the Second World War. He managed to make it home alive, and pursued a career in teaching (*to make ends meet*, Waters sings), but at what price? The man has started to lose his mind. He seems gripped by paranoia, which causes him to subject others—in this case the pupils in his class—to the same treatment to which he was subjected by his superiors and the enemy during combat: *Make 'em mad/Make 'em sad/Make 'em add two and two.* Or else *Make 'em do what you want them to/Make 'em laugh/Make 'em cry/Make 'em lay down and die.* Words inspired by Waters's conversations with Leonard Cheshire, a former Second World War bomber pilot.

Production

"One of the Few" is a mini masterpiece. Few instruments, few words, but an atmosphere that is absorbing, oppressive, harrowing, and immediate. The song starts with a bass note, a D played as a drone. It is played on the synthesizer, perhaps the Prophet-5 (by Waters or Kamen). The only rhythmic elements of the song are two ticking sounds, the first coming from a clock ticking quite slowly (on the left), the second from some kind of alarm clock ticking more rapidly (on the right). A steel-string acoustic guitar resonates in this strange atmosphere. The melody has touches of the oriental—one of Waters's hallmarks. It seems to be him playing, perhaps on his Martin D-35 or his Ovation Legend. Behind the guitar we hear the sound of waves lapping at the shore, or of heavy breathing. Then Waters launches into the lead vocal in a voice that is confidential, somber, and hypnotic. The word *teach* offered in answer to his second line is very faint, almost whispered, and seemingly repeated ad infinitum (from 0:37). Woodwind sounds recorded by Michael Kamen's orchestra (from 0:50) underpin the first part of the song. A voice, probably

Michael Kamen was on the synthesizer and conducted the National Philharmonic Orchestra on "One of the Few."

female, also harmonizes with Waters on some words of the penultimate line, before a sadistic laugh erupts at 0:59. Toward the end of the piece, the sounds of a school playground come more and more to the fore…An extraordinary piece by Roger Waters.

COVERS

"One of the Few" was covered by the British band Anathema (on the album *Resonance*, 2001).

The Hero's Return

Roger Waters / 2:43

Musicians

David Gilmour: six- and twelve-string acoustic guitars, electric rhythm and lead guitars
Roger Waters: vocals, bass, acoustic guitar (?), keyboards (?)
Nick Mason: drums
Michael Kamen: keyboards (?)
Andy Bown: keyboards (?)

Recorded

The Billiard Room, London: May–October 1982
Hook End Recording Studios, Checkendon: June, October 1982
Mayfair Recording Studios, London: June, October–November 1982; January 19, February 1983
Olympic Studios, London: June, September–October 1982
Abbey Road Studios, London: July 22 and 23, 1982
Eel Pie Studios, Twickenham: September 1982
RAK Studios, London: October 1982
Audio International Studios, London: January 26–30, 1983

Technical Team

Producers: Roger Waters, James Guthrie, Michael Kamen
Sound Engineers: James Guthrie, Andy Jackson
Assistant Sound Engineers: Andy Canelle, Mike Nocito, Jules Bowen

For Pink Floyd Addicts

Roger Waters wrote a second part to "The Hero's Return." This verse is missing from the album version, but appears on the single version released as the B-side to "Not Now John." "The Hero's Return (Parts 1 and 2)" reached a respectable number 31 on the Billboard charts.

Genesis

This composition by Roger Waters, originally entitled "Teacher Teacher," was created for the double LP *The Wall*, before eventually being removed from the track listing. During the recording sessions for *The Final Cut*, Waters updated it with new lyrics. The narrator is again a teacher, still the same one from *The Wall*, who talks alternately about the present time and his memories of the war. The present consists of his job, the role he has to perform of teaching *little ingrates* who, he says, like *to whine and mope about*. The present also encompasses his peculiar relationship with his wife, whom he can only really speak to when she is asleep. Out of fear of being misunderstood? This more than likely explains why he is unable to confide in her or reveal to her what he is feeling. And straightaway the past looms up again: a traumatic experience from the Second World War, the bombing of Dresden.

The teacher's experience then merges with that of Waters. *My memory smolders on/Of the gunner's dying words on the intercom*: these lines echo the movie *The Wall*, when the father of Pink (by implication, Waters's father), under aerial bombardment, tries to call in reinforcements over the telephone. And so the banners and flags, the dancing and singing, and the church bells celebrating victory seem pathetic to him. The hero's return is a bitter one.

Production

The arrangement of "The Hero's Return" is undoubtedly the most complex of any song on the album. The introduction is itself in a way a demonstration of the proficiency of Pink Floyd and its three co-producers. David Gilmour plays a melody on his "Black Strat" (with his Big Muff and his Electric Mistress), producing some very distorted effects, underpinned by inverted cymbals. He can also be heard on the rhythm guitar with palm muting and a very noticeable delay, in the same style as his playing on "Another Brick in the Wall (Part 2)." Then he seems to support the melody on his Martin D12-28 twelve-string, which he doubles and positions at the far ends of the stereo picture. He is backed by layers of sound (Prophet-5?) enhanced by a pedal sound (VCS3? Prophet-5?). Eventually Roger Waters comes in on his bass, adding weight to Nick Mason's snare drum, which soberly keeps time. In the first verse, Waters's lead vocal is sung in quite a high voice,

Although relations with Waters had soured, Gilmour's contributions were still a vital element of the Pink Floyd sound, as his guitar parts (mainly on his Black Strat) on "The Hero's Return" testify.

alternating with his falsetto voice to allow him to reach the highest notes. He doubles himself and uses a fairly short delay to give color to his performance.

After the first four lines (from 1:05 onward) there is a change in atmosphere: an electric piano joins in, the bass drum marks each beat, and Waters sings, his voice doubled an octave lower. The nature of the sound suggests that a harmonizer such as the Eventide H910 has been used here. In the following sequence, the ticking of an alarm clock underlines the monologue of the schoolteacher, who abandons himself to his dark memories once his wife is asleep (from 1:23 onward). The acoustic guitars support Waters's vocal, and all kinds of effects are employed throughout this

section: guitar distortion, piano drenched in reverb, various delays. "The Hero's Return" ends with a section that exudes a different flavor than the rest of the song. The sound setting is soft and acoustic, with a six-string (on the left) and a twelve-string (on the right) providing a strummed accompaniment to Waters's vocal and bass. And at the end of the song, a conversation on an aircraft radio echoes out.

Although overall "The Hero's Return" is not that different from its forerunner composed for *The Wall*, the arrangement has changed considerably, which was much more rock-based and binary. What's more, the last part is markedly different in terms of harmonics, and the lyrics have been totally reworked.

The Gunners Dream

Roger Waters / 5:18

Musicians
David Gilmour: electric rhythm guitars
Roger Waters: vocals, bass
Nick Mason: drums
Ray Cooper: tambourine
Raphael Ravenscroft: tenor saxophone
Michael Kamen: piano, electric piano (?), orchestral conducting
Andy Bown: piano (?), electric piano (?)
National Philharmonic Orchestra: orchestra

Recorded
The Billiard Room, London: May–October 1982
Hook End Recording Studios, Checkendon: June, October 1982
Mayfair Recording Studios, London: June, October–November 1982; January 19, February 1983
Olympic Studios, London: June, September–October 1982
Abbey Road Studios, London: July 22 and 23, 1982
Eel Pie Studios, Twickenham: September 1982
RAK Studios, London: October 1982
Audio International Studios, London: January 26–30, 1983

Technical Team
Producers: Roger Waters, James Guthrie, Michael Kamen
Sound Engineers: James Guthrie, Andy Jackson
Assistant Sound Engineers: Andy Canelle, Mike Nocito, Jules Bowen

1983

For Pink Floyd Addicts

"The Gunner's Dream" also references an incident making the headlines in the United Kingdom at the time: *And maniacs don't blow holes in bandsmen by remote control* refers to the IRA double bombing of the parade of the Blues and Royals in Hyde Park and the Royal Green Jackets in Regent's Park on July 20, 1982, in which eleven military personnel were killed.

Genesis

This song, which talks about how people's liberties are trampled by authoritarian regimes wherever they may be, contains some of the most beautiful lyrics written by Roger Waters, reminiscent of both Bob Dylan and Leonard Cohen. War memories again…We understand that the central character, a gunner on board an RAF aircraft, has had to parachute out. He is floating through the air. And he dreams of a lasting peace, an almost ideal world where *old heroes shuffle safely down the street, where you can speak out loud/About your doubts and fears*, where *no-one ever disappears*, where *no-one kills the children anymore*. Memories of the Second World War continue to haunt the RAF gunner, who became a teacher after the guns fell silent. " 'The Gunner's Dream' " is about powerlessness," Roger Waters explains. "The door opens suddenly and you find you're face to face with blokes in jackboots in a country like South America or Algeria or France during the Occupation. You cry 'No you can't do that to me—I'll call the police!' and they reply 'We are the police.' Your life slips into a nightmare. The most precious thing in this world is that your life is not controlled by someone else."[53]

Production

The song begins with an indistinct voice on the radio, probably the gunner who is preparing to bail out with his parachute, followed by the sound of an airplane flying over and the whistling of the wind…Over the top of this dramatic sound reconstruction, the purifying, radiant, but terribly melancholy notes of a grand piano ring out. When Roger Waters sings the beginning of the first verse, one can't help noticing a certain resemblance to "Isolation" by John Lennon (*Plastic Ono Band*). Waters delivers a moving performance. It is probably Michael Kamen that we hear on the grand piano, accompanied by Andy Bown on the electric piano (Fender Rhodes?). The bass and the National Philharmonic Orchestra then come in, bringing a richness to the sound. On the last line of the first part of the song, Waters is suddenly louder, his vocal immediately leading into a saxophone solo performed by Raphael Ravenscroft. The phrasing is superb, rich, and soulful. Nick Mason can be heard, beating time simply but effectively, with Ray Cooper alongside him on the tambourine. At the end of the solo, we can just make

Roger Waters wrote a poetic lyric in the spirit of Bob Dylan for "The Gunner's Dream."

out the sound of David Gilmour's Stratocaster, played clean, with a very pronounced tremolo (at around 3:01). A voice in the distance shouts *all right* (3:06), and Waters resumes his lead vocal. Mason's Ludwig announces the final verse, and the orchestration suddenly becomes harder. Gilmour plays a distorted rhythm part on his Strat, and the string arrangements provide a rich backdrop for Waters's vocal, which, once again, suddenly swells to the limits of its volume, ending in a kind of wail on the word *insane* (from 4:29). The song finishes simply, Waters now singing in a quiet voice again, accompanied by the keyboards and Michael Kamen's strings. In the dying seconds of the piece, the sound of trailing footsteps is heard, leading to the next song…

Of all the songs on the album, "The Gunner's Dream" is the favorite of Andy Jackson, the sound engineer. He remembers that originally Roger Waters had written not "Goodbye Max, Goodbye Ma" but "Goodbye Ma, Goodbye Pa." But during production, some members of the team acquired nicknames: Michael Kamen was rechristened "Spike," Andy Jackson "Luis," and James Guthrie "Max." Roger Waters was amused, and, according to Andy Jackson, hurried out into the studio and sang: "Goodbye Max, Goodbye Spike." […] "You know, just as a joke for the assembled audience—us guys."[141] But Waters liked the idea so much that he decided to keep *Max* in the final lyrics. "So there you go," Jackson continues, "yeah, in reality Max is James Guthrie!"[141]

Paranoid Eyes

Roger Waters / 3:40

1983

Musicians
David Gilmour: acoustic rhythm guitars
Roger Waters: vocals, bass
Nick Mason: hi-hat
Michael Kamen: piano, orchestral conducting
Andy Bown: organ
Ray Cooper: percussion
National Philharmonic Orchestra: orchestra

Recorded
The Billiard Room, London: May–October 1982
Hook End Recording Studios, Checkendon: June, October 1982
Mayfair Recording Studios, London: June, October–November 1982; January 19, February 1983
Olympic Studios, London: June, September–October 1982
Abbey Road Studios, London: July 22 and 23, 1982
Eel Pie Studios, Twickenham: September 1982
RAK Studios, London: October 1982
Audio International Studios, London: January 26–30, 1983

Technical Team
Producers: Roger Waters, James Guthrie, Michael Kamen
Sound Engineers: James Guthrie, Andy Jackson
Assistant Sound Engineers: Andy Canelle, Mike Nocito, Jules Bowen

Genesis
Beyond the portrait of the war veteran turned teacher, which Roger Waters continues to develop in this song, a whole generation is affected, the generation that went to war and returned with their hearts forever broken. Their sadness has given way to deep depression. A depression that cannot be overcome, except, perhaps, with strong drink: *You believed in their stories of fame, fortune and glory./Now you're lost in a haze of alcohol soft middle age*, Waters sings. Then: *The pie in the sky turned out to be miles too high.* Paranoid eyes, then? Maybe it's more a case of eyes fixed on the horrific truth.

Production
Although "Paranoid Eyes" is a sad song, it is nonetheless illuminated by the talent of Roger Waters, who, ever since *The Dark Side of the Moon*, had shown himself to be an exceptional lyricist, something that became all the more striking from *The Wall* onward. It became clear that his artistic approach no longer coincided with that of his fellow band members, who were much more interested in the music than the lyrics.

The song starts with the same trailing footsteps that we heard at the end of "The Gunner's Dream." In the background we hear the sounds of children playing. Michael Kamen is on the grand piano, and Roger Waters on vocals. His voice is sad, soft, and pleasant. Once again it is the orchestra directed by Michael Kamen that has the main supporting role in this piece. Brass sections and string sections alternate, always subtly and precisely arranged. There are plenty of percussion contributions from Ray Cooper, including a tambourine (at 0:21, for example), and some kind of rattle that moves about in the stereo image (listen at 0:50). The pub sounds in the background repeatedly illustrate the lyrics, with certain phrases emerging from the general hubbub, for instance *I'll tell you what…I'll give you three blacks, and play you for five* (at around 1:39). The beginning of the last verse gives way to a phase of richer instrumentation: two strummed acoustic guitar parts, a hi-hat, a bass, and an organ. "Paranoid Eyes" ends with a moving vocal from Waters, before the pub sounds fade away. And a few seconds before the end of the piece, an *Oi!* is heard in the distance, repeated by a delay.

Get Your Filthy Hands Off My Desert

Roger Waters / 1:17

Musicians
Roger Waters: vocals, acoustic guitar
Michael Kamen: orchestra conductor
National Philharmonic Orchestra: orchestra

Recorded
The Billiard Room, London: May–October 1982
Hook End Recording Studios,
Checkendon: June, October 1982
Mayfair Recording Studios, London: June, October–November 1982; January 19, February 1983
Olympic Studios, London: June, September–October 1982
Abbey Road Studios, London: July 22 and 23, 1982
Eel Pie Studios, Twickenham: September 1982
RAK Studios, London: October 1982
Audio International Studios, London: January 26–30, 1983

Technical Team
Producers: Roger Waters, James Guthrie, Michael Kamen
Sound Engineers: James Guthrie, Andy Jackson
Assistant Sound Engineers: Andy Canelle, Mike Nocito, Jules Bowen

An RAF Tornado, the aircraft that Nick Mason got to record for "Get Your Filthy Hands off My Desert."

Genesis

A vast number of Second World War combatants died fighting Nazism. It was a heavy price to pay for vanquishing the forces of evil and laying the foundations of a world based on understanding between peoples. Now what do we find thirty-odd years after the defeat of the Axis? The world is still at war.

On this track, the songwriter takes a probing look at world events, alluding directly to the Soviet invasion of Afghanistan, the Falklands War, and the invasion of Lebanon by the Israeli army. He makes a point of mentioning the warmongering leaders: Leonid Brezhnev, who *took Afghanistan*, Menachem Begin, who *took Beirut*, the Argentine dictator Galtieri, who *took the Union Jack*, and Maggie, who *over lunch one day/Took a cruiser with all hands/Apparently to make him give it back*. Roger Waters wonders: was the sacrifice of the soldiers of democracy who fought Nazi Germany all for nothing? Certainly, he saw the Falklands conflict as a neocolonial war from another age, but more than that it also served as an opportunity for Margaret Thatcher to restore her image: "I felt then, and I still feel today, that the British Government should have pursued diplomatic avenues more vigorously than they did, rather than steaming in the moment that the Task Force arrived in the South Atlantic. Some kind of compromise could have been effected, and lots of lives would have been saved. It was politically convenient for Margaret Thatcher to wham Galtieri because there's no way she would have survived another six months [in her job] without the invasion of the Falklands Islands."[81]

Production

Hey...get your filthy hands off my desert! It is with these memorable words, with a desert wind audible in the background (VCS3?), that this curious song begins. Then another voice asks: *What he said?* Suddenly a jet passes overhead at supersonic speed, and a bomb explodes. Nick Mason, who was in charge of sound effects, remembers the sound recording: "Through a high-ranking air force contact, I was granted permission to record a number of Tornadoes at RAF Honington in Warwickshire. It was an extraordinary experience to stand at the end of the runway trying to set a

The singer-songwriter on the acoustic guitar for one of his blistering anticolonialist attacks.

level for a sound so intense that as the afterburners were lit up the air itself was crackling with sonic overload."[5]

So the music starts to the sound of an explosion. We are a long way from the familiar Pink Floyd sound, as it is (in all probability) a string quartet that provides the main accompaniment. Conducted by Michael Kamen, the members of the National Philharmonic Orchestra perform a very nice arrangement written by their director. Then Roger Waters

delivers his anticolonialist indictment. He strums an acoustic guitar (Martin D-35?) and sings in an ironic tone. The combination of the chamber music and quirky lyrics makes for a caustic gem. Waters ends his lead vocal with humming, which he harmonizes in three parts. "Get Your Filthy Hands off My Desert" concludes to the strains of the string quartet and the remote sound of the Tornado flying off into the distance.

The Fletcher Memorial Home

Roger Waters / 4:12

Musicians
David Gilmour: electric lead guitar
Roger Waters: vocals, bass
Nick Mason: drums
Michael Kamen: piano and orchestral conducting
National Philharmonic Orchestra: orchestra

Recorded
The Billiard Room, London: May–October 1982
Hook End Recording Studios,
Checkendon: June, October 1982
Mayfair Recording Studios, London: June, October–
November 1982; January 19, February 1983
Olympic Studios, London: June, September–October 1982
Abbey Road Studios, London: July 22 and 23, 1982
Eel Pie Studios, Twickenham: September 1982
RAK Studios, London: October 1982
Audio International Studios, London: January 26–30, 1983

Technical Team
Producers: Roger Waters, James Guthrie, Michael Kamen
Sound Engineers: James Guthrie, Andy Jackson
Assistant Sound Engineers: Andy
Canelle, Mike Nocito, Jules Bowen

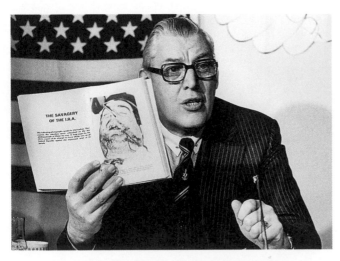

Ian Paisley, the Northern Irish political leader,
opposed any agreement with the Catholics.

Genesis

Roger Waters, with characteristic dark irony, has taken his father's middle name as the name of the "memorial home" at the center of this song. It is a way of honoring Eric Fletcher Waters, killed by the German Tiger tanks during Operation Shingle in January 1944. "He was in London all through '40, '41 and '42," explains Roger Waters, "and during that time he became interested in politics, and his politics became more and more left-wing until he joined the Communist Party, at which point he had a struggle with the dialectic between his Christianity and communism. In the end, he took the view that it was necessary to fight against the Nazis. He went back to the Conscription Board and said, 'Listen, I've changed my mind and so I would like to volunteer for the armed forces.'"[81] And Waters adds: "To have the courage to not go—and then to change your mind and have the courage to go—is a sort of mysteriously heroic thing to have done, which my brother and I have to live with."[81]

In fact the Pink Floyd songwriter's preoccupations here go beyond the Second World War. He would like to see gathered together in this retirement home the *incurable tyrants and kings* who have plagued the world since the war. And Waters, as master of ceremonies, introduces them one after the other: firstly the president of the United States, Ronald Reagan, and his ultra-authoritarian secretary of state Alexander Haig; then the Israeli leader Menachem Begin and his friends Margaret Thatcher and Ian Paisley (a Protestant and die-hard opponent of any kind of agreement with the Catholics in Ulster); then Leonid Brezhnev and his Communist party; then there is a bald man—the ghost of Senator Joseph McCarthy—along with the ex-president of the United States, Richard Nixon, and all the South American dictators. Waters deems all of these leaders guilty, referring to them as *wasters of life and limb*. And he would like to see the *final solution* applied to them…

Production

Not only is he a highly talented lyricist, Waters is also a very eclectic composer, his work reflecting a much more diverse range of musical influences than that of Gilmour or Wright, for example. You just have to compare "Set the Controls for the Heart of the Sun," "Grantchester Meadows,"

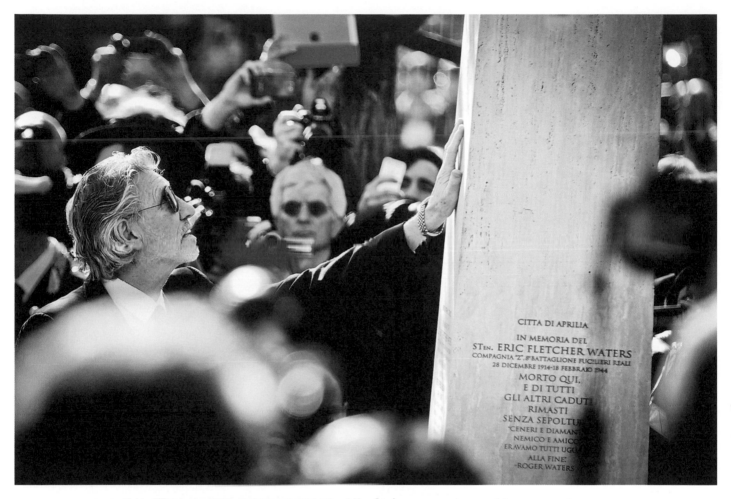

Roger Waters in 2014, paying his respects at the Anzio monument erected in memory of his father, Eric Fletcher Waters, and fellow servicemen killed in action.

"Cymbaline," "San Tropez," "Money," and "Another Brick in the Wall (Part 2)": all are musically very different. And "The Fletcher Memorial Home" is another example of this. This song puts the National Philharmonic Orchestra center stage. The arrangements written by Michael Kamen (who also plays the piano) are fantastic and obviously help raise Waters's writing to another level. Waters delivers a successful, moving performance; he alternates between quiet passages, with spoken parts, and his customary flights of lyricism (which he doubles). The only criticism concerns the way he seems to systematically opt for a strained voice, always stretched to its limits. It is a bit like the recurring use of echo on the ends of lines or on isolated words. One can have too much of a good thing. But the fact remains that the production is of an extremely high caliber, something that has always been a hallmark of Pink Floyd from the very beginning. We get a glimpse of the old Floyd trademark style in a superb instrumental sequence with Gilmour and Mason back in their familiar roles. Gilmour embarks on an excellent solo on his "Black Strat." He uses his Big Muff and his Electric Mistress, giving that characteristic sound that he has developed since *Animals*, via his Hiwatt amplifier and his WEMs. He harmonizes one of the lines of his solo with thirds, then with fifths (from 2:55). It is a three-guitar formula that he has only used on rare occasions, another example being the solo in "Dogs" on *Animals* (with different harmonization). Nick Mason holds his own, too, with a wonderfully effective accompaniment. The sound of his Ludwig has a near-live feel to it, much like on "In the Flesh" (*The Wall*). Meanwhile, Waters, who has been on the bass since the beginning of the piece, does a great supporting job, as does Michael Kamen with his piano and his orchestra. After a final verse, "The Fletcher Memorial Home" ends on a final chord, to the sound of seagulls screeching overhead.

Southampton Dock

Roger Waters / 2:12

Musicians
Roger Waters: vocals, bass, acoustic guitar, synthesizer (?)
Michael Kamen: piano and orchestral conducting
National Philharmonic Orchestra: orchestra

Recorded
The Billiard Room, London: May–October 1982
Hook End Recording Studios,
Checkendon: June, October 1982
Mayfair Recording Studios, London: June, October–November 1982; January 19, February 1983
Olympic Studios, London: June, September–October 1982
Abbey Road Studios, London: July 22 and 23, 1982
Eel Pie Studios, Twickenham: September 1982
RAK Studios, London: October 1982
Audio International Studios, London: January 26–30, 1983

Technical Team
Producers: Roger Waters, James Guthrie, Michael Kamen
Sound Engineers: James Guthrie, Andy Jackson
Assistant Sound Engineers: Andy
Canelle, Mike Nocito, Jules Bowen

Genesis

Southampton dock, which gave its name to the ninth track on *The Final Cut*, was the place from which the allied troops involved in the Normandy landings on June 6, 1944, departed and the place to which numerous British servicemen returned after the German capitulation. It was from here, too, that the cruise ship *Canberra* set sail on April 9, 1982, with two thousand men on board, to assist in the recapture of the remote Falkland Islands (four days after the main task force, which had embarked at Portsmouth).

The first verse is plain enough: silent and restrained, the British greet the return of the soldiers, many of whom are missing from the line. Then, in the second verse, we are left to wonder about the identity of the woman who, with her handkerchief in her hand and her summer dress clinging to her skin, *bravely waves the boys goodbye again*. Is this a mother watching her son set off, or a wife? Or is it Margaret Thatcher, prime minister of the United Kingdom, who made a point of being present for the departure (or return) of her soldiers? Which, in Roger Waters's eyes, would be the height of cynicism. The third and final verse is about war in general, with another reference to poppies, the red flower (the color of blood) worn on Remembrance Day (November 11). Fish (the singer with the progressive rock band Marillion) called "Southampton Dock" "the most powerful comment on the Falklands,"[36] though he lamented the fact that "Pink Floyd's *The Final Cut* didn't reach as many people as it should have. You know why? Because everyone was told it was sooo unhip [at the time] to like anything by the Floyd."[36]

Production

We hear the solitary cries of seagulls over Southampton dock. Roger Waters is on the acoustic guitar, which he plays with a capo placed on the third fret, in the key of F major (Martin D-35?). He accompanies himself with strumming, and the lyrics are half sung, half spoken, rather in the manner of Leonard Cohen. It is an emotional performance, and we sense he is genuinely moved by his words. A bass line is added in from the fourth line. A note played on the synthesizer (most probably a vocal sound) adds to the solemnity of the atmosphere (from 0:20). In

Southampton docks in 1945. It was from here that the *Canberra* would set sail, forty years later, for the Falkland Islands.

the second verse, the subtle swell of some French horns is heard, admirably orchestrated by Michael Kamen. A ship's horn sounds in the distance (at 0:53). In the last three lines, Waters resumes his singing an octave higher, his voice at the breaking point, and the effect—although repeated—brings a sense of tension to the words, especially as the vocal is undermixed (from 0:54 onward). Then, for the last verse, Michael Kamen is on the piano, accompanied by the brass and strings sections of the National Philharmonic Orchestra. Waters's performance is poignant and infused with sincerity, making "Southampton Dock" one of the most successful tracks on the album.

It is evident, listening to this superb song, that Waters had come to a point where he was no longer willing or able to continue with the Pink Floyd formula. He had set off in a new artistic direction. As Waters himself had said, referring to Rick Wright, they were no longer on parallel paths…This gives us a clue as to why Gilmour had wanted his own name removed from the credits: while the quality of the album was not in doubt, the problem was that this was no longer his record.

The Final Cut

Roger Waters / 4:46

Musicians

David Gilmour: acoustic rhythm guitars, electric lead guitar
Roger Waters: vocals, bass
Nick Mason: drums
Ray Cooper: tambourine
Michael Kamen: piano, harmonium, orchestral conducting
National Philharmonic Orchestra: orchestra

Recorded

The Billiard Room, London: May–October 1982
Hook End Recording Studios,
Checkendon: June, October 1982
Mayfair Recording Studios, London: June, October
to November 1982; January 19, February 1983
Olympic Studios, London: June, September–October 1982
Abbey Road Studios, London: July 22 and 23, 1982
Eel Pie Studios, Twickenham: September 1982
RAK Studios, London: October 1982
Audio International Studios, London: January 26–30, 1983

Technical Team

Producers: Roger Waters, James Guthrie, Michael Kamen
Sound Engineers: James Guthrie, Andy Jackson
Assistant Sound Engineers: Andy
Canelle, Mike Nocito, Jules Bowen

For Pink Floyd Addicts

"The Final Cut" appears on the eponymous video, as well as on the B-side of the promotional single for radio, "Selections from *The Final Cut*" (with "Your Possible Pasts" on the A-side).

Genesis

The album's title song, which had been rejected as a contender for *The Wall*, is the darkest work on *The Final Cut*, an album that already doesn't exactly inspire optimism! The narrator tells us he is *spiraling down to the hole in the ground where I hide*. This could be interpreted as the RAF gunner (who subsequently became the teacher in *The Wall*) experiencing another flashback in which his aircraft is downed by antiaircraft fire. Roger Waters actually composed this song for *The Wall*, but the narrator was not the teacher, who was both the bully and the bullied, but Pink himself, who slid into insanity. There were various reasons for his decline. Isolation, of course, though initially that was what he wanted, but also sexual frustration, which so plagues him that he is gripped by *a big hallucination/Making love to girls in magazines*. We also understand that he is feeling the pain of rejection: *Could anybody love him/Or is it just a crazy dream?/And if I show you my dark side/Will you still hold me tonight?* Roger Waters wonders.

So the final curtain is coming down on Pink's career, and the lives of all those left behind, be they fragile rock stars, marginals resigned to their fate, or sacrificed soldiers. And it seems there will be no encore. This realization dawns when we hear a gunshot ring out at the words *behind the wall*. In other words, behind the wall there is death, a void. So "the final cut" would be Pink's ultimate gesture, his sacrificial suicide. Unless…The last line contains a glimmer of hope: *I never had the nerve to make the final cut…*The "final cut" can be interpreted in various ways: it can be taken to mean the "final take," the "final edit," or "final cut" in a movie sense. According to David Gilmour, "it's also an expression for a stab in the back, which I think is rather the way Roger sees the film industry."[36]

Production

"The Final Cut" follows on naturally from the end of "Southampton Dock," with Michael Kamen on the piano introducing the first verse of the song. Roger Waters is on vocals, his voice quiet, and still in the same emotional register. He adds a bass, and is accompanied on the ride cymbal by Nick Mason. Dog barks can be heard in the distance (from 0:30 onward). Then the orchestration becomes denser, with the

Nick Mason, a faithful presence on *The Final Cut*, particularly on the title song.

National Philharmonic Orchestra, Mason's drums, Ray Cooper's tambourine, and two strummed acoustic guitar parts played by David Gilmour. The last line of the second verse is emphasized with a crescendo of strings, which is abruptly interrupted by a gunshot, then an enthusiastic shout heard in the distance (1:09). Waters brings more power into his voice in the third verse, whose harmonies and strings parts bear quite a resemblance to the chorus of "Comfortably Numb" on *The Wall*. We also hear backing singers in the instrumental bridge that leads to the next section (from 1:49). In this section Waters is accompanied only by Michael Kamen on the harmonium, before the band and the orchestra join

in, and he sings in a strained voice with plenty of delay added. David Gilmour, on his "Black Strat," launches into an excellent solo, the sound distorted by his Big Muff and colored by his Alembic F-2B preamp and his rotating Yamaha RA-200s. He harmonizes some of his lines and makes extensive use of his vibrato bar. At 3:25 a second guitar comes in briefly, probably an extract from another take that had not been wiped and was eventually kept. Finally, after the last verse, Roger Waters ends the song on the phrase that gave the album its name, *the final cut*. In the closing seconds of the piece we hear a voice, apparently from an answering machine, which disappears with a laugh.

Not Now John

Roger Waters / 3:42

Musicians
David Gilmour: vocals, electric rhythm and lead guitars, synthesizer (?), acoustic guitar (?)
Roger Waters: vocals, bass, acoustic guitar (?), synthesizer (?)
Nick Mason: drums
Andy Bown: Hammond organ
Ray Cooper: percussion
Doreen Chanter, Irene Chanter: backing vocals (?)

Recorded
The Billiard Room, London: May–October 1982
Hook End Recording Studios, Checkendon: June, October 1982
Mayfair Recording Studios, London: June, October–November 1982; January 19, February 1983
Olympic Studios, London: June, September–October 1982
Abbey Road Studios, London: July 22 and 23, 1982
Eel Pie Studios, Twickenham: September 1982
RAK Studios, London: October 1982
Audio International Studios, London: January 26–30, 1983

Technical Team
Producers: Roger Waters, James Guthrie, Michael Kamen
Sound Engineers: James Guthrie, Andy Jackson
Assistant Sound Engineers: Andy Canelle, Mike Nocito, Jules Bowen

Nick Mason's playing is particularly strong on "Not Now John."

Genesis

"Not Now John" stands as a kind of synthesis of everything Roger Waters is denouncing in *The Final Cut*. Margaret Thatcher, a recurring figure on the album, is targeted again: the United Kingdom, victorious over Argentina, apparently sees itself overpowering the "Russian bear," or, failing that, Sweden (a neutral country, moreover). We get the message: it is with an enormous snort of derision that the songwriter greets the return to the international scene of the intrepid Britannia of old! In this song he also suggests that the media, too, had a lot to answer for during the Falklands conflict. The songwriter likens the way in which the press and broadcast media (or some of them, at least) covered the war in the South Atlantic to a Hollywood movie: *Hollywood waits at the end of the rainbow./Who cares what it's about/As long as the kids go*. The humor is ferocious—and highly effective.

War, misinformation: two of the ills of liberal societies—the United States, Europe—that Waters condemns. And at work, the pressure to keep up crazy rates of production, due partly to competition from countries like Japan, inevitably leads to alienation. *Can't stop. Lose job. Mind gone! Silicon!*: the first line of the second verse says more than any long speech. For Waters, the only means of escape for British blue-collar workers, like their peers throughout the so-called free world, is alcohol or drugs. *Come at the end of the shift/We'll go and get pissed.* Could he be any clearer? "It's a very schizophrenic song," Waters would later say, "because there's this one character singing the verses who's irritated by all this moaning about how desperate things are, and doesn't want to hear any of it any more. There's part of me in that. Then there's this other voice which keeps harping back to earlier songs, saying, 'Make them laugh, make them cry, make them dance in the aisles,' which is from 'Teach.' So it's a strange song."[36]

"Not Now John," the only song on *The Final Cut* in which Roger Waters shares the vocals with David Gilmour, would be released as the A-side of the only single taken from the album—with "The Hero's Return (Parts 1 and 2)" on the B-side. It peaked at number 30 on the UK charts on May 7, 1983, and made it to number 7 in the United States (Mainstream Rock Tracks).

1983

Ray Cooper, another illustrious sideman to Pink Floyd on the recording of *The Final Cut*.

Production

The song opens on a crescendo by Andy Bown's distorted Hammond organ (on the right) and feedback from David Gilmour's "Black Strat" (on the left). Then, for the first—and last—time on the album, Gilmour's voice rings out. The piece has a rock vibe, much like that of "The Nile Song" (*More*). He accompanies himself on his Strat, the Big Muff very prominent. Roger Waters is on the bass, which itself has a slightly distorted sound. The playing is rhythmic and powerful, and meshes perfectly with the excellent drum part by Nick Mason, who delivers one of his best performances on this album. His Ludwig has a live tonality that perfectly matches the garage rock ambiance of the piece. We hear regular contributions from Ray Cooper on percussion instruments that are hard to identify (listen at 0:15). Gilmour's vocal is answered by two backing vocalists, Doreen and Irene Chanter. Waters takes over from Gilmour on the lead vocal (from 0:32 onward) with a bridge based on vocal effects—a high singing voice alternating with a spoken voice. This part ends with a resounding *bingooo!*, which is echoed by the backing vocals. Waters then sings the first chorus, which is a repeat of the chorus of "One of the Few," from the same album. He is accompanied by the backing singers, as well as two acoustic guitar parts on what sounds like a twelve-string guitar. There is also a synthesizer in the mix, producing an arpeggiator-style sound. David Gilmour is back on vocals for the second verse, which he concludes with a very good solo played on his Strat. The piece really lifts off with these spirited lines, which he delivers with the same feeling and fluidity as ever. Interestingly, at 1:52, he repeats a motif that had featured as part of his solo on "Another Brick in the Wall (Part 2)" (listen at 2:23). Knowing nod, or coincidence? His lyrical playing is underpinned by the accompanying vocals of the backing singers toward the end of the solo. The number continues with another verse/chorus, before ending with a final verse, this time sung by Waters in a kind of frenzy. His words are illustrated with shouts, laughs, and applause, and he rounds off with a classic *na na na na na!* He then launches into a series of questions in Italian, Greek, French, and English, accompanied throughout by a Gilmour solo (from 4:01 onward): *One, two, three, four!/Scusi, dov'é il bar (what?)/Se para collo, pou eine toe bar?/S'il vous plaît, où est le bar? (ooh, say it in English!)/Oi, where's the fucking bar, John?* And fervent voices from the crowd reply: *Rule Britannia! Britannia rules the waves!...Go Maggie!...Hammer, hammer, hammer...!* [a reference to *The Wall*]. The song fades out to the sound of applause, giving way to the sounds of passing traffic on a road..."Not Now John" is an excellent single, admirably produced, which probably deserved a higher position on the charts.

Two Suns In The Sunset

Roger Waters / 5:19

Musicians
David Gilmour: electric rhythm guitars
Roger Waters: vocals, bass, acoustic guitar
Andy Bown: Hammond organ
Michael Kamen: piano
Raphael Ravenscroft: tenor saxophone
Andy Newmark: drums
Richard Millard: voice on the radio

Recorded
The Billiard Room, London: May–October 1982
Hook End Recording Studios, Checkendon: June, October 1982
Mayfair Recording Studios, London: June, October–November 1982; January 19, February 1983
Olympic Studios, London: June, September–October 1982
Abbey Road Studios, London: July 22 and 23, 1982
Eel Pie Studios, Twickenham: September 1982
RAK Studios, London: October 1982
Audio International Studios, London: January 26–30, 1983

Technical Team
Producers: Roger Waters, James Guthrie, Michael Kamen
Sound Engineers: James Guthrie, Andy Jackson
Assistant Sound Engineers: Andy Canelle, Mike Nocito, Jules Bowen

For Pink Floyd Addicts

Raphael Ravenscroft, who was one of the sidemen working with Roger Waters and the other two members of Pink Floyd on *The Final Cut*, is known for his masterful saxophone solo on "Baker Street," the 1978 Gerry Rafferty hit.

Genesis

Roger Waters concludes his concept album with an irredeemably apocalyptic song. "That was a thought I had, driving home one night, thinking we all sit around and talk about the possibility of accidents or—as I put it in the song—people just getting so bloody angry that finally somebody pushes a button. Well, the song's all about that moment when suddenly it happens [...] It's very easy to go 'Oh yes, well, there may be an accident and the holocaust might happen.'"[36]

"Two Suns in the Sunset" comes upon us with all its morbid cruelty. The second sun, which appears in the east even though it is dusk, is the nuclear explosion. The narrator, powerless to do anything, watches in the rearview mirror from the driver's seat of his car, his head whirling with feelings of regret: *I think of all the good things/That we have left undone*, [...] *Could be the human race is run*. The end is drawing near: *As the windshield melts/My tears evaporate*. His final thought has an implacable logic to it: *Foe and friend/We are all equal in the end*.

Equal in the face of death and eternal obliteration: the Pink Floyd songwriter is thinking of the Cold War, embodied at the time by the nuclear arms race. Hence the importance of electing responsible men and women to the highest functions of state. Was Roger Waters thinking of Margaret Thatcher, the "Iron Lady," whose neocolonialist warmongering in the South Atlantic had alarmed him? Or of Ronald Reagan, who had arrived at the White House having played cowboys for the Hollywood cameras? Unless it was meant as a subliminal message to the masses: don't be afraid to live…

Production

The sounds of traffic that marked the end of "Not Now John" also provide the background to the first chords we hear from Roger Waters's acoustic guitar. His strumming is accompanied by Andy Bown on the Hammond organ. The drums soon make their entry, the ride cymbal leading in. It is not Nick Mason wielding the drumsticks, but Andy Newmark, a fantastic drummer whom Waters decided to engage to stand in for Mason, who couldn't come to grips

David Gilmour on stage in Utrecht with saxophonist Raphael Ravenscroft, who played on "Two Suns in the Sunset."

with the various changes in time signature. "Rhythmically, there are some 5/4 timings thrown in so the downbeat changes from bar to bar and it's confusing for Nick," Waters explained. "His brain doesn't work that way. That's why he didn't play on "Mother" on *The Wall*."[81] It is true that, in this song, the metrics of Waters's lyrics have priority over the metrics of the music, meaning the musicians have to be able to follow the twists and turns of his thought processes, which is no mean feat. But Newmark, with his experience of working with artists as diverse as Sly and the Family Stone, George Benson, and John Lennon, seems to cope well. Waters accompanies him with a very good bass line, Michael Kamen comes in on the piano from time to time, and David Gilmour plays chords highly colored by a deep tremolo, probably on a 1959 Gibson Les Paul Goldtop, slightly overmixed (on the left at the beginning, on the right from 1:02 onward). Obviously, for the concluding song on *The Final Cut*, it is Roger Waters who provides the lead vocal. His voice, with added delay, alternates between quiet and high-pitched, strained passages. On the bridge, especially, (from 2:18) he maybe overdoes the

trait, causing his singing to become rigid and tonca. David Gilmour's Gibson suddenly becomes more prominent, supporting the rhythm guitar with distorted passages. There are various interventions during the course of this bridge: an apathetic *oh no!* (2:23), a yell (2:31), a child's voice (*Daddy! Daddy!* at 2:34), and children's cries (2:46). But unlike the sound illustrations found on other songs on the album, these seem to fall flat.

After a final verse, Raphael Ravenscroft embarks on a superb solo on the tenor saxophone, very inspired and magnificently performed. During this coda the traffic noises heard at the beginning of the song become audible again; then, from 4:36, we hear a voice on the radio which, with black humor, announces the latest weather forecast: *And now the weather. Tomorrow will be cloudy with scattered showers spreading from the east...with an expected high of 4000 degrees Celsius...*This voice was recorded by Richard Millard, of Audio International Studios in Marylebone, London, who also provided the radio voice for the first song on *The Final Cut*, "The Post War Dream."

A MOMENTARY LAPSE OF REASON

ALBUM
A MOMENTARY LAPSE OF REASON

RELEASE DATE
United Kingdom: September 7, 1987

Label: EMI
RECORD NUMBER: CDP 7 48068 2 (CD version), EMD 1003 (vinyl version)
Number 3 (United Kingdom), on the charts for 34 weeks; number 3 (United States)

Signs Of Life / Learning To Fly / The Dogs Of War /
One Slip / On The Turning Away / Yet Another Movie /
Round And Around / A New Machine (Part 1) / Terminal Frost /

For Pink Floyd Addicts

Rick Wright did not become a member
of Pink Floyd again for the recording of
A Momentary Lapse of Reason. He was
paid a weekly salary of $11,000 as an or-
dinary employee.

A Momentary Lapse of Reason: New Album, New Aesthetics

Even before *The Final Cut* made it to number 1 on the UK charts, there was one thing the three remaining members of Pink Floyd agreed on: that they would not work together any longer. Or more precisely, Roger Waters would no longer record with David Gilmour and Nick Mason. It seems the idea of a tour to promote the album never crossed the three musicians' minds. "It would have been hard to imagine a show that could follow *The Wall*, anyway. But it was another factor in how David and I viewed the future," Nick Mason explained. "Both David and myself regarded playing live and touring as an integral part of being in the band. If being part of a Roger-led Floyd meant that there would be no live shows [...] and only aggravation in the recording studio, the future prospect seemed distinctly unappealing."[5]

So solo projects started to take priority. One year after *The Final Cut*, Roger Waters released *The Pros and Cons of Hitch Hiking* (May 1984), the concept he had proposed to his bandmates at the same time as *The Wall*. He then embarked on a tour comprising thirty-six concerts from April 16, 1984 (Stockholm) to April 14, 1985 (Lakeland, Florida), with, notably, Eric Clapton on the guitar for the 1984 shows. It was around this time, in June 1985 to be precise, that he and Steve O'Rourke parted company. This divorce came about after Waters announced he wanted to renegotiate his own contract but keep the negotiations secret. But, as Nick Mason would later comment, "Steve felt—both on moral grounds and also probably for financial reasons—that he was obliged to inform the rest of us."[5] Waters, feeling betrayed, appointed

as his new manager Peter Rudge, who had previously worked with the Rolling Stones and the Who. Waters began work on his personal project, writing the music for the Jimmy T. Murakami animated movie *When the Wind Blows*, released in 1986. Nick Mason recorded the album *Profiles* (1985) with Rick Fenn, the guitarist from 10cc, which David Gilmour was also involved in (vocals). As for the latter, he released his second solo album, the excellent *About Face*, on March 5, 1984 (in the United Kingdom), with Bob Ezrin on production, James Guthrie on sound, and featuring such distinguished musicians as Pino Palladino (bass) and Jeff Porcaro (drums). Another sign that a split was in the cards: Gilmour was the only member of Pink Floyd to participate in Live Aid on July 13, 1985, as guitarist for...Bryan Ferry.

Waters's Departure

In December 1985, Waters announced that he wished to leave Pink Floyd and sent a letter to the management of EMI and CBS in which he asked to be released from his contractual obligations, invoking the "leaving member" clause. In truth, this did not come as a great surprise to David Gilmour and Nick Mason, and they certainly had no intention of allowing him to prevent the band continuing on the pretext that he was its principal creative force. "If I'm honest," Roger Waters disclosed in June 2004, "my idea was that we should go our separate ways. What actually happened was, the reason that I finally left, signed the letter [...] was because they [CBS Records] threatened me with the fact that we had a contract

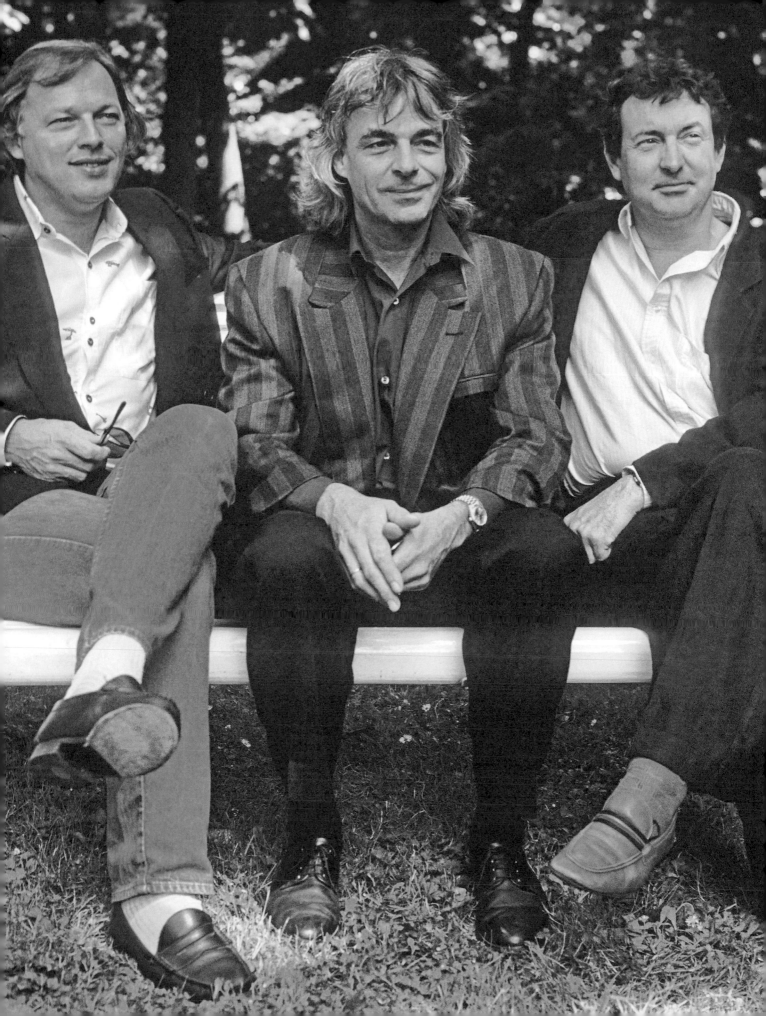

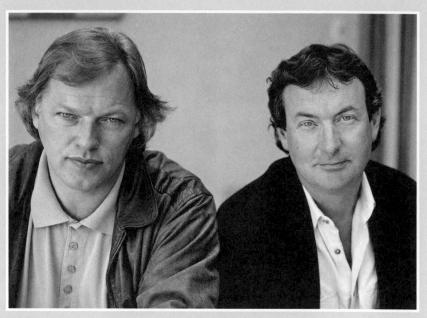

Bob Ezrin worked with the Floyd again on *A Momentary Lapse of Reason*.

The two remaining band members, David Gilmour and Nick Mason, together again for the band's thirteenth album.

with CBS Records and that part of the contract could be construed to mean that we had a product commitment with CBS and if we didn't go on producing product, they could (a) sue us and (b) withhold royalties on that product if we didn't make any more records [with them]. I said, 'That's ridiculous. We'd never have signed a contract like that.' They showed me the clause, and it was [indeed] ambivalent."[119] So according to Waters, he left Pink Floyd in order to avoid having to file a lawsuit that would inevitably have ruined him had he sought to prevent Gilmour and Mason from continuing to record for EMI and CBS under the Pink Floyd name. There was also the contract that EMI had asked him to sign when he composed the soundtrack to *When the Wind Blows* (for which he alone is credited), under which he had undertaken not to stand in the way of Gilmour and Mason's projects. It would have been hard for him to imagine back then—given that he had held sway over the band practically since *Wish You Were Here*—that Pink Floyd could ever carry on for any length of time without him…

The Pink Floyd Venture Continues

The idea of a new album bearing the Pink Floyd name soon took root in David Gilmour's mind, especially after the partial failure of the *About Face* promotional tour (March 31 to July 16, 1984), in which two concerts (in Frankfurt and Nice) had to be canceled due to poor ticket sales. This setback brought it home to him that the public was less interested in the individual projects of any of the band members). So Gilmour made the decision to continue with the Pink Floyd venture, especially as Waters had stung him by claiming that he wouldn't be capable of making it work. Gilmour stood up for himself, arguing that after twenty years in the band, his determination to continue was perfectly legitimate: "I'm 44 now, too old to start all over again at this stage of my career," he declared, "and I don't see any reason why I should. Pink Floyd is not

some sacred or hallowed thing that never made bad or boring records in the past. And I'm not destroying anything by trying to carry on!"[142] Nick Mason stood by him, confident that he had what it would take to pursue the venture without Waters. As Nick recalled, "David had in fact made up his own mind quite early on, and had been working on a number of demos."[5] Gilmour had several songs up his sleeve, some just an outline, others at a more advanced stage, and he had also got back in touch with some of his old contacts.

Among them was Bob Ezrin, who agreed to come back on board eight years after *The Wall*. Ironically, Ezrin had already been contacted by Waters, who wanted him to co-produce *Radio K.A.O.S* (1997). According to Nick Mason, the reasons why Ezrin chose Pink Floyd rather than Waters had to do with incompatible time schedules and the fact that he would have had to spend too long out of circulation working flat out with the irascible creator of *The Wall*. Waters, his ego bruised, viewed this defection as a second betrayal, and from then on would refer to his ex-bandmates as "muffins!" After all, in February 1986, before Gilmour contacted him, Bob Ezrin had agreed to work on *Radio K.A.O.S.*, and he and Waters had even set a date, April 16 in the United Kingdom, to start production of the album. But strangely, a fortnight prior to that date, Ezrin was nowhere to be found. After trying numerous times without success, Waters eventually managed to get hold of him on the telephone. "My wife says she'll divorce me if I go to work in England!"[140] Ezrin told him. Waters was dumbfounded, but it wasn't long before he realized the real reason Ezrin had turned him down: the Canadian producer had gone over to the opposing side. This decision—which was somewhat illogical since he would still have to come to the United Kingdom to work with Gilmour—seems to have been motivated primarily by his misgivings at the prospect of what was bound to be a fraught relationship, given Waters's intransigent character: "Dave didn't demand

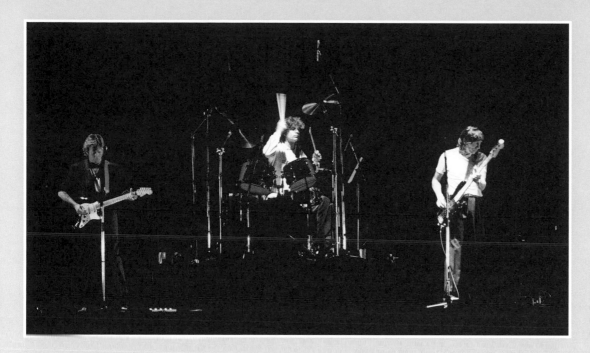

Roger Waters pursued a solo career from then on. Here with Eric Clapton in 1984.

things like Roger did,"[140] he explained, hinting at Waters's lack of consideration for his colleagues' private lives. It was also motivated by a fear of his authoritarianism: "At the time I met with Roger, I said I wanted to do the album, but I had an instinctive sense that he was being too rigid and intense in his attitudes about the project."[140]

The Return of Bob Ezrin

So Bob Ezrin and Gilmour joined forces once again to produce the band's thirteenth album, the first without Waters. Would they be equal to the task? Ezrin's initial idea was to edge Gilmour in the direction of his own latest musical passion: hip-hop! The Canadian producer was very taken with the music of Africa Bambaataa. The guitarist, pretty taken aback, apparently exclaimed: "Oh my God, that would be terrible." "He couldn't believe it," Ezrin went on. "He hated the idea."[141] Ezrin eventually listened to reason: this was not what the fans were expecting from the Floyd, especially after Waters's departure, so he encouraged Gilmour to revive the kind of sound that had made the band famous.

Among the other musicians involved in the project were keyboardist Jon Carin, whom Gilmour had met when they were both part of Bryan Ferry's lineup at Live Aid, the former Roxy Music guitarist, Phil Manzanera, and...Rick Wright. "I was in Greece," David Gilmour related, "and I think I had a visit from Rick's then wife, Franka [...], saying, 'I hear you're starting a new album. Please, please, please can Rick be part of it?' I left it for a while because I wanted to be sure that I knew what I was doing before I got anyone's hopes too high."[1] In fact, quite apart from the tensions that had emerged between the keyboardist and the other band members during the rather confrontational recording sessions for The Wall, they also faced a legal problem: the "leaving member" clause that Rick Wright had signed prevented him from officially rejoining the band. "I remember

having a meeting with them [Gilmour and Mason] and Steve [O'Rourke] in a restaurant in Hampstead," the keyboardist recalled. "I think they wanted to see how I was. I passed the test."[1] All the same, he would only have a secondary part to play when it came to the recording of the album.

As the team of musicians around the two official members of Pink Floyd grew, the music started to take shape. However, David Gilmour wasn't getting on as well as he had hoped. Roger Waters related something that Michael Kamen, the arranger of the orchestral parts of The Wall and The Final Cut, had said to him: apparently Bob Ezrin had told Kamen the tracks were "an absolute disaster, with no words, no heart, no continuity."[140] Again according to Waters, Steve Ralbovsky, an artistic director from CBS who had traveled to London, had been so disappointed on hearing the first recordings, because they had so little in common with the Pink Floyd aesthetic, that he urged Gilmour to start all over again. David Gilmour's version of events could not be more different: "A tissue of lies," he told Mark Blake. "I never stopped and started again. [...] Steve Ralbovsky did come down and wanted to hear a few things. He was a mate. It's entirely possible he wasn't impressed with it. We'd only been at it for three weeks, and there was a track I'd played him a year before that I'd done at home with [session drummer] Simon Phillips."[1] Gilmour added: "Whatever his thoughts were, he kept them to himself. We carried on, and by Christmas we had upped a gear and were on our way forward."[1]

A Lengthy Labor

The guitarist-songwriter was looking for a theme for a concept album, to continue the approach adopted on all Pink Floyd albums since The Dark Side of the Moon, and, in particular, for a lyricist who, while he may not outshine Waters, could at least prove a worthy successor. With this in mind, he first approached Eric Stewart (the ex-member of 10cc), then

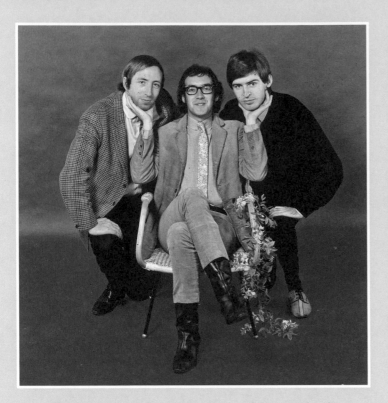

The poet Roger McGough, center, part of the comedy trio
the Scaffold (with John Gorman and Mike McGear).

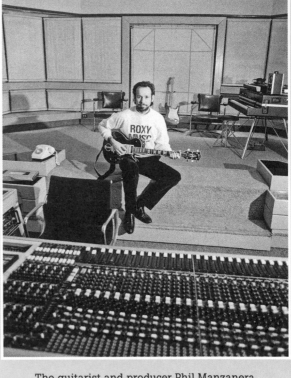

The guitarist and producer Phil Manzanera,
who collaborated with Pink Floyd on
A Momentary Lapse of Reason.

Roger McGough, a member of the Liverpool Poets (associated with the Beat movement), who, as well as having written dialogue for the movie *Yellow Submarine* (1968) by the Beatles and formed the rock band the Scaffold (with Peter Michael McCartney, the brother of Paul), had translated several Molière plays into the English language and published numerous collections of poems. When the collaboration with the 10cc songwriter and the Liverpool poet failed to produce anything very tangible, Gilmour turned to Carole Pope, the Canadian poet and singer with the band Rough Trade. "The idea to contact me came from Bob Ezrin," Pope commented. "It was January of 1987 and they were looking for somebody to rewrite a batch of David Gilmour's material, so I went over to England for a few weeks to lend assistance. Bob and David also asked me if I had any suggestions for concept albums in the Pink Floyd style. By the time I left England in February, they still couldn't decide what to do."[142] So the plan to produce a new conceptual work was abandoned, but not the search for a decent lyricist. In the end they settled on a former member of Blackhill Enterprises called Anthony Moore, an avant-garde musician and writer who, after living in Germany for a while and founding the trio Slapp Happy, had returned to the United Kingdom and recorded with Henry Cow and Kevin Ayers. It is he who wrote the lyrics to "Learning to Fly," "The Dogs of War," and "On the Turning Away."

Toward a New Aesthetic

Titled *A Momentary Lapse of Reason*, Pink Floyd's thirteenth album was released in the United Kingdom on September 7, 1987 (and the next day on the North American

continent). It consists of eleven tracks, all of them composed by David Gilmour, either individually or in collaboration with Bob Ezrin, Jon Carin, Phil Manzanera, or Pat Leonard. However, to suggest that this was a solo album by the guitarist (accompanied by Mason and Wright) in the same way as *The Final Cut* was a personal opus by Roger Waters (accompanied by Gilmour and Mason) would be an exaggeration. Despite Waters's absence, and the fact that Nick Mason and Rick Wright only really played second fiddle, the album does nonetheless come close to the classic Pink Floyd sound—at times very close, particularly on "One Slip," "Terminal Frost," and "Sorrow" (albeit without achieving the same kind of atmospheric ambiances as *Meddle*, *The Dark Side of the Moon*, or *Wish You Were Here*).

A Momentary Lapse of Reason would reach number 3 on the charts in the United Kingdom and the United States. It would fare even better in New Zealand, where it made it to number 1, and in West Germany, the Netherlands, and Norway, where it peaked at number 2. In France it sold some 550,000 copies. The press, meanwhile, remained generally lukewarm. "Neither progressive nor regressive, they just appear to have stopped,"[143] wrote Edwin Pouncey in *NME*, while William Ruhlmann referred to Gilmour's atmospheric instrumental music, adding that the music lacked a unifying vision and Waters's lyrical direction.[145] Roger Waters, meanwhile, resorted instead to dark irony: "I must say that, under the circumstances, it's a superb title for a so-called Pink Floyd record."[142] He also labeled it a quite clever forgery and branded Gilmour's lyrics very third-rate. All in all, it was probably Graeme Thomson, writing in the special issue of *Uncut*

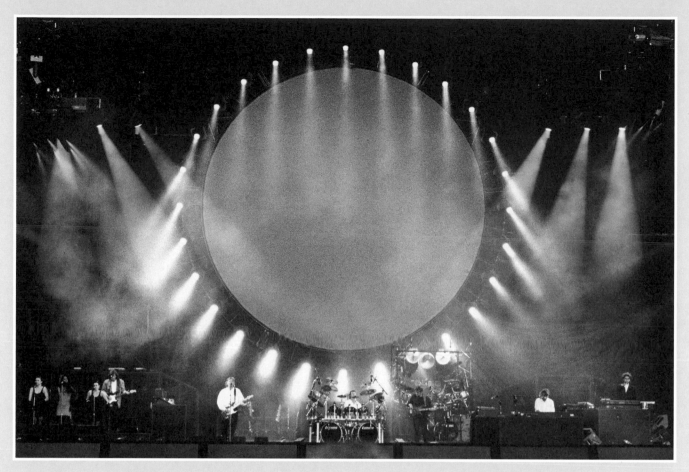

Pink Floyd and their musicians in concert on the "Momentary Lapse of Reason Tour" in 1988.

magazine dedicated to Pink Floyd, who best summed up the interest it awakened across a broad audience: "*A Momentary Lapse Of Reason* announced the return of Pink Floyd, which ultimately meant the chance to go [again] to an arena and hear them play 'Shine On You Crazy Diamond' and 'Money.'"[81]

Indeed, the day after the release of the album in North America, Pink Floyd embarked on a long tour—the first since *The Wall* and, more significantly, the first without Roger Waters. It had been organized by the Canadian Michael Cohl, an old hand who had been in the business since the sixties. Tim Renwick (guitars), Jon Carin (keyboards), Scott Page (saxophones, guitars), Gary Wallis (percussion), and backing singers Rachel Fury and Margaret Taylor all took part alongside David Gilmour, Nick Mason, and Rick Wright. The "Momentary Lapse of Reason Tour" kicked off on September 9, 1987, in Lansdowne Park, Ottawa (Canada), finishing with the show at Knebworth, in the United Kingdom, on June 30, 1990. Between these two dates, Pink Floyd played close to two hundred concerts, taking them from the United States to Europe via New Zealand, Australia, and Japan.

David Gilmour could ultimately draw reassurance from both the album sales and the incredible success of the tour, "a rehabilitative process for all of us," he later commented. This success would from that point on enable them to establish a credible presence, without the help of Roger Waters: "When the three of us sit down and play, it sounds like Pink Floyd. There's a very distinct value in that, which was

important for me to discover. There's something there that's bigger than any one person's ego."[29]

The Sleeve

Very telling! After a different approach on *The Wall* and *The Final Cut*, both of which bore the imprint of Roger Waters's headstrong personality, David Gilmour decided to call once again on the talents of Storm Thorgerson for the sleeve of *A Momentary Lapse of Reason*. The idea for the river of hospital beds disappearing into the distance was prompted by the song "Yet Another Movie," in which Gilmour sings: *a voice that lied/The sun that burned a fiery red/The vision of an empty bed*. The other image the brilliant designer had in his mind, as he revealed in his book, was "a lonely rower, or sculler, rowing himself down a dry cracked river bed. This was a reworking, I realise, of the swimmer in the dune for *Wish You Were Here*."[65] For the cover shot, seven hundred beds were carefully lined up on Saunton Sands beach in Devon (where several scenes from *The Wall* had also been filmed), and not in Death Valley, California, which had been the original plan. In the center of the picture is a man sitting on one of the beds, while on the right we can make out several dogs lying on the sand close to the shore (a reference to the song "The Dogs of War?") and, in the distance, an aircraft in the sky. It was a nightmare to produce, as Thorgerson recalled: "Not at first, but later. There were three tractors with trailers, several carts, thirty helpers, dogs and dog handler,

The *Astoria*, the houseboat which David Gilmour converted into a recording studio.

two models and two photographers, Bob Dowling and his young assistant Tony May (...), and one microlite."[65] Dowling scooped a gold award at the Association of Photographers Awards for this image. Inside the sleeve, we find a black-and-white photograph of the Floyd "survivors," Nick Mason and David Gilmour (not Rick Wright, as he was no longer an official band member, but a "guest"), taken by David Bailey.

Recording on the River

David Gilmour recalls a car journey along the Thames one evening in 1986: "I had been banned from driving for drunk driving for a year, being silly. So I was being driven, rather than driving myself, and as you're driven you sort of look out of the windows a lot more and as we drove along we looked, I looked out, and I saw this metal work on the top over the wall, and I said to the chap driving: 'Can we just pull over here and have a look?' And we pulled over and we stood on the pavement, we stood on the corner there and peered over and looked down and saw this incredible boat and this water and work on the top. And I thought 'Oh, that's fantastic.'"[146] The boat in question was none other than the *Astoria*, a mahogany-framed houseboat 27 meters in length, resembling a steamboat, built a century previously for the famous impresario (and mentor to Charlie Chaplin) Fred Karno, the upper deck topped by a vast metalwork canopy and large enough to accommodate an entire ninety-piece orchestra! A few weeks later, David Gilmour happened to discover that the boat was for sale, and bought it. He moved it from Taggs Island to Hampton Court and decided to install a recording studio, because he felt he spent too much time cooped up in recording studios with no windows. "David, aided and abetted by Phil Taylor, had constructed a studio in the converted dining room," Nick Mason wrote, "a shade on the small side, but with sufficient room for a drum kit, bass guitar and electronic keyboards. The control room, built in the main living room, had windows looking over the river

on two sides and across the riverside gardens on the third."[5] Bob Ezrin remembered: "Working there was just magical, so inspirational; kids sculling down the river, geese flying by."[1]

So the recording of *A Momentary Lapse of Reason* got under way in the hushed environment of the *Astoria*. The sessions took place between November 1986 and March 1987. Bob Ezrin later explained that because of the lack of space on board, they were not able to have their usual guitar amps in the room with them, so they opted for smaller models instead. As the Canadian producer put it: "After playing around with them in the demo stages of the project, we found that we really liked the sound. So a Fender Princeton and a little G&K [Gallien-Krueger] amp became the backbone of Dave's guitar sound for that record."[29] As producer, Ezrin introduced the band to new technologies such as samplers and drum machines. The equipment could be used to touch up the drum parts, for example. This proved to be a touchy subject for Nick Mason, who wasn't feeling in top form: "In fact, I found myself overwhelmed by the computers on this record," he confessed. "I hadn't played seriously for four years and didn't even like the sound or feel of my own playing. Perhaps I had been demoralised by the conflict with Roger."[5] Indeed, Waters had amiably described Mason's contribution to the Floyd as negligible. For most of the tracks he found himself forced to relinquish his drumsticks to heavyweights like Jim Keltner and Carmine Appice. He would come to regret this: "In hindsight I really should have had the self-belief to play all the drum parts."[5] But, as he rightly observed, neither he nor Gilmour had enough self-confidence after Waters's departure.

In February, recording moved to Mayfair Studios and Audio International Studios, both in London, which the band had used once before, for *The Final Cut* in 1982 and 1983. Britannia Row Studios was used as well. Bob Ezrin was feeling homesick and suggested the recording sessions be continued in larger studios closer to home, in Los Angeles. So the musicians all flew out to California, where,

Phil Taylor, David Gilmour's guitar technician and the architect behind the sound on the *Astoria*.

For Pink Floyd Addicts

Pink Floyd's thirteenth studio album had a succession of names, *Signs of Life*, *Of Promises Broken*, and *Delusion of Maturity*, before the band finally settled on *A Momentary Lapse of Reason*, a phrase taken from the song "One Slip."

between February and March 1987, they worked at A&M Studios, the Village Recorder, and the Can-Am Studios in turn. "In the A&M Studios, we were able to admire the talents not only of Messrs [Jim] Keltner and [Carmine] Appice," Nick Mason commented, "but also Tom Scott's saxophone and the keyboard work of Little Feat's Bill Payne."[5]

Andy Jackson was at the controls for the recording and mixing. The sound engineer, who had also worked on *The Final Cut*, was in charge of the technical production of the album, but also the various sound effects. James Guthrie, who had worked with him on the last Floyd record, was only involved in one remix ("Sorrow"). Nick Mason recalled that, on hearing the first version of the mix in Los Angeles, he had been dismayed by what he heard. He found it much too muddled and overloaded. Fortunately this issue would be resolved on the final mix. All the same, the album was still a far cry from what he had been hoping for. It wasn't Pink Floyd enough for his tastes, with the exception of "Learning to Fly."

The assistant sound engineers were Robert "Ringo" Hrycyna (Alice Cooper, Peter Gabriel, the Kinks), who had recorded the voice of Trudy Young in Toronto for "One of My Turns" on *The Wall*; Marc DeSisto (Mark Knopfler, U2, Patti Smith); Stan Katayama (Aerosmith, the Temptations, Judas Priest); and Jeff DeMorris (Sheila E., R.E.M., Cher). Not forgetting the indispensable Phil Taylor, who, besides his role as technical and instrument supervisor, was handed the delicate task of installing a full-fledged recording studio in David Gilmour's houseboat.

Technical Details

David Gilmour had wanted to reuse his old Soundcraft 2400 console on the *Astoria*. However, Phil Taylor, entrusted with the job of installing a studio worthy to be used for the next Pink Floyd album, convinced him to change it for a DDA AMR 24. There was definitely a Studer A80 twenty-four-track tape recorder, used for the recording of all the drums

and the bass guitars to preserve the roundness and warmth of the analog sound. The other instruments and vocals, on the other hand, would be recorded on a Mitsubishi digital thirty-two-track tape recorder (probably the X-850 model), a first for the band. In terms of the main monitors, the studio was equipped with Urei 813s, with Phase Linears (in all likelihood Pro 700s) for amplification.

In 1986 the Audio International Studios in London were equipped with a superb custom Cadac 48x24 console, with an Eventide Harmonizer, a Marshall Time Modulator, and a Lexicon 200 digital reverberator. The Mayfair Studios, meanwhile, had opted for Studer/Sony 3324 tape recorders and an SSL 6072 E console with Urei 813B monitors. Finally, at the A&M Studios in Los Angeles, Pink Floyd got to use George Martin's old console, the Neve 4872.

The Instruments

David Gilmour eventually abandoned his "Black Strat," which he lent to the Hard Rock Cafe at the end of 1986 in exchange for a donation to the Nordoff Robbins Music Therapy Centre charity. In 1984 he had purchased several Fender Stratocaster 1957 reissues. Of these, a cream-colored Strat and another in red with a maple neck became his favorites. But on the album it was mainly the red guitar—the '57V—that he played, fitted with EMG pickups and a shortened tremolo arm. Keen to try something new, he also opted for a white Steinberger, the famous headless guitar. In terms of amplification, according to Bob Ezrin he was usually plugged into a Gallien-Krueger (250 ML MKII combo) and a Fender Princeton. Phil Taylor, meanwhile, pointed out that the Gallien-Krueger, which was set to overdrive, was itself linked to a Fender Super Champ set to a clean sound. And to obtain his trademark sound, Gilmour used a Boss CS-2 pedal for compression, a TC Electronic 2290 for delay, and a Yamaha SPX90 for stereo chorus. Taylor also mentioned that very often Gilmour liked to play on his amp, which was beside him in the control room.

David Gilmour's "Red Strat," a 1957 reissue, which henceforth would take the place of his "Black Strat."

Although he only joined the recording sessions for *A Momentary Lapse of Reason* relatively late on, Rick Wright is credited as having played principally the Hammond organ B-3 and C-3, the piano, and especially the Kurzweil K250 (K1000?), the first digital synthesizer to use samples in its sound banks. There was another keyboard present, a Roland Super JX (JX-10), but it is not certain that Wright himself played it. It was more likely Bob Ezrin, Jon Carin, or Pat Leonard. Then there was the vocoder, probably the Roland VP-330 Plus, which can be heard on "A New Machine," used by David Gilmour.

As for Nick Mason, he stuck with his Ludwig, but added a Simmons electronic drum kit (the best of the genre).

The Musicians

Releasing a new Pink Floyd album proved a real challenge for David Gilmour and Nick Mason. It needed to be flawless, in terms of both lyrics/composition and production, as the band's fans and Roger Waters would be sure to pounce on any shortcomings. Since Nick Mason was having trouble getting back into the swing of things, and Rick Wright came on board too late, Gilmour was keen to make sure that the playing was top-notch at every stage of recording. To achieve this, he surrounded himself with fifteen or so musicians from elsewhere, all of them big names in their respective fields. However, *A Momentary Lapse of Reason* suffered as a result of this overly diverse lineup and the new technologies that tended to get in the way of a group sound.

The fifteen musicians were as follows:

Carmine Appice was the drummer with the New York band Vanilla Fudge from 1966 onward, then joined the band Cactus, before getting involved in various collaborations, notably with Rod Stewart and Duane Hitchings, with whom he co-wrote the international hit "Do Ya Think I'm Sexy?" in 1978.

The keyboardist Jon Carin, who was also involved in the writing of one of the songs on the album ("Learning to Fly"), carried on working with Pink Floyd afterward, and collaborated on some of Gilmour's and Waters's solo projects.

The percussionist Steve Forman began his career in the early seventies. Having become a prominent figure on the Californian rock scene after the recording sessions for Ray Manzarek's solo albums and two Poco albums (*Head Over*

Nick Mason, David Gilmour, and Rick Wright in front of the console on the *Astoria* during the recording sessions for the thirteenth studio album.

Heels, 1975; *Indian Summer*, 1977), he worked on a number of highly diverse collaborations, from Art Garfunkel (*Fate for Breakfast*, 1979) to Jennifer Warnes (*Famous Blue Raincoat: The Songs of Leonard Cohen*, 1987), to Glenn Frey (*The Allnighter*, 1984). Followed, in 1987, by the recording sessions for *A Momentary Lapse of Reason*.

Donny Gerrard (misspelled "Donnie" on the album) is a soul singer who started his career in the seventies in the band Skylark, based in Vancouver. Following a successful solo career, he became a highly respected session musician who played on numerous albums by international artists like Elton John, Ray Charles, Bruce Springsteen, and many others.

John Helliwell (also misspelled, as "Halliwell," on the sleeve) is the famous saxophonist from Supertramp. He got involved in parallel projects outside of his band on several occasions, including notably "Terminal Frost" on the Pink Floyd album.

Jim Keltner, another stand-in drummer, definitely ranks as one of the most respected drummers of his generation. His myriad collaborations included: George Harrison, John Lennon, Ringo Starr, Steely Dan, Simon & Garfunkel, Bob Dylan, Brian Wilson, Neil Young, Jack Bruce, and many more.

Darlene Koldenhoven is a singer with an impressive career. She worked on a great many projects, for instance with Tom Jones, Rod Stewart, REO Speedwagon, Ringo Starr, Lionel Richie, and Neil Young, to name but a few.

A session guitarist since the end of the seventies, Michael Landau had played with Joni Mitchell and James Taylor as well as Roger Daltrey and Miles Davis.

Pat Leonard, composer, producer, and keyboard specialist, is known for his work with Madonna on several of her records. He was also involved in numerous other recordings (notably for Carly Simon), and co-produced *Bête Noire* (1987) by Bryan Ferry. In 1992, he worked alongside Roger Waters on *Amused to Death*. After that he could be seen in the company of Fleetwood Mac, Julian Lennon, Elton John, Leonard Cohen, Marianne Faithfull, and others...

Tony Levin was one of the foremost bassists of the rock scene. A friend of producer Bob Ezrin, he took part in the recording of *Berlin* (1973) by Lou Reed, before working on several albums for Alice Cooper and Peter Gabriel (becoming his official bassist on *Peter Gabriel* (1977) and thereafter). He even played on *Double Fantasy* (1980) by John Lennon and Yoko Ono, before he hooked up with Pink Floyd. At that stage Levin had already become part of the King Crimson lineup. He would go on to record with the quartet Anderson Bruford Wakeman Howe (eponymous, 1989), Yes (*Union*, 1991), and Liquid Tension Experiment (from 1998 onward), confirming his preeminence on the prog scene.

Originally known for accompanying the stars of easy listening music, like Barry Manilow, onstage, the saxophonist Scott Page joined Supertramp in 1983 for its "Famous Last Words Tour," before recording *Free as a Bird* (1987) with them. He then went on tour with Toto, and not long after, David Gilmour persuaded him to take part in the recording of "The Dogs of War," followed by the tour to promote *A Momentary Lapse of Reason*.

Bill Payne was a big-name pianist-organist on the blues-rock scene, known principally for his role within the band Little Feat (with Lowell George). He also deployed his talents in the service of some of the most famous names in folk rock and American rock, such as J. J. Cale, the Doobie Brothers, Jackson Browne, and James Taylor.

Having written countless songs for other artists, the soul singer Phyllis St. James was involved in numerous recordings, notably for Randy Crawford, the Bee Gees, the Jackson Five, and Billy Preston, among many others.

Tom Scott is a studio musician of international stature, a saxophonist extraordinaire who played with Joni Mitchell, Carole King, Donovan, Steppenwolf, George Harrison, Joan Baez, and Steely Dan, to name but a few.

Carmen Twillie, the actress and session singer, is credited on numerous albums by Elton John, as well as Cat Stevens, Julian Lennon, Rod Stewart, B. B. King, and The Brian Setzer Orchestra, among many others.

Signs Of Life

David Gilmour, Bob Ezrin / 4:22

Musicians
David Gilmour: electric lead guitar, synthesizers, programming
Rick Wright: Kurzweil
Nick Mason: voice
Tony Levin: bass (?)

Recorded
Astoria, Hampton: November 1986 to February 1987
Britannia Row Studios, Islington, London: February 1987
Mayfair Studios, Primrose Hill, London: February 1987
Audio International Studios, London: February 1987
A&M Studios, Los Angeles: February to March 1987
The Village Recorder, Los Angeles: February to March 1987
Can-Am Studios, Los Angeles: February to March 1987

Technical Team
Producers: David Gilmour, Bob Ezrin
Sound Engineer: Andy Jackson
Assistant Sound Engineers: Robert Hrycyna, Marc DeSisto, Stan Katayama, Jeff DeMorris

For Pink Floyd Addicts

In the video for "Signs of Life," the man seen rowing is Langley Iddins, the caretaker of the *Astoria*, David Gilmour's houseboat studio. He is rowing through Grantchester Meadows.

The atmosphere on "Signs of Life" bears some similarity to the Japanese musician Kitarō, whose work is greatly influenced by the sounds of nature. His score for the Oliver Stone movie *Heaven & Earth* (1993) earned him a Golden Globe.

Genesis

It all begins with the sound of oars in the water—most likely the water of the river Thames. Then we hear indistinctly the voice of Nick Mason, who recites a few enigmatic phrases: *When the childlike view of the world went, nothing replaced it* [three times]. *I do not like being asked to* [three times]...*Other people replaced it. Someone who knows.* Nick Mason revealed that this sound effect of the boat gliding peacefully through the water was chosen because it was such a romantic sound.[147] Maybe the water of the Thames is meant to represent the "first signs of life"…

Production

"Signs of Life" seems to mark a return to the atmospheric style of the Pink Floyd of the pre-*Animals* era. David Gilmour would later confirm this, saying that the track was in fact based on an old demo. "I had to re-record a lot of things, but the rhythm guitar chords in the background are from a demo from way back in '78."[29]

The piece starts in earnest after thirty-nine seconds of river sounds (recorded by Andy Jackson), as if the listener is invited to share in the enjoyment of the *Astoria*'s surroundings. A layer of synthesizer (Kurzweil?) fades in, conjuring up a dreamlike ambiance. There is an accompanying melody, the sound of a glockenspiel rings out, a (synthesized) bass comes in from time to time, and the voice of Nick Mason pronounces the cryptic words against a background of a robotic sequence sounding very much like a VCS3. The melody comes more to the fore; other layers intensify the harmony. It is rather in the style of Brian Eno. Gilmour's "Red Strat," played clean and directly into the console, announces the second part of the piece (at 2:37). Here the general tone recalls the introduction to "Shine On You Crazy Diamond (Part 1)" (*Wish You Were Here*). Gilmour plays on, introducing harmonics and a melodic motif curiously reminiscent of the introduction to "Roundabout" by Yes on their album *Fragile* (1971). Each of his lines is repeated by a whistling sound played on the synthesizer. He continues in this way until the end of the piece; his phrasing and the sound of his "Red Strat" (which came with two Boss pedals, a CS-2 for compression and a CE-2 for chorus) recall his bluesy improvisations in the first part of "Shine On."

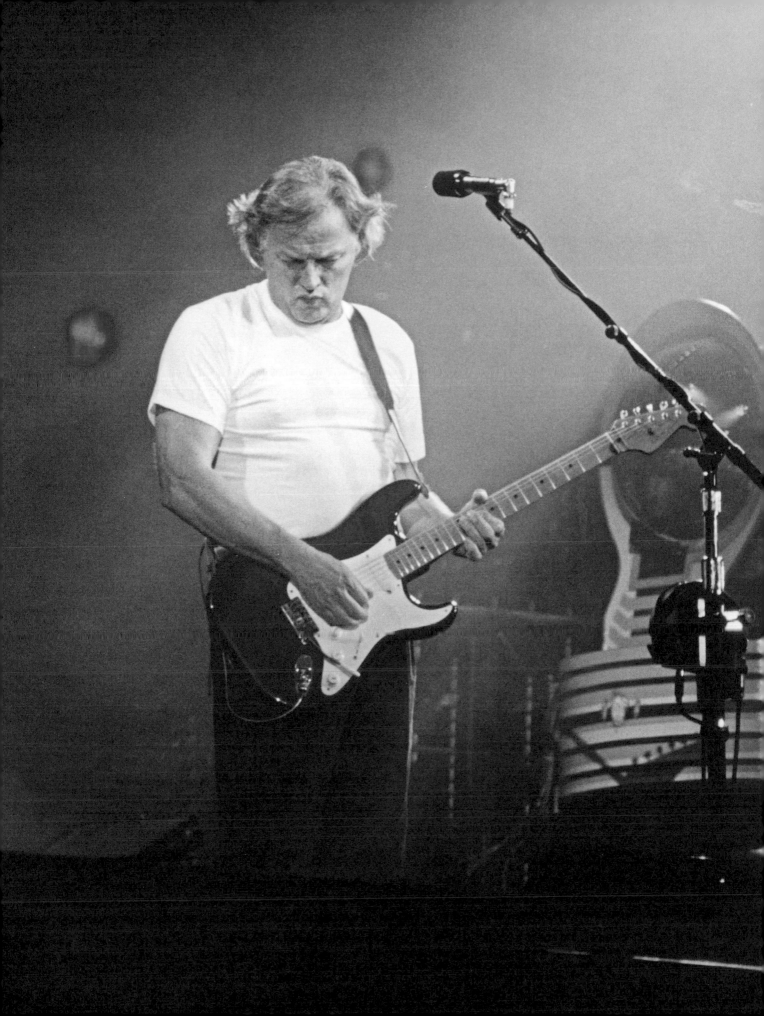

Learning To Fly

David Gilmour, Anthony Moore, Bob Ezrin, Jon Carin / 4:53

Musicians

David Gilmour: vocals, vocal harmonies, electric rhythm and lead guitars, programming (?)
Nick Mason: vocals
Rick Wright: keyboards, vocal harmonies (?)
Bob Ezrin: percussion (programming) (?)
Jon Carin: keyboards
Tony Levin: bass
Steve Forman: percussion
Darlene Koldenhoven, Carmen Twillie, Phyllis St. James, Donny Gerrard: backing vocals

Recorded

Astoria, Hampton: November 1986 to February 1987
Britannia Row Studios, Islington, London: February 1987
Mayfair Studios, Primrose Hill, London: February 1987
Audio International Studios, London: February 1987
A&M Studios, Los Angeles: February to March 1987
The Village Recorder, Los Angeles: February to March 1987
Can-Am Studios, Los Angeles: February to March 1987

Technical Team

Producers: David Gilmour, Bob Ezrin
Sound Engineer: Andy Jackson
Assistant Sound Engineers: Robert Hrycyna, Marc DeSisto, Stan Katayama, Jeff DeMorris

At a Ferrari exhibition in May 1987: motor racing was Nick Mason's other passion.

Genesis

"Learning to Fly" came into being during the course of a jamming session involving David Gilmour and Jon Carin soon after they had appeared alongside Bryan Ferry at Wembley at the massive Live Aid charity concert on July 13, 1985. Gilmour had already produced a demo of the song. Jon Carin, who had joined Gilmour on the *Astoria* to do some impromptu recording, worked out the keyboard part while Gilmour was off picking someone up from the station. The lyrics were penned by Anthony Moore. "[It was inspired] by the fact that several mornings Anthony [Moore] would be there hard at work, and I wouldn't show up. I'd call up and tell someone [that I was having a flying lesson] and they'd say, 'Dave's not coming in today 'cause he's learning to fly.' [That was] the starting point [for] something a bit wider."[148] So this song, in the literal sense, is about Gilmour's new passion for flying, a hobby he shared with Nick Mason (the two of them later bought their own aircraft), which also enabled him for a time to escape his obligations as a rock star. *There's no sensation to compare with this/Suspended animation, a state of bliss*, Gilmour sings. These lessons were also a way of overcoming fear. "We ended up sharing planes for a number of years, and frightening ourselves far more than we ever did on all those commercial flights,"[5] Nick Mason admitted.

The song can be read on several levels, though. As Gilmour himself commented to Karl Dallas in 1995, this song symbolized both a new departure for the band and a new venture for him, now sole captain of the Pink Floyd spaceship since the split with Roger Waters: "Yeah, well, 'Learning To Fly,' from the spiritual aspect of it, is about Pink Floyd taking to their wings again, as well as me taking to my wings again, and all sorts of things. And learning to fly, of course, physically. So there's a number of levels to that."[144] So this explains the lines *No navigator to guide my way home/Unladen, empty and turned to stone*, as the navigator, Roger Waters, has obviously now gone....

"Learning to Fly," which was side A of the first single taken from *A Momentary Lapse of Reason* (with "Terminal Frost" on the B-side), released on September 14, 1987, only reached number 70 on the US Billboard chart, but made it to number 1 on the Album Rock Tracks chart.

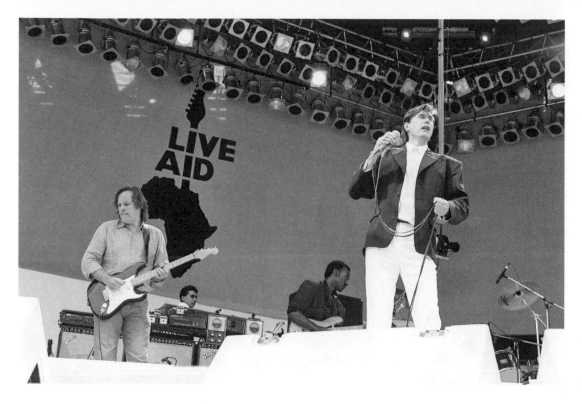

David Gilmour, guitarist for Bryan Ferry at *Live Aid* in July 1985, where he met the keyboardist Jon Carin.

Production

Of all the songs on the album, Nick Mason judged "Learning to Fly" to be the most faithful to the sound and spirit of Pink Floyd. However, the piece seems to have been formulated with radio in mind, more so than any other of the band's titles. Right from the intro, a nonchalant yet very effective rhythm pattern establishes a groove that draws one in. Jon Carin suggested that the rhythm was probably influenced by Steve Jansen and Yukihiro Takahashi. The drum kit composition and programming are quite complex and hard to pin down. It could be a combination of drum kit samples probably played by Jim Keltner, drum machines apparently programmed by David Gilmour and Bob Ezrin (LinnDrum? Linn 9000? E-mu SP 1200?), and Simmons drums. Percussion was added by Steve Forman, such as the tambourine that can be heard throughout the piece. On the bass is the excellent Tony Levin, who does a good job of supporting and energizing the groove. As far as the keyboards, shared between Jon Carin and Rick Wright, are concerned, again it is difficult to distinguish the numerous different parts, most of them played on either the Kurzweil K250 or an electric piano. On the lead vocal is David Gilmour, his first time back in this role since *The Wall* (apart from on "Not Now John" on *The Final Cut*), and although its timbre is immediately recognizable, his voice is slightly drawling, which is surprising. On the choruses he is accompanied by Darlene Koldenhoven, Carmen Twillie, Phyllis St. James, and Donny Gerrard on backing vocals. It is possible that they are joined by Rick Wright, but it is more likely that he is supporting on vocal harmonies. After the second chorus, the piece moves into a long instrumental bridge (from 2:08), during which we hear the voice of Nick Mason in the cockpit of a plane, as he summons his courage: *Friction lock—set/Mixture—rich/Propellers—fully forward/Flaps—set—ten degrees/Engine gauges and suction—check/Mixture set to maximum percent—recheck/Flight instruments...altimeters—check both/Beacon and navigation lights—on/Pitot Heater—on/Strobes—on/*(to control tower:) *Confirm three-eight-Echo ready for departure/*(control tower:) *Hello again, this is now 129.4/*(to control tower:) *129.4. It's to go./*(control tower:) *You may commence your takeoff, winds over 10 knots./*(to control tower:) *Three-eight-Echo/Easy on the brakes. Take it easy. It's gonna roll this time./Just hand the power gradually, and it...*

In the next verse, Gilmour's voice is drenched in reverb, with a powerful phasing effect added. In the background we hear the sound of the wind. As for the guitar, it is his "Red Strat" we hear, the sound distorted by the overdrive on his Gallien-Krueger amp, compressed by his Boss CS-2, and enriched by the stereo chorus of his Yamaha SPX90. He plays a rhythm part, but also an intoxicating riff that first appears in the intro and is repeated at points throughout the piece. There are several exceptional solos, notably after the first chorus (at 1:12), in the middle section, and in the coda (from 4:01 onward).

"Learning to Fly," the first song in the band's history without Roger Waters's input, is a very good track with much to like about it. The Waters touch is lacking, though, and one can't help drawing comparisons. David Gilmour comes across as not totally confident in his lead vocal, but the outcome proves he is up to the challenge. The only real disappointment is that the overall sound is not as rich as in the past, and the mix is at times rather crowded despite all the technical possibilities offered by the digital equipment.

The Dogs Of War

David Gilmour, Anthony Moore / 6:04

Musicians
David Gilmour: vocals, vocal harmonies, electric lead guitars
Tony Levin: bass
Scott Page: tenor saxophone
Tom Scott: saxophone (?)
Carmine Appice: drums, percussion (?)
Jon Carin: keyboards
Bill Payne: organ
Darlene Koldenhoven, Carmen Twillie, Phyllis St. James, Donny Gerrard: backing vocals

Recorded
Astoria, Hampton: November 1986 to February 1987
Britannia Row Studios, Islington, London: February 1987
Mayfair Studios, Primrose Hill, London: February 1987
Audio International Studios, London: February 1987
A&M Studios, Los Angeles: February to March 1987
The Village Recorder, Los Angeles: February to March 1987
Can-Am Studios, Los Angeles: February to March 1987

Technical Team
Producers: David Gilmour, Bob Ezrin
Sound Engineer: Andy Jackson
Assistant Sound Engineer: Robert Hrycyna, Marc DeSisto, Stan Katayama, Jeff DeMorris

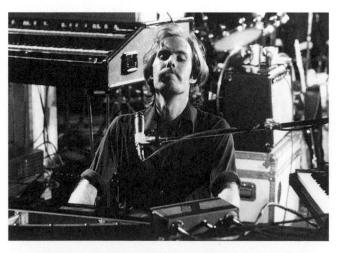

Bill Payne, the keyboardist in Little Feat, was on the organ for the recording of "The Dogs of War."

Genesis

David Gilmour has talked about how this song came about: "I had the idea [for a song] and explained it to Anthony [Moore] and he came up with the first draft of words; we chopped and changed it over quite a long time until it wound up as it is."[36] The music was then arrived at by an unconventional route, the musician admitted, involving a computer error and the accidental use of a laugh that had been sampled on one of his pieces of equipment. This third track provides little to smile about, however. The Gilmour-Moore collaboration takes as its theme the wars of the eighties, and specifically the mercenaries who would kill not for an ideology but simply for financial gain—*men of hate/with no cause* who *for hard cash, [...] will lie and deceive*, Gilmour sings. This is undoubtedly the most politicized Pink Floyd song of the post-Waters era.

Production

So it is with the sample of a laugh that "The Dogs of War" begins: Gilmour had "a sample of someone laughing and accidentally played it."[36] But the sound one hears no longer bears much resemblance to the original sound, as Gilmour has reproduced it on his keyboard at a much lower pitch than the original, giving it a dark, sinister resonance: "In the background," he said, "this laughter actually sounded like dogs yapping and the way I'd sung the demo also had elements of that long before we had that lyric."[36] The piece is principally built around cello sounds from the Kurzweil K250 and various interventions on the keyboards. Nightmarish percussion drenched in very deep reverb issues forth at regular intervals, heightening the song's very oppressive atmosphere. When Gilmour takes the lead vocal, the contrast is quite striking: his rock voice rips right through the string arrangements and seems to offer a glimmer of hope in this bleak landscape. In contrast to the noticeable lack of presence in his performance on "Learning to Fly," his singing on "The Dogs of War" is brimming with energy. It is a shame, however, that his voice is overprocessed, with too much delay and reverb added. The effects would have been more effective if they had been more subtle. He is accompanied, in the first chorus, by Darlene Koldenhoven, Carmen Twillie, Phyllis St. James, and Donny Gerrard on backing vocals, then, in the next chorus,

The drummer Carmine Appice, approached by Bob Ezrin to take Nick Mason's place on "The Dogs of War."

by Bill Payne on the Hammond organ. The instrumental section that then follows enables the drums and the bass respectively to make their entry (from 2:59 onward). "I like 'Dogs of War' because it's a great R&B track to play live,"[36] Nick Mason revealed. One can see why if one listens to the performance on *Delicate Sound of Thunder* (1988). However, when it was recorded, it was not Mason on the drums but Carmine Appice, one of the most accomplished drummers on the rock scene, having played at various times with Vanilla Fudge, Cactus, and Jeff Beck. "I came home one day and there was a message on my machine from Bob Ezrin. He said, 'Hey Carmine, I'm in the studio with Pink Floyd and there's a track that's just screaming for some Carmine fills.' I called him back, I said, 'Where's Nick Mason?' He said, 'He's here, but he's a bit rusty and everybody wants a bit of a change, so they're bringing in guest drummers.' So I went down and did it, it was pretty wild. Nick was there. I said, 'Why aren't you playing?' He said, 'Well, I've been racing my cars, my calluses are soft…'"[147]

So, with Tony Levin's powerful bass in support, the rhythm section is in place, and is remarkably effective. David Gilmour launches into a superb solo that owes much to the urban blues of the likes of Muddy Waters. His guitar sound is dirty and very "roots," and he seems to be playing his newly acquired white Steinberger, though it is impossible to identify it due to the quality of the digital recording. He is accompanied by Bill Payne's B-3 in a brilliant keyboard passage, before the piece switches from a 12/8 time signature into more of a rock tempo, in 4/4. Now it is no longer Gilmour's guitar that has the lead, but the incredible sax of Scott Page. Page would also go on to tour with the Floyd after the release of the album.

"The Dogs of War" ends with a final verse and chorus and a coda that gives Gilmour a chance to reply to Page's sax, both in his vocal and on his guitar. Although Tom Scott is also credited on the sax, it is hard to verify this. (It is possible he did play a few lines of the piece.)

One Slip

David Gilmour, Phil Manzanera / 5:09

Musicians

David Gilmour: vocals, vocal harmonies, electric rhythm and lead guitars, programming (?)
Richard Wright: keyboards (?)
Michael Landau: electric rhythm guitar
Tony Levin: bass, Chapman Stick
Jon Carin: keyboards
Bob Ezrin: keyboards, programming (?)
Jim Keltner: drums
Darlene Koldenhoven, Carmen Twillie, Phyllis St. James, Donny Gerrard: backing vocals

Recorded

Astoria, Hampton: November 1986 to February 1987
Britannia Row Studios, Islington, London: February 1987
Mayfair Studios, Primrose Hill, London: February 1987
Audio International Studios, London: February 1987
A&M Studios, Los Angeles: February to March 1987
The Village Recorder, Los Angeles: February to March 1987
Can-Am Studios, Los Angeles: February to March 1987

Technical Team

Producers: David Gilmour, Bob Ezrin
Sound Engineer: Andy Jackson
Assistant Sound Engineers: Robert Hrycyna, Marc DeSisto, Stan Katayama, Jeff DeMorris

Phil Manzanera, ex-guitarist of Roxy Music and leader of the band 801, was the co-composer of "One Slip."

Genesis

"One Slip" is the most "Floydian" number on *A Momentary Lapse of Reason*, in terms of both its musical atmosphere and Gilmour's voice, which takes us back to the great *Meddle* years. It is not by chance that it was a line from this song that was picked as the name of the band's thirteenth album: *One slip, and down the hole we fall/It seems to take no time at all/A momentary lapse of reason*. "One Slip" was written by Gilmour with Phil Manzanera, ex-guitarist of Roxy Music and the band 801. In fact Gilmour made no bones about the fact that Manzanera, himself a true alchemist of progressive rock in the seventies, had the dominant role in this song: "Most of the music for "One Slip" came from him," the guitarist acknowledged. "We spent a couple of days throwing ideas around and this was the one that fitted the album best."[36] The lyrics are somewhat idiosyncratic. "When Dave gets involved with different people and situations, it brings out different aspects of his personality," Jon Carin observed. "Working with Phil Manzanera on 'One Slip,' he wrote lyrics that he might not have ordinarily written."[53]

"A momentary lapse of reason": to what does this refer? An encounter on *the road to ruin*, then the sensual embrace of two people burning with desire who didn't want to remain alone as *the year grew late*. As a result of this nighttime embrace a child is born—at least that seems to be what is hinted at in the line: *The moment slipped by and soon the seeds were sown*. Hence the *momentary lapse of reason/ That binds a life for life*.

"One Slip" first came out as the B-side of the "Learning to Fly" single, then as the A-side of the third single taken from *A Momentary Lapse of Reason* (with, depending on the country, "Terminal Frost" and/or "The Dogs of War" live on the B-side). It peaked at number 50 in the United Kingdom on June 25, 1988.

Production

"One Slip" starts with programmed percussion sounds similar to those of marimbas or kalimbas. While the song very much reflects the sounds of that time, including the heavy use of sequencers and samplers, it nevertheless retains its Pink Floyd flavor, even if the harmonies, composed in the main by Phil Manzanera, are rather uncharacteristic of the

Tony Levin (seen here with his Chapman Stick), a member of King Crimson and bassist for Peter Gabriel, played alongside David Gilmour on the typically Floydian "One Slip."

band. In the introduction, apart from the various sequences and keyboard layers, we hear some strange beeps, and eventually an alarm going off (at 0:33). We are hearing Andy Jackson, the sound engineer who set off the alarm on the *Astoria*. He confirmed as much: "It was me putting the wrong code number in to set it off."[141] This elicited a surprised reaction from a colleague when he heard it. "Strangely enough," Jackson continued, "I had a friend who worked in another studio and they had exactly the same alarm system. And he said, 'Oh, God that sound! I can't believe you used that!'"[141]

After this alarm, the introduction resumes with a tom-tom break, punctuated by percussion contributions of various kinds, mainly from samples and drum machines, all of them kept on track by the ever-steady rhythm of a shaker. Then a guitar playing a rhythmic motif fades in (from 0:54). David Gilmour later stated that the highly talented Michael Landau played this introductory section. From the first verse, Gilmour is back in charge on his six-string, although it is hard to tell which guitar he is playing: his Steinberger or his Strat? According to Phil Taylor, Gilmour mainly used his "Red Strat" on the album. But the sounds are so laden with various

effects that there is room for doubt. Nevertheless we can make out some distorted rhythmic parts, and a guitar repeating a formula that gives the impression of a programmed sequence (on the left of the stereo image). Gilmour, who is also on vocals, performs an excellent lead vocal, which he double-tracks and harmonizes, accompanied in the choruses by the four backing vocalists. On the drums is the excellent Jim Keltner (Carmine Appice having stated that he himself only played on "The Dogs of War"). The groove is very effective, and is supported by a whole host of percussion instruments, as well as by Tony Levin with his superb bass line. It is he, incidentally, who comes in after the first chorus, this time playing his incredible Chapman Stick, a type of guitar that can have between eight and twelve strings, invented in 1969 by Emmett Chapman. On this occasion, Levin mainly uses the low strings, lending the song a different feel from anything in the Floyd discography. He is accompanied by all kinds of percussion contributions, before being joined by Gilmour on the guitar with a rhythmic sequence played clean. After a brief, rather atmospheric break, we arrive at the verse, then comes a final chorus, before the piece finishes with Tony Levin on his Chapman Stick.

On The Turning Away

David Gilmour, Anthony Moore / 5:42

Musicians
David Gilmour: vocals, vocal harmonies, acoustic guitars, electric rhythm and lead guitars
Nick Mason: tambourine (?)
Richard Wright: keyboards, vocal harmonies
Jon Carin: keyboards
Tony Levin: bass
Jim Keltner: drums
Darlene Koldenhoven, Carmen Twillie, Phyllis St. James, Donny Gerrard: backing vocals

Recorded
Astoria, Hampton: November 1986 to February 1987
Britannia Row Studios, Islington, London: February 1987
Mayfair Studios, Primrose Hill, London: February 1987
Audio International Studios, London: February 1987
A&M Studios, Los Angeles: February to March 1987
The Village Recorder, Los Angeles: February to March 1987
Can-Am Studios, Los Angeles: February to March 1987

Technical Team
Producers: David Gilmour, Bob Ezrin
Sound Engineer: Andy Jackson
Assistant Sound Engineers: Robert Hrycyna, Marc DeSisto, Stan Katayama, Jeff DeMorris

David Gilmour on his "Red Strat," delivering a solo in his signature style.

Genesis
A typically Gilmourian paradox. Having declared in interviews on several occasions that he (in contrast to Nick Mason) did not feel the same sense of political engagement as Roger Waters, David Gilmour—admittedly through the pen of Anthony Moore—now comes up with a full-blown protest song. "'Turning Away' is about the political situations in the world," the composer explained in December 1987. "We have these rather right-wing conservative governments that don't seem to care about many things other than looking after themselves."[149]

He hopes for a new age that will draw attention to the nobodies of this world, *the pale and downtrodden*. A new age in which society will be profoundly transformed, a kind of cultural revolution, in which the fortunate ones will demonstrate understanding and compassion toward people who are suffering and alone. A new age in which hearts are no longer made of stone: it is a utopian world that is evoked in this song co-written by Gilmour and Moore, but the piece does deliver a message of hope. *No more turning away from the coldness inside/Just a world that we all must share*, Gilmour sings... And this humanist vision struck such a chord with him that he himself got involved in the writing of the lyrics: "'Learning to Fly' and 'On the Turning Away' were his [Anthony Moore's] basic concepts," Gilmour explained, "but, [...] the last verses of those things completely steered it into a more positive thing, and I wrote the last verses of them."[150]

"On the Turning Away" was the A-side of the second single taken from *A Momentary Lapse of Reason* (with a live version of "Run Like Hell" on the B-side), released on December 12, 1987. Five days later, the song charted at number 55 in the UK.

Production
"On the Turning Away" came as a surprise for Pink Floyd fans: it was the first time the band had ventured into the world of Celtic music. Obviously it is handled in a rock style, but the music has a strong Celtic feel to it. The piece opens with a swirling bass note played on the synthesizer (Roland Super JX?). Then, against this meditative background, the soft voice of David Gilmour is heard with a generous dose of long reverb. The effect nicely underlines the meaning of the

1987

lyrics. The message is clear; it is almost as if one is listening to a sermon. Further keyboard layers are added to the arrangement from the second verse, along with a strummed acoustic guitar played by Gilmour and a bass guitar played by Tony Levin. Flute and tambourine sounds join the accompaniment, before the arrival of the drums and some resonant sounds, adding fullness to the following verse. Everything seems to suggest that it is Jim Keltner on the drums, especially as he makes his entrance with a snare roll, a technique that Nick Mason admitted having given up on long ago! Rick Wright, who shares the keyboards with Jon Carin, is on vocal harmonies. The third verse is followed by a short instrumental bridge (from 2:03), in which Wright performs a superb accompaniment on the Hammond organ,

while Gilmour plays a distorted rhythm pattern on the guitar (Steinberger or "Red Strat"?). Next we hear a brief intervention by Tony Levin on the fretless bass, probably his Music Man (at 2:35). For the last verse, Gilmour is supported by the four backing vocalists and Wright, and the song swells to an almost epic scale, enhanced by the Celtic color of the harmonies. He concludes the piece with an excellent guitar solo in his typical style, with flights of lyricism marked by very prominent delay and reverb, his playing as melodic and expressive as ever, involving the use of bends and the tremolo arm. Rick Wright later revealed that he had himself recorded a keyboard solo, but it was discarded at the mixing stage, "not because they didn't like it, they just thought it didn't fit,"[64] he explained.

Yet Another Movie

David Gilmour, Patrick Leonard / 6:13

Musicians
David Gilmour: vocals, vocal harmonies, electric rhythm and lead guitars, keyboards (?), programming (?)
Nick Mason: drums
Pat Leonard: keyboards, programming
Tony Levin: bass
Jim Keltner: drums
Steve Forman: percussion

Recorded
Astoria, Hampton: November 1986 to February 1987
Britannia Row Studios, Islington, London: February 1987
Mayfair Studios, Primrose Hill, London: February 1987
Audio International Studios, London: February 1987
A&M Studios, Los Angeles: February to March 1987
The Village Recorder, Los Angeles: February to March 1987
Can-Am Studios, Los Angeles: February to March 1987

Technical Team
Producers: David Gilmour, Bob Ezrin
Sound Engineer: Andy Jackson
Assistant Sound Engineers: Robert Hrycyna, Marc DeSisto, Stan Katayama, Jeff DeMorris

For Pink Floyd Addicts

Roger Waters had apparently rejected this composition by David Gilmour at the time of the recording of *The Final Cut*.

Genesis

One sound, one single sound/One kiss, one single kiss… David Gilmour commented that it was hard to explain "Yet Another Movie" and that it represented "a more surrealistic effort than anything [he had] attempted to do before."[36] It seems that the narrator is in the middle of a dream in which strange visions pass before him in turn: *A face outside the window pane* […] *A man who ran, a child who cried*, or *A man in black on a snow white horse* and *The sea of faces, eyes upraised*; or the scene that inspired Storm Thorgerson when he was designing the sleeve artwork: *The sun that burned a fiery red/The vision of an empty bed*. The words, like the music, seem to have no other purpose than to convey strange impressions, allowing listeners to form their own story. Which may be the thinking behind the song's title. This is the only track on the album that David Gilmour co-wrote with Pat Leonard.

Production

"Yet Another Movie" is undoubtedly one of the successes of the album. The arrangements are complex and detailed, but it is all to the benefit of the song. The introduction essentially consists of alternating bursts of synthesizer/percussion and silence, the sound shaped by various effects and samples, and the whole thing drenched in deep reverb. Fifty seconds pass before a first harmonic layer is heard. A magnificent rhythmic section involving the bass and drums carries the piece into a more jazz-rock phase in which the sounds of distorted guitars, digital keyboards, voice samples, and various effects all mingle together. We even hear snippets of dialogue taken (it seems) from the 1954 Elia Kazan movie, *On the Waterfront*, with the voice of Marlon Brando (from 1:10 onward). The drum part has the distinction of being played by two drummers and a percussionist simultaneously, as Nick Mason related: "On 'Yet Another Movie,' all three of us played together—the percussionist [Steve Forman], Jim Keltner, and me. We drummed in unison but, at other times, I kept the rhythm whilst the others played fills."[64] For the verses, David Gilmour sings and harmonizes with himself in a low register, with the resulting effect resembling that of a harmonizer. After the second verse, he embarks on a searing

Pink Floyd in concert in 1987. Nick Mason was supported by Jim Keltner and Steve Forman during the recording.

solo, the sound and the delays recalling the *Meddle* or *Dark Side* era. Then come two more verses, and again, Gilmour lets it rip with (presumably) his "Red Strat." This is arguably the best solo on the album; the sound is distorted, probably by his Big Muff, as it is a warmer effect than if he were using his overdrives. In contrast to other guitar soloists of the time, whose principal aim seemed to be to cram in as many notes as possible in record time, Gilmour stuck to lines that were less technical (having said that…), but all the more profound and dazzling. It is a sound that combines rock and space rock, the delay

and reverb taking the notes to ethereal heights! Following the last two verses, in which a delay with very pronounced feedback is applied to his voice, he takes a final solo, a slide solo this time, calling to mind a second time the sound of the albums of the early seventies. Another movie sound bite is audible in the background (from 5:17), this time from *Casablanca* (1942), the all-time Hollywood classic by Michael Curtiz, starring Humphrey Bogart and Ingrid Bergman. "Yet Another Movie" then concludes with a key change announcing the next track, "Round and Around."

Round And Around

David Gilmour / 1:13

Musicians
David Gilmour: guitars, programming
Jon Carin: keyboards, programming (?)
Bob Ezrin: programming (?)

Recorded
Astoria, Hampton: November 1986 to February 1987
Britannia Row Studios, Islington, London: February 1987
Mayfair Studios, Primrose Hill, London: February 1987
Audio International Studios, London: February 1987
A&M Studios, Los Angeles: February to March 1987
The Village Recorder, Los Angeles: February to March 1987
Can-Am Studios, Los Angeles: February to March 1987

Technical Team
Producers: David Gilmour, Bob Ezrin
Sound Engineer: Andy Jackson
Assistant Sound Engineers: Robert Hrycyna, Marc DeSisto, Stan Katayama, Jeff DeMorris

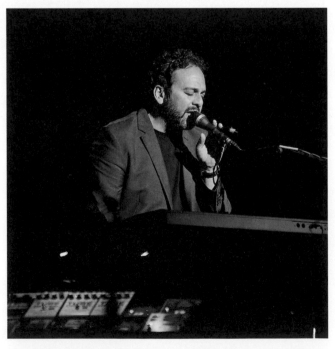

Jon Carin, one of David Gilmour's most loyal associates, who played on "Round and Around."

Genesis
The Pink Floyd atmospherics continue with "Round and Around." It is not really a song in its own right, but rather the finale to "Yet Another Movie" (which segues into it).

Production
The precise rationale behind "Round and Around" is rather unclear: why does this short instrumental, this kind of coda to "Yet Another Movie," bear a different title? If you don't count the few seconds of silence at the end of the track or the fade-out, the whole track is no more than fifty-five seconds long. In fact this title was one of a number of demos that David Gilmour had probably put together prior to the production of *A Momentary Lapse of Reason*.

In any event, "Round and Around" starts on the last slide note of "Yet Another Movie." Then there is a dramatic mood shift as we move into what is primarily a programmed sequence involving a bass sound and a loop consisting of various percussion elements (in the left channel). Swirling layers in stereo—probably from the Kurzweil K250—along with other synthesizers add to the dreamlike ambiance of this curious instrumental. Gilmour's 1955 Gibson Les Paul Goldtop comes in after a few bars with simple, short lines that are sometimes harmonized on two strings, with the familiar blues coloring that characterizes his playing. Then, after fifty-five seconds, "Round and Around" begins its fade-out. It is not the shortest track on the album, but the second shortest after "A New Machine (Part 2)" (0:39).

For Pink Floyd Addicts
The live version of "Round and Around," from *Delicate Sound of Thunder*, lasts little more than thirty seconds (0:33 to be precise). It is the shortest song ever to feature on a Pink Floyd record.

A New Machine
(Part 1)

David Gilmour / 1:46

Musicians
David Gilmour: vocals, vocoder, synthesizers, programming
Pat Leonard: synthesizers, programming (?)
Bob Ezrin: synthesizers, programming (?)

Recorded
Astoria, Hampton: November 1986 to February 1987
Britannia Row Studios, Islington, London: February 1987
Mayfair Studios, Primrose Hill, London: February 1987
Audio International Studios, London: February 1987
A&M Studios, Los Angeles: February to March 1987
The Village Recorder, Los Angeles: February to March 1987
Can-Am Studios, Los Angeles: February to March 1987

Technical Team
Producers: David Gilmour, Bob Ezrin
Sound Engineer: Andy Jackson
Assistant Sound Engineers: Robert Hrycyna, Marc DeSisto, Stan Katayama, Jeff DeMorris

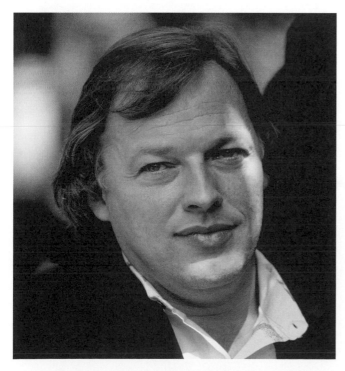

David Gilmour took an innovative approach on "A New Machine (Part 1)," using no acoustic instruments.

Genesis

"A New Machine" comes in two parts. The first serves as a kind of introduction to "Terminal Frost," while the second wraps it up. This first part was composed and written by David Gilmour alone (his first solo composition since "Childhood's End" on *Obscured by Clouds*). *I have always been here [...] Sometimes I get tired of the waiting*, he writes in the first verse. The last verse takes the form of questions and answers: *Do you ever get tired of the waiting? [...] Don't worry, nobody lives forever*, comes the reply. Gilmour never commented on the lyrics of this song. As he told the journalist Matt Resnicoff in 1992: "I don't know if I want to get into that. Whether you want to take [the song] as optimistic or not...I mean, a lot of people didn't use it as an excuse to go and jump off a cliff or something, did they?"[133]

So is this a song about imprisonment, or more generally about isolation? About patience, self-belief? One comment by David Gilmour may perhaps give us a clue as to what was in his mind: "On the *Momentary Lapse Of Reason* album, Nick's belief in himself was pretty well gone, and Rick's belief in himself was totally gone. And they weren't up to making a record, to be quite honest about it."[36] So perhaps lack of self belief and lack of belief in the future are an underlying theme of "A New Machine." Despite its title, this song has no connection whatsoever to "Welcome to the Machine" on *Wish You Were Here*.

Production

"A New Machine (Part 1)" is certainly one of the strangest tracks that Pink Floyd recorded. No acoustic instruments were used, and the arrangement mainly consisted of just a vocoder and some keyboards. The last time the band used this voice synthesizer was back in the days of *Animals* (on "Dogs" and "Sheep"). So Gilmour's singing is distorted by the vocoder, most likely a Roland VP-330 Plus, and backed by a layer of sound from the Kurzweil K250 and sounds from other synthesizers (also fed through the vocoder). But between the lines, there is stillness; only the dying chords, the reverb, and the repetitions produced by the delay penetrate the silence, in the last verse (at around 1:09), a held note fades in, a shrill, rather distorted note, which is a constant presence from here to the end of the track.

Terminal Frost

David Gilmour / 6:15

For Pink Floyd Addicts

There was a Pink Floyd tribute band from Liège, in Belgium, that went by the name of Terminal Frost.

Musicians

David Gilmour: electric rhythm and lead guitars, solo acoustic guitar, programming
Nick Mason: percussion (?)
Richard Wright: piano, Kurzweil, organ
Jon Carin: keyboards (?)
Bob Ezrin: keyboards (?), programming
Tony Levin: bass
John Helliwell: saxophone
Tom Scott: saxophone

Recorded

Astoria, Hampton: November 1986 to February 1987
Britannia Row Studios, Islington, London: February 1987
Mayfair Studios, Primrose Hill, London: February 1987
Audio International Studios, London: February 1987
A&M Studios, Los Angeles: February to March 1987
The Village Recorder, Los Angeles: February to March 1987
Can-Am Studios, Los Angeles: February to March 1987

Technical Team

Producers: David Gilmour, Bob Ezrin
Sound Engineer: Andy Jackson
Assistant Sound Engineers: Robert Hrycyna, Marc DeSisto, Stan Katayama, Jeff DeMorris

Rick Wright, likely creator of the atmospheric layers on "Terminal Frost."

Genesis

David Gilmour had already recorded a demo of "Terminal Frost" some time before the sessions for *A Momentary Lapse of Reason* got under way. "But there was a long period of time where I thought I might get words for it and turn it into a song," the composer explained. "In the end it decided for itself that it would remain the way it was."[36] There are just a few words faintly audible in the echo: *Oh, yeah, yeah…one thing…never, ever again.*

The words *terminal frost* can be read in two ways. The title of this instrumental can be taken to mean "ultimate coldness," or alternatively "total fiasco." In the first case one inevitably thinks of death; in the second, of a failed life. In either case, the piece doesn't exactly inspire optimism and comes across as just as dark as some of Roger Waters's compositions for *The Wall* and *The Final Cut*. Musically, though, there is little in common with the two conceptual works by the ex–Pink Floyd member. "Terminal Frost" follows in the same vein as "One Slip" and "Yet Another Movie": it is an atmospheric number. Gilmour's guitar is what makes it, but also the exquisite contributions of saxophonists Tom Scott and John Helliwell. The former, an icon of West Coast jazz and composer of the theme songs to the TV series *The Streets of San Francisco* and *Starsky & Hutch*, also played and recorded with the cream of the rock scene, from the Beach Boys to the ex-Beatles George Harrison and Paul McCartney, not to mention Rod Stewart, the Grateful Dead, and the Blues Brothers Band (of which he was one of the founding members). The latter, who joined Supertramp in 1972, was one of the architects of the success of albums including *Crime of the Century* (1974), *Crisis? What Crisis?* (1975), and *Breakfast in America* (1979). "Terminal Frost" featured as the B-side of the "Learning to Fly" single in some countries, including France and the West Germany.

Production

The rhythm part of the track starts with a programmed drum machine (LinnDrum? Linn 9000? E-mu SP 1200?) and percussion (tambourine, shaker). Tony Levin is on the bass, and his playing meshes perfectly with the sounds from these various machines to produce a typical eighties groove. "Terminal Frost" is an instrumental with quite an ethereal flavor and a

The saxophonist John Helliwell, known as a key figure in Supertramp, played with the Floyd on "Terminal Frost."

Even in a piece as remote from the blues tradition as "Terminal Frost," one can recognize in David Gilmour's playing the influence of the grand masters of the twelve-bar blues, and of Albert Collins in particular, who had an aggressive playing style—to the extent that some even used to claim he used an ice pick. (In 1978 he released an album entitled *Ice Pickin'*.)

dreamlike atmosphere, enhanced by the fact that the melody David Gilmour plays on the guitar features very prominent reverb and delay. The sound of his "Red Strat" is unmistakably distorted by his Big Muff and colored by the chorus of his Boss CE-2. Numerous keyboard parts, piano samples, and sound layers are audible, some played by Rick Wright, others presumably by Jon Carin and/or Bob Ezrin. In reply to Gilmour's guitar, we hear the saxophone of first John Helliwell, and then Tom Scott, each of them delivering an excellent performance. "Terminal Frost" flirts with a certain brand of jazz rock, a style more in tune with David Gilmour's tastes than Roger Waters's. Distorted guitars underscore the rhythm (at around 2:03), before it transitions into more of a rock beat,

with Wright, especially, playing an excellent accompaniment on the Hammond organ (from 2:49 onward). From time to time an acoustic guitar can be heard; this sound is almost certainly produced on the Kurzweil K250 (listen at 3:59, for example). Then, in the coda, Gilmour plays some solo lines, this time on a real acoustic guitar (Martin D-35?), the sound apparently faintly colored by a harmonizer (from 5:15). It is also possible to make out a voice (at around 4:26), an effect used regularly since *The Dark Side of the Moon*.

"Terminal Frost" is a good track, enjoyable to listen to, but probably not the best piece on the album. The quality is nowhere near that of the instrumentals we had become accustomed to hearing from the band in the past…

A New Machine (Part 2)

David Gilmour / 0:38

Musicians
David Gilmour: vocals, vocoder, synthesizers, programming
Pat Leonard: synthesizers, programming (?)
Bob Ezrin: synthesizers, programming (?)

Recorded
Astoria, Hampton: November 1986 to February 1987
Britannia Row Studios, Islington, London: February 1987
Mayfair Studios, Primrose Hill, London: February 1987
Audio International Studios, London: February 1987
A&M Studios, Los Angeles: February to March 1987
The Village Recorder, Los Angeles: February to March 1987
Can-Am Studios, Los Angeles: February to March 1987

Technical Team
Producers: David Gilmour, Bob Ezrin
Sound Engineer: Andy Jackson
Assistant Sound Engineers: Robert Hrycyna, Marc DeSisto, Stan Katayama, Jeff DeMorris

Genesis

"A New Machine (Part 2)" is obviously the continuation of the first part. The main difference is in the tense chosen by the narrator. This time he talks about the future, not the past, which immediately precludes all questions: *I will always be in here* [...] *It's only a lifetime.*

Production

In terms of production, this second part of "A New Machine" is built around the same elements as the first: vocoders, noise gates, reverb, delays, and synthesizers. The only notable change is in David Gilmour's singing, in that he reaches for higher notes, which he sings falsetto. But the effect remains just as surprising as in the first part, and it is a soundscape that Gilmour was very pleased with: "'New Machine' has a sound I've never heard anyone do," he commented. "The noise gates, the Vocoders, opened up something new which to me seemed like a wonderful sound effect that no one had done before; it's innovation of a sort."[133]

On his album *Trans*, Neil Young used a vocoder—as did David Gilmour on "A New Machine (Part 2)."

Although the vocoder was made popular in the seventies by groups like Kraftwerk or the Buggles, there was one musician who surprised everybody when he made extensive use of it on his 1982 album, *Trans*: Neil Young.

Sorrow

David Gilmour / 8:45

Musicians
David Gilmour: vocals, vocal harmonies, electric rhythm and lead guitars, keyboards, programming, drum machine
Rick Wright: Kurzweil, organ
Tony Levin: bass
Bob Ezrin: keyboards
Darlene Koldenhoven, Carmen Twillie, Phyllis St. James, Donny Gerrard: backing vocals

Recorded
Astoria, Hampton: November 1986 to February 1987
Britannia Row Studios, Islington, London: February 1987
Mayfair Studios, Primrose Hill, London: February 1987
Audio International Studios, London: February 1987
A&M Studios, Los Angeles: February to March 1987
The Village Recorder, Los Angeles: February to March 1987
Can-Am Studios, Los Angeles: February to March 1987

Technical Team
Producers: David Gilmour, Bob Ezrin
Sound Engineer: Andy Jackson
Assistant Sound Engineers: Robert Hrycyna, Marc DeSisto, Stan Katayama, Jeff DeMorris

For Pink Floyd Addicts

The first line of "Sorrow," *The sweet smell of a great sorrow lies over the land,* is borrowed from *The Grapes of Wrath* (1939) by John Steinbeck. In Chapter 25, he wrote: "The decay spreads over the State, and the sweet smell is a great sorrow on the land."

Genesis

David Gilmour revealed that this song was probably the only one where he had written the words before the music, "which is rare for me,"[133] he said. Once again, Gilmour's lyrics are infused with sadness, disillusionment...sorrow. *Plumes of smoke rise and merge into the leaden sky*: he is obviously alluding to the ravages of pollution, which mean that *green fields and rivers* are now nothing but a dream. The song's protagonist surveys the world around him and is frightened by what he sees: he is *haunted by the memory of a lost paradise.* He is gripped by anxiety: his blood has frozen, his knees and hands tremble...

What can he do about it? The truth is: nothing. Except to say his final goodbyes to this lost world. In the cryptic penultimate verse, we infer that the man plunges into the river—a river of *dark and troubled* waters that flow toward *an oily sea...*

Gilmour, who is realistic about his skills as a lyricist, especially compared to Roger Waters, nevertheless considers "Sorrow" to be one of his successes, as he confided to Alan di Perna in 1993: "I'm proud of some of ones I've done. 'Sorrow' is a very good lyric."[29]

Production

The environment of the *Astoria* clearly had an influence on the writing and production of "Sorrow." Phil Taylor remembered that, during the recording of *A Momentary Lapse of Reason*, David "stayed on board for one weekend and recorded the entirety of 'Sorrow' including all the guitar parts, vocals and the drum machine, so that when we reconvened on the Monday, there was only a bit of spit and polish required."[5] But rather than the romantic river ambiance one might have expected, the song is largely rock based, even containing hard-rock elements, if only in the incredible guitar introduction: "That very nasty distortion you hear at the beginning of the song," Gilmour explained, "is basically the result of the Steinberger going through two little amps in the studio—a Fender Super Champ and a Gallien-Krueger. I use a Boss Heavy Metal distortion pedal and a Boss digital delay pedal, which then goes into the Fender Super Champ. And that in combination with the internal distortion on the

Top: "Sorrow," one of David Gilmour's best lyrics. **Right:** The "Momentary Lapse of Reason Tour," which got under way in June 1987, took in Moscow in June 1989, with five shows at the Olympic Stadium.

Gallien-Krueger was how I got that particular sound."[152] In actual fact, there was a further step involved in creating the amazing sound on the intro, as Bob Ezrin recounted: "We actually hired a 24-track truck and a huge P.A. system, and brought them inside the L.A. Sports Arena. We had the whole venue to ourselves, and we piped Dave's guitar tracks out into the sports arena and re-recorded them in 3D. So the tracks that originally came from a teeny little Gallien-Kruger and a teeny little Fender, but piped through this enormous P.A. out into a sports arena, sound like the Guitar From Hell."[29] The result is truly impressive, and is enhanced by the low-pitched synthesizer drone in the background. It is only at about 1:50 that the piece really gets going, a drum machine programmed by Gilmour marking the beat, supported by Tony Levin's bass guitar and a programmed rhythm sequence on one of the keyboards. Atmospheric layers enrich the sonic texture, as well as distorted guitar effects involving long reverb and delays.

The verses are sung at quite a low pitch for Gilmour's range, and he doubles himself to lend weight to his voice. After the second verse we get the first, very spirited guitar solo. At the end of the following verse comes a middle section featuring the four backing vocalists. The effect contrasts with the monotone voice of the lead vocal, and marks a break from the regularity of the various programmed parts. A Hammond organ can be heard, no doubt played by Rick Wright, as well as guitar arpeggios, played clean. This part is followed by an instrumental break combining numerous effects such as voices with reverse reverb added, guitars and keyboard sounds drenched in reverb and delays, and, once again, the cries of seagulls produced using the wah-wah pedal (4:57)—this is the second time, the first being on "Is There Anybody Out There?" on *The Wall*, that Gilmour refers back to "Echoes" on *Meddle*. He explained the technique he used to achieve all these incredible sounds on his guitar: "I had just gotten the Steinberger and hadn't really played it all that much at that point. But I rather liked the sound it makes naturally. And then the combination of bending up with the wang bar on whole chords while simultaneously fading in with a stereo volume pedal...*that's the sound*."[152] Then, after a final verse in which he harmonizes with himself an octave higher, Gilmour performs a final absolutely superb solo lasting more than two and a half minutes, this one recorded in a simpler fashion: "Things like the solo at the end of 'Sorrow' were done on the boat, my guitar going through a little Gallien-Krueger amp,"[133] he explained.

THE
DIVISION
BELL

ALBUM
THE DIVISION BELL

RELEASE DATE
United Kingdom: March 28 or 30 (depending on source), 1994

Label: EMI
RECORD NUMBER: 1055 7243 8 28984 2 9 (CD), 1055 7243 8 28984 1 2 (vinyl)

Number 1, on the charts for 62 weeks (United Kingdom)
Number 1 (United States, Canada, the Netherlands, Germany)

Cluster One / What Do You Want From Me ? / Poles Apart /
Marooned / A Great Day For Freedom / Wearing The Inside Out /
Take It Back / Coming Back To Life / Keep Talking /
Lost For Words / High Hopes

LA CARRERA PANAMERICANA

The soundtrack of this documentary, which has never been released as an album, is a combination of old and new tracks by Pink Floyd. Representing the old are "Signs of Life," "Yet Another Movie," "One Slip," and "Sorrow" from *A Momentary Lapse of Reason* plus a live version of "Run Like Hell" from *The Wall*, while "Country Theme," "Small Theme," "Big Theme," "Carrera Slow Blues," "Mexico '78," and "Pan Am Shuffle" were written for the project.

The *Division Bell*, the Unhoped-for Revival

1994

The "Momentary Lapse of Reason Tour," which attracted more than four million spectators between September 1987 and June 1990, grossing some sixty million dollars, demonstrated that Pink Floyd definitely *could* have a future without Roger Waters. The question being asked upon their return from the mammoth tour was whether the leading group on the prog rock scene actually *did* have one. Their fears were fanned by the personal projects being pursued by each of the members of the group. David Gilmour in particular was moving from one collaboration to the next in the capacity of either guitarist or co-producer, notably with Kate Bush (*The Sensual World*, 1989), Paul McCartney (*Flowers in the Dirt*, 1989), Propaganda (*1234*, 1990), the Dream Academy (*A Different Kind of Weather*, 1990), Elton John (*The One*, 1992), and All About Eve (*Touched by Jesus*, 1991), and also as a composer ("Me and J.C.") for the movie *The Cement Garden*, directed by Andrew Birkin (1993). Nick Mason had written the soundtrack for the movie *Tank Malling* (1989, directed by James Marcus) in collaboration with Rick Fenn. And Roger Waters was still making news despite no longer being a member of the group, not least performing *The Wall* to a crowd of 300,000 on Potsdamer Platz in Berlin on July 21, 1990, and (with valuable support from the guitar hero Jeff Beck) recording the album *Amused to Death* (1992), unanimously acknowledged as the pinnacle of his solo career.

A Productive Renaissance

Hopes of seeing Pink Floyd back at the center of things revived on October 11, 1992, when David Gilmour, Nick Mason, and Rick Wright found themselves on the stage of the Royal Albert Hall in London once more, this time within the context of a benefit concert for AIDS research (the Chelsea Arts Ball). The idea of recording a new album under the Pink Floyd name most likely gained traction as a result of that event, the sessions for the soundtrack of the 1992 documentary *La Carrera Panamericana* having already, explains Nick Mason, sparked a desire on the part of the three musicians to throw themselves into the challenge of recording a new album.

Confident, since the phenomenal success of *A Momentary Lapse of Reason* and the ensuing tour, David Gilmour, Rick Wright, and Nick Mason made the decision to start recording some new pieces with a view to releasing another album, and work began at Britannia Row Studios in January 1993. The album would take shape over the course of the entire year in various studios, including Gilmour's floating studio the *Astoria*. The three members of the group would initially select twenty-seven pieces from the sixty or more ideas that had accumulated during these months of work, before whittling them down to eleven. Five of these were composed by David Gilmour alone ("Poles Apart," "A Great Day for Freedom," "Coming Back to Life," "Lost for Words," and "High Hopes"), four by Gilmour and Rick Wright ("Cluster One," "What Do You Want from Me?" "Marooned," and "Keep Talking"), one

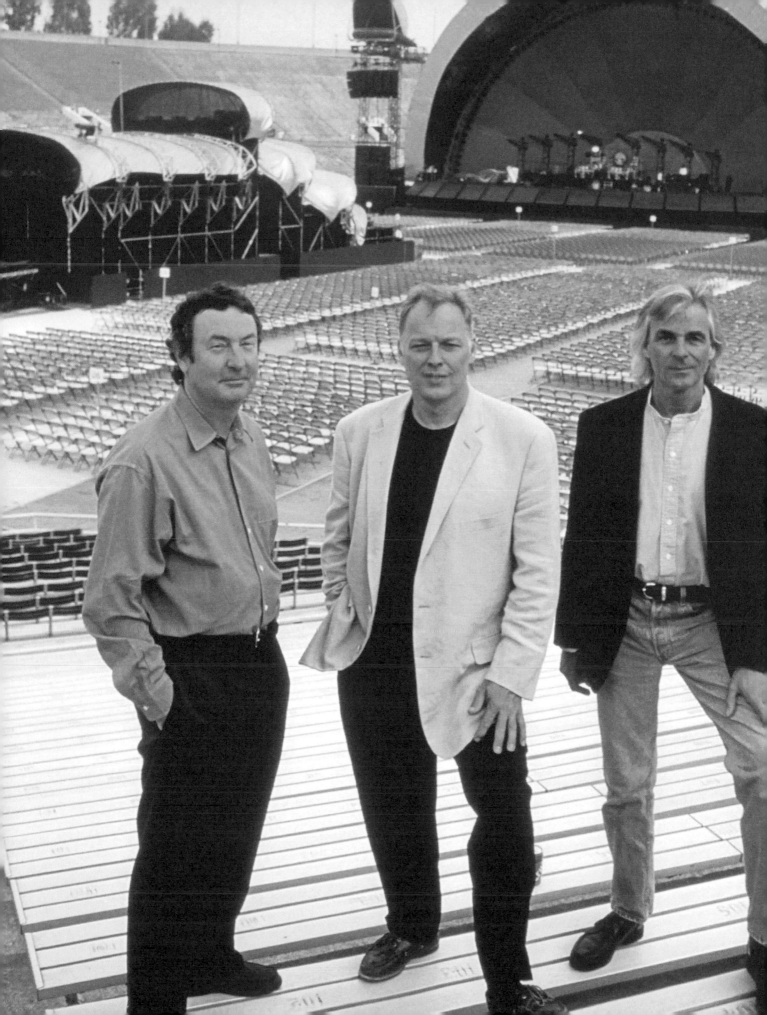

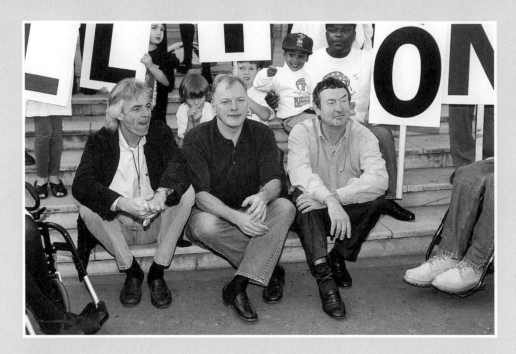

The three members of Pink Floyd in October 1994, a few months after the release of *The Division Bell*.

by Gilmour and Bob Ezrin ("Take It Back"), and one by Rick Wright alone ("Wearing the Inside Out"). Rick Wright once again played a major role in the creative development of the album, and was credited as composer (and singer) for the first time since *Wish You Were Here*. "On this one I have been involved right from the beginning," he told the music channel MTV. "Writing and singing, and it's a completely different situation this time, and I'm not on a wage. I'm in partnership with them, and very happy about that. We are actually the three of us making a Pink Floyd album."[91]

As far as the lyrics are concerned, Anthony Moore (who had already collaborated with the group on *A Momentary Lapse of Reason*) wrote the words for "Wearing the Inside Out." David Gilmour wrote the lyrics for all the other numbers either alone ("Coming Back to Life"), with Polly Samson ("What Do You Want from Me?" "A Great Day for Freedom," "Keep Talking," and "High Hopes"), or with both Nick Laird-Clowes (lyricist and singer-guitarist of the Dream Academy) and Polly Samson ("Poles Apart" and "Take It Back").

When David Met Polly

At this time, Polly Samson was the guitarist's girlfriend. (The couple would tie the knot on July 29, 1994, during the *Division Bell* tour.) Polly, whose mother was a writer of Chinese descent who served in Mao Zedong's Red Army, and whose father was a journalist for the *Morning Star*, worked in publishing. As a result of which she met the poet and playwright Heathcote Williams and had a son, Charlie, with him. After splitting up with Williams and living for a while in utter poverty, Polly then met the Pink Floyd guitarist. Initially providing moral and emotional support, she would gradually become more involved in the development of the album, encouraged by David Gilmour himself. "She inspired David and gave him a sense of confidence and challenged him," explains the producer Bob Ezrin. "Whatever David was thinking at the time

she helped him find a way of saying it."[1] Polly Samson was thus no stranger to the theme that runs through *The Division Bell*. "All, pretty much all the songs are connected to the theme of communication in some way or another,"[153] Gilmour would reveal to the famous interviewer Redbeard. This is borne out by the album's title. The division bell in question is the bell in the Palace of Westminster (Houses of Parliament) in London that is rung to inform the honorable members that they have only ten minutes in which to return to Parliament to vote on a bill. In a sense it announces the moment of truth.

Is this theme of relationships between human beings an answer to, or an echo of, some twenty years later, *The Dark Side of the Moon*, which dealt with some of the same issues? What seems certain is that Gilmour, Wright, and Mason were making a spectacular leap into the past musically, a return, in a certain sense, to the years in which the Pink Floyd legend was created, the period of *More* (for its acoustic ballads), but above all *Meddle*, *The Dark Side of the Moon*, and *Wish You Were Here* (for their "cosmic" moods). This was probably under the influence of Rick Wright, who had been absent from the previous album: "We made certain decisions," he explains, "for example *Momentary Lapse of Reason*, I was involved with it virtually near the last quarter of making the album, and just putting in a couple of Hammond tracks down or whatever. This, Nick, myself, and Dave were involved right from the beginning, in Britannia Row Studios just playing together. And out of that, the tracks came and decisions like: Nick will play all the drums, I will play all the keyboards (and Jon Carin came in as a programmer and played some of the keyboards); but it was to get the band feeling back."[153] This would not, however, prevent Wright from claiming after the release of the album that, finding his status uncertain, he had wanted to quit the project mid production. He would also reveal afterward that he was somewhat disappointed with the results, judging the album's thematic material to have been

David Gilmour with Polly Samson, who wrote some of the lyrics for Pink Floyd's latest album. The couple became husband and wife in July 1994.

insufficiently exploited. As for Roger Waters, the bassist's resentment toward his former colleagues would by no means diminish over the years. In 2004, he told John Harris he could not believe that Gilmour had left the lyric writing to his wife: "I mean, give me a fucking break! Come on. And what a nerve to call that Pink Floyd. It was an awful record."[30]

The Album: A Commercial Success but a Critical Failure

To launch their fourteenth and penultimate studio album, Pink Floyd held a press conference at Abbey Road Studios in London on November 30, 1993. It was on this occasion that Rick Wright's return as a full member of the band was officially announced. *The Division Bell* was released in the United Kingdom and continental Europe on March 28 (30 according to some sources), 1994, and on April 4 in North America. Given that it achieved number 1 in the band's home country, in the United States, Canada, Australia, and more or less all over Europe (including Scandinavia, Germany, the Netherlands...), it would be no exaggeration to describe the album as a triumph. A triumph that was to be confirmed over time by a stream of record industry certifications including double platinum in France and the United Kingdom (600,000 copies sold), triple Platinum in the United States (three million copies), and triple gold in Germany (750,000 copies). The critics, on the other hand, were generally acerbic to say the least. "Neither dazzling nor radical," wrote Stephen Dalton in *Vox* in May 1994, adding that "in this uncertain world of ours, the weather seldom

changes on Planet Floyd."[154] Tommy Udo of *NME* described the record as "very, very boring."[155] And Tom Graves, writing in *Rolling Stone*, went so far as to wonder whether *The Division Bell* was "still *really* Pink Floyd?"[156]

Two days after the European release of the album, Pink Floyd embarked on a long tour under the aegis of the Canadian promoter Michael Cohl. Performing with them were instrumentalists Guy Pratt, Tim Renwick, Gary Wallis, and Dick Parry, and backing vocalists Sam Brown, Claudia Fontaine, and Durga McBroom. The tour kicked off at Miami Gardens in Florida on March 30 and concluded seven months later with fourteen shows at Earls Court in London (finishing on October 29). After this, fans would have to wait more than ten years to enjoy another live set by the group, which Pink Floyd eventually played at Live 8 in July 2006—this time with the participation of...Roger Waters (his first live performance with the Floyd in twenty-four years)!

The Sleeve

It is to Douglas Adams, a friend of David Gilmour and famous science fiction author and scriptwriter (*The Hitchhiker's Guide to the Galaxy*, 1979) that Pink Floyd owed the title of their fourteenth studio album: *The Division Bell* (taken from the lyrics to "High Hopes," the last track on the album). This was immediately accepted by EMI and the three members of the Floyd. Storm Thorgerson got straight to work on the visuals. Because the main theme of the album is communication, or rather the difficulty of communicating, he immediately thought of those images that could be interpreted as

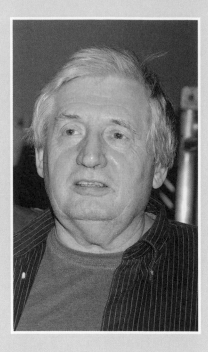

Left: Douglas Adams, who came up with the title for Pink Floyd's fourteenth studio album.

Right: Storm Thorgerson, whose sleeve design for this album was to be his last for the group.

representing different things depending on the viewing angle, for example a woman who appeared as either young or old, or the profiles of two faces that could be visually interpreted as forming the outline of a vase. "You couldn't see both simultaneously," he writes in his book. "One preference would exclude the other possibility, at least temporarily."[65] Thorgerson developed this approach further and had a sudden brainstorm after listening to the song "Keep Talking": two faces (or masks) depicted in profile talking to each other; two faces that, when viewed carefully, can also form a third. This is the concept he eventually ran with: "The single eyes of the two faces looking at each other become the two eyes of a single face looking at you, the viewer," he explains. "It was intended that the viewer should not see both at the same time. One saw the single face, or the two profiles. If one saw both it was alternating, like an optical illusion, which was even better because it meant that the viewer was interacting, or communicating, with the image directly, viscerally."[65]

Although the three members of Pink Floyd were not immediately wowed by Storm Thorgerson's concept, this changed after the portraitist Keith Breeden modified the illustrations, taking his inspiration from the Easter Island statues (giant Aku Aku totems). Four three-meter-high three-dimensional versions (two stone and two metal) were then fabricated and transported to Ely, in the Cambridgeshire countryside, ready for the shoot. It is Ely Cathedral that can be seen in the background of the photograph. "I visited the location for the photo shoot one chilly day in February," reveals Nick Mason. "It was a stunning scene, with the heads parked out in the fens. One of our biggest problems was trying to hide them from the press, who would have loved to pre-empt the album's release. Army surplus stores were raided and large quantities of camouflage netting were acquired to be draped over the heads in a rather half-hearted attempt to disguise them."[5]

The four points of light that can be made out between the mouths of the statues could perhaps have been intended to symbolize the four members of Pink Floyd. Was this a case of Thorgerson being mischievous? Or the sign of a general desire for reconciliation?

The Recording

The first stage in the development of the group's fourteenth studio album goes back to the very beginning of 1993, when a highly motivated David Gilmour, Rick Wright, and Nick Mason got together at the Britannia Row Studios for the start of the preproduction phase. Bob Ezrin was again co-producer (with Gilmour). After the first day's work, the band members were reassured: they still enjoyed playing together and had not been abandoned by their muse. They then invited Guy Pratt, the talented bassist who had been playing with the Floyd since the last tour, to join them. From that moment on, Pink Floyd was up and running. "We started off by going into Nick's studio, Britannia Row Studios in London in January 93 [at this time Nick was the last of the four band members to own shares in the studio, before selling them in the mid-nineties to Kate Koumi], with myself, Nick, and Rick, and Guy, the bass player from our last tour," explained David Gilmour to a Polish newspaper in 1994. "And we just jammed away at anything for two weeks, just playing anything that we had in our heads or that we made up on the spot."[93] Now that the differences between the musicians had been put aside and the ego problems forgotten, with no one and nothing to disrupt the newfound unity, not even the interminable conflict with Roger Waters, which was now resolved, a pleasant atmosphere prevailed. Two major pieces on the album emerged from this preparatory stage: "Cluster One" and "Marooned."

The three members of Pink Floyd had rediscovered their self-confidence. David Gilmour, who took on the role of de

Gary Wallis and Guy Pratt onstage with David Gilmour and Rick Wright (Wembley, August 1988).

facto leader of the group, was relaxed, no longer weighed down by the immense pressure he had been under during *A Momentary Lapse of Reason*. Nick Mason was determined to play all the drum parts himself, unlike on the last album, and was literally galvanized by such a serene and productive atmosphere. Finally, Rick Wright, now a full member of the band once more, was encouraged, somewhat in spite of himself, to compose material for the album. Nick Mason would explain that David Gilmour, frustrated at not obtaining any material from Wright, left a tape recorder running in secret, as a result of which three songs emerged from the keyboard player's improvisations, demonstrating how important Wright had been to the group right from the outset.

After this two-week preproduction phase, the sessions moved to another venue, as Gilmour reveals: "And then we took all that over to *Astoria* and started listening to all the tapes and working stuff out. We found that we had 65 pieces of music...which we worked on all of to a certain extent, and then we started adding these things. We had a couple of sessions which we called 'the big listen' where we listened to all these 65, and all the people involved with it voted on each track [...]."[91] Nick Mason, in his book, adds that some pieces were "rather similar, some nearly identifiable as old songs of ours, some clearly subliminal reinventions of well-known songs."[5] "And so we then arranged these 65 pieces of music in order of

popularity amongst the band," explains Gilmour, "and then we dumped 40 of them, and worked on the top 25, which in fact became the top 27 because a couple more got added in."[91] The sequence of rejected material was set aside and nicknamed "The Big Spliff" by Andy Jackson. For the time being, everyone felt there was enough material for a second album, but that project was put off until later. After substantial reworking, this material would eventually result in Pink Floyd's final album, *The Endless River*, in 2014.

After having worked on the *Astoria* from February to May, and before taking their summer vacation, the group got together with their tour musicians Guy Pratt, Gary Wallis, Tim Renwick, and Jon Carin (but not the backing singers) at London's Olympic Studios, a place the band knew very well, to shape nine of the best songs out of those selected. The idea was to find out what potential these pieces had before working on them in earnest. Reassured, in September they then recorded the base tracks for each of them with the same team—on the *Astoria* again—before completing and finalizing them as a threesome in two weeks. The final stages of production took place in a hurry, requiring the use of two other London studios: Metropolis and Creek Recording Studios. Bob Ezrin provided extremely valuable support in the selection of the different drum takes, and once again Michael Kamen was commissioned to do the various

David Gilmour's legendary Fender Stratocaster, serial no. 0001, which he would play in September 2004 at the Stratocaster 50th anniversary celebrations.

1994

orchestral arrangements. In this he was helped by Edward Shearmur, his principal assistant, who went on to have a brilliant career as a composer of movie scores.

The Technical Team

Andy Jackson was again sound engineer. He was assisted on the *Astoria* by Jules Bowen, who had previously worked on *The Final Cut*. The legendary Keith Grant was behind the mixing desk for the overdubs recorded at Creek Recording Studios (believed to be his own personal studio) at Sunbury-on-Thames. Grant was a brilliant sound engineer closely connected with Olympic Studios, who recorded some of the biggest names in rock during the course of his long career, not least the Beatles, the Who, Jimi Hendrix, Led Zeppelin, and David Bowie. The final mixing was shared between David Gilmour and Chris Thomas, with whom the group reunited twenty years after *The Dark Side of the Moon* (1973). In charge of the recording of the strings and horns, arranged by Michael Kamen, was Steve McLaughlin (an associate of Kamen's, but also a producer, sound engineer, and composer of movie scores). Finally, the indispensable technician Phil Taylor was responsible for looking after the instruments.

The Musicians

Chris Thomas was not the only one to reconnect with the Floyd again after a gap of twenty or so years: the highly talented Dick Parry, whose saxophone playing had lit up the albums *The Dark Side of the Moon* and *Wish You Were Here*, was once again part of the adventure. Among the other musicians contributing to the album were Jon Carin on keyboards and programming, Guy Pratt on bass and vocals, Gary Wallis on percussion, and Tim Renwick on guitar, all of whom would perform again with the Floyd in concert. The backing vocalists were Sam Brown, Durga McBroom, Carol Kenyon, Jackie Sheridan, and Rebecca Leigh-White.

Technical Details

Following preproduction of the album at Britannia Row Studios, the group moved to the *Astoria*, David Gilmour's

houseboat studio, for the recording sessions proper. The multitrack was an analog Studer A827 tape recorder, the entire team preferring the resulting sound quality to that obtained from digital machines (such as the main tape recorder used for the previous album). The console was again the DDA AMR 24 used for *A Momentary Lapse of Reason*. The group felt at ease on the houseboat and also asked to mix some of the songs there, although Phil Taylor explains that Andy Jackson wanted to do the mixing on an automated console. Their choice therefore fell on a fifty-six-channel AMEK Hendrix. Unfortunately, the automation would play tricks on them, causing problem after problem.

The programming of the various sequences was realized using Cubase on Macintosh. Finally, Phil Taylor notes that the mics they used to record David Gilmour's amps were Neumann U87s, Shure SM57s, and a Neumann KM86 for the Maestro Rover rotating speakers.

The Instruments

Rick Wright once again plays a prominent part on this album. In addition to his usual keyboards, his real innovation was a Kurzweil K2000, which he uses on most of the tracks. Nick Mason made a real leap forward by abandoning his Ludwig for a Drum Workshop kit: "It was time for a change. I've played a double Ludwig for a long time, but when Bill Ludwig III left the company, I opted for DW."[157] He uses two 22-by-18-inch bass drums, a 5-by-14-inch Edge snare drum, eight assorted toms, Paiste cymbals, and Promark sticks. His drumheads are DW Aquarian. All the drumming on the album is acoustic with the exception of "Coming Back to Life," which is probably programmed using samples of Mason's drum kit on the Kurzweil K2000RS.

David Gilmour uses mainly his "Red Strat" (a 1957 reissue made in 1984), as Phil Taylor has confirmed. Among the other guitars he played on this album are his 1955 Gibson Les Paul Goldtop, his Jedson lap steel, a classical guitar (believed to be his Ovation 1613-4), and a new acoustic, a Gibson J-200 Celebrity. As far as amplification is concerned, he uses two reissued 1959 fifty-watt Fender Bassman and two fifty-watt Hiwatt SA212 combo amps. He has replaced his Yamaha RA-200 with Maestro Rover rotating speakers. Finally, he uses an enormous number of effects. These are not easy to identify individually, at least in terms of the specific use he makes of them. Worth mentioning in addition to the guitarist's usual effects pedals are the Zoom guitar multiprocessor, Chandler Tube Drivers, Tube Works Blue Tube and Real Tube, and an amazing DigiTech Whammy WH 1.

A 1952 Gibson J-200 similar to the one played by Gilmour on this album

Cluster One

Richard Wright, David Gilmour / 5:59

Musicians
David Gilmour: electric lead guitar, programming
Rick Wright: piano, synthesizers
Nick Mason: drums
Gary Wallis: percussion (programming)

Recorded
Britannia Row Studios, Islington, London: January 1993
Astoria, Hampton: February to May, September to December 1993
Metropolis Studios, Chiswick, London: September to December 1993
The Creek Recording Studios, London: September to December 1993

Technical Team
Producers: David Gilmour, Bob Ezrin
Sound Engineers: Andy Jackson, Keith Grant (The Creek), Chris Thomas (mixing)
Assistant Sound Engineer: Jules Bowen (Astoria)

Rick Wright, co-composer with David Gilmour for the first time since *Obscured by Clouds*.

Genesis

In an interview given in November 2004 to *Floydian Slip*—"a weekly radio journey through the music of Pink Floyd," as the show describes itself—the sound engineer Andy Jackson explains how *The Division Bell* had been made: "When we first started collecting the jam material together, we divided it up into three categories, which were acoustic, blues and cosmic. And bits we glued together we called clusters. And the instrumentals, because they never had any reason to take on a new title, they just stayed with their old titles for a long time. And, in fact, 'Cluster One' was always 'Cluster One,' and it just stuck which was partly my doing."[158]

This instrumental is the first joint composition by David Gilmour and Rick Wright since "Mudmen" on *Obscured by Clouds* (1972), and the first writing credit for Wright since *Wish You Were Here* (1975). This track could be described as a "return to the future" because the three members of Pink Floyd seem to be moving forward by repeatedly referencing a glorious musical past, and in particular *Wish You Were Here* (the intro to "Shine On You Crazy Diamond Parts I–V"). "Cluster One" has never been performed live although it was played over the loudspeakers as part of the preliminary music before the band's concerts…

Production

The opening track of *The Division Bell* begins with a peculiar sound like some kind of interference gradually rising in volume. The origins of these noises are astounding, as Andy Jackson explains: "It is the sound of electromagnetic noise from the solar wind."[141] In reality, the idea came from Bob Ezrin, who had sent a message on one of the first Internet servers, hoping to track down someone who would be able to send him some noises from space. And somebody wrote back!" explains Jackson. "This guy who goes and stands on the top of Mount Washington, I think, in thunder storms holding this great big metal antennae! (Laughs) Recording the electromagnetic stuff!"[141] Other curious sounds (in stereo) are heard after thirty seconds or so. These are cracking noises made by the Earth that were recorded beneath the Earth's crust by seismologist G. William Forgey.

The music does not begin until around 1:06, when synth sounds, forming a single chord, establish themselves almost

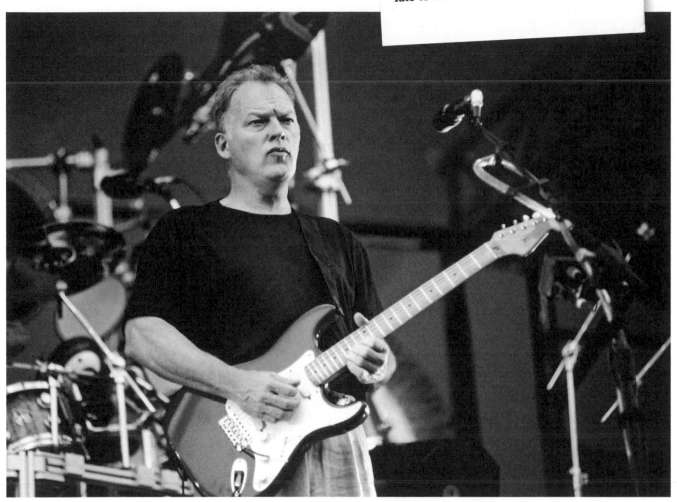

The effects on "Cluster One" were created by David Gilmour on his "Red Strat."

imperceptibly. The mood is ethereal and almost meditative. Piano notes of a kind only Rick Wright can produce then ring out, immediately evoking the traditional Floyd sound, and that of the more "cosmic" albums in particular. "My influence can be heard on tracks like 'Marooned' and 'Cluster One,'" explains the keyboard player. "Those were the kind of things that I gave the Floyd in the past and it was good that they were now getting used again."[160] David Gilmour accompanies him with various phrases and effects on his "Red Strat," including notes that are either reversed or manipulated by means of his volume pedal. The reverb and delays are deep and long. The piece then changes gear with shifting organ pads, and from 3:44 the piano and the

Strat engage in a dialogue. The guitarist's playing is bluesy and highly inspired—as is Wright's—inevitably bringing to mind the intro of "Shine On You Crazy Diamond." Rhythmic support then arrives in a form that smacks of programming using Cubase, but is more likely to be Nick Mason's new Drum Workshop kit. Mason is accompanied by percussion played (or programmed) by Gary Wallis.

"Cluster One" is an excellent opening track and a welcome surprise for all fans of the group's early period, with moods and sonorities that bear the unmistakable stamp of Pink Floyd. Good-quality recording has also made a welcome return, the warmth of analog recording having been more or less lacking from *A Momentary Lapse of Reason*.

What Do You Want From Me ?

David Gilmour, Richard Wright, Polly Samson / 4:22

Musicians
David Gilmour: vocals, electric rhythm and lead guitar, acoustic rhythm guitar (?)
Rick Wright: electric piano, organ, synthesizers, vocal harmonies (?)
Nick Mason: drums
Bob Ezrin: keyboards (?)
Jon Carin: keyboards (?)
Guy Pratt: bass
Sam Brown, Durga McBroom, Carol Kenyon, Jackie Sheridan, Rebecca Leigh-White: backing vocals

Recorded
Britannia Row Studios, Islington, London: January 1993
Astoria, Hampton: February–May, September–December 1993
Metropolis Studios, Chiswick, London: September–December 1993
The Creek Recording Studios, London: September–December 1993

Technical Team
Producers: David Gilmour, Bob Ezrin
Sound Engineers: Andy Jackson, Keith Grant (The Creek), Chris Thomas (mixing)
Assistant Sound Engineer: Jules Bowen (Astoria)

"What Do You Want from Me?" is one of the first Pink Floyd songs to feature words by Polly Samson.

Genesis
The line *You can drift, you can dream, even walk on water* might give the impression that in "What Do You Want from Me?" the Gilmour-Samson couple (with Rick Wright contributing to the music) has written a mystical song. At first glance the line seems to contain an obvious reference to Christ walking on water on the Sea of Galilee. Nothing of the sort! "A lot of the lyrics were the result of a collaboration between myself and my girlfriend, Polly Samson," explains Gilmour, "…and some, unfortunately, came after moments of lack of communication between us. The title 'What Do You Want From Me?' came out of exactly one of those moments."[36]

It is a song about the often complicated relationships between couples, whether still in their early stages or not. *Do you want my blood, do you want my tears?* The protagonist is unsure what his girlfriend expects of him. Does she know herself? This is far from certain. Is she reproaching him for something he is not aware of? Doubt creeps in, and with it, anxieties about how long the relationship can last. "I can't say my greatest desire is to be innovative or break new frontiers," David Gilmour told *USA Today* in 1994, "I just hope to make music that moves people a little bit and makes them think. We don't claim to have solutions to life's great problems."[161]

Production
The rhythm section of "What Do You Want from Me?" recalls that of "Have a Cigar" on *Wish You Were Here*. Although the tempo is slower, the drums and bass play a similar motif to that of the earlier track, and the fact that Rick Wright is again on electric piano (a Wurlitzer on "Have a Cigar"; a Fender Rhodes modulated with wah-wah on "What Do You Want from Me?") only adds to the resemblance. Nick Mason lays down an excellent groove on his Drum Workshop kit, with very present reverb that gives him a live sound, and is impeccably supported by Guy Pratt. David Gilmour plays an initial and absolutely mind-blowing solo in the intro. His "Red Strat" is colored by incredible spatialization (courtesy of his faithful Big Muff), and very pronounced reverb and delay. "I have always had a 3-D sound in my head," he explained in 1994. "I like to have some element of space and depth in

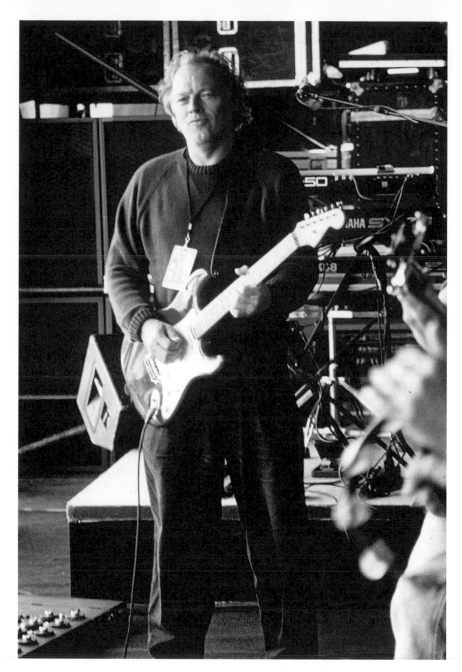

David Gilmour, wizard of the 3D guitar sound, brilliantly realized here on his "Red Strat."

everything we do. I can't seem to get away from that. And I listen to a lot of records and find them two-dimensional, just in the way they're mixed. And the sad part is that it's not hard to add dimension."[162] The two solos and various licks he plays on "What Do You Want from Me?" can be seen as a perfect demonstration of his approach to playing. And as always, his guitar work reflects his blues influences, in this instance the Chicago blues. In addition to the above, Gilmour also plays a distorted rhythm guitar part throughout the track, as well as an arpeggiated part on a clear-toned guitar colored in the bridge by a light chorus effect (from 3:01). For the second of these it is difficult to work out whether he is using his Strat plugged straight into the console or simply his new acoustic, the Gibson

J-200. In terms of the vocals, Gilmour has rediscovered the aggressive, rugged aspect of his voice that had been missing from *A Momentary Lapse of Reason*. He comes across as fully in command of his powers, and is supported by the five backing vocalists Sam Brown, Durga McBroom, Carol Kenyon, Jackie Sheridan, and Rebecca Leigh-White, with Rick Wright almost certainly singing vocal harmonies. In addition to the Fender Rhodes, it is also possible to make out some organ and some strings strongly resembling the string sounds produced by the ARP Solina, which have presumably been sampled. "What Do You Want from Me?" is a very good song, and it is worth emphasizing both the fully restored group spirit and the utter complementarity between the writing of David Gilmour and Rick Wright.

Poles Apart

David Gilmour, Polly Samson, Nick Laird-Clowes / 7:05

Musicians
David Gilmour: vocals, acoustic guitar, electric rhythm and lead guitar, programming (?)
Rick Wright: organ, keyboards
Nick Mason: drums
Jon Carin: keyboards, programming (?)
Guy Pratt: bass

Recorded
Britannia Row Studios, Islington, London: January 1993
Astoria, Hampton: February–May, September–December 1993
Metropolis Studios, Chiswick, London: September–December 1993
The Creek Recording Studios, London: September–December 1993

Technical Team
Producers: David Gilmour, Bob Ezrin
Sound Engineers: Andy Jackson, Keith Grant (The Creek), Chris Thomas (mixing)
Assistant Sound Engineer: Jules Bowen (Astoria)

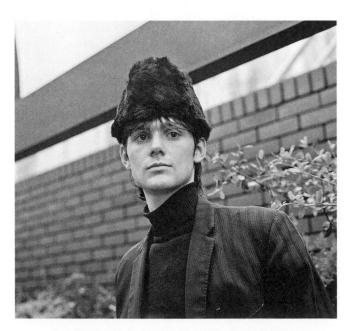

Nick Laird–Clowes, co-lyricist with David Gilmour and Polly Samson of "Poles Apart."

Genesis

Polly Samson and Nick Laird-Clowes co-wrote the "Poles Apart" words to music by David Gilmour (who also collaborated on the lyrics). In a 1994 interview, Polly, Gilmour's girlfriend, revealed that "It's about Syd in the first verse and Roger in the second."[163] Thus the *golden boy* addressed in the opening verse of the song, the boy with the light in his *eyes*, is the avant-garde genius who presided over the recording of *The Piper at the Gates of Dawn*, while the one *leading the blind* with *steel* in his *eyes* in the second verse is none other than the architect of *The Wall* and *The Final Cut*. On the one hand the memory of an enchanted time; on the other, the trauma of a breakup accompanied, if we read between the lines, by a sense of the impossibility of communication, but perhaps more importantly by the idea of liberation from an influence that had become oppressive. On the one hand a carefree Barrett who was fun to be around; on the other, a domineering, egotistical Waters. What are we to make of this? In the same interview, David Gilmour preferred to leave the meaning of the song in doubt and dodged the issue, explaining that he liked "to let the lyrics speak for themselves."[163] So listeners are free to interpret the words as they see fit.

Before he found himself writing lyrics for Pink Floyd, Nick Laird-Clowes acted as a sort of voice coach for David Gilmour, providing the guitarist with occasional advice on how to record his vocals. One day, Gilmour, who had run into difficulty with a particular song, which happened to be "Poles Apart," asked Laird-Clowes for some help, confessing that he had no lyrics for [the song]."[164] Nick Laird-Clowes explains that he thought for a moment before asking: "'You went camping with Syd Barrett! When you were 16, you were friends, long before the Floyd. What was he like in those days? I've heard all the other things, but what was he like?' And he [Gilmour] said, 'I never thought he'd lose that light in his eyes.' I said, 'That's it!' So I started writing, and then I said, 'Look, I've got this,' and he said, 'Oh, I've got this,' and she [Polly Samson] said, 'I've got this.' And that's when he said, 'Congratulations: you've co-written your first Pink Floyd song.'"[164]

Production

"Poles Apart" opens with an arpeggio from David Gilmour on his acoustic Gibson J-200. The guitar is doubled, and is

Nick Mason at his Drum Workshop kit for the recording of "Poles Apart."

unusual for its DADGAD tuning, an open tuning widely used in Celtic and Irish music as well as folk in general. "I thought it was something new that I had invented," explains Gilmour. "One day, I was on holiday in Greece and I had an acoustic guitar with me. I just decided to tune the bottom string down to D, and continued to experiment until I arrived at that tuning. Then I mucked around a bit and 'Poles Apart' fell out of it a few minutes later."[162]

Answering David Gilmour's two guitars is a very good fretless bass part played by Guy Pratt and some superb Hammond organ from Rick Wright. The verses are sung in a gentle, melancholy voice by a David Gilmour who seems to have regained all his former freshness and energy. He also adds some color and contributes an eminently Floydian touch by playing licks on his Jedson lap steel.

Nick Mason comes in on his Drum Workshop kit in the second verse, delivering a rhythm part in the inimitable style with which Pink Floyd fans are familiar, characterized by a real punch and an unmistakable groove, even in a medium tempo. This is followed by an instrumental section dominated by Wright's Hammond organ, which serves as both accompaniment and lead. The sonority of his keyboard is sumptuously clear and silky, and his radiant playing provides

a reminder of how essential his contribution was, and always had been, to the group. Another instrumental sequence follows (from 2:50) that is presumably highly symbolic. This time a stereo synth loop plays over string sounds produced on the Kurzweil K2000. This forms a sonic basis for the various different moods and effects that follow. We hear someone whistling (at 3:19), the sound of a woodblock being struck (3:24), breathing noises (3:28), a sort of circus music with barrel organ and a bell (a glass?) ringing in the background (from 3:35), the sound of a car pulling up and being parked (3:48), a baby crying (3:55), and finally a car starting up (at 4:00). This amounts to nothing less than an aural screenplay, one whose precise meaning provides plenty of food for thought. Given the nature of the words, Roger Waters and *The Wall* inevitably come to mind. Certain elements, such as the circus music, the bell, and the baby crying are probably intended to evoke the insanity and anxiety that were lying in wait for Syd Barrett. But as David Gilmour says, "I like to let the lyrics speak for themselves"…

The reprise of the final verse, delivered at a livelier tempo and accompanied by distorted Strat, is followed by a solo from David Gilmour, this time on his 1955 Gibson Les Paul Goldtop with, for a change, reasonably modest delay.

Marooned

Richard Wright, David Gilmour / 5:29

Musicians
David Gilmour: electric lead guitar, programming
Rick Wright: keyboards, piano
Nick Mason: drums
Jon Carin: keyboards (?)
Guy Pratt: bass (?)

Recorded
Britannia Row Studios, Islington, London: January 1993
Astoria, Hampton: February–May, September–December 1993
Metropolis Studios, Chiswick, London: September–December 1993
The Creek Recording Studios, London: September–December 1993

Technical Team
Producers: David Gilmour, Bob Ezrin
Sound Engineers: Andy Jackson, Keith Grant (The Creek), Chris Thomas (mixing)
Assistant Sound Engineer: Jules Bowen (Astoria)

1994

Part of the video for "Marooned" was filmed in the Ukrainian city of Pripyat, not far from Chernobyl. Images taken from the International Space Station are followed by shots of Pripyat set in a desolate landscape intercut with Soviet footage dating from before the Chernobyl disaster. There are also sequences of a man hiding in the abandoned buildings and a young girl gazing about uncomprehendingly.

Genesis

According to Andy Jackson, this fourth track on *The Division Bell* was originally given the working title "Cosmic 13" before being renamed "Marooned." We could venture to establish a link between the two titles by recalling that in April 1970 the astronauts of the Apollo 13 mission (the inspiration behind the working title) found themselves adrift in space following a technical incident. They were forced to take refuge in the lunar module before eventually making it safely back to Earth. If the above hypothesis is correct, this wonderful instrumental could have been intended to convey the extreme anguish felt by those astronauts marooned in space. David Gilmour would provide a very different explanation, however: "We called it 'The Whale Piece' for ages [because of certain sonorities]. 'Maroon' came up as a colour at one point in discussion for some title of something. 'Maroon' became 'Marooned' and it seemed to fit that tune [...] There's no particular huge significance to 'Marooned'; it's just an appropriate title."[165]

Either way, this track credited to David Gilmour and Rick Wright shares the cosmic atmosphere of the great albums, from *Meddle* to *The Dark Side of the Moon* to *Wish You Were Here*. In his book *Inside Out: A Personal History of Pink Floyd*, Nick Mason describes "Cluster One" and "Marooned" as follows: "[...] the truly significant thing was that each improvisation represented a kick-start to the creative process. And by allowing ourselves to play whatever came into our heads, with no taboo or no-go areas, I had the impression that we were expanding a field of vision that had become increasingly narrow over the past two decades."[5] David Gilmour plays one of his most dazzling solos, which goes a long way to explaining why "Marooned" received the 1995 Grammy Award for Best Rock Instrumental (the only Grammy ever won by Pink Floyd!).

Production

"Marooned" opens with a seaside atmosphere and seagulls mewing in the sky. "It had the scent of the sea about it, this tune," David Gilmour would explain, "[...] probably from the sound of the guitar doing the whale-type thing."[165] A keyboard, probably the Kurzweil K2000, then comes in, enhanced by abundant reverb. After a few very

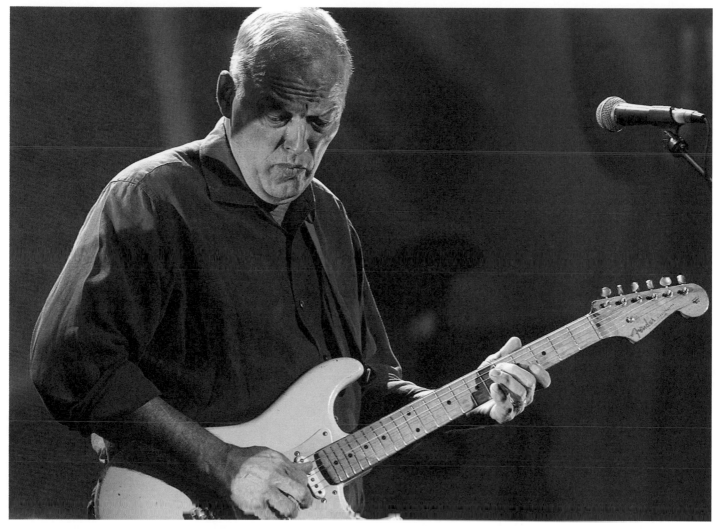
David Gilmour playing "Marooned" on his Fender Stratocaster no. 0001 at the Stratocaster 50th anniversary event.

cosmic-sounding bars, Gilmour's guitar surges in over a background of synth pads and bowed double bass (both also produced on the K2000), various keyboards, and a bass guitar most likely programmed using Cubase. Although this instrumental is based on harmonies composed by Rick Wright, who also plays an excellent acoustic piano part, the bravura role falls to the guitarist, who plays an improvisation of incredible intensity and inspiration for more than 4:30. "Dave played a storm on it," Andy Jackson has said. "Fantastic."[141] In addition to the overdrive obtained from his Chandler Tube Driver, the particular sound Gilmour obtains on his "Red Strat" derives from an effect he was using for the first time: a DigiTech Whammy WH 1 pedal that enabled him to do octave bends! "It's a great little unit, but I haven't even begun to explore half the things it does," explains Gilmour. "The fact that it allows you to bend a note

a full octave is quite shocking. It's so odd."[162] It was nevertheless this effect that provided the inspiration for "Marooned." "I think we basically wrote the first version of it the day I got the pedal," the guitarist has said. The most astonishing thing is how quickly he was able to put his solo together, confirming that "I probably took three or four passes at it and took the best bits out of each."[162] Gilmour gives a fantastic demonstration of his talents as a guitarist on this track, the sound of his Strat hanging in the air thanks to very present delay and spacious reverb. Nick Mason, meanwhile, provides an excellent accompaniment, his Drum Workshop kit sounding with plenty of warmth. "Marooned" ends in a meditative mood (on a chord of C, whereas the piece is in the key of E) generated by the ethereal sounds of the various keyboards. This second instrumental credited to Wright and Gilmour is without doubt one of the triumphs of the album.

A Great Day For Freedom

David Gilmour, Polly Samson / 4:18

Musicians
David Gilmour: vocals, vocal harmonies, acoustic rhythm guitar, electric lead guitar, nylon-string classical guitar (?)
Rick Wright: keyboards, piano (?), vocal harmonies (?)
Nick Mason: drums
Bob Ezrin: keyboards (?) piano (?)
Jon Carin: keyboards (?)
Guy Pratt: bass (?)
Tim Renwick: electric rhythm guitar (?)
Gary Wallis: percussion
Michael Kamen: orchestral arrangements
Unidentified Musicians: orchestra

Recorded
Britannia Row Studios, Islington, London: January 1993
Astoria, Hampton: February–May, September–December 1993
Metropolis Studios, Chiswick, London: September–December 1993
The Creek Recording Studios, London: September–December 1993

Technical Team
Producers: David Gilmour, Bob Ezrin
Sound Engineers: Andy Jackson, Keith Grant (The Creek), Chris Thomas (mixing), Steve McLaughlin (orchestra)
Assistant Sound Engineer: Jules Bowen (Astoria)

For Pink Floyd Addicts

The reference in this song to *The Ship of Fools* that *had finally run aground* was inspired by Hieronymus Bosch's famous painting by the same name.

Genesis

The wall mentioned in this song is by no means a reference to Pink Floyd's ultra-famous concept album. David Gilmour and Polly Samson, who wrote the lyrics to "A Great Day for Freedom," are casting their gaze on one of the major events of the post–Second World War years: the fall of the Berlin Wall in November 1989. "There was a wonderful moment of optimism when the Wall came down—the release of Eastern Europe from the non-democratic side of the socialist system. But what they have now doesn't seem to be much better. Again, I'm fairly pessimistic about it all,"[162] said the guitarist in 1994, referring to the bloody conflict that had been raging in the former Yugoslavia and the Balkans since 1991. Against the backdrop of the tragic events casting a shadow over parts of Old Europe at this time, David Gilmour and Polly Samson also express their personal feelings on private matters: *I dreamed you had left my side…It was clear that I could not do a thing for you*, sings Gilmour. This can perhaps be understood as a celebration of the relationship he and Polly were building over the smoking ruins of his marriage with Ginger (from whom he was divorced in 1990).

Production

"A Great Day for Freedom" is a romantic song, which was not common for Pink Floyd. It opens with bass notes on the synthesizer, forming a link with the previous track, "Marooned." Singing in a gentle, moving voice drenched in long reverb, David Gilmour launches more or less immediately into the vocal line, accompanied by a very beautiful piano part. The first two verses are followed by a refrain that is more radiant, at least in terms of the harmonies and arrangements. This time, resonant synth pads provide additional support for Gilmour's lead vocal, which is doubled, harmonized by another voice, and probably also colored by a harmonizer. A tambourine with reasonably short reverb is heard, and strings orchestrated by Michael Kamen make their first appearance on the album. These continue through the next two verses, reinforcing the melancholy aspect of Gilmour's performance. In the fourth verse (from 1:30) the sound of an acoustic guitar with nylon strings is added to the texture, although this seems to be a sampled instrument rather than a real classical guitar. From the subsequent

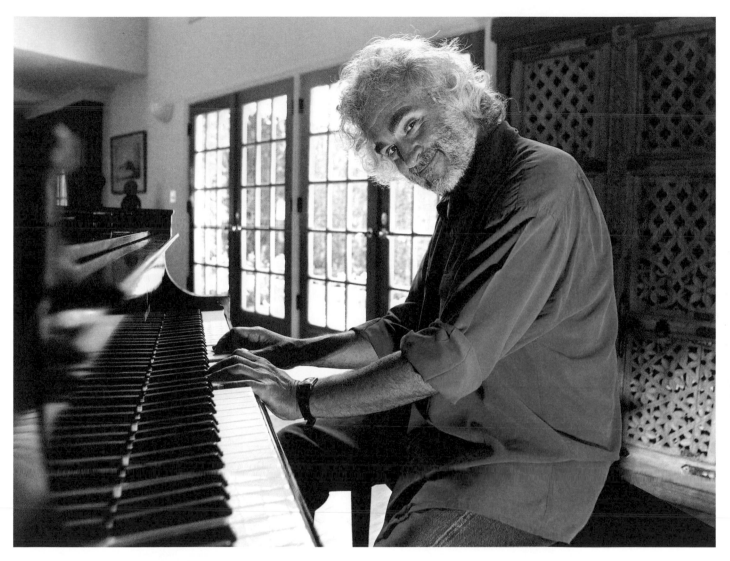

Michael Kamen, who wrote the orchestral arrangements for "A Great Day for Freedom."

refrain (from 1:47), Nick Mason accompanies his bandmates with some solid drumming consisting of numerous tom fills, supported in turn by Gary Wallis on percussion. In this section we can also hear a distorted rhythm guitar in the background, presumably played by Tim Renwick. At the end of the refrain, Gilmour launches into a solo almost two minutes long, in other words almost half the length of the song. He plays his 1955 Gibson Les Paul Goldtop with distortion, but also with a light phasing effect obtained the good old-fashioned way: by using a second tape recorder to capture and play back the signal. Michael Kamen's strings are sumptuous but never invasive, and serve as a wonderful foil for Gilmour's lyrical flights of fancy on his Gibson. Gilmour

also plays an acoustic rhythm guitar part, most probably on his Gibson J-200 (or could this be Tim Renwick?). Finally, the bass guitar sound poses a problem. It is by no means certain that Guy Pratt is playing that instrument on the track, all the bass-type sonorities that can be made out apparently being sampled sounds or deriving from a synthesizer.

"A Great Day for Freedom" is a nice song composed by David Gilmour alone, but probably under Bob Ezrin's influence. It is interesting to note that in the absence of Rick Wright as a writing partner, Gilmour has a tendency to compose romantic or melancholy songs, which was a key contribution during the Roger Waters–dominated Floyd years.

Wearing The Inside Out

Richard Wright, Anthony Moore / 6:49

Musicians
David Gilmour: electric lead guitar, vocal harmonies
Rick Wright: vocals, keyboards, piano
Nick Mason: drums
Bob Ezrin: keyboards (?)
Dick Parry: tenor saxophone
Jon Carin: keyboards (?)
Guy Pratt: bass
Gary Wallis: percussion
Sam Brown, Durga McBroom, Carol Kenyon, Jackie Sheridan, Rebecca Leigh-White: backing vocals

Recorded
Britannia Row Studios, Islington, London: January 1993
Astoria, Hampton: February–May, September–December 1993
Metropolis Studios, Chiswick, London:
September–December 1993
The Creek Recording Studios, London:
September–December 1993

Technical Team
Producers: David Gilmour, Bob Ezrin
Sound Engineers: Andy Jackson, Keith Grant
(The Creek), Chris Thomas (mixing)
Assistant Sound Engineer: Jules Bowen (Astoria)

For Pink Floyd Addicts

There are two videos of the group rehearsing "Wearing the Inside Out": one on the *Endless River* deluxe DVD edition and another on the iTunes deluxe edition.

Genesis

"Wearing the Inside Out" (whose working title was "Evrika" [Eureka]) was a red-letter moment in the later part of Pink Floyd's history. It was the first song to be composed by Wright alone, and the first on which he had sung lead vocal, since "The Great Gig in the Sky" on *The Dark Side of the Moon* some twenty years earlier. The lyrics were written by Anthony Moore, who had previously penned four songs for *A Momentary Lapse of Reason*.

In this song, Moore tells of the vicissitudes of a depressive individual both through that individual's own *eyes* (hence the use of the first-person singular) and through the *eyes* of a friend (using the third-person singular). *From morning to night I stayed out of sight*...The narrator, then, is hiding from other people, and is suffering from such severe depression that he is no longer able to speak. When Anthony Moore describes a flickering screen and a hero with cold skin who curses the world around him, the figure of Pink from *The Wall* inevitably comes to mind. In any case, this person is moving inevitably toward death, to his suffering. There is a reversal of the usual associations and sensations: *Extinguished by light I turn on the night*, sings Wright. By this we are apparently to understand that it is the light (representing contact with other people?) that is the source of the person's anxiety, and darkness that brings him a modicum of peace.

Does the second half of the song have a different message? Perhaps. The narrator's depression has admittedly not gone away, but it seems to lift a little as he recovers both the ability to speak and a desire to reconnect with people. (*Now he can have the words right from my mouth*, says his friend.) An optimistic interpretation of Wright's song would be that the desire to open up (*wearing the inside out* could mean to "reveal oneself") would allow the person to overcome all the betrayals he has suffered, notably at the hands of those close to him...The depression from which Rick Wright suffered in the seventies seems to have inspired the theme of "Wearing the Inside Out" just as it would inspire his second solo album, *Broken China*, in 1996.

Production

The mood of "Wearing the Inside Out," conveyed musically by wonderful harmonies and very delicate arrangements, is

resolutely peaceful, subdued even. Right from the intro, the sonorities surge up as if out of a dream. Synth pads soar over nonchalant percussion, some of which is programmed and some played "live," while David Gilmour treats us to a superb accompaniment on lead guitar modulated with volume pedal and DigiTech Whammy. All of this is sublimated by the well-rounded sonorities of Dick Parry, playing tenor saxophone with the Floyd for the first time since *Wish You Were Here*. Parry had left the music business a few years before. He had sent a Christmas card to David Gilmour, who was considering just then hiring a saxophonist for the album tour. However, even though the sax player had contributed to the group's biggest albums, he still had to be auditioned. "He told me that he thought he was playing better than he'd ever played,"[165] says Gilmour. The audition took place on the *Astoria*: "[...] he played about three phrases and myself and Bob [Ezrin] said, 'Fine, he's still got it.'"[165] In the end, given the quality of his playing, the two co-producers thought they could also use him on one of the tracks on the album. "The only one we could think of that would be really appropriate for sax was 'Wearing the Inside Out,' so we put him on it. Boom, he's got that tone. It's fantastic. You can recognize it straight away."[165]

Following this wonderful intro, Rick Wright launches into his lead vocal, colored by a harmonizer or similar effect. Sadly, this was the last lead he would ever sing for Pink Floyd. "I'd rehearsed it with Anthony Moore who wrote the lyrics," explains Wright, "but I basically hadn't really sung for twenty years. I did one take, and Bob Ezrin said 'Okay, that's it,' which I couldn't believe. I went in and listened to it, and yes, it is nearly it. We worked on it a bit. But it's a song that really suits my voice. I don't have a versatile voice. I'm not a Dave."[153] It is certainly true that Wright gives a moving performance, even if his lack of practice shows, and he conveys a good sense of the ordeals life has strewn in his way. Although his voice is not as serene as it had been in the early days, his inimitable gentle and reassuring timbre, familiar from "Echoes" and "Summer '68," is still there.

After the first verse, the backing vocals answer each of his phrases to great effect. The five backing vocalists then support Wright with harmonies, and Gilmour embellishes the end of each line with some very good bluesy, soaring licks on his Strat, again using the Whammy pedal to execute octave bends. At the end of this second verse, we hear a solo played on a keyboard whose resonant sonorities bring to mind the Minimoog (from 2:37). This is followed by a vocal bridge harmonized by a single voice, after which Gilmour takes an initial solo, which he shares with the silky tones of Dick Parry on sax. In addition to the pads, the keyboards heard in the accompaniment include the sound of a Fender Rhodes (or K2000?) and an acoustic piano. In the final verses, Wright also contributes to the backing vocals, and the warm tones of a Hammond B-3 can be heard coming through. Nick Mason—always perfectly at ease in medium tempi of this sort, where he manages to create a good groove while working his drums with no little power—lays down a very good beat. In this he receives the best possible support from Gary Wallis on programmed and "live" percussion, as well as from Guy Pratt's excellent bass. At 5:15, David Gilmour then launches into a second solo, lasting for more than a minute, on his "Red Strat." He was not fully satisfied with this performance, however: "Funnily enough, I never really liked the guitar solo on the out. Everyone else said they did like it, but I wanted to dump it and do something else on there, 'cos I thought, 'God, I've got too many damn guitar solos again. They're all over the bloody record.' I didn't think that one was so good, but lots of people like it, I guess. It's grown on me a bit."[165]

"Wearing the Inside Out" is one of the triumphs of *The Division Bell*, and for more than one reason: the quality of the composition and lyrics, Rick Wright's moving voice, and the return of the talented Dick Parry.

Take It Back

David Gilmour, Bob Ezrin, Polly Samson, Nick Laird-Clowes / 6:12

Musicians

David Gilmour: vocals, acoustic guitar (with EBow), electric rhythm guitar, programming (?)
Rick Wright: keyboards, organ
Nick Mason: drums
Bob Ezrin: keyboards, programming (?)
Jon Carin: keyboards, programming (?)
Guy Pratt: bass
Tim Renwick: electric rhythm guitar (?)
Gary Wallis: percussion
Sam Brown, Durga McBroom, Carol Kenyon, Jackie Sheridan, Rebecca Leigh-White: backing vocals

Recorded

Britannia Row Studios, Islington, London: January 1993
Astoria, Hampton: February–May, September–December 1993
Metropolis Studios, Chiswick, London: September–December 1993
The Creek Recording Studios, London: September–December 1993

Technical Team

Producers: David Gilmour, Bob Ezrin
Sound Engineers: Andy Jackson, Keith Grant (The Creek), Chris Thomas (mixing)
Assistant Sound Engineer: Jules Bowen (Astoria)

For Pink Floyd Addicts

During the instrumental section in the middle of the song, it is just about possible to make out a voice reciting the nursery rhyme "Ring around the Rosie": *Ring around the rosie/A pocket full of posies/Ashes, ashes/We all fall down!* This children's song is thought to date from the 1880s about the Great Plague of London (1665) that claimed some 75,000 lives.

Genesis

I was thinking all about her, burning with rage and desire... This line from the first verse leads us to believe that "Take It Back" is a love song. More specifically, a song about passion and its devastating consequences. A man is passionately in love with a woman—to the extent that he is totally obsessed with her and lives in permanent fear that she might withdraw her affection. This gives rise to jealousy, lies, and unrealistic promises on the part of the lover, who is transfixed by fear and ends up destroying everything... But David Gilmour, Polly Samson, and Nick Laird-Clowes, all three of whom share the lyric-writing credit, have made "Take It Back" much more than a simple love song. Not only does the heroine symbolize the feminine ideal, she is none other than Mother Nature herself—bestowing life and nourishing mankind. Laird-Clowes confirms: "[David Gilmour] had this great idea about Gaia [the Earth in Greek mythology] being a woman who could take the earth back anytime she wanted."[164] In the light of this, the message of "Take It Back" takes on a completely new dimension: if we treat her badly, if we subject her to the outrages of pollution and overconsumption, nature will take her revenge (*Then I hear her laughter rising from the deep*), making mankind the victim of his own reckless behavior (the *rising tide* that will engulf modern civilization). The message is clear: nature can take back everything she has given. In a sense, "Take It Back" can be seen as the ecological manifesto of the post-Waters Pink Floyd.

Released as a single on May 16, 1994, "Take It Back" peaked at number 23 on the UK charts on May 29.

Production

"Take It Back" opens with guitar-derived sounds drenched in very substantial reverb. These strange sonorities result from a combination of notes played with an EBow (an electronic resonator that creates a quasi-bowed effect) on David Gilmour's acoustic Gibson J-200 and fed through a Zoom (a guitar multi-effects processor). The guitarist explains that he decided one day to "stick the E-bow on the strings and see what would happen. It sounded great, so we started writing a little duet for the E-bowed acoustic guitar and a keyboard. We never finished the piece, but Jon Carin [keyboardist]

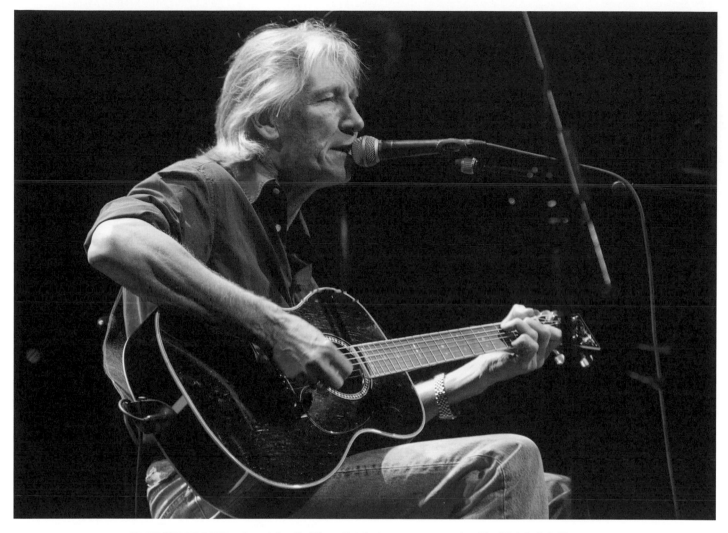

Roger Waters performing at the Syd Barrett tribute concert organised by Nick Laird-Clowes.

decided to sample the E-bowed guitar part. We kept the sample and ended up using it as a loop on 'Take It Back.'"[162] However, David Gilmour transformed the original sound of the loop by playing it backward! Enhanced by enormous reverb, the results are highly impressive.

He then plays a rhythm part with delay on his "Red Strat," the sound distorted and compressed courtesy of his Boss CS-2 pedal. A programmed sequence answers him with a similar motif, and Nick Mason, assisted by Guy Pratt's bass guitar, stresses the harmonic modulations of the intro with a series of cymbal–bass drum crashes. No sooner does the drumming get properly under way than U2 and the highly characteristic guitar of The Edge come to mind. Gilmour resumes the lead vocal after leaving Rick Wright to sing the previous song. This time he adopts his hard-edged rock timbre. As Wright has pointed out, Gilmour's is a versatile voice. He is accompanied in the refrains by the five backing vocalists, and after the second verse the song takes

a more cosmic turn with an instrumental break in which the loop of acoustic guitar played with the EBow makes a return (from 2:51). This sequence is made up of multiple sonorities drenched in reverb, ethereal-sounding synth pads, and various combinations of otherworldly sounds.

At around 3:02, an equally reverb-drenched voice can be heard reciting the nursery rhyme "Ring around the Rosie." When the lead vocal returns, distorted rhythm guitars reinforce the excellent drumming, with Nick Mason in turn supported by Guy Pratt's superb bass and Gary Wallis's percussion. Finally, in the closing refrains, the warm tones of Rick Wright's Hammond organ can be heard coming through the voices of David Gilmour and the backing vocalists. The track ends with the loop and the various guitars and sequencers from the beginning.

"Take It Back" is a very good song, and its choice as a single was thoroughly justified. Nevertheless, it is unexpected for Pink Floyd, and its US flavor offputting for some fans.

Coming Back To Life

David Gilmour / 6:19

Musicians

David Gilmour: vocals, acoustic rhythm guitar (?),
electric rhythm and lead guitar, programming (?)
Rick Wright: keyboards, organ
Bob Ezrin: keyboards (?), programming (?)
Jon Carin: keyboards (?), programming (?)
Guy Pratt: bass
Tim Renwick: guitar (?)

Recorded

Britannia Row Studios, Islington, London: January 1993
Astoria, Hampton: February–May, September–December 1993
Metropolis Studios, Chiswick, London:
September–December 1993
The Creek Recording Studios, London:
September–December 1993

Technical Team

Producers: David Gilmour, Bob Ezrin
Sound Engineers: Andy Jackson, Keith Grant
(The Creek), Chris Thomas (mixing)
Assistant Sound Engineer: Jules Bowen (Astoria)

Genesis

"Coming Back to Life" is a song with both words and music by David Gilmour. Once again, it is a song full of regrets… The narrator is addressing his partner (or ex-partner): *Where were you when I was burned and broken, while the days slipped by from my window watching?* The main character reproaches his former loved one for not having helped him when he needed it and for being interested only in someone else's words, in the past when the couple concerned indulged in a *dangerous but irresistible pastime.*

What pastime might this be? David Gilmour has answered this question: "Oh, it's sex, obviously. Sex and procreation."[36] For the wounded lover, this is a period of his life that now needs to be buried forever: *I knew the moment had arrived for killing the past and coming back to life*, sings Gilmour. This inevitably calls to mind the end of his marriage to Ginger and the start of his relationship with Polly. So the song is about the past, but it is also, and above all, about the present, which has in a sense brought him back to life…"This song is dedicated to my beautiful wife Polly," he says about "Coming Back to Life" on the DVD *David Gilmour in Concert* (2002).

David Gilmour may also be alluding to the early years of Pink Floyd, to the relationship between Roger Waters, Rick Wright, and Nick Mason on the one hand, and Syd Barrett on the other, at a time when he was beginning to decline. Could Syd be the narrator blaming the other members of the group for their attitude toward him? A Syd Barrett *Lost in thought and lost in time*?

Production

A Kurzweil pad forming a chord of C, which has lingered on from the end of the previous track, gradually rises in volume, setting an ethereal, meditative tone. David Gilmour's Strat can then be heard ringing out in space, his notes enhanced by generous reverb with a very present delay. He plays a clear-toned, bluesy solo that is highly inspired and brimming with emotion. His playing is magnificent in every respect: never demonstrative, but always searching for the right note, one that will get through to the listener. And this is a note he is always able to find, thanks not least to his multiple bends and use of the whammy bar. During the solo, he can be heard

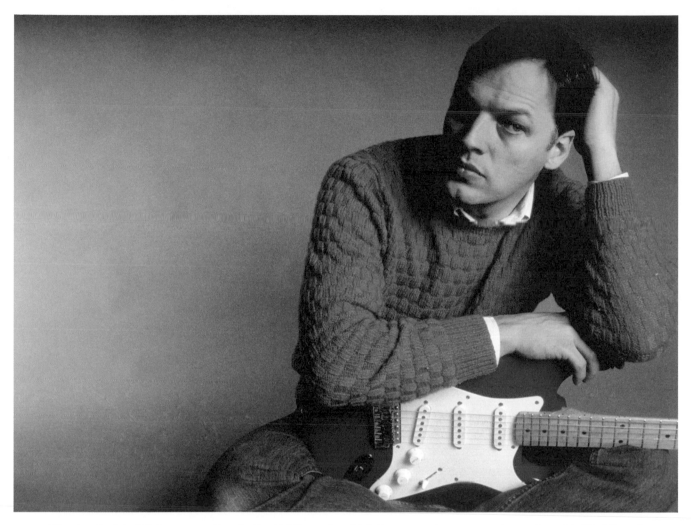

"Coming Back to Life," a composition by David Gilmour in which the songwriter once again excels on his "Red Strat."

moving up to the bridge pickup in order to give his phrases a little more attack (at 1:12). It is not until after 1:30 that he launches into the lead vocal. His singing is every bit as moving as his guitar playing, and impressive amounts of reverb and delay are added to his words, amplifying their meaning a little more. The synth pads simply magnify this rare moment when an artist has succeeded in creating a perfect symbiosis of music, lyrics, and performance. Gilmour is singing of his own painful personal experience, and expresses himself both powerfully and subtly. The spell is broken slightly by the entrance of a combination of drum machine programmed with the sound of a cowbell (as supplementary percussion), acoustic guitar positioned at the back of the mix (right channel), a clear-toned rhythm guitar part played by Gilmour

presumably on his Strat (also on the right), and bass guitar almost certainly played by the excellent Guy Pratt. From 3:26, the beginnings of the last three lines of the second verse are accompanied by Rick Wright with a swell on the irresistible Hammond organ. This is joined by another distorted guitar (doubled) that emphasizes the rhythm. Gilmour then launches into an initial and highly energetic solo (at 3:52), this time with very short reverb. His sound is distinctly rock, and in fact exudes a certain Californian color. After a final verse in which his voice betrays hope in a sunny future, he then plays a second solo that is just as inspired as the first and is supported by two very good organ parts. The track finishes cleanly for a change (at 6:08), and we hear the delay repeats caused by the action of removing his hand from the neck of his Strat (6:13).

Keep Talking

David Gilmour, Richard Wright, Polly Samson / 6:11

Musicians
David Gilmour: vocals, acoustic guitar (loop), electric rhythm and lead guitar, programming (?)
Rick Wright: keyboards
Nick Mason: drums
Bob Ezrin: keyboards (?), programming (?)
Jon Carin: keyboards (?), programming (?)
Guy Pratt: bass
Tim Renwick: electric rhythm guitar (?)
Gary Wallis: percussion
Sam Brown, Durga McBroom, Carol Kenyon, Jackie Sheridan, Rebecca Leigh-White: backing vocals
Stephen Hawking: voice

Recorded
Britannia Row Studios, Islington, London: January 1993
Astoria, Hampton: February–May, September–December 1993
Metropolis Studios, Chiswick, London: September–December 1993
The Creek Recording Studios, London: September–December 1993

Technical Team
Producers: David Gilmour, Bob Ezrin
Sound Engineers: Andy Jackson, Keith Grant (The Creek), Chris Thomas (mixing)
Assistant Sound Engineer: Jules Bowen (Astoria)

Genesis

During an interview with Redbeard on the show *In the Studio* in March 1994, David Gilmour revealed that his inspiration for "Keep Talking" was a British Telecom ad. "This was the most powerful piece of television advertising that I've ever seen in my life. I thought it was fascinating, and I contacted the company that made it and asked if I could borrow the voice track from it, this voice-over track from it, which I did, which is this voice synthesizer thing, and I applied it to one of the pieces of music we already had."[153]

For millions of years mankind lived just like the animals. Then something happened which unleashed the power of our imagination. We learned to talk. And (the following passage is played twice): *It doesn't have to be like this. All we need to do is make sure we keep talking.* These words that so moved David Gilmour are spoken by Stephen Hawking, the famous British physicist and cosmologist with motor-neurone disease. As its title has already made clear, this song is about the need for human beings to communicate, a need that is almost as important as breathing. "I have moments of huge frustration because of my inability to express myself linguistically as clearly as I would like to. A lot of people think that I express myself most clearly through the guitar playing."[36] Viewed from this angle, "Keep Talking" rings out as a kind of appeal for the liberation of the spoken word for the sake of global harmony. *There's a silence surrounding me, I can't seem to think straight*, sings David Gilmour after Stephen Hawking's opening phrases. And in the last verse: *What are you thinking?/ We're going nowhere/What are you feeling?/We're going nowhere.*

"Keep Talking" was chosen as the second single from *The Division Bell* (accompanied by "High Hopes"). Released on October 10, 1994, it reached number 26 on the British charts on October 29, 1994. The song is also on a three-track single with "High Hopes" and a live version of "One of These Days."

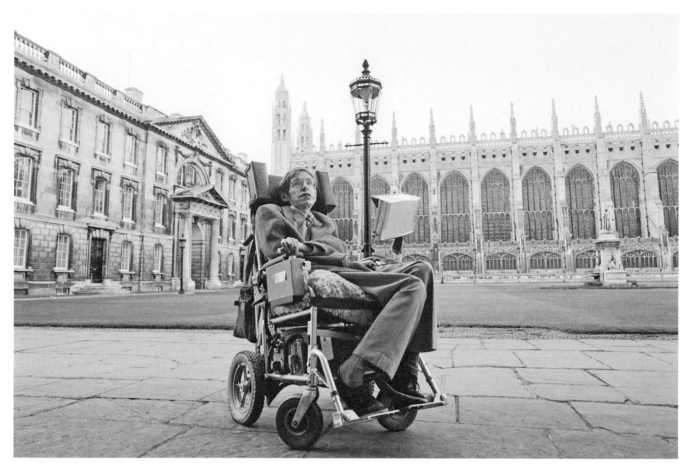

Stephen Hawking, the inspiration behind Pink Floyd's "Keep Talking." Seen here in Cambridge.

Production

The intro is constructed around the same loop of acoustic guitar played with the EBow, Zoom-enhanced and played backward, that can be heard on "Take It Back." In this case it is accompanied by numerous synthesizer effects. The beat is provided by programmed hi-hat, and resonant guitar chords with very present delay then join in. This somewhat cosmic-sounding mood is complemented by a lead guitar line from David Gilmour. Programmed drums then reinforce the beat, supported in turn by two rhythm guitars and a bass. Stephen Hawking's synthesized voice can be heard from 1:15: *For millions of years*…This is followed by the first verse, which is sung by Gilmour in an almost confiding voice. Nick Mason is playing his Drum Workshop kit and, along with the various programmed rhythm elements, lays down an excellent groove. Gilmour continues his lead vocal accompanied by backing vocals in a sort of question-and-answer dialogue, to some degree resembling Rick Wright's "Wearing the Inside Out." The physicist's voice is heard again at 2:38 with *It doesn't have to be like this*…and then Gilmour seems to answer him with a furious solo on his "Red Strat" with Big Muff distortion. Gilmour's phrasing is hard-edged rock, and he is accompanied by the superb rhythm section of Nick Mason, Guy

Pratt, and—with various programmed and "live" percussion instruments—Gary Wallis. Not to forget Rick Wright's Hammond organ, which now puts in an appearance. Wright also takes over from Gilmour's solo on a keyboard whose sound recalls the Minimoog, the phrasing bringing to mind some of the big moments of *Wish You Were Here*. Gilmour then resumes his dialogue with the backing vocalists, and while they sing the last four lines of the song, he plays another solo, this time using his Heil Sound Talk Box for the first time since *Animals*. Whereas on tracks like "Pigs (Three Different Ones)," he used it to create particular sonic effects, this time he plays a full-blown and highly successful solo, somewhat in the style popularized by Peter Frampton in the early seventies. Against the background of this Talk Box solo, Hawking's voice can be heard repeating the statement *It doesn't have to be like this*, (at 4:54), followed a few seconds later by *All we need to do is make sure we keep talking*. The track ends with a fade-out in an atmosphere dominated by the rhythm guitars, the various sequencer programming and rhythmic elements, and synth pads.

"Keep Talking" is an ambitious track that succeeds thanks to Stephen Hawking's extraordinary message and Pink Floyd's excellent execution.

Lost For Words

David Gilmour, Polly Samson / 5:16

Musicians
David Gilmour: vocals, acoustic guitar, electric guitar, programming
Rick Wright: keyboards, piano
Nick Mason: drums
Jon Carin: keyboards, programming (?)
Gary Wallis: percussion

Recorded
Britannia Row Studios, Islington, London: January 1993
Astoria, Hampton: February–May, September–December 1993
Metropolis Studios, Chiswick, London: September–December 1993
The Creek Recording Studios, London: September–December 1993

Technical Team
Producers: David Gilmour, Bob Ezrin
Sound Engineers: Andy Jackson, Keith Grant (The Creek), Chris Thomas (mixing)
Assistant Sound Engineer: Jules Bowen (Astoria)

For Pink Floyd Addicts

When the *Right One* walks out of the door, sings Gilmour in the third verse. Could the *Right One* be Rick Wright, fired by Waters from Pink Floyd toward the end of the recording sessions for *The Wall*?

Genesis

This song, which David Gilmour wrote with Polly Samson, tells of two friends. Or rather two former friends. The first is addressing the second, who makes no reply on the subject of the grievances he has caused: *I was spending my time in the doldrums* because *I felt persecuted and paralysed*. He then realizes that he is wasting his time on his enemies and that hostility is preventing him from facing up to reality. What is the point of wanting revenge? *To martyr yourself to caution* is not going to serve any purpose, sings Gilmour. The best solution would be to make peace, *But they tell me to please go fuck myself/You know you just can't win*.

No prizes for guessing that the two individuals in question are David Gilmour and Roger Waters. On the part of Gilmour, anger and incomprehension have given way to reflection and a desire to bury the axe: *So I open my door to my enemies—* an offer Waters flatly rejects: "[The] Future and world welfare don't rest on a reconciliation between Dave Gilmour and myself,"[36] the former Floyd bassist has declared.

Production

"Lost for Words" begins with a low C played on a synthesizer. We then hear resonant footsteps as someone walks toward a door that is then opened and closed. Could this symbolize a past being left behind? A bass drum and a hi-hat (both almost certainly programmed) immediately mark the beat. Synth pads then help to generate a darkish atmosphere, and dissonant notes on the piano ratchet up the tension a little more before the mood lightens again with the entry of two acoustic guitars positioned on either side of the stereo field. These are played by David Gilmour, delivering a folk-like accompaniment on his Gibson J-200 and accompanied by an organ whose particular sonority recalls a harmonium. Gilmour then plays a very good solo, still acoustic, and this time with Rick Wright on piano (but quite recessed in the mix). Nick Mason marks the start of the first verse with a tom break, and lays down a rhythm very much in the style of US folk rock, supported by Gary Wallis on tambourine and Guy Pratt on bass guitar. The very first notes of the melody inevitably bring to mind Bruce Springsteen and his superb song "Independence Day" (*The River*, 1980). David Gilmour sings in a clear, confident, and gentle voice.

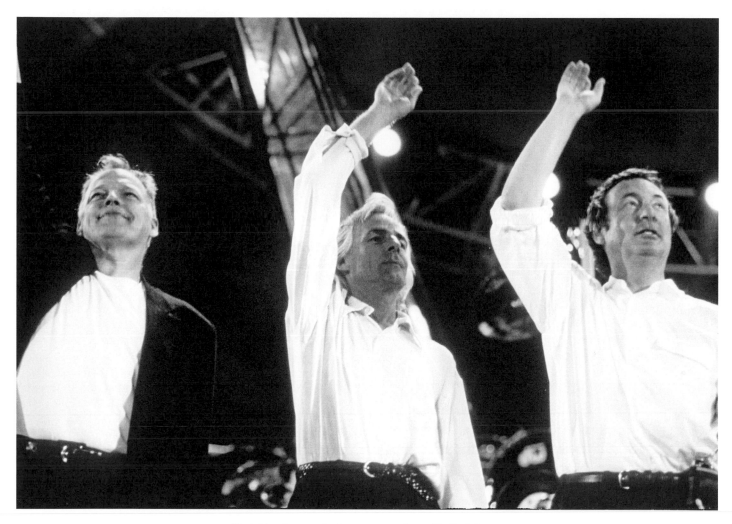

Pink Floyd: an unbroken communion with their fans.

He sounds serene, at peace. The emotions he expresses through the lyrics are not innocuous, they represent a painful period in his life, but the storm has now passed, and this calm is reflected in his performance.

The end of the third verse gives way to an instrumental bridge that opens with a series of strongly tremolo-colored notes on the Strat. Distorted, reverb-drenched guitar sounds and synth pads weave a dreamlike atmosphere in which crowd noises emerge reasonably distinctly. The scene is probably a boxing match, the perfect metaphor for the confrontation between Waters and Gilmour, and this would seem to be confirmed by the pair of boxing gloves illustrating the sleeve of the promotional single that was released in the US in March 1994 (the "clean" version, that is to say

with the word *fuck* expunged!). This interlude dominated by sound effects is followed by two more verses, after which Gilmour plays a second solo on his Gibson J-200, his performance in no way inferior to his legendary electric solos. "Lost for Words" ends with a fade-out accompanied by birdsong and church bells that gradually increase in volume, providing a link with the last title on the album: "High Hopes."

What to say about "Lost for Words"? This admission in song of the scars caused by his violent disagreement with Waters is a brave move on Gilmour's part. It also provides him with a way of once and for all ruling out the possibility of any further collaboration between the two men. He has extended the hand of friendship, but it has not been taken. End of story.

High Hopes

David Gilmour, Polly Samson / 8:32

Musicians

David Gilmour: vocals, vocal harmonies, classical guitar, lap steel guitar, programming
Rick Wright: keyboards, piano (?)
Nick Mason: drums
Bob Ezrin: keyboards (?), programming (?)
Jon Carin: keyboards (?) piano (?)
Guy Pratt: bass
Gary Wallis: percussion
Michael Kamen: arrangements, orchestral conducting
Charlie Gilmour, Steve O'Rourke: voices on the telephone
Unidentified Musicians: orchestra

Recorded

Britannia Row Studios, Islington, London: January 1993
Astoria, Hampton: February–May, September–December 1993
Metropolis Studios, Chiswick, London:
September–December 1993
The Creek Recording Studios, London:
September–December 1993

Technical Team

Producers: David Gilmour, Bob Ezrin
Sound Engineers: Andy Jackson, Keith Grant (The Creek), Chris Thomas (mixing), Steve McLaughlin (orchestra)
Assistant Sound Engineer: Jules Bowen (Astoria)

David Gilmour and Polly Samson refer to the Giant's Causeway in County Antrim in Northern Ireland. In Celtic legend, the causeway is linked to Fingal's Cave in Scotland, which gave its name to a Floyd composition for the soundtrack of *Zabriskie Point*. Is this intended as another allusion to Pink Floyd's past?

Genesis

David Gilmour has said that "High Hopes" was the last song on *The Division Bell* to have been completed, even though it was composed back in July 1993. It is also the song that sealed his lyric-writing partnership with Polly Samson: "I came up with a tiny bit of music, just had it on cassette, just a few bars of piano and then I went off to get away to a small house somewhere with my girlfriend Polly and try and make some progress on lyric writing and she gave me a phrase, something about 'before time wears you down' and I took it from there and got stuck into a whole sort of thing."[148]

"High Hopes" is an evocation of David Gilmour's youth in Cambridge, the expression of a profound nostalgia—a recurrent theme in Pink Floyd ever since the days of Syd Barrett—for a bygone world, *a world of magnets and miracles* in which *our thoughts strayed constantly*, where *the grass was greener*, *the light was brighter*, and nights spent in the company of friends were inexhaustible sources of wonder. The narrator, who seems to have come to the end of his days, and thus to have reached the time of judgment (*the division bell*), recalls this period (*before time took our dreams away*) with abundant emotion. It is clear that his friends have disappeared or are no longer friends, that his life has been strewn with obstacles and *consumed by slow decay*, and that the *dreamed-of world* is in reality crushed by the weight of *desire and ambition*. For the character in the song, life has flowed like an *endless river*, the title Pink Floyd would give their final album ten years later. Should we see this penultimate line of "High Hopes," the closing track on *The Division Bell*, as a deliberate desire for continuity?

According to Bob Ezrin, "High Hopes" is the best song on the album. "It's the best track on the record. It is all David. It knitted together the album. It's a monochrome, high-contrast musical painting, surrounded by a few little colourful elements, that form a wrapper around it. But the essence of the song is very stark. It's peculiarly English. And when the Floyd are being English, they are at their best. Sometimes they are almost Dickensian. So is this."[81]

"High Hopes" was released as a single on October 17, 1994 (with "Keep Talking" as the B-side). It reached number 26 on the British charts in October 1994.

Ely Cathedral in Cambridgeshire.

The bell that can be heard in this song is not actually the famous division bell of the Houses of Parliament. It is thought to be the bell of either Cambridge University or Ely Cathedral.

Production

The concluding track on *The Division Bell* opens in a distinctly pastoral mood, with birdsong, bells chiming in the distance, a buzzing bee…Each of these elements lends itself to symbolic interpretation: the birds resemble those at the beginning of "Cirrus Minor" (*More*), the village church bells are the same as the ones in the intro to "Fat Old Sun" (*Atom Heart Mother*), and the bee is not unlike that of "Grantchester Meadows" (*Ummagumma*). Is this intentional? Probably, given the context of the song. A second bell then rings out, putting an end to the gentle bucolic scene. Given its absolute regularity, this "division bell" (which always tolls on the same note of C) has presumably been sampled and programmed. It is answered by a piano, and a kind of dialogue between the two ensues. David Gilmour then launches into the lead vocal in a low and rather melancholy voice supported by the same piano (Wright? Carin?) and Guy Pratt's bass. Very discreet strings enter with the first bridge, and Gilmour starts to accompany himself on a nylon-string classical guitar (his Ovation 1613-4?), supported by a beat apparently composed of a tom sample and a rimshot (from 1:16). This passage also brings to mind Sting's superb song "Shape of My Heart" (1993). This is followed by another verse (at 1:54) and, eventually, the first refrain, sung by Gilmour in a higher voice and accompanied by Michael Kamen's strings, a tambourine, and a (programmed?) drum part. After a third voice and a second bridge, Gilmour plays one of his rare solos on a nylon-string guitar (from 2:58). In fact he plays two guitar parts: a first, consisting of the same motif played over and over again, in the right-hand channel, and a second, answering the first with Spanish-sounding phrases, in the left. He is accompanied by Michael Kamen's string

and brass arrangements and some rather military-sounding snare drums (samples?) that recall "Bring the Boys Back Home" from *The Wall*. In the final refrain of the song, Gilmour harmonizes with himself. This time, Nick Mason's drums are very present and launch the guitarist into an epic lap steel solo on his Jedson, most probably with Big Muff distortion. The instrument is tuned in E minor (E, B, E, G, B, E). Gilmour plays for almost 2:20, and it has to be acknowledged that this is one of the characteristic Pink Floyd sounds, reminiscent in particular of *The Dark Side of the Moon*. "I always had a fondness for pedal steels and lap steels. I guess it's because I could never come to grips with standard bottleneck playing."[162]

The track ends with a fade-out of the music over which the bell gradually returns, eventually ringing by itself for around twenty seconds. This is followed by twenty seconds or so of silence until at 8:18 a sort of hidden message can be heard in the form of a telephone conversation between the Pink Floyd manager, Steve O'Rourke, and Charlie, Polly Samson's young son: *Hello?/Yeah…/Is that Charlie?/Yes./ Hello Charlie!/*[the Charlie in question then mumbles something and hangs up]*/Great!* The reason for this little joke is that Steve O'Rourke insisted on making an appearance on the album.

"High Hopes" is also one of the high points on the album, not least for the different atmospheres it evokes. However, David Gilmour would explain that he had a lot of trouble re-creating the mood of his original demo: "I did a complete demo of that in a day at the studio. But for some reason, we couldn't use it because, I think, maybe the tempo wavered a little bit. It then took ages to capture a take that was anywhere near as good as the demo."[162] He can rest assured: the final result is definitely up to scratch.

THE ENDLESS RIVER

ALBUM
THE ENDLESS RIVER

RELEASE DATE
United Kingdom: November 10, 2014

Label: Parlophone Records Ltd.
RECORD NUMBER: 825646215423

Number 1, on the charts for 19 weeks (United Kingdom); number 1 (France, Belgium, Canada,
Netherlands, Germany); number 3 (United States)

Things Left Unsaid / It's What We Do / Ebb And Flow /
Sum / Skins / Unsung / Anisina / The Lost Art Of Conversation /
On Noodle Street / Night Light / Allons-y (1) / Autumn '68 /
Allons-y (2) / Talkin' Hawkin' / Calling / Eyes To Pearls /
Surfacing / Louder Than Words
BONUS TRACKS TBS9 / TBS14 / Nervana

For Pink Floyd Addicts

Syd Barrett, who died in 2006, Rick Wright, who died in 2008, and Storm Thorgerson, who passed away in 2013, were all predeceased by Steve O'Rourke, who departed this world on October 30, 2003.

The deluxe version of *Endless River* includes a number of bonus tracks: "TBS9," "TBS14," and "Nervana," as well as videos of "Anisina," "Untitled," "Evrika (A)," "Nervana," "Allons-y," and "Evrika (B)."

The Endless River Marks the End of the Road

July 2, 2005. The lineup for the Live 8 concert in Hyde Park, which took place just before the thirty-first G8 summit (in Scotland), was on a par with Bob Geldof's new and commendable ambition: the cancellation of the debt of the world's poorest countries. Paul McCartney, Elton John, the Who, Sting, U2, Madonna, and Coldplay all answered the call from the former lead singer of the Boomtown Rats. Far more surprisingly, Roger Waters, David Gilmour, Rick Wright, and Nick Mason were prepared to set aside their grudges for this humanitarian cause. "Breathe," "Money," "Wish You Were Here," "Comfortably Numb": the group performed four of its major compositions, and as darkness fell over the heart of London, the old magic kicked in, as if the years had left the four members of Pink Floyd, and most importantly their music, completely untouched… "After our final bow, we headed backstage where there was plenty of undisguised emotion on show," writes Nick Mason, "but I am delighted to report that, great troopers that we are, the four of us displayed that inscrutable and dry-eyed stoicism that is part of a fine Pink Floyd tradition… And there for now the story must pause."[5]

Completing the Cycle

However, the Pink Floyd story did not reach its conclusion with the reunion of the four musicians on the lawns of Hyde Park at the Live 8 concert, and neither did it end with the death of Rick Wright, aged sixty-five, on September 15, 2008, two years after Syd Barrett had died. Waters, Gilmour, and Mason as well as the wider musical world and the group's enormous fan base were deeply saddened by the loss of both these musicians.

The story was to continue with a new album, the main aim of which, for David Gilmour, was to perpetuate the memory of the deceased keyboard player, described by the Floyd guitarist as "such a lovely, gentle, genuine man," who would "be missed terribly by so many who loved him."[166] During the course of 2012, David Gilmour, assisted by Nick Mason, therefore delved into the group's relatively recent past—that is to say the twenty or so hours of improvisation recorded in 1993, the era of *The Division Bell*, only a small proportion of which had been used in the making of the album. "Initially, we had considered making *The Division Bell* as a two-part record," explains Nick Mason to Michael Bonner. "Half to be songs, and the other a series of ambient instrumental pieces. Eventually, we decided to make it a single album and inevitably much of the preparation work remained unused."[167] At the time, this second part, consisting of ambient music, had been baptized *The Big Spliff* (not without a touch of humor) by sound engineer Andy Jackson, who nevertheless envisaged that it would one day be released on disc as a follow-up or complement to *The Division Bell*.

The Makings of an Album

In August 2012, David Gilmour got back in touch with Phil Manzanera, who, having co-composed "One Slip" on *A Momentary Lapse of Reason*, had subsequently co-produced his solo album *On an Island* (2006). The guitarist asked him

Martin Glover of Killing Joke, better known as a producer by the name of Youth.

Phil Manzanera, one of the producers of Pink Floyd's last album.

to come and meet him at the *Astoria*, where he had also summoned Andy Jackson and Damon Iddins, who had been Gilmour's sound engineer since *On an Island*. The idea was to get the tapes out and see what could be done with them. Phil Manzanera recalls: "That was when I heard that Andy had put together a thing called *The Big Spliff*, which rather annoyingly I said, 'I don't wanna hear. I wanna hear every single piece or scrap that was recorded, everything. Outtakes from *Division Bell*. Everything.' So we commenced on a 20-hour epic listening session over six weeks."[167]

Manzanera made a meticulous note of what interested him in these twenty hours of music, which had been recorded on a range of media (DAT, twenty-four-track, even simple half-inch tape) and carefully archived. Before long he came up with a concept that would eventually become a symphony in four movements. "The door clanks, and you can hear them walking on the gravel towards the boat, the three of them, our heroes, they come onto Astoria and start jamming," explains Manzanera. "That's the first section. The second section, the boat takes off and we're in outer space. They arrive on a planet that is all acoustic [the third movement]. Then there's this end bit, where it goes back. So I had this narrative and I started putting all the things together."[167]

Phil Manzanera then spent several weeks assiduously re-creating the music, modifying the tonality of this part, changing the intro or finale of that part, adding a solo guitar here or there. In December, he played to David Gilmour and Nick Mason, who liked what he had done and, crucially, agreed that this material had the makings of an album.

Several months passed before any more progress was made. This was mainly because David Gilmour had started work on what was to become his solo album *Rattle That Lock* (2015). Some of the tapes were then sent to Youth. Properly known as Martin Glover, Youth was a member of the Pink Floyd circle who had invited Gilmour and Wright to take part in the sessions for *Naked* (1990) by Blue Pearl (the name of the house music duo he had founded with the American singer and Pink Floyd backing vocalist Durga McBroom) and who had also worked with Gilmour on

Metallic Spheres (2010) by the Orb. Youth is also known as a member of the Fireman (a duo with Paul McCartney) and Killing Joke, and as the producer of a number of highly successful albums such as *Urban Hymns* (1997) by the Verve. He remembers receiving a call from David Gilmour in June 2013: "He said, 'I've got this thing I've been working on, it's not quite been working out. Could you come down and have a listen?' So I jumped on the train, he picked me up and we drove to his farm in Sussex. David's got this amazing studio at the top of a barn. He put on this track up there. I was expecting to hear solo material. Within about 40 seconds, it sounded like Floyd. It was absolutely magical. The window was open and there were birds singing. June in England is the most beautiful place in the world you could be, listening to unreleased Pink Floyd recordings with David [...]."[167]

A Tribute to Rick Wright

Intended as a tribute to Rick Wright, this Pink Floyd symphony reworked by Phil Manzanera, Andy Jackson, and Youth comprises eighteen titles organized into four movements, each of which has its own specific mood. Half the pieces are short (less than two minutes), while only two, "It's What We Do" and "Louder Than Words," exceed six minutes. Another unusual aspect is that with the exception of the last track, "Louder Than Words," which is sung by David Gilmour, all the compositions are instrumentals. The overall result sounds a little like the better albums by Brian Eno, that master of ambient music, with the unique Pink Floyd atmosphere that was present from *A Saucerful of Secrets* via *Meddle* to *Wish You Were Here*, magnified by Gilmour's forever luminous guitar and Wright's greatly missed cosmic keyboards. In a sense, *The Endless River* sounds like a kind of retrospective of a long career that has been in a class of its own. "A requiem through familiar echoes," David Fricke would write in the *Rolling Stone* of November 7, 2014. Production duties were shared among David Gilmour, Phil Manzanera, Youth, and Andy Jackson. For the first time since *The Wall*, Bob Ezrin receives no production credit other than for the recordings that derive from the 1993 *Division Bell* sessions.

The "historic" reunion of David Gilmour, Rick Wright, Nick Mason, and Roger Waters at Live 8 in Hyde Park on July 2, 2005.

What was to be the very last original Pink Floyd album was released on November 10, 2014. Regarded as the final will and testament of one of the major groups in the history of rock music, it shot to the top of the charts in many countries including the United Kingdom (where it became the group's sixth number 1!), New Zealand, Canada, France (where it went on to achieve double platinum status), the Netherlands, Germany, and the Scandinavian countries. In the United States it climbed to number 3 and was eventually certified Gold. However, with the exception of *Record Collector*, which awarded the album five stars, the critics would exhibit less enthusiasm. From the moment of the album's release, journalists were on the lookout for a reaction from Roger Waters. But the former Pink Floyd bassist seemed to be taking a softer approach and refrained from taking any potshots at his former bandmates: "I left Pink Floyd in 1985, that's 29 years ago. I had nothing to do with either of the Pink Floyd studio albums, *Momentary Lapse of Reason* and *The Division Bell* nor the Pink Floyd tours of 1987 and 1994, and I have nothing to do with *Endless River*. Phew! This is not rocket science people, get a grip,"[168] he would declare with evident annoyance in 2014.

We therefore have to resign ourselves to *The Endless River* being the very last album by this group that made such an indelible impression on the history of rock music, a group that belongs in that rare category of bands that created their own, immediately identifiable world, a group that forged the way for progressive rock. But there it is, reality is not as cosmic as the albums of this group whose future was sealed by David Gilmour, the only person with the power to enable it to continue. But neither did Nick Mason seem capable of reconciling himself to the thought that it might all be over, revealing to *Rolling Stone*: "I think I'll let David do the, 'This is the last, this is the end.' I now believe when I'm dead and buried my tombstone will read, 'I'm not *entirely* sure the band's over.'"[169]

The Sleeve

While the spirit of Rick Wright presided over the development of the music for *The Endless River*, that of Storm Thorgerson (who is mentioned in the credits even though he passed away in April 2013) is present in the choice of illustration for the sleeve of Pink Floyd's last album. Entitled *Sky*, this is the work of the self-taught eighteen-year-old Egyptian artist Ahmed Emad Eldin and depicts (from behind) a man rowing into the sunset on a sea of clouds. Aubrey Powell, Storm Thorgerson's long-standing partner at Hipgnosis, has revealed that he came across the work of Ahmed Emad Eldin on the online portfolio site Behance, and chose this image for its particular atmosphere, which is in complete harmony with the music of *The Endless River*. For its creator, the illustration symbolizes "the intersection of life, nature, and what is beyond the world,"[159] in a sense an expression of new limits or frontiers. Neither the name of the group nor the title of the album is printed on Pink Floyd's final album.

The Recording

Most of the tracks on *The Endless River* were recorded during the sessions for *The Division Bell* in 1993, which

Andy Jackson, the talented sound engineer who had been working with Pink Floyd since the '80s.

took place in David Gilmour's houseboat studio, the *Astoria*. There are two exceptions: "Autumn '68," which dates back to June 1969 (at any rate Rick Wright's performance on the Grand Organ of the Royal Albert Hall does) and "Louder Than Words," which dates from the beginning of 2014. Following Phil Manzanera's initial selection of pieces and their organization into four sections, in November 2013 the tapes were then enhanced in David Gilmour's studio at his farm in Sussex, Medina Studio, this time under the supervision of the producer Youth. This was the first time in twenty years that Gilmour and Mason had found themselves together in the studio working on a Pink Floyd album. The initial takes involved Mason. "Nick was just great, straight away," recalls Manzanera. "It sounded like what Robert Wyatt calls 'Pink Floyd time.' It was just magic."[167]

The drum and guitar overdubs were worked on in Hove in the three days from November 11 to 13 and then the following week. Back at the *Astoria*, the two members of Pink Floyd and their team then listened to the tapes from November 20. With Wright's keyboards serving as a kind of spinal column, the decision was then taken to add new tracks that were to be recorded at the beginning of 2014. "It became an interactive process of mixing and recording," explains Andy Jackson. "You put drums on this, flesh this bit out, this bit needs a guitar solo. Then you assimilate that, do a layer of mixing to make it sound like a record and then go, 'Great, but this has now revealed that we need this...'"[167] "Louder Than Words" was recorded successively at Medina Studio and on the *Astoria*.

Before arriving at the final results, however, the team was forced to take account of changes in technology over the intervening twenty years. As David Gilmour would later comment, the Floyd owed it to themselves to endow the recordings dating from 1993 with a sound worthy of the twenty-first century. In order to achieve this, all the tracks were worked on in the benchmark digital audio workstation Pro Tools (Avid Technology). Given the coexistence of tracks from the 1993 sessions and the new overdubs dating from 2014, the complexity of the task would rapidly increase, as

Andy Jackson explains: "What happened with this album is quite interesting, as there were *huge* sessions in Pro Tools [...] we were constantly running out of voices [i.e., room for extra tracks], and it was really hard."[170] This situation would lead them to search for alternative solutions that would enable them to complete the recordings: "There would be times where David and I would be sitting there scratching our heads, going: 'We need to find five voices. Where are we going to find five voices?' You'd find five voices, and then 3 days later, we'd need another six."[170] As for the mixing, the sound engineer proceeded with an "in the box" mix, in other words in Pro Tools. However, David Gilmour also asked him to try an analog mix, using the Neve 88R console. With the new mix complete, they then organized a "blind test" of the two versions: "And it was just like chalk and cheese," reports Jackson, "It was a *huge* difference with the analog."[170]

As we have seen, responsibility for recording the latest (and indeed last) Pink Floyd album went to Andy Jackson. He was assisted by Damon Iddins, who, in addition to his collaborations with Muse, Blur, Björk, and Humble Pie—to mention just a few—also plays keyboards on this album. Moreover, some of the tracks that served as a basis for *The Endless River*, specifically those dating from 1993 and Britannia Row Studios, had been recorded by Phil Taylor.

Technical Details

The *Astoria* was now equipped with a superb forty-eight-track Neve 88R console, two Studer A827 tape recorders, a twenty-four-track Otari MTR-100, and a Quantum Scalar i80 storage system. Andy Jackson has pointed out that he did not use any digital reverb whatsoever, but instead relied on two EMT plates. As we have seen, the digital audio workstation was the famous Pro Tools from Avid Technology, probably one of the most widely used workstations in the world.

The Instruments

With Pink Floyd's final album, it is very difficult to identify the instruments played by each of the members of the

Some of the effects used by David Gilmour in 2014!

group. As the base tracks were laid down during the 1993 sessions devoted to *The Division Bell*, the keyboard, guitar, and some of the drum parts were inevitably played on the instruments used in the recording of that album (see page 521). However, when the group got down to updating the various tracks in 2013–14, other than in the case of Rick Wright's parts it is difficult to isolate the new overdubs recorded and mixed alongside the *Division Bell* base tracks. Nevertheless, it is possible to securely identify a few of the new instruments used. David Gilmour is once again playing his "Black Strat," which he had reclaimed ten years after loaning it to the Hard Rock Cafe at the end of 1986 (it had deteriorated seriously during that time). He also uses a Fender Telecaster Baritone that had been specially made for him under the supervision of Phil Taylor, a 1950 Gretsch Duo Jet fitted with a Bigsby vibrato tailpiece, and a Fender Deluxe lap steel.

As for the drums, Nick Mason rerecorded most of his 1993 parts: "When you revisit something you always think you can do something better or different. […] If you get the opportunity to revisit something, you do it."[169] He also brings out his Rototoms, his chimes, and his gong.

The Musicians

The musicians lending a hand to the three members of Pink Floyd on this album were drawn from a number of circles. Some were close associates of the group, such as Bob Ezrin and Andy Jackson, who play bass on several tracks, as does the excellent Guy Pratt. Jon Carin, on keyboards, is once again a part of the team, while Anthony Moore, a lyricist on the two previous albums, makes his keyboard debut on this album. Durga McBroom makes another appearance on backing vocals, while Louise Marshall and Sarah Brown contribute in this role for the first time. Also making their debut on a Pink Floyd album is the electronic string quartet Escala, consisting of Helen Nash, Honor Watson, Victoria Lyon, and Chantal Leverton. Finally, Gilad Atzmon makes a wonderful contribution on tenor sax and clarinet.

David Gilmour's custom Fender Telecaster Baritone.

Things Left Unsaid

David Gilmour, Richard Wright / 4:26

Musicians
David Gilmour: acoustic guitar (EBow), guitars
Rick Wright: Hammond organ, synthesizers, keyboards
Bob Ezrin: additional keyboards

Recorded
Britannia Row Studios, Islington, London: January 1993
Medina Studio, Hove: November 2013
Astoria, Hampton: 2013–14
Olympic Studios, London: 2013–14

Technical Team
Producers (1993): Bob Ezrin, David Gilmour
Producers: David Gilmour, Phil Manzanera, Youth, Andy Jackson
Sound Engineers: Andy Jackson, Damon Iddins, Phil Taylor (Britannia Row)

David Gilmour and Rick Wright (in 2006), still in harmony musically and intellectually on "Things Left Unsaid."

Genesis

We certainly have an unspoken understanding. But a lot of things unsaid as well, says Rick Wright; *Ah, well we shout and argue and fight*, adds David Gilmour, *and work it on out*; *The sum is greater than the parts*, concludes Nick Mason. The long musical journey along the *Endless River* is introduced by these few words spoken by each of the three members of Pink Floyd in turn. Are they evoking the group's past? Are these phrases intended as an affirmation by Gilmour and Mason of their friendship for Wright, who died in 2008? What is beyond doubt is that "Things Left Unsaid" sends the listeners back a few decades, to the floating, soaring music of *Wish You Were Here*, which, as well as being a tribute to Syd Barrett, happens to have been the keyboard player's favorite album. This musical mood is ushered in by the Hammond organ and David Gilmour's use of the EBow on his acoustic guitar.

Production

As the first piece on the album, "Things Left Unsaid" also opens the first of the four parts of *The Endless River*. The track takes the form of a highly ethereal instrumental that begins with a synth pad and synth sounds that gradually increase in volume. These sounds probably derive from the Kurzweil K2000 recorded in 1993 (alongside other keyboards). Rick Wright's voice emerges suddenly at 0:13. The last word of his phrase is subject to a highly emphatic echo with infinite repeats. Gilmour's voice is heard next, at 0:34. Then it is Nick Mason's turn to speak (0:45), his voice drenched in a kind of pre-reverb before growing more distinct. The end of his phrase is punctuated by a percussion instrument with abundant reverb. The cosmic vibe develops through numerous synth sounds, reversed guitar, and Hammond organ, before Gilmour eventually comes in on acoustic guitar (his Gibson J-200?) played with an EBow as in "Take It Back" and "Keep Talking" on *The Division Bell*. Instead of creating a loop that is then played backward, as in these earlier tracks, he plays a highly melodic solo, allowing his strings to vibrate freely under the influence of the EBow, the sound drawn out further by very present delay. The instrumental ends with the sound of Rick Wright's Hammond B-3 played through his Leslie speaker.

It's What We Do

David Gilmour, Richard Wright / 6:17

Musicians
David Gilmour: acoustic guitar, electric lead guitar, bass
Rick Wright: keyboards, synthesizers, strings
Nick Mason: drums
Recorded
Britannia Row, Islington, London: January 1993
Medina Studio, Hove: November 2013
Astoria, Hampton: 2013–14
Olympic Studios, London: 2013–14
Technical Team
Producers (1993): Bob Ezrin, David Gilmour
Producers: David Gilmour, Phil
Manzanera, Youth, Andy Jackson
Sound Engineers: Andy Jackson, Damon
Iddins, Phil Taylor (Britannia Row)

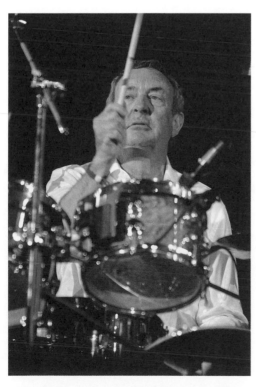

Nick Mason, whose drumming on "It's What
We Do" is instantly recognizable.

Genesis

In "It's What We Do," the seventies Pink Floyd once again takes pride of place, and it is virtually impossible not to be reminded of *Wish You Were Here*. Rick Wright's soaring synth and the utter elegance of Gilmour's guitar: it is all there. What immediately strikes the listener is that this music has aged not one bit, and continues to soothe the soul.

Production

The album's second track, which is also the second longest opens with Rick Wright on Hammond organ. This title clearly harks back to the sonorities and mood of "Shine On You Crazy Diamond." No sooner does the keyboard launch into a melodic line with a French horn sonority than the memory is jogged, causing us to wonder: have we gone back in time to 1975? The resemblance is heightened by a string pad that supports the organ. Gilmour creates a range of effects on guitar, each one outdoing what came before in terms of cosmic intensity. And then Nick Mason enters on the drums in his unmistakable style: a heavy, simple stroke that nevertheless imparts a real groove to the ensemble! David Gilmour is on bass, adopting a playing style that recalls that of Roger Waters. Over the years, Gilmour played bass uncredited on many of the group's tracks, which explains why his playing sounds so familiar. In addition to bass, he also plays numerous guitar parts in this piece. Initially he can be heard playing simple chords on an acoustic guitar (his Gibson J-200?), double-tracked in stereo (for example at 2:26), and then playing clear-toned lead, most probably on a Stratocaster. The sound is sustained by delay and he also uses his DigiTech Whammy pedal to shift octaves (listen at 2:29). His guitar gradually evolves toward a more distorted tone, and his characteristic floating phrases are truly inspired at all times. He also plays a riff on a second clear-toned guitar with tremolo generated by his whammy bar (listen at 3:37). Could this be his Fender Telecaster Baritone? In this section, Gilmour is accompanied by Wright on an electric piano of the Fender Rhodes type. Wright finally returns to his synthesized string sounds and concludes the piece in the company of Gilmour. "It's What We Do" gives the impression that the three members of Pink Floyd wanted to take the instrumental sequences of "Shine On You Crazy Diamond" a little further—to the delight of the listeners.

Ebb And Flow

David Gilmour, Richard Wright / 1:55

Musicians
David Gilmour: acoustic guitar (with and without EBow)
Rick Wright: electric piano, synthesizer
Nick Mason (?): cymbal, chimes
Recorded
Britannia Row, Islington, London: January 1993
Medina Studio, Hove: November 2013
Astoria, Hampton: 2013–14
Olympic Studios, London: 2013–14
Technical Team
Producers (1993): Bob Ezrin, David Gilmour
Producers: David Gilmour, Phil Manzanera, Youth, Andy Jackson
Sound Engineers: Andy Jackson, Damon Iddins, Phil Taylor (Britannia Row)

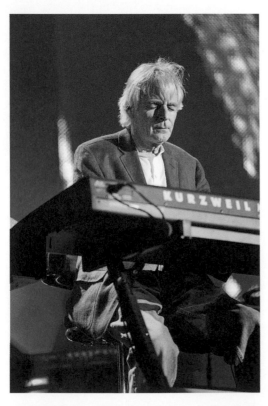

Sadness, melancholy…"Ebb and Flow" is a perfect expression of what Rick Wright went through in his twilight years.

Genesis
The first movement of the symphony that is *The Endless River* ends with "Ebb and Flow." This piece of ambient music is based around David Gilmour's EBow guitar and Rick Wright's electric piano. It gives expression to a range of sentiments: solitude, sadness, melancholy, hope in new beginnings…

Production
The tone of Rick Wright's electric piano recalls that of the Fender Rhodes, and his playing seems to invite a meditative response from the listener. The sonorous keyboard is ushered in by Nick Mason's ride cymbal (possibly sampled?) and sounds of the *Metallic Spheres* type. Its notes literally float around the stereo field, supported by a C on the synth that is sustained until the end of the track. David Gilmour contributes once more on his Gibson J-200 acoustic guitar, played lead and with the EBow as on "Things Left Unsaid." His phrases are enhanced by vast amounts of reverb and by the delay that complements the sonority of his playing so well. Chords, played again on his—this time clear-toned—acoustic guitar mark the harmonic transitions (listen at 0:42). On his last note played with the EBow, chimes ring out (at 1:20) and then a cymbal (at 1:24), introducing a coda made up of strange sonorities that are once again drowned in reverb. "Ebb and Flow" provides the perfect conclusion to this first part of the album, the three constituent pieces linking together naturally and harmoniously. In this section, Pink Floyd proposes an alternative way of appreciating their music: as a tribute to Rick Wright in the form of a quest for the absolute.

Sum

David Gilmour, Nick Mason, Richard Wright / 4:48

Musicians
David Gilmour: electric rhythm guitar, lap steel, bass, VCS3
Rick Wright: Farfisa organ, piano
Nick Mason: drums
Damon Iddins: additional keyboards

Recorded
Britannia Row, Islington, London: January 1993
Medina Studio, Hove: November 2013
Astoria, Hampton: 2013–14
Olympic Studios, London: 2013–14

Technical Team
Producers (1993): Bob Ezrin, David Gilmour
Producers: David Gilmour, Phil Manzanera, Youth, Andy Jackson
Sound Engineers: Andy Jackson, Damon Iddins, Phil Taylor (Britannia Row)

Genesis

Although the second movement of *The Endless River*, like the first, gives pride of place to the keyboard work of the late lamented Rick Wright, its orchestration is very different. The ethereal atmosphere is abandoned in favor of a more aggressive, harrowing music in which both David Gilmour and Nick Mason play an important role. The first bars of "Sum" inevitably bring to mind the psychedelic journeys of *A Saucerful of Secrets*, and even, more recently, "Yet Another Movie" on *A Momentary Lapse of Reason*.

Production

"Sum" begins with a sequence of sounds played by David Gilmour on a VCS3, Gilmour, along with Roger Waters, having been one of the first to use this synthesizer in rock music. An organ can be heard pulsating in the background: this is the same passage that occurs in the intro to "Cluster One" on *The Division Bell* (between 1:08 and 1:38). Another pulsating sound, played on Rick Wright's legendary Farfisa organ, the characteristic sound of Pink Floyd's early albums, then takes over from this strange intro (from 0:34). It plays for almost forty-five seconds until Gilmour's (Fender Deluxe?) lap steel, its sound strongly distorted and prolonged by a delay with a distinctly floating quality, is heard ringing out. The lap steel is supported by another, equally distorted, rhythm guitar. Nick Mason then comes in on the cymbals before marking each beat on his bass drum. He then accompanies virtually the rest of this rock section predominantly with tom fills, allowing Gilmour the necessary space for some very good phrases on his lap steel, and also enabling Wright's subtle work on the acoustic piano to come through. Throughout the piece, numerous effects generated on the VCS3 create a somewhat stressful atmosphere. Finally, a synth played presumably by Damon Iddins introduces a melodic line toward the end of this sequence, before "Sum" draws to a close with a final section dominated by VCS3 effects. The mood at the beginning of this movement contrasts starkly with that of the first, a salutary change of direction that enables Pink Floyd to avoid the danger of creating a work lacking in contrast.

David Gilmour and Rick Wright at London's Royal Albert Hall in 2006, with Guy Pratt, Phil Manzanera, and Steve DiStanislao.

Skins

David Gilmour, Nick Mason, Richard Wright / 2:37

Musicians
David Gilmour: electric lead guitar
Rick Wright: keyboards
Nick Mason: drums, Rototoms, gong, chimes
Andy Jackson: bass
Youth: effects

Recorded
Britannia Row, Islington, London: January 1993
Medina Studio, Hove: November 2013
Astoria, Hampton: 2013–14
Olympic Studios, London: 2013–14

Technical Team
Producers (1993): Bob Ezrin, David Gilmour
Producers: David Gilmour, Phil Manzanera, Youth, Andy Jackson
Sound Engineers: Andy Jackson, Damon Iddins, Phil Taylor (Britannia Row)

Youth (shown here in 1982), one of the creators of the Pink Floyd sound on "Skins" and the other tracks on the album.

Genesis

"Skins" is the logical continuation of the previous track. In terms of atmosphere, it is located somewhere between "A Saucerful of Secrets" and "On the Run" from *The Dark Side of the Moon*. The beating heart of this piece, which could be described as phantasmagorical, is Nick Mason's drumming.

Production

Whether consciously or not, Pink Floyd is continually revisiting the past in this album. "Skins" clearly contains something of the spirit and color of a track like "A Saucerful of Secrets," recorded in 1968. The main architects of this revival are David Gilmour and Nick Mason. The first goes in search of the shrillest possible notes, close to the bridge of his guitar (the "Black Strat"?), and almost certainly with the help of a bottleneck (or similar, given the guitarist's aversion to that particular item!). The resulting sonority is simultaneously stressful and cosmic. He also makes use of extremely spacious reverb accompanied at all times by impressive delay. Nick Mason, meanwhile, returns to a style of drumming he used to favor on the group's early albums and tracks like "Saucerful," "Remember a Day," and "Up the Khyber." It has to be said that his drumming on "Skins" is extraordinary, and far superior to his level of skill back in the day. His snare drum sounds like it has never sounded before, while his Rototom passages possess an astonishing fluidity. "I hadn't played them in a long time, apart from when I went out onstage with Roger a few years ago, when we did *Dark Side* [in 2006–07]. They needed a bit of dusting off."[171] And to make an even better job of reviving the past, he also gets out his gong, the symbol par excellence of the early years, when it was monopolized by Roger Waters (listen at 1:45). For the record, Mason had lent the gong to a store in Camden and had to reclaim it for the album: "It's probably one of those instruments that everyone probably thought would never again see the light of day, but it was so great to get it out."[171] The rhythmic part ends at 1:45 and gives way to an atmosphere in which effects, realized in part by Youth, dominate the whole of the last part of the piece. In "Skins," Nick Mason demonstrates that his talents as a drummer have been largely underestimated over the course of his career.

Unsung

Richard Wright / 1:07

Musicians

David Gilmour: electric guitar, piano, VCS3
Rick Wright: Farfisa organ, piano

Recorded

Britannia Row, Islington, London: January 1993
Medina Studio, Hove: November 2010
Astoria, Hampton: 2013-14
Olympic Studios, London: 2013-14

Technical Team

Producers (1993): Bob Ezrin, David Gilmour
Producers: David Gilmour, Phil
Manzanera, Youth, Andy Jackson
Sound Engineers: Andy Jackson, Damon
Iddins, Phil Taylor (Britannia Row)

Genesis and Production

"Unsung" is an instrumental credited exclusively to Rick Wright, and reintroduces a slightly calmer atmosphere (explained by the absence of Mason's drumming).

It is not unreasonable to wonder what the point is of this short instrumental track—the briefest on the album—which seems to have no obvious justification either rhythmic or harmonic. Conceived as a simple transition, it nevertheless possesses a certain mysterious power and appeal. "Unsung" is based around Rick Wright's pulsing Farfisa organ, high above which soars David Gilmour on his Strat, using his Whammy pedal for octave shifts, and creating sounds resembling whale song. Piano chords ring out strongly in support of the chord changes. Although most probably played by Rick Wright in the first instance, David Gilmour later reinforced these chords. Gilmour is also responsible for the various sounds produced on the VCS3. We also hear chimes and cymbals. These were probably sampled as they are not credited to Nick Mason in the album liner notes.

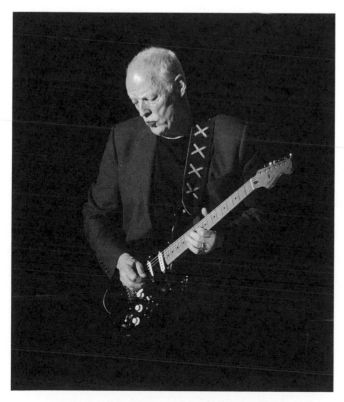

For Pink Floyd Addicts

The DigiTech Whammy is a pedal used by numerous guitarists. In addition to David Gilmour, it can be found at the feet of U2's The Edge, Matthew Bellamy of Muse, Jonny Greenwood of Radiohead, and Jack White of the White Stripes.

"Unsung," a Rick Wright composition exalted by David Gilmour's inspired guitar work

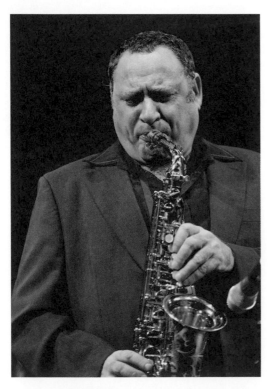

Anisina

David Gilmour / 3:16

Musicians
David Gilmour: piano, keyboards, acoustic guitar, electric rhythm and lead guitar, lap steel, bass, backing vocals
Nick Mason: drums
Gilad Atzmon: tenor sax, clarinet

Recorded
Britannia Row, Islington, London: January 1993
Medina Studio, Hove: November 2013
Astoria, Hampton: 2013–14
Olympic Studios, London: 2013–14

Technical Team
Producers (1993): Bob Ezrin, David Gilmour
Producers: David Gilmour, Phil Manzanera, Youth, Andy Jackson
Sound Engineers: Andy Jackson, Damon Iddins, Phil Taylor (Britannia Row)

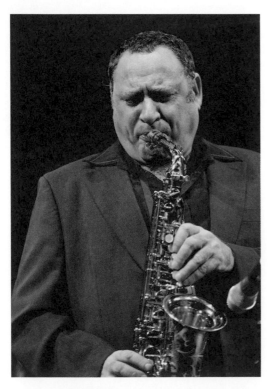

The saxophonist Gilad Atzmon, a virtuoso who brings a touch of jazz to "Anisina."

Genesis

"Anisina" brings the second part of *The Endless River* to a close. As indicated by the title, which is Turkish for "in memory of," this is a tribute to Rick Wright. However, the Pink Floyd organist is no less physically absent from this recording, the atmosphere of which is reminiscent of "Us and Them" on *The Dark Side of the Moon*. One notable difference is the presence of Gilad Atzmon, whose saxophone and clarinet add a highly distinctive touch. Like David Gilmour's, Atzmon's playing has an especially strong emotional appeal.

Production

"Anisina" is a curious ballad in which it is difficult to recognize the Pink Floyd sound—other than in David Gilmour's lap steel, perhaps. It is relatively serene in mood, devoid of both shocks and stark contrasts. An allusion to Rick Wright is clear in the opening notes on the Steinway. But that is where the resemblance ends, for what follows is pure Gilmour. Indeed David Gilmour is something of a one-man band on this track, looking after all the keyboards, the bass, and the guitars, not to mention the backing vocals! In terms of the guitar, he can be heard initially on his acoustic Gibson J-200, playing doubled chords in order to emphasize the first beat of specific bars. Instead of strumming his acoustic guitar, from the very beginning of the album, Gilmour has simply been using it to mark the beginning of the bars and transitions. He also supports the melodic motif of the piano on what is most probably a clear-toned Stratocaster (from 0:35), and answers the entry of the clarinet, played by the excellent Gilad Atzmon, with phrases on his lap steel. There follows a kind of bridge in which Gilmour sings backing vocals by himself, his several vocal tracks sounding highly ethereal. The tenor sax enters during the following sequence before being resubstituted by the clarinet, on which Atzmon plays a solo in a reasonably high register, still accompanied by Gilmour, who shifts octaves on his lap steel with the help of his Whammy pedal. The guitarist then reaches for what is almost certainly his "Black Strat," playing with a distortion that sounds as if it may have been generated by the Big Muff. It is worth noting the very good accompaniment from Nick Mason, who provides solid rhythmic support. "Anisina" ends with a very beautiful clarinet improvisation and a rainstorm atmosphere.

2014

The Lost Art Of Conversation

Richard Wright / 1:42

Musicians
David Gilmour: guitars, percussion
Rick Wright: piano, synthesizers
Recorded
Britannia Row, Islington, London: January 1993
Medina Studio, Hove: November 2013
Astoria, Hampton: 2013–14
Olympic Studios, London: 2013–14
Technical Team
Producers (1993): Bob Ezrin, David Gilmour
Producers: David Gilmour, Phil
Manzanera, Youth, Andy Jackson
Sound Engineers: Andy Jackson, Damon
Iddins, Phil Taylor (Britannia Row)

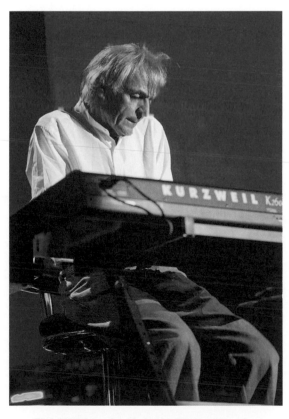

Rick Wright, who plays the Kurzweil on the
soothing "Lost Art of Conversation."

Genesis

Is it a question here of back to square one, back to "Things Left Unsaid" and "It's What We Do"? This melancholy composition by Rick Wright with obvious chill-out properties is based around Wright's piano and keyboards and David Gilmour's guitar. It would have been utterly at home on *Broken China*, the second solo album by the Pink Floyd keyboard player.

Production

The third movement of *The Endless River* thus opens with an instrumental credited to Rick Wright alone. Classifiable as ambient music, this short piece begins with floating synth pads that are again reminiscent of the intro to "Shine On You Crazy Diamond" (*Wish You Were Here*), all the more so as David Gilmour plays a clear-toned Stratocaster exactly as he does on the 1975 track. A river is heard flowing and birds singing, giving "The Lost Art of Conversation" a highly meditative feel. Wright then picks out a few notes on an acoustic piano in that unmistakable style of his. Gilmour reinforces the ethereal mood with chords that are treated to volume pedal and drenched in distant, Dantesque reverb. Despite the generally cosmic atmosphere, the Floyd keyboardist is unable to conceal his love of African American music, and the second part of the his composition develops a more bluesy, more jazzy feel. On the other hand, Gilmour takes it upon himself to add orchestral timpani, which can be heard toward the back of the mix (at 1:23). Finally, it is worth noting that the transition to the next track, "On Noodle Street," is one of the most successful and natural sounding on the album.

On Noodle Street

David Gilmour, Richard Wright / 1:42

Musicians
David Gilmour: electric lead guitar
Rick Wright: Fender Rhodes
Nick Mason: drums
Jon Carin: synthesizers
Guy Pratt: bass

Recorded
Britannia Row, Islington, London: January 1993
Medina Studio, Hove: November 2013
Astoria, Hampton: 2013–14
Olympic Studios, London: 2013–14

Technical Team
Producers (1993): Bob Ezrin, David Gilmour
Producers: David Gilmour, Phil
Manzanera, Youth, Andy Jackson
Sound Engineers: Andy Jackson, Damon
Iddins, Phil Taylor (Britannia Row)

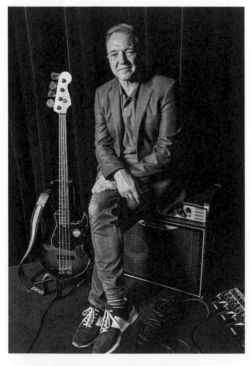

Guy Pratt, a traveling companion of
Pink Floyd for many years.

Genesis
"On Noodle Street" is one of the many pieces to emerge from the long jam sessions by David Gilmour, Rick Wright, and Nick Mason at Britannia Row Studios in 1993. The title raises a number of questions. Is it an example of Floydian humor? What kind of noodle is meant here? The edible sort? The intellectually challenged sort? The improvisatory sort?

Production
Although the transition from the preceding track, "The Lost Art of Conversation," is perfect, it has to be acknowledged that this improvisation is of relatively minor interest, other than as part of the overall instrumental concept. Nick Mason plays the same rhythmic figure from bar five without any pickup or variation and could almost be a loop. He is supported by some rather apathetic bass playing from Guy Pratt, who showed greater inspiration on the previous album. David Gilmour, who generally excels with radiant interventions on his various guitars, seems to have deliberately remained in the background, delivering a semi-funk, semi-rock accompaniment devoid of any particular brio—in other words exactly the kind of thing a guitarist cooks up on his instrument during interminable jam sessions. The only contributions that succeed in enlivening the overall atmosphere are Jon Carin's synths, with their great chord-based swells, and above all Rick Wright's Fender Rhodes, with its colorful accompaniment sounding not unlike the vibraphone, an instrument he played on Pink Floyd's first few albums. In the group's defense, it should be pointed out that "On Noodle Street" needs to be considered from a global point of view rather than as a piece in its own right. It should be seen as just piece of the puzzle—the final assembled image being the third movement of *The Endless River*.

Night Light

David Gilmour, Richard Wright / 1:42

Musicians
David Gilmour: guitars, acoustic guitar
(with and without EBow)
Rick Wright: synthesizers
Recorded
Britannia Row, Islington, London: January 1993
Medina Studio, Hove: November 2013
Astoria, Hampton: 2013–14
Olympic Studios, London: 2013–14
Technical Team
Producers (1993): Bob Ezrin, David Gilmour
Producers: David Gilmour, Phil
Manzanera, Youth, Andy Jackson
Sound Engineers: Andy Jackson, Damon
Iddins, Phil Taylor (Britannia Row)

The EBow, a guitar effect used by David Gilmour on acoustic (rather than electric, as here) guitar.

Genesis

This is ambient music in the spirit of Brian Eno or Vangelis, but benefiting from the added elegant virtuosity of David Gilmour, who once again reveals himself to be a big fan of the EBow. Meanwhile the keyboards, and more precisely the evanescent synth pads, are classic Rick Wright and have been an integral part of the Pink Floyd style ever since *A Saucerful of Secrets*.

Production

"Night Light," which to some extent recalls the intro to "Keep Talking" on *The Division Bell*, represents a dab of additional color in the sonic palette that constitutes the third movement of *The Endless River*. It may seem difficult to justify the individual constituent pieces of this movement, but by listening to them all together, their full impact can be appreciated. Rick Wright uses imposing synth pads, in which it is possible to discern sonorities ranging from strings to the organ, to generate a mood of serenity that would be the envy of many a Tibetan monk. David Gilmour accentuates this Zen atmosphere even further with guitar passages played with the EBow. His notes and effects are sustained by a delay with infinite repetitions, and are drenched in cosmic reverb. He seems to be playing a Gibson J 200 acoustic, but various guitar effects blend with his phrases, making it difficult to identify the instrument. Gilmour can nevertheless be credited with the ingenious idea of combining the sonorities of the EBow with an ethereal and meditative style of music. The result is pure magic, even if this type of instrumental piece, which relies overly on improvisation rather than on carefully thought-through composition, presents a number of weaknesses.

Allons-y (1)

David Gilmour / 1:57

Musicians
David Gilmour: electric rhythm and lead guitar, lap steel
Rick Wright: Hammond organ
Nick Mason: drums
Jon Carin: synthesizer, percussion loop
Bob Ezrin: bass
Recorded
Britannia Row, Islington, London: January 1993
Medina Studio, Hove: November 2013
Astoria, Hampton: 2013–14
Olympic Studios, London: 2013–14
Technical Team
Producers (1993): Bob Ezrin, David Gilmour
Producers: David Gilmour, Phil Manzanera, Youth, Andy Jackson
Sound Engineers: Andy Jackson, Damon Iddins, Phil Taylor (Britannia Row)

For Pink Floyd Addicts

"Allons-y" is the second title in the Pink Floyd catalog that pays tribute to the language of Molière. The first, despite its somewhat Hispanic spelling, was "San Tropez" on *Meddle*.

Genesis

Although this composition is credited to David Gilmour alone, it contains a number of allusions to the concept album *The Wall*, which at the same time demonstrate the multifaceted talent of the guitarist. Here, Gilmour is both soloist and creator of moods, one of the trademarks of Pink Floyd and a key to its success since the end of the sixties.

Production

Worked on during the rehearsals at Britannia Row Studios in January 1993, it is not difficult to see why "Allons-y (1)" was not used on *The Division Bell*. What David Gilmour has come up with here is a kind of pastiche of "Run Like Hell." So why did he include it in *The Endless River*? It remains a mystery. "Allons-y (1)" begins in similar fashion to the earlier piece, with Gilmour playing a guitar rhythm (the sound sustained by delay), each of whose triad chords has a powerful percussive snap. Nick Mason provides solid support on drums, exhibiting the sheer drive that has characterized his playing ever since the early days. He is supported in turn by Bob Ezrin on bass guitar. This is Ezrin's first contribution on bass for Pink Floyd, demonstrating (should any further proof be needed) the breadth of his musical talent. Rick Wright is on Hammond organ, displaying his customary superb command of this legendary keyboard. Meanwhile, Jon Carin is responsible for a range of synths and effects. The liner notes credit him with a percussion loop, although this is very difficult to make out. Concerning the various guitar parts, Gilmour plays a distorted solo (from 0:41), presumably on his "Red Strat" and most probably recorded in 1993. On the other hand, the particular sound of his contributions on the Fender Deluxe lap steel (listen from 0:21, toward the left of the stereo field) and the absence of this specific instrument from *The Division Bell* suggest that they were added during the 2013–14 sessions. Finally, in the bridge and at the end of the piece, Gilmour also plays a number of slightly Spanish-sounding phrases, apparently on his Fender Telecaster Baritone, with distortion and colored by vibrato. "Allons-y (1)" is a difficult piece to appraise, a task not helped by the existence of "Run Like Hell," which has admittedly been around since 1979…

Autumn '68

Richard Wright / 1:35

2014

Musicians
David Gilmour: electric lead guitar
Rick Wright: the Grand Organ of the Royal Albert Hall
Nick Mason: gong
Damon Iddins: additional keyboards

Recorded
Royal Albert Hall, Kensington, London: June 26, 1969
Medina Studio, Hove: November 2013
Astoria, Hampton: 2013–14
Olympic Studios, London: 2013–14

Technical Team
Producers (1993): Bob Ezrin, David Gilmour
Producers: David Gilmour, Phil Manzanera, Youth, Andy Jackson
Sound Engineers: Andy Jackson, Damon Iddins, Phil Taylor (Britannia Row)

The Grand Organ of the Royal Albert Hall, on which Rick Wright composed the melody of "Autumn '68."

Genesis

"Autumn '68" takes us back to the early years of Pink Floyd, which probably helps to make this piece the most moving on *The Endless River*. It was recorded by Rick Wright on June 26, 1969, on the Grand Organ of the Royal Albert Hall, a few hours before the quartet performed *The Final Lunacy* (in other words the musical concept *The Man and The Journey*) there. The composition was originally around twenty minutes long. "I think at that point, Rick was toying with ideas for writing a symphony,"[167] explains Youth, whom the group entrusted with the production of their final album in 2013. Youth took the Royal Albert Hall tapes to his studio in Spain in order to listen to them and rework them and identify places where he thought Gilmour's guitar could be introduced. Interviewed in 2014, Youth revealed that at the time he "was fighting a severe parasitic infection: I thought, 'Even if I die in a week, or a day, I've gotta finish this before I go—and don't hold back!'"[167]

Phil Manzanera has also shared an anecdote in connection with "Autumn '68," the title of which clearly echoes Rick Wright's "Summer '68" on the second side of the LP *Atom Heart Mother*: "At the time, playing the organ at the Royal Albert Hall was very controversial. When the Mothers of Invention played there, Don Preston went up and played 'Louie Louie' on the organ and it was considered sacrilege! It was a great moment of rebellion. It sounds silly, doesn't it? But it was a big deal for a rock band to get into the Royal Albert Hall."[172]

Production

When Pink Floyd gathered at the Royal Albert Hall in London for the last gig of their UK tour, Wright would take advantage of a break before the show to improvise on the Grand Organ. Andy Jackson explains how his playing came to be caught on tape: "There was a Revox and some mics going in, so it was recorded. Damon [Iddins, engineer] is also our librarian, and he tracks all the things that are coming through, and he went, 'Oooh, I'll tell you what I've got! This is great!' It's a great sound."[170] Thus it was that forty-four years later, "Autumn '68" (recorded in 1969, despite the title) resurfaced and was dusted down and enhanced by the organist's two traveling companions.

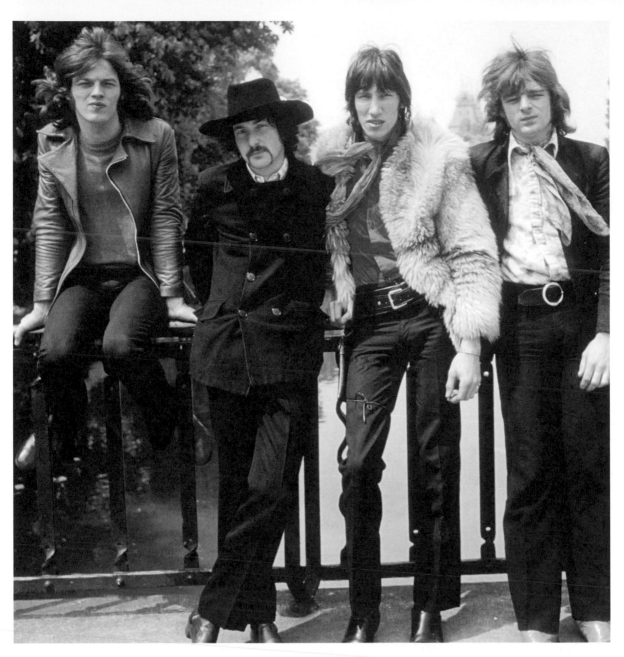
Back to 1968 for Gilmour, Mason, Waters, and Wright.

What can be said about these ninety-five seconds? They clearly possess a certain emotional charge, not least because they date back to a time when Pink Floyd was still on the verge of an incredible career. Ninety-five seconds out of a total of twenty minutes. What does the rest of the recording hold? Was this really a work in the making or was it a simple improvisation with no intended future? There are a lot of questions that "Autumn '68," in its current form at least, is unable to answer. Nick Mason's gong crashes in the introduction and intermittently throughout the piece, there are some contributions on the synthesizer from Damon Iddins, and David Gilmour plays a number of licks on electric guitar. The results are on the harrowing side. The whole thing is something of a puzzle, and all the more so as this quasi-mystical piece is sandwiched between

the two versions of "Allons-y." Whatever we might think of this short piece, however, credit must be given to Gilmour and Mason for having the generosity of spirit to revive this short testimony from a time when Rick Wright's future lay before him.

Pink Floyd was joined onstage at the Royal Albert Hall concert of June 26, 1969, by members of the brass section of the Royal Philharmonic Orchestra and the Ealing Central Amateur Choir, conducted by Norman Smith. The show culminated in the firing of two Waterloo cannons and the detonation of a gigantic pink smoke bomb. This magnificent finale earned Pink Floyd a lifetime ban from the Royal Albert Hall. Nonetheless, the group was allowed back into the hall seven months later, on February 7, 1970.

Allons-y (2)

David Gilmour / 1:32

Musicians
David Gilmour: electric rhythm and lead guitar, lap steel
Rick Wright: Hammond organ
Nick Mason: drums, gong
Jon Carin: synthesizer, percussion loop
Bob Ezrin: bass

Recorded
Britannia Row, Islington, London: January 1993
Medina Studio, Hove: November 2013
Astoria, Hampton: 2013–14
Olympic Studios, London: 2013–14

Technical Team
Producers (1993): Bob Ezrin, David Gilmour
Producers: David Gilmour, Phil Manzanera, Youth, Andy Jackson
Sound Engineers: Andy Jackson, Damon Iddins, Phil Taylor (Britannia Row)

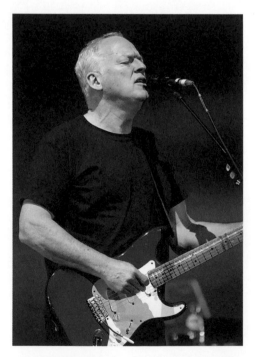

David Gilmour plays a very fine solo in the second part of "Allons-y."

Genesis and Production

"Allons-y (2)" is a reprise of "Allons-y (1)," again featuring the Pink Floyd trio plus Bob Ezrin on bass and Jon Carin on synthesizer. The transition between "Autumn '68" and "Allons-y (2)" is subtly done, with synth pads taking over from Rick Wright's organ. Nick Mason's gong rings out, after which the drummer turns his attention to his bass drum, on which he marks each beat of the bar. The piece then takes up the rhythm and theme of "Allons-y (1)," enabling David Gilmour to launch into a solo split between two guitars, one answering the other. The bridge again introduces a Spanish touch, with a number of different guitars competing to underline the main motif. It is not until the finale that we are eventually able to make out the percussion loop programmed by Jon Carin. A synth pad, gradually increasing in volume, ushers in the next track, "Talkin' Hawkin'." In truth, the two parts of "Allons-y" earn their places as a means of integrating "Autumn '68." The first part ends with a Spanish color that announces Rick Wright's organ harmonies, while the reprise restores a certain impetus to the ensemble. "Autumn '68" can therefore be seen as serving as a kind of instrumental bridge between the two parts of "Allons-y." The only drawback is the excessive resemblance of the French-titled composition to "Run Like Hell."

Talkin' Hawkin'

David Gilmour, Richard Wright / 3:29

Musicians
David Gilmour: acoustic rhythm guitar, electric rhythm and lead guitar, lap steel, backing vocals
Rick Wright: piano, Farfisa organ, synthesizer
Nick Mason: drums
Guy Pratt: bass
Durga McBroom: backing vocals
Stephen Hawking: electronic voice

Recorded
Britannia Row, Islington, London: January 1993
Medina Studio, Hove: November 2013
Astoria, Hampton: 2013–14
Olympic Studios, London: 2013–14

Technical Team
Producers (1993): Bob Ezrin, David Gilmour
Producers: David Gilmour, Phil Manzanera, Youth, Andy Jackson
Sound Engineers: Andy Jackson, Damon Iddins, Phil Taylor (Britannia Row)

Rick Wright plays in the intro of "Talkin' Hawkin'," another tribute to the famous author of *A Brief History of Time.*

Genesis

This composition continues the idea of "Keep Talking" on *The Division Bell.* In it, the Pink Floyd guitarist once again turns to statements made by scientist and author Stephen Hawking. The following words are quoted in this track: *Speech has allowed the communication of ideas, enabling human beings to work together to build the impossible. Mankind's greatest achievements have come about by talking. Our greatest hopes could become reality in the future. With the technology at our disposal, the possibilities are unbounded. All we need to do is make sure we keep talking.*

Production

This concluding instrumental of the third movement of *The Endless River* opens with effects realized on a synthesizer, possibly the VCS3. The piece begins properly with a piano riff played by Rick Wright, supported by the very good bass of Guy Pratt and some excellent drumming from Nick Mason, whose ride cymbal reinforces the aerial, floating quality of the music. Before long, David Gilmour joins the others on his Fender Deluxe lap steel, which was apparently added during the 2013–14 sessions. An initial bridge provides him with an opportunity to play solo phrases on what is almost certainly one of his Strats, and to throw off some chords on his acoustic (which he doubles), but also to provide some ethereal backing vocals alongside Durga McBroom, who had been touring with Pink Floyd since the 1987 "Momentary Lapse of Reason Tour."

In the second bridge (from 1:12), Gilmour provides a balalaika-style accompaniment on one of his guitars, the first time he has adopted this style since "Fat Old Sun" (*Atom Heart Mother*) in 1970! Stephen Hawking's voice then launches into his message (at 1:30), with the balalaika-style guitar in the background: *Speech has allowed...,* and a little later (at 1:54): *Our greatest hopes...*The final bridge of the piece gives the guitarist a chance to play some good solo licks and enables McBroom to launch into some superb vocal improvisations reminiscent of "The Great Gig in the Sky". Hawking's voice makes a final entry at 2:30: *All we need...*The piece ends with a coda dominated by Wright's Farfisa organ, whose sonority evokes Pink Floyd's past, specifically *More.* "Talkin' Hawkin'" is one of the triumphs of the album.

Calling

David Gilmour, Anthony Moore / 3:38

Musicians
David Gilmour: keyboards, electric lead guitar
Anthony Moore: keyboards
Nick Mason: percussion
Andy Jackson: effects

Recorded
Britannia Row, Islington, London: January 1993
Medina Studio, Hove: November 2013
Astoria, Hampton: 2013–14
Olympic Studios, London: 2013–14

Technical Team
Producers (1993): Bob Ezrin, David Gilmour
Producers: David Gilmour, Phil
Manzanera, Youth, Andy Jackson
Sound Engineers: Andy Jackson, Damon
Iddins, Phil Taylor (Britannia Row)

2014

A Whammy pedal, an effect much used by
David Gilmour on this album.

Genesis

The music of this first piece in the final movement of *The Endless River* is ambient through and through. The mood is nevertheless pretty dark, as if the *calling* of the title were foretelling some momentous event. This is a composition by David Gilmour and Anthony Moore, who had already worked with Pink Floyd—as a lyricist—on the album *A Momentary Lapse of Reason*. With "Calling," Moore, who is actually an experimental music and effects specialist, takes on the role of co-composer.

Production

After "Anasina," "Calling" is the second title on *The Endless River* in whose recording Rick Wright played no part. There is therefore every reason to believe that the track dates from 2013 to 2014. The tone is set in the intro by various effects deriving from multiple sources: samples, synths, and sounds deformed by highly sophisticated processes of one kind and another. The sounds pan from side to side of the stereo field, and an astral pulse surges as if from nowhere moments before the extraterrestrial signals are interrupted by a violent kettledrum beat drenched in interstellar reverb. We then hear an oriental-sounding melody, played on a synthesizer against a background of a piano or guitar string being assiduously strummed. (This, at least, is what the strange noise sounds like.) This somewhat hallucinatory atmosphere is enhanced by synth pads, while the melody is taken up initially by a synthesizer whose sound is prolonged by infinite reverb, a second time by sampled piano, and a third time by the distorted guitar of David Gilmour, who uses his Whammy pedal to execute astonishing octave shifts (listen, for example, at 2:37). Nick Mason contributes to the recording by striking his timp with considerable power, often accompanying himself on cymbals to create either dynamic punctuation marks (for example at 2:15) or crescendos (at 3:14). Toward the end of the track, the melody becomes more harmonious and accessible and less dark-hued.

Great talent and an enormous amount of skill has gone into the making of "Calling," but considered in isolation from the context of *The Endless River*, it is difficult to square the piece with the musical style of Pink Floyd.

Eyes To Pearls

David Gilmour / 1:51

Musicians
David Gilmour: electric rhythm and lead guitar, keyboards, effects
Rick Wright: Farfisa organ, Hammond organ, keyboards
Nick Mason: drums, gong
Andy Jackson: bass

Recorded
Britannia Row, Islington, London: January 1993
Medina Studio, Hove: November 2013
Astoria, Hampton: 2013–14
Olympic Studios, London: 2013–14

Technical Team
Producers (1993): Bob Ezrin, David Gilmour
Producers: David Gilmour, Phil Manzanera, Youth, Andy Jackson
Sound Engineers: Andy Jackson, Damon Iddins, Phil Taylor (Britannia Row)

Genesis

This David Gilmour composition might strike the first-time listener as bearing a resemblance to "Set the Controls for the Heart of the Sun" on *A Saucerful of Secrets* (a track moreover credited to Roger Waters). But only for the first time listening, because even if a number of references to the past can be detected in it, as a whole it does not sound anything like vintage Pink Floyd. In terms of the development of *The Endless River*, the oarsman is continuing his journey along the waterway and the final stage is approaching…

Production

David Gilmour has constructed "Eyes to Pearls" around a hook he almost certainly plays on a clear-toned Strat plugged directly into the console. Thanks in part to the reverb, the sound of the guitar and his playing are somewhat reminiscent of Hank Marvin. Gilmour accompanies himself on another guitar that serves here as bass (presumably his Fender Telecaster Baritone), colored by fairly strong tremolo. Nick Mason thickens the texture with some furious beating of his gong before supporting the rhythm on his toms. Reversed cymbals then punctuate the Hammond organ chords, calling to mind "One of These Days" (*Meddle*). This is indeed a deliberate allusion, Gilmour precisely copying the beginning of the solo he plays on that track on his double-neck Fender pedal steel guitar with Fuzz Face distortion (listen at 1:20). Nostalgia guaranteed. Andy Jackson has come out from behind the controls and plays bass for the second time on the album. (The first time was on "Skins.") Throughout the track we hear numerous synth effects and reversed sounds. "Eyes to Pearls" has an unfinished air and gives the impression of being a demo rather than a definitive version.

Nick Mason on drums in "Eyes to Pearls," which harks back to "One of These Days" from the album *Meddle*.

Surfacing

David Gilmour / 2:46

2014

Musicians
David Gilmour: acoustic guitar, lap steel, bass, backing vocals
Rick Wright: synthesizers, keyboards
Nick Mason: drums
Durga McBroom: backing vocals

Recorded
Britannia Row, Islington, London: January 1993
Medina Studio, Hove: November 2013
Astoria, Hampton: 2013–14
Olympic Studios, London: 2013–14

Technical Team
Producers (1993): Bob Ezrin, David Gilmour
Producers: David Gilmour, Phil
Manzanera, Youth, Andy Jackson
Sound Engineers: Andy Jackson, Damon
Iddins, Phil Taylor (Britannia Row)

Durga McBroom of Blue Pear, who sang
backing vocals on "Surfacing."

Genesis and Production

Credited to David Gilmour, "Surfacing" is the penultimate piece in this Pink Floyd symphony. The atmosphere of the track resembles that of "Poles Apart" on *The Division Bell*, mainly because of the acoustic guitar parts that David Gilmour arpeggiates in a similar way. There seem to be three acoustic guitar tracks here: one in the center of the stereo field and another at either extremity. Augmented by a slight delay, the strings sometimes sound a little overloaded. The sound resembles that of Gilmour's Ovation Legend 1619-4 rather than that of his Gibson J-200. Or could it be a combination of the two? Rick Wright supports the guitarist with synth pads punctuated by drum and bass crashes. Gilmour adds phrases on his Fender Deluxe lap steel before launching with Durga McBroom into backing vocals (from 0:35) that are every bit as breathy as on "Talkin' Hawkin'" on the same album. What is remarkable is that the two singers continue their vocals until the end of the piece, sounding almost like sampled backing vocals. Nick Mason ensures a metronomic beat, favoring his superb Paiste cymbals (mainly the ride). Gilmour improvises on his lap steel with a distorted sound. He always seems to be able to find the resources to play, never becoming jaded despite recording countless solos since the early days. "Surfacing" ends cleanly and logically. The last few seconds of the piece are filled with seagull sounds created by David Gilmour by playing close to the bridge of his lap steel. Intermingled with these birdcalls are church bells that usher in the last piece on the album, "Louder Than Words."

Louder Than Words

David Gilmour, Polly Samson / 6:37

Musicians
David Gilmour: vocals, acoustic guitar, electric rhythm and lead guitar, Hammond organ, effects
Rick Wright: Fender Rhodes, piano, synthesizer
Nick Mason: drums, percussion
Bob Ezrin: bass
Louise Marshall, Durga McBroom, Sarah Brown: backing vocals
Escala (Helen Nash, Honor Watson, Victoria Lyon, and Chantal Leverton): strings

Recorded
Britannia Row, Islington, London: January 1993
Medina Studio, Hove: November 2013
Astoria, Hampton: 2013–14
Olympic Studios, London: 2013–14

Technical Team
Producers (1993): Bob Ezrin, David Gilmour
Producers: David Gilmour, Phil Manzanera, Youth, Andy Jackson
Sound Engineers: Andy Jackson, Damon Iddins, Phil Taylor (Britannia Row)

David Gilmour and Polly Samson, a love that speaks louder than words...

Genesis

"Louder Than Words," the only track on the album with lyrics, brings to a close not only the Pink Floyd symphony that is this album, but also the group's musical adventure, which had begun forty-seven years before. It is with this composition, therefore, that the curtain falls for the last time on Pink Floyd's recording career. Composed by David Gilmour with lyrics by his wife, Polly Samson, this song takes stock of the relations between the members of the group, Roger Waters included, at the time of their brief reunion for Live 8 in 2005. "At Live 8, they'd rehearsed, there were sound checks, lots of downtime sitting in rooms with David, Rick, Nick, and, on that occasion, Roger," explains Polly Samson. "And what struck me was, they never spoke. They don't do small talk, they don't do big talk. It's not hostile, they just don't speak. And then they step onto a stage and musically that communication is extraordinary. So, I'd kind of made some notes at that time. I went off into my room absolutely without a piece of music, and wrote that lyric."[173] During an interview with Daniel Kreps for *Rolling Stone*, David Gilmour fills in a few more details: "Polly came up with the idea for 'Louder Than Words' as something that describes what we achieve when we make the music that we make. Neither Rick nor I are the most verbal people and so Polly was thinking it was very appropriate for us to express what we do through the music, but she's helping us describe it in words as well."[11] The lyrics, which turn the spotlight on the Pink Floyd alchemy, on the extraordinary harmony and complementarity between the four musicians (at least until the divorce from Waters), are of great lucidity. "Louder Than Words" therefore meshes perfectly with the theme that had already been explored several times by Pink Floyd since *The Dark Side of the Moon*: communication and the lack of it between human beings.

Production

Pink Floyd's last track was completed at David Gilmour's Medina Studio toward the end of the sessions for *The Endless River*. It begins with the sound of church bells, which are carried over from the previous track, "Surfacing." Are they announcing a wedding, a holiday, a celebration? Or are they harking back to "Fat Old Sun" on *Atom Heart Mother*? All that can be said for sure is that they are not here by chance,

Roger Waters and Nick Mason in May 2015, admiring the commemorative plaque at Westminster University (formerly Regent Street Polytechnic), Pink Floyd's birthplace.

AN ENVIRONMENTALLY AWARE VIDEO

Most of the video of "Louder Than Words," directed by Aubrey Powell, were shot in the Aral Sea (Kazakhstan), whose desiccation, caused by Soviet cotton field irrigation projects, has resulted in the disappearance of almost every sign of life from the area. Since the nineties, various projects have been undertaken in order to try to prevent the Aral Sea from drying up completely. This is therefore in part an environmental video…

that they convey a symbolism that the group must have wanted at this precise place on the album. After a second or two of the pealing bells, which are joined by the ticking of a metronome, Gilmour launches into arpeggios on his electric guitar (presumably his Strat). His notes are steeped in reverb and colored by a chorus effect. He is answered by chords played on an acoustic guitar, probably his Ovation Custom Legend 1619-4, almost certainly in "Nashville" tuning (as on "Comfortably Numb" and "Hey You" [*The Wall*]). This second guitar is subject to an emphatic delay whose repetitions veer off into the opposite stereo channel. Rick Wright then comes in with an acoustic piano solo in his own inimitable style. The emotional power of this solo is all the greater when one stops to consider that it is the last by the late pianist on this final Pink Floyd album. Gilmour adds another, strummed, acoustic guitar, which is supported (from 0:28) by Bob Ezrin's bass. Nick Mason makes his entrance in the first verse alongside David Gilmour, who sings what is his first lead vocal on an original recording in more than twenty years. It was Andy Jackson and Youth who persuaded him to pick up the mic again, Gilmour himself having little enthusiasm for singing, as Youth confirms: "Everyone around him was saying how he hates doing vocals, and he always leaves them to the last minute…"[175] Given Gilmour's status as one of the best rock singers in the world, whose voice is one of the Pink Floyd trademarks, this attitude comes as something

of a surprise. For "Louder Than Words" he needed to get into shape in order to regain his usual high vocal standard. "Because the studio was in his home, he'd try it every day until he got all the lines he wanted. He ended up just doing it alone. It had been a while since he sang, so he had to get his voice limbered up, a bit every day."[175] As a great fan of Leonard Cohen, it occurred to Gilmour that he could sing the refrains in a lower register and get Louise Marshall, Durga McBroom, and Sarah Brown to sing the backing vocals an octave higher. This is surprising, given his apparent facility in forcing his vocal cords. The effect is interesting, but ultimately suffers from a lack of dynamism. In addition to Mason on drums and Ezrin on bass, Gilmour supports his vocal with lead guitar and a Hammond organ part in the refrains, while Wright accompanies on Fender Rhodes and acoustic piano, and the Escala quartet, with string contributions that are discreet to say the least, is reasonably recessed in the mix (listen, for example, at 1:59). After the final refrain, Gilmour launches into one last solo, probably on his "Black Strat," with floating, soaring phrases and devoid of any trace of aggressiveness. This effect is reinforced by the backing vocals that accompany him throughout, accentuating the feeling of fluidity. It may not be one of his best-ever solos, but as always it is the emotion that counts. The piece ends with a reprise of the beginning of the first track on the album, "Things Left Unsaid."

BONUS TRACKS DVD / BLU-RAY

The deluxe edition of *The Endless River* is available on DVD and Blu-ray. The package includes a 24-page book, postcards, and a bonus disc with six videos and three new songs.

TBS9

David Gilmour, Richard Wright / 2:28

Musicians
David Gilmour: electric guitar, keyboards (?)
Rick Wright: keyboards, piano
Nick Mason: drums, percussion
Guy Pratt: bass
Recorded
Britannia Row, Islington, London: January 1993
Medina Studio, Hove: November 2013
Astoria, Hampton: 2013–14
Technical Team
Producers (1993): Bob Ezrin, David Gilmour
Producers: David Gilmour, Phil Manzanera, Youth, Andy Jackson
Sound Engineer: Phil Taylor

Genesis and Production
"TBS9" is one of the improvisations included in the original *Big Spliff* project but left aside when Gilmour, Mason, Manzanera, Jackson, and Youth began to work on the definitive structure of what would become *The Endless River*.

"TBS9" is a piece of ambient music that could easily have found a place in the first movement of the album. Based on a single hypnotic chord played by Rick Wright on the Farfisa organ, the resulting ethereal atmosphere is reinforced by multiple synth and other keyboard parts, chimes, and guitar effects generated in all likelihood on David Gilmour's lap steel. It is interesting to note the presence of various sound effects at the beginning of the piece that sound as if Nick Mason had sat down at his drum kit but not yet begun to play, his snare drum being made to vibrate by the sound of the keyboard bass notes alone. A minute later he launches his drum part for real, mainly working his various cymbals: ride, crash, and hi-hat. Wright adds a piano part, and Guy Pratt accompanies him on a bass that sounds as if it might be fretless. The finished piece reveals a potential that is worthy of being better exploited.

Phil Taylor, master of David Gilmour's guitars and sound engineer on "TBS9" and "TBS14."

TBS14

David Gilmour, Richard Wright / 4:12

Musicians: **David Gilmour:** electric lead guitar / **Rick Wright:** synthesizer, Farfisa organ, Hammond organ / **Nick Mason:** drums / **Guy Pratt:** bass / **Recorded:** **Britannia Row, Islington, London:** January 1993 / **Medina Studio, Hove:** November 2013 / **Astoria, Hampton:** 2013–14 / **Technical Team:** **Producers (1993):** Bob Ezrin, David Gilmour / **Producers:** David Gilmour, Phil Manzanera, Youth, Andy Jackson / **Sound Engineer:** Phil Taylor

Genesis and Production

"TBS14" is very much a logical continuation of the previous track. Recorded during the sessions for *The Division Bell* and also destined for inclusion in the *Big Spliff* project, like "TBS9" it failed to make it all the way to *The Endless River*.

This second bonus track has apparently been worked on and honed less than the first. It is an improvisation by the three members of Pink Floyd plus Guy Pratt. The group is working an initial theme, led by David Gilmour with a guitar motif that he tries to develop one way and another. The sound of his guitar (a Strat?) is strongly colored by tremolo,

chorus, and a delay with generous repeats. Wright is at the synthesizer before switching to the Farfisa. At 2:25 the musicians then gravitate around a second theme with a funky character driven by Guy Pratt's bass and Mason's drums. Wright plays a very interesting accompaniment on Hammond organ, as does Gilmour on rhythm guitar. As with "TBS9," the listener can feel the potential of "TBS14," and it is a matter for regret that it was not worked up more by Pink Floyd. Interestingly, Phil Taylor recorded both "TBS9" and "TBS14."

Nervana

David Gilmour / 5:31

Musicians: **David Gilmour:** electric lead guitar / **Rick Wright:** Hammond organ / **Nick Mason:** drums / **Jon Carin:** keyboards / **Guy Pratt:** bass / **Gary Wallis:** percussion / **Recorded:** **Britannia Row, Islington, London:** January 1993 / **Medina Studio, Hove:** November 2013 / **Astoria, Hampton:** 2013–14 / **Olympic Studios, London:** 2013–14 / **Technical Team:** **Producers (1993):** Bob Ezrin, David Gilmour / **Producers:** David Gilmour, Phil Manzanera, Youth, Andy Jackson / **Sound Engineers:** Andy Jackson, Damon Iddins, Phil Taylor (Britannia Row)

Genesis and Production

The third and final bonus track in *The Endless River* deluxe box set is called "Nervana." This piece, which saw the light of day during a jam session during the recording of *The Division Bell*, evolves around a very heavy metal guitar riff by David Gilmour. It inevitably brings to mind "The Nile Song" on the soundtrack to the movie *More*. A more probable explanation is that it was inspired by the groups on the grunge scene that were all the rage during the first half of the nineties, especially Nirvana. Hence the title…"Nervana."

David Gilmour plays a long, distorted intro on his 1950 Gretsch 6121 Chet Atkins, fitted with a Bigsby. After

thirty-seven seconds, he launches into a riff of a relatively unusual kind for Pink Floyd. The rest of the group enters in support of their guitarist after a few bars. Rick Wright is on Hammond organ, Jon Carin on keyboards, Guy Pratt on bass, Nick Mason on his Drum Workshop kit, and Gary Wallis on percussion. Gilmour ends the instrumental, which would have benefited from being sung, with a solo on his Gretsch in the best tradition of rock 'n' roll (from 3:34). "Nervana" is a good rock number, but lacks any great originality, and it is not difficult to see why a place could not be found for it on *The Endless River*.

Glossary

Bend: a guitar technique in which the guitarist pulls on a string with a finger of his or her fretting hand in order to raise a note by a semitone or more.

Bottleneck: a tube of glass (or metal) that guitarists place on one finger and then slide along the strings to produce a metallic sound. This style of playing originated with the pioneers of the blues, who indeed used the neck of a glass bottle. The bottleneck is generally used in *open tuning*, in other words when the instrument's six open strings form a chord (G or D, for example).

Break: an instrumental interlude that interrupts the development of a song. A hiatus, in other words, that eventually reintroduces the main musical material.

Bridge: a musical passage connecting two parts of a song. The bridge generally links the verse to the refrain.

Chicago blues: there are several different types of Chicago blues. Electric Chicago blues, an amplified version of Delta blues, is embodied mainly by the artists of Chess Records, from Willie Dixon to Howlin' Wolf via Muddy Waters and Sonny Boy Williamson II.

Coda: this Italian term denotes an additional section, of varying length, that concludes a song or track.

Compressor: an electronic circuit that serves to amplify low-volume sounds or, conversely, to reduce high-volume sounds during recording or mixing.

Cover: a recording or performance of a preexisting song or track, usually in an arrangement that differs from the original version.

Cowbell: a percussion instrument used in popular music (such as rhythm 'n' blues) as well as in classical music (Gustav Mahler, Richard Strauss) and avant-garde music (Karlheinz Stockhausen, Olivier Messiaen) in the European tradition.

Delay: an electronically obtained effect that retards a sound signal by feeding it back to the initial signal, repeating it the desired number of times. Similar to the echo.

Effects pedal: a small electronic device whereby the sound of an instrument is subjected to a particular effect. Generally operated by foot, as in the case of the fuzz box, there are also wah-wah, distortion, chorus, delay, and flanger pedals, among others.

Fade-in: the process of gradually increasing the sound (generally at the beginning of a song).

Fade-out: the process of gradually reducing the sound (generally at the end of a song).

Fretless (bass): a (generally electric) bass guitar whose frets have been removed in order to approximate the sound of the upright bass. One of the masters of the fretless bass was Rick Danko of the Band.

Fuzz: a distorted sound effect obtained by saturating the sound signal, mainly by means of a foot pedal known as the fuzz box. The Rolling Stones, along with the Beatles ("Think for Yourself") and Jimi Hendrix ("Purple Haze"), were pioneers of the fuzz box. This effect is used mainly on guitars.

Groove: the moment when musicians, in total communion with one another, imbue a song or track with its own special atmosphere, an alchemical process that takes in both rhythm and harmony and is felt by all the musicians as one.

Jam: a generally informal and improvised gathering of musicians motivated as a rule by the mere pleasure of playing together.

Kazoo: a device with a membrane that modifies the sound of the voice. Originally from Africa, it was adopted by blues, folk, and subsequently rock musicians.

Larsen: a physical phenomenon that occurs when an amplified output (the speakers of an amp, for example) is located too close to an input device (especially the pickup of an electric guitar or a singer's mic). This results in a hissing noise or a strong buzz. Since the sixties, this feedback effect has been much used by rock guitarists. The best example can be heard in the guitar intro to the Beatles' "I Feel Fine," which is often cited as the very first Larsen effect recorded on disc.

Lead: a term that denotes the principal voice or instrument on a song or track (*lead* vocal or *lead* guitar, for example).

Leslie speaker: a cabinet housing a rotating loudspeaker, typically used with Hammond organs. The swirling acoustic effect can be adjusted as required.

Lick: a short musical phrase within a well-defined musical style (blues, rock, country, jazz, etc.), played to complement or accompany the arrangement and/or melodic line of a song.

Mute: a technique to turn off the sound on a channel strip. Alternatively, the term is used to mean deadening a string on a guitar.

Nashville tuning: a branch of country and western music that developed in the Tennessee city in the fifties, characterized by the use of string sections and backing vocalists, and representing a clear break with authentic hillbilly.

Open tuning: an alternative method of tuning a guitar to obtain a chord made up generally of the six open strings. This technique (for example, open G, D, and A tunings) is commonly used in the blues.

Overdubbing/overdub: a procedure by means of which additional sounds (for example, a guitar part or a second voice) are added to a recording. (See also: *Rerecording*.)

Palm mute: a guitar technique that involves stopping the strings with the right hand (in the case of right-handed guitarists), while simultaneously playing the notes with a pick.

Pattern: a sequence that recurs throughout a track and that can be repeated indefinitely to form a loop.

Phasing: an electronic effect that subjects the audio signal to various filters and oscillators, allowing a more rich and powerful sound to be obtained, especially on distorted guitars.

Playback: the partially or fully formed instrumental part of a song that provides the singer or instrumentalist with an adequate musical basis over which to record his or her performance.

Power chord: this type of guitar chord is made up of two notes, the tonic and the fifth, and is highly effective in rock music, above all when combined with distortion.

Premix: a rough mix or stage in the recording process that consists of mixing the various tracks of a multitrack tape recorder to gain an idea of the progress made so far.

Rerecording: a technique for recording one or more tracks while listening to a previously recorded track or tracks.

Reverb: an effect created in the studio, either electronically or using a natural echo chamber, in order to provide certain sounds (particularly voices) with a sense of space and acoustic relief during the recording or mixing process.

Riff: a short phrase that recurs regularly throughout a song or track.

Rimshot: a drumming technique that involves striking the rim and head of the snare drum (or tom) at the same time. This produces an accented, attacking sound.

Roots: this term, used as both a noun and an adjective, denotes a return to the origins of popular music, from blues to Appalachian music.

Score: a notated musical arrangement.

Shuffle: a musical style that originated in Jamaica in the fifties, a kind of rhythm 'n' blues that can be seen as a forerunner of ska. Also, a slow rhythm practiced by slaves.

Songwriter: a term used in the United States to denote a single individual who writes both the words and the music of a song.

Strumming: a guitar technique that involves brushing the right hand (in the case of right-handed guitarists) across the strings, with or without a pick. This is one of the most widespread techniques employed on the instrument.

Sustain: the ability of an instrument to maintain a note over time. This is a property not least of electric guitars, on which it is frequently extended by various artificial means, such as distortion, sustainer pedals, and the like.

Topical song: a song prompted by a politically or socially conscious movement and dealing with a specific event.

Track listing: the list of songs on an album.

Walking bass: a style of bass guitar accompaniment (and left hand on the piano) that involves playing a single note on each beat of the bar. Boogie-woogie pianists made this style of playing their own in the honky-tonks of the southern United States during the early years of the twentieth century.

Bibliography

The works here have served as references for the analysis of the songs.

1 Blake, Mark. *Pink Floyd: Pigs Might Fly*. London: Aurum Press, 2007.

2 Watkinson, Mike, and Pete Anderson. *Crazy Diamond: Syd Barrett & the Dawn of Pink Floyd*. London: Omnibus Press, 1991.

3 Miles, Barry. *Pink Floyd: The Early Years*. London: Omnibus Press, 2006.

4 Wale, Michael. *Vox Pop: Profiles of the Pop Process*. London: George G. Harrap, 1972.

5 Mason, Nick. *Inside Out: A Personal History of Pink Floyd*. London: Weidenfeld & Nicolson, 2004.

6 Blake, Mark. *Comfortably Numb: The Inside Story of Pink Floyd*. Boston: Da Capo Press, 2008.

7 Chapman, Rob. *Syd Barrett and British Psychedelia: Faber Forty-Fives: 1966–1967*. London: Faber & Faber, 2012.

8 Jones, Nick. "Freaking Out with the Pink Floyd," *Melody Maker*, 1967.

9 Fitch, Vernon. *Pink Floyd: The Press Reports*. Ontario, Canada: Collector's Guide Publishing, 2001.

10 Parker, David. *Random Precision: Recording the Music of Syd Barrett, 1965–1974*, London: Cherry Red Books, 2001.

11 Miles, Barry. *London Calling: A Countercultural History of London Since 1945*. London: Atlantic Books, 2010.

12 *New Musical Express (NME)*, June 10, 1967.

13 Interview with Norman Smith, *Sound on Sound*, May 2008 (cited in the Beatles Bible).

14 Perrone, Pierre. "Norman Smith: Engineer for The Beatles, Producer for Pink Floyd and, Briefly, a Pop Star," *Independent*, March 7, 2008.

15 Laing, Dave. Interview with Norman Smith, *The Guardian*, March 11, 2008.

16 Interview with Phil May by Richie Unterberger, June 1999, www.richieunterberger.com.

17 Palacios, Julian. *Syd Barrett & Pink Floyd: Dark Globe*. London: Plexus Publishing, 2008.

18 Cavanagh, John. *Pink Floyd's The Piper at the Gates of Dawn*. London: Bloomsbury Academic, 2003.

19 Interview with Vic Singh by Mike Goldstein and RockPoP Gallery, September 2007, www.rockpopgallery.com.

20 "A Rambling Conversation with Roger Waters Concerning All This and That," *Wish You Were Here Songbook*, 1975, www.ingsoc.com.

21 Interview with Jenny Spires by Michelle Coomber, June 16, 2015, www.eyeplug.net.

22 Wilhelm, Richard. *Yi King: The Book of Transformations*. Paris: Health & Beauty Editions, 1994.

23 *Top Pops & Music Now*, November 1967.

24 *NME*, November 1967.

25 Povey, Glenn. *Pink Floyd*. London: 2008 (French translation: Denis-Armand Canal, Paris: Place of the Victories Editions, 2009).

26 *Jam! Music*, "All the Wright Answers from Pink Floyd's Keyboardist," interview with Rick Wright, December 18, 1996, www.pink-floyd.org.

27 Scott, Ken, and Bobby Owsinsky. *Abbey Road to Ziggy Stardust: Off the Record with The Beatles, Bowie, Elton & So Much More*. Los Angeles: Alfred Music Publishing, 2012.

28 Interview by David Sinclair, *Guitar Heroes*, May 1983.

29 Interview by Alan Di Perna, *Guitar World*, February 1993.

30 *Mojo*, November 2004.

31 *Recording Magazine*, interview by Cyril Vautier, January 2004.

32 *Q Magazine*, December 1992.

33 Interview with Steven Cerio, www.stevencerio.com.

34 Interview with Roger Waters, *ZigZag Magazine*, June 1973.

35 Interview with Syd Barrett, 1968, http://forums.stevehoffman.tv.

36 MacDonald, Bruno. *Pink Floyd: Through the Eyes of…the Band, Its Fans, Friends and Foes*. London : Da Capo Press, 1997.

37 *Mojo*, December 2009.

38 Interview by Melanie Geffroy, *Rolling Stone*, July 12, 2016, www.rollingstone.fr.

39 *Mojo*, May 1994.

40 Gonin, Philippe. *Pink Floyd: Atom Heart Mother*. CDNP, 2011.

41 *Mojo*, July 1995.

42 Chapman, Rob. *A Very Irregular Head: The Life of Syd Barrett*. Boston: Da Capo Press, 2012.

43 Interview of David Gilmour, September 15, 2008, www.guitarworld.com.

44 *The Remarkable Roger Barrett* (at 3:27), documentary, Chrome Dreams, 2006.

45 Harris, John. *The Dark Side of the Moon: The Making of the Pink Floyd Masterpiece*, London: Harper Perennial, 2006.

46 Shea, Stuart. *Pink Floyd FAQ: Everything Left to Know…and More!* New York: Backbeat Books, 2009.

47 Interview of Rick Wright, *Top Pops & Music Now*, September 15, 1969.

48 Interview of Barbet Schroeder by Hannah Benayoun, www.festival-cannes.co.

49 Interview of Barbet Schroeder, DVD *More*, M6 Video.

50 Paringaux, Philippe. *Rock & Folk*, September 1969.

51 Interview of David Gilmour, *Classic Guitar*, 2006, www.musicradar.com.

52 *Beat Instrumental*, January 1970.

53 Schaffner, Nicholas. *Saucerful of Secrets: The Pink Floyd Odyssey*. London: Sidwick & Jackson, 1991.

54 Interview of Storm Thorgerson, www.nme.com.

55 Radio program presented by Nicky Horne, *The Pink Floyd Story*, in six episodes, broadcast in December 1976 to January 1977 on Capitol Radio, London, on www.brain-damage.co.uk/pink-floyd-band-interviews/december-24th-1976-capital-radio-pf-story-p.html.

56 Interview of Roger Waters, *Sounds*, October 1970.

57 *The Carillon* (student magazine), October 16, 1970.

58 Interviews of Nick Mason and Rick Wright by Ted Alvy, KPPC-FM, Pasadena CA, October 16, www.pinkfloydz.com.

59 Bootleg recording of the concert on January 23, Théâtre des Champs-Élysées, Paris.

60 Geesin, Ron. *The Flaming Cow: The Making of Pink Floyd's Atom Heart Mother*. Stroud, UK: History Press, 2013.

61 Interview of Angus MacKinnon, *NME*, February 12, 1977.

62 Interview of David Gilmour, *The Sun*, September 26, 2008.

63 *Rock Milestones: Pink Floyd Meddle*, DVD, Edgehill Publishing/Hurricane International

64 Jones, Cliff. *Another Brick in the Wall: The Stories Behind Every Pink Floyd Song*. New York: Broadway Books, 1996.

65 Thorgerson, Storm. *Mind over Matter: The Images of Pink Floyd*. London: Omnibus Press, 2015.

66 Interview of Jean-Charles Costa, *Rolling Stone*, January 6, 1972.

67 *NME*, November 13, 1971.

68 *Rock & Folk*, March 1972.

69 *La Vallée*, DVD, M6 Video, 2015.

71 *Guitar World*, April 27, 2012.

72 Interview by Mark Paytress, *Mojo*, December 2008.

73 Interview of Adrian Maben, *Pink Floyd: Live at Pompeii*, DVD.

74 Interview of Barbet Shroeder by Jean-Michel Guesdon.

75 *Guitar World*, September 15, 2008.

77 Interview of Dominique Blanc-Francard by Jean-Michel Guesdon.

78 Interview of Peter Erskine, *Disc*, June 17, 1972.

79 Interview of Andrew Means, *Melody Maker*, June 17, 1972.

80 Gonin, Philippe. *Pink Floyd. The Wall*. Marseille, France: The Word and the Rest, 2015.

81 *Uncut*, "The Ultimate Music Guide, Pink Floyd," April 2015 (Special Issue).

82 *Mojo*, March 1998.

83 *The Making of The Dark Side of the Moon*, DVD, Eaglevision, 2003.

84 www.fastcodesign.com

85 Interview of David Cavanagh, *Uncut*, November 2013.

86 Interview of Mitch Gallagher, *Premier Guitar*, March 9, 2012.

87 Interview of Roger Waters, *Rolling Stone*, September 6, 1982.

88 *Guitar Heroes*, May 9, 1983.

89 *Rolling Stone*, May 15, 2003.

90 Interview of Rick Wright, *The Pringle Show*, Montréal Radio, December 1978.

91 www.pink-floyd.org

92 Rose, Phil. *Which One's Pink? An Analysis of the Concept Albums of Roger Waters & Pink Floyd*. Ontario, Canada: Collector's Guide Publishing, 1998.

93 "Questions and Answers with David Gilmour," June 1994, www.pink-floyd.org.

94 Interview of Alan Parsons, www.ultimate-guitar.com.

95 Interview of Nick Kent, *NME*, November 1974.

96 Allan Jones interview, *Melody Maker*, September 09, 1975.

97 Interview by Peter Erskine, *NME*, September 20, 1975.

98 Interview by Robert Christgau, *The Village Voice*, December 1, 1975.

99 Interview by Richard Buskin, *Sound on Sound*, December 2014.

100 Cooper, Gary and Nick Sedgewick. *Pink Floyd: Wish You Were Here Songbook: An Interview with David Gilmour*. London : Pink Floyd Music Publishers, 1975.

101 Interview with Brian Humphries, *Circus Magazine*, September 1975.

102 Gilmour, David. *The Story of Wish You Were Here*, DVD, Eagle Vision, 2012.

103 *Circus Magazine*, September 1975.

104 Taylor, Phil. *Pink Floyd: The Black Strat, A History of David Gilmour's Black Fender Stratocaster*. Milwaukee, WI: Hal Leonard Books, 2008.

105 *Rock & Folk*, January 1976.

106 "A Rambling Conversation with Roger Waters Concerning All This and That," www.pink-floyd.org.

107 Interview with Jim Beviglia, December 9, 2015, http: // americansongwriter.com.

108 Dallas, Karl. "Floyd's Soundtrack Becomes New Album," *Melody Maker*, August 7, 1982.

109 Fricke, David. "Pink Floyd: The Inside Story," *Rolling Stone*, November 19, 1987.

110 *Guitar World Presents Pink Floyd*. Milwaukee, WI: Hal Leonard Books, 2002.

111 Interview with Karl Dallas, *Melody Maker*, January 29, 1977.

112 Interview with Frank Rose, *Rolling Stone*, March 24, 1977.

113 Interview with John Harris, *Mojo*, December 2004.

114 Dallas, Karl. *Bricks in the Wall*. New York: Shapolsky Publishers, 1987.

115 Interview with Gerald Scarfe, January 2016, www.teamrock.com.

116 *Guitar World*, October 2009.

117 *Mojo*, December 1999.

118 *Circus*, March 1980.

119 Interview with Bob Ezrin by David Kunow, October 9, 2011, www.consequenceofsound.net.

120 Interview by Chris Brazier, *Melody Maker*, December 1, 1979.

121 Interview by Kurt Loder, *Rolling Stone*, February 7, 1980.

122 *Rock & Folk* (Special Issue), *Disco 2000: The Essentials*, 1999.

123 *Mojo*, October 1999.

124 Interview with Gerald Scarfe, August 2007, http:// rockpopgallery.typepad.com.

125 Interview with Chris Brazier, *Melody Maker*, December 1, 1979.

126 Interview with Roger Waters by Tommy Vance, *The Friday Rock Show*, BBC Radio 1, November 30, 1979, www.pink-floyd.org.

127 White, Timothy. *Rock Lives: Profiles and Interviews*. New York: Henry Holt, 1990.

128 Article of Sean Michaels, *The Guardian*, March 2013.

129 Interview by Ryan Lipman, February 1, 2013, www.dailytelegraph.com.

130 Interview by Denise Winterman, *BBC News Magazine*, October 2, 2007, www.news.bbc.co.uk.

131 Interview by James Wood, *Guitar World*, 2012.

132 *Rock Compact Disc Magazine*, no. 3, September 1992.

133 Interview by Matt Resnicoff, *Musician Magazine*, August 1992.

134 Interview of by Joe DiVita, January 2016, www.loudwire.com.

135 *Uncut*, May 2007.

136 *Uncut*, intro Final Cut, June 2004.

137 Interview of Roger Waters, http://ultimateclassicrock.com.

138 *Sounds Magazine*, May 1983.

139 *Melody Maker*, March 19, 1983.

140 Interview of Roger Waters by Chris Salewicz, August 14, 1987, www.rocksbackpages.com.

141 Interview of Andy Jackson by Craig Bailey, January 2001, www.floydianslip.com.

142 *Penthouse*, September 1988.

143 *NME*, September 12, 1987.

144 Interview with David Gilmour by Karl Dallas, 1995, https://kdarchive.wordpress.com.

146 "Inside David Gilmour's Astoria Houseboat Recording Studio," September 24, 2009, www.newshub.co.nz.

147 www.carmineappice.net

148 http://floydlyrics.blogspot.fr/

149 *Only Music*, December 1987.

150 Interview of David Gilmour on Australian Radio, 1988, www.pink-floyd.org.

151 Liner notes, "Shine On You."

152 Interview of David Gilmour by Joe Bosso and Bill Milkowski, *Guitar World*, January 1988.

153 *In the Studio with Redbeard*, March 15, 1994, www.inthestudio.net.

154 *Vox*, interview by Stephen Dalton, May 1994, in *Uncut, The Ultimate Music Guide, Pink Floyd*, April 2015.

155 Interview by Tommy Udo, *NME.*, April 9, 1994 in *Uncut, The Ultimate Music Guide, Pink Floyd*, April 2015.

156 Interview by Tom Graves, *Rolling Stone*. June 16, 1994.

157 *Batterie Magazine*, no. 70, July–August 1994.

158 Interview of Andy Jackson, November 26, 2004, www.floydianslip.com.

159 www.vice.com/en_us/article/ meet-the-teenage-egyptian-artist-behind-pink-floyds-new-album-art

160 Interview of Rick Wright by Mark Blake, August 1996, www.pink-floyd.org.

161 *USA Today*, April 25, 1994.

162 Interview by Brad Tolinski, *Guitar World*, September 1994.

163 *Q Magazine*, November 1994.

164 Interview of Nick Laird-Clowes by Will Harris, "Nick Laird-Clowes of The Dream Academy," 2015, www.rhino.com.

165 "Questions and Answers with David Gilmour," June 1994, www.pink-floyd.org.

166 Interview by Adam Sweeting, *The Guardian*, September 16, 2008.

167 Interview by Michael Bonner, *Uncut*, March 4, 2015.

168 Interview by Kory Grow, *Rolling Stone*, October 2, 2014.

169 Interview by Andy Greene, *Rolling Stone*, October 31, 2014.

170 Interview by Mike Mettler, *The SoundBard*, October 22, 2014.

171 Interview by Mike Mettler, *Digital Trends*, November 10, 2014.

172 *NME*, September 26, 2014.

173 *Entertainment Weekly*, September 16, 2015.

174 Kreps, Daniel. "David Gilmour on Pink Floyd: 'It's a Shame, but This Is the End,' *Rolling Stone*, October 9, 2014.

175 *Uncut*, November 2014.

Translation by Richard George Elliott and Jackie Smith by arrangement with Cambridge Publishing Management

Jacket design by Amanda Kain
Cover copyright © 2017 by Hachette Book Group, Inc.

Original title: *Pink Floyd, La Totale*
Texts: Jean-Michel Guesdon and Philippe Margotin
Published by Éditions du Chêne/EPA—Hachette Livre 2017

Black Dog & Leventhal Publishers
Hachette Book Group
1290 Avenue of the Americas
New York, NY 10104

www.hachettebookgroup.com
www.blackdogandleventhal.com

First English-language Edition: October 2017

Black Dog & Leventhal Publishers is an imprint of Hachette Books, a division of Hachette Book Group. The Black Dog & Leventhal Publishers name and logo are trademarks of Hachette Book Group, Inc.

The publisher is not responsible for websites (or their content) that are not owned by the publisher.

The Hachette Speakers Bureau provides a wide range of authors for speaking events. To find out more, go to www. HachetteSpeakersBureau.com or call (866) 376-6591.

LCCN: 2017930325
ISBNs: 978-0-316-43924-4 (hardcover), 978-0-316-43923-7 (ebook)

Printed in China

1010

10 9 8 7 6 5 4 3